The Photobook:
A History *volume 1*
Martin Parr and Gerry Badger

ΦΦ

Phaidon Press Limited
Regent's Wharf
All Saints Street
London N1 9PA

Phaidon Press Inc.
180 Varick Street
New York, NY 10014

www.phaidon.com

First published 2004
Reprinted 2005, 2007 (twice), 2012
© 2004 Phaidon Press Limited

ISBN 978 0 7148 4285 1

A CIP catalogue record for this book
is available from the British Library.

Designed by HDR Visual
Communication
Printed in Hong Kong

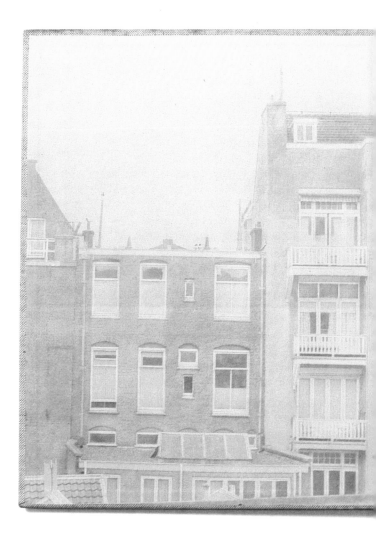

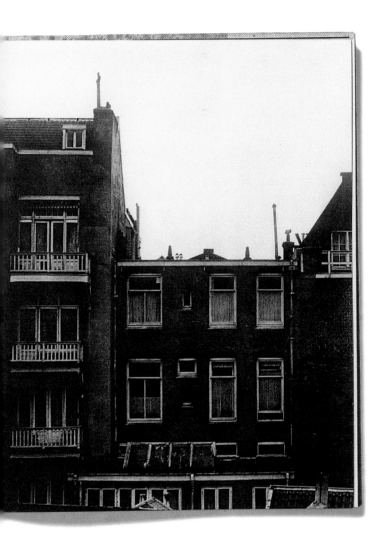

Joan van der Keuken and Remco Campert **Achter Glas** (Behind Glass)
C de Boer Jr, Amsterdam, 1957

Preface
by Martin Parr

For many years, I've been obsessed with the photobook. This two-volume publication is a manifestation of that obsession. When I was studying photography at Manchester Polytechnic in 1971, I remember buying a second edition of Robert Frank's *The Americans* (1959). It was the first book I'd ever bought for myself. An inspiring teacher, it opened my eyes to the true potential of photography; it showed me that the medium can interpret feelings as well as describing places. But it also alerted me to the way in which a well-made book can bring a group of photographs to life. The combination of remarkable images and good design in a book that is beautiful to open and pleasurable to leaf through is an ideal way of conveying a photographer's ideas and statements. This understanding launched my mission to locate these rare books, both new and old. I became hooked on the idea of the photobook, and my collection slowly expanded.

My subsequent major moments of photographic inspiration have also come through books. For example, Nobuyoshi Araki's *Shokuji* (The Banquet, 1993) and Dr H Killian's *Facies Dolorosa* (1934) expanded my ideas about what photography can do. While the former demonstrated the potential of technical or stylistic devices such as the ring flash and the close-up, the latter emphasized the value of the vernacular in photography. Although it was simply motivated by a doctor's desire to record the symptoms of his patients, it crossed the boundary from science into art.

I find it an amazing idea that a volume of photographs, even one from the distant past, can explode into life at any time, when stumbled upon by a sympathetic reader. As one turns the pages, they can provide a flash of inspiration, changing the way in which both photographers and other readers think about the world. In terms of researching the history of photography, the photobook is the final frontier of the undiscovered; one is constantly coming across new finds. This makes the search for these elusive new titles all the more exciting. About twelve years ago I went on a trip to Tokyo, on the look-out for some original books by master Japanese photographers such as Shomei Tomatsu. Having wandered into Jimbocho, an area of Tokyo crammed with second-hand book shops, I was pleased to find a copy of Tomatsu's *11.02 Nagasaki* (1966). I was familiar with the pictures but had not seen the original book. With its powerful gravures and strong design, the book was a much more impressive vehicle for the images. Next to it was an even bigger treat: a copy of Daido Moriyama's *Sashin yo Sayonara* (Bye Bye Photography). Published in 1972, this dictionary of ideas and techniques exploring contemporary Japanese life is a wonderful, radical book. Now, Moriyama is fêted throughout the world and *Sashin yo Sayonara* is an acknowledged masterpiece, but in those days he was hardly known outside Japan. This alerted me to the fact that although we're familiar with the famous photobooks from Europe and the United States, we know very little about what has been published outside these territories.

Japanese photobooks also demonstrate the way in which photographers learn and gain inspiration from such books as they circulate around the globe. Key Western publications like Andy Warhol's

catalogue to his exhibition at the Moderna Museet, Stockholm, of 1969 and Ed van der Elsken's *Een Liefdesgeschiedenis in Saint Germain des Prés* (Love on the Left Bank, 1956) are good examples of books that have stimulated the expansion of photographic language and ideas in Japan.

My work as a photographer has taken me all around the world. In each country I encounter dealers and photographers who have excellent knowledge of their particular photographic history and culture. I've hardly met a photographer over the past few years without asking for a list of his or her favourite books. Whenever possible, I try to locate and purchase these volumes. I also jump at any opportunity to visit a good collection of books, since there is no better way of learning than seeing the discoveries of other collectors. Talking to book dealers and collectors, and expanding my own collection, I became increasingly aware of how much more there was to learn. There is no scholarly consensus as to exactly what books are out there, and no comprehensive listing of the world's most important photographic books. This was how the initial idea for this publication came about. Not only would it provide this basic information, but it would also narrate a new history of photography through the specific story of the photobook.

The photography critic Gerry Badger was the ideal writer for such a study, due to his expertise in this area and his broad knowledge of the history of photography. We divided the publication into chapters, each covering a group of books with a particular identity. It soon became clear that we had too many entries for one book, so we extended the project to two volumes of nine chapters each. Volume I starts with the nineteenth century and because it includes Japanese photography, which emerged as a major force in the late 1950s but continues to excel today, it takes us roughly up to the 1990s. While the second volume deals mainly with contemporary work, we do revisit the nineteenth century and the early part of the twentieth when we focus, for example, on books produced by companies and the role of the picture editor. In all, the volumes feature roughly 450 books, with each group prefaced by an introductory text and every book given its own individual entry.

Since it's easier to spot the landmarks of photographic publishing with the benefit of hindsight, the greatest challenge of this project has been to identify the contemporary works that are likely to become classics of the future. The task is further complicated by the sheer numbers of high-quality books currently being produced. The insights and knowledge of my fellow photographers have been invaluable here, since they tend to have a good nose for the book that transcends the ordinary and will age well.

All histories are of course subjective, and these volumes are no exception. What we have done is to try and start this project without preconceptions. No book or photographer has been automatically included just because the official history dictates it; many key figures from other histories have been excluded. And we've omitted a number of great photographers because they've never made a great book. Some photographers, such as Lee Friedlander and Eikoe Hosoe, had a particular talent for making exciting books, and thus have been honoured with more than one entry. We've also been keen to include innovative or rigorous books by unknown and even anonymous photographers.

In the end, our selection inevitably constitutes a highly subjective list, with which many people will disagree. But we have gone out of our way to be inclusive, welcoming books from countries beyond the usual European–American axis, which are normally overlooked in other histories. I believe we've achieved the correct balance between celebrating some of the famous high points of photographic publishing and discovering many new, exciting and brilliant books that have been patiently waiting to explode into life.

Introduction
The Photobook: Between the Novel and Film

There are countless reasons why photographers take pictures, and many uses to which those pictures are put. Some take photographs to express themselves creatively, some to record their view of the world, some to change our perception of the world, some simply to pay the mortgage. Photographs can function as historical documents, as political propaganda, as pornography, as repositories for personal memories, as works of art, as fact, fiction, metaphor, poetry. The medium has such a diversity of aims and ambitions – creative, utilitarian, propagandist, therapeutic, shamanistic – that a single shared history would seem to be an impossible conceit. From its very inception, photography predicated different histories, for it was conceived as the hybrid offspring of art and science, partly a surrogate method of making paintings, partly a new tool for garnering empirical knowledge, a new way of discovering the world. We have come to learn that the history of art is not unitary and all-inclusive; the history of photography is even less so.

Traditionally, there have tended to be two main kinds of photographic history: one focused on technical developments – the technological approach – the other on aesthetics, dealing with the 'great' photographers and their 'masterworks' – the formalist approach. The two most widely distributed histories prior to the 1970s, by Beaumont Newhall and Helmut Gernsheim respectively,[1] attempted an amalgamation of both, but with the aesthetic firmly at the top of the agenda. A few prescient individuals in the 1930s, notably Robert Taft, Gisèle Freund and Walter Benjamin,[2] concerned themselves with the socio-political implications of photography, but only since the advent of postmodernism and representational theory has the imbalance in favour of the aesthetic been rectified by socio-cultural studies of the medium. Photography is not like fine art – a specific, somewhat hermetic area of cultural practice located within a fairly rigid socio-economic spectrum. It is both an art medium and a mass medium, and it is a number of other things as well.

The story told here embraces the aesthetic and the technical, the art and the mass medium, yet it has hardly been considered by historians. It is, as the photo-historian Shelley Rice has described it, 'a secret history embedded in the well-known chronologies of photographic history',[3] ignored and somewhat disregarded in the past, perhaps because it was so obvious – right there under our noses, taken for granted. This is the history of photography that is found in the photographic book, or as it has recently come to be termed: the 'photobook'.

What is a photobook? This may seem a redundant question with an obvious answer. A photobook is a book – with or without text – where the work's primary message is carried by photographs. It is a book authored by a photographer or by someone editing and sequencing the work of a photographer, or even a number of photographers. It has a specific character, distinct from the photographic print, be it the simply functional 'work' print, or the fine-art 'exhibition' print. However, while this might serve as a basic definition, it is not that simple. This study focuses on a specific kind of photobook and a particular breed of photobook producer. The photographer/author has been

considered here as auteur (in the cinematic sense – the autonomous director, who creates the film according to his or her own artistic vision), and the photobook treated as an important form in its own right. As the Dutch photography critic Ralph Prins has put it:

> *A photobook is an autonomous art form, comparable with a piece of sculpture, a play or a film. The photographs lose their own photographic character as things 'in themselves' and become parts, translated into printing ink, of a dramatic event called a book.*[4]

The photographer John Gossage, a keen collector and assiduous maker of photobooks, has said that a great photobook should fulfil the following criteria:

> *Firstly, it should contain great work. Secondly, it should make that work function as a concise world within the book itself. Thirdly, it should have a design that complements what is being dealt with. And finally, it should deal with content that sustains an ongoing interest.*[5]

Not all of the books featured here contain these qualities in equal measure. The volume that does so is a rare beast indeed. But there are enough of these attributes in each work selected to warrant its inclusion. For the most part, we have considered the photobook as a specific 'event', as Prins terms it, in which a group of photographs is brought together between covers, each image placed so as to resonate with its fellows as the pages are turned, making the collective meaning more important than the images' individual meanings. In the photobook, the sum, by definition, is greater than the parts, and the greater the parts, the greater the potential of the sum. But great photobooks can be made from not-so-great photographs. Moï Ver's remarkable *Paris* (1931) is probably the most notable example of this: the individual images are not particularly striking, but the way in which they are choreographed creates an astonishing work. In the true photobook each picture may be considered a sentence, or a paragraph, the whole sequence the complete text.

Other factors, too, can affect the photobook. Some have texts that coexist with the photographs, complementing them and enhancing the book. In others, words and pictures fight each other, in some cases positively, in others not. Design is also important. The monumental Soviet propaganda photobooks of the 1930s are first and foremost great examples of book design, but they are also great photobooks by virtue of the fact that the graphic design has provided a framework in which the photographs are made to speak with a cinematic complexity and dynamism seldom equalled.

Every facet of the book-maker's craft can contribute to the success of a photobook – the binding, the jacket, the typography, the paper. The printing, of course, can be an especially vital element. Most photobook lovers who remember the 1950s and 60s regret the passing of the rotogravure era, when pictures were reproduced in sensuous blacks that were almost tactile in their effect, reminding us that the photobook is a three-dimensional object meant for handling. The best photobook-makers recognize this fact. However, it is not always a question of expensive production, but of the correct production for the photographs in question. Photobooks can be roughly produced and function better because of this lack of preciousness, provided that the approach accords with the pictures. One of the best Czech photobooks published after World War II, Zdenek Tmej's *ABECEDA: Duševniho prázdna* (Alphabet of Spiritual Emptiness, 1946) was printed on paper that is barely better than that used for newspapers, but in lustrous gravure, and the combination perfectly complements the photographs – taken clandestinely during the war.

As we define it, the photobook has a particular subject – a specific theme. That subject may be as broad as the universe, like *Atlas photographique de la lune* (Photographic Atlas of the Moon, 1896–1910) by Maurice Loewy and Pierre Puiseux, or as narrow as close-ups of rippled mud, as in Alfred Ehrhardt's *Das Watt* (Mudflats, 1937). It might be as formally precise as the geometry of plants found in Karl Blossfeldt's *Urformen der Kunst* (Art Forms in Nature, 1928), or as casually intuitive as the psychological expression of the urban experience demonstrated in Daido Moriyama's *Sashin yo Sayonara* (Bye Bye Photography, 1972). It can be as simple as the anonymous book consisting only of photographs of wreaths sent to Lenin's funeral (*Leninu*; To Lenin, 1925), or as rich as a dictionary, as in Josef Šudek's *Praha panoramatická* (Prague Panorama, 1959), but the theme will generally be clear, if not immediately obvious.

And in the main, it will not simply be a survey of a photographer's 'greatest hits', a career review. Monographs, or anthologies of a particular photographer's work at a given time in his or her career have therefore not been included. However, that being said, we must immediately qualify it. One of the most distinguished and influential photobooks might be considered a monograph in the strict sense – namely Henri Cartier-Bresson's *The Decisive Moment* (1952). Even that photobook among photobooks, Walker Evans's *American Photographs* (1938), was compiled as a 'catalogue' for a mid-career retrospective exhibition, gathering together images from different projects made under widely differing circumstances. But like *The Decisive Moment*, Evans's book was made with *intent*, and that intent was not simply to display the photographer's oeuvre in the formal sense of the monograph, but something more ambitious – unlike even such a splendidly designed and important monograph as Edward Weston's *The Art of Edward Weston* (1932). So monographs have been included where, in our opinion, they transcend the strict confines of that particular genre.

This, however, brings us to another point about the photobook, analogous to that continual and often fractious debate about whether a print is 'original' only if it was made by the photographer. There is a genre of photobook that might be made by someone who is not even a photographer, comprised entirely of 'found' imagery, where the photograph might be considered simply as a building block in a potentially new structure. Here, the author's task is not one of creating the photographs, but of selection and ordering, giving a new and potent voice to the material of others, especially when the original voice has become muted by time or neglect. The principle of collaging, utilizing one's own or appropriated images, has always been an integral part of the photographic enterprise, especially by 'non'-photographers. Just as the incorporation of 'found' photographs by painters and Conceptual artists is a fundamental part of contemporary art practice, the reordering and publication of other photographers' material – particularly that designated as 'anonymous' or 'photographer unknown' – constitutes an important genre of photobook, with a wide and varied potential. The editor-author of such books is as deserving of recognition as the photographer who creates a book from his or her own work.

The sections of Volume II dealing specifically with the collaged photobook promise to be amongst the liveliest and most creative areas of this survey, but even in Volume I there are some excellent examples. These include many books in a propagandist vein: Alexander Gardner's *Gardner's Photographic Sketch Book of the War* (1866), which was compiled from the Civil War negatives of numerous photographers; László Moholy-Nagy's modernist manifesto, *Malerei Fotografie Film* (Painting Photography Film, 1925); and the American War Information Unit's harrowing *KZ* (1945), an anthology of concentration-camp photographs distributed to the German civilian population at the end of the war.

Our primary criterion for the photobook is that it should be an extended essay in photographs, and that it follows its theme with 'intention, logic, continuity, climax, sense and perfection', as Lincoln Kirstein put it.[6] The photobook, in short, is the 'literary novel' amongst photographic books. And if that in itself is no guarantee of quality, and sometimes a guarantee of pretension, at the very least it is a statement of intent – an indication that something more ambitious than the commonplace photographically illustrated book has been attempted, or in certain cases, achieved without any self-conscious attempt being made.

Those familiar with the photobook might raise an eyebrow at some of our omissions and inclusions in this work. A number of the greatest American modernists, for example, are conspicuous by their absence. Many photographers who have published their work in magazines or in 'popular' book editions, or have directed their primary efforts into making fine photographic prints for sale through the gallery system, have not made what we would define as a cogent photobook. This history therefore inevitably relegates certain names high in the art-photographic canon to the sidelines, while bringing others, somewhat disregarded, into the spotlight. There is no Alfred Stieglitz, no Edward Weston, no Ansel Adams. Stieglitz's *Camera Work* was omitted because, despite its sumptuous production, it was essentially a magazine. Weston and Adams have not been included because as photobook-makers they did not rise to their level as photographers, and Weston's two finest books were simply

anthologies of his best pictures. Indeed, it would seem that their concentration on the single, autonomous 'fine' print somewhat cramped their potential as book-makers. In general, American high modernism was an underachieving area for photobooks, being in the main rather conservative and reluctant to venture beyond admittedly elegant, but somewhat rigid, conventional book forms.

The focus of this study is by no means on 'art-photography' books. Some of the best photobooks were done on commission for companies or governments by the finest photographers, typographers and designers. And even when the books are made by artists, they are not necessarily artistic in intention. The hands of El Lissitsky and Alexander Rodchenko, for example, never seemed to be far away from the best Soviet propaganda books, and Man Ray produced some of the finest work of his life for the Paris Electricity Supply Company. Some books, such as those produced by archaeologists, astronomers, engineers or Jewish organizations after World War II, may attest more to the power of the camera as witness than to the intricacies of design and typography, but they still make for haunting photobooks. The functional photobook, if executed with consistency and visual intelligence, has the capacity to operate on a different level from that originally envisaged, the ability to move and provoke in a way unintended by its makers – that is to say, it has the capacity to display a distinctive *photographic* or *book* voice. Thus, although intention is an important criterion for the photobook, it should be recognized that, as in literature, the 'intentional fallacy' applies in a number of cases.

It must be stressed that photobooks have been produced throughout history, no matter what status the photographic medium was granted by the art museum. For many years only the United States accepted photography into the museum in a truly wholehearted manner, yet creative photobooks were produced in many countries, some of them livelier and more interesting, it might be argued, due to the very fact that they were free from the potentially deadening influence of museum culture. The museum's adoption of photography in the United States naturally led to many excellent photobooks being published there in the second half of the twentieth century, and this is certainly acknowledged here. But a museum culture demands rigid hierarchies. We have attempted to look beyond the accepted canon towards countries as far apart as Australia and Argentina, wherever fine photographic books are being made. For example, *Tiborc*, made by the Hungarians Kata Kálmán and Iván Boldizsár in 1937, or Sune Jonsson's *Byn med det blå huset* (The Village with the Blue House, 1959) from Sweden, are disregarded, even largely unknown books that stand comparison with the better known, and we have included many such examples. It is not our aim, however, to construct a new canon in this book, but to investigate a fascinating and important area of photographic practice.

The photobook has been a fundamental means of expression and dissemination for photographers since the earliest practitioners pasted their images into albums resembling those they would once have filled with sketches. Indeed, nineteenth-century photography was basically book related. The proper place of photography was deemed to be the library or the archive, though populated with original prints rather than printed reproductions. Most of the superb nineteenth-century prints for which collectors and museums are now paying enormous sums have found their way into frames and onto walls only because the albums and books in which they once resided have been systematically plundered and broken up. Until well into the twentieth century most photographers were more likely to see their work in print than in galleries, and those 'vintage' Henri Cartier-Bresson or André Kertész prints for which collectors compete so fiercely are frequently agency 'file' prints, sent out to printers for reproduction in books or magazines. Despite its current splash in the art galleries, photography remains essentially a printed-page medium.

For most contemporary photographers the photobook is a basic source of information about photography – what's happening, who's doing what, what's 'cutting edge'. Photographers discover the medium's traditions and generate their own ideas through photobooks, and most have a collection of them, whatever their photographic tastes. Almost every photographer's ambition is to make a book, and it is certainly an astute career move. Young photographers are still discovering and being inspired by the likes of Walker Evans's *American Photographs* and Robert Frank's *The Americans* (1959), which remain perpetually in print like the classics of literature.

If the history of creative photography is considered as a whole, the publishing and dissemination of photographers' work in book form has been more crucial and far-reaching than the showing of photographs in galleries. Unlike exhibitions – or indeed mass-media journals – which literally come and go, photographic monographs are always around, convenient and portable expressions of a photographer's work that have the potential for rediscovery and republication at any time, anywhere. The photobook, coming somewhere between the mass medium and the hermetic art form, has been a significantly more important factor in the globalization of creative photography than any number of gallery shows, spreading ideas from the United States to Europe to Japan and back again. It is quite possible to trace how photographic fashions move between continents after the publication of a specially innovative book. For example, William Klein's *Life is Good and Good for You in New York: Trance Witness Revels* (1956) exercised an immense influence on young Japanese photographers of the 1960s. Inspired by Klein's example, they made their own rough-hewn publications, locally distributed and in such small editions that they now sell for thousands of pounds amongst the international fraternity of serious photobook collectors.

From the very beginnings of the photographic medium, photography and publishing have gone hand in hand. The first great artistic statement in photography was not a single image but William Henry Fox Talbot's book *The Pencil of Nature*, published as a part-work between 1844 and 1846. Consisting of original prints accompanied by printed commentaries, it virtually defined the art of photography from the outset – as a picture-making 'art' certainly, but also as a methodology for gathering information, and a visual medium with a clear narrative imperative.

In the nineteenth century original prints were pasted into books by hand, although from the start, the search was on for a way in which to print photographs in ink. It was only after the development of the halftone printing block that photo-publishing could be made available to a true mass market. In the 1920s and 1930s particularly, the photobook became an essential tool of the documentary movements in the United States, Western Europe and the Soviet Union, to be used for the purposes of information or propaganda. In that period, too, photographers and artists from the modernist avant garde combined with typographers and designers to explore the photographic medium in multi-faceted and diverse ways, finding a new freedom of expression for the notion of photography as a dynamic and socially progressive force in art. Not only new concepts of what photography might achieve, but also new forms for the photobook were developed during this astonishingly creative epoch for all the arts, and laid the groundwork for the development of the genre after World War II, not just for photographers' 'personal' work but for political or commercial purposes.

These particular periods and centres of intense creative activity constitute a specific focus within this study – France in the 1850s, Germany in the 1920s, the Soviet Union in the 1930s, Japan in the 1960s, and the United States in the 1970s and 1980s. Also under consideration is the notion of the book as an autonomous art form, where not only the imagery but also the design and presentation of the volume makes it an object in itself. Such works as Germaine Krull's *Métal* (Metal, 1928) and Kikuji Kawada's *Chizu* (The Map, 1965) are so beautifully crafted and designed that they merit consideration as fine bookworks as well as photographic masterpieces.

The history of the photobook, or rather, the history of photography as expressed through the photobook, has been neglected in the past for the same reasons that some commentators now deem it a subject of pertinent interest. Previously the photobook seemed to slip down the crack (or rather the yawning chasm) between the aesthetic and contextual battalions in the photo-critical wars. Now it might be viewed as a bridge across that chasm, linking the art to the mass medium.

Another possible reason for the photobook's relative neglect might be that it is very much photographer-driven. Although publishing is clearly a team effort, the instigators, the editors and often the financiers of many photobooks are the photographers themselves. In other words, photographers generally have a large degree of control over their book products, so that the photobook represents the photographers' view of their medium. And that, to put it bluntly, has frequently been of less interest to those academics, curators and theorists with their own critical axes to grind. Critics

such as Susan Sontag, Rosalind Krauss and others have found a contradiction in the very idea of the photographer as auteur.[7] This question is an ongoing debate, for the history of 'creative' photography might even be described as a dance by photographers round the totem pole of auteurship. One of photographic history's major themes is upward mobility, a case of the ambitious photographer seeking a rise in status from journeyman to auteur, from auteur to artist. It was granted generally to the medium in the 1960s by the art museum, snatched away in the 1970s by postmodern theory, only to make a spectacular comeback in the 1990s courtesy of the contemporary art market and the rise of the 'artists utilizing photography' syndrome. However – as always where photography is concerned – the plot thickens. There is the question of where to look for our photographic auteurs: in the mass-circulation magazines, or on the gallery wall? We believe that there is a discernible third, intermediate forum for the photographic auteur – the medium of the photobook – and that this can be considered photography's 'natural' home.

Certainly, one of the basic questions facing the artist-photographer, particularly since the development of halftone reproduction, has been 'book or wall?' Does one make one's photographic statement through the medium of the page or the original print? Of course, most photographers will use both exhibitions and books to disseminate their work, but the question is not an idle one. For the decision about the primary outlet for the work affects its making, to a greater or lesser degree. And more importantly, it can, and has, affected the kind of art that photography might be – whether totally formalist, wholly exclusive, pandering to the relatively confined system of the museum, or more populist (in the best sense), searching for the interesting territory of potentially unlimited fertility defined by the photographer Lewis Baltz. 'It might be more useful, if not necessarily true', he suggested, 'to think of photography as a narrow, deep area between the novel and film'.[8]

To consider the history of the creative photobook as a primary rather than a marginal facet of photographic history is to consider a different photographic history from that dictated by the exigencies of either the art museum or mass-circulation magazine. Although the history of the photobook is closely bound up with both museum and magazine, it also has a large degree of autonomy. There are photographers who have made important contributions with their books, whom the museum or magazine world would consider marginal. For example, a work like *Chizu* is known only to a relatively small circle of cognoscenti and book collectors with large pockets, yet it can be considered in many respects the equal of Evans's *American Photographs* or Frank's *The Americans*. It was brought out in one small edition in Japan, and will probably not be republished. But that is typical of photobooks. They can be published, sink with hardly a trace, become cult items, and appear in book dealers' catalogues, to be rediscovered and possibly reprinted. Unlike exhibitions, they are always around, out there somewhere, convenient and portable expositions of a photographer's work, with the potential for rediscovery, revival and revivification at any time. In 2001 six of the best books by Kawada's contemporaries – such as Daido Moriyama and Takuma Nakahira – were published in Europe in the *Japanese Box*,[9] making them much more widely available to European and American photographic enthusiasts. This volume will hopefully restore such marginalized works – along with many others – to their deserved place in the mainstream of photography.

The photobook has an important role within the history of photography. It resides at a vital interstice between the art and the mass medium, between the journeyman and the artist, between the aesthetic and the contextual. It is a ragged and sprawling subject, with more than its fair share of anomalies, and these will arise during the course of the narrative. Meanwhile, we will simply state that the responsibility for the selection of the works and photographers rests with its authors, and the choice has been determined by our opinions.

1

Topography and Travel
The First Photobooks

From its very inception, photography has been closely and inevitably connected with publishing. Allan Porter[1]

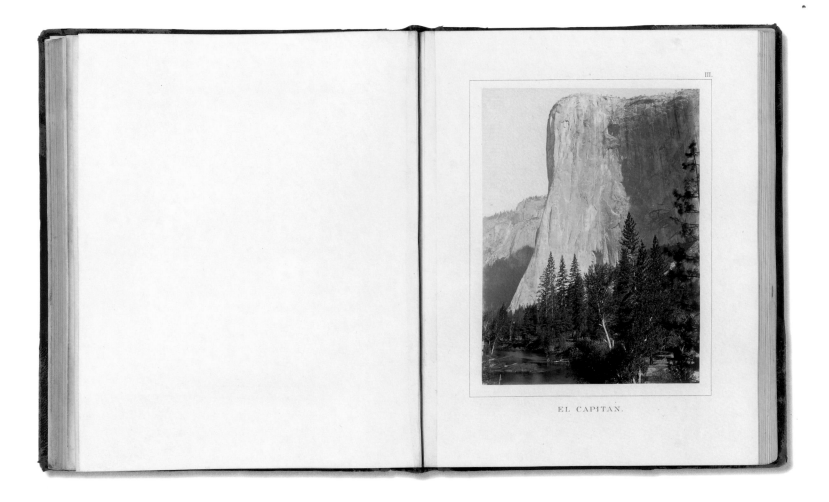

EL CAPITAN.

Josiah Dwight Whitney
The Yosemite Book
J Bien, New York, 1868

Of all the great nineteenth-century landscape photographs, those of Carleton E Watkins are the most perfectly poised between document and art.

In March 1839 William Henry Fox Talbot of Lacock Abbey, Wiltshire, a typically Victorian mixture of amateur scientist, man of letters and would-be artist, suggested to his friend, the botanist William Jackson Hooker, that they collaborate on a book about British plants.[2] This would be illustrated by a novel picture-making process that Talbot was developing, a process he termed 'photogenic drawing'. A few months later, at a joint meeting of the French Academies of Arts and Sciences, Count François Arago announced the miraculous invention of Louis-Jacques-Mandé Daguerre, a method for making faithful impressions of objects on sheets of copper, coated with light-sensitive silver salts.

Arago's announcement trumped the efforts of Talbot, much to the Englishman's chagrin. The endemic rivalry between the two major colonial powers of the nineteenth century was to be played out in yet another arena. For the time being the French had the upper hand in the new medium of 'photography', as it came to be called. But the legacy eventually bequeathed by Talbot to the world was to prove immeasurably greater than that of either Daguerre or the other Frenchman credited with inventing a plausible process of photography, Hippolyte Bayard.

In the beginning the daguerreotype was regarded as aesthetically and technically superior to Talbot's photogenic drawing, or calotype. The silvered copper plate produced a jewel of an image, highly detailed and uncannily precise. The Englishman's 'plates', by contrast, were sheets of sensitized writing paper. His images were coarsened by the paper fibres, and were hardly 'mirrors of nature'; they were essentially impressionistic smudges, like roughly drawn sketches compared to finished paintings.

Furthermore, Talbot's was a two-step operation, an apparent disadvantage. But the more complicated system he developed turned out to be the medium's salvation. Firstly, exposure in the camera and development of the paper 'plate' produced an image in which the tonal values of the original scene were reversed. When this 'negative' was placed in contact with another sheet of sensitized paper in a printing frame and 'exposed' to light, a positive print was obtained. It may have been a cumbersome process, but it was one that could be repeated time and time again, producing a theoretically limitless number of identical images.

Both the French methods produced unique originals. If they were to be reproduced they had to be re-photographed, with a consequent loss of technical quality. Despite its early success, the daguerreotype became obsolete within a relatively short period,[3] while Talbot's system, the paper negative, blessed with the priceless capacity to bear repeated and identical progeny, formed the basis for all modern photography.

It can be seen from Talbot's correspondence with Hooker that even while photography was in its first experimental stage, the idea already existed to take these seemingly miraculous illustrations from life and paste them into a book, as one might compile an album of watercolour sketches, hand-coloured engravings, or pressed flowers. And once a few important technical problems had been refined – a task that took a few years, while the daguerreotype reigned supreme – it was an even more logical step for an entrepreneurial Victorian mind like Talbot's to turn that simple deduction to commercial advantage, and produce numbers of these albums for sale. On 29 June 1844, the pictures for the first fascicle, or instalment, of *The Pencil of Nature* were printed by the Talbotype Manufacturing Establishment in Reading, a factory established to print not only his own calotypes but also those of others. Made up of five original calotypes, bound in paper wrappers and printed with accompanying letterpress texts, it was priced at 12 shillings and found 274 customers.

There is a body of opinion amongst some photographic historians that Anna Atkins's three-volume *Photographs of British Algae: Cyanotype Impressions* (1843–53) rather than Talbot's *The Pencil of Nature* should be recognized as the world's first photographically illustrated book, but against it is the fact that it was printed in a very small number of copies for purely private circulation. Also, Atkins's cyanotypes (blueprints) were made without a camera and could be considered photographic process prints rather than photographs, although they are both documents and photo-images of rare beauty. The consensus is still inclined to award the palm to Talbot, possibly because *The Pencil of Nature* has a far more alluring ring to it than *Photographs of British Algae*.

Crucially, however, *The Pencil of Nature* was not simply a book of photographs; it was a manifesto. As Beaumont Newhall has written, Talbot's book was several things in one, an advertisement, an experiment, a calling card, a history, an aesthetic achievement and a polemic: 'It was a show book, an account of the history of the invention, and a demonstration of its accomplishments in the form of 24 actual photographs.'[4] The book does not succeed at every level of this ambitious programme. It has the air of a Victorian scrapbook, an amateurish aspect, in that it is somewhat provisional in formal terms, as if flung together rather than carefully considered. This experimental, tentative nature offends some. The view of another American photo-historian, Joel Snyder, represents the general opinion of many, especially those with an aesthetic axe to grind:

> *The categories into which the pictures fall are entirely conventional: there are ten architectural and travel pictures, four still lifes, three inventories (chinaware, glass, and books), two copies of handmade prints, one of a page from an ancient book, two of a plaster cast, a print of a leaf, and finally, a print of a bit of lace. In addition to the conventionality of the categories (curiously, portraiture is not included) the pictures themselves make no attempt to declare their independence from existing practices of illustration, in terms either of subject matter or pictorial format. Photography had been invented, but it was still undefined.*[5]

Snyder's observations, perfectly correct in themselves, seem a little curmudgeonly however. Much of *The Pencil of Nature* is taken up with demonstrating photography's faculty and potential utility as a documentary medium. Talbot, ever the simple practical man, was anticipating the common-or-garden *practice* of photography, placing its scientific aspect before the aesthetic.

Contemporary reaction to *The Pencil of Nature* was mixed, though generally favourable. The book's significance was certainly acknowledged, but the mundane nature of a number of the images left some perplexed. 'The selection of objects is sometimes not very felicitous', wrote one reviewer in *The Atheneum*.[6] Another critic stated, 'In the twelve plates which have now been published in *The Pencil of Nature* we see illustrated the beauties and the defects of photography.'[7] The long gaps between the publication of the fascicles certainly irritated the high-and-mighty editors of that august publication, who remarked, with the wonderful lack of prescience that frequently accompanies the categorical statement, that 'the labour consequent on the production of photographs is too great to render them generally useful for the purposes of illustration'.[8] However, posterity might in all fairness concur with the considered opinion of the *Literary Gazette*: 'We have only to add another tribute of our applause to that gentleman for the skill with which he has overcome the difficulties of a first attempt at photographic publication, and the excellence he has already attained in executing his designs.'[9]

By the time the sixth instalment of *The Pencil of Nature* was issued in 1846, the original 274 subscribers had dwindled to 73. The Reading factory published several other works, including the first 'themed' photobook, *Sun Pictures in Scotland* (1845), 23 photographs of Scottish places associated with Sir Walter Scott. However, for reasons that remain unclear, it closed in 1847. The idea was probably a few years in advance of its time: ambitious statements attempted with imperfect methods. Cost and the technical problems of the calotype, especially a tendency to fade rapidly, were issues that hindered demand. Another problem was Talbot himself, hampered, it seems, by stubborn pride, a poor business sense, and his decision to take out restrictive patents on his invention. Only in Scotland, where the patent restrictions did not apply, was there much progress during the 1840s. The Edinburgh partnership of David Octavius Hill and Robert Adamson not only produced the finest calotype images of the 1840s, but also published a number of albums.[10]

The next event of real import with regard to photography's development, as well as that of the photobook, was the Great Exhibition of 1851, held in Joseph Paxton's Crystal Palace, which was specially constructed in Hyde Park. In that great shop window of Empire and Victorian capitalism, the usual rhetoric about the brotherhood of man and the advantages of free trade that accompanied such events barely masked the implicit sub-texts reinforcing the economic hegemony and superiority of Western culture – and the incessant rivalry between the French and the English.

Photography played an important role in this demonstration of the high Victorian capitalist ethos. Principally, the world's first open photographic exhibition was held, attracting 700 entries from six nations. The second role for photography in this extravaganza was in the shape of the photobook. Photography was used to illustrate the exhibition catalogue, *Reports by the Juries*, 155 calotypes printed from negatives made by Hugh Owen of Bristol and Claude-Marie Ferrier of Paris. The photography in these volumes is strictly functional, but the book itself is both a valuable document and a considerable logistical task – necessitating the production of some 20,000 prints – giving the lie to the notion that photography was unsuitable to illustrate books in any great numbers. Over 100 copies of the book were given to the notables involved in the exhibition, and 15 were presented to Talbot himself for his gesture of waiving the rights to his photographic publishing patent. In this back-handed way, Talbot at last received some kind of public recognition for his invention.

Judging by the imagery they showed in Hyde Park, it was clear that the French photographers were more technically advanced than the British in making photographs with paper negatives. As a result of their superiority, the next significant step towards the industrialization of the photobook took place in France. As generally happened in early photography, commercial and artistic success stemmed from technical advances that, at the end of the 1840s and early 1850s, followed one upon the other with almost bewildering rapidity. Photographic processes attracted opportunist entrepreneurs as computer software does today.

Between 1847 and 1851 Louis-Désiré Blanquart-Evrard, a cloth merchant with an interest in chemistry, made a number of presentations to the French Académie des Sciences, in which he

summarized the various efforts he had made to improve on Talbot's calotype process. In September 1851 he opened his Imprimerie Photographique at Lille, an establishment of some 40 workers, mainly countrywomen, designed specifically to offer 'artists and amateurs the production, in unlimited numbers, of positive prints from glass or paper negatives'.[11] Between 1851 and 1857, when the factory ceased production, Blanquart-Evrard printed or published at least 20 albums and large archaeological/travel works. Roughly 1,000 negatives are known to have been published, so the output of positive prints in this short period must have run into tens of thousands.

The first of Blanquart-Evrard's publications, and several that followed, were typical. *L'Album photographique de l'artiste et de l'amateur* (Photographic Album for the Artist and the Amateur, 1851) reflects his desire to declare his intended range of material from the outset. The book was a diverse anthology featuring antiquarian subjects – images from India, Italy, Greece and the Middle East – reproductions of artworks, views of cities and monuments. Like *The Pencil of Nature* it is a manifesto and showcase of sorts. Unlike *The Pencil*, it did not contain any text.

With *Etudes photographiques* (Photographic Studies, 1853) and *Etudes et payages* (Studies and Landscapes, 1853), pictures for the painter to copy were added to the range. These were views from rural life, still lifes, woodland and snow scenes, taken by different photographers, both amateur and 'professional' (although the distinction was somewhat moot at the time, since photography was generally at the service of other interests). Almost every pictorial genre, except for portraiture and the nude, was included in the various *Etudes*, *Mélanges* and *Variétés* published in the early 1850s by the Imprimerie. There was also a *Souvenirs* series, which generally featured the work of a single photographer, and could therefore be considered the first series of books created by photographic auteurs. Louis-Rémi Robert's *Souvenir de versailles* (Souvenir of Versailles, 1853), and John Stewart's *Souvenirs des pyrénées* (Souvenirs of the Pyrenees, 1853) are excellent showcases for two little-known but talented early figures.

A step onwards from the *Souvenirs*, and undoubtedly the greatest achievement of the Imprimerie, were the three books of travel and antiquarian photographs from the Middle East. The publication of the first of these in 1852 by Gide et J Baudry of Paris is a landmark in the history of the photobook: Maxime Du Camp's *Egypte, nubie, palestine et syrie* (Egypt, Nubia, Palestine and Syria), illustrated with 125 salt prints, which were also made at the Imprimerie.[12] This famous volume is renowned for its stark images, an approach that radically departs from the Romantic model. It is also notable for the fact that Du Camp's travelling companion was the celebrated writer Gustave Flaubert. This book was followed by two further publications in similar Orientalist vein – John Beasley Greene's *Le Nil* (The Nile, 1854), and Auguste Salzmann's *Jérusalem* (Jerusalem, 1854 and 1856).

We have concentrated on the output of the Lille Imprimerie not simply because it was so precociously prolific, but because Blanquart-Evrard's publications set the agenda for much that followed, both in France and England. It is worth noting, however, that there were rivals to the Lille oufit, particularly the Imprimerie in Paris opened by H de Fonteny in October 1851, only a month after the Lille factory, and which remained in operation somewhat longer. The parallels between the two establishments are striking. De Fonteny's list, for example, included Charles Nègre's *Midi de la france* (South of France, 1854–5), Viscount Vigier's *Album des pyrénées* (Pyrenees Album, 1853) and Félix Teynard's *Egypte et nubie* (Egypt and Nubia, 1858).

Studies of travel, picturesque landscapes, ancient monuments and works of art, genre imagery, archaeological, engineering and ethnographic documents constitute the basic oeuvre of the earliest photographic books, reflecting the pedagogical cultural interests of the educated classes, with their tendency to be high-minded and 'improving'. This is especially true of those 'amateurs' who took up the negative/positive medium from the outset. Both the editions of Blanquart-Evrard and those of de Fonteny read like inventories or reports, and that was to remain the basic form of the photobook, with a few notable exceptions, until well into the twentieth century. Photography in the nineteenth century, particularly as published in books or albums, was essentially a methodology for garnering facts, part of the knowledge industry. The role of the photographic author, despite the relatively recent subsuming of their product into the realm of aesthetics, was that of illustrator.

However, that generalization having been made, an important point should be stressed. The late twentieth-century dichotomy between the 'two cultures' of art and science did not exist in the mid nineteenth century. The same philosophy of empirical observation inflected the expression of both science and art, drawing them together as much as later generations have tended to split them apart. Illustration had a higher place in the scheme of things than it does in the twentieth century, where the modernist notion of art for art's sake has made art and illustration mutually exclusive. The cultural climate of the nineteenth century demanded that even journeymen professionals adopt a thoroughly cultured approach, giving to illustration the same care and attention reserved for the most ambitious artistic endeavours.

Early in 1857 Blanquart-Evrard's pioneering establishment closed, followed a year later by its main rival, de Fonteny. The reasons for these closures are not absolutely clear, but, as with the demise of Talbot's Reading enterprise, can reasonably be guessed at. Like most failed business ventures, it would seem to have been a matter of economics. The technical problems that had plagued Talbot had been more or less ironed out, but photography on paper, despite its artistic achievements and powerful demonstration of the medium's potentiality, remained too expensive.

There was also a viable rival to photography on paper, which combined the daguerreotype's advantages in terms of image fidelity with the paper negative's faculty for infinite reproduction. This new system, introduced by Frederick Scott Archer in 1851, was the collodion glass plate, or as it came to be known, the wet-plate process. This was an extremely tricky method, which required the plate to be coated on the spot, exposed whilst damp, then developed immediately, but the results were deemed worth the huge effort involved. Prints struck from glass negatives were sharp and seamless – the only textures being derived from the subject, not from the chemical support as in paper. The fuzzy textures that comprised both the calotype's charm and its drawback in terms of absolute fidelity were largely banished within a few short years.

The ascendancy of France in the photography on paper of the early 1850s stemmed not just from the fact that the most viable techniques in negative making and printmaking were developed there. Around the end of the 1840s French photography was better organized. English photography was somewhat fragmented, the province of individuals – and as we have seen, dominated by one individual. Crucially, French photography was recognized, encouraged and actively sponsored by the French government and other official bodies. French photography, in short, had a *mission*. It was yet another example of the vast cultural divide accruing from a physical divide of only 21 miles at its narrowest. Photography in both countries was regarded as a documentary medium, particularly useful in serving those branches of knowledge with an emphasis on the historical. But the English and French views of history were somewhat different, English individualism opposing French collectivism. The English view of history, in effect, was parochial, centring around the parish, the district, the county and the institutions growing up around the most powerful families of the nation. The French view tended more towards the nation as a whole, towards that revered, almost mystical French notion of *La Patrimoine* (cultural heritage).

In 1851 French photography was literally given a mission. The Missions Héliographiques, under the auspices of the Commission des Monuments Historiques, employed five photographers – Hippolyte Bayard, Henri Le Secq, Gustave Le Gray, Edouard-Denis Baldus and O Mestral – to photograph historic works of architecture in the French regions. The first government photographic archive was set up with the aim not only of retaining these works for the nation but of distributing them, by means of publication, to the educated public. The project did not get as far as that – the work deposited by the photographers disappeared into the vast maw of the state archives – but the idea, a publicly funded programme in line with Blanquart-Evrard's commercial initiative, and frequently a joint venture between the public and private sectors, was to drive French photography until well after the turn of the century, and has its successors to this day.

The popularity of the Orientalist volumes from Blanquart-Evrard and de Fonteny demonstrated a ready market for works of an antiquarian and exotic nature. The bright light of the Mediterranean

and countries further east provided ideal climatic conditions as well as suitably diverting subject matter for those photographers building up the medium's vocabulary and potentiality. Readers back home in Britain or France were captivated by photography's capacity to 'take them there', and bring them directly in contact with the long ago and far away.

As the wet-plate glass negative and the albumen print[13] replaced both the calotype and the daguerreotype, a new professionalism replaced the amateurism, or rather the 'gentleman professional' status of the first generation of photographers. Photographic outfits that were businesses first and foremost were established in Europe, the Middle East and the Far East – places where Britain or France had colonial interests – and also in the United States, which was colonizing its own interior following the Civil War. Many of these companies provided portrait and general studio services. Others specialized in making topographical and architectural views for sale to those who were part of a new social phenomenon called 'tourism' – not exactly mass tourism as we know it today, but the beginnings of foreign travel for those not quite at the pinnacle of the social scale.

The rise of photography and tourism went hand in hand. The most famous tourist entrepreneur, Thomas Cook of Derbyshire, had begun by arranging day-long rail excursions in 1841. He transported over 165,000 people to the Great Exhibition of 1851, where some of them might have been entranced by the photographic displays in the Crystal Palace. Then in 1865 he spread his wings worldwide by arranging the first organized tours to Egypt and those renowned cruises down the Nile by package steamer.

It is quite possible that customers on Cook's first Egypt tours were inspired to make the journey by the Egyptian photographs of Francis Frith, published in the early 1860s. Frith, who coincidentally was also from Derbyshire, was the most successful of the photographic entrepreneurs following the calotype era, and it was his Egyptian photographs – made on three journeys to Egypt and the Holy Land between 1856 and 1859 – that made his reputation. Their success enabled him to start Frith and Company of Reigate, the largest publishers of topographical photographs in the 1860s and 1870s, whose various albums and books of photographs set the tone for later generations of travel books at the more populist end of the market.

Many purveyors of topographical views made up albums of images at the customer's request, or sold them singly so that the purchaser could construct his or her own albums. These could not be considered photobooks, but Frith's Egyptian books were of a completely different order. Published by the London publisher James S Virtue, and the London and Glasgow publisher William Mackenzie, with printed texts and letterpress descriptions, they were luxurious productions. However, as was common practice for early photobooks, they were published as partworks, in fascicles containing from one to three images at a time, so that people could buy only the pictures they liked. Frith had used three cameras on his first trip, a small stereoscopic camera for three-dimensional views, and two larger cameras, taking plates of around 9 by 7 inches, and 20 by 16 inches respectively. The 20 mammoth-plate (20 by 16 inches) views were the most spectacular published to that date, and are still held to be models of the technical perfection that nineteenth-century photographers could achieve with wet-plates and albumen printing.

In 1863 Frith's achievement in the Middle East was matched by Francis Bedford and C G Fontaine, who both published Middle Eastern travel books. Fontaine's book was notable for prints that approached Frith's large series in size, while Bedford's marked a journey to the Eastern Mediterranean by the Prince of Wales. These volumes essentially marked the last great achievement of the Middle Eastern travel book. Although the area naturally attracted photographers to cater for the new tourist market, they were necessarily of a much more commercial disposition, and therefore more inclined to present a routine view.

There were, however, fine travel books emanating from other parts of the world, like Josiah Dwight Whitney's *The Yosemite Book* (1868), with photographs by Carleton E Watkins, and William Bradford's spectacular *The Arctic Regions* (1873), but the next great innovation in the nineteenth-century photobook can be marked by two volumes published in the 1870s. The quantum leap was a

technical rather than an artistic one, but was of immense importance because it demonstrated that photobooks no longer needed to be illustrated with original photographic prints, laboriously made and pasted in by hand. The problem with a photographic print as opposed to a lithographic illustration was that the 500th print was as laborious and as expensive to make as the first. Therefore, almost from the beginning of photography, there had been attempts to combine photography with traditional graphic printing techniques, and these efforts were brought to fruition at the beginning of the 1870s.

As far back as 1839–40 daguerreotypes were acid etched to provide a plate suitable for printing in ink – a technique that achieved a limited degree of success. More frequently, daguerreotypes and other photographs were copied by hand, using the simple expedient of tracing them and making plates for reproduction as etchings, engravings or aquatints. Indeed, 'photographs' appeared in books, newspapers and journals throughout the nineteenth century – and into the twentieth – in the guise of engravings, until the development of the halftone block and the rotogravure press made the cheap and seamless reproduction of actual photographs in ink a daily reality.

The secret of all photomechanical reproduction lay in transferring the photographic image to a plate or matrix that could then be inked and printed. The problem was in accurately reproducing the great tonal range of photographs, and it took over a decade to perfect this. The solution lay in a discovery made in the 1850s by Alphonse Louis Poitevin – one of the great unheralded figures of photography – who found that gelatin in combination with either potassium or ammonium bichromate hardens in proportion to the amount of light that falls on it. Various other technical heroes of early photography – Josef Albert, Joseph Wilson Swan, Paul Pretsch and the eminent photographer Charles Nègre – used this property to produce the matrixes necessary to develop numerous photomechanical processes – heliogravure, photogravure, collotype, autotype, carbon print – leading to the next development in the history of the photobook – mass production.[14] Although books of original photographs were published up until around 1900, the number of these greatly diminished after 1875.

John Thomson's *Illustrations of China and its People* (1874), as well as *Voyage d'exploration à la mer morte* (Expedition to the Dead Sea, 1868–74), by Honoré d'Albert, Duc de Luynes and Charles Nègre, are both key works, for their fine photography certainly, but also for their technology. Thomson was one of the most important nineteenth-century book-makers, using both original prints and various photomechanical processes in his numerous volumes. Nègre, amongst the best early French photographers, was a leading figure in the development and employment of photomechanical processes. These early methods were still labour-intensive and could be termed hand-craft processes, but they represent another significant step in the industrialization of the photographic process – a step towards the halftone block and the photobook as we know it today.

The first three decades of photography not only produced some wonderful imagery, but also a number of photobooks that are as cogent and as intelligent as any in its history. This era was marked by intense activity, experimentation and achievement on the technical front, especially in the craft of making photographic prints and the development of photomechanical printmaking processes. Such sustained invention contributed immensely not only to the art of photography, but also to the printing and production of photobooks.

AA (Anna Atkins)

Photographs of British Algae: Cyanotype Impressions

'The difficulty of making accurate drawings of objects as minute as many of the Algae and Conferva, has induced me to avail myself of Sir John Herschel's beautiful process of Cyanotype, to obtain impressions of the plants themselves, which I have much pleasure in offering to my botanical friends.' Thus begins the introduction to Anna Atkins's three-volume *Photographs of British Algae*, an epic, unprecedented work that was ten years in the making. It is unprecedented because the first part of the book was issued in October 1843, pre-dating the first part of William Henry Fox Talbot's *The Pencil of Nature* by some eight months.[15] Atkins may be credited, therefore, with the authorship of the world's first photobook, although it has been argued that *Photographs of British Algae* – privately printed with handwritten texts, produced for private circulation – was an album rather than a book, and quite different

in ambition from *The Pencil*. That may be so, and although as an album it is strictly speaking outside the remit of this history, it is a groundbreaking publication that cannot be ignored. Atkins did as much as Talbot in fostering the conception of photographs in book form. Furthermore, she succeeded in demonstrating the best qualities of the many photobooks that were to follow her pioneering example.

Firstly, Atkins's images are beautiful. Made as botanical illustrations, they fulfil that function to perfection, but like the best photography, they do much more. They combine scientific information with aesthetic pleasure – exuding a semi-abstract formalism that prefigures Karl Blossfeldt's plant close-ups of almost a century later. Yet her vibrant blue cyanotypes are entirely devoid of the hyper-real creepiness that makes his images so cold and seemingly unnatural. Secondly, the technology she utilized was entirely appropriate to book-making. The cyanotype perfectly suited her cameraless photogram methodology. It was easier to use and much more permanent than Talbot's fugitive calotype method.

Although there are not many copies, both her books and the individual plates have generally survived the years in much better condition than most early books and albums.

Finally, Atkins's book is a total conception, an example of fine design as well as photography. She designed the titles, hand-wrote the captions and texts, and made cyanotypes of them, so that text and imagery are completely integrated. The argument as to whether *Photographs of British Algae* or *The Pencil* was the first photobook is surely a specious one, and largely irrelevant. As Larry J Schaaf has written: 'It is unlikely that Atkins and Talbot would have compared the two, and they certainly did not have any concern over the question of priority. They shared a vision but were after different goals. *The Pencil of Nature* was an elegant promotion for an invention; Atkins's production was the first realistic attempt to apply photography to the complex task of making repeatable images for scientific study and learning.'[16]

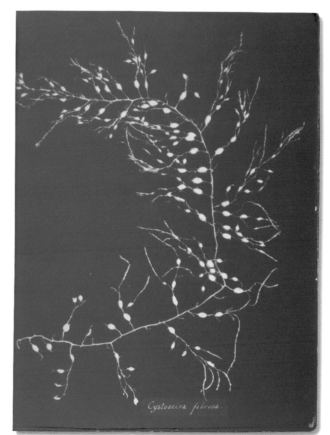

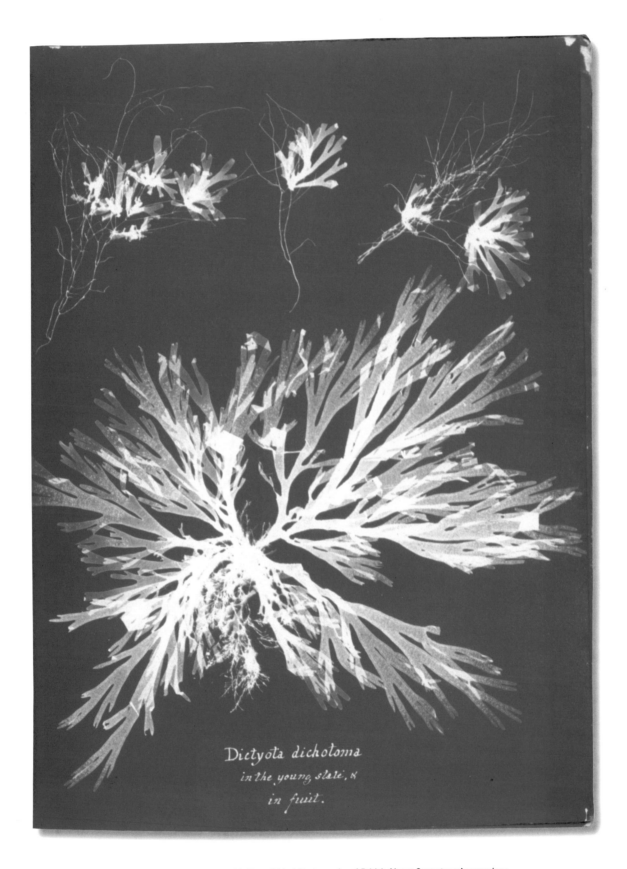

AA (Anna Atkins) **Photographs of British Algae: Cyanotype Impressions**
Anna Atkins, Halstead Place, Sevenoaks, 1843–53
255 × 205 mm (10 × 8 in)
Blue paper wrappers
3 volumes containing a total of 14 pp of text and 389 cyanotype photograms
Text by Anna Atkins

William Henry Fox Talbot **The Pencil of Nature**
Longman, Brown, Green & Longmans, London, 1844–6
300 × 238 mm (13¹₂ × 9¼ in)
Originally paper wrappers to each fascicle
24 calotypes published in 6 fascicles with letterpress commentaries
Part I (5 calotypes) published 29 June 1844; Part II (7 calotypes)
published 31 January 1845; Part III (3 calotypes) published 10 June
1845; Part IV (3 calotypes) published 2 August 1845; Part V (3 calotypes)
published 7 January 1846; Part VI (3 calotypes) published 23 April 1846
Text by William Henry Fox Talbot

William Henry Fox Talbot
The Pencil of Nature

As we have already seen, contemporary reaction to *The Pencil of Nature* was mixed, and many commentators today remain somewhat ambivalent about it. The 24 pictures published in Talbot's six fascicles are, as many have pointed out, a motley bunch. But that is hardly the point. The book's strength is its didactic aspect. It is, like many of the great photobooks, about more than just the photographs. *The Pencil of Nature* is photography's first manifesto – and a most eloquent one at that.

It is Talbot the inventor and polemicist, not Talbot the artist, who undoubtedly has the more secure place in photographic history. The introductory account of his experiments, and his commentaries on the plates, are arguably as important as the images themselves. *The Pencil of Nature* is the blueprint – and a remarkably sound and accurate one – not only for the art, but also for the media that both photography and the photobook would become.

To Talbot's level-headed, scientific way of thinking, photography would function most usefully as a documentary art, a system for garnering the facts of the world. In *The Pencil of Nature* he delineated (with the conspicuous exception of single-figure portraiture) the principal concerns of photography for the next few decades – travel, topography, architecture, archaeology, cataloguing, art reproduction. Time and again he shrewdly draws attention to the camera's characteristics, its advantages – or its possible disadvantages: 'The instrument chronicles whatever it sees and certainly would delineate a chimney-pot or a chimney sweeper with the same impartiality as it would the Apollo of Belvedere.'

The most successful image is probably *The Haystack*, where Talbot begins tentatively to discover a photographic rather than painterly language. Yet even here he stresses the useful aspect of the camera's aesthetic: 'One advantage of the discovery of the Photographic Art will be, that it will enable us to introduce a multitude of minute details which add to the truth and reality of the representation, but which no artist would take the trouble to copy faithfully from nature.'

In *The Ladder*, an image of three friends posing self-consciously for the camera, he anticipates the snapshot, remarking on the delights of taking group portraits in his accompanying text: 'Groups of figures take no longer time to obtain than single figures would require since the camera depicts them all at once.' In the notes to *Articles of China* he half-jokingly predicts the use of photography to provide evidence in criminal cases – an application that was quickly put into use: 'And should a thief afterwards purloin the treasures – if the mute testimony of the pictures were to be produced against him in court – it would certainly be evidence of a novel kind.'

Maxime Du Camp
Egypte, nubie, palestine et syrie
(Egypt, Nubia, Palestine and Syria)

Maxime Du Camp and his close friend Gustave Flaubert left France at the end of October 1847, under the auspices of an 'archaeological mission' for the French Ministry of Education. Du Camp had received instruction in Gustave Le Gray's waxed-paper process, and when the party returned home after a journey lasting almost three years, he had made some 220 negatives. Flaubert's input into the photographic side of things is unclear, but his disparaging written comments suggest that he left 'Max' to get on with it while he took advantage of the more lubricious pleasures offered by the Middle East.[17] The expedition followed the broad outlines of what was a standard itinerary during the nineteenth century, which largely persists to this day. The book traces the journey up-river from ancient site to ancient site, then moves across to Palestine, in the practised manner of lithographic volumes of Middle Eastern views, such as David Roberts's widely known *The Holy Land and Egypt* (1842–9).

So far all is familiar, standard operating procedure. Du Camp's pictures, however, are not; they are wholly new. Faced with a scene before his camera, Du Camp – neither trained artist nor experienced photographer – seems to have disregarded any preconceived Romantic accretions attached to his subject, and by intuition discovered a gritty, elevational reality. His imagery demonstrates a conspicuously rigorous point of view for a neophyte photographer, unfettered and remarkably consistent. One searches long and hard for a judicious angle, for a shot in which the subject was not tackled head-on with minimum regard for the niceties of graceful composition.

The elevational style is quite deliberate, in keeping with the pseudo-scientific imperative of the enterprise. Du Camp's mission was to acquire evidence rather than to make poetic statements. In many of the images, Hadji Ismael, the expedition's Nubian boatman, was posed to provide an index of scale for buildings. Glimpsed in the middle distance, or from afar, on the topmost part of a structure, he adds to the book's visual consistency. Turning the pages becomes like a game of 'find the Nubian', lending it a human, almost humorous aspect – until, that is, one reads both Europeans' accounts of the trip and discovers their utter contempt for the Egyptians.

Du Camp's images are determinedly unlovely but astonishing nevertheless. Yet this brutal directness has a grace and integrity of its own. His monuments seem less the forlorn, picturesque remains of an ancient civilization, than the grim evidence of centuries of pillage. Far from being a poetic homage, these pictures appear to be an indictment. Du Camp's single foray into photography resulted in a superbly conceived and well-made volume, and an exemplary demonstration of the photographic art, fully meriting its reputation as the first completely realized photobook.

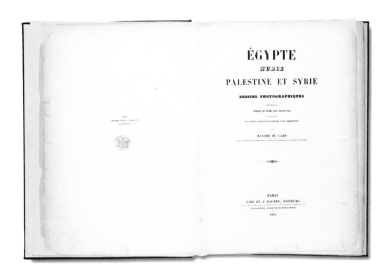

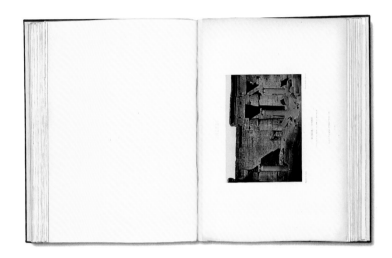

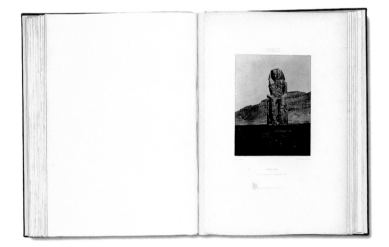

Maxime Du Camp **Egypte, nubie, palestine et syrie** (Egypt, Nubia, Palestine and Syria)
Gide et J Baudry, Paris, 1852
440 × 315 mm (17¼ × 12½ in)
Originally hardback with full black leather
125 salted-paper prints from paper negatives, printed by Blanquart-Evrard,
published in 25 *livraisons* of 5 prints per *livraison*
Text by Maxime Du Camp

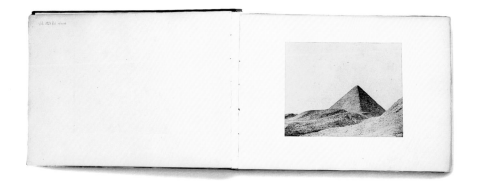

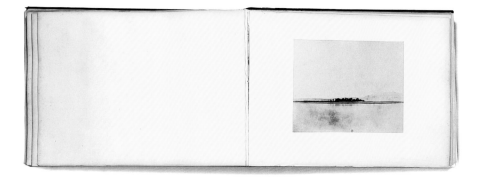

John Beasley Greene **Le Nil – monuments – paysages** (The Nile – Monuments – Landscapes)
Imprimerie Photographique de Blanquart-Evrard, Lille, 1854
395 × 560 mm (15½ × 22 in)
Hardback with blue decorated leather, black leather spine and corners
2 volumes containing a total of 94 salted-paper prints, printed by Blanquart-Evrard from
waxed-paper negatives, published in *livraisons* of 3 prints per *livraison*

John Beasley Greene
Le Nil – monuments – paysages
(The Nile – Monuments – Landscapes)

John Beasley Greene was a young Egyptologist, the
son of a wealthy American banker living in Paris. He
made two visits to the Middle East in the early 1850s
to excavate and to make photographs. *Le Nil* (The Nile),
a masterpiece from Blanquart-Evrard's Lille factory, is
divided into two sections – *Monuments*, consisting of
48 plates, and *Paysages* (Landscapes), of 46 plates.

Le Nil reveals Greene to be one of the most eccen-
tric, singular talents in the field of photography on paper.
In his photographs of the Egyptian monuments, where
Maxime Du Camp was elevational Greene was all ang-
les. He combined an idiosyncratic sense of camera
placement with an innate feel for extremes of light.
Unlike Du Camp's or Auguste Salzmann's, his images
are thus uncertain documents for the archaeologist,
but highly evocative renditions of light and shadow.
They are so individualistic in viewpoint that they belie
conventional Romanticism to hint at much more per-
sonal, slightly uneasy feelings. 'Macabre' was the term
that Eugène Durieu applied to them in an obituary fol-
lowing Greene's untimely death at age 24 in 1856. And
yet, however eccentric, they remain obdurately 'real'.
Their conceptual model is clearly not the sketch or
lithograph but the thing itself.

One wonders what Greene imagined he was photo-
graphing, particularly in the *Paysages* section of the
book. The answer would often have to be 'nothing', or
at least 'just space and light' – the desert floor, a few
jumbled rocks or a barely visible building in the middle
distance, seemingly made of the same gritty matter as
the land itself, against a featureless sky. There have
been few more consistently minimalist landscapes in
the history of art, and yet their impulse in all likelihood
was not minimalism, nor reductive expressionism, but
a simple desire to record what was there. It is as if he
were determined to oppose the conventional view,
which saw Egyptian architecture as immense and
monumental, wishing to show it at its true scale in re-
lation to the vastness of the desert. His desertscapes
catch the 'infernal emptiness' in a way that painters
could not, and few photographers did before the end
of the 1860s. As Maria Morris Hambourg has written
regarding the early photography of the Middle East:
'While the photographers' primary intentions were to
unveil early civilizations, their photographs ... actually
unsettled the accepted accounts. What had been clas-
sified and measured and noted, what had been drawn
in scrupulously detailed archaeological reconstructions
... was now replaced with evidence that was contin-
gent, fragmentary, and unquantifiable.'[18]

Auguste Salzmann
Jérusalem
(Jerusalem)

Like John Beasley Greene, Auguste Salzmann was an archaeological photographer. His mission to Jerusalem was quite specific – to provide visual evidence supporting the controversial theories of his friend L F J Caignant de Saulcy on Judaic and Greek architecture. De Saulcy had postulated that certain remains there dated from the time of Solomon. With the help of an assistant named Durheim, Salzmann made around 200 waxed-paper negatives of the Jerusalem monuments. His findings were first published by Blanquart-Evrard in 1854, but the second edition (published by Gide et J Baudry in 1856, with prints by the Blanquart-Evrard establishment) is the better known. It was an expensive book, a *livraison*, or fascicle of three prints costing 24 gold francs. A single print was 10 francs, compared with 5 francs for a print from Maxime Du Camp's book.

Salzmann's images are specifically architectural, topographical and archaeological – unlike Greene's, which are not specifically anything. Salzmann was acutely attentive to both patina and pattern in attempting to define the architectural strata of a city in which building was built upon building, thus leaving a vertical record of the various cultures that had occupied the city and left their remains on the foundations built by earlier conquerors. Like those of that other measured recorder, Du Camp, Salzmann's pictures tended towards flatness, and therefore abstraction, with pattern etched upon pattern, and textures frequently picked out by the judicious use of sharp shadows. This makes for images that may be informative to the expert, but are abstract and mysterious to the layman. Salzmann himself described his pictures as having 'a conclusive brutality', but to modern eyes their poetic aspect seems paramount.

It would appear that Salzmann was at one and the same time both expert and layman, dispassionate observer and enthusiast. His pictures have this dual qual-

ity, flickering rapidly between documentary and poetry. This, one might suggest, is the ideal goal for any photographer, though Salzmann probably wouldn't have thought of himself as a creative photographer as such. Nevertheless, it seems clear that, intuitively or not, the enthusiast tended to win out over the flat recorder in these pictures, making them uncertain documents. This may not be the primary reason why Salzmann's book left de Saulcy's case 'not proven' and as controversial as ever: whether these pictures constitute photographic evidence or not, both sides of the dispute saw only what they wanted to see.

Auguste Salzmann **Jérusalem: étude et reproduction photographique des monuments de la ville sainte**
(Jerusalem: Photographs of the Monuments of the Holy City)
Gide et J Baudry, Paris, 1856
Album 615 × 435 mm (24¼ × 18 in)
Originally bound in leather
Text volume 435 × 305 mm (17¼ × 12 in), 92 pp
Paper wrappers
2 volumes containing a total of 174 salted-paper prints from waxed-paper negatives, printed by Blanquart-Evrard, published in 58 *livraisons* of 3 prints per *livraison*
Text by Auguste Salzmann

Captain Linnaeus Tripe
Photographic Views in Madura

Although French photographers working in the Orientalist mode made many of the finest early travel books using paper negatives, their British counterparts also had their moments. This was especially true in India, where much of the early photographic documentation was made by enthusiastic amateurs, employed in both the military and civil administrations. Two of the finest exponents of the waxed-paper negative, the surgeon Dr John Murray, and the army captain Linnaeus Tripe, not only made many fine photographs, but also had them published.[19]

British photography in India was officially encouraged to a greater degree than back home in England. In February 1855 the British East India Company – the continent's effective ruler – decided that its programme of recording ancient Indian architecture would, in the future, be carried out by photographers rather than draughtsmen. In 1856 Captain Linnaeus Tripe, who had demonstrated great expertise in photographing Burmese views, was commissioned by the Madras Presidency to photograph architecture and antiquities in the South of India. Tripe, in accepting the commission, formulated an ambitious brief for himself. In addition to antiquarian subjects, he proposed to photograph geography, topography, geology and natural history. Finally, he stated, 'the picturesque may be allowed, perhaps supplementally'.[20]

Basing himself in Bangalore, Tripe photographed extensively from December 1857 to April 1858, bringing back to Madras Presidency no fewer than 255 large paper negatives, 16 large glass-plate negatives and 160 stereoscopic photographs. Six books of views – amongst the finest in early British photography – from the large negatives were published in 1858, but the Governor of Madras discontinued the programme for financial reasons in 1860. The books were not a commercial success, and the amateurs who supplied the presidency with photographs were much cheaper.

Of Tripe's Madras books, *Photographic Views in Madura* is the grandest, containing more pictures than the others.[21] Like all the rest, it demonstrates Tripe's aesthetic and technical mastery. He certainly allowed the picturesque into his work, perhaps centrally rather than supplementally, but not at the expense of description, and his pictures – like those of Félix Teynard – display a sure delineation of light and space. He toned his prints with hyposulphite of gold, which not only ensured their chances of remaining well preserved but gave them their distinctive rich violet hue. He also managed to include clouds in his pictures – rare for early photographs – their somewhat gritty rendition adding to the individualistic character of his imagery.

Captain Linnaeus Tripe **Photographic Views in Madura**
Madras Presidency, Madras, 1858 (Vol I shown)
460 × 440 mm (18 × 17¼ in)
Originally bound in leather
4 volumes containing a total of 48 albumenized salt prints from waxed-paper negatives
Descriptive notes by Martin Norman (Vols I–III) and the Rev W Tracy (Vol IV); photographs by Captain L Tripe, Government Photographer

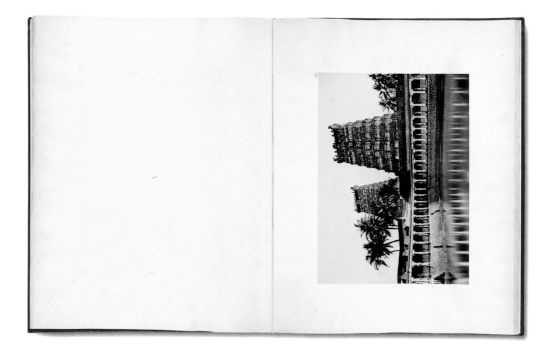

Félix Teynard
Egypte et nubie
(Egypt and Nubia)

Louis de Clercq
Voyage en orient
(Journey to the Orient)

Like Maxime Du Camp, John Beasley Greene and
Auguste Salzmann, Félix Teynard was not principally a
photographer. He was a civil engineer from Grenoble,
who made the journey to Egypt in 1851 'to study cer-
tain questions of personal interest'.[22] His great Middle
Eastern work, which constitutes his entire body of
known photographs except for a few French images,
was published in 32 *livraisons*, beginning in 1853. The
printing was completed in 1858 by Blanquart-Evrard's
main rival, the firm of Fonteny in Paris, issued through
the publishing house of Goupil.

Teynard's vision is quite distinctive. He could be said
to combine the best qualities of the others – Du Camp's
frontality, Greene's spatial awareness, Salzmann's tex-
tural density – with his own particular feel for light and
shade. His imagery is distinguished by shadows that
are almost alive. He often utilizes the bold shapes cast
by the Egyptian sun as blocks of negative space in his
intuitive yet impeccably ordered compositions. Another
singular feature of his work is that he (almost) lets con-
temporary Egyptian life intrude into the generally anti-
quarian trope – not in the form of the usual exotic
Orientalist picturesque, but with some harsh, unlovely,
yet true townscapes from Middle Egypt.

Louis de Clercq's six-volume *Voyage en orient* (Jour-
ney to the Orient), containing a grand total of no less
than 222 prints, can be said to be the culmination of a
tradition, the last of the 'first generation' of travel photo-
books, that is, the 'amateur' generation. Published pri-
vately in 1859–60 by its author, its appearance more or
less coincided with the first great Orientalist book of
the professional generation, Francis Frith's *Egypt and
Palestine*. Frith, like most other photographers of the
late 1850s – particularly the professionals – had aban-
doned the paper negative in favour of collodion on glass,
the wet-plate system. De Clercq's book could thus be
considered the last great fling for paper photography.

Because his book arrived on the scene at a time
when paper photography was already an anachronism,
de Clercq has perhaps not been given full due as a
photographer. Those who know these rare volumes,
however, regard him as at least the equal of Du Camp,
Salzmann, Teynard and other French pioneers of Mid-
dle Eastern photography using the paper negative. His
vision is characterized by its precision and assured-
ness. One feels that he always set up his camera with-
out much hesitation. And he stands out in another
respect: he was an excellent maker of photographic
panoramas. Using two or three negatives, he solved
both the aesthetic and technical problems of the pano-
rama, and his combination prints are remarkably seam-
less and artfully constructed.

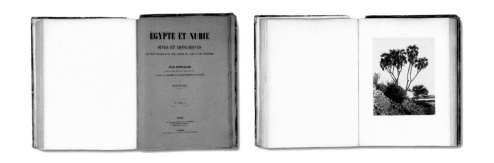

Félix Teynard **Egypte et nubie: sites et monuments** (Egypt and Nubia: Sites and Monuments)
Goupil et Cie, Paris, 1858
505 × 375 mm (19¾ × 14¾ in)
Originally bound in leather
2 volumes containing a total of 160 salted-paper prints from waxed-paper negatives made in 1851,
printed by Fonteny et Cie, Paris, published in 32 *livraisons* of 5 prints per *livraison*
Introduction and captions by Félix Teynard

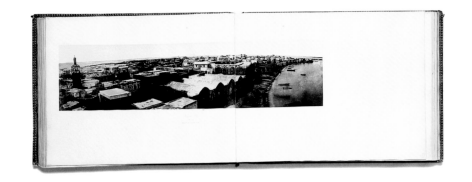

Louis de Clercq (Louis-Constantin-Henri-François-Xavier de Clercq) **Voyage en orient: receuil photographique exécuté
par Louis de Clercq, 1858–1859**
(Journey to the Orient: Photographs by Louis de
Clercq, 1858–1859)
Louis de Clercq, Paris, 1859–60
527 × 749 mm (20¾ × 29½ in)
Originally bound in leather
6 volumes containing a total of 222 albumen prints
from waxed-paper negatives
Vol I *Towns, Monuments and Picturesque Views of
Syria*; Vol II *Syrian Castles from the Time of the
Crusades*; Vol III *Views of Jerusalem and Holy Sites
in Palestine*; Vol IV *Stations of the Cross on the Via
Dolorosa in Jerusalem*; Vol V *Picturesque
Monuments and Sites of Egypt*; Vol VI *Journey
in Spain*
Text by Louis de Clercq

Francis Frith **Egypt, Sinai and Jerusalem**
James S Virtue, London, 1862–3
745 × 535 mm (29¹⁄₂ × 21 in)
Hardback with full red leather
20 albumen prints from wet-collodion
negatives, published in 10 fascicles of
prints per fascicle
Descriptions by Mrs Stuart Poole and
Reginald Stuart Poole

Francis Frith
Egypt, Sinai and Jerusalem

Francis Frith
Egypt and Palestine

Francis Frith made three visits to Egypt and the Holy Land during 1856–9. He produced prints of around 9 by 7 inches and 20 by 16 inches, along with stereoscopic views, which were published from 1858 to 1863 by James S Virtue, William Mackenzie, and Negretti and Zambra in various editions. Images from the smaller formats were also incorporated into various illustrated editions of the Bible. The two editions featured here contain the first of the 9 by 7 inch and 20 by 16 inch prints, constituting one of the most renowned nineteenth-century photobooks.

The story of his sojourn to the Middle East is as well known as Maxime Du Camp's, for Frith wrote informative commentaries on the plates. He was particularly revealing about the difficult business of making wet-plate photographs in the heat and dust of Egypt. The process necessitated mixing chemicals 'on site' in a dark tent, coating the plate, exposing it while damp (hence the term 'wet plate'), and developing it immediately – a difficult enough technique under normal conditions, but an immense one in the desert. At one point, we are told, his collodion solution almost boiled in the heat.

The large-view prints in the book have justly become famous, therefore, as much for their technical as for their artistic achievement, demonstrating photography's astonishing capacity to render the form and texture of the actual. Compared to the mammoth-plate American photographs of Carleton E Watkins, however, Frith's vision seems more conventional, somewhat four-square and obvious. The excellent smaller pictures are another matter – proof that a less unwieldy camera tends to free the photographer's vision. With the 9 by 7 inch view camera, Frith was liberated not only from the technical difficulties, but also from the aesthetic responsibilities of making a grand statement. Regrettably, following the success of these views and the setting up of Frith and Company, he devoted himself less to taking photographs, no doubt due to the exigencies of running the business.

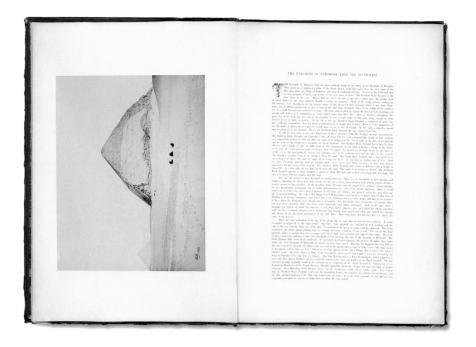

Francis Frith **Egypt and Palestine**
James S Virtue, London and New York, 1858–9
435 × 303 mm (17 × 12 in)
Hardback with full red leather
2 volumes containing 76 albumen prints from
wet-collodion negatives, published in 25
fascicles of 3 prints per fascicle
Descriptive notes by Francis Frith

Désiré Charnay
Cités et ruines américaines
(American Cities and Ruins)

The nineteenth century has been described as photography's era of exploration, when many photographers were not so much artists as explorers and scientists. And of all the first generation of photographic travellers, none fits the description of 'explorer' better than Désiré Charnay. Almost every far-flung part of the globe has a talented early photographer associated with it – Felice Beato in Japan, John Murray in India, John Thomson in China, any number in the Middle East – but the locations associated with Charnay could hardly be further apart. Charnay photographed in Central America and Madagascar, but in addition he also travelled to South America, particularly Chile and Argentina in 1875, and to Java and Australia in 1878. By nineteenth-century standards he was extremely well travelled.

His photographs of Madagascar, taken in 1863, are interesting enough. Consisting primarily of portraits, with some landscapes, they document a country little visited by early photographers. But they are altogether more modest and smaller in scale than the work by which he is best known, and which produced yet another classic photobook, his *Cités et ruines américaines* (American Cities and Ruins) of 1862–3. The world of archaeological exploration had been astonished in the early 1840s by the discovery made by the American John Lloyd Stephens of the Mayan ruins of Yucatán. In the 1850s Charnay was inspired by Stephens's best-selling account of his discoveries, *Incidents of Travel in Yucatán* (1843), a book illustrated with the brilliant, highly detailed drawings of Frederick Catherwood. Charnay acquired the support of the French Ministry of Public Education to mount an expedition to the Yucatán. After a further contribution to his expenses made by Pierre Lorillard of New York,[23] he photographed in Yucatán

between 1858 and 1860, hampered by the difficulties of jungle travel, the remoteness of the sites, and the small matter of a civil war in Mexico.

Eventually, however, he published a book of 49 of his photographs,[24] with an accompanying text volume containing a lively account of his many adventures, and an essay on the monuments by the architectural theorist, Viollet-le-Duc. But it is Charnay's photographs that draw us today. They are rough and untutored, similar to Maxime Du Camp's, and display a no-nonsense directness. They are also somewhat gritty, reflecting the difficult conditions under which Charnay worked, and that realism also extends to their virtues as documents. They are remarkable records, still retaining their validity in depicting the condition of these great architectural monuments soon after their discovery. And not least, they confirm how remarkably accurate Catherwood's draughtsmanship had been in recording forms and details that were completely alien to him.

Désiré Charnay (Claude-Joseph-Louis-Désiré Charnay) **Cités et ruines américaines** (American Cities and Ruins)
Gide et A Morel, Paris, 1862–3
Album 750 × 600 mm (29¹⁄₂ × 23¹⁄₂ in)
Originally hardback with full red leather and red slipcase box
Text volume 240 × 150 mm (9¹⁄₂ × 6 in), 544 pp
49 albumen prints from waxed-paper and wet-collodion negatives
Preface, text and photographs by Désiré Charnay; texts by Viollet-le-Duc and Ferdinand Denis

Josiah Dwight Whitney
The Yosemite Book

Josiah Dwight Whitney, after whom the highest peak in the Sierra Nevada is named, was State Geologist of California, and in that capacity supervised the Geological Survey of California, which took place from 1860 to 1874. Publication of the survey's findings was unsystematic, to say the least, but this handsome volume was printed in 1868, in an edition of 250, as part of that effort, although it also served as a commemoration of the 30 June 1864 transfer of the Yosemite

Valley and the Mariposa Big Tree Grant from federal government to state control, effectively making Yosemite the world's first national park. To illustrate the book, Whitney chose the San Francisco photographer Carleton E Watkins. He admired the dramatic mammoth-plate pictures that Watkins had taken of Yosemite in 1861, and commissioned him to make new photographs for the survey.

The prints made for the book are not Watkins's spectacular mammoth-plate size, however. They are roughly whole-plate in dimension, but nevertheless superb examples of the landscape photographer's art.

Watkins's major virtue is that, of all the great nineteenth-century landscape photographers, his images are the most perfectly poised between document and art. He seemed never to have sought the picturesque, but did not go out of his way to avoid it either. His pictures thus have a universal appeal that rendered them highly popular, his Yosemite images of 1861 making a strong case in persuading the federal government to ensure that the valley would be preserved in perpetuity for the public.

Josiah Dwight Whitney **The Yosemite Book: A Description of the Yosemite Valley and the Adjacent Region of the Sierra Nevada, and of the Big Trees of California**
J Bien, New York, 1868
298 × 248¼ mm (11¾ × 9¾ in), 116 pp
Hardback with brown cloth, brown leather spine and corners
28 albumen prints from wet-collodion negatives (24 by Watkins, 4 by Harris)
Text by Josiah Dwight Whitney; photographs by Carleton E Watkins and W Harris

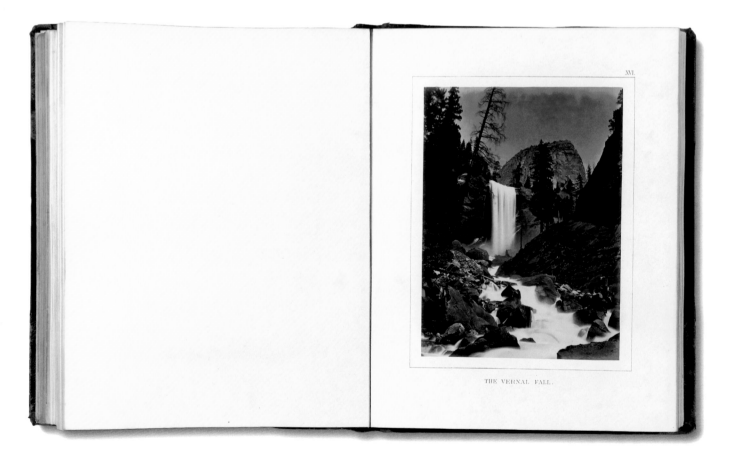

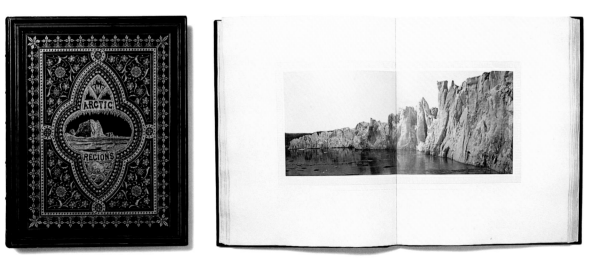

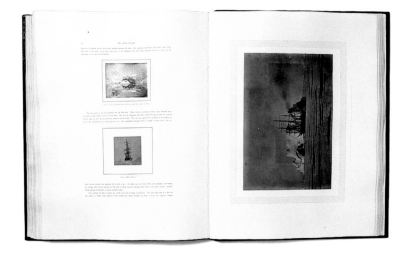

William Bradford **The Arctic Regions: Illustrated with Photographs Taken on an
Art Expedition to Greenland**
Sampson Low, Marston, Low and Searle, London, 1873
612 × 485 mm (24 × 14³⁄₄ in), 90 pp
Hardback with full brown decorated leather
129 albumen prints from wet-collodion negatives
Text by William Bradford; photographs by John Dunmore and
George Critcherson

William Bradford
The Arctic Regions

In 1869 William Bradford, the American painter of ma-
rine and polar subjects, chartered a steamship named
The Panther and had it fitted out to withstand the
rigours of Arctic travel. Bradford had been generously
sponsored to the tune of $20,000 (£5,000) by a wealthy
patron, Le Grand Lockwood. This sum enabled him to
hire the services of two photographers, John Dunmore
and George Critcherson, from the Boston photographic
firm of James Wallace Black, to accompany him on a
projected expedition to Greenland. The purpose of the
journey – a glorified sketching trip – was to enable
Bradford to gather material for his paintings at first
hand, with the secondary purpose of exploring the re-
gion. For this reason the noted Arctic explorer Dr Isaac
Hayes joined the party.

The three-month summer trip to the far North was
a complete success. Not only did the expedition yield
Bradford enough sketches and photographs to furnish
him with motifs for years, but the published account
of the journey became one of the nineteenth centu-
ry's most spectacular photographically illustrated travel
books. Bradford's chronicle of the expedition was pub-
lished in London in 1873. He seemed adept at attract-
ing sponsorship. The book was subsidized by Queen
Victoria herself, along with several other members of
the British royal family, and there is no doubt that the
volume is one of the most sumptuous of the century.

Recent research has suggested that Bradford him-
self was responsible for some of the photographs, but
the artist rightly credits Dunmore and Critcherson for
the overall excellence of their efforts. And if one con-
siders that the problems of making wet-plate nega-
tives were compounded by the extreme conditions,

the pictures obtained by the expedition were thor-
oughly deserving of all the praise they received. Dun-
more and Critcherson's images may be counted not
only amongst the earliest, but also the best polar photo-
graphs. Using a large negative size – around 12 by 18
inches – they conveyed both the harsh grandeur of
the landscape through which they travelled, and the
rigours of polar travel. They also contributed to, indeed
largely invented, that staple of arctic expedition pho-
tography, the tiny ship struggling through towering
sheets of ice – the classic, but nevertheless compelling
cliché of man against the elements. Their most stunning
image, however, the book's *coup de théâtre*, is undoubt-
edly the two-part panorama of the Semitsialik Glacier,
which is 24¹⁄₂ inches wide. This early example of a 'double-
page spread' affirms the book's monumental status.

John Thomson
Foochow and the River Min

John Thomson
Illustrations of China and its People

When John Thomson returned to Great Britain in 1872 after photographing in China and Formosa for almost two years, he immediately set about publishing the mass of material he had accumulated on an extremely productive trip. The imagery he had compiled was certainly worthy of publication, for Thomson was one of the best photographers ever to set foot in China. He tempered a vision and iconography in a broadly Orientalist mode with a sensitivity that was derived from an innate feeling for his fellow man and that has earned him the doubtful sobriquet of 'the first photojournalist'. Certainly, Thomson's Chinese pictures display the reserve and dispassionate objectivity of the European traveller but, that being said, his images display more empathy than most in the Orientalist vein.

Thomson is unusual amongst nineteenth-century photographers in that he was equally adept at photographing landscape and people. He was also an assiduous maker of photobooks, and it may be his concentration on the book form that has prevented his reputation from matching the quality of his work. He was concerned to see his pictures produced in the most efficacious way, and his bibliography covers a number of photomechanical processes reflecting that desire. He made three important China books in the early 1870s, of which the first and most sumptuous, *Foochow and the River Min*, contains carbon prints. Although by definition a photomechanical process – in that a matrix and pigment are involved – the carbon print is nevertheless as labour-intensive as photographic printmaking. Its permanence and rich tonalities, however, bring a just reward. *Illustrations of China and its People*, published the year after *Foochow*, brings us much closer to the modern photobook. It is printed in collotype, which was not only cheaper and easier, but enabled both photographs and captions to be printed on a single sheet of paper, obviating the task of pasting in the prints separately.

Richard Ovenden has argued that Thomson's Chinese photographs represent one of the first bodies of work to focus on street life in a concentrated way, prefiguring much later photography, including his own in London: 'Thomson's books ... presented this great land in a way that had not been attempted hitherto ... they provided a kind of encyclopaedia which conveyed images of the land, architecture, industry and commerce of China, as well as something of the people ... Seen in this context, his photography of the street people was innovatory. By contrasting the superb landscape photographs with images of urban social problems, Thomson was trying to convey the whole of China as faithfully as possible. He succeeded in combining traditional representations of different types with personal investigations into the life and experiences of the individuals, a technique which he exploited more fully in *Street Life in London*.'[25]

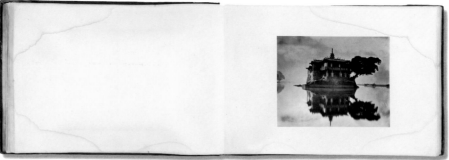

John Thomson **Foochow and the River Min**
The Autotype Fine Art Company, London, 1873
365 × 550 mm (14¹⁄₂ × 21³⁄₄ in)
Hardback with green leather, leather spine and corners
80 autotype (carbon) prints
Text by John Thomson

John Thomson **Illustrations of China and its People**
Sampson Low, Marston, Low and Searle, London, 1874 (Vol I shown)
490 × 360 mm (19¹⁄₄ × 14¹⁄₄ in), 586 pp
Hardback with decorated blue leather
4 volumes containing 218 b&w photographs arranged on 96 collotype plates,
each plate with guard leaf and page of letterpress descriptive text
Text by John Thomson

Honoré d'Albert, Duc de Luynes
Voyage d'exploration à la mer morte
(Expedition to the Dead Sea)

This rare book is closely connected with an important event in the development of photobook production, and with a unique photographic competition. In 1856 Honoré d'Albert, Duc de Luynes, archaeologist, scientist and connoisseur, initiated a competition in conjunction with the Société Française de Photographie (SFP) to find the best method of photomechanical reproduction. The major prize of 7,000 francs was awarded 11 years later to Alphonse Louis Poitevin for his method of photolithography.

Poitevin's system had been shortlisted for the award back in 1856, so why the inordinate delay? It was simply the fact that the judges considered none of the processes entered to be perfect, and delayed their decision until it was clear that nothing better was imminent. Thus Poitevin became victor by default.

Meanwhile, the competition's instigator, the Duc de Luynes, had led a geological expedition to the Dead Sea in 1864 and, upon his return, proposed to publish the pictures taken by the party's photographer, Louis Vignes. But rather than choosing the eventual winner of his competition to make the photomechanical reproductions of these negatives, the Duc selected Charles Nègre, who had also been shortlisted for the prize. Nègre had developed a photogravure method that produced beautiful prints, but was even more complicated and unwieldy in practice than Poitevin's method – an impediment that clashed with the competition's aim of finding the most practicable system. However, the Duc clearly preferred Nègre's results, and paid him 23,250 francs to produce the 64 gravure plates in the book, a commission worth far more than winning the competition prize.

The Duc's decision was clearly based on aesthetics. As albumen prints made from them show, Vigne's negatives were high in contrast and lacking in shadow detail, probably the result of underexposure and overdevelopment. Nègre's photogravure process, though complex, improved them considerably. As James Borcoman has written, 'It is remarkable how Nègre was able to open up the shadows and fill them with light, detail and space.'[26] To the small but vitally important field of nineteenth-century photomechanical processes, Nègre brought not only technical expertise but also the eye of a master photographer. The book may be something of a hybrid – a number of the pictures, including the splendid panorama shown here, are hand-drawn lithographs made from the photographs – but it remains one of the finest photomechanically printed books of the era.

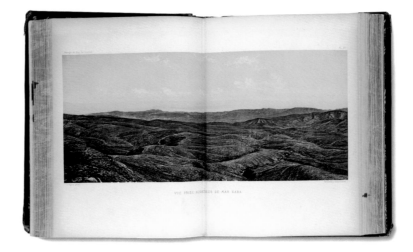

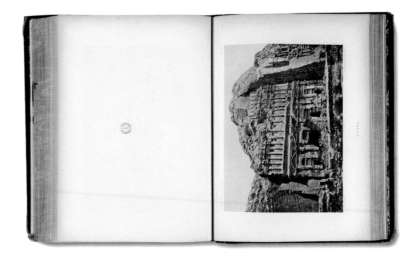

Honoré d'Albert, Duc de Luynes **Voyage d'exploration à la mer morte, à petra et sur la rive gauche du jourdain**
(Expedition to the Dead Sea, Petra, and the Left Bank of the River Jordan)
Arthus Bertrand, Paris, 1868–74
345 × 250 mm (13½ × 9¾ in), c 1,000 pp
Originally hardback with marbled paper and leather spine
4 volumes, 3 of text, 1 of plates with 64 hand-pulled b&w photogravures by Charles Nègre
from original wet-collodion negatives by Louis Vignes, 18 lithographs by Eugène Ciceri
after photographs by Vignes and de Sauvair, drawings and maps
Text by Honoré d'Albert; photographs by Louis Vignes

Facing Facts
The Nineteenth-Century Photobook as Record

The distinction between art and document seems inappropriate when applied to the earliest photograph … All photography was documentation; authenticity, and the removal of human imperfection from the transcription of nature were thought to be the essential qualities of the photograph. While the artist might try to influence political and social attitudes, or address the soul, the spirit or the senses, the photograph was seen simply as a superior instrument for recording visual fact. Alan Fern[1]

James Nasmyth and James Carpenter
**The Moon: Considered as a Planet,
a World, and a Satellite**
John Murray, London, 1874

The comparison of a withered apple and a
wrinkled hand to the moon's surface would
have been considered a pedagogical
masterstroke by nineteenth-century readers.

Like Alan Fern, in the quotation cited on the left, we have not drawn the distinction between art and document in the early photobooks, since all photography at the medium's inception was documentary in nature. But this is not to say that many of the first generation of photographers, particularly those employing the paper processes, were unaware of the photographic medium's aesthetic charms. They frequently entertained a greater degree of sophistication with regard to photography than we sometimes give them credit for.

The assigning of books to either Chapters 1 or 2 might be defined, not in terms of art or document, but in terms of the changes that occurred in photography around 1860. Firstly, the daguerreotype and the calotype, had become obsolete. The hegemony of collodion on glass was almost complete, although photomechanical processes were rapidly being perfected and would soon provide a viable alternative to the wet-plate and albumen print for book illustration. Secondly, the leading figures of photography's first two decades – mostly those working on paper – were mainly amateurs. The new generation taking their place was much more businesslike and professional in outlook. There are of course degrees of overlap, but the architectural, travel and topographical views that constitute the majority of books in Chapter 1 – while essentially documentary in nature – could be described as demonstrating an antiquarian rather than a wholly scientific or political interest, with the exception of Anna Atkins's *Photographs of British Algae*. But even her conception indicated as much care for the aesthetic as the purely documentary.

Nevertheless, the basic truth of Fern's contention is evident, especially with respect to the photographic book. It concurs with an observation made by Joel Snyder about American Civil War photographs, which may be applied generally to the photographic culture of photography's first four decades. This culture, on the whole, expressed a remarkably broad consensus of attitudes about accuracy, objectivity, art, documentation and visual interest. Snyder wrote that in the nineteenth-century photograph, 'accuracy is identified with fine detail, objectivity with distance, art with craftsmanship, documentation with transcription, and interest with the obligations of a good citizen and not with any intrinsic qualities of the picture'.[2]

Photography was a child of scientific materialism, a product of the Industrial Revolution. The medium came into being around the time that the modern industrial state reached the apogee of its first stage of development in Western Europe. It was invented just two decades into the hundred-year period from about 1815 to the beginning of World War I in 1914 – a period when Europe's industries were the most advanced in the world, and when its colonies, chiefly those of Britain and France, expanded from an area covering around 35 per cent of the earth's surface to around 85 per cent.

In the camera the colonial imperative found a near perfect tool, an instrument that added greatly to the storehouse of nineteenth-century Western knowledge – far outweighing the pencil and brush in terms of collecting, recording, storing, cataloguing, surveying and categorizing the material things of the world. The camera helped create a body of knowledge that both facilitated and justified the colonial enterprise, not as an act of material exploitation – although it certainly was that – but as a 'civilizing' exercise. The occupier garnered knowledge about the occupied, and the object of such knowledge was thus inherently vulnerable, subject to scrutiny and control, subject to authority. Knowledge was power, for in a sense, a thing existed only if it was *known*.

The proper place for the documentary photograph – which in the first three decades of the medium meant the vast majority of photographs – was the library or the archive rather than the exhibition salon, the album or portfolio rather than the gilded frame. Even the Blanquart-Evrard albums of 'artistic' studies were intended less as self-contained works of art in themselves than as the raw visual material from which the artist's or connoisseur's fancy might take flight. The phrase used by Eugène Atget at the end of the century, *documents pour artistes*, is a perfect reflection of nineteenth-century attitudes, and even lingered into the next century.

The conceptual model for the nineteenth-century photobook was the report rather than the romance, which is not the case with the majority of twentieth-century photobooks, even those in the so-called 'documentary' mode. The landscape and architectural studies of the Middle Eastern monuments were seen as no more or less artistic than the construction studies of British and French engineering feats. For example, Roger Fenton was considered, and considered himself, the leading English artist-photographer of the 1850s. Yet as well as making landscapes, picturesque studio tableaux, and still lifes, he also documented objects in the British Museum, recorded architecture, and in his major engagement with the photobook became a news photographer, being widely credited with the invention of a new and gritty photographic genre – war photography.

One might equivocate about declaring Fenton the sole inventor of war photography. He was not the only photographer to record the first war in which the new medium was involved – the Crimean. James Robertson also photographed there, and the Frenchman Charles Langlois made pictures of the conflict that were every bit as effective as Fenton's, and perhaps more dramatic. They were not, however, published in lavish folio volumes by Messrs Thomas Agnew and Sons at a price of 60 golden guineas. Fenton may not have invented war photography, but he certainly exploited and popularized it.

Between the Crimean War and the American Civil War a number of other conflicts, such as the Indian Mutiny of 1857, were witnessed by the camera. But these were minor skirmishes compared with the bitter conflict between the states, which in photographic terms was important for two reasons. It was the first war to be photographed systematically from beginning to end by professional

photographers working both commercially and in certain cases also for the military. And it gave rise to two of the finest photobooks of the nineteenth century.

Even more than in the Crimea, photography of the Civil War was a business, run by a man who, like Francis Frith, was not just a photographer but a brand name. Such was Mathew Brady's success at self-promotion that his name has become synonymous with Civil War photography, to the unfair exclusion of his fellow entrepreneur, Edward Anthony. In fact, Brady took very few photographs in the field, although he was credited for the work of the many photographers he employed. But he was certainly responsible for spotting the commercial opportunity afforded by the war, and for organizing a team of photographers to exploit it. With Anthony, he also arranged the printing and effective distribution of the images.

The authors of the two great photobooks to emanate from the Civil War, Alexander Gardner and George N Barnard, were both ex-Brady photographers who had left their employer to set up in business for themselves, whilst also making photographs for the Union forces at one time or another. The leading Civil War photographers were an enterprising bunch, and the intricate web of business relations between them has still not been completely untangled by photo-historians. Like Fenton's Crimean volumes, both *Gardner's Photographic Sketchbook of the War* (1866) and Barnard's *Photographic Views of the Sherman Campaign* (1866) were marked not only by the limitations of the cumbersome wet-plate process, but also by the representational conventions of the day. Both are essentially topographical books, yet instead of depicting a Grand Tour itinerary and showing the landscape of antiquity, they record an army's campaign and illustrate the landscape of war.

But *Gardner's Photographic Sketchbook* departed from convention in one particular area, revealing a new side to the representation of war. Several pictures by Gardner himself and by another of the book's photographers, Timothy O'Sullivan, were of bloated corpses lying on the battlefield. These images caused a sensation when published, both as photographs in the *Sketchbook*, and as wood engravings in popular journals. They began a debate about the propriety of such photographs that has continued to this day.

Another of today's hotly debated photographic issues also surfaced in the *Sketchbook*, although less contentiously then than now, and that is the question of 'doctoring' photographs, or arranging events for the camera. One of the most famous of the *Sketchbook* pictures, Gardner's *Home of a Rebel Sharpshooter*, depicts the corpse of a young man lying in a sniper's redoubt. The image shows subtle signs of having been arranged, tidied up. The young soldier's rifle is leaning against the walls of the bunker at an aesthetically convenient, unrealistic angle, but absolute confirmation comes from the fact that the same corpse turns up in another of Gardner's battlefield pictures, taken at a spot about 30 metres from this one. The photographer and his assistants had moved the cadaver to a more picturesque location, fabricating one of the war's most iconic images.

With contemporary audiences still in thrall to the documentary potential of the camera, this didn't matter very much. Their acceptance of photography's veracity remained largely unquestioning, and even sharp-eyed viewers who had noticed Gardner's deception wouldn't have cared much. What would have mattered far more to the average nineteenth-century viewer was the fact that the young man was clearly dead, and that they were looking at an actual corpse. This was more important than the precise details, which had also been given a degree of poetic licence by Gardner in his caption to the image.

It was the superficial veracity of the photography that interested the nineteenth century, a century in which the empirical observation of the world was of primary importance. The knowledge gained by scientific observation gave the governing classes of the industrial nations the complex apparatus of control necessary to keep potentially unruly underclass populations in line, both at home and abroad. Photographic documentation – like the Civil War photographs – provided a powerful and persuasive aid in writing the histories that would be compiled by the winners. Following the war, many of the same photographers would be employed by government or private

enterprise – such as the railway or mining companies – to make photographic surveys of the Western territories that were being colonized by the Union victors.

The process of colonization by camera was not confined to far-off lands. Photography was quickly adopted as part of the apparatus of state and private capital control by the military, the police and the burgeoning academic professions, which were rapidly gaining power and influence as an integral arm of the bourgeoisie. Science in the nineteenth century, sponsored by a rigidly codified class system, had a vested interest in producing the visual evidence that would substantiate the assumptions that underpinned the social hierarchy. This included defining the 'other', and utilizing photography to survey underclass social groups such as the poor, criminals, the ill and the insane, plus the transgressive gender – women – and indigenous peoples from the colonies. As a tool of colonialism, the camera was as useful, and almost as ubiquitous, as the gun.

Of course, this was a largely unconscious tendency, for those engaged in collecting all this new knowledge considered the fruits of their labours to be 'pure' fact, objective and empirical observations, the unvarnished and absolute truth. If the camera lied, it was in the inconsequential area of individual viewpoint and emphasis, not in the fundamental area of collective cultural and class hegemony. To the nineteenth-century photographer seeking to document the facts of his time, the medium was to all intents and purposes *sui generis*. Photography was regarded as a transparent vehicle for the transcription of fact, a means by which the world virtually represented itself.

Photography was placed at the service of such major sciences as geology, astronomy, archaeology, physiology, zoology and anthropology. But it was also used in the furtherance of much more dubious scientific enterprises – physiognomy, comparative criminology, phrenology and sexology. We may term such activities, either wholly or in part, as pseudo-sciences, in which the comparison of superficialities served not so much to uncover new knowledge as to reinforce old prejudices. This was the age in which it was believed that criminal and other antisocial or psychopathic tendencies – such as being poor – could be determined by physiognomic comparison. Phrenology and other such pseudo-sciences were practised and actively espoused by a professional class only too willing to reinforce the gap between themselves and the lower orders.

There is more of a correlation than might be supposed at first glance between *The People of India* (1868–75) – an anthropological survey by Dr John Forbes Watson and Sir John William Kaye – and Guillaume-Benjamin Duchenne de Boulogne's medical treatise *Mécanisme de la Physionomie Humaine* (The Mechanics of Human Physiognomy, 1862). Both evince a desire to compare, label and analyze, a desire that at its most benign may be seen merely as a comparative methodology for evaluating knowledge. In a less benign light it can be read as part of the whole process of subjugating and controlling those who were seen as a potential threat to the proper ordering of society.

The real 'documentary' value of so much nineteenth-century documentary photography is open to question. For example, one of the classics of nineteenth-century astronomical literature, *The Moon: Considered as a Planet, a World, and a Satellite* (1874), by James Nasmyth and James Carpenter, a book containing beautiful woodburytype prints of moon landscapes, is not at all what it seems. The 'lunar landscapes' are not photographs of the moon itself, but of a plaster model, yet the authors' reason for this deception was scientific accuracy. Technically, they argued, photographs of the actual moon would not be as pin sharp as those obtained from a painstakingly made plaster model. Elsewhere in the book, as in the picture of a smoking lunar crater, or the comparison of the moon's surface with a wrinkled hand and a withered apple, modern readers might wonder whether the whole enterprise was a joke, but to nineteenth-century readers it would be absolutely serious. The hand and apple would be considered a pedagogical masterstroke, the use of the plaster model a judicious practical strategy rather than a bizarre anomaly.

Even a project like Eadweard Muybridge's famed 11-volume *Animal Locomotion* (1887) was not all it seemed. He employed three batteries of cameras to capture regularly timed sequences of people and animals in motion, but as academic Marta Braun as pointed out, he would frequently omit an image that was the next logical step in the sequence in favour of one that made the whole more

pictorially acceptable. Furthermore, the fact that his human subjects were often photographed naked – in the pursuit, of course, of scientific 'accuracy' – clearly lent a prurient aspect to the enterprise, gaining a potentially broader audience than the purely academic and artistic community. As Braun has written, we should understand these evocative and beguiling pictures 'not as scientific studies of locomotive mechanics but as a treasure trove of figurative imagery, a reiteration of contemporary pictorial practice and a compendium of social history and erotic fantasy.'³

The kind of assumptions informing such a neutral and nominally objective project as the Clarence King and George Wheeler geographical surveys of the American West – for which Timothy O'Sullivan was the photographer – also contain anomalies. O'Sullivan's brief was to document the geography and geology of the West from 1867 to 1874, in order to aid map-making, mining surveys and other enterprises calculated to 'open up' – that is to say, exploit – these sparsely inhabited but potentially rich territories. However, there was a less practical and less objective side to the way in which O'Sullivan approached his task. Clarence King was a leading advocate of 'Catastrophism', the theory that the world was formed by means of a divine 'Big Bang', or a series of violent upheavals, evidence of God's wrath. King believed that proof could be seen in fractured geological formations. O'Sullivan therefore tended to focus on the more angular and distinctly unlovely aspects of the landscape, even tilting his camera carefully to secure more jagged angles and thus better prove the theory. The demands of science and theology coexist, sometimes uneasily, in the work of O'Sullivan – as they do in the work of other nineteenth-century documentary photographers.

But it is easy to overemphasize the negative side of the uneasy dichotomies in nineteenth-century documentary photography, the complex relationships between knowledge and power, between science and pseudo-science, and also between the documentary and the artistic. In a level-headed study of nineteenth-century portraiture that investigated these complexities, Peter Hamilton and Roger Hargreaves attempted to redress the negative bias of much recent scholarship:

> While it is important to understand how a technology like photography played a part in the exercise of power, it is also important to remember that photography in the nineteenth century offered new and sometimes emancipatory images both of society and the individual within it. Such pictures were not available before photography, and in a very real way they offered ways of visualizing things that had not been 'seen' hitherto, thus helping to 'envisage' social, and other entities not apparent before.⁴

One of the most prevalent documentary genres of twentieth-century photography is that designated – often loosely – as 'social documentary'. This is often understood – equally loosely – to mean photography made on the city streets. As in much nineteenth-century photography of this kind, the documenting of urban social conditions had a complex agenda – in both political and representational terms – but is enshrined in three landmark photobooks – Thomas Annan's *Photographs of Old Closes, Streets, Etc., taken 1868–1877* (1878–9, republished as *The Old Closes and Streets of Glasgow* in 1900), John Thomson's *Street Life in London* (1877–8), and Jacob A Riis's *How the Other Half Lives* (1890). All three books were motivated in part by a reforming desire, to alleviate the wretched living conditions of the urban working classes, but also by the Victorian urge to typify. Of the three, Annan's arguably contains the 'best' pictures, but is the least radical, in the sense that he was not a crusading photographer. He was hired by the Glasgow Improvement Trust to document slum areas that were to make way for model housing. In short, the political fight was already won, and Annan's pictures were made to serve as historical, topographical documents rather than persuasive sociopolitical evidence. Nevertheless, they testify eloquently both to the traditional urban fabric of Glasgow and to the social conditions of the people living there.

Thomson had become interested in class mores when in China and, upon his return to London in 1874, began to photograph London 'types', much as he had photographed social types in the Far East. He had met a young journalist, Adolphe Smith, who was well connected in liberal social reformist circles. Smith's father-in-law was Blanchard Jerrold, editor of the liberal *Lloyd's Weekly London Newspaper*, and author of *London: A Pilgrimage* (1872), a collaboration with the French graphic

artist, Gustave Doré. The book was a social survey of London from top to bottom, but concentrating on the London poor, who had become a major political issue since the 1850s.

Jerrold's brother-in-law, Henry Mayhew, had written an even better-known polemic on the conditions of the London labouring classes in *London Labour and the London Poor* (1861), a gathering together of articles he had written for newspapers and journals during 1849–52. His approach was typical of the time. He treated his subjects like an ethnographer or anthropologist, venturing into London's poorest areas, interviewing his subjects and writing about them as 'characters' or 'types'.

This, as they readily acknowledged, is the approach taken by Smith and Thomson in *Street Life in London*, an anthropological method with which Thomson would already be familiar from his work in the Far East. The poor of East and South London would be almost as alien to him as the Chinese of Foochow. Structurally, *Street Life in London* is a combination of street portraiture – staged tableaux, due to the limitations of the equipment – and interviews with the subjects. Thus it was a direct predecessor of the journalistic pictures stories that would appear in illustrated magazines from that period onwards. It was also a direct successor to similar investigative journalistic ventures illustrated by graphic drawings rather than photographs, such as *London: A Pilgrimage*, and indeed *London Labour*, which was illustrated with engravings derived from daguerreotypes taken by Richard Beard.

Jacob A Riis's *How the Other Half Lives* (1890) carried the process of photographic social documentary even further. Riis, a Danish immigrant to the United States, was concerned with the New York rather than the London poor, and utilized two technical advances in photography to make the pictures more immediate, and also to disseminate them more quickly and cheaply. Firstly, he used flash – then a dangerous, volatile and unpredictable process – in order to make instantaneous photographs indoors and in badly lit places. Secondly, the photographs in *How the Other Half Lives* were printed by means of the recently developed halftone block. It was the first book to make extensive use of halftone photographic illustrations and, although the reproductions are fairly primitive, and more than half the volume is illustrated with line drawings made from photographs, it nevertheless represents a crucial step forward.

The primary task of the nineteenth-century photobook was taxonomic, to collect and classify. It gathered the world between its covers. The documentary photobook was a powerful and persuasive surrogate for the things that the scientists, explorers and colonial opportunists of the industrialized world could not transport back to the dusty glass cases in the buildings that were specially constructed to accommodate the things gathered by the knowledge industry. The geologist could bring back the rock, but not the mountain – yet photography could. The archaeologist could bring back the stone relief, but not the whole temple (though it was tried on occasion) – photography could. The anthropologist could bring back the carved mask, but not the tribesman (though that too was tried from time to time) – photography could. The astronomer could not go to the moon – yet (at least in a sense) photography could.

But what of the distinction between art and document in the nineteenth-century photobook? In Weston Naef's pioneering survey of the subject, *The Truthful Lens*, Lucien Goldschmidt commented:

> *Many of these works were illustrated to provide documentation, visual evidence, and information, a fact that in no way detracts from the power exerted by the photographic record contained in them. We are here in the presence of true artists, the unwitting creators of memorable images.*[5]

That is indeed so, but even at the end of the nineteenth century, the notion of the subjective photograph and subjective photobook was far outweighed by the belief that the proper use for photographs and photographic books was to convey objective, empirically observed knowledge. Given its taxonomic imperative, we might say that the most exemplary of nineteenth-century documentary photobooks were the great multi-volume projects carried out over years, sometimes decades – the 8-volume *The People of India* (1868–75) by John Forbes Watson and John William Kaye, Eadweard Muybridge's 11-volume *Animal Locomotion* (1887), the 12-part *Atlas photographique de la lune* (Photographic Atlas of the Moon, 1896–1910) of Maurice Loewy and Pierre Puiseux, and Edward S Curtis's 20-volume *The North American Indian* (1907–30) (see Chapter 3).

The twentieth-century photobook, even in the documentary mode, became largely subjective. Nevertheless, the conceptual objectivity of the classic nineteenth-century documentary book still remains a persuasive – if perhaps, lesser – model. This is especially true of Germany, a country with a strong museum and archive culture. The nineteenth-century taxonomic and typographical legacy continued throughout the twentieth century and into the twenty-first, at work in the conceptually rigorous, multi-volume projects of photographers like August Sander and Bernd and Hilla Becher, in the bookworks of artists such as Ed Ruscha and Christian Boltanski, in the 'New Topographical' school of 1970s American photographers, and in many single-book projects – such as Hiroshi Sugimoto's *Theaters* (2000) (see Chapter 9).

These books, and the contemporary pervasiveness of this approach, prove that even when the photographer's motive is artistic as much as it is documentary, even though we have outgrown the mistaken notion that the camera cannot lie, and when we can alter reality at the touch of a computer button, photography remains a powerful, persuasive and favoured tool for cataloguing the things of the world.

Philip Henry Delamotte **Photographic Views of the Progress of the Crystal Palace, Sydenham**
Directors of the Crystal Palace Company, London, 1855
500 × 350 mm (19½ × 13¾ in)
Hardback with full red cloth
2 volumes containing a total of 160 albumen prints from
wet-collodion negatives

Philip Henry Delamotte

Photographic Views of the Progress of the Crystal Palace, Sydenham

A defining moment in early photography was the Great Exhibition of 1851, at which the smug English were taken aback to discover how much progress the French – and even the Americans – had made with the medium. The event, however, confirmed the validity of the photobook, with the photographically illustrated *Reports By The Juries*. And when the Crystal Palace in Hyde Park was sold off to private enterprise, dismantled, then re-erected on a permanent site at Sydenham, the photographer Philip Henry Delamotte documented this epic process. His published record of the Crystal Palace's reconstruction is one of the earliest and best examples of an important genre of photobook – the construction diary – a genre of particular relevance to the nineteenth century, when the Industrial Revolution led to the gigantic engineering projects that so characterized the era.

It is also the first 'company' book, publications that were commissioned by a firm's directors to laud their wares.

The greatest exhibit of the Great Exhibition was the Crystal Palace itself, developed by Joseph Paxton, and the prototype for so much that was to follow – succeeding exhibition halls, shopping galleries and railway stations, the skyscrapers of the United States, the Forth Bridge, the Eiffel Tower. These were all building types made both possible and necessary by the Industrial Revolution, projects that would be avidly recorded during the course of construction by photographers. It is pleasing, therefore, to note that one of the first and most influential of the nineteenth-century engineering behemoths had a worthy photographer in the person of Delamotte.

As numerous commentators have noted, early photography exhibits an interesting dichotomy, a 'personality' split between the old and the new – between photographs that reflect pre-existing modes of visual expression and those that tread new ground. It was

similar with the Crystal Palace. Here was a structure enclosing apparently infinite space in a radical way with newly developed methods, filled to overflowing with plaster casts of Greek statues and Victorian bric-a-brac.

Delamotte's photographs of the exhibits were more formally conventional than his views of the construction process and the empty structure itself, but the book is noteworthy for its diverse approach. He even included images of workmen taking their traditional British tea break, one fellow lying nonchalantly inside a wheelbarrow. But Delamotte's most memorable images remain those where the repeated lines of the cast-iron skeleton, the girders and struts, beams and pillars formed an abstract web and created a new kind of picture. The repeated pattern of bays and aisles is deliberately reminiscent of a cathedral, and indeed the Crystal Palace *was* a cathedral – for the worship of capitalism and Victorian positivism.

Roger Fenton

Photographs Taken Under the Patronage of Her Majesty the Queen in the Crimea

It is ironic that the only photographic books published by both Roger Fenton and Gustave Le Gray, the two best architectural and landscape photographers of their generation, were of a military nature. Fenton's was the first extensive record of a war, while Le Gray's was a specially commissioned album on military manoeuvres at Châlon. But as John Szarkowski has noted, 'a good photographer can photograph anything well',[6] and early war photography, by nature of the equipment available, was very much a matter of landscape photography and formal portraiture, rather than action.

It can be taken for granted that Fenton's images do not show action, but there are things he could have included that he chose not to. We must conclude therefore that artistic, representational and commercial sensibilities dictated the form of the work as much as technical limitations. Whether the pressures influencing the view he was to take were commercial or patriotic, Fenton clearly decided to put, in modern parlance, a positive 'spin' on the Crimean War of 1854–6, the only war that Britain fought in Europe between the end of the Napoleonic conflict in 1815 and the beginning of the Great War in 1914. It was a conflict that became a byword for military incompetence and near disaster, despite the eventual British and French victory over the Russians.

There are therefore no bloated corpses, emaciated wounded, or sick soldiers racked by cholera and dysentery. Instead we find formal portraits of officers and other protagonists on the Allied side, and some severe topographical landscapes of the terrain over which the conflict was fought, with what might or might not be the smoke of battle in the far distance. One image in this collection has come to symbolize early war photography: *The Valley of the Shadow of Death*, a bleak, shallow valley strewn with cannonballs.

Yet Fenton's book is a moving and magnificent piece of work, for it defines what photography both can and cannot do. Some might argue that it cannot do much; it cannot give us the heat of battle, the pain and the desperation, or delve into the cause of futile conflicts. But Fenton still managed to 'take us there', providing a vivid picture in a way that newspaper reporters could not. We see the overcrowded harbour at Balaklava, the serried ranks of ships and piles of cannonballs, the faces of generals, colonels, officers and men, and the barren, stony ground that was won at great cost, including the loss of much of Britain's light cavalry. The picture, of course, is a partial and partisan one, but Fenton also demonstrates conclusively that even documentary photography – successful documentary photography at that – can frequently be about feeling rather than actuality.

Roger Fenton **Photographs Taken Under the Patronage of Her Majesty the Queen in the Crimea by Roger Fenton Esq**
Thomas Agnew & Sons, Manchester, 1856
670 × 520mm (26¼ × 20½ in)
Originally portfolio with full red leather
160 salted-paper and albumen prints from wet-collodion negatives, sold in sets as follows:
Incidents of Camp Life; Historical Portrait Gallery; Views of the Camps; The Photographic Panorama of the Plateau of Sebastopol; The Photographic Panorama of the Plains of Balaclava and the Valley of Inkerman

Alexander Gardner
Gardner's Photographic Sketchbook of the War

'In presenting the *Photographic Sketchbook of the War* to the public, it is designed that it shall speak for itself.' Alexander Gardner's introductory remarks to his *Sketchbook* are somewhat disingenuous. For the view of the Civil War presented in this early masterpiece of documentary photography is as mediated as any in the history of photography. And yet the book was revolutionary in taking war reportage a stage further in veracity, for it was the first to show photographs of the slain, and to shock its public with their stark brutality, leading Gardner to claim that 'verbal representations of such places, or scenes, may or may not have the merit of accuracy; but photographic presentments of them will be accepted by posterity with an undoubting faith'.

One might suppose that sharp-eyed observers – even during an era when credulity concerning the photograph's veracity was at its height – would notice that the same judiciously arranged corpse appeared in separate images in different locations, but Gardner's point remained a valid one. Documentary presentation – representation and re-presentation – was the essence, and the *Sketchbook* remains a valuable historical document, even if its truth is clearly 'the truth told slant', to quote Emily Dickinson. Modern viewers have come to read every photographic document with a degree of suspicion, but Gardner's contemporaries were also quite capable of distinguishing for themselves between wholly unvarnished and subtly enhanced truths.

To the modern eye, the subject-matter of the *Sketchbook*, apart from the few well-known images of battlefield corpses, is puzzling. Many pictures seem to relate only peripherally to war – or at least war viewed as violent action – describing preparations for battle or its aftermath. Besides scenic views of the battlefields themselves, the *Sketchbook* images show villages, towns, army camps and topographical features adjacent to battle sites, and buildings of state such as courthouses and prisons, or houses where prominent officers were quartered. There is an emphasis on lines of communications, with numerous photographs of bridges, railways and other military engineering feats.

Cumbersome equipment was partially, but not wholly, responsible for the images' static nature. The documenters of the Civil War were primarily architectural or landscape photographers, satisfying a demand for topographical pictures, general images of sites and locations that had great meaning for the public of the day. Topographical accuracy, not drama, was the watchword. Nevertheless, Gardner had lured many of the best operatives away from his former employer, Mathew Brady. Included in the *Sketchbook* are images by Timothy O'Sullivan and George Barnard, besides Gardner himself. They knew how to put an evocative picture together, and how to 'take' the viewer to the site. In short, the *Sketchbook* is a major work of art.

Alexander Gardner **Gardner's Photographic Sketchbook of the War**
Phillip & Solomons, Washington, 1866
306 × 420 mm (12 × 16½ in), 206 pp
Hardback with full blue leather
2 volumes containing a total of 100 albumen prints from wet-collodion negatives
Text by Alexander Gardner; photographs by Alexander Gardner, James Gardner, Barnard and Gibson,
Wood and Gibson, Timothy H O'Sullivan, D B Woodbury, William Pyle and John Reekie

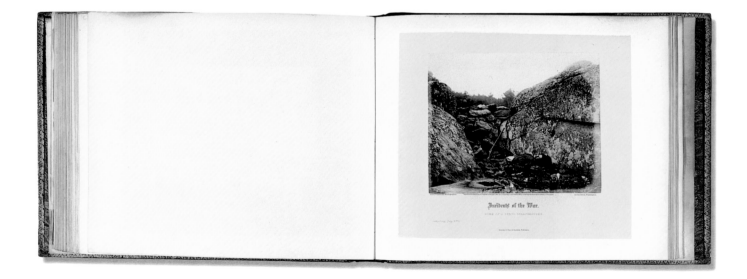

George N Barnard **Photographic Views of the Sherman Campaign**
George N Barnard, New York, 1866
415 × 492 mm (16¼ × 19¼ in)
Hardback with red cloth, red leather spine and corners
61 albumen prints from wet-collodion negatives

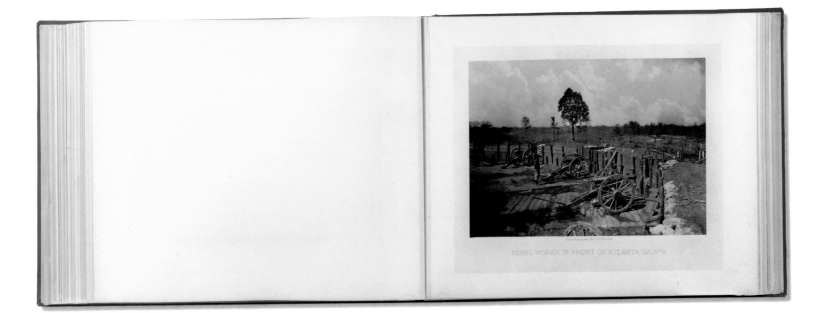

George N Barnard
Photographic Views of the Sherman Campaign

George Barnard's photographic record of General Sherman's campaign demonstrates a similar iconographic approach to that of Gardner's *Sketchbook*. But because it is the work of one photographer, and furthermore, as Keith Davis puts it, a photographer who compiled the work with a 'conscious mixture of documentary and artistic intentions',[7] Barnard's book is more unified, the work of a singular photographic as well as an editorial sensibility.

Barnard was involved in war photography from the conflict's beginnings, and is believed to have been working for Mathew Brady when he photographed the Battle of Bull Run in 1861. Later, he was employed by the Union's Department of Engineers to photograph maps for copying and to make topographical views. It was as official photographer of the Military Division of the Mississippi that he joined Sherman's march through Georgia and the Carolinas in 1864, photographing the terrain over which this decisive campaign was fought. When the war ended Barnard took a trip along the same route to photograph scenes that the exigencies of war had made impossible to capture, and he published the results (of work from both 1864 and from 1866) in the same year as *Gardner's Sketchbook*, in which he was also represented.

Barnard's clarity and precision clearly stem from the value put upon these qualities by the Department of Engineers, and in this he is little different from many nineteenth-century photographers. Yet the fact that he also needed to make his book attractive to potential subscribers gave an aesthetic as well as a documentary imperative. In many images, for instance, he overcame the problem of blank skies inherent to the collodion process by printing-in clouds using a separate 'sky' negative. These enhanced skies, much praised in their day, can seem distracting to modern taste. Much more noteworthy from today's perspective is Barnard's innate sensitivity to mood and metaphor. As Keith Davis has written, the book is 'distinguished from all other compilations of Civil War photography by its meditative mood, and the centrality of landscape imagery to its overall effect'.[8] Barnard was superbly attentive not only to the marks of conflict on the land, but apparently to their symbolic meaning. This is the first great landscape photobook, but it is of a wounded, brutalized land – gouged and scarred and broken. Its tone is stoically calm, yet bleak, and is all the more so for being so lucidly understated.

Though evidently of its time, Barnard's work demonstrates an empathy for landscape that, like the photographs of Carleton E Watkins or Timothy O'Sullivan, strikes an immediate chord with today's generation. He shows himself to have been one of the finest landscape photographers, treating those culturally loaded Civil War sites – already in the process of becoming mythic when he pictured them – with respect, but also with a matter-of-factness that is heroic in itself, and served to punctuate the hyperbole of myth.

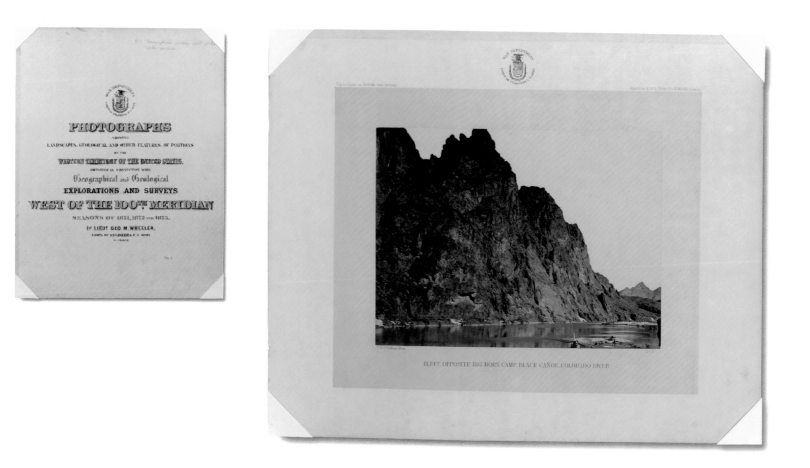

Timothy O'Sullivan **Photographs showing Landscapes, Geological and other Features,
of Portions of the Western Territory of the United States**
US Government Printing Office, Washington DC, 1874–5
476 × 381 mm (18¾ × 15 in)
Originally bound in leather
50 albumen prints from wet-collodion negatives

Timothy O'Sullivan

**Photographs showing Landscapes, Geological
and other Features, of Portions of the Western
Territory of the United States**

The publishing history of Timothy O'Sullivan's work for
the US War Department-sponsored surveys of the
American West is complicated, and beyond the scope
of this text.[9] His photographs were published both in,
and as adjuncts to, multi-volume reports, and it may be
argued that in a sense they lie outside the mandate of
this book. Nevertheless, both O'Sullivan's importance as
a photographer and the nature of the US Government
volumes make the whole Western survey enterprise
an excellent example of nineteenth-century documen-
tary photography and photographic publishing.

These photographs have made O'Sullivan arguably
the best-known nineteenth-century American landscape
photographer. He took them between 1867 and 1874,

working for the scientific survey expeditions, led ini-
tially by Clarence King, geologist and mountaineer, and
then by Lieutenant George Montague Wheeler of the
US Army. The purpose of the expeditions was explor-
atory, but it was exploration with a political objective,
namely, colonization. As Brigadier General A A Humph-
reys, who had given both King and Wheeler their or-
ders, wrote in the first volume of Wheeler's report, an
important part of the brief was 'the selection of such
sites as may be of use for future military operations or
occupation, and the facilities for making rail or common
roads'. And any judgement passed upon a parcel of
land was to be made on the basis of the qualities that
'affect its value for the settler'.[10]

But in common with other nineteenth-century sur-
veys of this nature, the expeditions came back with
information of all kinds – topographical, cartographic,
geological, ethnographic, archaeological and photo-
graphic. All was published in the great volumes, and in

O'Sullivan's case, not just original photographic prints,
but also heliotypes (photogravures) and lithographic
transcriptions of photographs were included.[11]

Whether or not O'Sullivan's pictures were deliber-
ately designed to prove King's 'Catastrophism' theory,
they have a particular, somewhat peculiar, character of
their own. They are not as dry as was once thought
by photographic critics, but they are unusual in that,
unlike the work of most nineteenth-century landscape
photographers, not a hint of the picturesque intrudes.
And yet they are far from simple records of what was
before the camera. O'Sullivan was able to make perfect
documents yet invest them with a clear and credible
personal meditation on nature, and man's relationship
to it. Much of the knowledge contained within the
reports of King and Wheeler is now redundant; O'Sul-
livan's photographs are not.

John Forbes Watson and John William Kaye
The People of India

In general, early photographic documentation in Britain was not a matter for the state, as it was in France, where the government was quick to sponsor the new medium and reap its potential advantages. Nevertheless, in a slightly less organized way, the British Empire documented itself, and nowhere more than in India – the 'Jewel in the Crown' of the Empire. Of all government institutions, the India Office used photography the most assiduously as an aid to understanding, and therefore controlling the diverse peoples it commanded in the Subcontinent.

This book was the joint effort of Dr John Forbes Watson, Director of the India Museum in London, and Sir John William Kaye, Secretary of the India Office's Political and Secret Department. The India Office had received a number of fine studies of Bengalis from an unknown photographer in 1863, and this was partly the stimulus, as was the interest in photography of the Viceroy of India, Lord Canning, and also the numerous photographs sent to the Office from all over India by local British photographers, amateur and professional, at the behest of the authorities. Using the work of more than 15 photographers, and the reports, studies and written anecdotes of a number of writers, the eight volumes of *The People of India*, comprising more than 450 photographs, were published by the India Office between 1868 and 1875. It did not cover the whole of India since it was not a commercial success and the series was discontinued in 1875.

What we have is both an example of the interplay between photographs and text, and a fascinating insight into the mind of the British Raj. The photographs are, for the most part, conventional studio-type portraits of individuals, though there are some fine group studies. It is the texts that are most revealing: a mixture of gossip, ethnography and military intelligence report, with little attempt at distance or objectivity. The superiority of the writers over their subjects, and indeed the photographers over their sitters, is taken for granted at every turn. As John Falconer has written, the whole enterprise served to reinforce notions of dominance and control, while the typological classification is 'often concerned with matters of political reliability and loyalty, criminal tendencies, and amenability to progress and education.'[12]

John Forbes Watson and John William Kaye, eds **The People of India**
W H Allen and Co., London, 1868–75
334 × 242 mm (13⅛ × 9½ in)
Hardback with full decorated brown leather
8 volumes containing a total of 468 albumen prints from wet-collodion negatives
Texts by various authors; photographs by J C A Dannnenberg, Lieut R H De Montmorency, Rev E Godfrey, Lieut W W Hooper, Major Houghton, Capt H C McDonald, J Mulheran, Capt Oakes, Rev G Richter, Shepherd and Robertson, Dr B Simpson, Dr B W Switzer, Capt H C B Tanner, Capt C C Taylor, Lieut J Waterhouse and others

John Thomson, FRGS, and Adolphe Smith
Street Life in London

Street Life in London is a pioneering work of social documentation in photographs and words, but it does not wholly break with the constraints of its era, as one could argue that Jacob Riis did some 12 years later. Some commentators have considered it a dubious social document because the pictures are staged, but if that were a real criterion for documentary photography, much of it would be disqualified. All documentary photography is a point of view, and that of Thomson and Smith was certainly honestly held. The book has also been criticized for taking a popular journalistic approach rather than an authentically socio-political one, but such comment fails to take into account the blurred boundaries between serious science, popular science and outright charlatanism during that era.

Let us focus instead on what *Street Life in London* achieved, especially Thomson's photography. Charles Nègre had made 'street photographs' in the early 1850s, but apart from a few isolated efforts, this book presents the first concerted body of work to deal with life on the streets of a major European or American city. Furthermore, it set the photographs into a socially progressive, reforming context. To be sure, Thomson was working within a long-established art/literary tradition – the 'Small Trades' or 'Cries of London' genre – but not only did he translate a graphic convention into photography, he also did it well. He may have dealt with 'types' rather than individuals, but no more so than August Sander and others in the twentieth century. His images, of necessity, were directed and posed, but are as lively as the street-trader portraits of Eugène Atget (facing similar technical problems) two decades later. Indeed, some of Thomson's complex street ensembles, such

as *Recruiting Sergeants at Westminster*, have a verve and naturalness that belies the manner of their making.

There is one image that takes us straight into the twentieth century – to Paul Strand's *Blind Woman* of 1916, to be precise. Thomson's *The Crawler*, a photograph of a destitute old woman who neither knew nor cared that she was being immortalized on a glass plate, is the picture that finally breaks the mould. The image establishes an immediate psychological intimacy with the viewer. It is shocking, a portent of the much more involved and intimate social documentary mode of the twentieth century. *Street Life* would be important for this picture alone. As it is, in terms of the concept of the photographs, and the volume's aims and ambitions as a book, *Street Life in London* is one of the most significant and far-reaching photobooks in the medium's history.

John Thomson, FRGS, and Adolphe Smith **Street Life in London**
Sampson Low, Marston, Searle and Rivington, London, 1877–8
270 × 200 mm (10½ × 8 in), 172 pp
Hardback with full decorated burgundy leather
36 woodburytypes, first issued in 12 monthly parts of 3 pictures each
Text by Adolphe Smith; photographs by John Thomson

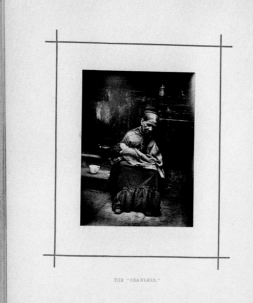

Thomas Annan **The Old Closes and Streets of Glasgow**
James MacLehose and Sons, Glasgow, 1900
380 × 280 mm (15 × 11 in), 122 pp
Hardback with full red cloth
50 photogravures from wet-collodion negatives taken between 1868 and
1899, engraved by Annan from photographs taken for the City of Glasgow
Improvement Trust
Text by William Young

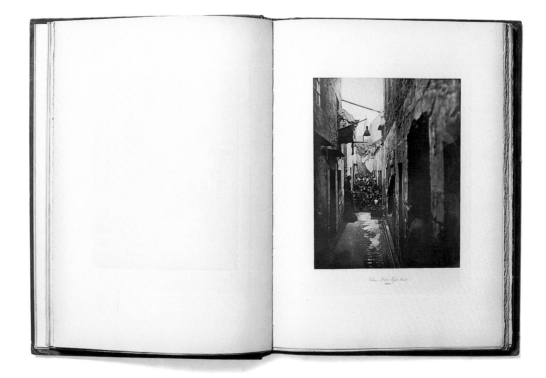

Thomas Annan
The Old Closes and Streets of Glasgow

When Thomas Annan was commissioned by the Glasgow Improvement Trust in the mid-1860s to document the older, working-class areas of the Scottish city, it was not because his photographs might be utilized in a campaign to alleviate social conditions in these areas. The trust had already won the political battle. Rather, Annan was commissioned to record the historical fabric of the old streets before they were replaced by more modern housing, in the same way that Charles Marville documented the areas of Paris demolished by Baron Haussmann in the furtherance of his more grandiose town-planning schemes. Despite the penchant for photographing picturesque antiquity, Annan's masterpiece is relatively rare in nineteenth-century British

photography, a public commission recording humble city landmarks that were about to disappear.

The Scottish 'close' and 'wynd' – the terms are almost interchangeable – were familiar landmarks in any city with a densely packed medieval street pattern: narrow passageways leading either from one street to another, or into the middle of a building block. It is the consistently narrow form of the alley that gives formal coherency to most of Annan's imagery – he simply stood the camera in the middle of the passageway and shot down it. This lends the pictures an irresistible rhythm, a sense of leading somewhere. Coupled with the numerous glimpses of the closes' indigenous inhabitants, the device makes these compelling pictures amongst the most intimate and 'modern' in feeling of nineteenth-century documents. There is nothing quite like them (Marville apart) prior to Eugène Atget.

Apart from rare albums containing albumen prints, this remarkable work was published in two distinct editions, some 20 years apart. The first, which came out in 1878–9, comprises 40 large (enlarged) carbon prints, a rich, gritty, purple-brown in tone. The second (shown here), published in 1900, includes 50 photogravures, printed in a warm brown tone. Clearly, it was decided that time would lend enchantment to these scenes, for the gravures are not only warmer and more romantic in feeling, but many have been retouched, and the starker edges of Annan's impeccably direct vision have been smoothed out a little.

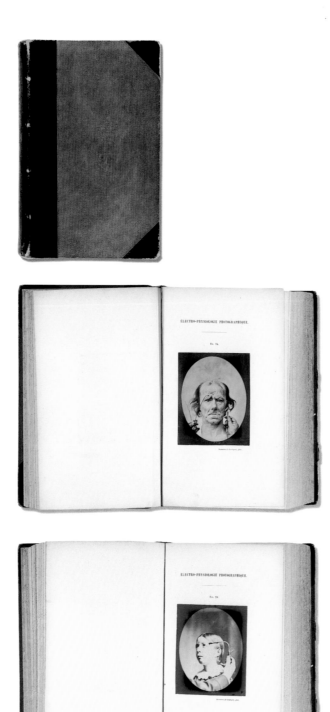

Guillaume-Benjamin Duchenne de Boulogne **Mécanisme de la physionomie humaine**
(The Mechanics of Human Physiognomy)
Ve Jules Renouard, Paris, 1862
Album 267 × 170 mm (10¹⁄₂ × 6³⁄₄ in), 270 pp
Hardback with green cloth, green leather spine and corners
71 albumen prints from wet-collodion negatives
Text volume 267 × 170 mm (10¹⁄₂ × 6³⁄₄ in), 80 pp
Blue paper wrappers
1 albumen print
Text by Duchenne de Boulogne

Guillaume-Benjamin Duchenne de Boulogne
Mécanisme de la physionomie humaine
(The Mechanics of Human Physiognomy)

The physiognomic photography of Guillaume-Benjamin Duchenne de Boulogne produced one of the nineteenth century's most remarkable bodies of published scientific work.[13] Today it is more valued for its aesthetic qualities – the disturbing, surreal nature of the images being the evident attraction. In its day, however, Duchenne's work was widely influential. Charles Darwin, for example, corresponded with Duchenne and drew on his work for his book *The Expression of Emotions in Man and Animals* (1872). Jean-Martin Charcot followed his mentor, Duchenne, initiating photographic studies of hysteria at the Salpêtrière Hospital in Paris, and commissioning a series of publications, the most important of which was probably *Iconographie photographique de la salpêtrière* (Photographic Iconography of Salpêtrière, 1876–80) by Désiré Bourneville and Paul Regnard.

The story of how Duchenne electrically stimulated the facial muscles of patients at the Salpêtrière – the leading mental hospital in France – is well known, and certainly gives rise to disquieting connotations that may be part of the imagery's perennial fascination. But his purpose is sometimes misunderstood. Although he worked at the Salpêtrière, Duchenne – unlike Charcot and many others involved in broadly similar studies – was not interested in dementia and 'abnormal' behaviour, but in the 'normal' physiological and psychological expression. There was also a religious side to the work, a search for divine laws. As Duchenne, a deeply religious man, wrote in his introduction to the book: 'The spirit is thus the source of expression. It activates the muscles that portray our emotions on the face with characteristic patterns. Consequently the laws that govern the expression of the human face can be discovered by studying muscle action.'

Another important aim of the book was aesthetic: to provide artists with a guide to facial expression so that they could achieve more naturalistic effects in their work, and he included the expressions on statues as well as living patients. The psycho-sexual intrudes, too. While his male subjects were confined to the more-or-less basic mechanical functions of the facial muscles, his female subjects were directed in more complex emotional and erotic dramas, demonstrating such emotions as 'terrestrial love' and 'celestial love'. Thus, like many works of the nineteenth century, the scientific and documentary were mixed – sometimes pointedly, sometimes confusedly – with the aesthetic and the religious, or quasi-religious, and even the erotic. Few photographic books of the century exhibit these apparent contradictions as strongly as Duchenne de Boulogne's.

Jacob A Riis
How the Other Half Lives

'Long ago it was said that "one half of the world does not know how the other half lives". That was true then. It did not know because it did not care. The half that was on top cared little for the struggles, and less for the fate of those who were underneath, so long as it was able to keep its own seat.' Jacob A Riis, social reformer and documentary photographer, begins his best-known book with this homily, immediately setting out the work's didactic tone and the stance he will be taking. His book is about the tenements of New York: the overcrowded slums of the Lower East Side that were home to boatloads of immigrants who had come to

the United States to seek a better life. It is a book about the American Dream, its flipside at least. Riis charts the rise of the tenement and the slum landlord, and takes us by means of colourful and highly charged language into the various ethnic communities that inhabited the Lower East Side – Italian, Chinese, Jewish, Black.

The solution, as Riis presents it, is primarily the building of new model tenements. His tone is passionate, anti-capitalist, empathetic, but also of its time. Modern readers might be taken aback by the kind of casual racism that would be considered normal for the era.

His sociological method is anecdotal, emotive, subjective and not very scientific. But allied to that was the camera, which lent credence to the basic truth of his argument, if not his exaggeration and prejudices.

In one sense, *How the Other Half Lives* is hardly a photobook at all; it is a socio-political polemic, illustrated partly with photographs, partly with line drawings. And yet it is also one of the most important photobooks ever published. It represents the first extensive use of halftone photographic reproductions in a book. These reproductions are rough, to say the least, but it is the beginning, not of a photographic genre, but a photographic attitude, an ethos – humanist documentary photography – in which the photographic social document is employed to bear critical witness to what is going on in the world.

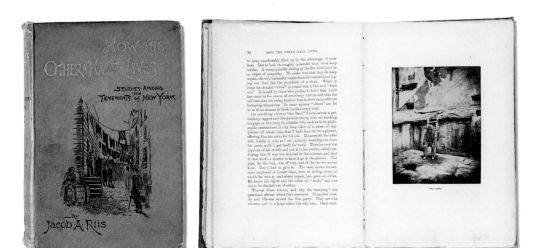

Jacob A Riis **How the Other Half Lives: Studies among the Tenements of New York**
Charles Scribner's Sons, New York, 1890
220 × 152 mm (9¼ × 6 in), 304 pp
Hardback with full green decorated cloth
18 halftone b&w photographs, 23 engraved illustrations
Text by Jacob A Riis; illustrations chiefly taken from photographs by Jacob A Riis

Josef Maria Eder and Eduard Valenta **Versuche über Photographie mittelst der Röntgen'schen Strahlen**
(Photographic Experiments with Röntgen Rays)
R Lechner, Vienna, 1896
488 × 341 mm (19¼ × 13½ in)
Portfolio
15 b&w photogravures

for aesthetic as for scientific value. And like another of the earliest books, *The Pencil of Nature*, Eder's book is at once a manifesto and an advertisement, a technical treatise and a showcase, highlighting a photographic process that would prove immeasurably useful, but also a technique that is replete with a luminous, eerie beauty.

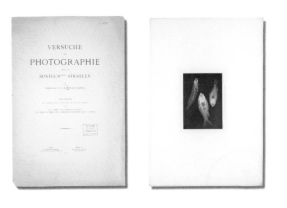

Maurice M Loewy and M Pierre Puiseux
Atlas photographique de la lune
(Photographic Atlas of the Moon)

On 9 July 1894 Maurice Loewy and Pierre Puiseux of the Observatory of Paris made an announcement to the French Academy of Sciences. The observatory was about to embark on one of the most ambitious astronomical projects of the nineteenth century – to make the first complete photographic atlas of the moon on a large scale. (If printed complete, the satellite's diameter would be about 1.8 metres.) The use of photography rather than drawn cartographic observations, Loewy postulated, would result in an atlas of unparalleled quality, more accurate and richer in detail than any drawing could produce.

The first negatives were made that year using the observatory's telescope. They were 180 mm (7 in) in diameter, and were enlarged some 8 to 15 times to produce the photogravure plates for the atlas. The gravures, each image measuring around 572 by 458 mm (22½ by 18½ in) were published in 12 fascicles of 6 plates each (except the first, which consisted of 5 plates). The first fascicle was released in 1896, the twelfth, and final part, not until 1910. Following Loewy's death in 1907, Puiseux was assisted by Charles le Morvan for the completion of the atlas. The lengthy duration of the project is explained by the fact that perfect weather conditions are needed for astronomical photography. Over that period only 50 to 60 nights per year exhibited the calm, clear conditions needed, and out of those evenings when photography was possible, only four or five faultless negatives would accrue.

Atlas photographique de la lune (Photographic Atlas of the Moon) is regarded as the ultimate achievement of nineteenth-century astronomical photography, and can be regarded, along with Muybridge's *Animal Locomotion* (1887) and Edward S Curtis's *The North American Indian* (1907–30), as one of the great photographic publishing ventures. In the nineteenth century the only comparable project was the American *Atlas of the Moon* (1896–7), made at the Lick Observatory in California, but the French volume is considered superior. Indeed, it was well into the twentieth century, during the 1970s, before Bernard Lyot at the Pic du Midi Observatory, and G P Kluiper, using negatives taken by various universities, obtained results that were clearly better than those of Loewy and Puiseux. As with all books published in fascicles, complete copies are rare, and the individual photogravure plates, amongst the largest and finest ever made, are prized by collectors for their sheer aesthetic beauty.

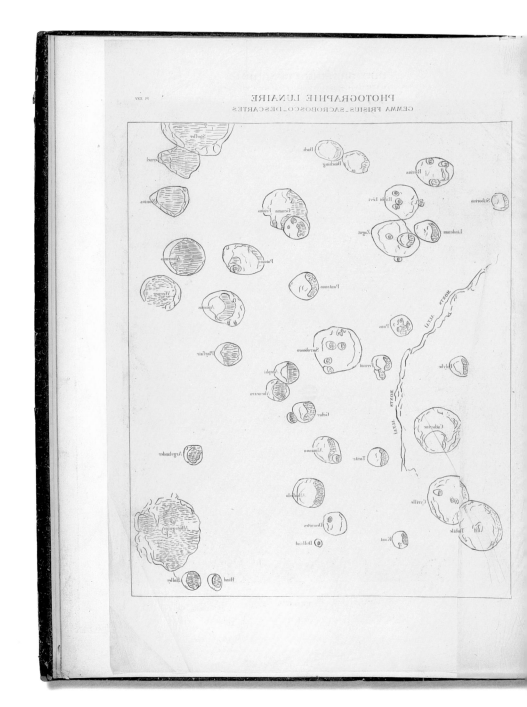

Maurice M Loewy and M Pierre Puiseux **Atlas photographique de la lune** (Photographic Atlas of the Moon)
L'Observatoire de Paris and the Imprimerie Nationale, Paris, 1896–1910
755 × 600 mm (29¾ × 24 in)
Originally published in 12 fascicles with green paper wrappers and accompanying text supplements, 310 × 231 mm (12¼ × 10 in)
71 full page heliogravures and 11 smaller title vignettes
Vol I Plates I–V (1896); Vol II Plates VI–XI (1897); Vol III Plates XII–XVII (1898); Vol IV Plates XVIII–XXIII (1899); Vol V Plates XXIV–XXIX (1900);
Vol VI Plates XXX–XXXV (1902); Vol VII Plates XXXVI–XLI (1903); Vol VIII Plates XLII–XLVII (1904); Vol IX Plates XLVIII–LIII (1906); Vol X Plates
LIV–LIX (1908); Vol XII Plates LX–LXV (1909); Vol XII Plates LXVI–LXXI (1910)

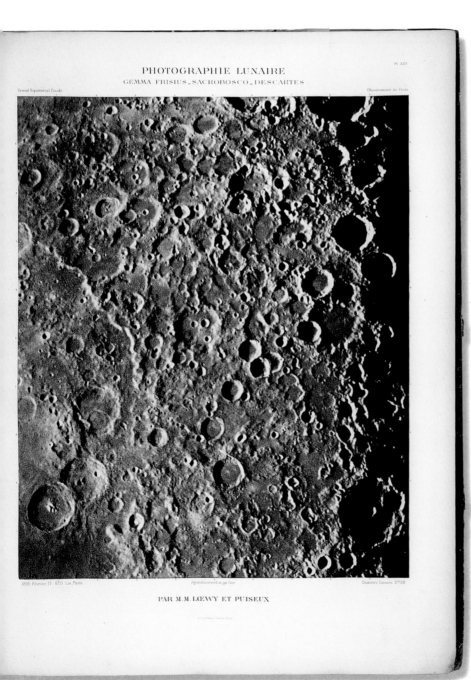

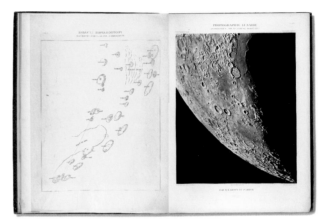

Owen Simmons

The Book of Bread

The Book of Bread is one of those rare books that can be judged by its cover, or rather, by its name. It is, as its title says, a book about bread. As Owen Simmons states in his introduction, it is a companion volume to 'that most excellent "Book of Cakes"'. A monograph about the manufacture of bread, it is the bread-maker's bread book, illustrated with photographs, about which Simmons – evidently a man who did not hold with false modesty – writes: 'However critical readers might be, they will be forced to admit that never before have they seen such a complete collection of prize loaves illustrated in such an excellent manner.'

The photographic reproductions – as opposed to the two original silver-gelatin prints pasted into the book – Simmons continues, were produced, with no expense spared, after various trials using different processes, especially for the colour illustrations: 'The loaves are now reproduced photographically correct, of exactly full size, and the colours are as nearly perfect as it is possible for them to be by any process at present known.' The book was also published in a deluxe edition of 350 with bromide prints for all the photographs and a morocco binding.

Simmons might be a little over confident about the reproduction, but as far as the aesthetic quality of the photographs go, his boasts are not misplaced. The late Sam Wagstaff, who amassed one of the finest photo-

graphic collections of the twentieth century, once said that there was a photographer for everything – someone who was the best at photographing shoes, or clouds, or mountains. Simmons evidently found the best photographer of bread, though sadly, he failed to credit him.

The nineteenth-century photobook was primarily an archive in which the things of the world were stored and catalogued. Here, at the beginning of the twentieth century, one of the humblest, yet most essential of objects is catalogued as precisely, rigorously and objectively as any work by a 1980s Conceptual artist.

Owen Simmons **The Book of Bread**
Maclaren & Sons, London, 1903
292 × 233 mm (11¹₂ × 9¹₄ in), 360 pp
Hardback with full green cloth
12 colour and 27 b&w photographs (8 tipped-in), 2 pasted-in silver gelatin prints
Text by Owen Simmons; photographer unknown

Sir Benjamin Stone **Sir Benjamin Stone's Pictures: Records of National Life and History
(Vol I – Festivals, Ceremonies, and Customs)**
Cassell and Company Ltd, London, Paris, New York and Melbourne, 1906
291 × 236 mm (11½ × 9¼ in), 236 pp
Hardback with full red cloth
96 b&w photographs
Introduction and descriptive notes by Malcolm MacDonagh

Sir Benjamin Stone

Sir Benjamin Stone's Pictures

Sir Benjamin Stone, Member of Parliament for the Birmingham constituency, was a keen 'amateur' photographer, with a passion for, as he put it, 'unfaked' photographs. In 1897 he was a prime mover behind the National Photographic Record Association, which aimed to gather together an archive of photographs documenting every facet of contemporary British life, printed as carbon prints or platinotypes for permanence.[18] As well as being its primary motivator, activist and publicist, Stone was also the association's most prolific photographer. In 1906, only four years before the association was disbanded owing to its members' apathy, Stone published an example of the kind of thing he wanted to achieve with the group: two volumes of his own work, the first on British customs, the second on the Houses of Parliament.[19]

In the preface to Volume One Malcolm MacDonagh writes of Stone's passion and his hopes for the medium,

expressed in his own work and that of the association: 'But while photography is his mistress, he has always used it wisely and as a means to a well defined end – to leave to posterity a permanent pictorial record of contemporary life, to portray the manners and customs, the festivals and pageants, the historic buildings and places of our own time.'

Stone was so assiduous in following his own brief that he left over 14,000 negatives to the Birmingham City Libraries. Unfortunately, as a photographer, he was straightforward rather than inspired. Much of his work is worthy but dull. Superficially it is a project like August Sander's in the 1920s, typological and methodical in nature, but Stone's work, unlike the German's, lacks a real socio-political perspective. He was an MP, a member of the establishment, and much of his work is smug in that typically English way, substituting nostalgia for real contemporary relevance. However, in a subject like English festivals, where nostalgia was the point, he was at his best, and this volume makes for a fascinating photobook. The inherent surreality of such practices as

the Abbots Bromley Horn Dance, or the Sea Garlanding at Abbotsbury, saves the work from sentimentality.

These two volumes mark the end of the nineteenth-century documentary photobook in Britain – documentary photography in the typological mode. Stone's *Festivals, Ceremonies and Customs* reflects back on half a century of documentary practice that was never quite carried forward into the next century. But his fascination with lore and customs also looks forward to the renewed, though much more personal, documentation of the eccentric British in the 1960s and 70s, by such photographers as Tony Ray-Jones, Ian Berry, Patrick Ward and David Hurn.

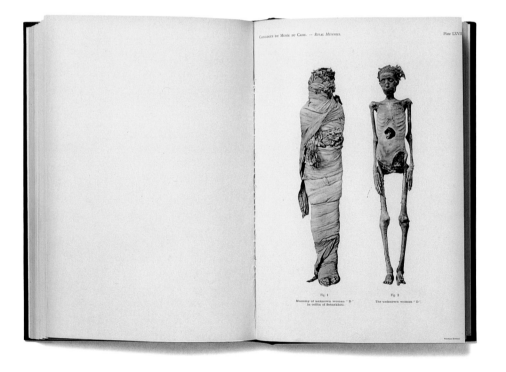

G Elliot Smith
The Royal Mummies

In 1881, in a secluded sepulchre close to Luxor, no fewer than 40 mummies of Ancient Egyptian royalty were found, including some of the greatest kings and queens of the XVIIIth and XIXth Dynasties.[20] They had been brought from their own violated tombs in the nearby Valley of the Kings by devoted priests of the XXIIIrd Dynasty and secretly reburied in a single tomb. These ancient monarchs, who once held sway over an entire empire, were disinterred and transported down river where, due to a bizarre anomaly in local customs law, they entered Cairo under the appellation of 'dried fish'. In the Bulak Museum they suffered further indignities: they were stripped naked before invited officialdom and propped up for the photographer.

Emile Brugsch, the first European to enter the tomb, took the photographs of this unprecedented find, and earned the approbation of the anatomist G Elliot Smith, who wrote the text for this book: 'Brugsch['s] excellent photographs make minute descriptions unnecessary.' Archaeological photography is 'no frills' photography – the picturesque and the interpretive are to be avoided. The ideal qualities of a successful archaeological photograph are the widest possible tonal range, the greatest depth of focus, and a lack of spatial distortion. Brugsch fulfilled this rather dry brief admirably. Nevertheless, this is an astonishing photobook, primarily because of its subject matter, but also because of the rigorous presentation of the photographs.

It is impossible not to think of the lives of those long-dead beings catalogued here – kings, queens, princes and princesses. What were they and their lives like? What did they think and say and do? As Roland Barthes has written, a photograph of a corpse is as living as that of a live being, because the camera 'certifies, so to speak, that the corpse is alive, as corpse: it is the living image of a dead thing'.[21] We cannot feel such perverse confusion between the quick and the dead when looking at a leathery mummy lying mute in a glass case. Stillness – live stasis – is photography's natural state. Thus Brugsch's pharaohs, standing bolt upright against a standard backdrop – much the same as the subjects of Nadar or Richard Avedon – are more suffused than most images with the medium's intense melancholy. If we realize that the condition of the royal mummies has deteriorated substantially since Brugsch recorded them, that melancholy is compounded.

G Elliot Smith **Catalogue général des antiquités egyptiennes du musée du caire. Nos. 61051–61100: The Royal Mummies**
Imprimerie de l'Institut Français d'Archéologie Orientale, Cairo, 1912
327 × 222 mm (13 × 8¾ in), 228 pp
Hardback with marbled paper, cloth spine and corners
104 collotypes printed by Berthaud
Text by G Elliot Smith; photographs by Emile Brugsch

Theodore M Davis
The Tombs of Harmhabi and Touatânkhamanou

In 1902 the coveted concession to excavate in Luxor's Valley of the Kings was granted by the Egyptian Service des Antiquités to Theodore M Davis, a retired attorney from New York. The Valley had been thoroughly explored over a period of many years, but throughout the next decade, Davis and the various professional archaeologists he retained found six major tombs. The handsome excavation reports, with their distinctive green covers – funded by Davis himself – are not quite as scientific as modern archaeologists would wish, but they form a valuable record of a patrician style of Egyptology that has long since vanished. The last volume in the series is particularly distinguished by some fine photography.

In 1908 Davis and his team discovered the tomb of Horemheb, the last pharaoh of the XVIIIth dynasty. Though it had inevitably been plundered during antiquity, it is one of the Valley's most important and imposing architectural monuments. To record the find Davis hired a 29-year-old Englishman named Harry Burton, who was rapidly gaining a reputation for his fine photographs. It is Burton's work that makes this the most important of Davis's publications, for he not only provides an exhaustive record of the tomb and its contents – just as it was found, with ancient builders' rubble cluttering the corridors – but begins his photographic report with a series of landscapes of the Kings' Valley. Firmly in a no-nonsense archaeological vein, they are the finest photographs made of this highly evocative place.

The book's title refers to two tombs, that of Horemheb (Harmhabi) and that of Tutankhamun (Touatânkhamanou) – an anomaly that requires explanation. Just prior to the discovery of Horemheb's sepulchre, Davis found a pit with funerary items bearing Tutankhamun's name and, assuming he had found the tomb of an obscure, minor pharaoh, he included it in his book.

Davis concluded his text with this sentence, now famous in the annals of Egyptology: 'I fear that the Valley of the Kings is now exhausted.' Believing that to be the case, he relinquished his digging concession, and it was taken up by another amateur excavator, the Englishman, Lord Carnarvon. In 1918 Carnarvon embarked on a number of fruitless excavating seasons, and Davis's prediction seemed to have come true. Then, in November 1923, at the start of their final season, a workman found a couple of rock-cut steps – and the rest is history. Davis's team had mistaken the remains of Tutankhamun's funerary feast for the tomb itself; Carnarvon's team had found the real thing. However, at least Burton benefited from this major blunder. He was called back to the Valley to photograph the most famous excavation in archaeological history.

Theodore M Davis **Excavations Bibân el Molûk: The Tombs of Harmhabi and Touatânkhamanou**
Constable and Company, London, 1912
355 × 260 mm (14 × 10¼ in), 232 pp
Hardback with full green cloth
82 b&w photographs and 11 colour illustrations
Texts by Theodore M Davis, Gaston Maspero and George Daressy; photographs by Harry Burton; colour illustrations by Lancelot Crane

Photography as Art
The Pictorial Photobook

My aspirations are to enable Photography and to secure for it the character and uses of High Art by combining the real & Ideal & sacrificing nothing of Truth by all possible devotion to Poetry and beauty. Julia Margaret Cameron[1]

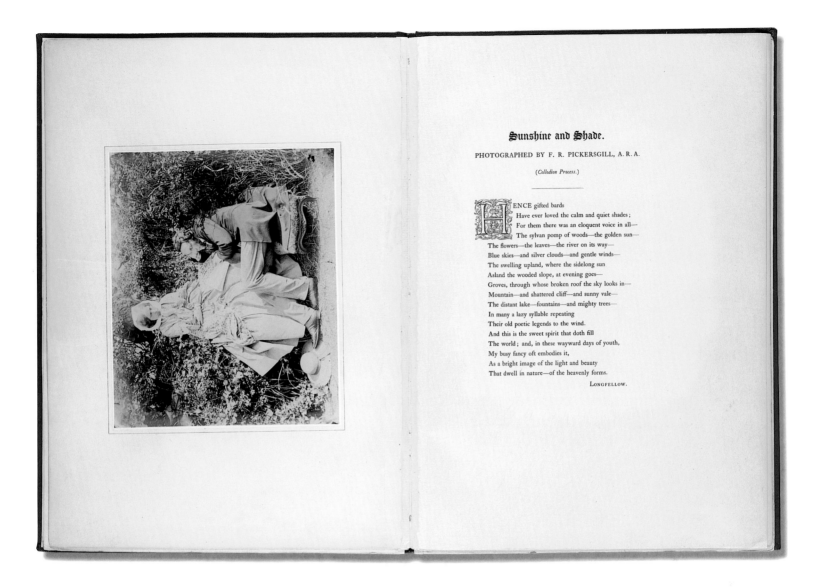

Sunshine and Shade.

PHOTOGRAPHED BY F. R. PICKERSGILL, A. R. A.

(Collodion Process.)

HENCE gifted bards
Have ever loved the calm and quiet shades ;
For them there was an eloquent voice in all—
The sylvan pomp of woods—the golden sun—
The flowers—the leaves—the river on its way—
Blue skies—and silver clouds—and gentle winds—
The swelling upland, where the sidelong sun
Asland the wooded slope, at evening goes—
Groves, through whose broken roof the sky looks in—
Mountain—and shattered cliff—and sunny vale—
The distant lake—fountains—and mighty trees—
In many a lazy syllable repeating
Their old poetic legends to the wind.
And this is the sweet spirit that doth fill
The world ; and, in these wayward days of youth,
My busy fancy oft embodies it,
As a bright image of the light and beauty
That dwell in nature—of the heavenly forms.

LONGFELLOW.

Philip Henry Delamotte, ed.
The Sunbeam: A Book of Photographs from Nature
Chapman and Hall, London, 1859

The epitome of the pictorial photobook, *The Sunbeam* depicts the kind of idealized pastoral scenes evident in the work of Constable and the English watercolourists.

Although the majority of nineteenth-century photobooks were documentary in nature, some of the most important and influential were not. These espoused the notion of photography as an art, and were generally in that vein that is broadly termed 'pictorialist'. Pictorialism is a somewhat tricky term to define, but two distinct usages of the word are employed here. Firstly, there is the photographic movement that was known as Pictorialism from the 1880s onwards. This saw photography as 'fine art' and reached its zenith between 1890 and World War I, before slowly ebbing away as the more progressive photographers rejected its values and developed what came to be known as 'photographic modernism'. Secondly, there is what might be termed the pictorialist impulse in photography, which is the desire to deny and obfuscate the mechanical and essentially documentary nature of photography. This is not confined to the Pictorialist era, but rears its head frequently throughout photographic history, albeit in different forms. In 1901, in his book *Photography as a Fine Art*, Charles Caffin defined the ethos succinctly: 'There are two distinct roads in photography – the utilitarian and the aesthetic; the goal of one being a record of facts, and of the other an expression of beauty.' Caffin went on to formulate a scale of values, with functional photography – photographs of machinery, buildings, war and daily news at the bottom, while at the top 'there is the photograph whose motive is purely aesthetic: to be beautiful' – the photographic equivalent of painting.[2]

Back in the 1840s, however, when the half-science, half-art of photography was invented, the issue of the new medium's status as an art form was not a crucial one. In the early days there were many

technical problems that had to be overcome before photographers began to worry about the artistic merit of their hard-won creations. Getting a technically satisfactory result was the primary goal and being such a tricky and almost serendipitous process, photography was talked about in terms of the marvellous rather than the aesthetic. For at least a decade after the announcement of this new wonder in 1839, it was referred to as an 'art-science'.

Nevertheless, it was assumed from the first that there was an aesthetic as well as a practical side to photography. From the time of François Arago's announcement of the invention of the daguerreotype, the photograph had a relationship not only with science and documentation, but also with painting, if only for the implications it threw up around the thorny question of realism in painting. For those opposing the new tendency towards realism in 1840s painting, photography only showed how ugly the world was when unimproved by the mediating hand of the painter.

In the first decade and a half of the medium, many of the leading photographers – especially those using variants on William Henry Fox Talbot's negative/positive system, that is, photography on paper – were amateurs, members of the well-educated classes. They were the kind of people who also sketched and made watercolours, who collected antiquities and geological specimens, who pressed flowers in albums and arranged dead butterflies in glass cases. One might say that they had the money and the leisure to dabble in both art and science. But frequently, as we have seen in the cases of Talbot and Anna Atkins, the dabbling was of a very high order.

The early photographic amateur was also the kind of person who formed and frequented learned societies. Thus, in the medium's two countries of origin, France and England, the Société Héliographique (later the Société Française de Photographie) was founded in 1851, and the Photographic Club of London (later the Royal Photographic Society) was founded in 1853. True to the perception of the medium at the time, both the SFP and the RPS were 'art-science' organizations, and have remained so to this day.[3] It is in the nature of such learned societies to publish journals and papers, and to hold annual exhibitions – 'salons' – of their work. Thus the institutional framework for the future consideration of photography as a fine art was established, as well as the audience for photobooks featuring photography practised for its own sake.

In December 1852 an 'Exhibition of Recent Specimens of Photography' opened at the rooms of the Society of Arts. And in January 1853 the inaugural meeting of the new Photographic Society (of London) was held. Both French and English societies began to arrange annual salons, but it was in the pages of their journals, *La Lumière* in France, and the *Journal of the Photographic Society* (later the *Photographic Journal*) in England, that the aesthetics of the new medium were debated. The penchant for 'art' photography was perhaps more prevalent in Britain than in France. The increasing trend towards professionalism was looked upon somewhat askance by British amateurs, who, ever alive to class, felt that functional photography was being commandeered by those in 'trade'. Thus they would turn their attentions towards a more lofty form of photography.

From 1850 to 1860, photography made enormous strides – technically, aesthetically, philosophically and commercially. During that decade, the 'art' photography movement became firmly established in the photographic societies, chiefly amongst the gentlemen (and lady) amateur photographers, with their exhibitions, print-exchange clubs and publications. The goal of the art photography coterie was recognition for the medium as a fine art, on a par with painting. They aimed to achieve this primarily by moving away from what they regarded as the medium's besetting sin – its baldly functional, mimetic propensity. Unlike the professional journeymen, they looked towards painting and literature rather than unmediated life for their models, and in the beginning at least, towards any school of painting except the realist – somewhat paradoxically, it might seem, for those working in a medium that had helped establish the realist tendency in painting.

The primary genre for art photographers was the landscape, preferably endowed with picturesque ruins, and it was the combination of nature and the antique that inspired a number of art photobooks in the 1850s, notably William Russell Sedgfield's *Photographic Delineations of the Scenery, Architecture and Antiquities of Great Britain and Ireland* (1845–55) and William and Mary Howitt's *Ruined Abbeys and Castles*

of Great Britain (1862). These books deal with the subject of Englishness, and similar volumes published in France dealt with the notion of *La Patrimoine*. But whereas the French studies in patriotic vein declare themselves much more openly, and are systematic and topographical, stemming from a laudable attempt to document the country's architectural heritage for detailed study, the English efforts tend towards the parochial, the unsystematic and the picturesque.

The epitome of the genre is Philip Henry Delamotte's *The Sunbeam: A Book of Photographs from Nature*, published in 1859. Delamotte edited a journal of the same name, the main rival to Henry Hunt Snelling's *Photographic Art Journal*, and the book he compiled anthologizes issues of the magazine. In the main it depicts the kind of idealized and domesticated pastoral landscapes seen in the work of such painters as John Constable or the English watercolourists.

The 1850s saw the rise of another genre, termed 'High Art' photography by its practitioners, such as William Lake Price, whose *A Manual of Photographic Manipulation* (1858) was one of the first wholly aesthetic treatises on photography. Its title's usage of the word 'manipulation' gives the High Art photographer's game away: a total rejection of realism in favour of the fabricated tableau vivant using posed models. These elaborate salon photographs were sometimes made by combining different negatives to create complex pictures that aped the 'higher' themes of painting. The Swede, Oscar G Rejlander, who scored a great hit in 1857 with his combination print, *The Two Ways of Life* (which managed the tricky feat of mixing Victorian moralizing with discreet nudity), and Henry Peach Robinson, who was also a writer, were the acknowledged masters of this sort of thing. Robinson's book, *Pictorial Effect in Photography*, published in 1869, firmly established him as both the leading photographer and advocate of Victorian art photography.

Though frequently maligned by her contemporaries, such as Robinson, the most talented art photographer in England during the 1860s was Julia Margaret Cameron. Towards the end of her brief career, she published a photographic book that utilized the tableau-vivant strategies of High Art photography and made a concerted photographic sequence with narrative drive and painterly flair. The book was *Idylls of the King*, published in 1874, an illustrated version of Alfred Tennyson's poem. Cameron's costume drama has been widely criticized in the modern era for its mawkishness and artificiality, but many of the images nevertheless retain her idiosyncratic use of space and the intimacy that made her such an innovative figure in nineteenth-century photography. For all its awkwardness, the book remains the first credible example of an important genre that continues to this day – the book of photographed tableaux.

One of the most important book-makers amongst nineteenth-century art photographers was a doctor born in Cuba of English-American parentage – Peter Henry Emerson. Emerson had an innate antipathy for Robinson – a feeling that was reciprocated – and in a book he published in 1889 entitled *Naturalistic Photography for Students of the Art*, made a plea that was to be repeated at intervals in the history of photography. As such, his treatise – a 'bomb dropped in a tea party' as R Child Bayley described it[4] – might be regarded as the beginning of the long transition into modernism. *Naturalistic Photography* argued that photography was an independent medium, with its own inherent characteristics that should be strictly adhered to if it was to attain its full potential as a great art form. The essay therefore exhorted photographers to return to photography's first principles – that is to say, to record the world 'naturalistically'. But there was a problem with Emerson's polemic. His view of naturalism was nevertheless based on painterly notions. Though he eschewed the kind of artificial salon painting upon which Robinson and his followers based their photography, he favoured the sentimental soft-focus realism of such French painters as Jean-François Millet. In his book, he put forward an elaborate case for this approach, stating that since the human eye did not see everything in crisp focus, photographs with a sharp focus from foreground to background – the vast majority of documentary photographs for instance – were not naturalistic.

Naturalistic Photography was heavily criticized for some of its views on focusing and the degree of technical control a photographer had over the presentation of his subject. Robinson, himself heavily attacked by Emerson, retorted by writing that 'healthy human eyes never saw any part of a scene out

of focus'.[5] Eventually Emerson became frustrated by what he found to be photography's technical shortcomings, and he published a black-bordered pamphlet in 1890 entitled 'The Death of Naturalistic Photography', in which he renounced many of his earlier ideas. He wrote:

> *I have … compared photographs to great works of art, and photographers to great artists. It was rash and thoughtless, and my punishment is having to acknowledge it now … In short, I throw my lot in with those who say that Photography is a very limited art. I deeply regret that I have come to this conclusion.*[6]

Theory, however, is one thing, and practice another, and three years before writing *Naturalistic Photography* the didactic Emerson had made a much more effective polemic that he could not retract, in the form of a great photobook. *Life and Landscape on the Norfolk Broads* (1886), made in collaboration with his friend T F Goodall, is, like many of the greatest photobooks, at once a cogent showcase for the work and an effective statement about the medium. Goodall's essay at the end of the book – a preview of some of the ideas that Emerson would expound in *Naturalistic Photography* – is as persuasive as Lincoln Kirstein's afterword to Walker Evans's *American Photographs* (1938).

Despite Emerson's call for 'naturalism', most art photographers of the late nineteenth and early twentieth century still distrusted the camera when it presented its most mechanical face (hence Emerson's retraction in 'The Death of Naturalistic Photography'). They sought to mitigate this in various ways, by employing differential focusing, hand-printing techniques and elaborate methods of presentation, no less so in their photobooks than in their exhibition prints. *Life and Landscape* was published with magnificent platinum prints, both expensive and laborious to make, although all Emerson's other volumes, such as *Pictures of East Anglian Life* (1888), *On English Lagoons* (1893), and what many regard as his masterpiece, *Marsh Leaves* (1895), were made with photogravures.[7] Indeed, photogravure – hand-pulled, it should be noted – became an almost standard technique for the finer books of the pictorialist era, such as Alvin Langdon Coburn's *London* (1909) and *New York* (1910), and the huge art-documentary project, Edward S Curtis's *The North American Indian* (1907–30).

Emerson was one of the most active photographic polemicists in the last decade and a half of the nineteenth century. However, at the beginning of the twentieth century he had all but finished with photography; pictorialism had become not only institutionalized, but an international movement, with the formation of organizations like Linked Ring and Photo-Secession, which promoted the exhibiting of prints and the exchange of pictorialist ideas. After 1900, Emerson never again exhibited or published a print. But although he had opted out of these new developments, he kept in touch with the medium in a typically eccentric way, setting up a committee to award medals to photographers whom he judged worthy of accolade. The last recipient, towards the end of Emerson's long life, was a true modernist, the Hungarian photographer Brassaï. In 1933 he was surprised to receive a letter from Emerson informing him that he was to be awarded a bronze medal for his book *Paris de nuit* (Paris by Night) (see Chapter 5), one of the key modernist photobooks. Brassaï was both astounded and bemused by this letter, which he thought was from a madman, especially with regard to its postscript: 'Are you Italian or French or what?'[8]

It took some time for pictorialism to segue into modernism – three or four decades perhaps. By the time Emerson had opted out of photography, his role as its chief polemicist had already been taken over by a figure who was to be at the hub of the transition for much of that time – Alfred Stieglitz. As mentioned, Stieglitz does not feature in this publication because he never made a plausible photobook. Some might argue that the quarterly magazine he published and edited between 1903 and 1917 – *Camera Work* – could be regarded as a photobook series to equal any in the medium's history. Certainly, the production quality of the magazine was better than most books – hand-pulled photogravures once more – but the contents of any single issue were perhaps a little too disparate – no great fault in a magazine but not in accordance with most definitions of the cogent photobook. The possible exception to this was the final edition in June 1917, a double issue largely devoted to the work of a single photographer, Paul Strand, but even this monograph was larded with reviews and other articles. Nevertheless, many see this single publication as marking the beginning proper of modernism, the nail in the coffin of pictorialism.

Modernist photography was a departure, both technical and formal, from pictorialist tenets. Firstly, the concept of 'straight' photography was paramount. This embraced the mechanistic, documentary nature of the camera, and attempted to make the print look painterly through selection, framing and viewpoint, rather than through manipulation. Secondly, the values of the artistic avant garde were adopted, ranging from a concentration on 'modern' subject matter – the city, industry, machinery – to the exploration of abstraction, or experimenting with the representation of space in the manner of the Cubists.

Strand demonstrated some of these tendencies in *Camera Work*. He showed views of a bustling New York, and several abstract close-ups of objects that focused solely on light and form. Most radically, he included a number of head-and-shoulders street portraits, taken without their subjects' knowledge, that were made not for their socio-documentary value, but primarily for expressive purposes. The shocking *Blind Woman*, a street vendor with a 'Blind' sign around her neck, is widely regarded as the first truly 'modernist' photograph, 'direct' and 'brutal' in its effect, as Stieglitz put it. Ten years later, when the young Walker Evans saw a copy of it in the New York Public Library, he was 'bowled over'.⁹

Alas, history seldom works so neatly that a single issue of a magazine, even with such ground-breaking work and put together by such a dominant figure as Stieglitz, could turn off the dimming lamp of pictorialism in favour of the bright lights of modernism. A much more cataclysmic cultural upheaval, however – World War I – had a profound effect on photography. Certainly, modernist photography began to develop rapidly after the war, and Strand's pictures mark a crucial moment in the transition from pictorialism, but it should also be noted that modernist art and photography developed differently in different countries, a point that will be revisited in the next chapter.

The legacy of pictorialist thinking lingered for quite some time in the work of the more conservative modernist photographers, in terms of attitudes towards the status of the medium, its presentation and aesthetic. The radical modernist photography practised primarily by non-photographers in Russia and Germany was very different from the purist modernism that was developed out of pictorialism in the United States by Stieglitz, Strand and such followers as Edward Weston. But many photographers muddled along, borrowing from both pictorialism and the less radical tenets of modernism, the safer aesthetic rather than the more dangerous political elements. A good example is Laure Albin-Guillot, probably the most successful commercial photographer in Paris during the 1920s. Her style was a calculated blend of pictorialism and modernism. She has been associated with Art Deco, especially with regard to her *Micrographie décorative* (Decorative Microphotography, 1931), a book of abstract photographs taken through the microscope that was partly intended for use by decorators employing that style. Art Deco both commercialized and tamed modernism for the bourgeoisie, thus undercutting, even in its most populist and mass-produced manifestations, the utopian, broadly socialist ideals of the avant garde. It might have been *moderne*, but it was never quite modernist. Further examples of pictorial-modernist photobooks may be found in František Drtikol's *Žena ve světle* (Woman in Light, 1930), Art Deco mannerisms translated into photography, and Erich Mendelsohn's *Amerika* (America, 1925). Mendelsohn was a radical architect, yet in his photography the battle between pictorialism and modernism is especially acute, and one sees from picture to picture the butterfly of modernist photography struggling to emerge from the chrysalis of pictorialism. Even a photographer like Germaine Krull, who produced one of the key modernist photobooks in her 1928 *Métal* (Metal), reverted to a more pictorialist style two years later in her more traditional *Etudes de nu* (Nude Studies) of 1930. Part of the fascination of the portfolio is to watch Krull struggling to take the nude into more obviously modernist territory.

The transition from pictorialism, even at the time of the modernist photobook's zenith, towards the end of the 1920s, was not complete, and would not be until after World War II. Unlike pictorialism, which was a well-defined movement in photography, there were a number of very different photographic modernisms, and although it looked as if it might all come together into one international movement in the 'Film und Foto' exhibition in 1929, the moment was illusory. Political and cultural events conspired to ensure that modernist photography remained a somewhat disparate, fragmented entity.

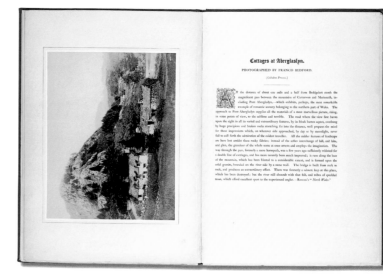

Philip Henry Delamotte, ed. **The Sunbeam: A Book of Photographs from Nature**
Chapman and Hall, London, 1859
365 × 260 mm (14½ × 10¼ in)
Originally bound in leather
20 albumen prints from wet-collodion negatives
Texts by various authors; photographs by J D Llewelyn,
'Phoebus' (John Leighton), Joseph Cundall, Lebbeus Colls,
Sir Jocelyn Coghill, Philip Henry Delamotte, Francis Bedford,
Dr Holden, Henry Taylor, F R Pickersgill, George Washington
Wilson and Thomas Wilson

Philip Henry Delamotte
The Sunbeam

It might be argued that modernist photography began in the British amateur photographic circles of the 1850s, the societies and print-exchange clubs where prints were swapped and commented upon. The raison d'être for many of these photographs was primarily technical – in those days it was an event simply to obtain a well-exposed negative and richly toned print – but the wider purpose was photography for its own sake.

If that argument has any validity, it might also be surmised that the modernist photobook began here, with Philip Henry Delamotte's *The Sunbeam*, a professionally published version of the amateur albums that were compiled and circulated in England during that decade. *The Sunbeam*, edited by Delamotte, was one of the first photographic magazines, as opposed to journals, in that it was illustrated with photographs – original albumen prints. Beginning in January 1857, five issues appeared, each containing four prints, then in 1859 the same 20 photographs were gathered together in book form – *The Sunbeam: A Book of Photographs from Nature*.

The Sunbeam was a true photobook, an amalgamation of image and text. Facing each picture in the book were printed texts, either poems or antiquarian and classical writings. The whole mood of the work, familiar in British art, is pastoral. The images by Delamotte and the 11 other contributing photographers show, as Mark Haworth-Booth has written, a 'mid-Victorian vision of earthly paradise',[10] the new Jerusalem that was to be built in 'England's green and pleasant land'. It is an England of water, meadows, cottages, churchyards, noble trees and spires. Even more than the village, the ideal habitat would seem to be the cathedral or university town, and the only view of a city shows St Paul's Cathedral rising above the Thameside warehouses at its foot, but without the smoke and modern industrial smog that would characterize Alvin Langdon Coburn's proto-modernist view of the church only 45 years later.

We might sneer at its Victorian complacency, but *The Sunbeam* represents a step forward not only for the photobook as an integrated concept (with the photographs dominating), but for photography that looks beyond the purely documentary without resorting to the crude aping of salon painting.

Victor Albert Prout (attributed to)
The Thames from London to Oxford in Forty Photographs

The origins of photography lie in the world of the diorama, a cross between art and spectacle where the world was depicted in what today would be termed a 'wide-screen' manner. From the start, photographers sought to expand the field of vision in a similar way. Many panoramas were created simply by photographing consecutive images and joining them together, but there were also attempts to make cameras that would produce wide-vision images using a lens that swung round and 'scanned' progressive sections of the picture plane over an angle of between 120 and 180 degrees. In the early 1840s the German-born, Paris-based photographer Frederick von Martens made a number of spectacular daguerreotype panoramas of Paris that were almost 508 mm (20 in) wide.

In 1862, one of the most singular (and now rarest) early photobooks was published by Messrs Virtue and Company in London. *The Thames from London to Oxford* appeared with 40 remarkable panoramic photographs by the little-known Victor Albert Prout. It is not certain whether Prout used one of the 'Pantoscope' panoramic cameras patented by John Johnson and John Harrison that same year, but they are not 'joined' panoramas. They display the kind of perspective that suggests that they were taken with a swinging lens – that is to say, a genuine panoramic camera.

But while their possible technique is of interest, what seems much more important is how good they are as pictures. Prout surveys the Thames from London to Oxford, the relationship of the river to its banks, to the skyline, and to the people who use it. His model may have been Dutch panoramic landscape drawings of the seventeenth century, but more likely the image aesthetic was driven by the dictates of his equipment and the river itself. Thanks to the incessant horizontality of its banks, a river is an ideal subject for the panoramic photograph, yet although the picture form is there 'naturally', so to speak, Prout still had to make the best of it. And it can be concluded that he did, usually managing to find a vertical element just where he needed it to counteract the ruthless horizontal. In this rare and beguiling volume, Prout created a set of consistently attractive photographs that both refer to yet extend pastoral landscape traditions, adding, as Roy Flukinger has written, 'a delicate, dramatic feeling to the world of the river'.[11]

Victor Albert Prout (attributed to) **The Thames from London to Oxford in Forty Photographs**
Virtue and Company, London, 1862
383 × 303 mm (15 × 12 in)
Portfolio with cloth and leather spine
40 albumen prints from collodion negatives

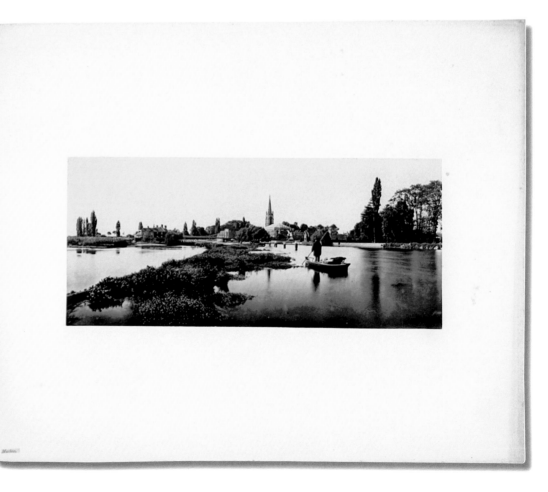

William J Stillman
The Acropolis of Athens

Like the works of Peter Henry Emerson, this is a 'modern' photobook. Indeed, it may be considered a precursor of the twentieth-century modernist photobook in that self-expression is deemed as important as making a record. Stillman's title determines the book's tone – the Acropolis is 'illustrated picturesquely and architecturally in photography', with the artistic side of the enterprise being placed before the documentary. Stillman is much closer to the modernist ideal than Emerson: his work is nominally in a straightforward nineteenth-century topographical mode, fulfilling the brief of documenting the Parthenon and Erectheum, but it also functions as a conscious vehicle for the photographer's artistic ambitions.

Stillman takes us on a tour of the Acropolis in 25 well-executed and richly toned photographs that transport us from far to near, beginning with distant views that place the hill and its monuments in context, and ending with close-ups of statue fragments. He has an especially acute formal sense, and would seem to use it quite self-consciously rather than intuitively. He utilizes the edges of the frame particularly well, seemingly for deliberately formal rather than practical reasons. In an image like the view of the Parthenon's east side, showing the famous curvature of the stylobate, he chooses a low angle and plays the mass of the temple against a large blank space on the left of the frame – a most undocumentary documentary picture. In a figure of Victory he carefully allows statue fragments to intersect the edges of the picture, creating a deliberately expressive close-up rather than an image that is simply a detail.

A painter, journalist, US Consul in Crete and model for Dante Gabriel Rossetti, Stillman had an interesting and varied career. To label him a proto-modernist would be to go too far, but anyone considering his photographs from a purely stylistic point of view would probably date them much later than 1868–9. Photographing the Acropolis was clearly a highly personal project, and it shows in the work. He needed to make money from the endeavour, but he also believed – quite rightly – that he could make better photographs of the monument than anyone else.

William J Stillman **The Acropolis of Athens: Illustrated Picturesquely and Architecturally in Photography**
F S Ellis, London, 1870
530 × 340 mm (21 × 13 in)
Originally hardback with full red leather
25 carbon prints by the London Autotype Company
Foreword by William J Stillman

Julia Margaret Cameron

Alfred Tennyson's 'Idylls of the King' and Other Poems Illustrated by Julia Margaret Cameron

When in 1874 Alfred (Lord) Tennyson, Britain's Poet Laureate, invited Julia Margaret Cameron to make photographic illustrations for a popular edition of his most popular poem *Idylls of the King*, she threw herself into the project with her customary enthusiasm. Over the course of three months she cajoled family, friends and neighbours to pose for the tableaux-vivants photographs, and took over 180 negatives to find the 12 required for publication. But when the edition was ready she professed disappointment that her large-format prints had been reduced to much smaller woodcuts. With Tennyson's encouragement, and at her own expense, she brought out an edition featuring the original

photographs at full scale, which appeared just before Christmas 1874.

Cameron's genre work in the tableau-vivant style – of which *Idylls of the King* is the only published example[12] – has generally aroused the disapprobation of twentieth-century modernist critics, who regard it as sentimental and false. Helmut Gernsheim, for instance, called the *Idylls* 'affected, ludicrous, and amateur'.[13] And yet the two editions of the *Idylls* were the only photobooks published by Cameron, one of the greatest nineteenth-century photographers. Furthermore, it is one of the first examples of the 'directed' photograph. Finally, it is amongst the initial instances of the *beeldroman*, or 'photonovel', where photographs are deliberately fabricated and arranged in sequence to tell a tale.

Even on its own terms, the work succeeds very well. Tales of dashing knights and distressed damsels might

not be to our contemporary taste, but anyone looking beyond this should find that, despite their surface sentimentality, the *Idylls* pictures exhibit many of the virtues of Cameron's exceptionally personal vision. Like her portraits, they seem to inhabit a particular psychological space – intimate, somewhat claustrophobic – a reflection of her confined world, but not a negative one. Even when languorous, as many of the *Idylls* images are, they burst with energy, suggesting that inner creativity is a way of escaping imprisonment. Of all nineteenth-century portraits – and these *are* portraits in spite of their assumption of the genre framework – Cameron's photographs demonstrate a psychological intimacy and intensity that is compellingly modern, indeed timeless.

Julia Margaret Cameron **Alfred Tennyson's 'Idylls of the King' and Other Poems Illustrated by Julia Margaret Cameron**
Henry S King, London, 1874
457 × 356 mm (18 × 14 in)
Hardback with red leather, leather spine and corners
12 albumen prints (plus frontispiece portrait of Tennyson) from wet-collodion negatives
Extracts from poems by Alfred Tennyson handwritten by Julia Margaret Cameron and lithographed

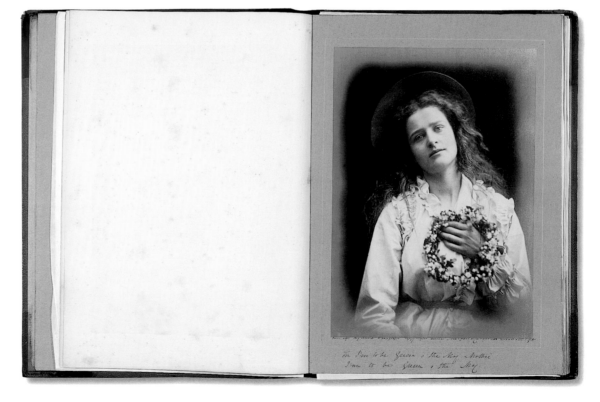

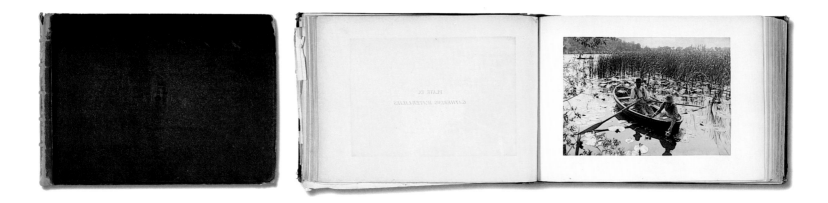

P H (Peter Henry) Emerson and T F (Thomas Frederick) Goodall **Life and Landscape on The Norfolk Broads**
Sampson Low, Marston, Searle and Rivington, London, 1886
280 × 405 mm (11 × 15¾ in), 82 pp of text, plus tipped-in plates
Originally bound in green cloth (standard edition of 175)
40 platinotypes
Texts, commentaries and 27 photographs by P H Emerson and T F Goodall; 13 photographs by Emerson

P H (Peter Henry) Emerson
and T F (Thomas Frederick) Goodall
Life and Landscape on the Norfolk Broads

Although it would be three years before he would write his controversial polemic *Naturalist Photography*, this was the first major book to put Peter Henry Emerson's ideas on the subject into practice. It was certainly the most sumptuous, even in its 'ordinary' edition (shown here; there was also a deluxe edition of 25), being the only one of his books to be illustrated with platinum prints rather than photogravures.

Life and Landscape indicates that Emerson's revolt against the faux-painterly style of salon favourites like Henry Peach Robinson was similar to the postmodernist reaction against modernism. That is, it tended to

evince more style than actual substance. Despite his arguments for differential focusing as the authentic equivalent of how the eye sees, his naturalism boiled down to the fact that he simply chose a different – albeit more credible – painterly model for his style. Emerson's close collaborator T F Goodall took some of the photographs and wrote most of the texts for the book. His final essay was a polemical treatise on Emerson's method (and as such foreshadowed *Naturalist Photography*). Here, he stated that the model was French *plein air* (open air) painting, proto-Impressionism filtered through James Abbott McNeill Whistler, rather than the pre-Raphaelite Brotherhood. In short, the influence was Millet rather than Millais.

Sentimentality may intrude here – an agrarian utopia is never far away – but in spite of the soft-focus miasma,

Life and Landscape is a true photobook, in that it has a clear subject – indeed a documentary subject. It is also a marriage of words and images, and the texts by Goodall and Emerson – sociological, anecdotal, mythical and empirical by turns – are a not inconsiderable part of the book's success. Like so many key photobooks, *Life and Landscape* is determinedly didactic. It is a carefully constructed thesis in photographs, a 'documentary' record of an area that the photographer knew and loved, and a demonstration of the art of photography as he saw it.

The photographs are magnificent – the technical achievement, both in the taking and in the printmaking, is breathtaking. If a great photobook is defined by both having and implementing a coherent, unified concept, then this book certainly makes the grade.

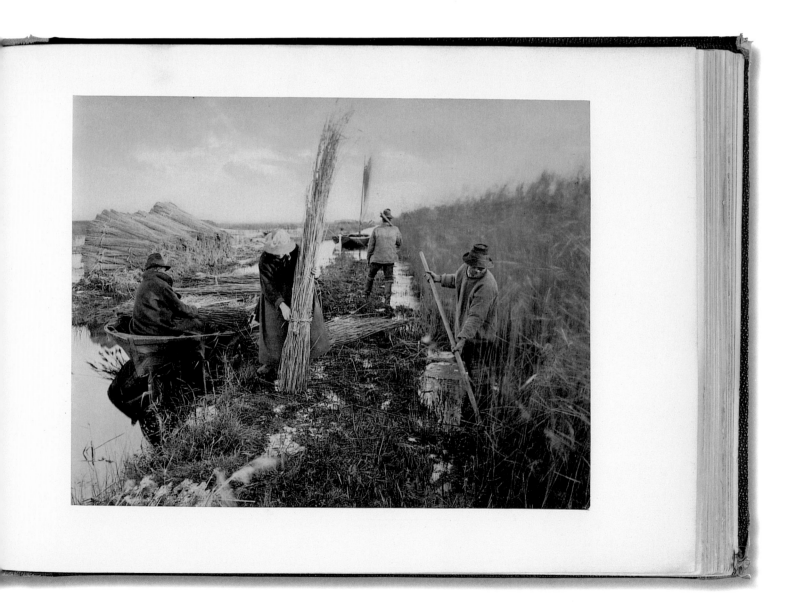

P H (Peter Henry) Emerson
Marsh Leaves

Many consider Peter Henry Emerson's *Marsh Leaves*, published only five years before he retired from active photography, to be his finest. Certainly, the 16 photo-etchings take his art to where it could probably go no further, and as a fusion of text and imagery the book is entirely successful.

Emerson's text, consisting of 60 short prose pieces, follows a similar pattern to that established in his earlier books, particularly his *Idylls of the Norfolk Broads* of 1887, which had an antique literary model in the *Idylls* of Theocritus. *Marsh Leaves* is a collection of short essays on rural themes, made up of local anecdotes, rural wisdom and folklore, tales told to the author, rec-ollections, observations and meditations. As both his literary and photographic work had demonstrated since *Life and Landscape on the Norfolk Broads*, Emerson had gradually been coming to a resolution of that book's sometimes uneasy blend of the documentary with the metaphorical. Both his literary and pictorial style had moved towards the symbolic and the intangible. As Ian Jeffrey has written, 'a phrase, a gesture, a moment, an image – fragments; nothing in *Marsh Leaves* is developed, nothing resolved'.[14] The photographs are as pared down and as shadowy as the paintings or etchings of James Abbott McNeill Whistler, with which they share an obvious affinity.

But the mood, if anything, is much bleaker than Whistler's. 'The expression of a landscape is as muta-ble and as fleeting as the flash in a woman's eye', Emerson writes in the book's text, but it is a cold and dis-tant woman indeed that he embraces in *Marsh Leaves*. Most of the images are minimalist to the point of noth-ingness – a distant tree or boat, the smudge of a distant shoreline. 'Lonely' and 'bleak' often crop up in the titles, and this chill mood is reinforced by the fact that many of the images were taken during the winter or on damp, misty mornings. It is one of the most beautiful books about isolation and solitude, perhaps death, ever made, and Emerson's spare, evocative pictures were seldom equalled by the later Pictorialists.

P H (Peter Henry) Emerson **Marsh Leaves**
David Nutt, London, 1895
294 × 190 mm (11¹⁄₂ × 7¹⁄₂ in), 166 pp
Hardback with decorated cloth and leather spine
16 warm-toned photo-etchings
Text by P H Emerson

Ferdinando Ongania
Streets and Canals in Venice

Ferdinando Ongania's *Streets and Canals in Venice* (seen here in its English edition, published a year after the original Italian *Calli e Canali di Venezia*), was a lux-uriously produced, yet popular volume of topograph-ical photographs. It was typical of commercial travel photography: the images were anonymous, straightfor-ward pictures of a location – in this case, Venice – and yet, by virtue of its lavish scale and fine, hand-produced photomechanical reproduction, the volume was at the high end of the market.

Venice was the ideal city for the purveyor of 'art' views, not only unique in history and location, but since the fall of the Venetian Republic – the Serenissima – in 1798, a primary destination for the nineteenth-century tourist. It was arguably the first city to become one vast museum, wholly dependent on mass tourism. The chief rival for this dubious distinction was Florence, but Venice had two advantages. Its island situation meant that it could not accommodate the new industries of the nineteenth century, and its canals lent the city a unique ambience. These circumstances ensured that the city would gradually atrophy, but the Venetians' loss was undoubtedly the tourists' gain.

The striking backdrop provided by the ubiquitous water was to the photographer's advantage: one might say that it is difficult to take a bad photograph in Ven-ice. But equally one could say that it is difficult to take a really good one. The book's images are not particularly inspired, but are eminently clear, no-nonsense records of a wonderful townscape, though given a pictorialist spin by the careful posing of typical townspeople, and the sumptuous means of reproduction. *Streets and Canals* might not be high art, or at photography's cut-ting edge, but as a travel book, a record of a place for a winter evening, it is a joy to behold.

Edward S Curtis
The North American Indian

The North American Indian has the distinction of being the largest, the longest, the most ambitious and the most expensive project ever attempted in photography.[15] In a lecture delivered in Sante Fe in 1924 – when the project was two-thirds of the way to completion – its author Edward S Curtis made perhaps the most succinct explanation of its aims. Declaring that the traditional way of life of the Native American was rapidly vanishing, he stated that his goal was to document 'the old time Indian, his dress, his ceremonies, his life and manners'.[16]

But although the project was nominally a documentary one, the photographic mode chosen by Curtis to implement it was his favoured pictorialism. This approach – romantic and picturesque, sentimental and nostalgic – coloured the whole nature of the publication. It also predicated imagistic manipulation, so that the book gives us (allowing for the slight changes in emphasis that a project of such length naturally entailed), a particular representation of the Native American. It was a complex mélange of ideas that embraced not only the artistic and the scientific but also – knowingly and unknowingly – the political.

The sentimental tone that engulfs the enterprise fatally flaws its politics. Although Curtis was personally sympathetic about the indignities heaped upon the Native American, the work's viewpoint went hand in hand with the attitudes of those in the government who were fencing Native Americans into reservations, forcing them to become American citizens yet denying them the full franchise. In short, the colonialist notion of the 'noble savage' is never far away.

Over the years, the pictorial element of Curtis's great endeavour has tended to outweigh the ethnographic. This has perhaps blinded commentators to the fact that it can be regarded as the culmination of nineteenth-century colonial photography, whereby a race that is 'other' is represented in word and image by the dominant Western culture, which controls the means of representation. Thus, as Mick Gidley has argued in his comprehensive study of Curtis, the 'image' of the Indian he presents is not one that reflects actuality, but the preconceptions of the dominant culture. Curtis's view is a brilliantly realized and persuasive one – his images are amongst the most popular of photographs – but that is precisely its danger.

Edward S Curtis **The North American Indian**
 Plimpton Press, Norwood, Mass., 1907–30 (Vol II shown, 1908)
 20 text volumes, 340 × 316 mm (13¹₂ × 12¹₄ in); 20 portfolios, 304 × 254 mm (12 × 10 in)
 Hardback with full brown leather
 1,505 sepia-toned photogravures in text volumes (75 in volume 2); 722 sepia-toned photogravures in portfolios
 Edited by Frederick Webb Hodge; foreword by Theodore Roosevelt; text and photographs by Edward S Curtis

Ferdinando Ongania, ed. **Streets and Canals in Venice**
 B T Batsford, London, 1893
 542 × 360 mm (21¹₄ × 14¹₄ in)
 Hardback with full brown cloth
 100 warm-toned photogravures
 Preface by P Molmenti; descriptive notes by P Molmenti
 and unnamed others; note by Ferdinando Ongania

Alvin Langdon Coburn **New York**
Duckworth & Co, London, and Brentano's,
New York, 1910
408 × 318 mm (16 × 12 in), 52 pp
Hardback with grey mottled paper and
brown leather spine
20 tipped-in warm-toned photogravures
Foreword by H G Wells

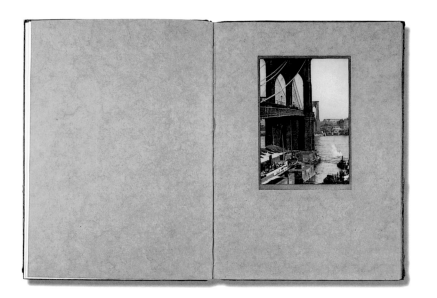

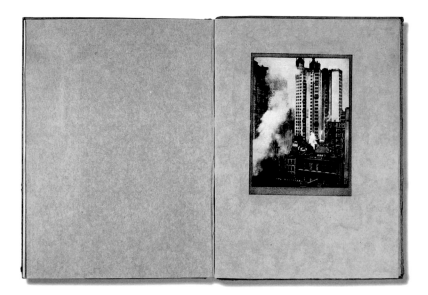

Alvin Langdon Coburn
New York

Like Peter Henry Emerson, Alvin Langdon Coburn was an Anglo-American photographer of distinction, another significant figure in the transition from pictorialism to modernism, from nineteenth- to twentieth-century photography. Unlike Emerson, however, he was an active member of the pictorialist circles that were at their most vibrant during the first decade of the twentieth century. He was an advocate for photography both old and new – he reprinted the negatives of early pioneers like David Octavius Hill and Robert Adamson, and Dr Thomas Keith – but unlike his fellow proselytizer, Alfred Stieglitz, Coburn made photobooks.

In 1909 and 1910 he published two books of identical design, illustrated with hand-pulled photogravures, one featuring pictures of London, the other of New York. These exemplify the concern of the more advanced pictorialists with 'modern' subjects, namely the twentieth-century city – a shift in attitude that triggered the final push towards photographic modernism. Of the two books, it is the *New York* volume that might be considered the more proto-modernist in spirit, not only because New York itself was the most palpably modern city, epitomized by that great leitmotif of early modernist photography, the skyscraper, but also because the form of the city, as created by these large, monolithic buildings, pushed Coburn towards a more radical way of seeing.

In his image of the Brooklyn Bridge, for instance, he split the frame neatly in two, the bridge on one side, empty space on the other. He made narrow vertical pictures to accommodate the upward thrust of the skyscraper, and he constantly flattened the picture-space, almost like a Cubist, using long lenses to layer the city's activities. The last, and perhaps key picture in the book, is of the Park Row Building, a massive slab of a skyscraper that towers over the lower, older buildings at its feet. The picture prefigures Stieglitz's later series of views from the Shelton Hotel, but whereas Stieglitz is all steely, lifeless perfection, Coburn is all Impressionist hustle and bustle: Pissarro or Monet with a camera. The cloud of smoke that erupts from the left foreground is a characteristic element. Smoke and steam often appear in Coburn's *New York* pictures, as they do in his famous view of St Paul's, in the *London* book. There, however, the mood evoked was of the nineteenth century, of dark satanic mills. Here, it is strictly of the twentieth, of bustling modernity, of giant, impersonal economic forces at work. Much of the work in *New York*, tending towards the abstract, demonstrates the faceless, inhuman quality of the modern city and modern society, where a human being becomes an ever smaller cog in an ever larger machine.

Arnold Genthe
Pictures of Old Chinatown

The German-born Arnold Genthe trained as a philologist and had mastered eight ancient and modern languages before emigrating to San Francisco in 1895 to tutor young Germans. He subsequently became a professional photographer and is best known for two very different bodies of work: his documentation of the 1906 San Francisco earthquake and the fire that followed it, and his book *Pictures of Old Chinatown*, published in 1908. The book is a hybrid in several ways, a cross between the work of Jacob A Riis and Edward S Curtis, one might say. Like Riis's *How the Other Half Lives* (see page 53), it is an investigation of an immigrant community within a great American city – the sizeable Chinese community in San Francisco. But like *Curtis's The North American Indian* it is a European view of an exotic culture.

Where Genthe was highly innovative, however, was in his choice of camera. He used a very small camera, deliberately concealed under his coat in order to catch his subjects unawares. This makes this book one of the first and most important examples of the candid-camera approach to documentary photography.

Despite the distance generated by such an approach – the psychological gap between the 'spy' Genthe and his subjects – the photographer's view is a sympathetic one, cool and studied, yet respectful and empathetic. The same feeling applies to Will Irwin's lucid and interesting text, which does not prejudge in the way, for instance, the social reformer Riis did when writing about the Chinese in *How the Other Half Lives*. The pictures were made before the 1906 earthquake and fire, and document a way of life that was indelibly altered by that event. There is the inevitable taint of the exploitative, uncaring outsider about the whole enterprise, but one of the things that most shines through the pictures – candid or not – is Genthe's evident passion for the subject, his desire to document fully what he saw as a way of life under threat.

Arnold Genthe **Pictures of Old Chinatown**
Moffat Yard and Company, New York, 1908
232 × 161 mm (9¼ × 6¼ in), 162 pp
Hardback with orange cloth and pasted photograph
47 b&w photographs
Text by Will Irwin

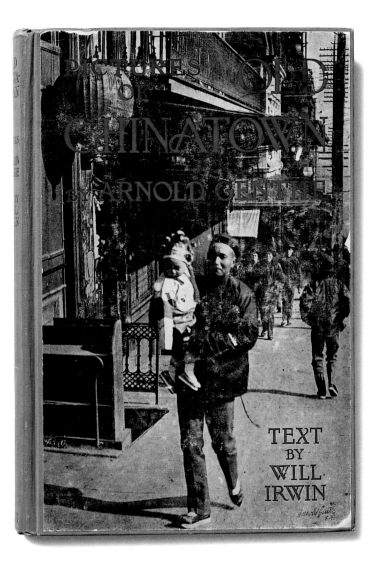

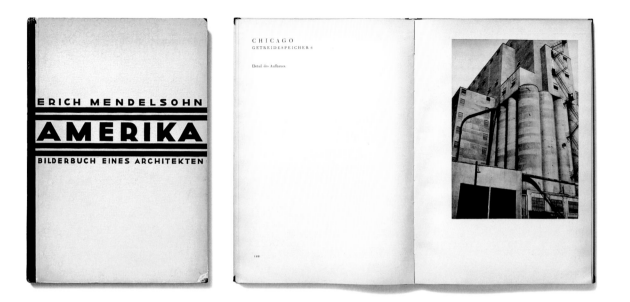

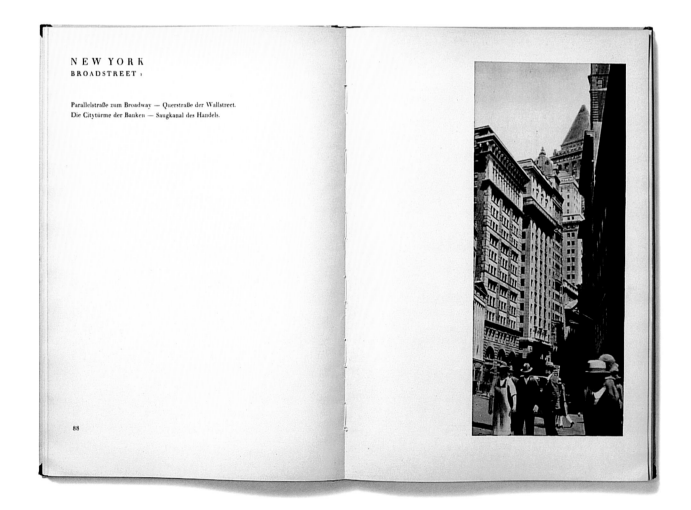

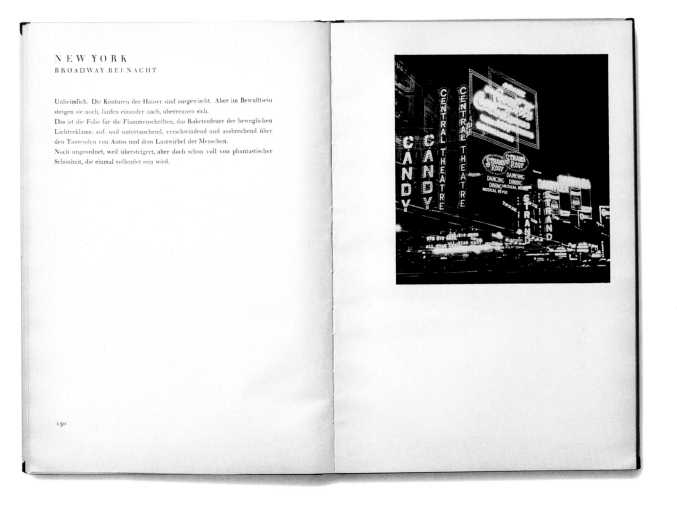

NEW YORK
BROADWAY BEI NACHT

Unheimlich. Die Konturen der Häuser sind ausgewischt. Aber im Bewußtsein steigen sie noch, laufen einander nach, überrennen sich.

Das ist die Folie für die Flammenschriften, das Raketenfeuer der beweglichen Lichtreklame, auf- und untertauchend, verschwindend und ausbrechend über den Tausenden von Autos und dem Lustwirbel der Menschen.

Noch ungeordnet, weil übersteigert, aber doch schon voll von phantastischer Schönheit, die einmal vollendet sein wird.

150

Erich Mendelsohn **Amerika: Bilderbuch eines Architekten** (America: An Architect's Picturebook)
Rudolf Mosse Buchverlag, Berlin, 1928, 6th edition
345 × 243 mm (13$\frac{1}{2}$ × 9$\frac{1}{2}$ in), 228 pp
Hardback with white paper and black cloth spine and cardboard slipcase (not shown) with
jacket (1st edition; not shown) and jacket and bellyband (2nd edition; not shown)
100 b&w photographs
Text by Erich Mendelsohn

Erich Mendelsohn
Amerika: Bilderbuch eines Architekten
(America: An Architect's Picturebook)

In 1924 the German architect Erich Mendelsohn made an extensive trip across the United States, taking photographs of modern architecture, which he published in a popular photobook, *Amerika: Bilderbuch eines Architekten* (America: An Architect's Picturebook, 1925).[17] He was a talented amateur photographer, and his images are powerfully expressive, romantic in the mode of Alfred Stieglitz, and like Stieglitz's work, a combination of the pictorial and the modernist.

Mendelsohn's opinion of the United States and American architecture expressed in the book is mixed too. 'This country gives everything: the worst of Europe, abortions of civilization, but also hopes for a new world.'

His views on American architecture were equally rigorous: 'Today the castles of commerce are still borrowed symbols of power, while their rear elevations, with their logical structure, are frequently even now surprising tokens of a true future.'

It was this emphasis on the 'true' and the 'logical' that characterized Mendelsohn as a modernist. He turned his camera not just on the facades of buildings, but also on their rears, with their accretions of fire-escape stairs. His enquiring eye examined not just buildings, but also streetscapes, cars and passing pedestrians, as well as purely functional structures like giant billboards and the reinforced-concrete grain elevators of Buffalo that were such an inspiration to him and to other European modern architects like Le Corbusier. To postwar Europe these were not just signs of modernity but symbols of plenty.

And yet, although Mendelsohn was a thoroughly modern architect, he was essentially a pictorialist photographer, albeit one who was rapidly discovering a more modernist photographic language. He was probably unconcerned with matters of photographic style, and was led to this new language through his subject matter, of which he had a highly sophisticated understanding. He often ignored the standard etiquette of professional architectural photography, tilting his camera vertiginously. Cropping his pictures into thin verticals, he emphasized the height of the American city, demonstrating a possible familiarity with the pictorial language of Alvin Langdon Coburn or early Stieglitz. In all, this is a fascinating transitional photobook, the work of a talented amateur photographer with prior knowledge of pictorialist modes groping towards a proto-modernism as he worked.

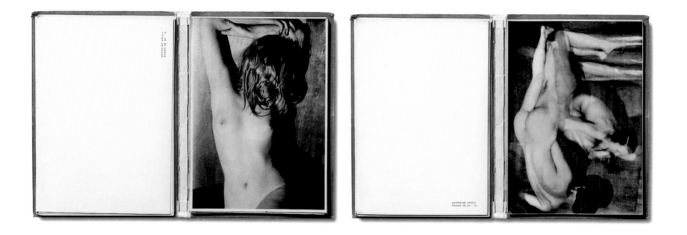

Germaine Krull **Etudes de nu** (Nude Studies)
Librairie des Arts Décoratifs, Paris, 1930
225 × 162 mm (8¾ × 6½ in), 52 pp
Portfolio with orange paper, buff paper spine and ties; 2 folded-page title sheets and 2 folded-page texts
24 loose-laid b&w photogravure plates
Text by Germaine Krull; preface by Jean Cocteau

Germaine Krull
Etudes de nu (Nude Studies)

After the astounding achievement of her first great portfolio *Métal* (Metal, 1928, see page 95), which was at the forefront of radical modernism, one might argue that Germaine Krull's *Etudes de nu* (Nude Studies) constitutes a retrograde step. Certainly, the approach taken by her nude studies is modernist-pictorial rather than the out-and-out progressive modernism of *Métal* – in spite of the fact that *Etudes* was published later. But whatever the style, Krull's pictures are highly elegant, and the variety of approach within the book suggests a full engagement with the nude genre. While most of

the images fall towards the pictorialist end of the spectrum, several are modernist and experimental.

Despite contracting a marriage to the Dutch filmmaker Joris Ivens in 1927, Krull's primary sexual preference was for her own gender. And although on occasion she still seems bogged down in traditional representations of the nude, there is an evident empathy, an intimacy, with her sitters. As with the nudes of the American photographer Imogen Cunningham, this intimacy outweighs the formal, although Krull's pictures are still somewhat reserved. Where she tries to push the formal envelope a little further down the modernist path, as in the two double exposures, the end result seems a little forced, but the several close-ups begin to

approach the New Vision abstraction of Edward Weston and others (which was based on optical science and objectivity), though without their glacial coolness.

The great fascination of *Etudes de nu* is in observing Krull's struggle with the conventions of the nude genre, her own sensibilities, and the restrictions regarding the photographic nude that pertained even in Paris. Perhaps if she had used one of the more clandestine outlets for nude photography existing in Paris at the time to publish some of the explicit lesbian images that she had made in Berlin around 1924, the results might have been even more challenging on several different levels – the formal, the personal, the psychological and the erotic.

F R (František) Drtikol
Žena ve světle (Woman in Light)

František Drtikol's *Žena ve světle* (Women in Light) was a popular example of 1930s Czech photographic publishing. The book is not so much modernist in the progressive sense, as *moderne* – pictorial in content but with a veneer of modernism. Drtikol was basically a pictorialist rather than a modernist, one of the leading photographic exponents of the movement that stylized modernism, Art Deco.

Drtikol studied photography in Munich, and set up a highly commercial studio in Prague in 1910, specializing in portraits and nudes. *Žena ve světle* is typical of his Art Deco phase, and just as Art Deco proper derived from Art Nouveau, the photographer's earlier nudes were Photo Secessionist in style, favouring heavily worked bromoil and gum prints.[18] The only thing that changed when he went 'modernist' was the creation of geometrically shaped plywood sets composed of angular and circular forms, which he lit dramatically with a single arc lamp. He shot his models from dynamic viewpoints, and sometimes his imagery plays around with mock-Cubist effects, but usually he gives us the style rather than the substance of modernism. In contrast to the generally purist views of the photographic modernists, Drtikol opted for a painterly approach, heavily reworking his prints by hand. He preferred pictorialist-style pigment prints over the modernist's favoured silver gelatin,[19] and these are used to great effect in *Žena ve světle*.

Despite its populist vision, this is a handsome and well-designed book. Drtikol remained a consistent and obsessive photographer of the female nude, his artistic persona managing to convey both a muscular heterosexuality and a formalist asexuality. These are quite clearly 'artistic' nudes, and remain extremely popular to this day.

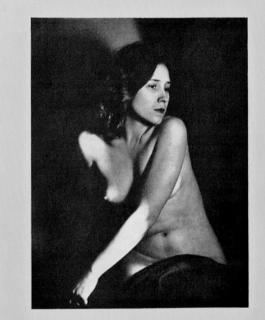

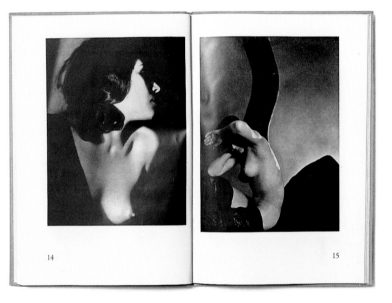

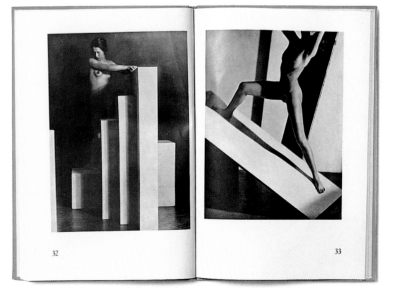

F R (František) Drtikol **Žena ve světle** (Woman in Light)
E Beaufort, Prague, 1930
248 × 171 mm (9¾ × 6¾ in), 62 pp
Hardback with full orange cloth and jacket
46 b&w photographs
Introduction by J R Marek

Laure Albin-Guillot
Micrographie décorative
(Decorative Microphotography)

Like František Drtikol's *Žena ve světle*, Laure Albin-Guillot's sumptuous *Micrographie décorative* (Decorative Microphotography) is regarded as a classic Art Deco photobook. Yet a pertinent comparison might also be made with Karl Blossfeldt's *Urformen der Kunst* (Art Forms in Nature) (see page 96), for like Blossfeldt, Albin-Guillot combined the scientific with the artistic. The project was a rare collaboration, as Paul Léon, director of the École des Beaux Arts, points out in his introduction, not only between scientist and photographer but also between husband and wife.

Albin-Guillot was one of the most successful Parisian photographers of the 1920s, her style a commercially astute blend of pictorialism and modernism. She was renowned for a wide range of photography, her portraits, nudes and landscapes, her illustrations for books of modern French poetry, her cosmetic and pharmaceutical advertisements. *Micrographie décorative*, however, was a much more personal project, a memorial to her husband, who had died in 1929. He had been a specialist in preparing specimens for the microscope, and his wife had made microphotographs for him.

It is these artistic experiments that are represented in *Micrographie décorative*, issued in an edition of 305. Albin-Guillot's images of her husband's microscopic preparations were privately printed by photogravure onto various coloured and metallic papers by the well-established Parisian printing house of Draeger Frères, who were responsible for many artists' books. *Micrographie décorative* was favourably received, the shimmering patterns echoing the lapidary and marquetry work of Art Deco designers. Its limited circulation, however, and the luxurious nature of the production, ensured that this particular example of artistic/scientific photography did not achieve the widespread popularity of Blossfeldt's botanical studies. It was included in Beaumont Newhall's historical overview of photography at New York's Museum of Modern Art in 1939, 'Photography 1839–1939'.

Laure Albin-Guillot **Micrographie décorative** (Decorative Microphotography)
Draeger Frères, Paris, 1931
425 × 364 mm (16¾ × 14¼ in), 48 pp
Spiral bound with card portfolio case
20 photogravure plates on coloured and metallic paper
Preface by Paul Léon

Anton Bruehl
Mexico

Anton Bruehl was born in South Australia, the son of European immigrants. He moved to New York in 1919, where he studied at the Clarence H White School of Photography, and went on to pursue a highly successful career in commercial photography for 40 years. Working in a popular modernist style, and known particularly for his work in colour, he published several photobooks, of which *Mexico* is considered the finest. A self-assigned, non-commercial project, this venture had particular personal significance for Bruehl.

The book, printed in an edition of 1,000, features 25 fine photogravures of Mexico created in the modernist-pictorial vein. The images are close in style to those made by Paul Strand in Mexico in 1932–4, although Bruehl's pictures do not display the sense of suffering that colours much of Strand's work. Nevertheless, like Strand, Bruehl seems to have been aiming for a timeless vision of humanity. It is clear from his opening remarks in the volume that he shared the fascination with Mexico exhibited by many American artists and intellectuals during the 1930s, but it is also apparent that Mexican society mattered less to him than the chance to make interesting photographs in expressive mode. These pictures, he states in the introduction, 'show nothing of Mexican cathedrals, public buildings, or ruins. They do not undertake to present Mexico.'

This admirably honest disclosure suggests, therefore, that Bruehl's pictures should be judged primarily on the formal terms by which he conceived them. The immediate difference between his work and Strand's is that Bruehl does not emphasize religious imagery. He gives us grave peasants, marketplaces and one or two modernist angles on wide-brimmed Mexican hats. In other words, the book is an interesting demonstration of the kind of formalist modernism that does not even pretend to make any social analysis of what is being photographed. On its own – somewhat limited – terms, however, it is seductive photography, beautifully printed and presented in a handsome volume, an exemplary combination of modernist angles with pictorialist values.

Anton Bruehl **Mexico**
> Delphic Studios, New York, 1933
> 414 × 320 (16¼ × 12¾ in), 60 pp
> Hardback with full linen, black leather spine and slipcase (not shown)
> 25 b&w photographs
> Text by Anton Bruehl; design by A G Hoffman

Photo Eye
The Modernist Photobook

The quality of a work need not be dependent absolutely on a 'modern' or an 'old' theory of composition. It is dependent on the degree of inventive intensity which finds its technically appropriate form. All the same, it seems to me indispensable that we, the creators of our own time, *should go to work with up-to-date means.*
László Moholy-Nagy [1]

Schirner, Berlin

70 71

Werner Gräff, ed.
Es kommt der neue Fotograf!
(Here Comes the New Photographer!)
Verlag Hermann Reckendorf, Berlin, 1929

A determinedly didactic book, *Es Kommt der neue Fotograf!* is at once showcase for diverse photo-imagery and treatise for an all-inclusive modernist photography.

Although modern art had been developing steadily since the end of the nineteenth century, the hiatus of World War I and the political situation created in its aftermath had a far-reaching impact on the development of modernism. The war's devastating effect, and the revolutionary climate that followed it – leading to a successful Socialist revolution in Russia and an abortive one in Germany – could not fail to impact on the arts. Even in the non-revolutionary countries, the emerging postwar landscape had been irrevocably changed, no matter how much entrenched vested interests attempted to paper over the cracks and re-establish the prewar status quo.

Not only did the revolutionary mood in Europe lead to revolutionary art, but it could be said that following the Great War the twentieth century truly began. As well as social upheaval, technological changes – especially in communications – ensured that the machine would play a much more prominent role in people's lives than ever before. Two primary agendas arose – firstly, to deal with the social legacy of the war, and secondly, to deal with the twentieth century. There was a need to confront the problems as well as grasp the opportunities engendered by the rapidly changing means of communication – the cinema, the wireless, the telephone and advances in printing techniques, which changed the world of both publishing and photography.

In certain countries the book, whether in the form of the limited-edition artist's book or the mass-produced letterpress volume, was an important part of modernist theory and practice. Thus the question of the modernist photobook cannot be discussed without consideration of the modernist

book as a whole. Also of crucial significance was the fact that modernist photography, although ostensibly international in outlook, developed very differently in Western Europe, Russia and the United States, with a corresponding effect on the character of the photobook in these three regions.

In Europe the book played a fundamental role in the aesthetic thinking of the era, and attitudes towards photography, from both photographers and others in the modernist vanguard, were open, sceptical, liberal and experimental. The European avant garde generally became interested in photography following the war, both in terms of the book and in terms of its widespread utilization as a conceptual tool. Modernist photobooks began to appear around the early 1920s, although one remarkable manifesto of experimental photography was published in 1913. *Fotodinamismo futurista* (Futurist Photodynamics) was the work of Anton Giulio Bragaglia, a member of the Italian Futurist movement, which celebrated all aspects of the modern age, particularly speed and mechanization. Bragaglia invented 'photodynamism', a term used to define the experiments in photographing movement that he made with his brother Arturo from 1911 onwards. They conducted these particular experiments partly to counter the objections of some Futurists that photography was too static to interest them – that it froze contemporary reality rather than expressed its hectic dynamism. Picking up from Etienne-Jules Marey's studies in 'chronophotography' of the 1890s – the photographic depiction of movement – the Bragaglias sought by means of multiple and overlapping exposures to encapsulate a sense of flowing motion in their imagery. They attempted to create in photography imagery that was similar to many paintings by their fellow Futurists, which were also influenced by Marey as well as by the fractured spaces of Cubism. Bragaglia's success, however, led to certain jealousies within the always volatile Futurist coterie. Anton's 1913 'polyphysiognomical' portrait of the painter Umberto Boccioni is a Futurist masterpiece, but Boccioni fell out with the brothers, declaring that photography was 'outside art'. 'We have always rejected with disgust and contempt even the remotest connection with photography,'[2] he stated, conveniently forgetting his own photographic experiments seven or eight years previously. Bragaglia was 'excommunicated' from the Futurist group, and turned to less interesting photographic pursuits.

The cradle of the modernist book was Russia, both before and after the Bolshevik Revolution. This extraordinary period of book-making and design by Russian avant-garde artists between 1910 and 1934 was echoed in the 1920s and 1930s in France and Germany. The first modern art movement to take root in Russia was Futurism, partly an offshoot of Italian Futurism, but like most things Russian, with a character and local inflection all of its own. The Russian Futurists were the first great artist book-makers of the twentieth century, seeking to achieve a new and viable integration of the visual and the textual, a strategy that would be continued by the Constructivists, the leading Russian art movement of the 1920s. Constructivism had originated around 1914, and was typically characterized by the use of industrial materials such as glass, plastic and metal, arranged in abstract compositions. The Constructivists, who saw themselves not as artists but as 'workers', drew on the Futurist tradition, but, importantly, replaced the cheap, handmade, often primitivist, yet iconoclastic nature of the Futurist book with mechanistic, geometric mass production, a crucial conceptual shift that eventually saw photography subsumed into the graphic and typographical mix.

After the Bolshevik Revolution of 1917, the whole social and political role of art in Russia was questioned by both artists and political commissars. As Margit Rowell has written:

> The role of the artist would also be recast as a catalyst for social change, conceived first as a 'worker', comparable to the proletarian worker, and eventually as a 'constructor' or 'engineer'. The notion of art as the expression of individual genius was officially proscribed, and replaced by an art that would be politically effective, socially useful and mass produced.[3]

In the 1920s Constructivism was willingly pressed into this populist role, while still retaining its avant-garde credentials. Lenin was not concerned with the aesthetic battles raging amongst Russian artists, but he was acutely aware of art's political power. For a brief but crucial period until the Stalinist regime the Soviet avant garde enjoyed the support of his cultural bureaucracy. The fact that many of the leading artists embraced Bolshevism helped create a new kind of art for a new society.

The most radical step taken by the Russian avant garde was not their experiments in an increasingly reductive abstraction, but their repudiation of easel painting altogether, denouncing fine art as a redundant tool of reactionary bourgeois culture. Instead, they utilized the formal language that they themselves had developed in the applied arts. The result was a revolution in graphic design and the machine arts – film, photography, typography – paralleled in Germany and elsewhere in Europe by the Dadaists, yet given the distinctive Soviet twist.

At the heart of Constructivism was graphic design, a vital part of book, magazine and poster production. And one of the key graphic techniques used extensively by such figures as Alexander Rodchenko and El Lissitsky was photomontage. Also known as photocollage,[4] it is almost as old as photography itself, but was 'rediscovered' around 1919 by Berlin Dadaists like Hannah Höch and Raoul Hausmann, and in Russia by Gustav Klutsis.[5] The Constructivists turned to the technique eagerly, since it was theoretically perfect for their avowed aims. Photomontage was both figurative and abstract, real and illusory, commonplace and marvellous, simple and complex, a technique that could satisfy the artistic ambitions of its practitioners while getting a message across. Furthermore, it seemed closer in concept than straightforward photography to that great proletarian art form: cinema.

Most of the leading Constructivists used photomontage extensively. El Lissitsky, who spent much of the early 1920s in the West and had close contacts with his German counterparts, made a series of photomontages to illustrate his friend Ilya Ehrenburg's 1922 book, *6 Provesti o Legkikh Konstakh* (6 Tales with Easy Endings). Rodchenko employed photomontage for numerous book covers in the 1920s, ranging from popular mystery novels to several volumes of poetry by Vladimir Mayakovsky. The best-known of these collaborations is Mayakovsky's love poem to Lili Brik, *Pro Eto* (About This), published in 1923. Its famous bug-eyed cover portrait and eight photocollaged illustrations make it one of the supreme classics of Constructivist book design and photography. An avant-garde complexity was retained in that work, both formally and in narrative terms, but both Rodchenko and El Lissitsky, after acceding to the prevailing political imperative, would simplify their palettes, becoming masters of the big, bold, somewhat simpler photomontage style that graced the Soviet books, posters and magazines of the 1930s, when propaganda pure and simple was the aim.

In Germany the avant garde pursued broadly similar goals to the Soviets. Relationships between German and Russian artists were close, and would have been even closer if the attempted German Socialist revolution in 1918 had succeeded. But although many German, French and other European artists were in sympathy with the Soviet experiment, the artistic production of Western Europe was also defined by capitalist culture. Here, formalism wasn't a dirty word, nor a forbidden goal. And advertising, not propaganda, was the public arena for the boldest graphic experimentation.

A vital training ground for 1920s German modernism – especially for photography – was the Bauhaus, founded in Dessau in 1919. Under its director, the architect Walter Gropius, this radical institution proposed a new form of art and design education for the modernist age, based partly on the Arts-and-Crafts socialism of English artist/designer William Morris and its German equivalent, the Deutscher Werkbund organization of 1907, but focusing on the application of craft to mass production. *Kunst und Technik, eine neue Einheit* (Art and Technology, a New Synthesis) was the school's motto. The *Vorkurs* (Foundation Course) was the great innovation of the Bauhaus, and remains the pattern for art education today. Students were taught the fundamentals of form and design, and how to apply them across a wide range of disciplines, including not just painting, architecture and sculpture, but interior design, fashion, dance, theatre, typography, film and photography.

The Bauhaus did not offer formal photographic tuition until 1929, long after the Hungarian László Moholy-Nagy took over the running of the basic course in 1923. Moholy-Nagy's enthusiasm for photography and his emphasis on such areas as graphic design and typography were fundamental, shifting the school's emphasis away from its Arts-and-Crafts foundation towards mass production and communication, from a handmade to a machine aesthetic that had much in common with Russian Constructivist tenets. Indeed, as Moholy-Nagy wrote in the Budapest magazine *Ma*, his basic philosophy was a Constructivist one, founded on a utopian vision of an industrialized and socialized society:

'Constructivism is pure substance. It is not confined to picture frames and pedestals. It expands into industry and architecture … objects and relationships. Constructivism is the socialism of vision.'[6]

Book production was always a part of the Bauhaus programme, and Moholy-Nagy was co-editor with Gropius of a number of monographs explaining the school's philosophies. In 1925 he wrote *Bauhaus Bücher 8, Malerei Fotografie Film* (Painting Photography Film), one of the most renowned of the series. It became the primary manifesto for the experimental wing of European modernist photography, burying the bourgeois sentimentality in which pictorial photography was rooted, and establishing what was termed the Neue Optik (New Vision). The New Vision was based on the appliance of optical science and objectivity to photography, with little of the transcendentalism that marked American modernism, though Moholy-Nagy's motives were more pedagogical than political.

The New Vision, as the title of Franz Roh's book, *Foto-Auge* (Photo-Eye, 1929) suggests, was concerned with machine vision, the vision of the camera as opposed to the photographer. Photography's capacity to see what the human eye cannot, or to see the world in unexpected and challenging ways, was valued for its potential to free contemporary man from bourgeois aesthetic preconceptions, thus revealing a 'modern' vision, both objective and true. What many saw as a basic fault of the camera, its indiscriminate encompassment of everything within its field of vision, was regarded as a great virtue. This democratic faculty, which would render the work of professionals and amateurs, artists or journeymen almost indistinguishable, laid the foundations for a possible universal enlightenment.

By the late 1920s Germany was at the forefront of European photography, and around the end of the decade, a number of fundamental photobooks were published by German photographers, each establishing in its own different way the parameters of photographic modernism. Karl Blossfeldt's *Urformen der Kunst* (Art Forms in Nature, 1928) demonstrates what was to become a perennial tendency in German photography: the examination of 'typologies'. This involves the repetitive documentation of types in order to differentiate between the individual constituents of a subject category. Blossfeldt's close-ups of plant forms revealed not only their generic differences but also their relationship to forms borrowed from nature by culture. In its rigorous fusing of the documentary with the formal, Blossfeldt's work is the direct predecessor of the approach of such contemporary German photo-artists as Bernd and Hilla Becher or Thomas Struth.

This is also true of the work of August Sander. He was a photographer of 'types', but types in society. Sander's *Antlitz der Zeit* (Face of Our Time, 1929) (see Chapter 5) was an epic look at class in Weimar Germany, a project firmly in the documentary mode in that it had political intent, but also exemplifying the same modernist tenets as Blossfeldt's work – seriality and objectivity. The latter was a key concept. It also surfaced in another extremely influential book, Albert Renger-Patzsch's *Die Welt ist Schön* (The World is Beautiful, 1928). Renger-Patzsch's close-ups of both natural and man-made objects were not as objective as they seemed, but they provided a powerful polemic for the 'purist', straight photograph, a tendency that was also prevalent in American modernist circles.

This flowering of photobook publication at the end of the 1920s, especially in Germany, was encouraged by the fact that there was a market for such volumes, an extension of the public's demand for photographically illustrated magazines. Technical advances in both photography and the printing trade since the turn of the century had led to a boom in magazine publishing. Inventions like Edouard Mertin's rotary printing cylinder of 1910 made printing, including the seamless integration of photographs with text, cheaper and easier. The introduction of the 35 mm camera, the Leica, in 1923, was both a practical and a symbolic innovation. It made photography more obviously spontaneous than ever before, reinforcing its symbolic role as a totem of modernity, and confirming the medium as the main carrier of visual information to the masses.

Following World War I Germany was not just at the forefront of improvements in cameras and lenses – thanks to Messrs Leitz and Zeiss – but was the home of the best illustrated magazines and editors. Such journals as *Neue Berliner Zeitung* and *Münchner Illustrierte*, under its brilliant picture editor Stefan Lorant, developed the full potential of a new way of presenting photographs – the photoessay – and fostered a new breed of professional – the photojournalist.

The years 1928–30 may be seen as a particular highpoint for European photographic modernism, the point when photography was at its most international in outlook, optimistic and utopian, before being both galvanized and disrupted by the advent of fascism in the 1930s. The apogee was probably the most important modern photography exhibition of the twentieth century, the 'Film und Foto' (FiFo) exhibition of 1929. Organized by the Deutscher Werkbund in Stuttgart, the exhibition attempted, and largely succeeded, in synthesizing much of modern photography for a brief historical moment, bringing together photographers from Germany, Russia, France, Czechoslovakia, the United States and elsewhere. It linked still photography with film, did not discriminate against vernacular, scientific or commercial photography in favour of art, and, importantly, exhibited anonymous photographers alongside established names, amateurs alongside professionals. Indeed, perhaps the most important feature of 'Film und Foto' was that it promulgated a democracy of vision, aware of the medium's potential place in society as well as in the arts. This inclusive, rather than exclusive, mission for photography was reflected in the two major photobooks published around the exhibition. Like Moholy-Nagy's Bauhaus photobook, Werner Gräff's *Es kommt der neue Fotograf!* (Here Comes the New Photographer!), and Franz Roh's *Foto-Auge* were determinedly didactic, at once showcases for diverse photo-imagery and treatises setting out the aspirations of an all-inclusive modernist photography.

The primary axis of influence in European modernist photography was between Moscow, Berlin and Paris – from the former to the latter – with Prague an important branch road. Paris came into its own in the 1930s, when fascist dictatorships of opposing political persuasions closed down possibilities in both Russia and Germany. The gathering storm in Eastern Europe drew many artists to Paris, which became the leading European centre for photojournalism and documentary photobooks, and also for photobooks by avant-garde artists.

The Parisian art movement that drew most on photography was Surrealism, whose members were naturally intrigued by photography's ability to slip unexpectedly between reality and unreality. They experimented freely with the medium, employing both straightforward photography and montage, and techniques like photomontage and solarization.[7] The main Surrealist photographer was the American expatriate and one-man art industry, Man Ray. Inspired by Dada – the anarchic art movement that had emerged in Europe around 1915 – he had begun to experiment with 'cameraless' photo-imagery in the early 1920s, as well as making a living as a commercial photographer. He gathered a whole coterie of artists and photographers around him – Lee Miller and Berenice Abbott among them – at his Montparnasse studio, in the rue Campagne Première.

The first modernist photoworks of note to be published in Paris were Man Ray's *Champs délicieux* (Delicious Fields), as far back as 1922, a portfolio of 12 original photograms, with a preface by Tristan Tzara, as well as Germaine Krull's *Métal* (Metal), in 1928, also a portfolio, but of collotypes depicting industrial structures. Man Ray was not only the most important Surrealist photographer, but also the leading book-maker, although other members of the Surrealist group such as Georges Hugnet, Claude Cahun, Roger Parry and Hans Bellmer made significant bookworks incorporating photography. Amongst Man Ray's best books was *Facile* (1935), a collaboration with the poet Paul Eluard that is as masterly a synthesis of image and text as Mayakovsky/Rodchenko's *Pro Eto*.

Prague was a flourishing centre of both advanced photographic concepts and artists' bookmaking. Czech art and photography is an intriguing mixture of cultural influences, and there were many avant-garde groups in the 1930s that were influenced by both Constructivism and Surrealism. Polyglot figures such as Vítězslav Nezval and Karel Teige, embraced not only literature and the visual arts but architecture and the performing arts as well. Photographers like Jaromír Funke, František Drtikol, Josef Sudek and Jindřich Štyrský borrowed freely from East and West, and their work is a seductive blend of Gallic sensuality and Russian gloom, exemplified in such books as Nezval's *ABECEDA* (Alphabet, 1926) and Štyrský's *Emilie přichází ke mně ve snu* (Emily Comes to Me in a Dream, 1933).

Since the United States did not suffer to the degree that Europe did in the Great War, American modernist art in general lacked both the nihilistic tendencies (exemplified in Dadaism) and the

utopian urges (exemplified in Constructivism) that emerged in the conflict's aftermath and infused much European avant-garde art (including photography). Such vital, if contrary tendencies, born out of turmoil and suffering, gave the Europeans a much broader sense of purpose. In the United States, the modernist photobook was a relatively late development. Here, modern photography, at least until the beginning of the 1930s, was dominated by one figure, Alfred Stieglitz, whose philosophy was almost the antithesis of European avant-garde thinking. The Stieglitz view of photography was unashamedly elitist, based on a high-art aesthetic and a craft ethos that made a fetish of the 'fine print'. Thus the gallery wall rather than the printed page was seen as the correct home for photographic art. Crucially, however, American photographic modernism was almost fanatically concerned with emphasizing photography's separateness from the other visual arts, and maintaining its purity at every turn. Contrary to the dominant notion pertaining in Germany, the idea of the 'straight' photograph in the United States meant aesthetics, subjectivity and purity as opposed to democratization, objectivity and pluralism – a theoretical position that seemed aimed at limiting rather than expanding the medium's potential. Although, as Maria Morris Hambourg has rightly pointed out, 'the distinctly American manner of precise description and technical brilliance subsumed a variety of individual approaches',[8] the general outlook was both narrow and inward looking.

Indeed, one might say isolationist. For more than a decade American art turned inwards, searching for historically defined American qualities and largely ignoring the ferment of ideas galvanizing European art. The search for the 'American-ness' of American art uncovered many fine things – a renewed appreciation of folk art and Civil War photography, for instance – and nurtured many fine artists, but the corollary of this cultural navel-gazing was an inevitable provincialism. So much so that Christopher Phillips has noted that during the 1920s, 'it was difficult for even a sympathetic observer in the United States to follow the complex trajectory of the new photography in Europe or to gauge accurately the ideas that shaped its practice'.[9]

Such attitudes meant that there were few modernist photobooks of any note published by American photographers until well into the 1930s (especially if one excludes the expatriate Man Ray). It was not until after the beginning of the Great Depression that American photography took note of the developments in photography that had swept Europe for almost a decade. Even then it was to reject all those ideas that did not conform to a 'pure' photographic and broadly realist outlook – which was not only the way that American modernism had developed, but was seen as the only appropriate mode in a decade of economic and social deprivation.

As far back as 1917 Stieglitz's own publishing venture, the quarterly journal *Camera Work*, had raised the curtain on American photographic modernism in the realist mode with its final issue, featuring the work of Paul Strand. The magazine closed for economic reasons, yet one might say that its handmade, Arts-and-Crafts luxury was out of step with the times, and in launching Strand with the journal's swansong, Stieglitz was passing the baton on to the younger generation, clearing the way for something new. But the purist tendency, the insistent turning inwards and the inherent bourgeois conservatism of the leading American photographers held them back, despite some fine individual achievements. After that momentous issue of *Camera Work*, it would be around a decade and a half before a photobook that matched the best European efforts in the field was published in the States.

It is to be regretted that although he published his work in various arenas, Stieglitz never made a concerted photobook of one of his more significant bodies of work – his cloud studies maybe, or his portrait and nude studies of his wife, the artist Georgia O'Keeffe. The same is true of Edward Weston, who did publish a number of books, but whose concentration on obtaining the single image and then making the perfect print was probably to his detriment as a book-maker. Or perhaps it was his resolute refusal to become involved in politics during the 1930s. It was those whose work was touched – to whatever degree – by the events of the times who contributed most to the emergence of the American photobook in that decade, and laid the foundation for a tradition that would flourish after the war. It wasn't necessary – as some photographers did – to join the American Communist Party, but to focus on people rather than rocks, upon culture rather than nature.

The history of the American photobook in the 1930s is therefore largely bound up with the social documentary movement, which will be discussed in the following chapter. There is, however, one key American book – in the 'documentary mode' certainly – that should be considered in a wider modernist context. That is the 'photographer's photobook' – Walker Evans's *American Photographs*, published in 1938.

Evans liked to claim that he was apolitical, but he certainly moved in actively liberal circles, and worked for the New Deal government in the shape of Roy Stryker's Farm Security Administration (FSA) Photographic Unit. It would be fair to say, however, that his cultural interests were chiefly literary rather than either socio-political or painterly, and it is his application of his literary influences to his work that makes *American Photographs* such a different kind of photobook. The allusive, metaphorical, even textual references that Evans made, both in individual images and in his sequencing, added a new dimension to the book's whole dynamic. *American Photographs* introduced elements of 'structure and coherence; paradox and play and oxymoron'[10] – the qualities that he himself demanded from photography. And such qualities are reinforced by Lincoln Kirstein in the afterword to the book, which might be taken both as a summation of Evans's own feelings, and a key manifesto for photographic modernism. Kirstein lays out a programme for a photography that is essentially documentary, but is also an art – an art that goes beyond the partisan, if passionate, recording of the documentarists, yet proposes a far more ambitious and wide-ranging brief for photographic art than mere modernist-formalism. In what is undoubtedly his masterpiece, Evans threw down a gauntlet for modernist and socio-documentary photographers, a gauntlet that would be picked up by photographic book-makers on both sides of the Atlantic following World War II.

Anton Giulio Bragaglia **Fotodinamismo futurista** (Futurist Photodynamics)
Nalato Editore, Rome, 1913, 2nd edition
250 × 197 mm (10 × 7¾ in), 48 pp
Paperback with jacket
17 b&w photographs
Text by Anton Giulio Bragaglia

Anton Giulio Bragaglia
Fotodinamismo futurista (Futurist Photodynamics)

Fotodinamismo futurista (Futurist Photodynamics) is not only one of the most interesting of the numerous Futurist manifestos, it is also the first modernist photobook, in the sense that it is the first theoretical text on photography presented in the context of the twentieth-century avant garde. It arose from the Bragaglia brothers' efforts to find a photographic expression of the Futurists' obsession with speed and motion using what they called 'photodynamism'.

The book's tone, as in most Futurist manifestos, is assertive and confident, even aggressive. Bragaglia acknowledges the precedent of Etienne-Jules Marey's 'chronophotography', but criticizes it unmercifully, explaining how photodynamism is not only superior to Marey's technique, but also to other forms of photography and cinematography, since it is the only way of substantially capturing the essence of movement in a photograph. Bragaglia asserts that chronophotography and even cinematography merely combine mechanical, frozen images together – 'We despise the precise, mechanical, glacial reproduction of reality, and take the utmost care to avoid it' – whereas speed applied to

actions or objects renders them immaterial or invisible – 'dematerialized in motion'. Bragaglia's photodynamism would trace the shape of this dematerialization, thereby capturing not the surface appearance but the dynamic and psychological essence of movement – 'the complete external unfolding of the intimate drama can be expressed in one single image'. Rather than stiff, external expression, Bragaglia's method catches the heart of the matter, extracting 'the inner, sensorial, cerebral and psychic emotions that we feel when an action leaves its superb, unbroken trace'.

After all this hyperbole, the 17 halftones grouped together at the back of the book may come as a slight anticlimax, since the use of deliberate blurring to express motion has become a commonplace in photography. But this is its putative start. Some of the classics of Futurist photography are here – *The Typist*, *The Slap* and others – illustrating Bragaglia's time-exposure and super-imposition method to perfection. They are raw and exciting, perhaps examples of work in progress rather than finished art, since the proscriptions of the Futurist painters cut short the Bragaglias' experiments when they were at a crucial stage. Certainly they are the prototypical beginnings of a truly modernist vision, finding a visual language that was purely photographic.

Vladimir Mayakovsky and Alexander Rodchenko
Pro Eto. Ei i Mne (About This: To Her and Me)

Alexander Rodchenko's cover and illustrations for the publication of Vladimir Mayakovsky's epic love poem *Pro Eto* (About This) is one of the first, and certainly the finest, examples of the Constructivist marriage between typography and photomontage in its first phase – before it became exclusively propagandist in tenor. It is also one of the best examples in photobook history of a union that is rather more difficult to bring off successfully – that between photography and text. For this we not only have Rodchenko's skills as a designer to thank, but also Mayakovsky's conception of the poem's text as a visual as well as a literary experience.

Pro Eto is a passionate poem celebrating Mayakovsky's lover, Lili Brik, wife of the critic Osip Brik, written during a hiatus of several months in their relationship due to a quarrel. The cover portrait portrays Lili, a charismatic woman, while the poem describes a tempestuous liaison with more than a hint of bourgeois revisionism, despite Mayakovsky's frequent rhetoric about the need to eliminate themes of personal emotion and love from revolutionary art. At the poem's heart is the paradox of two people forming a self-contained, even selfish, relationship in a society aspiring towards collectivism. Mayakovsky's text also deals frankly with his ambivalence towards many of the leading Bolsheviks, and his sense of alienation – from both the mercurial, difficult Lili, and the strictures of revolutionary society.

Rodchenko employs the montage technique superbly to crowd each picture space with multiple imagery, containing apparently contrasting juxtapositions and abrupt shifts in scale that suggest all the complexities and paradoxes of Mayakovsky's verse. It shifts back and forth between the maelstrom of Mayakovsky's personal life and the brave new mechanistic modernity of Soviet society. The formal strategies of point and counterpoint, of piling up image upon image, of finding visual equivalents to complement words – or sometimes to contradict them – are utilized here in the service of individual creative expression, but in later years Rodchenko would put them to equally effective use in the service of state propaganda.

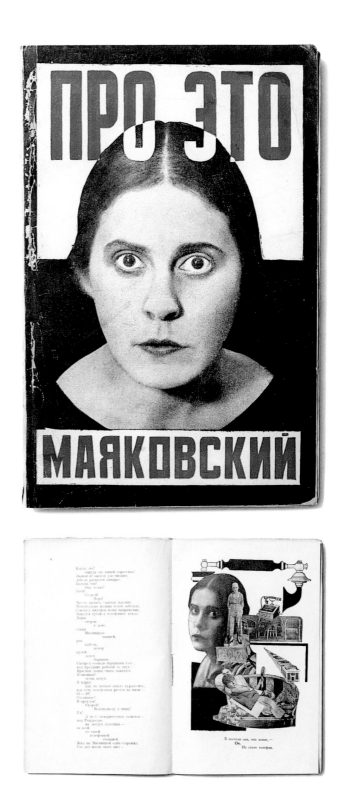

Vladimir Mayakovsky and Alexander Rodchenko **Pro Eto. Ei i Mne** (About This: To Her and Me)
Gos. Izd-vo, Moscow, 1923
231 × 156 mm (9 × 6 in), 48 pp
Paperback
8 b&w photomontages
Poem by Vladimir Mayakovsky; cover and illustrations by Alexander Rodchenko

László Moholy-Nagy
Malerei Fotografie Film
(Painting Photography Film)

Moholy-Nagy had not been an aficionado of photo-
graphy for long before he wrote *Malerei Fotografie
Film* (Painting Photography Film) – number eight in a
series that he co-edited with Walter Gropius for the
Bauhaus, illustrating the new ideas emanating from the
establishment. The book, published in 1925, was imme-
diately successful and highly influential; an expanded
edition was published in 1927 (featured here),[11] and a
Russian edition (cover on right) was launched in 1929.

In this theoretical treatise in text and pictures
Moholy-Nagy condemns the subjectivity of pictorialism
(using an Alfred Stieglitz picture as a punchbag), and sets
out the framework of what he calls the 'New Vision',
featuring his own work and that of others. The New
Vision thesis put forward in this book argues that the
camera should be left alone to record whatever happens
to be before the lens: 'in the photographic camera we
have the most reliable aid to a beginning of objective
vision'. This is a typically modernist call to respect the
inherent qualities of a medium – form follows function
– but is very different from the American purist dogma
of the 'straight' photography variety. Moholy-Nagy, heav-
ily influenced by the Constructivists, embraces film,
montage, typography, cameraless photography, news
and utilitarian photography.

Throughout, the pedagogical, utopian tone of the
Bauhaus is in evidence. The images selected display
all the formal innovations of New Vision photography
– dramatically angled chimneys, patterns of flight and
movement and so on. But Moholy-Nagy stresses the
medium's distinctions from fine art. Photography, espe-
cially combined with type, would be a new 'visual

literature'. Objectivity, clarity, communication rather than
transcendental subjectivity were the primary goals of
the new photography. The modern photographer would
be a worker, adept at displaying his skills in the service
of society, and equally at home in the related fields of
photomontage, typography or film. The photographer
of the future would be a contemporary renaissance
man or woman – and none fitted the bill better than
Moholy-Nagy – the renaissance sparked this time not
by the printing press but by the camera: 'The tradi-
tional painting has become a historical relic and is
finished with. Eyes and ears have been opened and are
filled at every moment with a wealth of optical and
phonetic wonders. A few more vitally progressive years,
a few more ardent followers of photographic tech-
niques and it will be a matter of universal knowledge
that photography was one of the most important fac-
tors in the dawn of a new life.'

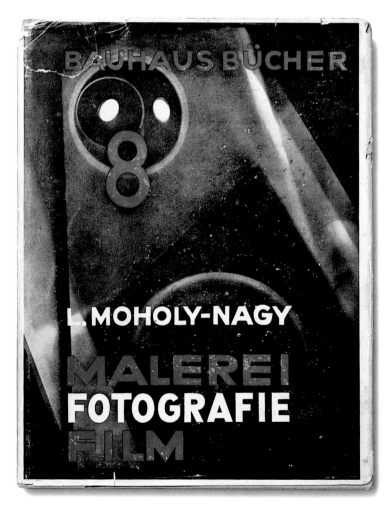

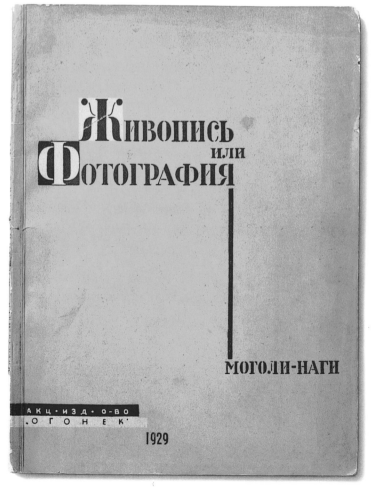

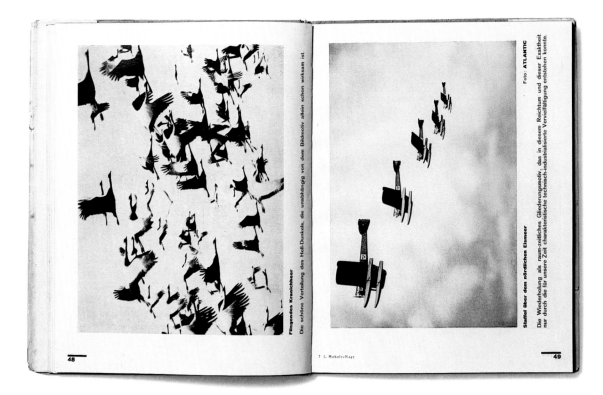

László Moholy-Nagy **Malerei Fotografie Film** (Painting Photography Film)
Bauhaus Bücher 8, Albert Langen Verlag, Munich, 1927, 2nd edition
(Russian edition published in 1929)
235 × 185 mm (9¼ × 7¼ in), 140 pp
Hardback with full yellow cloth and jacket
c.100 b&w photographs
Text and design by László Moholy-Nagy

Vítězslav Nezval
ABECEDA (Alphabet)

Written by Vítězslav Nezval in 1922, the 24-poem sequence *ABECEDA* (Alphabet) is an important landmark of the Czech avant garde for several reasons. Firstly, it takes as its subject the very basis of poetry, the letters of the alphabet, depicting each in brief, playful stanzas. Secondly, in 1926 the famous Czech dancer Milča Mayerová turned the texts into a series of choreographed movement pieces, which were directed by Jiři Frejka for the Liberated Theatre. And thirdly, also in 1926, *ABECEDA* was published as an illustrated book, designed by the leading Czech graphic designer and architect, Karel Teige.

In *Malerei Fotografie Film* (Painting Photography Film) Moholy-Nagy defined a new Constructivist art form, a combination of text and photography that he called 'typofoto'. Teige's collaboration with Nezval and Mayerová – and also the photographer Karel Paspa – is a classic 'typofoto' book, a Constructivist alphabet, and what might in retrospect be termed one of the first Conceptual artists' books.

Teige was the orchestrator of this modernist *Gesamtkunstwerk* (total art work), which drew together a wide range of artistic disciplines. He designed the book and made the photomontages from Paspa's photographs of Mayerová's 'choreographic compositions'. But it is Mayerová who is clearly the star of the enterprise, its guiding spirit. Her poses for the various letters of the alphabet, wearing a gymnast's singlet, shorts and fetching bathing cap, are by turns playful and erotic. Posing women as letters of the alphabet was not a new idea, but Mayerová was no acquiescent, droopy nymph of a model; she was a thoroughly modern Millie, bold and active, athletic, sexy and confident. Turning poetry into modern dance, she as much as Nezval was the inspiration for this important book, which attempted to challenge both conventional artistic hierarchies and class distinctions with an art that could be equally embraced by a professor or a street cleaner.

By virtue of Mayerová's infectious exuberance, this book is not only a modernist landmark, but great fun. It is typical of the optimistic, utopian first flush of modernism – unfortunately so short lived – when the new art was intended to help create a shining new society.

Vítězslav Nezval **ABECEDA: Taneční komposice: Milča Mayerová** (Alphabet: Choreographic Compositions by Milča Mayerová)
Nákladem J Otto, Prague, 1926
302 × 233 mm (12 × 9½ in), 60 pp
Paperback
25 b&w photomontages
Poems by Vítězslav Nezval; photographs by Karel Paspa; design and photomontages by Karel Teige

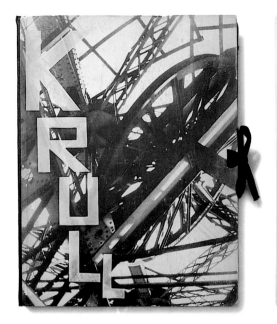 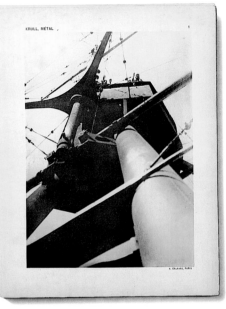 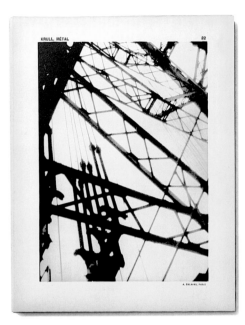

Germaine Krull **Métal** (Metal)
Librairie des Arts Décoratifs, Paris, 1928
290 × 225 mm (11½ × 8¾ in), 134 pp with 2-pp text booklet
Portfolio with black cloth spine and ties
64 loose laid b&w collotype plates
Edited by A Calavas; preface by Florent Fels

Germaine Krull
Métal (Metal)

Those who believe that photographic modernism is a boys' club can be cheered by the achievements of two female photographers at a surprisingly early stage in the modernist era. Imogen Cunningham and Germaine Krull have been somewhat overlooked in photographic histories compared to their male counterparts, yet not only were they prominent in early modernist circles, their contributions were fully recognized at the time. Cunningham's abstract close-ups and nudes were considered by some contemporary critics to be superior to Edward Weston's.

Krull worked in Berlin, Russia, Holland and Paris during the 1920s, all primary centres of European modernism. Her greatest success came with the publication of the sumptuous *Métal* (Metal), by the Librairie des Arts Décoratifs. Compared to the classical, somewhat static studies of Charles Sheeler or Albert Renger-Patzsch, Krull's views of industrial structures in Holland and Paris – including as a leitmotif that icon of modern engineering, the Eiffel Tower – seem more fluid and poetic, much more 'modern', reproducing the jagged angles of New Vision photography and the fractured spaces of the Futurists.

Krull's vision is also determinedly cinematic, for although the sheets are loosely laid in the portfolio, they are numbered, and the sequence is important. Krull worked closely with her husband, the Dutch avant-garde film-maker Joris Ivens, and *Métal* is closely related to his film *De Brug* (The Bridge), which, like the portfolio, was first shown in 1928 (although some copies of Krull's work may have been released prior to the date given inside the book). She helped in the film's making and took some of the *Métal* images while on location.[12] However, in her dramatic, vertiginous close-ups, angled vision and radical use of the frame edge, Krull goes further than Ivens in symbolizing the forward-looking, progressive thrust of modern engineering. *Métal* is several steps ahead of her nude portfolio, and sealed her international reputation as a leading modernist. Along with Moï Ver's *Paris*, it is surely the finest example of a modernist photobook in the dynamic, cinematographic mode.

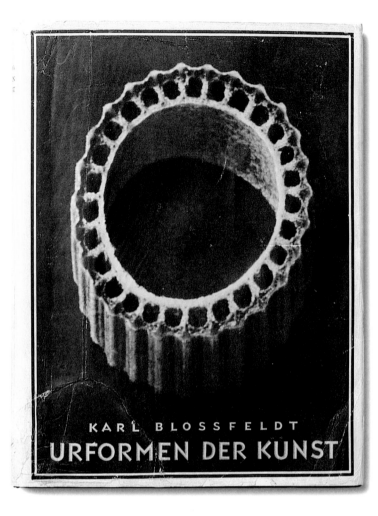

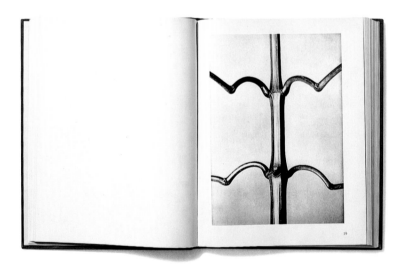

Karl Blossfeldt **Urformen der Kunst** (Archetypal Forms of Art)
Verlag Ernst Wasmuth AG, Berlin, 1928
300 × 252 mm (12½ × 10 in), 148 pp
Hardback with full green cloth and jacket
120 b&w photographs
Introduction by Karl Nierendorf

Karl Blossfeldt
Urformen der Kunst (Archetypal Forms of Art)

Karl Blossfeldt's *Urformen der Kunst* (translated, not quite literally, in the English edition of 1929 as *Art Forms in Nature*) is one of the most striking books in photographic history, as well as one of the most popular, running into numerous editions over the decades. It was a key model for the 'typologies' school of contemporary German photography, but Blossfeldt's photobook masterpiece was not a Conceptual work of art. It was, like so much German photography of this period, pedagogical in nature, as much founded on the Arts-and-Crafts ethos as Bauhaus principles.

Beginning in 1900, Blossfeldt – a rare combination of craftsman and art historian – made thousands of photographic enlargements of plant leaves, stems and seed pods in order to reveal the link between the structure of plants and artistic form. His book was less of an artistic statement than a teaching manual, a pattern book, a model for the courses he taught on the sculpture of living plants at the Kunstgewerbemuseum School in Berlin. In 1925 his work caught the attention of Karl Nierendorf, a banker and collector of avant-garde art. Nierendorf encouraged Blossfeldt to exhibit his photographs in art exhibitions, and edited the work for this publication, as well as writing the introduction.

Nierendorf undoubtedly had a significant influence in ensuring that the book was constructed with a formal rigour and philosophical consistency that move it far beyond the scientific record. Blossfeldt may have been a photographic 'amateur', but his scrupulous lighting, framing and arrangement techniques ensured that the points he sought to make about the relationship between nature and art are presented without obfuscation. He knew what he wanted to achieve, and he controlled it at every juncture, even spending months looking for exactly the right plant specimen to photograph. We might be looking not at plant details but directly at architectural decorative elements – finials, bosses, brackets, parapets, stair rails – carved in wood or cast in metal, in styles that owe far more to the *fin de siècle* aesthetic movement Art Nouveau than to the stark lines of modernism.

This duality of vision is both striking and beguiling. The semi-abstract nature of Blossfeldt's work ensures its modernist credentials, although in reality his inspiration is much more rooted in the nineteenth-century German tradition of natural philosophy. Nevertheless, however one chooses to label these images, their popularity has remained constant, ever since the book's first edition. This is one of the few modern photobooks to be bought by art dealers with the intention of breaking it up and selling the individual plates to be framed and hung on a wall.

Albert Renger-Patzsch
Die Welt ist Schön (The World is Beautiful)

One of the best-known titles in photobook history, *Die Welt ist Schön* (The World is Beautiful) was originally going to be called *Die Dinge* (Things). From *Things* to *The World is Beautiful* is quite a leap, and is wholly significant in a photobook, for although the pictures inside might remain the same, a title can position a book differently in one's mind and influence one's whole reading of it. While *Things* would seem to predicate a certain neutrality of stance, *The World is Beautiful* – insisted upon by the publisher for commercial reasons – is a much more culturally loaded title, especially at the end of such an unsettled decade as the 1920s in Germany.

Seen by many as the epitome of the 'straight' photographic ethos because of its apparent stark objectivity, Renger-Patzsch's book can now be regarded as considerably less radical than it seemed to many at the time, whatever its title. Certainly, unless *Die Welt ist Schön* was meant to be ironic – and the book's contents hardly support such a reading – it comes across as somewhat pompous, almost wholly formalist in its aspirations and pointedly ignoring the socio-political aspect of progressive German modernism. Those commentators looking to promote Renger-Patzsch's modernist credentials tend to concentrate on the industrial and natural images – the smokestack, the telegraph poles, the viper, the flower and so on – and conveniently ignore the implications of the book's sequencing, its gradual progression towards God and its sententious ending of church interiors and the final image of hands clasped in prayer like Albrecht Dürer's famous drawing.

The single aspect of New Vision aesthetics that it explores with great thoroughness is the close-up, and therein lies both the book's impact and its limitation. As with Blossfeldt, the close-up allows the viewer to see the world as never before and, in the case of Renger-Patzsch, provides the unifying element for some disparate subject matter. But it also tends to close off readings of the work, except for the purely formal or the vaguely platitudinous. Despite its wide influence on 'straight' photography, this reactionary aspect of the book aroused suspicion even at the time. Franz Roh made a scathing reference to it in *Foto-Auge*, and Alfred Döblin took a swipe at it in the introduction to August Sander's *Antlitz der Zeit* (Face of our Time) when he claimed that Sander's methodology achieved a 'scientific viewpoint above and beyond that of the photographer of detail'.[13]

Albert Renger-Patzsch **Die Welt ist Schön** (The World is Beautiful)
Kurt Wolff Verlag, Munich, 1928
290 × 223 mm (11½ × 8¾ in), 226 pp
Hardback with full blue cloth, jacket, printed bellyband and card slipcase
(not shown)
100 b&w photographs
Introduction by Carl Georg Heise

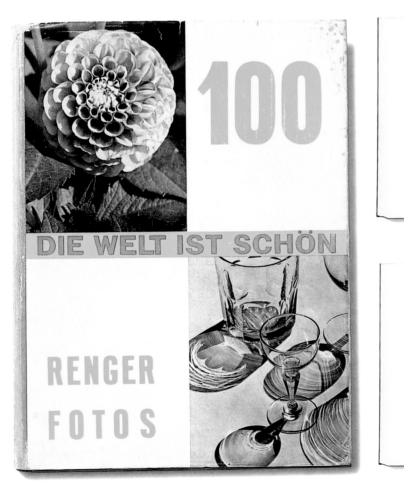

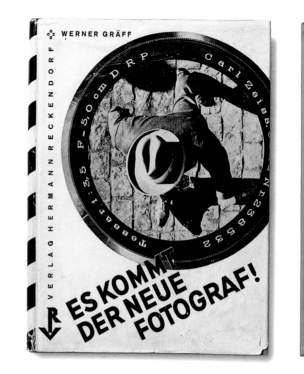

Werner Gräff, ed. **Es kommt der neue Fotograf!**
(Here Comes the New Photographer!)
Verlag Hermann Reckendorf, Berlin, 1929
259 × 196 mm (10¼ × 7¾ in), 128 pp
Hardback with full orange cloth and jacket
c.148 b&w photographs
Foreword by Werner Gräff

Werner Gräff
Es kommt der neue Fotograf!
(Here Comes the New Photographer!)

Franz Roh and Jan Tschichold
Foto-Auge … Oeil et photo … Photo-Eye

If Edward Steichen's publicity machine proclaimed his 1955 extravaganza 'The Family of Man' 'the greatest photographic exhibition of all time', photo-historians given to such contests are more likely to award the palm to 'Film und Foto' (FiFo), organized in Stuttgart in 1929 by the Deutscher Werkbund arts organization. Not since the great international exhibitions of the 1850s and 1860s had there been such a broad display of the photographic arts, intended not just to show photography, but to examine its place in society.

Importantly, the exhibition attracted leading modernist photographers not just from Europe but from the United States (Edward Weston, for instance), and Russia (El Lissitsky and Rodchenko). It included amateur work, commercial and utilitarian photography, and provided an almost indispensable survey of the

New Vision in photography. With László Moholy-Nagy as one of the exhibition's leading organizers, the Bauhaus ethos was very much in evidence. The ideas expressed in his book *Malerei Fotografie Film* (Painting Photography Film) were reflected not just on the walls of the Neuen Ausstellunghallen, but in the pages of the two photobooks published around the show – Werner Gräff's *Es kommt der neue Fotograf!* (Here Comes the New Photographer!) and Franz Roh and Jan Tschichold's *Foto-Auge* (Photo-Eye).

Both books are variations on Moholy-Nagy's seminal polemic, and both adopt similar picture-essay formats to run through the various genres and stylistic features of New Vision photography. Werner Gräff's volume, however, has as much of a practical as a theoretical slant. It can be considered a 'how-to' compendium of the new photography, and is divided into sections, each several pages long, showing either formal strategies like tilting the frame or repeating similar elements, close-ups and so on, or genres such as photograms, montage, advertising and magazine photography.

Foto-Auge, a 'nervous and important book',[14] as Walker Evans characterized it, functions much more

as a catalogue of the 'FiFo' exhibition, reproducing work featured in the show, from Atget to Weston. Franz Roh's introductory essay is a key text, and is printed in German, French and English, reflecting the book's trilingual title. Unfortunately, the English translation from Roh's original German is an appallingly literal one, but the essay sets out the usual New Vision thesis, concentrating on camera vision and the democracy and social usefulness of photography. At one point Roh reveals an interesting rift, or potential rift, of opinion between the more socially minded factions of German modernism and others, when he takes what is clearly a dig at the conservative, formalist approach of photographers like Albert Renger-Patzsch: 'Our book does not only mean to say "the world is beautiful", but also: our world is exciting, cruel and weird. Therefore pictures were included that might shock aesthetes who stand aloof.'

Franz Roh and Jan Tschichold, eds. **Foto-Auge ... Oeil et photo ... Photo-Eye**
Akademischer Verlag, Dr Fritz Wedekind & Co., Stuttgart, 1929
296 × 208 mm (11¾ × 8¼ in), 94 pp
Paperback with red bellyband (not shown)
76 b&w photographs
Introduction by Franz Roh

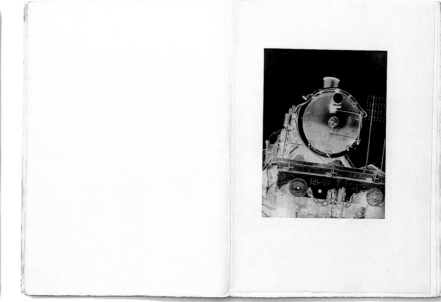

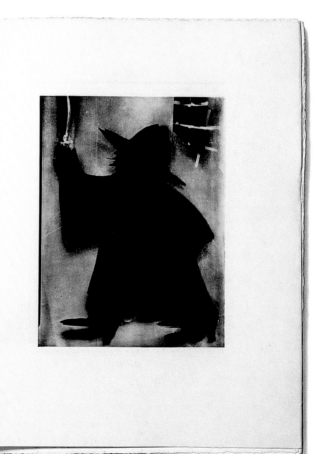

grand papier, et qu'il faisait habiller de reliures splendides par Marius Michel.

C'était, par exemple : *l'Armée Française*, par Jules Richard, édition Boussod-Valadon, grand in-folio, avec des illustrations en noir et en couleurs d'Edouard Detaille. Quand nous avions eu de bonnes notes, il nous les montrait avec toutes sortes de précautions, en fronçant le sourcil et en clappant de la langue avec impatience quand nous approchions nos mains tremblantes de ce formidable ouvrage.

J'admirais la finesse du trait et le fondu photographique des personnages. Un joli travail de couleurs les faisait vivre. Je m'hallucinais, je les voyais tourner, je voyais la fumée des canons s'étirer lentement sur les pages. Un véritable trompe-l'œil, comme dans un panorama. Je conçus à ce moment qu'il pouvait y avoir au monde d'inexplicables merveilles.

❀

Une grande joie pour moi, c'était, les soirs d'été, d'aller sur le balcon, avec deux ou trois camarades, regarder ramper les voitures et les silhouettes fantastiques des passants. Il y avait à ce moment une série de crimes dans Paris. Gamahut, Marchandon, l'assassin de M⁰ᵉ Ballerich. Marie Regnault venait d'être assassinée par Pranzini deux maisons plus haut. Des ombres glissaient sur les murs comme des oiseaux de mauvais augure, grandissantes jusqu'à la menace. Nous pressentions des catastrophes, nous espérions quelque chose de terrible. Parfois, un incendie qui respirait au loin nous en envoyait la sourde promesse. Nous montions souvent, sans être vus, par un petit escalier intérieur, dans un assez grand cabinet qui servait de débarras et qui était rempli de choses bizarres. Là, nous

— 60 —

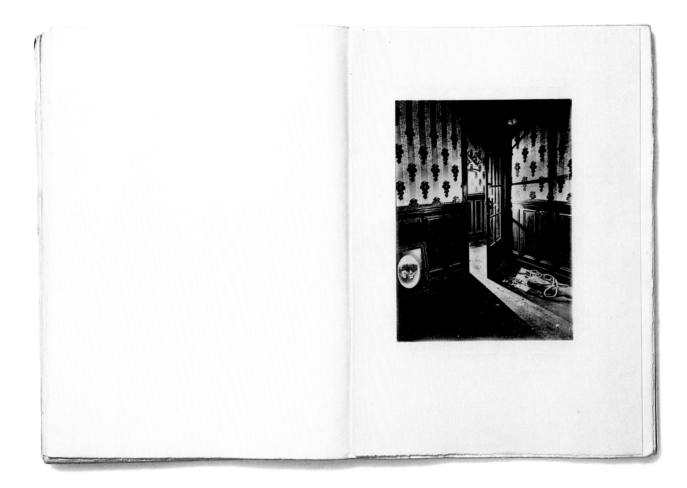

Léon-Paul Fargue and Roger Parry **Banalité** (Banality)
Editions de la Nouvelle Revue Française, Gallimard, Paris, 1930
390 × 285 mm (15¼ × 11¼ in), 84 pp
Paperback
16 b&w photographs
Texts by Léon-Paul Fargue; photographs by Roger Parry; 'compositions' by Fabian Loris

Léon-Paul Fargue and Roger Parry
Banalité (Banality)

Many members of the Surrealist group not only wrote, painted and photographed, but also experimented freely with the book form, including photobooks. Georges Hugnet and Claude Cahun both made photocollages and illustrated books, while Roger Parry, a student of the photographer Maurice Tabard, produced a series of beautiful photographs to illustrate a deluxe edition of Surrealist poems and prose pieces by Léon-Paul Fargue. The original version of *Banalité* (Banality), published in 1928, was not illustrated, but in 1929, intrigued by Fargue's fantastical writing, Parry made 16 photographs based on his imaginings, which were published in an illustrated version of the book in 1930 (there is also a special edition with tipped-in prints).

The *Banalité* images are like a crash course in New Vision photography over 16 lessons. Parry utilizes multiple exposure, photogram (assisted by the artist and actor Fabian Loris), photomontage, solarization, and negative print, employing each technique with such verve and imagination that the potential lack of unity in the suite of photographs is never an issue.

Ironically perhaps, one of the most famous images of the group, which takes us into new and disquieting territories, is a straightforward photograph, although clearly objects have been arranged within it. An inverted nineteenth-century portrait of a couple leans against a wall in a room, which is otherwise empty except for a rolled-up carpet, a piece of rope and a pile of dust and debris. A light shines from an equally deserted corridor through a half-open door. The image pulses with a sinister aspect, like a scene-of-the-crime photograph without the corpse. This unexplained malevolence also appears in another photograph, a still life of a group of glass jars and bottles and a rubber glove. Parry may have begun *Banalité* by investigating the various tropes of modernist/formalism, but along the way, he discovered Surrealism, and made some of its most enduring and intriguing photographs.

E (Emmanuel) Sougez
Regarde! (Look!)

During the 1930s, especially, publishers showed great enterprise in employing photography to illustrate books for children, commissioning some of the finest photographers, and utilizing the medium in both a realistic and a fantastic way. The children's photobook of that era is a serious study in itself, and is largely outside our remit. However, several of the best books published expressly for children have been included in this volume.

The great thing about children's photobooks from this period of high modernism was that publishers gave photographers a freer rein than they might have enjoyed if illustrating adult books, where their audiences had much more rigid expectations of what they wanted to see. Thus prestigious names from both the photographic and art worlds were happy to illustrate books for young readers. Edward Steichen's *The First Picture Book* (1930) is a case in point, a vehicle for Steichen to present some of his best New Vision still lifes. That was a realist book, whereas *Le Cœur de pic* (The Heart of Spades) by Lise Deharme and Claude Cahun (see page 108), is in the fantastic mode.

Unsurprisingly, children were not neglected by the European propaganda industries. There are many examples from Russia, Germany and the other totalitarian countries, where all the prevailing styles of propaganda photography were used, varying from the pseudo-documentary approach to the complex deployment of photomontage.

Emmanuel Sougez's *Regarde!*, as the title suggests, takes the simple approach. Like Steichen's book, or Paul Henning's *Beautiful Things Around You* (1946), it contains simple but effective photographs of everyday things – a shattered window, a rose in a vase, a pigeon, a boiled egg. Precise, elegant and lyrical, these images constitute a model modernist project, being ideal vehicles for showing anyone, not just children, how to look at and appreciate the beauty that is all around us.

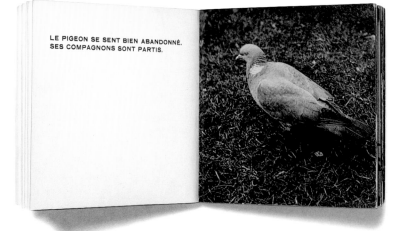

E (Emmanuel) Sougez **Regarde!** (Look!)
Editions H Jonquières, Paris, 1932
169 × 177 mm (6⅝ × 7 in), 52 pp
Hardback with stud binding and grey cloth spine
24 b&w photographs

Jindřich Štyrský
Emilie přichází ke mně ve snu
(Emily Comes to Me in a Dream)

There were three masters of the 1930s Surrealist erotic photomontage or tableau – Hans Bellmer and Georges Hugnet in France, and Jindřich Štyrský in Czechoslovakia. Together with his lover and collaborator, Toyen (Marie Cerminová), Štyrský was one of the most active members of the Czech group of Surrealists, both as an artist and as a polemicist. Primarily a painter, he was also a poet, writer, collagist, typographer and publisher. In the early 1930s he sporadically published a magazine called *Erotiká*, and from 1931 a limited-edition artist's book imprint entitled *Edice 69* (Edition 69), of which the last of six published, *Emilie přichází ke mně ve snu* (Emily Comes to Me in a Dream), is the most renowned.

Emilie was printed in an edition of 69 copies (59 standard, as illustrated here, and 10 deluxe).[15] The prospectus for the imprint coyly stated that such a limited run was necessary to prevent the books from falling into the wrong hands: those who would look at its eroticism with less than the lofty, sophisticated minds for which they were intended. And Štyrský certainly didn't hold back in terms of erotic content. Taking cut-out fragments of hardcore pornographic images (mainly from German and English sources), he juxtaposed them with the macabre (skeletons, coffins, soldiers in gas masks) and incongruous elements (a light bulb, a plant detail taken from Blossfeldt), pasting them on to backgrounds such as starry skies, an underwater landscape, or a derelict building.

The result is a typically Surrealist erotoscape, featuring sex and death. But in contrast to his own gloomy straightforward photographs, and the mock-macabre elements, Štyrský's montages are playful in mood – far from the misogynist obsessions of Hans Bellmer. This sense of play was clearly important to Štyrský. In his introduction to *Emilie*, a diaristic confession, he stresses that the truly erotic, as opposed to the pornographic, is defined by a lightness of touch and mood, and should be both fun and serious: 'The sister of the erotic is the involuntary smile, a sense of the comic, shudder of horror. The sister of pornography, however, is always only shame, a feeling of disgrace and distaste. You will look at some of these strongly erotic photomontages with a smile on your lips, and others with a sense of horror.'[16]

Jindřich Štyrský **Emilie přichází ke mně ve snu** (Emily Comes to Me in a Dream)
Edice 69, Prague, 1933
200 × 130 mm (8 × 5 in), 38 pp
Paperback with jacket
10 tinted photomontages
Texts by Jindřich Štyrský and Bohuslav Brouk

Paul Eluard and Man Ray **Facile**
Editions GLM, Paris 1935
244 × 184 mm (9¹⁄₂ × 7¹⁄₄ in), 28 pp
Paper wrappers
9 b&w photographs
Poems by Paul Eluard; photographs by Man Ray

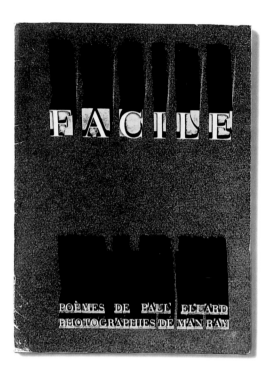

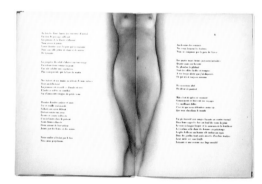

Avoue le ciel n'est pas sérieux
Ce matin n'est qu'un jeu sur ta bouche de joie
Le soleil se prend dans sa toile

Nous conduisons l'eau pure et toute perfection
Vers l'été diluvien
Sur une mer qui a la forme et la couleur de ton corps
Ravie de ses tempêtes qui lui font robe neuve
Capricieuse et chaude
Changeante comme moi

O mes raisons le loir en a plus de dormir
Que moi d'en découvrir de valables à la vie
A moins d'aimer

En passe de devenir caresses
Tes rires et tes gestes règlent mon allure
Poliraient les pavés
Et je ris avec toi et je te crois toute seule

Tout le temps d'une rue qui n'en finit pas.

A LA FIN DE L'ANNÉE, DE JOUR EN JOUR PLUS BAS, IL ENFOUIT SA CHALEUR COMME UNE GRAINE.

1

Nous avançons toujours
Un fleuve plus épais qu'une grasse prairie
Nous vivons d'un seul jet
Nous sommes du bon port

Le bois qui va sur l'eau l'arbre qui file droit
Tout marché de raison bâclé conclu s'oublie
Où nous arrêterons-nous
Notre poids immobile creuse notre chemin

5

Paul Eluard and Man Ray
Facile

The poet Paul Eluard, his wife Nusch and the photographer Man Ray make a perfect *ménage à trois* in this book – an alliance of words, photographs and a *corps exquis*. This small book has come to be regarded as one of the iconic French photobooks of the 1930s by virtue of its inclusion in many exhibitions devoted to the Surrealist movement. Strictly speaking however, it is more Surrealist by association than by style, since Eluard's poems are symbolist in nature.

The rather ugly cover photograph of metal type, spelling out the authors' names, hardly does justice to its contents, but it is the only jarring note. *Facile* is a suite of love poems by Eluard to Nusch, his 'muse', and for him the eternal woman. He evokes the creative power of women – *Tu es la ressemblance* (You are the resemblance) – with constant references to flowers, growth, germination, unfolding. The result, as tends to happen when male writers rhapsodize about the 'eternal woman', is sentimental and distinctly uncorporeal, but in and around the poems drift Man Ray's photographs of a nude Nusch.

If Eluard's flights of French intellectual fancy lack down-to-earth passion, the imagery does not. Though ethereal rather than earthy, his pictures exude an elegant eroticism, especially when printed in photogravure so luscious that one just wants to touch it. Man Ray's pictures of Nusch are appropriately simple, either done in high key tones, often solarized, or mysteriously dark and backlit. It is their integration into the design and text, however, that makes this such a landmark modernist book, and an inspiration to generations of graphic designers. The images float over the text, and intertwine with it, both complementing and grounding Eluard's high-flown sentiments, such as the following, one of the final verses in the suite:

Nue dans l'ombre et nue éblouie
Comme un œil frissonnant d'éclair
Tu te livres à toi-mème
Pour te livrer aux autres

(Nude in the shadows, nude dazzled
Like an eye glistening in the light
You give yourself to yourself
To give yourself to others)[17]

Hans Bellmer
La Poupée (The Doll)

Hans Bellmer
Les Jeux de la poupée (The Games of the Doll)

If the Surrealists were the most sexually obsessed artistic group of the twentieth century, Hans Bellmer was the most sexually obsessed Surrealist. In 1933 he constructed his first *Doll* – an artificial girl/woman whose parts he could position at will: 'I tried to re-arrange the sexual elements of a girl's body like a sort of plastic anagram. I remember describing it thus: the body is like a sentence that invites us to rearrange it, so that its real nature becomes clear through a series of endless anagrams.'[18]

Based on E T A Hoffmann's Olympia, the automated daughter of Dr Coppelius in his famous tale *The Sandman* (1816), the doll became the bizarre impetus for Bellmer's work. It was the basic impulse behind innumerable erotic photographs and drawings, and inspired his photobook magnum opus, *La Poupée* (first published in 1934, in a very limited German edition, *Die Puppe*), which had 10 black-and-white photographs mounted on Normandy vellum and was printed in an edition of 100. In 1949 a more elaborate version, *Les Jeux de la poupée*, with 15 hand-coloured photographs, was published in an edition of 150.

The pathology was complex and perverse, but the art Bellmer derived from his darker impulses accorded fully with Surrealist concepts of eroticism. The Surrealists were concerned with exploring passion, recognizing, even revelling in, the excesses and perversions released by untrammelled desire. Yet at the same time they would intellectualize these primal urges by seeking, as Robert Stuart Short has pointed out, 'enhancing, equivalents, fetishes, and dream symbols'.[19] They entertained an intense fascination with the dissolution of appearances, and with that ultimate dissolution of the self – death, especially violent and criminal death. Le Comte de Lautréamont's famous simile, which was adopted by the Surrealists – 'as beautiful as the chance meeting on a dissection table of a sewing machine and an umbrella'[20] – states their position precisely. Bellmer's *Doll* echoed this; it was an articulated puppet with emphatic pudenda, which could be disassembled and rearranged. Bellmer used it like a visual de Sade, cutting up the body of his girl/woman and reassembling it in the fetishistic image of his own morbid delirium. His programme was dissolution, dismemberment and rearrangement – a familiar if extreme objectification and fragmentation of the female form. It was a chilling poeticizing, no less, of ritual sex murder.

Although such sentiments seem shocking or degrading to most of us, Bellmer's oeuvre nevertheless retains a certain capacity to move – by virtue of its obsessive capacity, its very willingness to confront such gruesome evidence of the human psyche's depths, and possibly the cathartic power of its mediation. It is undoubtedly a major achievement of the pornographic imagination, arguably an honest, authentic, even moral art.

Hans Bellmer **La Poupée** (The Doll)
Editions GLM, Paris, 1936
170 × 128 mm (6¾ × 5 in), 44 pp
Paperback with jacket
10 silver gelatin prints
Introduction by Hans Bellmer

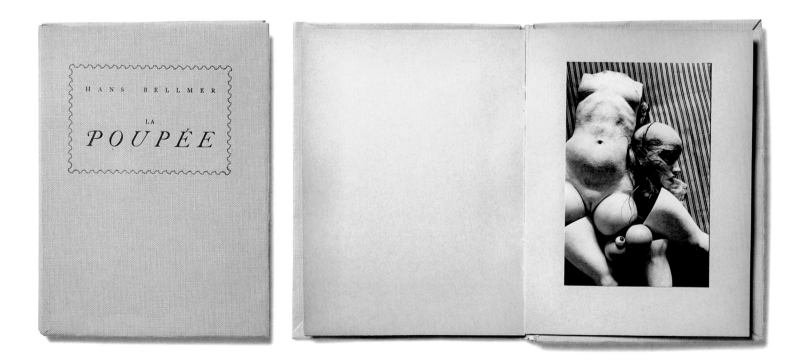

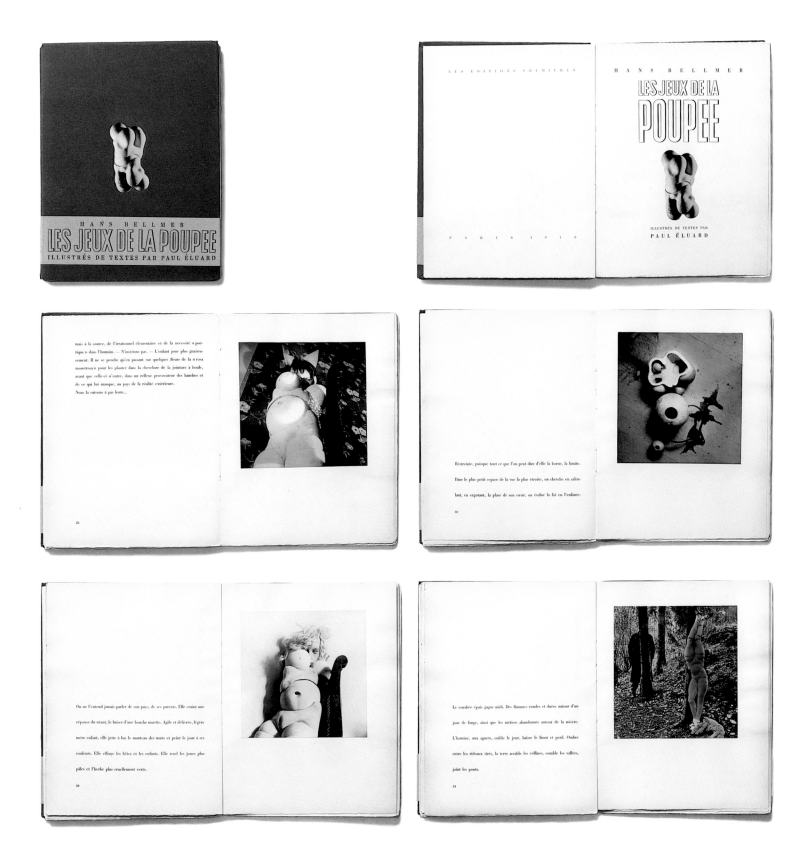

Hans Bellmer **Les Jeux de la poupée: Illustrés de textes par Paul Eluard** (The Games of the Doll: Illustrated with Texts by Paul Eluard)
Les Editions Premières, Paris, 1949
249 × 192 mm (9³⁄₄ × 7¹⁄₂ in), 86 pp
Hardback with jacket and bellyband
15 hand-coloured silver gelatin prints
Texts by Paul Eluard

Lise Deharme
Le Cœur de pic (The Heart of Spades)

Claude Cahun has become celebrated of late for her gender-bending photographic self-portraits, which are seen as a precursor to those by the American contemporary photographer Cindy Sherman. She is also known for her adventures in Jersey during World War II, where she lived with her lover, Suzanne Malherbe. This has tended to detract from other aspects of her work, particularly that she was a respected member of the French Surrealist circle, a maker of photomontages and illustrator of books. Her montages were used to illustrate *Aveux non avenus* of 1930, and *Le Cœur de pic* (The Heart of Spades) of 1937. *Aveux non*

avenus was made in collaboration with Malherbe, and contains several self-portrait montages, but consists mainly of arcane Symbolist text, with the montages playing a secondary role.

Le Cœur de pic is a collection of 33 poems by the writer Lise Deharme. They are described as being for children, but French Surrealist children must be made of sterner stuff than ordinary kids: Deharme's imagery is not just dark in an *Alice in Wonderland* sense, but positively disturbing. The garden/flower imagery adopted is definitely of the *Fleurs du Mal* variety:

Le rose couleur de sang
m'à brûlé les mains en mourant
puis son parfum s'en est allée
dans les eaux du fleuve Lethé

(The blood-coloured rose
has burnt my hands in dying
then its perfume has vanished
in the waters of the River Lethe)

Cahun illustrates these melancholy thoughts with a panoply of Surrealist melancholy objects, usually centred on the double meaning of the book's title – gardens (spades) and card games (hearts, spades). Most of her pictures are tabletop tableaux – a little model gardener amongst giant flowers, or the juxtaposition of incongruous objects like a giant cat and a tower. As in many of the best Surrealist photobooks, the relationship between text and image is crucial, sometimes in close harmony, sometimes in tantalizing opposition.

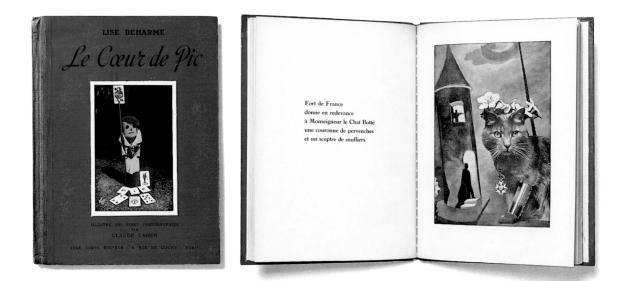

Lise Deharme **Le Cœur de pic** (The Heart of Spades)
Librairie José Corti, Paris, 1937
277 × 216 mm (11 × 8½ in), 56 pp
Hardback with full red cloth and grey cloth spine
20 b&w photographs
Preface by Paul Eluard; poems by Lise Deharme; photographs by Claude Cahun

Man Ray
La Photographie n'est pas l'art
(Photography is Not an Art)

For an artist so active in the photographic medium, and whose photographs are regarded by some as amongst the greatest of the twentieth century, Man Ray demonstrated a surprisingly ambivalent attitude to photography. Were he alive today, it would possibly pain him to learn that he has become far more influential as a photographer than as a painter, or even as a maker of Surrealist objects. The reason for his ambivalence is not

hard to find. He came to Paris in 1921 as an ambitious young artist, but found it easier to make a living through his photographic skills than from his artistic talent. Although he incorporated photography into his Dadaist practice, much of his photographic activity was given over to conventional portrait and fashion commissions. This rankled with him, and 'photography is not an art' was a constant theme in his work.

La Photographie n'est pas l'art is one of the most enigmatic yet advanced of all his books. The images are set off against a typical nonsense 'text' by the founder of Surrealism André Breton. As Herbert

Molderings has noted, the photograph 'becomes an operational element in visual/literary constructions which seek to appeal to our thoughts as well as to our imagination'.[21] Apparently slight, and with nominally little artistic value, the photographs – such as a simple picture of a seahorse labelled *Histoire naturelle* – become art by virtue of their titles and their incorporation within the book's sequence. In this sense they are essentially Duchampian ready-mades, and they have Duchampian puns for titles. For example, a picture of a wooden parapet and its shadow has the caption *Passages entre deux prise de vues*, which can

Georges Hugnet
Guide Rose: Huit jours à trébaumec
(Pink Guide: Eight Days in Trébaumec)

Georges Hugnet, Surrealist poet and obsessive maker of photomontages (many of them erotic), has been a little neglected, but at last there appears to be a revival of interest in his work. He was a prolific book-maker, often facilitating other people's books. *La Sept-ième face du dé* (The Seventh Face of the Die, 1936) and *Huit jours à trébaumec* (Eight Days in Trébaumec) – published in 1969 but using collages dating from many years before, and therefore essentially a modernist book – show him at his best.

Huit jours à trébaumec is a spoof from beginning to end, a surreal, erotic travel tale based on the Michelin Guide. It is not only a guide but ostensibly a journal and photo-album of a trip along the Brittany coast, with many amorous adventures and bad puns along the way. From the village of Lé Fes Plen Doat, we proceed to Trébaumec (a pun on the French phrase, *très beau mec*, a very handsome guy), where our protagonist is welcomed by his hostess, Nina Varin-Lestaque, president of the Club de fureteuses (The Busybody's Club), which seems to be a luxurious brothel. And so the tale, and the erotic frolics, begin.

Beautifully printed in photogravure, Hugnet's photomontages are both complex and witty. True to form,

most of them feature a naked or semi-naked woman somewhere, although one of the most deliciously funny contains a troupe of naked male athletes inhabiting what might be an Atget photograph of Versailles. This volume could be regarded as the last great romp of a 1930s Surrealist, but Hugnet reminds us that the Surrealists took their play seriously. The whole production, by Henri Mercier, is of the highest quality, images and text being printed on Rives BFK paper and laid in loose between the paper wrappers and pink jacket, then housed in a grey linen slipcase. Hugnet also reminds us that the Surrealists knew at least as much as any postmodernist about the artistic effect of appropriation, incorporation and simulation.

Georges Hugnet **Guide Rose: Huit jours à trébaumec** (Pink Guide: Eight Days in Trébaumec)
Henri Mercier, Paris, 1969
390 × 180 mm (15¼ × 7 in), 104 folded pp
Paper wrappers with jacket and grey linen slipcase (not shown)
82 b&w photomontages
Text by Georges Hugnet; design by Henri Mercier

Man Ray **La Photographie n'est pas l'art** (Photography is Not an Art)
Editions GLM, Paris, 1937
252 × 162 mm (10 × 6¼ in), 34 pp, 17 single loose pages
Hardback with full blue cloth and black paper jacket with cut-out window
12 b&w photographs
Text by André Breton

be translated either as 'Passage between two points of view' or 'Passage between two snapshots'.

This remarkable little book, a return to Man Ray's Dada roots, presages the postmodern artist's photobook in terms of its self-reflexive attitude and complex referential twists and turns. It can be taken as a summation of his experiments in photography, and might be said to be his photographic swansong. The year the book was published (1937), he decided to give up photography altogether, and rented a studio in Antibes in order to devote himself to painting.

Gustavo Ortiz Hernán **Chimeneas** (Chimneys)
Editorial Mexico Nuevo, Mexico City, 1937
282 × 216 mm (11 × 8½ in), 242 pp
Hardback with half brown leather and purple silk (deluxe edition)
48 b&w photographs
Novel by Gustavo Ortiz Hernán; photographs by Augustín Jiménez,
Enrique Gutmann and Augustín Victor Casasola

Gustavo Ortiz Hernán
Chimeneas (Chimneys)

During the 1930s in Mexico, Augustín Jiménez was considered to be as important a photographer as Manuel Alvárez Bravo. He was not only wide-ranging in both style and practice – making industrial and advertising as well as editorial New Vision photographs – but he was also photography instructor at the Escuela Nacional de Artes Plásticas, and a noted cinematographer. He worked on the films of Juan Bustillo, Luis Buñuel and Adolfo Best Maugard, including the latter's legendary *La Mancha de sangre* (The Spot of Blood, 1937), banned because of 'sordid' subject-matter, and then lost for many years until fragments were discovered in 1994.[22]

The proletarian underworld of prostitution that Jiménez shot so expressionistically in *La Mancha de sangre* has its echoes in the melodrama of Gustavo Ortiz Hernán. Hernán's novel itself was an example of the so-called *agorista* genre: gritty realist novels much influenced by American writers such as Theodore Dreiser and Upton Sinclair, whose purpose was as much to expose the iniquities committed against the proletariat as to tell a story. Indeed, the photographic illustrations look like those for a documentary report rather than a work of fiction.

It is Jiménez who makes this illustrated version of Hernán's novel *Chimeneas* an important modernist photobook, despite the presence of works by two other photographers. Augustín Victor Casasola's archive

photographs of the revolution are mixed with Enrique Gutmann's social documentary studies before Jiménez raises the stakes with a display of modernist strategies ranging from New Vision formalism to photomontage. His best known picture in the book, *Un hombre que piensa* (A Man who Thinks) is his take on El Lissitsky's famous Constructivist montage *The Constructor*. Depicting a rear view of a shaved head, in which are montaged several mechanical constructions, it makes a clarion call for revolution, both political and artistic.

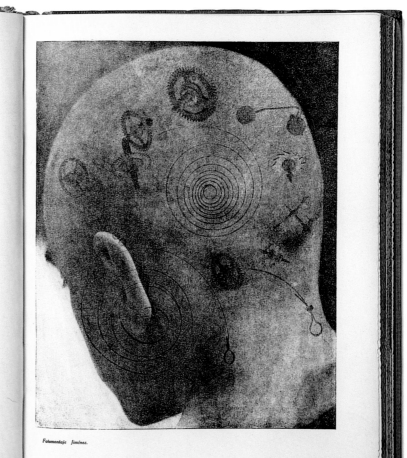

en las tinieblas. Y son estos momentos, en que el cuerpo está en reposo, aún a medía mañana, gracias a la huelga, y en que el cerebro parece desprenderse del cráneo —y crecer—, los únicos en que se logra desgajar de lo impreciso alguna astilla de verdad.

Así, divagando, es como se encuentra Germán Gutiérrez, de 24 años, soltero, lampiño, quien ha podido permanecer en la cama hasta muy entrada la mañana por el asueto que le concedió la huelga en su rutina de tenedor de libros de la Casa A. Cambrón y Cía. (fundada en 1865).

Deben haber tenido mucho cuidado los escritores del periódico —piensa— para redactar la noticia de la huelga:

HUELGA EN LA PERFECCIONADA

El Sr. Aurelio Cambrón, gerente de la fábrica, hace declaraciones

deben haber tenido cuidado, porque si no podían haber hecho el mismo juego de palabras que recrea a los obreros. Con la simple supresión de la "m" en el apellido de don Aurelio...

Y Germán, en su monólogo, después de leer el encabezado del diario, siente tristeza y está a punto de embarcarse en un pensamiento hondo y largo. La vida. ¿Qué la vida es comer hoy y mañana, y sentirse hostigado por el patrón, y cuando mucho ser "un joven con aspiraciones"? Pequeños deberes, goces mínimos, penas

26

Fotomontaje Jiménez.

Un hombre que piensa.

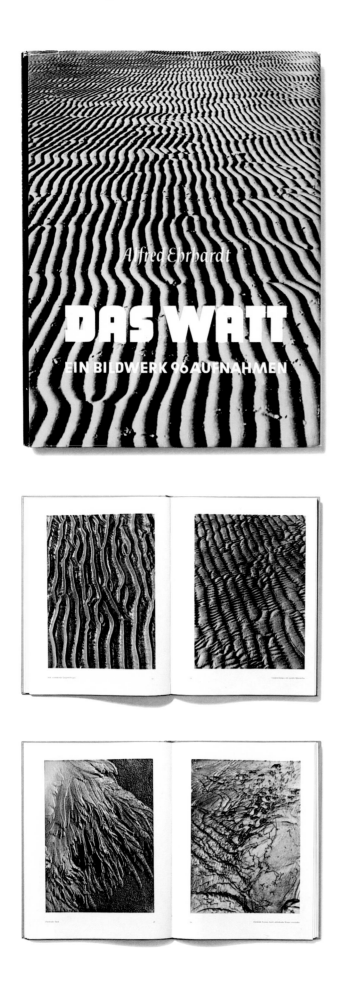

Alfred Ehrhardt **Das Watt** (Mudflats)
Verlag Heinrich Ellermann, Hamburg, 1937
289 × 221 mm (11¼ × 8¾ in), 112 pp
Hardback with full grey cloth and jacket
96 b&w photographs
Introduction by Dr Kurt Dingelstadt

Alfred Ehrhardt
Das Watt (Mudflats)

The modernist New Vision style was characterized by a tendency to find subjects both in the city and in nature that made good abstract or semi-abstract photographs. One of the most fruitful modernist subjects was the seaside. Sand, sea and rocks lent themselves particularly well to the abstraction treatment, and a number of notable books were made in this vein, such as Arvid Gutschow's *See – Sand – Sonne* (Sea – Sand – Sun) of 1930. These popular books might also be seen as related to the German outdoor health ethic, as expressed in naturism and the cult of exposing one's body to the elements.

The best of this genre is arguably Alfred Ehrhardt's *Das Watt* (Mudflats). The date of publication is significant, since it contradicts the widely held belief that New Vision modernism all but disappeared after the Nazis came to power in 1933, subsumed into the propaganda machine in the form of journalistic photography or modernism in the documentary mode. While it is true that the New Vision ethic peaked just after the 'Film und Foto' exhibition of 1929, it was not proscribed by the Nazis like other aspects of modern art. Of course, a good number of Germany's best photographers were Jewish, and many wisely left the country, so modernist work of this quality tended to be much rarer during the Nazi era.

Ehrhardt's photographs of a commonplace subject – mudflats after the tide has receded – are simple, striking and carefully crafted. Although this kind of thing had often been done before, Ehrhardt does it particularly well. He chooses the low sun of morning or evening, shooting either directly into the light or with strong sidelighting to make the most of the ripple effects left by the departing tide. The sheen produced by the sun raking across the wet mud heightens the modelling effect. This is both an attractively designed and finely printed book – an island of tranquil beauty in a cultural sea that was becoming increasingly barbaric.

Kiyoshi Koishi
Shoka Shinkei (Early Summer Nerves)

Yoshio Shimozato
Mesemu Zoku (Genus Mesemb)

Photography in Japan during the 1930s was highly institutionalized; the Japanese predilection for organizing into groups or clubs was extremely evident, and there were numerous societies promoting pictorialist photography, which was the dominant mode in Japanese photography at that time. However, for every tendency there is a reaction, and European modernism was beginning to be championed by the more progressive photographers, who formed their own clubs in vehement opposition to the pictorialist groups.

The two books here emanate from these avant-garde photographic clubs, and exhibit the primary influences on the movement: German New Vision photography and French Surrealism. László Moholy-Nagy's *Malerei Fotografie Film* was serialized in Japanese magazines, while the work of Man Ray was also widely published, and these became the two dominant models for Japanese modernists.

Kiyoshi Koishi's *Shoka Shinkei* (Early Summer Nerves) demonstrates both of these influences, especially the first. Koishi exhibited the work, a suite of 10 photographs, at the Naniwa Photography Club in Osaka in 1932, and the club published it as a book a year later. To say that the work is 'New Vision meets Surrealism' is perhaps to diminish its impact. It is an accurate description, but Koishi adds his own voice to the genre by giving it a typically Japanese inflection. The book also adheres to traditional Japanese standards of exquisite presentation, and is particularly noteworthy for its striking cover, made of zinc.

Yoshio Shimozato was a member of another modernist group (Shinzokei Bijutsu – The New Plastic Arts Association), based in Nagoya. He was also a painter, and was strongly influenced by Surrealism. In 1940, together with other members of this active society, he self-published a book of photographs of the cactus mesembryantheum, which he cultivated himself. Again, the resulting images show the twin influences of modernist abstraction and Surrealism, with the eroticism of Surrealism to the fore – an aspect that particularly appealed to Japanese photographers.

Kiyoshi Koishi **Shoka Shinkei** (Early Summer Nerves)
Naniwa Photography Club, Osaka, 1933
368 × 285 mm (14¹₂ × 11¹₄ in), 50 pp
Spiral bound with zinc cover
10 b&w photographs
Text by Kiyoshi Koishi

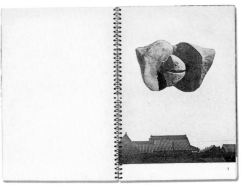

Yoshio Shimozato **Mesemu Zoku: Chogenjitsushugi Sashin-shu**
(Genus Mesemb: Surrealist Photography Collection)
Yoshio Shimozato, Nagoya, 1940
183 × 128 mm (7¹₄ × 5 in), 48 pp
Spiral bound with card cover
Text by Yoshio Shimozato; photographs by Yoshio Shimozato,
Minoru Sakata, Yasuhei Sato, Taizo Inagaki, Tsugio Tajima and
Hideo Sano

Walker Evans
American Photographs

American Photographs holds a well-deserved place at the top of the pantheon, and should be studied assiduously by any photographer attempting the tricky business of compiling a coherent photobook. It is a complex, elliptical, hugely ambitious work, exemplifying all the qualities that Evans demanded from serious photography. However, it must be said that it is also a flawed book, its ambition perhaps finally outstripping its achievement, particularly in its second section, which is less fully realized than the first.

The 'catalogue' to the first one-man show ever given to a photographer at the Museum of Modern Art, New York, *American Photographs* states its theme from the outset. Its initial sequence begins with an image of a photographer's shop, and includes a window display of penny snapshot photographs and a torn movie poster. Thus it declares itself not just a book about the world, but about photography – how photography represents the world, and the tales that photographs can be made to tell.

It constitutes a document of 1930s America so persuasive that John Szarkowski has remarked: 'It is difficult to know now with certainty whether Walker Evans recorded the America of his youth, or invented it.'[23] Image after image combines complex form with complex content. The pictures are full of bitter irony and poignancy, piling up metaphors about the gap between intention and reality, about sight, about violence and poverty, about restricted lives behind mean facades, about the indomitable hope of those little people who attempt to fashion, however crudely, their own piece of the American Dream. How deftly Evans employs photography's propensity for 'picking up searing little spots of realism and underlining them, quietly, proportionately'.[24] How well he takes his cue from film and literature to give the book a clear but fluid narrative structure, a sense that it must be 'read' as well as looked at.

In the second section the momentum that had been built up so well possibly flags a little, as the book settles down to being merely an inventory of things. Nevertheless, in his cogent and wide-ranging essay (not the least of the book's virtues), Lincoln Kirstein seems merely prescient and bold rather than outrageous when he thunders: 'What poet has said as much? What painter has shown as much? Only newspapers, the writers of popular music, the technicians of advertising and radio have, in their blind energy

Walker Evans **American Photographs**
The Museum of Modern Art, New York, 1938
225 × 200 mm (9 × 8 in), 196 pp
Hardback with full black cloth, jacket and yellow bellyband (not shown)
87 b&w photographs
Essay by Lincoln Kirstein

accidentally, fortuitously, evoked for future historians such a powerful monument to our moment. And Evans's work has, in addition, intention, logic, continuity, climax, sense and perfection.'

Kirstein was wrong about that last virtue, perfection, for one of the fascinating things about *American Photographs* is its provisional nature, its sense of a 'book in the making' rather than a perfectly finished product. In this, however, it only reflects the nature of photography itself, with all its paradoxes and infuriating loose ends. *American Photographs* remains a great work of art, for it showed us all – including the photographer himself – just what might be accomplished by the photobook.

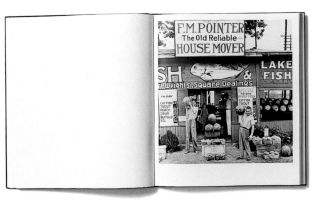

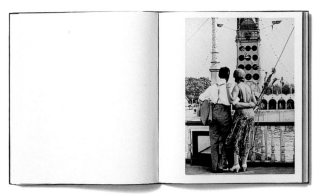

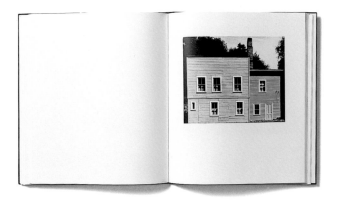

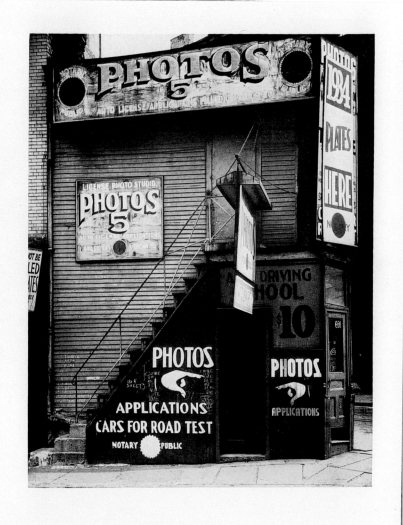

A Day in the Life
The Documentary Photobook in the 1930s

Documentary photography as it evolved in the 1930s had ardent advocates and detractors. There was little agreement about the practice, purposes and values of photographic documentation, but all sides acknowledged that the distinguishing feature of documentary photography was its use of natural materials and 'straight' technique. Photographic documents isolated and defined actuality; they possessed a quality of authenticity that led to their use as evidence. But while facts were acknowledged as the basic component of documentation, the information conveyed by photographic facts could be sharply altered, even totally transformed by the sequence and manner of its presentation. Anne Wilkes Tucker[1]

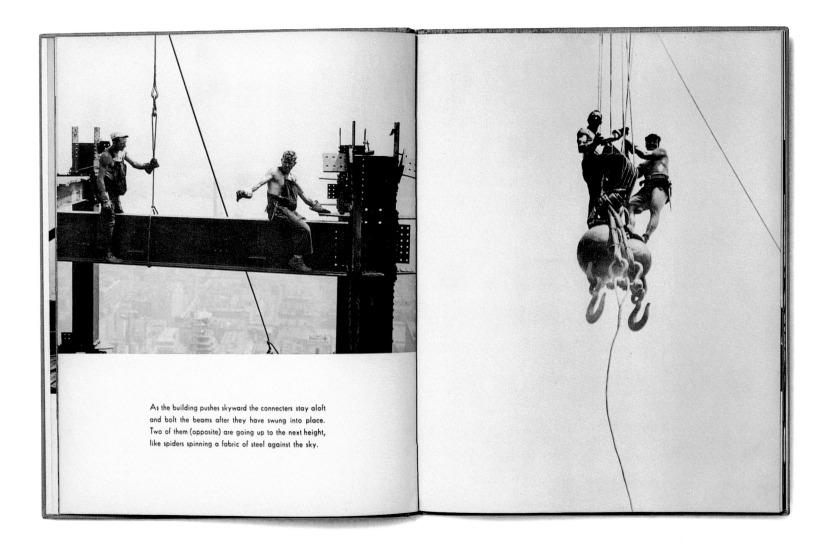

As the building pushes skyward the connecters stay aloft and bolt the beams after they have swung into place. Two of them (opposite) are going up to the next height, like spiders spinning a fabric of steel against the sky.

Lewis W Hine
Men at Work: Photographic Studies of Modern Men and Machines
The Macmillan Company, New York, 1932

Hine's major and best-loved photobook is in the typical 'heroic worker' mode of the 1930s documentary photographer. It celebrates the dignity of labour and that most 'modern' industrial subject – the American skyscraper.

In one form or another, the documentary mode remains the photobook's dominant genre. As Anne Wilkes Tucker states, it is difficult to find two commentators who will agree on an unequivocal definition of the term. Next to that old chestnut as to whether or not photography is an art, probably the most enduring argument in photography criticism is, what is 'documentary'?

The complexity of this debate, and the fact that there are no clear-cut answers, may be gauged by the fact that Walker Evans, the most cannily articulate of photographers, was always careful not to talk about 'documentary' photography, but 'photography in the documentary mode', or 'documentary style'. Although he began photographing in an era when to call oneself a documentary photographer was to proclaim an ethos, or even an ideology, Evans was well aware that a photographer's primary reason for making documentary pictures could range from a radical desire to change society to a psychological need to grasp that slippery entity we call reality. The documentary style was used for every purpose from propaganda to education to artistic expression. However, in the tumultuous 1930s, there *was* what could be described as a 'documentary movement' in the strict sense, especially in the United States. But it was by no means as homogeneous as some commentators would have us believe, and the books discussed in this chapter embrace a wide range of approaches whilst still falling within a generally documentary rubric.

The modernist revolution in photography during the 1920s and 1930s produced two primary modes of progressive photographic expression. Firstly, many photographers advocated a painterly,

neo-pictorialist tendency to legitimize the medium. Disdaining the camera's stark tendency to record everything in front of it without discrimination, they set about improving upon it. Photographs were cut, cropped, painted upon, montaged together into new images, chemically enhanced. Indeed, every technique imaginable was used to forge a new, expressive language and foil the camera's apparently dumb, inexpressive take on the world. Secondly, there was the purist reaction to that: a conviction that it was necessary, even a sacred duty, to use the camera in a rigorous, 'straight', manner, tampering with nothing and making an unvarnished, truthful record of life. Some of those who espoused the second tendency tried to claim the moral high ground for it, insisting that 'straight' photography was not simply a technique, or a style, but an ethic. 'Straight' meant righteous thinking as well as straightforward technique – true to the medium, true to the subject. But documentary photographs are always only an idea of the truth, not unmitigated fact.

Credit for the term 'documentary' is usually given to the Scottish film-maker and writer John Grierson, who used it in 1926 to describe Robert Flaherty's film, *Moana*. He was a highly influential figure in the 1930s documentary movement, on both sides of the Atlantic, not only a practitioner but a manager and polemicist, organizing film units for both the British and Canadian governments. His work exemplifies much of the large-scale, 'official' documentary projects of the 1930s.

The utopian, pedagogical thrust of much modernism, which was pressed into the service of state propaganda in the totalitarian countries, took a slightly different form in the democracies, although the differences were not perhaps as great as might be expected. Much state-aided documentary was sponsored by those who shared in the concept of state control, either from the left, or from liberal-conservatives like Grierson. Interestingly, Grierson had a similar doctrinaire Calvinist background to another Scot who made a massive impact on the dissemination of information in the English-speaking world – John Reith, the first Director General of the BBC. Indeed, the term 'Reithian' has come to mean the kind of benevolent paternalism practised by the BBC throughout the British Empire, an attitude paralleled in many respects by the New Deal administration in America. The films, radio programmes, books, journals and informational philosophies initiated by Grierson and Reith, and their American counterparts such as Rexford Tugwell, Roy Stryker and others charged with 'selling' the New Deal, were intended to rescue society from itself. If less extreme, the determinism displayed by the documentary movement in the democratic states – whether on the left or the right – certainly had close affinities with the propaganda ministries of the Soviet and Nazi regimes. Just as in Russia or Germany, the documentary movement, despite protestations to the contrary, was neither neutral nor objective.

As Grierson himself defined it, documentary was the 'selective dramatization of facts in terms of their human consequences', and further, a means of educating 'our generation in the nature of the modern world and its implications in citizenship'.[2] Richard Griffiths, an American documentarist of more leftist opinions, went even further. Documentary, he wrote, was 'primarily not a fact-finding instrument, but a means of communicating conclusions about facts'.[3] Facts were not so much discovered as preordained. Thus, whether or not it was termed 'information' or 'education' rather than 'propaganda', the avowed aim of the documentary film, photograph, or written report was to persuade, to sell an idea. In the totalitarian states the idea was a singular one, brooking no opposition – to show how well the governing dictatorships were doing. In the democracies, with freedom of speech an imperative, it was to show how well or how badly society's institutions were faring. Nevertheless, even here, too much negative emphasis, or the merest whiff of revolution, were not condoned, even from those charged by a government's documentary programme to find out the 'facts'. Such programmes might have been reformist, but they were not supposed to be revolutionary.

In this regard it should be noted that, such is the ambiguous nature of the photograph, the same pictures – perhaps reordered or with alternative captions – could be used to support either reform, revolution, or the unaltered maintenance of the status quo. And again, paradoxically, such is the veristic power of the photograph that it, not the written word, was deemed the great persuader. As with all photography, however, context was everything, and a particularly effective context was the picture/text

format of the documentary photographic essay, where – in conjunction with judicious sequencing of the images – forewords, afterwords or captions could be used to ensure that the reader's understanding, his or her 'reading' of the photographs, was the right one. Because the form had more than a passing relationship to the propaganda photobooks of the totalitarian states, most documentary books published in the democracies exhibited the same close collaboration between photograph and text as that adopted by propaganda books. Indeed, in the documentary photobook of the 1930s we perhaps see a closer relationship between image and text than at any other time during the photobook's history.

The sheer visual elan of the Soviet method, such as its virtuoso way with typography and graphics, was highly influential, though its influence on the West was filtered through Germany. German innovations in advertising and magazine photography probably had the greater direct impact, but since they had been so influenced by the Soviet example, the Russian model was widely disseminated throughout Europe and the United States, especially by photographers with a left-wing viewpoint. Margaret Bourke-White, one of America's most successful editorial photographers, actually visited Russia, the first foreign photographer to be given access to Soviet industrial sites. She was heavily influenced by the Russian proclivity to dramatize facts in a New Vision manner, an attitude that found a more ready acceptance in commercial and magazine photography, and in photojournalism, than in the more rigorous echelons of the state-sponsored documentary movement.

There has been a tendency to discuss documentary photography and photojournalism as if they were two vastly different entities. This trend developed during the late 1960s and 70s, when photography began to gain wide acceptance by the museum. Photojournalism was seen by many – including photographers ambitious for artistic status – as 'commercial', while documentary was not. Thus a hierarchical value system developed – the residues of which are still with us – in which 'art' documentary was rated above photojournalism, which was rated above newspaper photography.

This was palpably not the case in the 1930s, except in the eyes of a few diehard salon amateurs or an unashamed elitist like Alfred Stieglitz. Most photographers of a realist persuasion – or any other for that matter – would happily work for the picture magazines, which were proliferating and changing the face of documentary photography. In the United States, Henry Luce's *Life* (founded in 1936), and its competitor *Look* (1937), reached huge audiences, the editors of *Life* boasting in 1939 that it was 'the greatest success in publishing history'.[4] Of course, the magazine achieved this success by being positivist and patriotically upbeat, a determined antidote to the more critical and radical documentary. This naturally drew the disapprobation of the more serious and committed photographer. 'Here,' trumpeted *Life*, 'set down for all time, you may look at the average American in 1936 as he really is', and 'take stock of some of the things which are magnificently *right* about America'.[5]

Paris, as so often in modern photography, was to prove an important centre, not only for documentary photography, but for the documentary photobook. Domiciled a few doors down the street from Man Ray was an elderly French documentary photographer called Eugène Atget. The chance proximity of the two was to have an immense effect on the medium's future. Atget had no pretensions to recognition as an artist, but Man Ray found an unconscious surreal quality in his haunting pictures of Parisian streets and parks. Berenice Abbott, Man Ray's pupil, saw in them the epitome of the straight modernist documentary style. Following his death in 1927, Abbott bought half of Atget's archive of prints and negatives, and began to foster the Frenchman's posthumous reputation – so successfully in the long run that the blue plaque outside his former home at 13 bis rue Campagne Première now hails him as 'the father of modern photography'.

Atget's work – selected by Abbott – was included in 'Photo-Eye', and in 1930 she arranged for a book of his photographs, with an introduction by the writer Pierre MacOrlan, to be published in France, the United States and Germany. After a first flush of enthusiasm, Atget's reputation subsided for many years, but that initial flurry of interest, and especially the book, ensured that he influenced those who mattered most – those who themselves became influential photographers, including Walker Evans, Bill Brandt and Henri Cartier-Bresson. *Atget: photographe de paris* (Atget: Photographer of Paris) can therefore be accounted an extremely important photobook.

The Atget book came out just prior to another, very different view of Paris, by Moï Ver (Moshé Raviv-Vorobeichic). The Lithuanian photographer had studied at the Bauhaus, and went to Paris to study film. His *Paris* (1931) was inspired both by Bauhaus photography and cinema-montage techniques, and is a breathtaking compendium of odd angles, multiple exposures, sandwiched negatives and fractured spaces that are very different from the calm, contemplative, personalized world of Atget. A quartet of significant Parisian books appeared in a three-year period, the third being the photobook debut of the Russian writer Ilya Ehrenburg, *Moi Parizh* (My Paris), published in 1933, and the fourth being Brassaï's *Paris de nuit* (Paris by Night) of 1933. The Brassaï book has become one of the best-known 1930s photobooks, and has tended to overshadow the other three, though these are finally beginning to gain the reputations they deserve.

Ehrenburg's candid street portraits, shot with a Leica, reflect some of the themes of Atget, but in their use of the small camera they look forward to such figures as Henri Cartier-Bresson. Atget's posthumous photobook had demonstrated large-format view-camera documentary in the finest traditional manner. Ehrenburg covered some of the same ground as Atget, but with a Leica it resulted in a very different vision of the city. He was evidently proud of this new-fangled machine, for both the El Lissitsky-designed jacket and a frontispiece show the Russian photographer positively strutting with this fine piece of German engineering, which contributed much to the dynamism of early 1930s German photography – just before the Nazis persecuted the avant garde and closed down so many possibilities.

The new smaller cameras played an important role in the success of the picture magazines, giving the documentary photographer a much more ready access to his subject, whether the everyday moments in life, or the big events. It took photographers into areas that, while not impossible, were much more difficult for larger cameras. As the centre of illustrated magazine culture shifted inevitably from Germany to Paris in the 1930s, a new generation of photographers working out of that city – most notably André Kertész and Henri Cartier-Bresson – developed a small-camera street-photography vocabulary that pervaded journalistic documentary photography. This would prevail until the general advent of colour – and even then, that represented a change of material rather than a change of mode.

The standard 'day-in-the-life' type of picture essay developed by the illustrated magazines is rightly denigrated by commentators for its sentimental and often patronizing simplicity, yet at its best it was an integral part of the 1930s documentary tradition. One of the key 1930s photobooks, Brassaï's *Paris de nuit*, is rooted in this tradition. It is an extended magazine picture story rather than a social documentary project, stemming from motives of popular journalistic enquiry rather than from serious socio-political analysis, but none the worse for that. The same could be said of Weegee's *Naked City* (1945), which results from an even more disreputable kind of journalism: the sensationalist tabloid newspaper.

Walker Evans once wrote that the photographer 'is in effect voyeur by nature; he is also reporter, tinker, spy',[6] and this dubious combination of personality traits characterizes the general tone of many magazine-derived photobooks. Evans might have added flâneur (from his favourite writer Baudelaire) to his list of qualities. The more commercial documentary photographers – and documentary *was* 'commercial' in the 1930s – certainly had more than a touch of the flâneur about them. Ehrenburg, for example, poked his politically sharp nose into down-and-out Paris, and the city's café life. The young Evans himself wandered New York, looking up (or down) in a vertiginous New Vision manner, taking night jobs so that he could wander the sidewalks by day, while Brassaï did exactly the opposite, sleeping by day and prowling the city by night.

Brassaï and Weegee were essentially spies – voyeurs – delving into the lives of socially transgressive elements in society – night people and criminals – with all the sensationalism of dime thriller novels. So too was Bill Brandt in his own quiet way. Operating in England, he was acutely aware of class, and both his great documentary books of the 1930s (*The English at Home*, 1936, and *A Night in London*, 1938) utilize the vast contrasts between the rich and poor as much as the heavy, Expressionist contrast he put into his prints, a legacy most probably of his German background and his grounding in Surrealism. Like many photographers, he was not averse to constructing his truths. He employed

members of his own family to 'act' in certain of his photographs, a fact that for some might deny their validity as documents. The books are nevertheless classics of their kind, revealing more overtly than others that documentary is a construct like any other photographic genre.

Another photographic spy was Dr Erich Salomon, who like Brandt, but unlike the majority of documentary photographers, observed his own class. The Erminox, an extremely fast medium-format camera, enabled him to work unobtrusively indoors in available light. His book, *Berühmte Zeitgenossen in unbewachten Augenblicken* (Famous Contemporaries in Unguarded Moments, 1931) is a fascinating glimpse behind the scenes at political conferences, a rare published document of the mores of the upper rather than the lower orders, and a book that is seen as the epitome of the 'candid camera'.

Lincoln Kirstein fulminated against this type of approach to documentary. 'The candid technique has little candour. It sensationalizes movement, distorts gesture, and caricatures emotion. Its only inherent characteristic is the accidental shock that obliterates the essential nature of the event it pretends to discover', he wrote in his afterword to Evans's *American Photographs*.[7] He was undoubtedly correct about the technique in the wrong hands, but even as he wrote those words, his friend and protégé Evans was already beginning to stalk subway passengers in New York, a Contax camera hidden beneath his overcoat. For many, Evans's large-format urban landscapes, interiors and formally posed sharecropper portraits largely defined the 1930s documentary aesthetic, but the spontaneity – and the transgressive quality – of the candid approach had always attracted him as much as the studied monumentality of the large camera. He was impressed by the spontaneous informality of Ben Shahn, whom he taught photography, and replicated that approach in his own small-camera work. The conceptual, existential tenor of the subway imagery, and another series made on a Chicago street corner, was quietly influential, and would look forward to a mode of documentary photography that would emerge after World War II.

The most extensive Western documentary enterprise of the 1930s was government-initiated, one of the many cultural projects generated by Franklin D Roosevelt's New Deal programme with a dual aim in mind – to inform and to educate, and to keep America's artists working. If, as previously indicated, the post Great War tendency for the United States to look inwards was something of a negative force with regard to American modernism – hindering the acceptance of European innovation for a decade or more – there was another side to the coin. The same navel-gazing worked as a positive force in the development of American documentary photography. Following the Wall Street Crash, the United States was in trouble, and would buckle down and haul itself out by its own efforts. That made an excellent subject for any photographer worth his or her salt. The New Deal, and especially the WPA – the Works Project Administration – completed the process of America awakening to itself that was begun after World War I, seen in the intense cultural debates that sought to define the essence of American art and culture. Absolutely central to that process was the documentary impulse – manifest not only in photography and photobooks, but on radio and the silver screen, in newspapers, magazines, painting, theatre, music and literature.

By the time the European New Vision was seen widely in America, its avant-garde credo of interdisciplinary formal experiment was already passé. It was also rendered irrelevant, not only by innate American suspicion of the European avant garde, but also by the socio-economic climate, which demanded that artists give their society's plight serious attention in the form of documentary realism. As Maria Morris Hambourg has written:

> *Avant-garde European tendencies had arrived in some strength only after the Crash, at a time when many American photographers had already distilled a realistic style. Thus European photographic strategies had no time to develop, and those not easily translatable into the American idiom were rejected as alien mannerisms.*[8]

The best-known of the documentary photography projects in 1930s America is of course the prosaically named photographic unit of the Farm Security Administration – or FSA. It has come to epitomize documentary photography. This is not only because some of the best and most ambitious photographers worked for it, including Walker Evans, Dorothea Lange, Ben Shahn and Russell Lee, or because they produced some of the most iconic images of the decade – Lange's *Migrant Mother*

(1936) for instance. It is also because the images were in the public domain and, for a small fee, could be used freely by the publishing media in almost any context. The FSA photographers made photobooks of their own, but importantly, the archive of the unit provided the illustrations for a wide range of publications, in both the conservative and liberal press.[9]

The native models for the American documentary photobook were twofold. Firstly, Jacob A Riis's *How the Other Half Lives* (1890) had been a great influence on that crusading breed who were beginning to form themselves into new professions like sociology and social work. Secondly, the 'social photographer' Lewis W Hine, a fine example of this breed, was still active in the 1930s, although his reputation wasn't as great as it would become in the 1940s, following his death. He became the guiding spirit of the New York Photo League, a radical documentary group that had developed from the earlier Workers' Camera Club of New York, itself an organization inspired by the workers' camera clubs in Germany and elsewhere. The radical work that endeared the liberal progressive Hine to Photo League members had been made in the early years of the century for reformist organizations like the National Child Labor Committee, and published in magazines like *Survey* and sociological reports such as the *Pittsburgh Survey* (1909–14). In these publications Hine had not only exposed the iniquities of under-age labour, but had used means of presentation as broad as any Russian Constructivist to get his message across – photomontage, gatefolds, accordion folds, pamphlets and postcards – 'every permutation of the picture-text marriage', noted historian Daile Kaplan.[10]

His major work from the late 1920s and 1930s was less radical in both form and content, and exemplified, like much documentary from the Depression decade, the contradictions of the documentary notion – the dichotomy between form and content, between intention and effect, objectivity and subjectivity, even between photographs and text. As one of his most distinguished successors, Robert Adams has pointed out, Hine's vocation was complicated: 'He wanted to show, he said, both what was bad so we would oppose it, and what was good so we would value it.'[11] Such a credo suggests fair-mindedness, concern for the truth, a lack of partisanship.

One man's fair-mindedness is another's prejudice, however. Objectivity to one side of the political spectrum is propaganda to another. For example Hine's major photobook of the 1930s, his *Men at Work* (1932), was an example of appreciative acquiescence rather than reforming zeal. It was a celebration of the American worker, and included a number of images from his renowned series on the construction of the Empire State Building, one of capitalism's last hurrahs before the Depression began to bite. *Men at Work* was a determinedly American version of German New Vision paeans to industry, such as E O Hoppé's *Deutsche Arbeit* (German Industry, 1930) or Renger-Patzsch's *Eisen und Stahl* (Iron and Steel, 1931). This modernist positivism, extolling the best of America, not unnaturally makes the *Men at Work* pictures the most loved of Hine's work, but as Alan Trachtenberg has argued, their contradictions are manifest.[12] Whilst rightly celebrating the dignity of labour, such books could easily be company reports for the industrialists and property speculators who employed these men as cheaply as they could, and who probably opposed their unionization. Without extensive textual analysis, formalist documentary runs the risk of giving us little except platitudes. As Bertolt Brecht pointed out,[13] a photograph of the Krupp factory exterior (or the construction of the Empire State Building) – no matter how formally adroit – tells us nothing of the complex socio-political forces that brought it into being.

Such issues mattered to many making documentary photobooks or books in the documentary mode during the troubled 1930s. Thus the most renowned examples of the genre in 1930s America tend to be marriages of text and photographs. But those who might think that the image/text strategy avoids the pitfalls should reconsider. Both the rhetoric of the text and the rhetoric of the photographs must be considered part of a delicate, almost impossible balance. Most masterpieces of the 1930s documentary photobook tend to wear their contradictions on their sleeves.

This is certainly the case with the most commercially successful of American documentary photobooks, *You Have Seen Their Faces*, published in 1937. The book's rhetoric tends to be mercilessly over-emphatic. Its authors, Erskine Caldwell and Margaret Bourke-White, were both radical and

commercially astute – a contradiction, certainly, but hardly an uncommon one. Following her Russian visit Bourke-White demonstrated that she had absorbed the lessons of Rodchenko and the magazine *USSR in Construction* (see Chapter 6) in her book *Eye on Russia* (1931) and work for *Fortune* and *Life* magazines. She was a flamboyant, naturally commercial photographer, and when photographing Southern tenant farmers for her collaboration with her husband Caldwell, she naturally utilized the heightened Soviet style that she had employed for her advertising and industrial photography. Caldwell couldn't resist the role of 'creative' writer, and used a degree of poetic licence in 'reporting' the thoughts and opinions of his subjects, a tactic that drew much critical flak for its lack of documentary integrity, despite the success of *You Have Seen Their Faces* in the bookshops. It was even criticized in another well-regarded classic of 1930s documentary, the Walker Evans/James Agee collaboration *Let us now Praise Famous Men* (1941), a fascinating record of a *Fortune* assignment that expanded into much more. Agee evidently disapproved of Bourke-White's 'champagne socialist' persona, but he disapproved of many things, including anyone who suggested that his purple prose might have benefited from a little editing. Thus what might have been the best documentary report of the New Deal era seems fatally flawed by an over-long self-aggrandizing text. The book's admirable intention, an equitable and creative marriage between photographs and text, and a properly complex view of the exigencies of the sharecropper's existence, is mired by Agee's over-indulgence and lack of critical distance.

Another classic writer-photographer collaboration, *An American Exodus* (1939), a record of the westward migration of farmers from the Oklahoma dustbowl by Paul Schuster Taylor and Dorothea Lange, also came in for criticism. No less a luminary in the world of documentary photography and film-making than Paul Strand ruminated in the Photo League's magazine *Photo Notes* on the tricky marriage of words and photographs, and found Lange and Taylor wanting. His verdict was that 'many of the photographs do little more than illustrate the text. Or vice versa, the text at times simply parallels the information given by the photograph. Thus there is a tendency towards negation rather than active interaction between word and image.'[14] He called for more photographs possessing 'that concentration of expressiveness that makes the difference between a good record and a much deeper penetration of reality'.[15]

Strand's mixture of documentary intent and fine-art practice contained its own contradictions, and it would seem that he projected these on the Lange–Taylor book without trying to understand their position. Strand criticized Lange for not including her most expressive images – the iconic *Migrant Mother* for example – whereas the duo had deliberately excluded it in order to maintain a sober, even-handed tone in the work. Lange's photographs in *An American Exodus* are the antithesis of Bourke-White's. Taylor, unlike Agee, scrupulously kept his text as dry as possible, knowing full well that his subject was emotive enough in itself. Both Lange and Taylor were concerned, in their concept of good documentary practice, neither to sensationalize, aestheticize nor patronize. Their determination to be as objective as possible, and more importantly, to carry that objectivity into the presentation of the material, makes *An American Exodus* arguably the best of the many photobooks dealing with the Depression.

On her darkroom door Lange tacked a quotation from the sixteenth-century English statesman and essayist, Francis Bacon: 'The contemplation of things as they are/without substitution or imposture/without error or confusion/is in itself a nobler thing/than a whole harvest of invention.' This could hardly be improved upon as a photographic credo, but the problem with photography is that the elusive goal – reality – is achieved as often in the breach as in the observance. It the end, perhaps the finest documentary photobooks were made by those photographers who were not quite so committed to the documentary cause, who were more aware of photography's contradictions, and who actively used those contradictions, without fighting or ignoring them. Foremost among them were August Sander, Walker Evans and Bill Brandt, who utilized the medium's ambiguities as well as its certainties, and demonstrated that the documentary photobook was a complex, subtle, yet passionate art, and not just a bald manifesto.

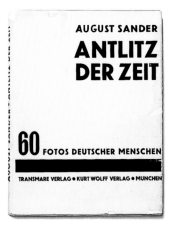

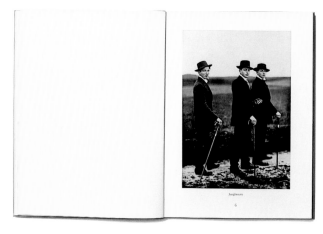

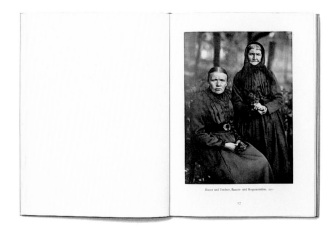

August Sander **Antlitz der Zeit: 60 Fotos Deutscher Menschen**
(Face of Our Time: 60 Photographs of Germans)
Transmare Verlag and Kurt Wolff Verlag, Munich, 1929
291 × 221 mm (11½ × 8¾ in), 140 pp
Hardback with full yellow cloth, jacket and slipcase (not shown)
60 b&w photographs
Introduction by Alfred Döblin

August Sander
Antlitz der Zeit
(Face of Our Time)

August Sander's great project, *Man in the Twentieth Century*, a portrait study of the German people, was only exceeded in size by Edward S Curtis's American Indian study of 1929. But whereas the Curtis enterprise was essentially nineteenth-century in concept, a positivist, somewhat sentimental exercise in a neo-colonialist genre, Sander's magnum opus (whatever its roots in the dubious nineteenth-century 'science' of physiognomy) was thoroughly of the twentieth century – sceptical, objective, lucid.

Antlitz der Zeit (Face of Our Time) was an interim report on the way to the ultimate multi-volume publication that Sander proposed,[16] a mere 60 pictures out of hundreds. But many of his classic images are included in this seminal photobook, and the essential qualities of Sander's vision can be seen. He took typical examples of professions, trades and social classes in Weimar Germany, and photographed them in their familiar environments in order to build up, piece by piece, a dispassionate image of the 'face' of society. As Alfred Döblin wrote in the book's introduction: 'Just as one can only achieve an understanding of nature or of the history of the physical organs by studying comparative anatomy, so this photographer has practised a kind of comparative photography and achieved a scientific viewpoint above and beyond that of the photographer of detail. We are free to interpret his photographs any way we wish, and taken as a whole, they provide superb material for the cultural, class and economic history of the last 30 years.'

The scientific and pedagogical import of Sander's work is perhaps open to question, and Döblin's claim may be a little overstated. Furthermore, Franz W Seivert, a critic more to the left than Sander, wrote: 'These are people only inasmuch as they personify economic categories as bearers of certain class relationships and interests.'[17] Theorists from Walter Benjamin onwards have queried the kind of 'knowledge' imparted by photography. Sander's artistic achievement, however, is never in doubt. One of his work's miracles is how, despite his nominal objectivity, his political view shines through. If anyone disproves Benjamin, it is Sander. Note, for example, the acidity of his view of young farmers on their way to market shown here, or the evident compassion in his image of widows. His work is not neutral. It is not just penetrating, but was seen as positively dangerous, a little too acute in its analysis of society and class, by those with certain vested interests. This is made clear by the fact that when the Nazis came to power in Germany in 1933, publisher's copies of *Antlitz der Zeit* were seized, the plates destroyed, and the negatives confiscated by Hitler's Ministry of Culture.

E O (Emile Otto) Hoppé
Deutsche Arbeit (German Industry)

Albert Renger-Patzsch
Eisen und Stahl (Iron and Steel)

Deutsche Arbeit (German Industry) and *Eisen und Stahl* (Iron and Steel) emanate from the period in German photography when the modernist approach was at its height, and the German economy and industry were in a desperate situation prior to the fall of the Weimar government and the triumph of the Nazis. But following Hitler's election as Chancellor in 1933, modernism would enter an era of decline, and German industry would make a dramatic recovery.

Emile Otto Hoppé, a banker turned photographer, illustrated one of the books in Ernst Wasmuth's well-known *Orbis Terrarum* series. *Deutsche Arbeit* is not an *Orbis Terrarum* book, but shares a similar design, the sepia-toned plates of Hoppé's photographs being immediately distinctive. The book is a curious blend of the modernist and the conservative. Hoppé's images of the primary German industries – power, iron and steel, shipbuilding and aircraft construction – are more conventional than the likes of say Germaine Krull. Generally Hoppé is straightforward, espousing a pictorialist-documentary mode with few of the dizzy angles of the New Vision, although he does indulge in them from time to time, albeit tentatively.

However, *Deutsche Arbeit* bursts into full, flamboyant modernist mode in the shape of its jacket – not once, but twice, for this is one of the few photobooks to feature a reversible jacket. On one side is one of Hoppé's more dynamic photographs, a close-up of a ship's propeller, while the other side features a striking graphic design of belching factory chimneys.

Albert Renger-Patzsch's *Eisen und Stahl* – another attempt to persuade a sceptical public that all was well with the German economy – is almost as conservative, although Renger-Patzsch has a few more New Vision tricks up his sleeve in these pictures of the iron and steel industry. As usual he shows himself a master of the dynamic close-up, as he did in *Die Welt ist Schön* three years previously, but both books, like many documentary publications of the 1930s, skirt between the informative and the propagandist without being entirely convincing in either capacity.

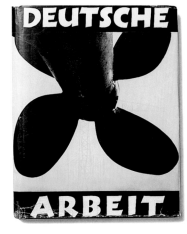
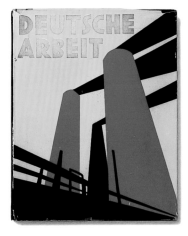

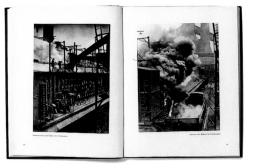

E O (Emile Otto) Hoppé **Deutsche Arbeit** (German Industry)
Verlag Ullstein, Berlin, 1930
275 × 220 mm (10¾ × 8¾ in), 128 pp
Hardback with black paper, grey cloth spine
and reversible jacket
92 sepia photographs
Foreword by Bruno H Bürgel

Albert Renger-Patzsch **Eisen und Stahl** (Iron and Steel)
Verlag Hermann Reckendorf, Berlin, 1931
302 × 218 mm (12 × 8½ in), 96 pp
Hardback with silver/orange paper, blue cloth spine,
and jacket
97 b&w photographs
Introduction by Dr Albert Vögler

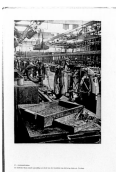

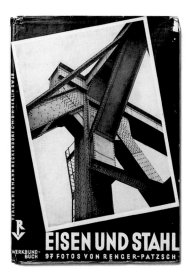

Lewis W Hine
Men at Work

'We call this the Machine Age. But the more machines we use the more do we need real men to make and direct them.' Hine's brief introduction to this book published for adolescents by the Macmillan Company reaffirms his commitment to the working man. It is in the typical 'heroic worker' mode of the 1930s, seen at its apotheosis in the Soviet Union, but also in the work of Hoppé and Renger-Patzsch in Germany, or Vladimír Hippmann in Czechoslovakia. Hine obliges his audience with the usual images of machine shops, blast furnaces, boiler makers and sheet-metal workers, but he had access to a subject that the

others didn't: the most 'modern' industrial subject of all – the building of an American skyscraper.

On the title page Hine opens boldly with an image of an intrepid workman seemingly suspended in space, on a steel cable high above New York City, and throughout the book it is those pictures taken during the construction of the Empire State Building in 1930–1 that inevitably draw the reader's attention. For readers of the day, the Empire State had an almost talismanic significance. It was not only the world's highest building and a potent symbol of the modern age, but its very construction epitomized capitalist derring-do in commencing its construction so soon after the Wall Street Crash of 1929. From the proletarian side it demonstrated the heroism of the working man, whom

Hine was celebrating, in the person of those daring artisans who toiled so nonchalantly at such dizzying heights with minimal safety precautions.

The inherent political contradictions in these pictures have already been discussed, but there is no doubt that he believed in the heroism of these men, and photographed them accordingly, though without any undue exaggeration in the matter of camera angle or lighting. Indeed, it is Hine's matter-of-factness that makes these images so empathetic and believable, thereby unfortunately heightening rather than diminishing the contradictions – while at the same time producing some memorable photographs.

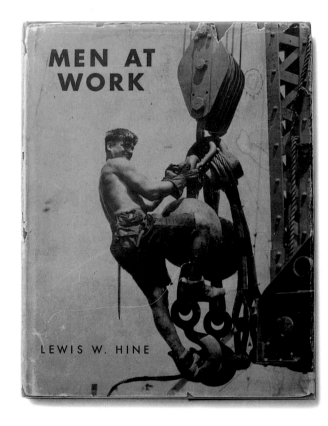

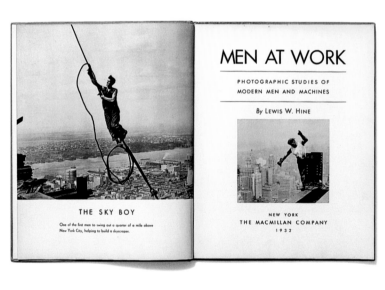

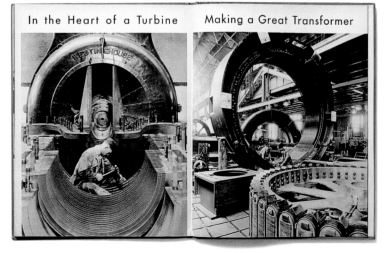

Lewis W Hine **Men at Work: Photographic Studies of Modern Men and Machines**
The Macmillan Company, New York, 1932
259 × 207 mm (10¹₂ × 8 in), 48 pp
Hardback with full green cloth and jacket
51 b&w photographs
Introduction by Lewis W Hine

Berenice Abbott
Atget: photographe de paris
(Atget: Photographer of Paris)

This book of Eugène Atget's work, published three years after his death, presents a certain problem. Chosen by Berenice Abbott and Henri Jonquières from the former's collection of his work, the selection gives a partial and quite particular view of his photographic practice: a modernist, aestheticized interpretation. But if the editors had known more about Atget's commercial practice, the details of his career and his personal philosophies, they would have acknowledged that any selection of around 100 works from an oeuvre approaching 8,500 images, even if chosen by the photographer himself, would tell only a small part of the story.

Whether or not, as some commentators have asserted, Atget is being distorted here, and a journeyman documentary photographer has been miscast as a modernist, one thing is quite clear: the selection was made with the best of intentions, out of respect for the old man's work, and it shows precisely how it spoke to a younger generation of photographers. By that criterion it is an excellent selection, containing many wonderful pictures and giving exquisite visual pleasure – the most striking images from more than thirty years spent documenting the streets, buildings, parks and gardens of Old Paris. No matter how one might try to rationalize, to demystify, contextualize and deconstruct Atget's pictures and professional practice, there is an extra dimension to this work, described as follows by Max Kozloff: 'The viewer of these images falls prey to a loveliness unbounded by any consideration of trade. Going through this archive more carefully, one can be enveloped in reserves of poignancy, for which the extensively modest function of the imagery and the mechanistic aspects of its coverage do not prepare.'[18]

The book's view of Atget, amplified over the years by Abbott in numerous exhibitions, in the French and German editions of this book, and in her later publication, *The World of Atget*,[19] dominated for many years, but even as our knowledge and understanding of the photographer's life and work grows, we still look to these pictures for the essence of Atget. Ultimately, however, his own aims and intentions remain as ineffable as ever. In a contemporary review of the book, the young Walker Evans expressed a clear idea of what Atget at least meant to photographers and documentary/modernist practice: 'His general note is lyrical understanding of the street, trained observation of it, special feeling for patina, eye for revealing detail, over all of which is thrown a poetry which is not "the poetry of the street" or "the poetry of Paris" but the projection of Atget's person.'[20]

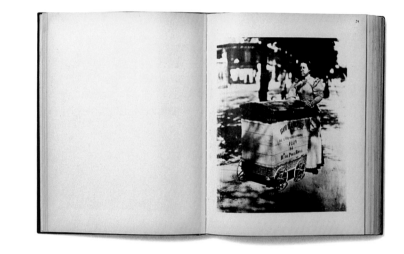

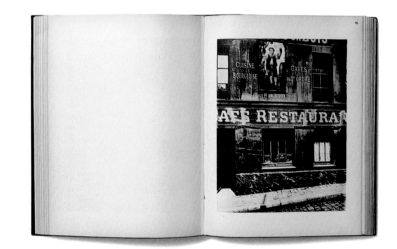

Berenice Abbott, ed. **Atget: photographe de paris** (Atget: Photographer of Paris)
E Weyhe, New York, 1930
272 × 212 mm (10¾ × 8½ in), 222 pp
Hardback with full burgundy cloth, cardboard slipcase (not shown) and fold-out printed list of picture titles taped to inside rear cover
96 b&w photographs
Edited with Henri Jonquières; preface by Pierre MacOrlan; photographs by Eugène Atget

Moï Ver (Moshé Raviv-Vorobeichic)
Paris

The Paris of Eugène Atget was essentially a Paris of the past. Even when he photographed aspects of contemporary life, it was as if they were about to disappear. The Paris seen in Moï Ver's astonishing book, published only a year after Atget's monograph (see page 127), is unequivocally the Paris of the here and now, or of the future.

Walter Benjamin once wrote of the 'infernal stillness' in Atget's work. He could not have said the same of Moï Ver's. The Lithuanian's Paris is all motion, a city of fractured spaces and activity. There is little or no time to rest and contemplate in this dynamic city. It is not a Paris of historical buildings and grand parks, but of factories, crowds and automobiles, of flappers and neon lights. Moï Ver achieves these effects by utilizing all the formal strategies of Bauhaus New Vision photography – partly through blur, grain and acute angles, but chiefly by sandwiching images together in a highly cinematic way, like one shot dissolving into another. He had come to Paris, after all, to study cinema. He also utilizes cinematic montage techniques in the book's design – cutting, repeating and piling up images, sometimes printing them upside down. The result is a hectic, chaotic, energized city, the antithesis of Atget's, and even when Moï Ver picks up on similar themes – shop windows, signs, mannequins – he treats them very differently. Indeed, it was an approach that would not reappear until the 1950s and 60s, with William Klein, Ed van der Elsken, Daido Moriyama, and other 'stream-of-consciousness' photographers, whose work was influenced by the Beat writers, hand-held camera movie-making and improvized performance art.

One image perhaps sums up the difference between old and new, between Atget's pre-World War I Paris and Moï Ver's futurist Paris, looking ahead possibly to post-World War II consumerism. A combination image shows a man pulling a hand-cart – representing one of Atget's *Petits métiers* (Small Trades) – with a group of motor vehicles superimposed over and around him, crowding him out, the automobile putting the pedestrian in his place, the modern brutally thrusting aside the antique.

Not the least amazing thing about this book is that, taken individually, Moï Ver's images are not all that memorable, indeed most are frankly quite banal. Yet photobooks are about synthesis and sequence, and that is where Moï Ver has triumphed, with a fresh and startling photobook masterpiece.

Moï Ver (Moshé Raviv-Vorobeichic) **Paris**
Editions Jeanne Walter, Paris, 1931
292 × 224 mm (11½ × 8¾ in), 82 pp
Paperback with jacket and glassine outer jacket
78 pages of primarily combination photographs
Introduction by Fernand Léger

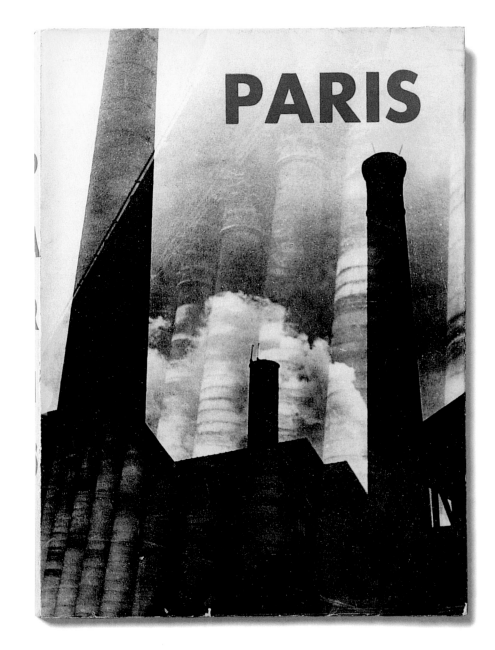

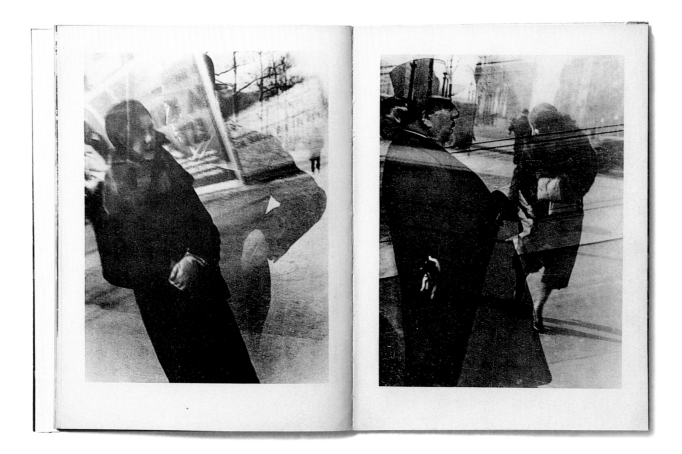

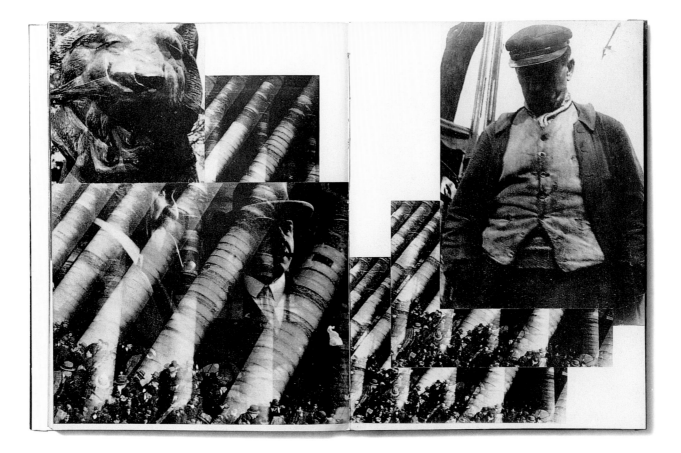

M Vorobeichic (Moï Ver)

Ein Ghetto im Osten (Wilna)

(A Ghetto in the East (Vilnius))

In the same year that his *Paris* was published, Moï Ver – under his real name of Moshé Vorobeichic – produced *Ein Ghetto im Osten* (A Ghetto in the East). The book, with both Hebrew and German text, featured his photographic record of the Jewish ghetto in the Lithuanian capital of Vilnius, documenting a way of life that would soon disappear under terrible circumstances. Even more so than *Paris*, *Ein Ghetto im Osten* was ostensibly a documentary book, but as he had done in his view of the French city, Moï Ver could not resist pushing the envelope of the documentary form.

Once again, he used a variety of New Vision strategies, the most obvious being to take many images from upstairs windows looking on to the narrow streets of Vilnius's old Jewish quarter. This created odd angles and a dynamic *mise en scène* for his pictures of people going about their everyday business on the street, dramatizing commonplace activities such as market shopping and conversing with neighbours. Everyday European scenes were exoticized, and Vilnius was turned into an Eastern bazaar, an unfortunate if unintentional connotation in view of the far right's accusations of the foreignness of Jews.

But Moï Ver did not stop there. He also introduced cinematic cutting and montaging techniques to heighten the interest. He combined elements of imagery, sometimes by double-printing negatives, sometimes by repeating identical or similar pictures, sometimes by pasting different photographs together, often with self-conscious free-form edges. Strangely, all this modernist-formalist tinkering does not detract from the book's documentary value. In general it is an emotionally distanced and respectful view, very different, for instance, from Roman Vishniac's much more engaged view of prewar ghettos. Nevertheless, Moï Ver remains a singular figure in photobook history, and this little volume, while not as radical as *Paris*, is a laudable attempt to make something interesting from a fairly routine assignment. A poignancy has been added in hindsight: it was made at the beginning of a desperately traumatic time for European Jewry.

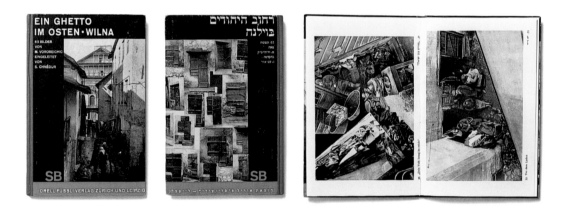

M Vorobeichic (Moï Ver) **Ein Ghetto im Osten (Wilna)** (A Ghetto in the East (Vilnius))
Orell Füssli Verlag, Zurich and Leipzig, 1931
187 × 125 mm (7½ × 5 in), 80 pp
Hardback with German and Hebrew covers
65 b&w photographs
Introduction by S Chneour

Helmar Lerski

Köpfe des Alltags: unbekannte Menschen

(Everyday Heads: Unknown People)

Born of Polish descent in Zurich in 1871, Helmar Lerski (Israel Schmuklerski) was, like Moï Ver, involved in film-making, and was a singular figure in photographic and photobook history. He was a stills photographer, special-effects director and cameraman on a number of masterpieces of German Expressionist film in the 1920s, such as Paul Leni's *Waxworks* (1924), and Fritz Lang's *Metropolis* (1927). Seeing which way the wind was blowing in Germany, he moved to Palestine in 1931, and went on to direct one of the most significant landmarks in Zionist cinema, *Avodah* (Work) of 1935, a documentary about Jewish settlers in Palestine.

His filmography of the 1920s explains a great deal about his photographic approach, which was close to August Sander's in its concentration on types, but diametrically opposed to it in terms of technique and documentary intent. His work consisted mainly of portraits, but whereas Sander was careful to photograph his subjects in their social settings, Lerski used the studio, and focused entirely on the head, effectively de-socializing them. Using studio lights and a system of mirrors, he lit them in an intensely dramatic, hyperbolic way that reflects the Expressionist lighting of the films on which he worked, especially the psychological thrillers and horror films. The effect is striking to say the least. His sitters' faces look as if they are under water, or glistening with cosmetics.

And yet despite this, the book does have a tenuous social dimension. Lerski's sitters are unknown – 'everyman' – identified only in a pseudo-Sander fashion as 'street sweeper', 'beggar', or 'washerwoman'. Many were hired from employment agencies, and were therefore seeking work, a widespread state of affairs in the last days of the Weimar Republic. The back cover of the book is designed like a newspaper page featuring the 'wanted ads', emphasizing the link with modern labour practices. Twentieth-century man is seen as an anonymous but heroic individual within a collective society that, whether capitalist or socialist, both feeds on the individual and feeds him through the complex processes of work.

In his introduction to the book Curt Glaser states Lerski's intentions: 'The modern photographer, like the painter, realizes that a true portrait must express his own opinion of the sitter's nature.' And that is the difference between Lerski and Sander; Lerski was clearly determined to impose his truths on his sitters, whereas Sander was content to draw out the nature of his. Their respective books demonstrate the difference between the subjective and objective approaches.

Dr Erich Salomon
Berühmte Zeitgenossen in unbewachten Augenblicken
(Famous Contemporaries in Unguarded Moments)

During the 1920s, prior to the Nazi takeover of Germany, Dr Erich Salomon was one of the best-known photographers in Europe. He was almost as famous as many of the celebrities he caught with his Erminox camera and its ultra-fast lens, which boasted an f-stop of 0.9. Renowned as the 'father of the candid camera', Salomon was a photographic spy with a difference. Rather than following the normal practice of the middle-class photographer capturing the lower orders unawares, Salomon generally confined his efforts to his own class, which was not even middle class, but the ruling class. As an ex-lawyer from a German-Jewish banking family, Salomon (and his Erminox) boasted a ready entrée to the most rarefied social circles. He had access to the movers and shakers in European politics, finance, industry and the arts, because that was his milieu. He moved in those circles by right, and despite his somewhat outré profession – which would otherwise have disqualified him – he was trusted.

Berühmte Zeitgenossen (Famous Contemporaries) is Salomon's autobiography in words and pictures, but unlike Robert Frank's *The Lines of My Hand* (1972) (see page 261) and others of that ilk, it qualifies as a documentary book, on two counts. Firstly, he was wholly dispassionate as a photographer; secondly, he documented a particular world from the 'inside', to which no other photographers had gained intimate access.

Salomon's stamping grounds were the places where the deals were done that affected the peace and stability of a shaky Europe following World War I – the international conferences, the parliamentary assemblies. But he also pioneered photography in places that frowned upon it, such as courtrooms and opera houses. His style was simple and unfussy. He was not a formal master, but since nine-tenths of the photographer's job is to put himself where the photograph can be taken, he can be forgiven for his tendency to compose a little clumsily. He shows us much that is normally hidden about the process of politics: the process of making history. It was Salomon, for instance, who proved what we could all have guessed: that much of the political deal-cutting that affects our lives is considerably aided by a full stomach, a glass of cognac and a fat cigar.

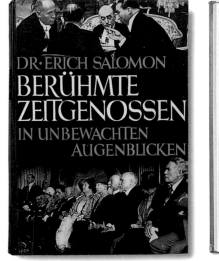

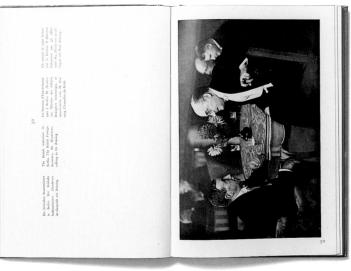

Dr Erich Salomon **Berühmte Zeitgenossen in unbewachten Augenblicken**
(Famous Contemporaries in Unguarded Moments)
J Engelhorns Nachf, Stuttgart, 1931
250 × 178 mm (9³⁄₄ × 7 in), 252 pp
Hardback with full blue cloth and jacket
112 b&w photographs
Text by Dr Erich Salomon

Helmar Lerski **Köpfe des Alltags: unbekannte Menschen**
(Everyday Heads: Unknown People)
Verlag Hermann Reckendorf, Berlin, 1931
292 × 230 mm (11³⁄₄ × 9 in), 176 pp
Hardback with full black cloth and jacket
80 b&w photographs
Introduction by Curt Glaser

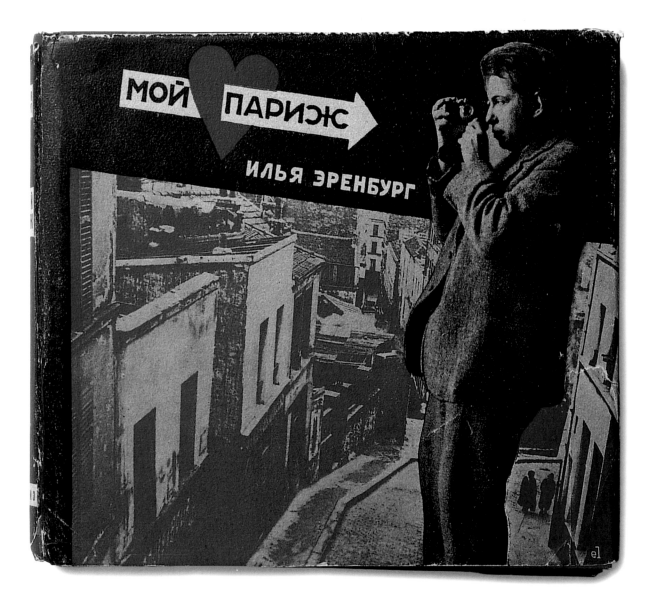

Ilya Ehrenburg
Moi Parizh (My Paris)

The Russian writer, journalist and revolutionary propagandist, Ilya Ehrenburg, was also an accomplished photographer, as the presence of two photobooks by him in this volume suggests. *Moi Parizh* (My Paris) is a significant addition to the photographic bibliography of this most photographed of cities, made by a man who lived there for many years. It constitutes a highly dispassionate look at a city that usually provokes at least a degree of romantic sentiment from visitors and residents alike.

Moi Parizh was published two or three years after Moï Ver's *Paris* and Abbott's book on the work of Atget

and, while it owes little to the former, certain parallels with the latter are striking. Ehrenburg echoes almost exactly, for example, a row of shop mannequins, fairground horses and candid portraits of road repairers and a carter. The whole book, which consists in the main of street candids, shot with a Leica (itself the proud subject of two images), is reminiscent of Atget's early 'Small Trades' series, a project it is assumed the Frenchman abandoned because of the limitations of making street portraits with a cumbersome view camera.

With 35 mm Ehrenburg has no such problems, and extends his range of subjects to include all kinds of Parisian street-users, especially the proletariat, thereby contradicting the widely held view of Paris as the

bourgeois city par excellence. Besides small traders and workmen, there are sequences showing concierges, drunks on benches, urchins, passing pedestrians and the homeless, with the bourgeoisie largely absent. Ehrenburg also contributes a dry social commentary on his pictures, which have the liveliness and sometimes the gaucherie of similar early street images by Walker Evans or Ben Shahn. In all of this remarkable book we are allowed only the merest glimpse of a tourist hotspot. Instead, Ehrenburg contributes a frank, unsparing view of the Parisian proletariat, of which the socialist dissident Atget himself would surely have approved.

Ilya Ehrenburg **Moi Parizh** (My Paris)
IZOGIZ, Moscow, 1933
162 × 188 mm (6½ × 7½ in), 238 pp
Hardback with blue paper and jacket
121 b&w photographs and 2 b&w photomontages
Text by Ilya Ehrenburg; design by El Lissitsky

Paul Morand **Paris de nuit** (Paris by Night)
Editions Arts et Métiers Graphiques, Paris, 1933
250 × 193 mm (10 × 7½ in), 74 pp
Spiral bound with card cover
60 b&w photographs
Introduction by Paul Morand; photographs by Brassaï

Paul Morand
Paris de nuit (Paris by Night)

Brassaï's nocturnal vision of Paris is so well known, and his book *Paris de nuit* (Paris by Night) has been so influential – the first in a long line of noctambulations by photographers – that someone coming to the volume for the first time may entertain preconceptions that are not matched by the original. For example, much of the work seen in a later manifestation of his nocturnal work, *The Secret Paris of the Thirties* (1976) – his images of prostitutes, brothels, gangsters and homosexual clubs, pictures that have become synonymous with his name – are conspicuous by their absence. Some of this more edgy work was published in 1932 in a book entitled *Voluptés de paris* (Pleasures of Paris), but contractual disagreements meant that Brassaï never acknowledged it.[21] *Paris de nuit*, the book

that actually made his reputation, is relatively chaste by comparison, since it contains the images that were deemed publicly palatable. Indeed, compared with the three other important photobook views of Paris published around the same time, by Abbott in 1930 (see page 127), Moï Ver in 1931 (see page 128) and Ilya Ehrenburg in 1933 (see page 132), Brassaï's vision as displayed in this book seems more conventional, at least in the formal sense. He was, however, breaking ground by wandering round at night, and emphasizing the nocturnal city's otherworldly glamour, even if he could not show its seediness as fully as he might have liked.

Paris de nuit is also a ravishing book object in a purely physical sense. The printing represents arguably the most luscious gravure ever seen, the blacks being so rich and deep that after handling the book one expects to find sooty deposits all over one's fingers. The gradation of tones is wonderfully subtle,

describing an apparently infinite range of black and near-black tones. The layout, with its characteristic full-page bleeds, never more felicitously employed, takes us from image to image, from page to page, and across night-time Paris, with effortless panache.

Instead of seeing *Paris de nuit* as a great 'might have been', therefore, one should think of it as amongst the best produced and influential photobooks ever. It demonstrates that the urban flâneur was a crucial figure in 1930s documentary photography, perhaps as important as the social reformer. The book took a definitive step into new territories, which would be colonized by the likes of Weegee, Bill Brandt and others, and not least by Brassaï himself, when his 'secret' night work from Paris would eventually be widely published.

Julia Peterkin and Doris Ulmann
Roll, Jordan, Roll

This is one of the most singular documentary photo-books of the 1930s, also brought out in a deluxe edition (not shown). In many ways it is a throwback to the bad old days, the ultimate example of a photographer and writer dropping in on their economically disadvantaged fellow human beings and coming up with a thoroughly sententious, patronizing and dubious documentary study. By comparison with Julia Peterkin and Doris Ulmann, both Edward S Curtis and Arnold Genthe approached their great white hunting trips with tact and sobriety. And yet if one looks beyond the personalities of the two authors, beyond Ulmann's rather dated (even for the 1930s) pictorial style, her portraits have an integrity and power that make one wish they did not come in such a package. If ever there was a lesson about the context in which photographs are viewed, this is it. However, Ulmann acquiesced to the context, and presumably approved of the sentiments expressed in Julia Peterkin's text, so her work must be judged accordingly.

The background to *Roll, Jordan, Roll* is well known, but worth retelling. Ulmann was a wealthy New Yorker who had studied photography with Clarence White and had set up as a portrait photographer on Park Avenue before deciding to depict rural American life, such as the Shakers and Mennonites, and rural communities in the Appalachians. Peterkin was a popular novelist raised in the Gullah coastal region of South Carolina. She married the heir to one of the state's richest plantations, on which Ulmann's photographs were taken.

The book looks at the lives of the plantation's black workers, no longer slaves, perhaps, but still tied to feudalism by economic circumstances that Peterkin or Ulmann could hardly comprehend. Peterkin demonstrates this again and again, describing their lives as if they were a lost South Seas tribe as opposed to workers on her own estate, with innumerable condescending observations about their basic simplicity and cheerfulness. Ulmann's photographs are formally modernist, but conceptually pictorial; thus good, straightforward portraits – not unlike Paul Strand's – are overlaid with an unnecessary miasma of sentimentality. The pictures, however, are not as supercilious as the words, and might have done their subjects justice if not dragged down by Peterkin's breathtakingly racist text, all the more staggering for its total unselfconsciousness, as if it were a simple statement of the natural order of things.

Julia Peterkin and Doris Ulmann **Roll, Jordan, Roll**
Robert O Ballou, New York, 1933
222 × 162 mm (8¾ × 6¼ in), 252 pp
Hardback with full blue cloth and jacket
70 b&w photographs
Text by Julia Peterkin; photographs by Doris Ulmann

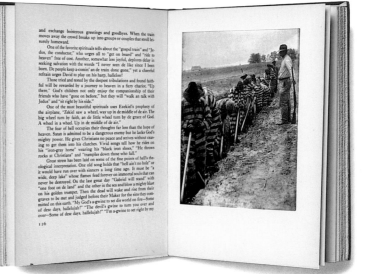

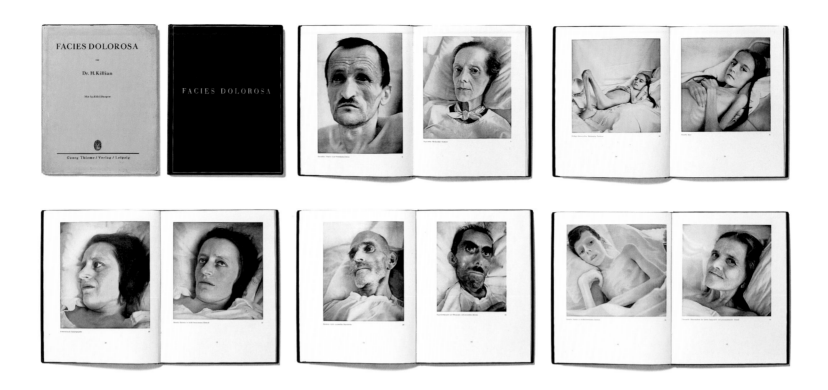

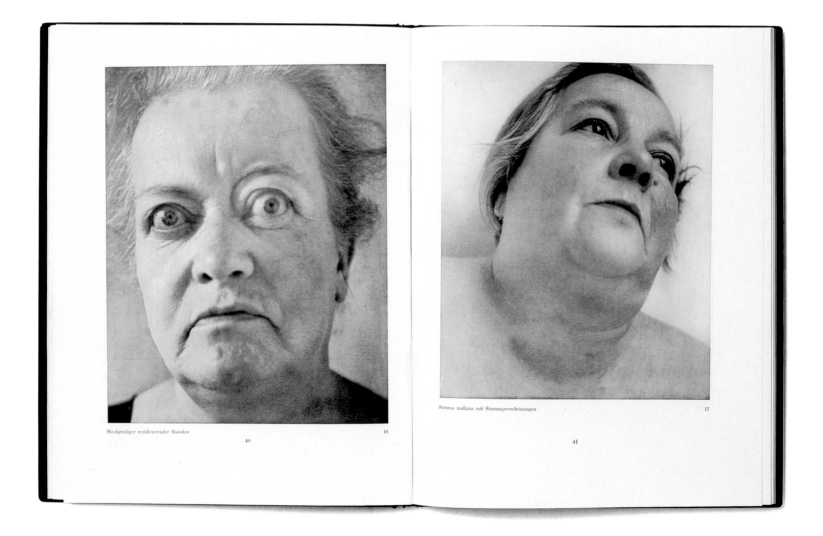

Dr H (Hans) Killian
Facies Dolorosa

Facies Dolorosa, by the distinguished German diagnostician Dr Hans Killian, is nominally a scientific work of empirical observation, dealing with the first stage in any diagnosis: the external examination of the patient. In that sense this volume should appear to be the most 'documentary' of all those considered in this chapter, but that is far from the case. This is due partly to the formal nature of Killian's photographs, partly to the presentation of the book.

The photographs depict patients lying in bed – young, old, male and female. They are usually shot from fairly close up, so that many of them simply show a face sticking out of white hospital sheets, with the patient's prognosis printed beneath. Sometimes the patient is shown more than once, as his or her illness progresses.

The diseases are mainly serious, and many subjects look sedated or resigned, while some are clearly in pain. The book is firmly in that nineteenth-century tradition whereby both physiological and psychological conclusions were drawn from physiognomic observation. As a diagnostic tool today, *Facies Dolorosa* would be considered unreliable, not only because the photographs are in black and white, but also because the skin tones have been dulled by the printing. Thus any tell-tale changes in skin colour have been eliminated. However, the book was taken very seriously at the time, running into a number of editions, and Killian's eminence is still recognized in Germany in the form of the Hans Killian Prize.

To the layman the chief characteristic of the book lies in its strangeness, its departure from the norms of clinical photographic practice. Killian does not usually photograph head-on, but from the side, and often at the patient's level, like a visiting family member. This makes them, at one level, extremely intimate photographs, empathetic portraits of the sick. Yet at another level they are intensely cold and dispassionate, a result of the printing process – collotype – in a range of light greys. The compression of the tonal field endows the skin and the white sheets with similar values. The effect is to amortize the flesh so that the images look like photographs of marble statuary.

The tension between the intimate and the stone cold makes for a haunting and memorable book – moving yet creepy, blurring the line between living and dead, between the serene and the demented. Whatever its value as a diagnostic tool, *Facies Dolorosa* certainly resonates with a disturbing and powerful beauty. A work of photographic science has undoubtedly crossed the border into photographic art.

Dr H (Hans) Killian **Facies Dolorosa: Das Schmerzensreiche Antlitz** (Facies Dolorosa: The Face of Pain)
Georg Thieme Verlag, Leipzig, 1934
280 × 220 mm (11 × 8½ in), 88 pp
Hardback with full black cloth and jacket
64 b&w photographs
Text by Dr Hans Killian

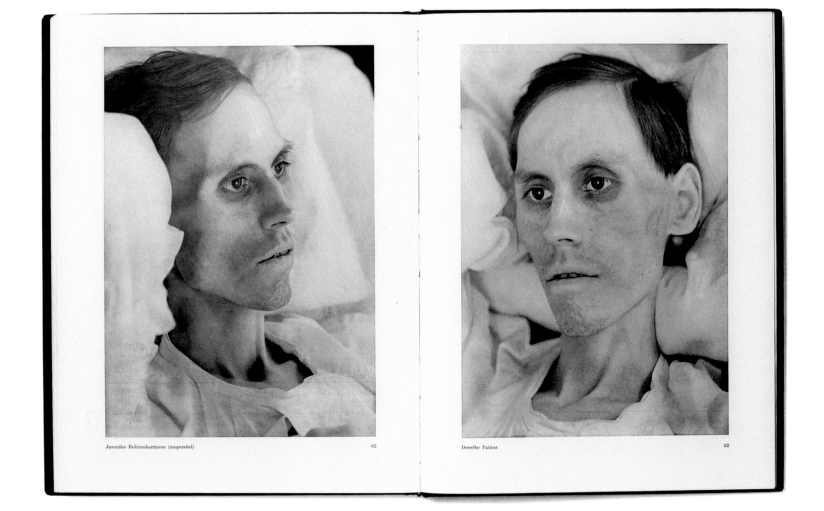

Juveniles Rektumkarzinom (inoperabel) 62 Derselbe Patient 63

Bill Brandt
A Night in London

Bill Brandt
The English at Home

It is instructive to compare these two volumes, one of which was originated in Britain, the other in Paris. *A Night in London* is superior in both conception and execution, but Brandt enlivens even the more conventional formula of *The English at Home* with his individualistic vision. His continental upbringing made him both an insider and an outsider, and he thus casts a broader eye than usual on the Britain of the 1930s.

In both books the issue of class is an important feature. Brandt came from a privileged background, but managed to focus on the lower classes without the sense of condescension that frequently accompanied the middle-class Englishman investigating the lower order like an anthropologist examining a foreign tribe. It may be that Brandt felt something of an outsider in his own society, or perhaps his sense of the fantastic helped him, but he photographed all classes with an unusual degree of sympathy, using the pages of his books to bring out stark contrasts, which if obvious, like the nobs and tic-tac men at race meetings, were always pertinent and had never quite been highlighted in this way before, or even since. The images of cramped working-class life in *The English at Home* must have shocked readers who expected a cosy, conventional look at the old country.

A Night in London contains fewer weak pictures, partly because the night brought out Brandt's predilection for the mysterious and the fantastic – a feature even in this, his 'documentary' work. It is of course known that Brandt staged some of the pictures – using friends and relatives as actors, even in raffish roles like a prostitute and her client – but so did many other documentary photographers of the day. Most cameras were too slow to allow much available-light work, so staging was often a necessity, and in Brandt's case – like Brassaï's for instance – the view of East End pubs and Piccadilly nightclubs was hardly an inauthentic one.

The fact that Brandt – whose later nude imagery displays an interesting sexuality to say the least – was able to show something of the seamier side of London life also makes it the more involving book. The dark clearly enabled Brandt, as David Mellor put it, to let 'imperatives of desire, dream, and phantasy disclose far grander, if far darker schemes.'[22]

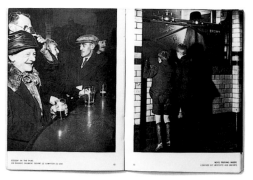

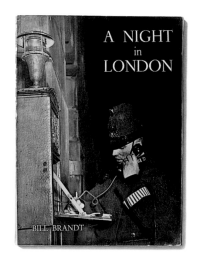

Bill Brandt **A Night in London**
Country Life, London, Editions Arts et Métiers
Graphiques, Paris, and Charles Scribner's Sons,
New York, 1938
254 × 185 mm (10 × 7¼ in), 72 pp
Paperback
64 b&w photographs
Introduction by James Bone

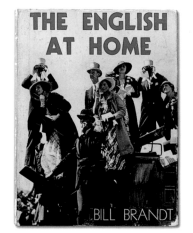

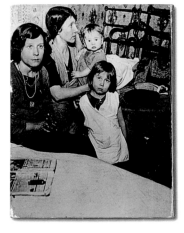

Bill Brandt **The English at Home**
B T Batsford Ltd, London, 1936
238 × 187 mm (9¼ × 7½ in), 72 pp
Hardback (front and back cover shown)
with glassine jacket (not shown)
63 b&w photographs
Introduction by Raymond Mortimer

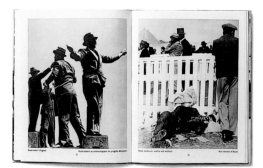

Ilya Ehrenburg
!No Pasarán! Ispania, Tom II
(They Shall Not Pass! Spain, Volume II)

Robert Capa
Death in the Making

It is said that the history of war is written by the victors, but the history of the Spanish Civil War, as far as the outside world knows it, was written by those supporting the Republicans, who were the eventual losers. The reason for this is that, apart from the fascist bloc, the rest of the world opposed a military rebellion against a legitimate government. Furthermore, in terms of the fight against fascism, Spain – however tragic the outcome for the country – was simply a battle, and the greater war was eventually won by the alliance of Western democracies and Soviet Russia. But from the beginning, the Republicans had the most eloquent advocates in their camp – Pablo Picasso, Ernest Hemingway, George Orwell – and the cream of international photographers, as represented in these two books.

The first, compiled by Ilya Ehrenburg, is the second of two volumes on the Civil War published by the Soviet state publishing house, Ogiz-Izogiz. It is the superior of the two volumes, partly because the picture selection is more telling, and partly because the design was by El Lissitsky, including another of his famous covers. The first part was published in the same year and was designed by Yeugeni Goliakovki.

Both the double Russian volumes and the Robert Capa book are diaries of the war. Ehrenburg's passionate, partisan text – totally committed to the Republican cause – is illustrated by propaganda posters that introduce each chapter, and harrowing documentary/news photographs. The latter were taken by a number of photographers, including the well-known Capa and David 'Chim' Seymour, as well as the less well-known Kassos and Mayo, and not least, by Ehrenburg himself.

Unlike Ehrenburg's book, Capa's diary in *Death in the Making* is picture- rather than text-led. It contains not just Capa's own photographs – including many that defined modern war photography – but also images by his lover, the journalist Gerda Taro, who was accidentally killed by a tank near Brunete in 1937. In a real sense, this book is her memorial, as Capa's eloquent frontispiece announces: 'For Gerda Taro/Who spent one year at the Spanish Front/And who stayed on.'

The Spanish Civil War was an important conflict, not just because it was the first direct challenge to fascism, but also in terms of modern photojournalism. It witnessed the birth of the modern war photographer, exemplified by Capa, a figure who, because of his nominal independence from the military authorities, could perhaps be considered a more reliable witness than the 'official' photographers. If, as they say, truth is the first casualty in the fog of war, the 'independent' photojournalist who focuses not so much on the conflict as the people caught up in it, can at least help us peer through the mist a little.

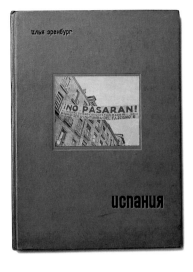

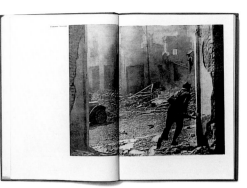

Ilya Ehrenburg **!No Pasarán! Ispania, Tom II**
(They Shall Not Pass! Spain, Volume II)
OGIZ-IZOGIZ, Moscow, 1937
312 × 230 mm (12¼ × 9 in), 152 pp
Hardback with full grey cloth and halftone photograph
98 b&w photographs and b&w poster reproductions
Text by Ilya Ehrenburg; various photographers; design by El Lissitsky

Robert Capa **Death in the Making**
Covici Friede Inc., New York, 1938
285 × 210 mm (11 × 8½ in), 98 pp
Hardback with full beige cloth and jacket
148 b&w photographs
Preface by Jay Allen; photographs by Robert Capa and Gerda Taro; arrangement by André Kertész

Kata Kálmán and Iván Boldizsár
Tiborc

Tiborc is the first part of a classic documentary project that took over two decades to complete, spanning the awful hiatus of World War II. The book's authors, photographer Kata Kálmán and the writer Iván Boldizsár, were members of a group of progressive intellectuals in the 1930s – composed of sociologists, artists, writers and researchers – who sought to raise public awareness about the plight of exploited agricultural and industrial workers.

Between 1934 and 1937, Kálmán and Boldizsár investigated the lives of farmworkers in Hungary. Kálmán made portraits of them – men, women and children – while Boldizsár interviewed each of her subjects, and the results, consisting of 24 portraits and interviews, were published in *Tiborc*. The book's title emanates from the the archetypal peasant character, Tiborc, who appears in József Katona's renowned Hungarian nationalist play of 1821, *Bán Bánk*, which was set to music in 1861 by Francis Erkel and is considered Hungary's best-loved opera.

It is interesting to compare *Tiborc* with another photographer/writer collaboration investigating poverty-stricken farmers: Walker Evans's and James Agee's *Let us now Praise Famous Men*, published in 1941 (see page 144). In general, Kálmán's photographs, tightly cropped head-and-shoulder shots, demonstrate the same serene disinterest shown by Evans, with perhaps a hint of Helmar Lerski's Expressionism, but the writing is a different matter. Kálmán's sobriety is matched by Boldizsár's, with none of the hyperbole displayed by Agee in his wildly overwritten text, the self-indulgence that makes *Famous Men* so exasperating and so suspect as a sociologically objective document, or even a socially partisan one.

In 1955 Kálmán and Boldizsár continued their work by revisiting their original subjects or their descendants, and making a further series of portraits and interviews. This work was published in a sequel to the original, *The New Face of Tiborc*, and reveals the changes that happened to these workers in the interim. The new book is a much more optimistic work, reflecting great social change, a sense of progress and confidence in the future.

Kata Kálmán and Iván Boldizsár **Tiborc**
Cserépfalvi, Budapest, 1937
310 × 241 mm (12¹⁄₄ × 9¹⁄₂ in), 50 pp
Hardback with decorated natural cloth
24 b&w photographs
Introduction by Zsigmond Móricz; interviews by Iván Boldizsár;
photographs by Kata Kálmán

Margaret Bourke-White and Erskine Caldwell
You Have Seen Their Faces

Margaret Bourke-White made *You Have Seen Their Faces* with her future husband, the writer Erskine Caldwell. It was the most financially successful of the documentary photobooks published in America during the Depression, and one of the most controversial. Some of the reasons for its controversy were undoubtedly political. Bourke-White was distrusted by the right because of her left-wing leanings, especially after publishing a book that was sympathetic to the Soviet experiment. She was scorned by the left, however, because she did not let her political conscience interfere with her material comforts. Both sides probably envied her for being one of the most successful women in America.

There were, however, philosophical objections to *You Have See Their Faces* from a purely factual, documentary point of view, and these hinged on the whole style of the book, the rhetoric of both text and photographs. The book's theme was a popular one in 1930s media circles – which meant Northern, largely Yankee circles – the iniquities of the Southern tenant farming system. Old ground dating back to the Civil War, already harvested by Caldwell in novels like *Tobacco Road* (1932), was being raked over once more. The word 'sharecropper' was an emotional one, and this report from Dixie did not seek to dampen this emotion – indeed quite the reverse.

This is a partisan book, and makes no attempt to be anything else, with both text and imagery at least a notch higher on the emotional scale than *An American Exodus* by Dorothea Lange and Paul S Taylor (see pages 142–3) – though the rhetoric is perhaps not as heightened as some commentators would have us believe. Bourke-White cut her teeth on industrial photography and, as a result of her visit to Russia, knew something of Soviet propaganda techniques, part of which she brings to this book – low angles,

dramatic lighting and so on. Sometimes her use of flash tends to freeze her subjects like rabbits caught in a car's headlights, but it would seem that subtlety is not one of the book's primary aims.

Caldwell's text has been much criticized for the fact that he put words that weren't actually there into the mouths of Bourke-White's subjects, but, as most documentary books of the 1930s demonstrate, 'truth' is a construct, and this is not the only book guilty of that crime – if indeed it is a crime. *You Have Seen Their Faces* illustrates how the fine lines that govern the art of documentary photography – lines relating to rhetoric, emphasis, determinism, prejudgement, objectivity and subjectivity – are distorted at the artist's peril. Although some of the criticism of the book has been trenchant indeed,[23] the book's faults would seem to boil down to a tendency towards sentimentality and hyperbole – a shortcoming, but not a capital offence.

Berenice Abbott
Changing New York

Berenice Abbott, who rescued and promoted the work of Eugène Atget, and was also a friend of Walker Evans, was one of the most important American advocates of modernist-documentary photography, both in her writings and in her own photography. In her view, modernist photography meant documentary, and documentary was an art, albeit an art of reality. To her the poetic and historical aspects of the documentary mode were its most important, although she was not opposed to its reformist role. She demonstrated this in her contribution to the bibliography of 1930s documentary – *Changing New York*.

Changing New York is clearly inspired by Abbott's understanding of Atget. Her theme is one firmly in the Atget mould – the constant regeneration and renewal of the modern city, the old squeezed out by the new, the small trader squeezed out by big business. She demonstrates that she has absorbed the iconography of Atget and Evans, the shopfronts and signs, the street traders and furniture, the contrast between ancient and modern. And yet, despite its splendid New Vision-style cover, and the individual excellence of Abbott's images, *Changing New York* falls a little short in reflecting the city's dynamism. This is partly due to the design and sequencing, which does not fulfil the promise of the striking cover. Abbott's documentary photography, too, tends to remain firmly on the surface of things, while

her great mentors, Atget and Evans, though nominally utilizing surface facts, in reality continuously chipped away at the surface and revealed the melancholy truths beneath. She also lacks either the dogged noncomformity of Atget or the caustic irony of Evans.

Nevertheless, this is both a comprehensive and a personal view of New York in the 1930s when, despite the Depression, some of the most enduring twentieth-century monuments were being developed, and old neighbourhoods cleared away for the new skyscrapers. *Changing New York* not only fulfils Abbott's criterion for the historical importance of the documentary mode, but also demonstrates its power as a medium of personal expression.

Berenice Abbott **Changing New York**
E P Dutton & Company Inc., New York, 1939
289 × 226 mm (11½ × 9 in), 208 pp
Hardback with full blue cloth and jacket
97 b&w photographs
Preface by Audrey McMahon; texts by
Elizabeth McCausland

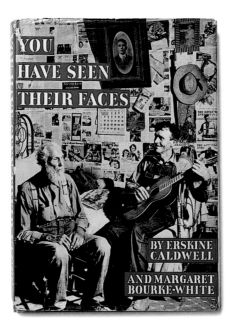

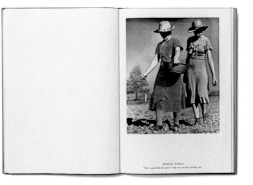

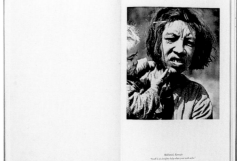

Erskine Caldwell and Margaret Bourke-White **You Have Seen Their Faces**
Duell, Sloan and Pearce, New York, 1937
300 × 210 mm (11¾ × 8 in), 190 pp
Hardback with jacket
75 b&w photographs
Text by Erskine Caldwell; photographs by Margaret Bourke-White

Dorothea Lange and Paul S Taylor
An American Exodus: A Record of Human Erosion

Of all the documentary photobooks stemming from the New Deal, and the FSA in particular, *An American Exodus* by Dorothea Lange and her sociologist husband Paul Schuster Taylor is the most considered. Not only does it have the closest integration of text and image, but the whole book was compiled with scrupulous attention to the presentation of facts, without either hyperbole or undue rhetoric on the part of photographer and writer. For instance, Lange did not include her best-known picture, *Migrant Mother* – an iconic FSA image even then – or some of her other more expressive photographs, because she did not want 'stand-out' images to overwhelm the rest and disturb the book's balance. She was criticized for this by Paul Strand, who was always an artist before he was a documentarian, but Lange's decision would seem to have been a wise one, in view of the shortcomings of other documentary books of the period.

This scrupulousness with regard to style does not mean that the book is altogether devoid of a political viewpoint. *An American Exodus* sits firmly in the proletarian corner. 'This is your country, don't let the Big Men take it away from you', a sign reads at a wayside gas station in one of Lange's pictures. Lange and Taylor are quite clear about blaming greedy men as well as implacable Nature for the Dustbowl and the mass displacement of poor agricultural workers caused by wholesale change within American agricultural practices.

Taylor notes down the evidence, piling up the grim facts and figures with the sociologist's calm objectivity. Lange compiles the visual indictment with a great deal of artistry. That is to say, her pictures are as direct as those of Walker Evans, though without his studied disinterest. Lange was much more of a 'people person' than Evans ever was, and this marks her work, perhaps making her more suited to the propagandist purposes of the FSA. Evans may have been the more coldly intellectual and ironic photographer, but Lange was warmer and more humane, displaying an overt empathy that, importantly, could be transmitted to the public. However, both she and Taylor seemed to have been acutely aware of piling on too much heart-wringing rhetoric. They have included just enough to make their sympathies clear, and to keep their audience engaged. This makes *An American Exodus* the most balanced of New Deal documentary books, and therefore a model for the genre.

Dorothea Lange and Paul S Taylor **An American Exodus: A Record of Human Erosion**
Reynal & Hitchcock, New York, 1939
262 × 196 mm (10¼ × 7¾ in), 158 pp
Hardback with full blue cloth and jacket
112 b&w photographs
Text by Paul Schuster Taylor; photographs by Dorothea Lange

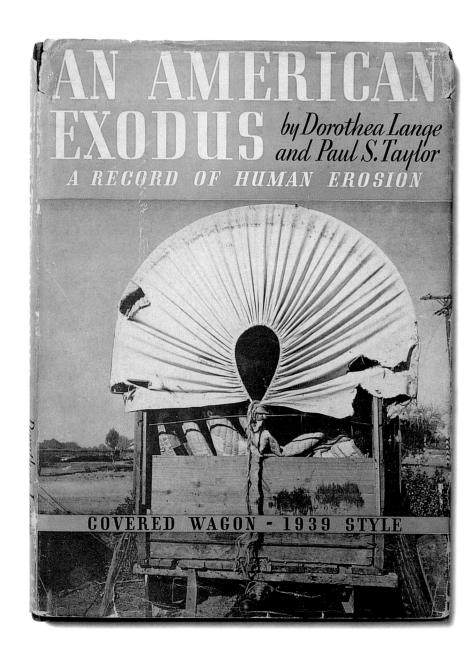

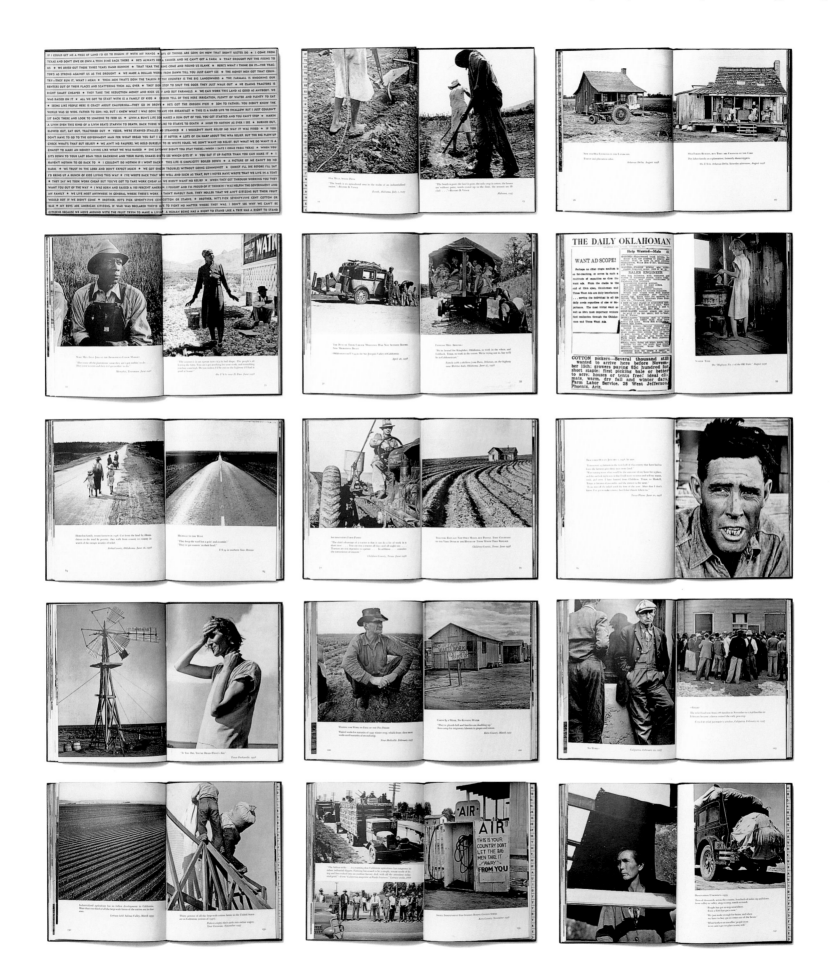

James Agee and Walker Evans
Let us now Praise Famous Men

In 1936, Walker Evans was seconded from his duties as a photographer with the FSA to accompany writer James Agee to Alabama on an assignment for *Fortune* magazine. As part of *Fortune*'s innovative 'Life and Circumstances' series, Evans and Agee were to report on the experiences of Southern tenant farmers. The piece was rejected, primarily because Agee objected to the mass of material they had gathered being edited down. Harper and Brothers, who had contracted to publish it as a book, also turned it down. However, Houghton Mifflin of Boston bravely brought it out in 1941.

Let us now Praise Famous Men is regarded today as a classic of American literature, but critical opinion remains divided about the merit of Agee's text. There is no argument about Evans's photographs – direct, unflattering, painfully honest and free from condescension. But the same cannot be said for Agee's inventive yet often overheated prose. It may seem odd to talk about text when dealing with a photobook, but the relationship between text and image was a primary issue in 1930s documentary books, and especially crucial in this volume, which is seen by many as the epitome of the genre. It is, however, a highly experimental book, pushing the boundaries of the way in which documentary should treat the world. Agee's inventory of

the families' possessions is one thing, as is meditating on the morality of what he was doing. But these dilemmas are submerged in a self-conscious insistence on making every sentence a piece of 'creative' writing, the persistent 'me, me, me' that takes the text beyond documentary and into the realms of the didactic, the confessional, the polemical, the diaristic – and ultimately, the patronizing. If an editor had been given the opportunity to expunge the worst excesses, it would have been a truly great book. However, it is still a fascinating precursor of the stream-of-consciousness mode that would pervade American art of the 1950s, and Evans's photographs – his only excursion into 'true' documentary – remain amongst the finest ever made.

James Agee and Walker Evans **Let us now Praise Famous Men**
Houghton Mifflin, Boston, 1941
205 × 135 mm (8 × 5½ in), 472 pp
Hardback with full black cloth and jacket
32 b&w photographs
Text by James Agee; photographs by Walker Evans

Jak Tuggener
Fabrik (Factory)

It seems inconceivable that a photobook extolling contented, peaceful workers and the gradual replacement of heavy, 'dirty' industries with new, 'clean', technologically-based ones like electronics and hydro-electric power should be published as early as 1943, but this book was. The answer to this apparent paradox is that

it was published in Switzerland, and focuses on the progressive state of that country's industry when the rest of European industry was either in ruins or given over entirely to armaments. Swiss neutrality enabled Jak Tuggener to practise modernist documentary photography freely, and he makes a fine job of it in this book, employing several different modes to great effect. As Arnold Burgauer cogently states in his introduction, Tuggener is a jack-of-all-trades: he exhibits, 'the

sharp eye of the hunter, the dreamy eye of the painter; he can be a realist, a formalist, romantic, theatrical, surreal.' Tuggener moves effortlessly between large-format lucidity and grainy, blurred impressionism, in a book that is a decade ahead of its time. It points the way, in the darkest days of World War II, to the bright new economic future that Western Europe would enjoy after the conflict, when technological advances irrevocably changed the workplace.

Jak Tuggener **Fabrik: Ein Bildepos der Technik**
(Factory: A Photoessay on Technology)
Rotapfel-Verlag, Erlenbach-Zurich, 1943
310 × 230 mm (12¼ × 9 in), 112 pp
Hardback with full beige cloth and jacket
95 b&w photographs
Introduction by Arnold Burgauer

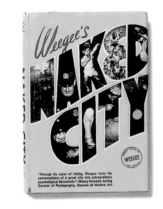
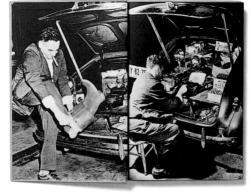
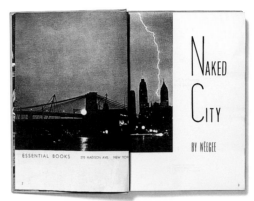

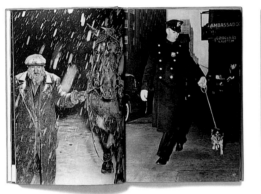
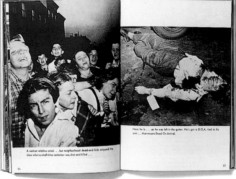

Weegee (Arthur Fellig) **Naked City**
Essential Books, New York, 1945
240 × 160 mm (9¹⁄₂ × 6¹⁄₂ in), 246 pp
Hardback with full beige cloth and jacket
239 b&w photographs
Foreword by William McCleery; text by Weegee; jacket
text by Nancy Newhall; design by Henry Stahlhut and
Michael Polvere

Weegee (Arthur Fellig)
Naked City

In many ways the legend that Weegee himself fabricated – that of the cigar-chomping, sensationalist *paparazzo* with a radio tuned into the police frequencies – detracts from his photobook masterpiece, *Naked City*. Even its dime-novel title and Weegee's own, Runyonesque, wiseguy commentaries can blind one to the fact that this is one of the great documentary photobooks.

That it is a populist book is not in doubt, but this should not detract from the notion that Weegee has constructed a personal view of a great city, seen by a man of the people for the people, and that beneath the concentration on the seamy side of life is a degree of social commentary. The genre might be tabloid-newspaper photography, but Weegee's visual sensibility, and even social concern, operate at a higher level. As Nancy Newhall's jacket text states: 'Through his sense of

timing, Weegee turns the commonplace of a great city into extraordinary psychological documents.'

Weegee's view is a partial one. The diet of death, disaster and sleaze is relentless, but to suggest that this is all there is to the book is quite wrong. It would be stretching a point to claim a socio-political agenda, but if one looks past the cynicism and the wisecracks in his text, his is the authentic voice of the proletariat. An image like *The Critic*, his caustic view of bejewelled *grande dames* apparently confronted by a heckler as they arrive at the Metropolitan Opera House, may be crude social commentary, but it reflects the voice of the little guy. Likewise, his gleefully voyeuristic shots of dead gangsters, car-crash victims, or bobbysoxers in orgasmic ecstasy at a Frank Sinatra concert mirror the prurient curiosity of Joe Public.

Although it contains some daytime shots, *Naked City* is essentially a nocturnal book, to be put alongside Brassaï and Brandt. It is Weegee who reeks most

pungently with the whiff of the streets. Paris, London, New York – it is interesting to compare these very different impressions of the modern nocturnal city by a trio of different documentary photographers, impressions that have coloured the views of three generations. London is mysterious, fogbound and classbound. Paris is the gay city – in both senses of the word – a byword for sexual licence. New York is tough, hard and gritty, a city of Wild West violence. Each view says as much about the photographer as the city, but similar ones have been put forward by many artists and writers. As for Weegee's *Naked City*, beneath its Rabelaisian, tough-guy exterior, this is a book with a heart.

Medium and Message
The Photobook as Propaganda

Under Stalin's regime, which ruled the Soviet Union from 1929 to 1953, photographs lied. Stephen F Cohen[1]

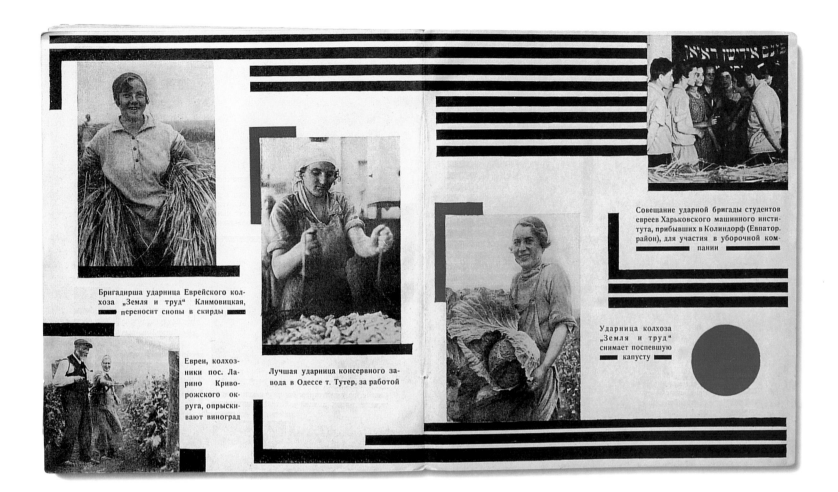

Anonymous
Udarniki (Shockworkers)
OGIZ, Leningrad, 1930–1

An early example of the superb design and
layout that characterized the classic period
of Russian propaganda books (1931–40),
Udarniki employs a Mondrian-like grid of
dynamic red and black graphics.

In one of the various dictionaries published by the Cambridge University Press, the word 'propaganda' is defined as follows: 'Information or ideas that are methodically spread by an organized group or government to influence people's opinions, esp. by not giving all the facts or by secretly emphasizing only one way of looking at the facts.'[2] It could be argued that much photography and photobook publishing is propaganda, in that it is made – particularly if the photographs were taken expressly for publication – to present a particular point of view and to influence people. But the second part of the above definition is crucial. In propaganda facts are emphasized, even doctored, in order to construct a specious argument that brooks no opposition, that leaves no room for doubt or dissension. Thus we tend to reserve the word 'propaganda' for totalitarian states, where any published information must toe the party line and cannot be regarded as neutral; where any opposing point of view is ruthlessly proscribed. To link propaganda almost exclusively with totalitarian states, therefore, is to take a pejorative view of it, and that, strictly speaking, is propagandist in itself. But in 'democratic' societies, propaganda is understood as that which totalitarian states practise and democracy opposes. In democracies, where there are many differing points of view on offer, if a fact is described as a fact, it surely *is* a fact, and the art of convincing people that this is so is called 'persuasion', or 'advertising', or even 'documenting'. In short, one man's propaganda is another's truth.

Nevertheless, the kind of propaganda book that will primarily be examined here – propaganda at its high point – was practised during a specific period, roughly from the beginning of the 1930s until

the mid-1970s, and in this extreme form, primarily by totalitarian states. Although, for example, much of the documentary material disseminated by the New Deal administration in the United States during the 1930s was designed to sway people towards the government's point of view, and therefore could be (indeed was) termed 'propagandist', there is a palpable difference between the 'information' departments of a democracy and the propaganda ministry of a totalitarian state.

For some, any distinction is moot, simply splitting hairs between bending the truth and downright lying. They would claim that the propaganda of corporate advertising campaigns, capitalist public relations companies, or an organization like the Voice of America is as insidious and as hollow as anything put out by the Soviets or Nazis. One can make that argument, of course, but the point about totalitarian propaganda is that, in a nutshell, it is *total*. The control of its content, its production and its dissemination by the state is absolute. And crucially, there is no other even mildly dissenting source of information or difference of opinion.

The terms 'Soviet' and 'propaganda' have become almost synonymous in some people's minds, and indeed the Soviets have been credited with the invention of the modern propaganda machine. But the Russian attitude towards propaganda is perhaps understandable if one considers the early years of the Bolshevik Revolution. Following 1917, and particularly during the Civil War of 1918–20, propaganda was used as a weapon by the Reds. Lenin considered that the most effective medium would be the cinema, since so many amongst the Russian masses were illiterate. Film-making, however, was a complex, lengthy and expensive process, requiring special conditions for showing, whereas the photographic image, just as believable, was relatively easy, quick and cheap to print, either in books, or in the Bolshevik's ultimate propaganda weapon – the poster. These could be turned out in enormous numbers, and stuck up anywhere, their simple bold graphic design, whether containing photographic information or not, obviating the illiteracy problem. The Soviet poster is one of the most striking features of the communist experiment, used in every decade – especially during times of war or threat – but never to greater effect than in the Civil War or the years immediately following the Reds' victory. The famous 'propaganda trains' – mobile cinemas, soap boxes and billboards – carried the Bolshevik message when the outcome of the Civil War was in the balance. It is said that the Bolsheviks primarily owed their victory to two factors: Lenin's formidable organizational and political skills, and his propaganda machine.

The relationship of Russian avant-garde art, particularly photography, to the propaganda effort is extremely interesting. Clearly, photography was of great value as a propaganda tool. Additionally, many of the formal innovations of the Constructivists – in photomontage, typography, graphic design – as taught in schools like the INKhUK (Institute of Artistic Culture) and the VKhUTEMAS (Higher State Artistic and Technical Workshops), whilst not formulated specifically for propagandist purposes, were at the service of society, that is, the state, and therefore readily available to the agitprop commissars. It has often been remarked how close the techniques of propaganda were to those of capitalist advertising. During the 1920s propaganda and publicity coexisted quite happily, with El Lissitsky designing both propaganda posters and the publicity for Soviet stands in international fairs, while Alexander Rodchenko used photomontage on the covers of detective novels.

In the 1930s, after Stalin had consolidated his grip on power, and the reign of terror had begun in earnest, it is widely thought that such artists as Lissitsky and Rodchenko produced propaganda books unwillingly, either under threat or coercion, or that they were at least frustrated that their talents were not being employed on higher things. However, it gave them the opportunity to utilize avant-garde ideas and techniques, and even took them to new heights, albeit under the disingenuous guise of Socialist Realism. As Margarita Tupitsyn has pointed out,[3] those on contracts with IZOGIZ, the State Publishing House for the Arts, were well paid and received privileges given only to the elite.

Any discussion of the Soviet propaganda photobook of the 1930s must begin not with an individual book, but with a magazine. Between 1930 and 1940, *USSR in Construction* (*SSSR na Stroike*) employed the best Soviet photojournalists and graphic designers. Amongst the photographers were Max Alpert, Arkadi Shaikhet, Georgi Zeima, Boris Ignatovich, Semen Fridland and Georgi Shaikhet. Designers

included the husband-and-wife teams of El Lissitsky and Sophie Küppers, and Alexander Rodchenko and Varvara Stepanova. They were undoubtedly the best in their field, and the very nature of the magazine, a lavishly produced monthly published in four separate editions – Russian, English, German and French (and later, Spanish) – ensured that the magazine's editorial offices became a hot-house of ideas. All the visual strategies of the propaganda photobooks, designed by Lissitsky, Rodchenko and others – the elaborate photomontages, innovative photography, fold-out pages, transparent overlays and so on – were developed in *USSR in Construction*, one of the most beautifully produced magazines of the twentieth century.

Crucially, the magazine was published primarily during the era when Stalin decreed that Constructivism was a bourgeois art form and that Socialist Realism was to be the only acceptable form of art for Soviet Russia. But one primary medium employed by the Constructivists – the photograph – being essentially a realist, documentary medium, was ideal for the persuasive job required of propaganda. Photography was realistic, believable, malleable. Through photomontage, where images could be reconstructed by cutting and pasting, entirely fictitious scenarios could be fabricated, yet even the most fantastic retained the photograph's single greatest asset – its believability.

Stalin made full use of this. For example, few photographs existed of him from the days of the October Revolution; he had played only a minor part in those momentous events. His propaganda artists, however, with scissors and paste and a little imagination, could 'prove' that he had really been at the heart of every important event during the Revolution, faithfully at the side of Lenin.

What could be added to photographs could also be taken away – particularly images of Trotsky, who had been everything during the Revolution that Stalin had not, the co-architect of the Bolshevik triumph, and therefore especially hated by the Georgian tyrant. Trotsky, and the tens of thousands of commissars and party officers who fell foul of Stalin and were liquidated, were murdered twice over as it were, for their images were removed from any official photograph in which they appeared, a policy that literally required an army of retouchers. And if the photograph had already appeared in print, it was incumbent on the owners of the publications to cut out the faces of the purged, or scrawl over them with ink, if they did not want to suffer a similar fate. Indeed, Rodchenko was forced to deface his personal copy of one of the great photobooks he designed, *10 Let Uzbekistana SSSR* (Ten Years of Uzbekistan, 1934), after many of the Uzbek party leadership featured in the book were murdered in the Great Purges of 1937.

The photographic albums published by the State Publishing House generally followed the same ideological form as *USSR in Construction*. Each separate issue was thematic, and usually took the form of a report on the rebuilding of Soviet Russia, as do the photobooks. There are regional reports, like *XV Let Kazakhskoi* (Fifteen Years of Kazakhstan, 1935) or *Moskva Rekonstruiruetsya* (Moscow Under Reconstruction, 1938), books extolling Soviet military might, such as *Krasnaya Armiya* (Red Army, 1934), and progress reports on different Soviet industries, like *O Zheleznodorozhnom Transporte SSSR* (About Rail Transport in the USSR, 1935), or *Pishchyevaya Industriya* (The Food Industry, 1936). The tone is relentlessly upbeat, bombastic (one imagines a soundtrack of Shostakovich), and is never short of two hyperboles where one would have sufficed. The State Publishing House was regarded as an important arm of the state, and had a budget to match. No expense was spared in the production of these volumes, which are determinedly elitist, even luxurious, published by the government for its own internal consumption by commissars and party managers – unlike *USSR in Construction*, which (apart from its deluxe editions) was aimed at an international audience. Great attention was paid to their design, and they were produced with the best printing, papers and binding.

Much of their inspiration was cinematic. The technique of montage, of quick cutting and piling image upon image, developed so brilliantly in Soviet cinema, was replicated in the photobook. Lissitsky, who exchanged ideas on a regular basis with the documentary filmmaker Dziga Vertov, commented: 'We are approaching the book constructed like a film: plot, development, denouement.'[4]

However hollow some of their boasts, these mighty volumes document the emergence of the Soviet Union as a major twentieth-century industrial and military power. The iniquities of Stalin's

awful regime cannot be glossed over, and one inevitably questions the complicity of all those who served the propaganda machine, but whatever one's ideological objections, it cannot be denied that Soviet propaganda books have a certain grandeur. They have been the model, not just for propaganda books in other totalitarian states, but for company reports in the capitalist world as well. The talents of Lissitsky, Küppers, Rodchenko, Stepanova and others gave them an almost irresistible visual panache, a multiplicity of graphic invention and photographic artistry.

Like Soviet Russia under the Communists, Germany under the National Socialists was a totalitarian state ruled by force. And the power that wielded that force was not just tangible, it was also symbolic, couched in mythical terms and expressed in propagandist images. As Peter Reichel has commented: 'National Socialist Germany impressed itself on the memory both of those who lived through it and of subsequent generations, above all visually: in images of the double-edged power of the NS regime, images of its monumental and apparently boundless shaping force, and of its extraordinary destructive force.'[5] From their beginnings in the Weimar Republic, the Nazis projected an image centred round the cult of the Führer and incorporating all the elements by which contemporary Germans and subsequent generations instantly recognized them – the swastika, the flags, the drums, parades, rallies and torchlight processions. Arguably, it was the insidious coherence of the Nazi image, as much as anything, that singled the National Socialist Party out from the many competing political parties in the Weimar Republic and ensured its triumph in the early 1930s. The Russians, of course, had parades and flag-waving, too, but the Nazis did it better.

Nazi propaganda ideology, despite the basic enmity and political differences between the two countries, roughly followed the Russian model, which became the pattern for all totalitarian ideologies of any persuasion, left or right, secular or religious. Both Hitler and Stalin, the twin demagogues, shared an antipathy towards modern art, and just as the Soviets closed the VKhUTEMAS, the Nazis closed the Bauhaus. But although Hitler and Stalin opposed modernism in art and ideas, they oversaw an unprecedented modernization of their respective states, and were quick to avail themselves of the power of the modern mass media, which had derived from modernist values.

Germany, however, did not have the advantage of figures like Lissitsky or Rodchenko. Most artists of comparable stature had been driven away by the Nazis' vitriolic campaign against modernism, resulting in exhibitions like the infamous 'Entartete Kunst' (Degenerate Art) in July 1937. The National Socialists' threat was clear from early on. The simple fact was that many of Germany's best artistic brains were Jewish, and their incalculable loss impoverished both German art and its propaganda output. But Nazi propaganda was not simply inferior to its Russian equivalent in terms of artistic quality. There was another vital difference – its racism. Whatever its shortcomings in practice, whatever the ancient tribal and class enmities in Russia, whatever the anti-semitism, Russian Communism was not first and foremost a racist ideology. In the National Socialist creed, on the other hand, blatant racism was the primary ideological plank. Nazi ideology, society and propaganda were fuelled, driven, warped and tainted by it. If the Soviets' world view was radically polarized, myopic, paranoid and simplified, it was almost humanist compared to that of the Nazis. On top of the personality cult surrounding the Führer, therefore, the extolling of German industry and military might, Nazi propaganda utilized aesthetics for more sinister purposes: the political and pseudo-scientific vilifying of German Jewry in preparation for its extermination. This propaganda revived the dubious nineteenth-century 'science' of physiognomic studies and any amount of false history to laud the Aryan and 'prove' the Jew an *Untermensch*.

The Nazis were quick to use not only the photobook but also the illustrated magazine for propaganda. Probably the most effective was the *Illustrierte Beobachter* (Pictorial Observer), founded in July 1926. Its first issue established the future trend of Nazi iconography. The cover featured a photomontage by Heinrich Hoffmann, Hitler's personal photographer, and therefore an important figure in the propaganda hierarchy. Unlike Stalin, who had a complex about his unprepossessing looks and pockmarked face, Hitler was not camera shy, and Hoffmann turned out a series of picture essays and books featuring both the public and private life of the Führer, consolidating the Hitler cult. A number

of the books he published on the Führer tend to emphasize his role as 'Father and Teacher of the People' as much as demonstrating the fact that he ruthlessly wielded absolute power in his capacity as Party Head and General-in-Chief of the Armed Forces. In March 1932, Hoffmann published two of his best-known books, which set the tone for others: *Hitler über Deutschland* (Hitler over Germany) and *Hitler wie ihn keiner kennt* (The Unknown Hitler). They exuded a tone similar to that of Hollywood fan magazines, with images set up to give a glimpse into his private life and show that the 'god' was also human. But as Reichel observes:

> *However multifaceted and graphic the image of the new idol may have been, it was nevertheless highly contrived and idealized: Hitler on the family sofa, soldier Hitler at the front, Hitler the car enthusiast, Hitler surrounded by children, Hitler with dog whip and binoculars, Hitler in 'his' mountains, among the farmers and the youth of Germany, Hitler at the edge of the forest, at his desk, on the telephone, reading a newspaper, Hitler with Nietzsche bust or Goebbels' piano, Hitler as the 'good man', the 'irresistible tribune of the people'.*[6]

During the Weimar Republic almost every political party had a magazine supporting it. The main magazine of the left, the *Arbeiter Illustrierte Zeitung* (Workers' Illustrated Newspaper), was artistically light years ahead of the poisonous *Beobachter* and the other Nazi journals. The *AIZ* was distinguished particularly by the brilliant anti-Nazi photomontages of John Heartfield (Helmut Herzfeld), one of the century's great collagists. Working in a manner directly influenced by the Soviets (he also contributed to *USSR in Construction*), Heartfield and other avant-garde leftists ensured that they at least won the aesthetic propaganda battle – before political events left the playing field to the National Socialists alone.[7]

The Nazis had one propagandist of genius to call upon – the film-maker Leni Riefenstahl. Her two masterpieces of the propagandist's art, *Triumph des Willens* (Triumph of the Will, 1935), a record of the Sixth Nazi Party Rally in Nuremberg in 1934, and *Olympia* (1938), her film of the 1936 Berlin Olympics, are amongst the most important visual references in our retrospective understanding of Nazi culture. Her style, a combination of German and Soviet Expressionist influences, reflected the bombast of the Nazi photobooks, with the added emphasis of movement and martial music. A lavish photobook, *Schönheit im Olympischen Kampf* (Beauty in the Olympic Games, 1938), culled from stills shot during the making of the Olympic film, managed to capture something of the pace and beauty of the film – without quite being a successful photobook.

The lead established by the Nazi propaganda photobook was taken up by the other fascist countries, notably Spain and Italy. For example, Manilo Morgagni's *Italia imperiale* (Imperial Italy, 1937) is an enormous book of photographs, illustrations and photomontages, extolling the virtues of Mussolini's Italy, although it owes as much to the Soviet model as the Nazi one. In communist countries, both in Europe and elsewhere, the propaganda photobook, particularly that deriving from the 1930s Soviet model, remains popular to this day, and still surfaces wherever governments – whether left or right – seek to control mass communications. The Chinese, especially during the Mao Zedong era, when the leader's cult of personality was as marked as that of Stalin or Hitler, produced many propaganda photobooks, and they are also published in other Asian countries, such as North Korea.

Even in the democratic countries, societies with a freer press, books are still made to persuade, and if the propaganda of the democratic countries – whether from government or private enterprise – is more benign, it is just as determined and tendentious, and often more insidious. The crucial difference is that in democracies there are alternative points of view. That is what was missing in Stalin's Russia or Hitler's Germany, or in the other countries where totalitarianism reigned.

Anonymous
Leninu (To Lenin)

One of photography's great fascinations is the way in which it can throw a sharp beam of illumination on totally unexpected and ephemeral facets of history. This extraordinary book, published following the funeral of Lenin in 1924, does this in a most surprising way, and whether or not it qualifies as propaganda in the strict sense, it is symptomatic of the myth-making and the cult embodied in the personality of the Bolshevik Revolution's leader after his death.

Superficially, it is nothing but a record of the wreaths sent to Lenin's funeral, photographed and catalogued according to the class and status of the multifarious groups that sent them. These range from the members of the Supreme Soviet state to the various national, regional and local commissars, to the military and the various workers' representative groups and collectives throughout Russia, as well as foreign socialist parties. Each wreath is photographed in exactly the same way – head-on – and an accompanying caption notes the name of the donor, with a description of the wreath's make-up – its size, the type of flowers, leaves and so on.

That is all. There are no further frills; it is a book that is as rigorous in spirit as any Conceptual artist's photobook of the 1970s or 80s. It is interesting to speculate as to whether, at the time of the book's publication, the order in which these wreaths were included, whether or not they were given a full-colour or a black-and-white reproduction, caused anguish and political repercussions. As a documentary book, its 'first' life must have been over quickly. As a photobook, resonating with the poetry of history, it adds a morbid but strangely fascinating footnote to a defining moment in the history of the twentieth century.

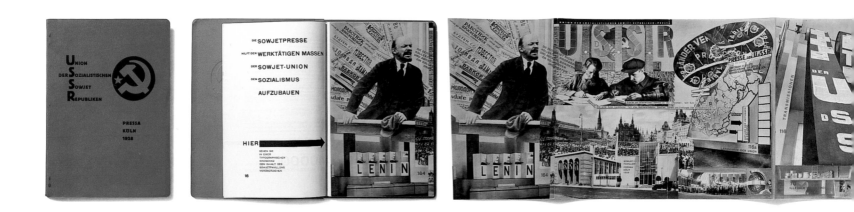

Anonymous **Union der Sozialistischen Sowjet Republiken**
(Union of Soviet Socialist Republics)
Katalog des Sowjet-Pavillons auf der Internationalen Presse-Austellung, Cologne, 1928
212 × 150 mm (8½ × 6 in), 112 pp
Paperback
18-pp accordion fold-out with tinted monochrome photomontage by El Lissitsky and Sergei Sen'kin
Design by El Lissitsky and Sergei Sen'kin

Anonymous
Union der Sozialistischen Sowjet Republiken
(Union of Soviet Socialist Republics)

The official catalogue of the Soviet Union Pavilion for the International Press Exhibition (PRESSA) held in Cologne in 1928 might be termed a 'one-picture' book, but as anyone seeing it for the first time is likely to exclaim – what a picture! The catalogue's main feature is an 18-page, accordion fold-out photomontage, which reiterates the primary attraction of the Soviet exhibit – a photomontage frieze that spectacularly extolled the virtues of the Revolution. All the chief iconographic

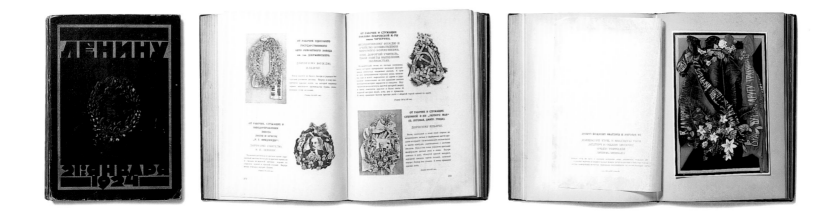

Anonymous **Leninu. 21st Yanvarya 1924** (To Lenin. 21st January 1924)
GOZNAK, Moscow, 1924
275 × 203 mm (11 × 8 in), 520 pp
Hardback
494 photographs, including 13 tipped-in plates with tissue guards (7 colour, 6 b&w)

themes of Soviet propaganda iconography are included – happy, vigorous male and female workers, efficient factories and productive collective farms, determined soldiers, superbly fit athletes and joyous youth, and of course, at frequent intervals in the composition, portraits of the late Lenin, leading his people from beyond the grave into the glorious future.

There is a degree of uncertainty as to who actually designed both the frieze and the pavilion. A committee of no fewer than 49 members met in Moscow to prepare and discuss initial designs, but it is thought that one of the prime movers behind the frieze was Gustav Klutsis, the most radical of Soviet photomontagers,

indeed the man who claimed to have invented the genre. However, presumably because of his personal and cultural connections in Germany, El Lissitsky was chosen to head the design team, along with Sergei Sen'kin, apparently to the annoyance of Klutsis.[8]

The catalogue is important for several reasons. It is a magnificent technical achievement: unfolded, the montage is some 2,700 mm (106 in) in width, one of the first examples of the kind of book production that was to become commonplace in the 1930s. Secondly, although the montage itself is perhaps over-complex – in Klutsis's view, over-formalist – it is an impressive piece of work. Thirdly, and perhaps most importantly,

it denotes a crucial change of direction for El Lissitsky himself. The PRESSA commission might be said to mark the moment when he turned away from the form-alist, experimental approach that had hitherto marked his Constructivist and photographic work, and began to place his enormous creative talents fully at the service of the Soviet propaganda machine. It was the moment when, as Margarita Tupitsyn has put it, 'the technique of photomontage was shifted from its avant-garde function of fragmenting and deframing to the new purpose of synthesizing and totalizing'.[9]

Anonymous
Udarniki (Shockworkers)

The *udarniki* (shockworkers) were Stalin's elite industrial 'troops', the teams of 'hero' workers who outproduced their fellow Soviets, and it is they who are celebrated in this book, which is much more modest than the other Soviet volumes featured here. *Udarniki* was published early on in the classic period of Russian propaganda books (roughly from 1931 to 1940). It is a paperback book, printed on rough paper, but that does not detract from a superb design and layout that looks back to the Constructivist photobooks of the 1920s in terms of a rigorously maintained, almost classical framework to contain the photographs. Yet within that matrix the designers, A R Dideriks and V M Khodasevich, are continuously inventive.

The rigour of the book begins with its cover, where nine portraits of shockworkers – as fine of those of Lewis Hine – are contained in a Mondrian-like grid of red lines. The theme of black and red continues in both design and typography, acting as an elegant and effective foil for the photographs, which, like the rest of the book, are more restrained and less bombastic than those in most Soviet books. But it is nevertheless a propaganda book, and there are the usual pictures of workers studying their productivity targets, in which shockworkers had a vested interest. Interestingly, there is also a section reminding us that in the Soviet Union women workers were valued as equals to the men, at a time when this was certainly not the case in the Western world.

There is less photomontage than in some later books, although photographs, typography, and graphic framework are pulled together seamlessly throughout. Every so often the designers throw in a double-page spectacular to demonstrate what they can do. One magnificent spread shows construction workers erecting a building's steel frame. It is shot from a low viewpoint, looking up at a New Vision angle, the beams, with workers astride them, forming a strong diagonal line. Between the beams, at 90 degrees, is a slogan in red, which reads: 'Socialist competition – the main method of fulfilling the five-year plan in four years.' Though it might be nominally simple, *Udarniki* is nevertheless ambitious in its aims, and is the one of the most perfectly realized books following Constructivist design principles.

Anonymous **Udarniki** (Shockworkers)
OGIZ, Leningrad, 1930–1
208 × 187 mm (8¼ × 7½ in), 198 pp
Paperback
Numerous b&w photographs
Design by A R Dideriks and V M Khodasevich

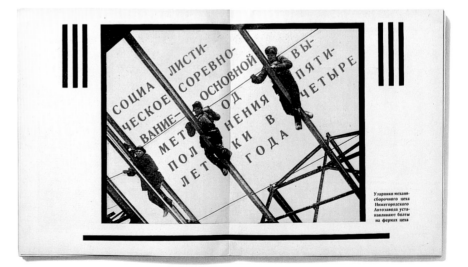

I V Federov et al
SSSR Stroit Sotzialism
(The USSR Builds for Socialism)

The endpapers of this book, decorated in cream and red, contain a famous phrase repeated in 32 languages, beginning with English – 'Workers of the world unite!' This multi-lingual exhortation, and the fact that the picture captions are in English, German and French as well as Russian, indicate that this is a propaganda book intended for export. One of the major books designed by El Lissitsky, it is in fact a report on Stalin's first Five-Year Plan. Whether Stalin's initiative was a success or not in actuality (it fell short in certain respects, but could claim some great achievements) it was presented as an outstanding feat within the pages of this book.

SSSR Stroit Sotzialism (The USSR Builds for Socialism) begins with the declaration that established the Soviet Union. This is followed by an introduction detailing the ways of fulfilling the Five-Year Plan's targets, before the photographic sections survey its attainments, especially in the crucial sectors of mining, power, steel production, heavy industry and the collectivization of agriculture.

The book is one of the first fruits of the contract that Lissitsky signed with the State Publishing House IZOGIZ in 1932, in which he agreed both to design issues of the magazine *USSR in Construction*, and to work on individual books. His magazine designs influenced his photobooks. Indeed, many of them are like more permanent issues of *USSR in Construction*, with the same themes and ideas. In *SSSR Stroit Sotzialism*, Lissitsky employs montage in his layouts, but generally it is simpler and more straightforward in concept than his work in the magazine, or in other propaganda books, particularly his own spectacular seven-volume report on Heavy Industry for the Seventh Congress of Soviets of 1935 (see pages 160–1). Here, he tends to group whole pictures together in patterns to make his montages rather than using fragments of photographs and collaging them in a 'cut-and-paste' manner. Nevertheless, the pace and rhythm of his layouts show both a cinematic influence and a master graphic designer at work, and this book is an important step in the formulation of both his mature *USSR in Construction* style, and the masterpiece he designed for the Seventh Congress.

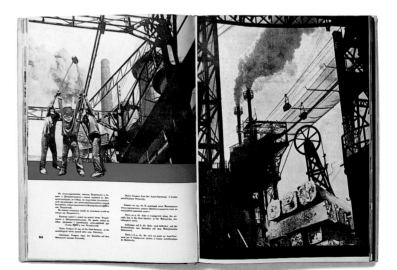

I V Federov et al, eds. **SSSR Stroit Sotzialism** (The USSR Builds for Socialism)
IZOGIZ, Moscow, 1933
338 × 250 mm (13¹⁄₂ × 10¹⁄₄ in), 286 pp
Hardback with beige paper, grey-blue cloth spine and cardboard slipcase (not shown)
281 b&w photographs including photomontages
Various anonymous photographers; design by El Lissitsky

L Tandit, ed. **XV Let Kazakhskoi ASSR** (Fifteen Years of Kazakhstan ASSR)
IZOGIZ, Moscow and Leningrad, 1935
282 × 242 mm (11¼ × 9½ in), 228 pp
Hardback with full red silk cloth and silver cloth slipcase
Numerous monochrome photographs in various tints, fold-outs, maps, printed acetate overlays
Texts by the Editorial Board of the Kazakhstan Newspaper; photographs by E M Langman and D N Shul'kin;
design by Nikolai Troshin

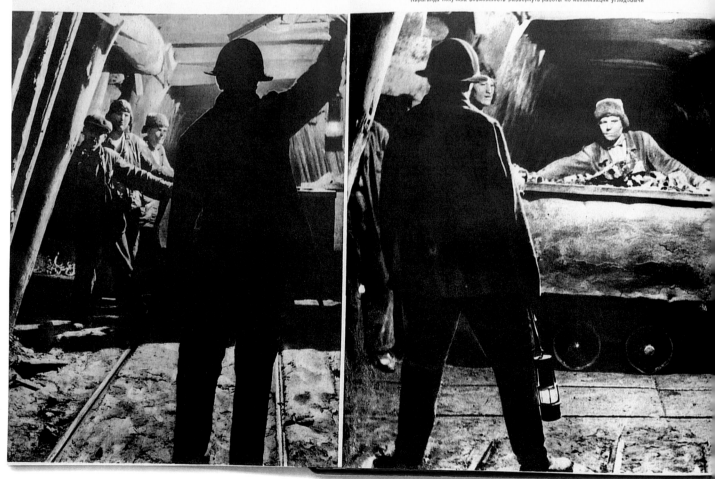

L Tandit
XV Let Kazakhskoi ASSR
(Fifteen Years of Kazakhstan ASSR)

M Tursunkhodzhaev
10 Let Uzbekistana SSR
(Ten Years of Uzbekistan)

The Soviet Republics of Asia Minor were seen as important components of the USSR, as denoted by these lavish photobooks celebrating the anniversaries of the accession to the Union of Uzbekistan and Kazakhstan.

10 Let Uzbekistana SSR (Ten Years of Uzbekistan), designed by Alexander Rodchenko and Varvara Stepanova, is one of the most beautiful of Soviet propaganda books, and one of the most notorious. The Russian edition appeared in 1934, while an Uzbek edition, with a few politically inspired alterations, came out in 1935. In 1937 Stalin carried out one of his customary 'purges' of the local party commissars, so that many of those shown in the book's numerous official portraits had been liquidated or sent to labour camps, and had attained the status of 'non persons' in Russian eyes. The book, as David King notes, 'suddenly became illegal literature'.[10] Its owners were required either to dispose of it, or to carry out their own personal liquidation in its pages by inking over the faces of the disappeared, neatly cutting out their heads, or slicing out the pages (as seen overleaf) – a fate that befell more than one Soviet photobook.

That said – and it is disturbing to see these defaced pages – the book is one of Rodchenko's and Stepanova's finest designs. Many of the pictures feature those New Vision angles that are such a feature of Rodchenko's work. The book also contains a number of transparent printed overlays on photographs, and a notable page with a baleful cut-out silhouette of Stalin, perhaps expressing the designers' unconscious wish to expunge him in the same way.

XV Let Kazakhskoi ASSR (Fifteen Years of Kazakhstan), designed by Nikolai Troshin, is an even more luxurious production. The book is bound in red silk, and Troshin clearly had the budget to engage in some complicated and expensive graphic effects. The transparent overlay was again a favoured design device, and Troshin devised some spectacular pages, using irregular photographic elements that folded across the photograph beneath to create what are in effect almost three-dimensional photomontages. More conventional, but equally spectacular, is a stunning fold-out montage on the subject of mining.

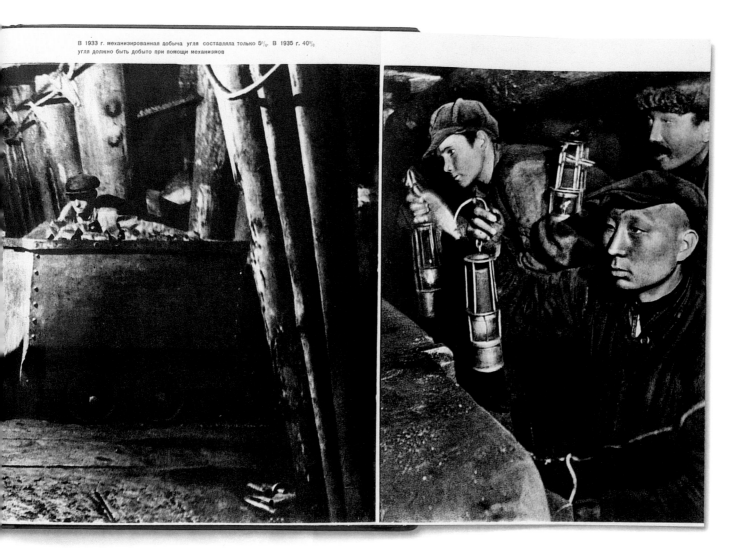

M Tursunkhodzhaev, ed. **10 Let Uzbekistana SSR** (Ten Years of Uzbekistan)
OGIZ-IZOGIZ, Moscow and Leningrad, 1934
292 × 240 mm (11½ × 9½ in), 236 pp
Hardback with full buff linen and hinged red cloth slipcase, 2 variants
Numerous monochrome photographs in various tints, fold-outs, maps, diagrams, coloured acetate overlays
Photographs by E Langman, A Shterenberg and others; design by Alexander Rodchenko and Varvara Stepanova

B M Tal'
Industriya Sotzializma
(Socialist Industry)

Following his success with *The USSR Builds for Socialism*, El Lissitsky was commissioned to design a multi-volume report along similar lines for the Seventh Congress of Soviets in 1935, an interim review of the progress of Stalin's second Five-Year Plan. In tone and content *Socialist Industry* closely follows the style of the magazine *USSR in Construction*, and El Lissitsky and his wife Sophie Küppers (who had become his close collaborator by this time) took many of the more radical design ideas they had conceived for the periodical and developed them in book form.

The result is a cornucopia of graphic design and photomontage, arguably the high point both of Lissitsky's book-designing career and of the Soviet propaganda photobook, rivalled, but certainly not surpassed by *Moskva Rekonstruiruetsya* (*Moscow Under Reconstruction*, 1938) by Alexander Rodchenko and Varvara Stepanova (see pages 168–9). It is the couple's most cinematic photobook, the result of their theoretical discussions on the techniques of montage with the film-maker Dziga Vertov. In no other book is the imagery quite so brilliantly piled up, one picture upon the other, the ideas constantly inventive and dazzling. It is as if Lissitsky found the normal form of the book page so restricting that he was compelled to push beyond its boundaries at every turn. Thus we have fold-outs, overlays, peek-a-boo images, half pages, accordion fold-outs and gatefold pages, and even stuck-in pieces of cloth. The complex photocollages almost gallop across the pages and beyond them in exuberant proclamation of the book's simple message – Production is Up on the Last Five-Year Plan! Fascicle number two, which is the largest, and devoted to the key areas of oil, mining and steel production, is particularly fine, and bulging with ideas.

It is sobering, and also inspiring, to think that all this invention has gone into what is essentially a report, and a report that was being consumed by those party apparatchiks who knew the truth or otherwise of what was being sold to them. Since the book is a review of the progress of Soviet Socialism Inc., negativity would be unthinkable. All Soviet propaganda books are relentlessly upbeat, but Lissitsky and Küppers have given new meaning to the word 'positive', investing a down-to-earth subject with a metaphysical quality somewhat at odds with the dialectic materialism of Marxism and much more in keeping with the incessant desire culture of consumer capitalism.

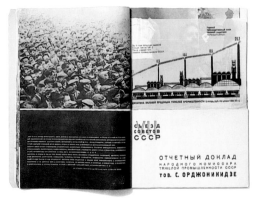
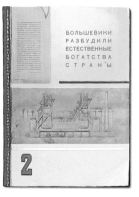
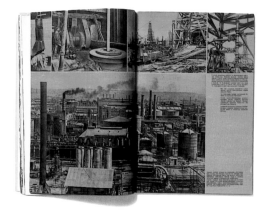
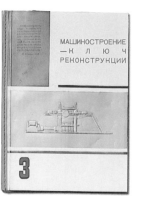
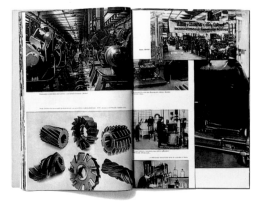

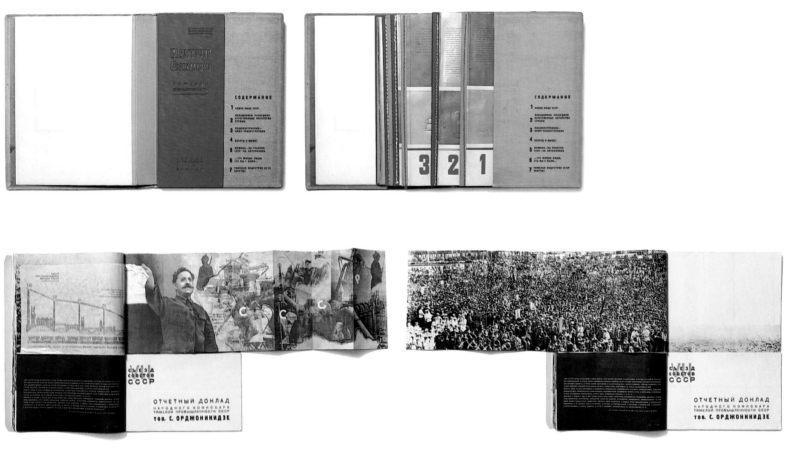

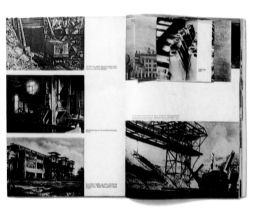

B M Tal', ed. **Industriya Sotzializma: Tyazhelaya Promyshlennost'k VII Vsesoiuznomu S'ezdy Sovetov**

(Socialist Industry: Heavy Industry for the Seventh Congress of Soviets)
IZOGIZ, Moscow, 1935
370 × 270 mm (14$\frac{1}{2}$ × 10$\frac{3}{4}$ in)
6 paperback volumes, 1 folder of maps in slipcase
Numerous monochrome photographs, colour illustrations, maps and diagrams
Text by A M Litvak; photomontages by V F Shtranikh; illustrations by M A Medvedev, F P Slutzky
and P N Staronosov; design by El Lissitsky

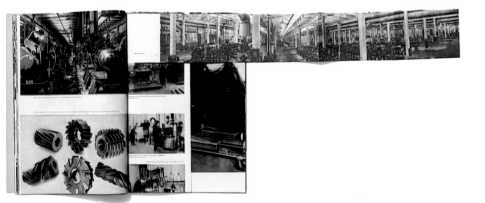

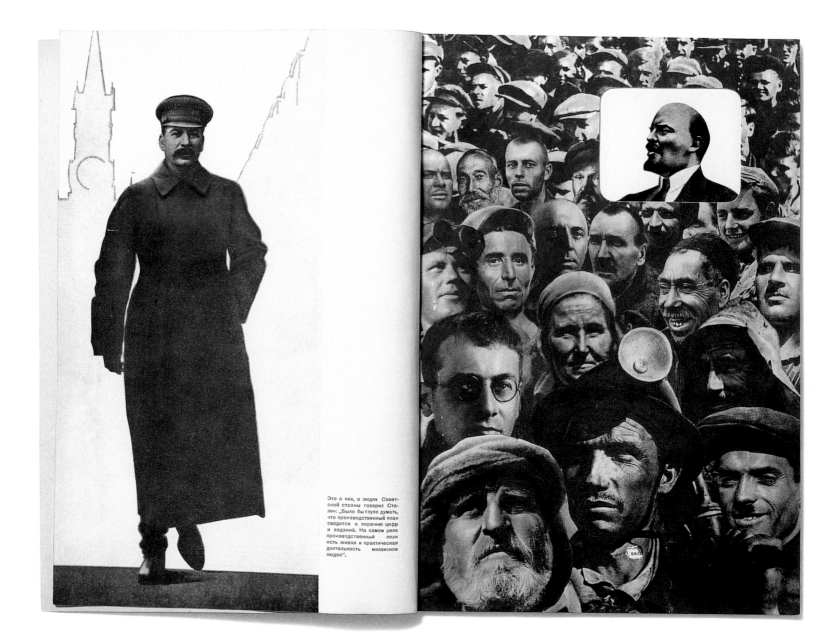

Это о них, о людях Советской страны говорил Сталин: „Было бы глупо думать, что производственный план сводится к перечню цифр и заданий. На самом деле производственный план есть живая и практическая деятельность миллионов людей".

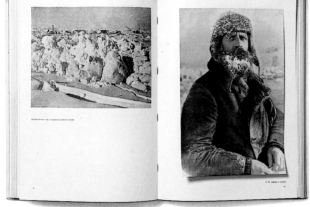

L Mekhlis, I Verite, I Bogovy and I Baevsky
Geroicheskaya Epopeya (Heroic Epic)

Amongst the grandest Soviet photobooks, the monumental *Geroicheskaya Epopeya* (Heroic Epic) celebrates one of the most glorified events in 1930s Stalinist Russia – the epic Arctic voyage of the icebreaking ship, *Chelyuskin*. This tale of exploration was mythologized as much as the British romanticized the ill-fated Antarctic expeditions of Shackleton and Scott. Led by the celebrated polar explorer Otto Schmidt, and leaving Murmansk in late 1933, the *Chelyuskin* expedition sought to force the North East Passage through the polar ice to Vladivostock in a single season. On 13 February 1934 the *Chelyuskin* became stuck fast in the ice to the north of Chukotka in Siberia, and after the loss of some lives, the crew and expedition members were forced to camp out the rest of the winter on a large ice floe.

Eventually, the group was daringly rescued by Soviet fliers, who landed their specially fitted-out planes on the ice. Fliers and expedition members returned to a heroes' welcome in Moscow, and then embarked on a triumphal tour of the Soviet Union. The leading players in the drama were created the first 'Heroes of the Soviet Union', and Stalin's propaganda machine at last had something more interesting to deal with than productivity figures.

The story is told in a thick, luxuriously produced volume, through photographs, paintings and montage, with an especially good fold-out collage at the point where the heroic fliers enter the plot. The overall effect is that of an enormous album: photographs and paintings are mixed together with memorabilia from the journey, such as cuttings from the camp's notice board. 'We are not giving up', one message poignantly reads. The photographs are for the most part splendid, especially since many were clearly taken under difficult circumstances. There is evidence of retouching and a certain amount of imaginative reconstruction, but this was standard in any Soviet propaganda book. A nice touch is that the artist who hand-coloured some of the photographs – one Grigoryev – is given a credit along with the photographers.

L Mekhlis, I Verite, I Bogovy and I Baevsky, eds. **Geroicheskaya Epopeya** (Heroic Epic)
Pravda, Moscow, 1935
350 × 265 mm (14 × 10½ in), 158 pp
Hardback with full white cloth, clear acetate jacket and hinged slipcase (not shown)
Numerous monochrome and colour photographs, illustrations and gatefolds
Texts for photographs by I Baevsky; texts for maps by M Frindliand; photographs by P Novitzky, A Shafran, N Komov, V Remov, G Ushakov,
M Troyanovsky, P Vikherev and A Karasyov, hand-coloured by Grigoryev; design by P Freiberg, S Telingater and N Sedel'nikov

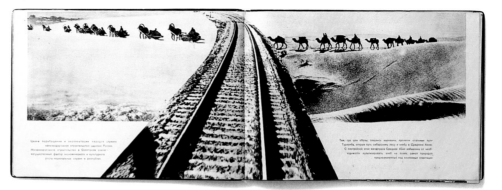

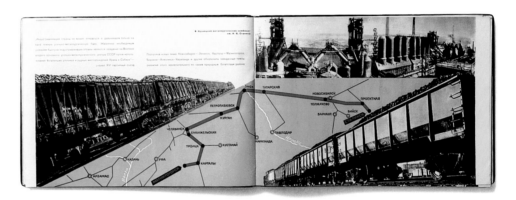

M V Ammosov, I V Ivliev, V I Popov, A B Kalatov, eds. **O Zheleznodorozhnom Transporte SSSR** (About Rail Transport in the USSR)
Transzheldorizdat (State Railway Publishing House), Moscow, 1935
240 × 345 (9½ × 13¾ in), 150 pp
Hardback with blue vinyl, silver spine, metal relief of train mounted on front cover and slipcase (not shown)
Numerous b&w photographs, 5 with tissue guards, 5 tipped-in colour illustrations, 4 fold-out spreads
Various anonymous photographers; design by Nikolai Troshin

M V Ammosov, I V Ivliev, V I Popov, A B Kalatov
O Zheleznodorozhnom Transporte SSSR
(About Rail Transport in the USSR)

Like Owen Simmons's *Book of Bread* (see page 56), the content of this 'Book of Trains', *O Zheleznodorozhnom Transporte SSSR* (About Rail Transport in the USSR), can be judged by its cover, which features a metal relief train. A report on rail transport in the Soviet Union, its dark blue front is adorned with a low-relief metal model of a locomotive engine. This also reveals something of the book's tone, for although it is an eminently serious review of the Russian rail system, there is also an element of the enthusiastic trainspotter's record about it. These magnificent engines are certainly the stars of the volume. They feature in some fold-out pages and many dramatic photographs, shot from low angles to create the maximum impression of power and efficiency.

In this book the use of photomontage becomes more sophisticated and complex. Early on there is a magnificent double-page spread that graphically symbolizes the vast size of the Soviet Union and the enormous efforts required by the State Railway Company to unify it. In one image, railway tracks vanish to the far horizon; on the right-hand side we see a camel 'train' in the desert, on the left-hand side, a sleigh 'train' in the snow.

Nikolai Troshin employs the full panoply of montage effects – superimpositions, fold-outs, and so on – as well as some dynamic photo-editing, to tell what is, after all, a standard tale. The book begins with the country, and the tracks spanning it, then the building of the railway infrastructure. It progresses, always featuring the locomotives prominently, to signalling and communications systems (the latest thing in the 1930s), then stations, and the sumptuousness of the rolling stock, then finally (to emphasize that this is a socialist country), the workers' clubs and leisure facilities.

S B Ingulov, ed. **Pishchyevaya Industriya** (The Food Industry)
OGIZ-IZOGIZ, Moscow, 1936
379 × 250 mm (15 × 9¾ in), 180 pp
Hardback with full cream vinyl and slipcase (not shown)
2 colour reproductions of paintings, 3 colour photographs and 58 b&w photographs
Various photographers; design by El and S Lissitsky

S B Ingulov
Pishchyevaya Industriya (The Food Industry)

S B Ingulov
Pishchyevaya Industriya (The Food Industry)

In 1936, El Lissitsky was commissioned by the State Publishing House for the Arts to design two publications on the subject of the Soviet food industry using the same material – one presented as a book, the other as a portfolio. By this time he was suffering increasingly from ill health, necessitating spells away in a sanatorium. Thus the bulk of the design work fell to Sophie Küppers. It seems that most of the credit for *Pishchyevaya Industriya* (The Food Industry) should thus go to her, although her husband corresponded with her at regular intervals from his Georgian sanatorium during most of the design process to ensure that she not only followed his general ideas, but did not transgress the rigid Soviet rules of political representation.

Küppers, a German, was not completely at home with those rules, despite having lived in the Soviet Union for a number of years. *Pishchyevaya Industriya* is therefore something of a hybrid, partly because of its subject matter, partly because of the circumstances of its production.[11] It seems closer to the tone and iconography of capitalist consumer advertising than to a

S B Ingulov, ed. **Pishchyevaya Industriya** (The Food Industry)
OGIZ-IZOGIZ, Moscow, 1936
497 × 407 mm (19½ × 16 in), 56 pp
Lilac silk, hessian-lined, padded portfolio box
Numerous monochrome and colour photographs and illustration
Text by A M Litvak; various anonymous photographers; design
by El and S Lissitsky

Russian industrial report, a product of Western modernism rather than of Soviet Constructivist ideas or Socialist Realism. Each image, either painting, photograph, or photomontage, is shown either singly or in pairs on a page, floating in a white border, and printed in various colours of monochrome, or even in full colour. Some are signed by the photographers who made them, such as Vladimir Gruntal, Semen Fridland, Anatoly Skurikhin, and, in the case of a montage showing the production of sunflower oil, by Küppers herself. The images, too, seem to flirt with non-Soviet tropes, such as the splendid close-up of a cockerel's head, which is Surrealist in tone. Thanks to the prominent part played by Küppers, *The Food Industry* is a fascinating instance of German modernist ideas threatening the careful iconography of Soviet propaganda.

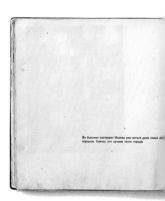

V M Gorfunkel, ed. **Moskva Rekonstruiruetsya** (Moscow under Reconstruction)
Institute IZOSTAT, Moscow, 1938
345 × 340 mm (13³⁄₄ × 13¹⁄₂ in), 126 pp
Hardback with full blue vinyl
Numerous monochrome photographs in various tints, gatefolds, maps and diagrams
Text by Viktor Sklovsky; photographs by E Langman, G Petrusov, Ya Khalip, G Zel'ma and Boldyrev; design by Alexander Rodchenko and Varvara Stepanova; cover design by N Zhukov and S Kovan'ko

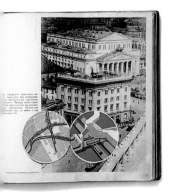

V M Gorfunkel
Moskva Rekonstruiruetsya
(Moscow under Reconstruction)

Moskva Rekonstruiruetsya (Moscow under Reconstruction) is one of the grandest of the Soviet photobooks designed by Alexander Rodchenko and Varvara Stepanova. Like most Soviet propaganda books, the title is quite literal: it documents the extensive reconstruction of Moscow during the 1930s, when Stalin used his absolute power to transform the city as brutally as Baron Haussmann had transformed Paris in the nineteenth century.

The book begins conventionally enough, with the usual portraits of Lenin and Stalin, and some full-page photographs, but it is not too long before the graphic pyrotechnics begin. A four-page fold-out panoramic photograph of a new hotel in Manezhnaya Square is followed a few pages later by the first of the 'keyhole' effects, of which Rodchenko and Stepanova seemed extremely fond. A circular lift-up flap in a photograph reveals another beneath. And so begins a whole raft of graphic effects, each piled upon the other. There are cutaways, fold-outs, a spectacular map section with a separate photographically illustrated booklet pasted into it. The 'keyhole' effect makes a number of reappearances, as in a photograph of an apartment building where sections lift away to reveal photographs of the interiors.

Photographically, one of the strongest sections deals with the extension of the metro system. Rodchenko and Stepanova use some fine architectural photographs to maximum effect – that is, as monumental full-page images, before climaxing the sequence with another 'keyhole'. A flap in a photograph of a building reveals that underneath it is a metro station, its complex interchanges represented by a coloured axonometric drawing.

As with many Soviet propaganda books, one might ask whether – amongst all the graphic exuberance, the paintings, drawings, maps and diagrams – the photographs become lost, and therefore whether this is a true photobook. The answer to this complicated question is that in the greatest examples, such as this one, the book's primary message is carried by photographs, and Rodchenko and Stepanova were well aware of it. Whenever they set a photograph into a page or a graphic framework, they do so to maximum effect.

S B Reyzin
Pervaya Konnaya (First Cavalry)

F E Rodionov
Raboche-Krest'yanskaya Krasnaya Armiya
(Red Army of Workers and Peasants)

Pervaya Konnaya (First Cavalry) is an important propaganda photobook, partly because it was designed by Rodchenko and Stepanova, and partly because it gives a fascinating insight into the history of the Soviets in the immediate aftermath of the 1917 October Revolution. The First Cavalry held an important place in the mythology of the Soviet Union due to its involvement in the Civil War between the Reds and the Whites, and because of its founder, Klimenti Voroshilov, later the first Marshal of the Soviet Union and an important figure in the development of the embryonic Red Army. This book celebrates and details the role of the cavalry and is also effectively a history of the Civil War.

One of the most sumptuous of Soviet propaganda books, *Pervaya Konnaya*, like so many, uses not only photographs (some of them by Rodchenko himself), but also paintings, drawings and various kinds of ephemera to tell the story of the brave Cossack cavalry brigades who helped turn the tide in the vicious war. The book is large in scale, and Rodchenko and Stepanova have resisted the temptation to complicate matters. They have generally used the pictures one to a page to gain maximum impact. Occasionally there is even a double-page spread, and when the images feature both cavalry and horses, as many do, the effect, to say the least, is dashing. The Boys' Own tenor, however, is

offset by some grim pictures of massacres and hangings. As with all Soviet books on a historical theme, the pictures have sometimes been heavily doctored, and documentary accuracy is not always guaranteed.

Krasnaya Armiya (Red Army) is a survey of the Soviet military forces, their various units, their equipment, capability and so on. In short, it is a book version of one of those memorable May Day parades in Red Square, when the might of Soviet military power was trundled by in a very public display. However, there is nothing trundling about this book – its designer, El

Lissitsky, saw to that. His photographic layout is as lively as one might expect from one so well versed in Constructivist angles and the complex layerings of the photomontage. The book's *coup de théâtre* comes at the beginning, with a fold-out coloured montage that features Stalin, the red star and the troops in one of Lissitsky's most bravura pieces of propaganda collage.

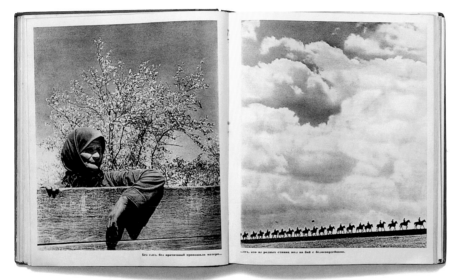

S B Reyzin, ed. **Pervaya Konnaya** (First Cavalry)
OGIZ-IZOGIZ, Moscow, 1937
355 × 305 mm (14 × 12 in), 306 pp
Hardback with red leather and embossed inset page with gold finish
Numerous monochrome photographs in various tints, illustrations and maps
Text by O L Leonidov; photographs by M G Prekhner, Alexander Rodchenko, A S Shayhet, I M Shagin; design by Alexander Rodchenko and Varvara Stepanova

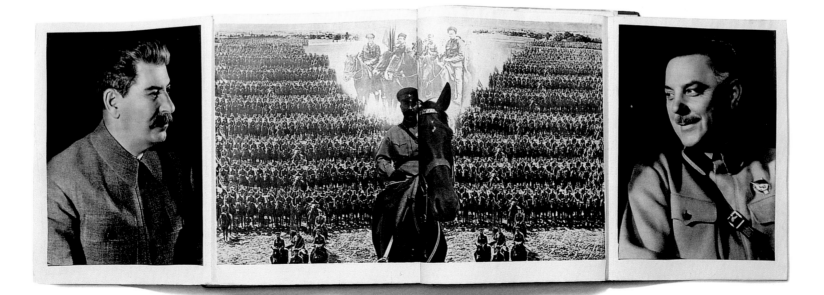

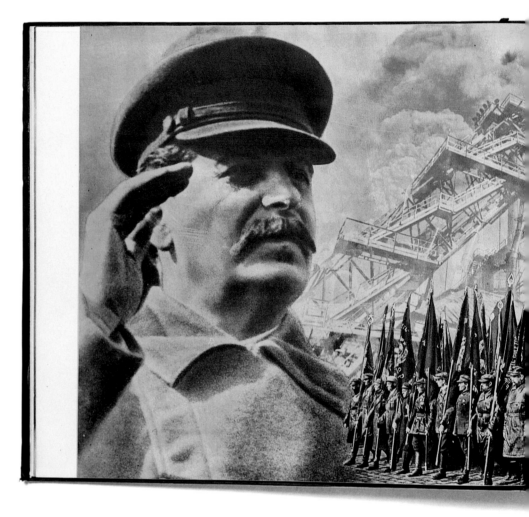

F E Rodionov, ed. **Raboche-Krest'yanskaya Krasnaya Armiya** (Red Army of Workers and Peasants)
OGIZ-IZOGIZ, Moscow, 1934
305 × 355 mm (12 × 14 in), 200 pp
Hardback with blue cloth doubling as slipcase
Numerous monochrome photographs in various tints and photomontages, 1 fold-out photomontage
Photographs by G Zel'manovich, D Debabov, A Polyakov, A Shaykhet, P Lass, M Khan, A Skuririkhin,
I Shagin and V Gryuntal; design by El Lissitsky

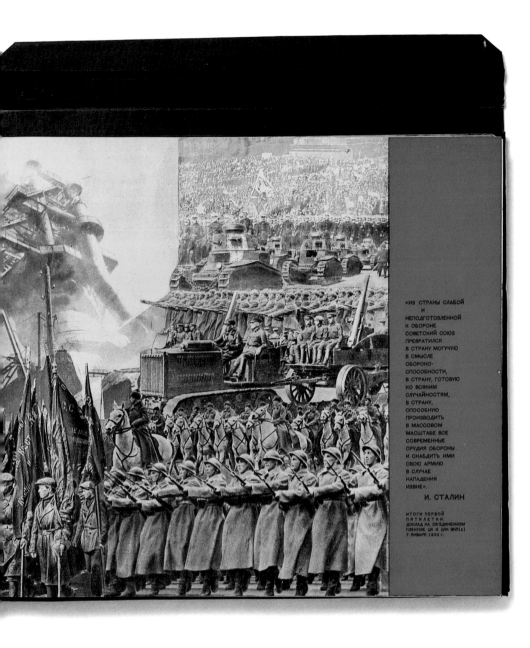

«ИЗ СТРАНЫ СЛАБОЙ
И
НЕПОДГОТОВЛЕННОЙ
К ОБОРОНЕ
СОВЕТСКИЙ СОЮЗ
ПРЕВРАТИЛСЯ
В СТРАНУ МОГУЧУЮ
В СМЫСЛЕ
ОБОРОНО-
СПОСОБНОСТИ,
В СТРАНУ, ГОТОВУЮ
КО ВСЯКИМ
СЛУЧАЙНОСТЯМ,
В СТРАНУ,
СПОСОБНУЮ
ПРОИЗВОДИТЬ
В МАССОВОМ
МАСШТАБЕ ВСЕ
СОВРЕМЕННЫЕ
ОРУДИЯ ОБОРОНЫ
И СНАБДИТЬ ИМИ
СВОЮ АРМИЮ
В СЛУЧАЕ
НАПАДЕНИЯ
ИЗВНЕ».
И. СТАЛИН

ИТОГИ ПЕРВОЙ
ПЯТИЛЕТКИ.
ДОКЛАД НА ОБЪЕДИНЕННОМ
ПЛЕНУМЕ ЦК И ЦКК ВКП(б)
7 ЯНВАРЯ 1933 г.

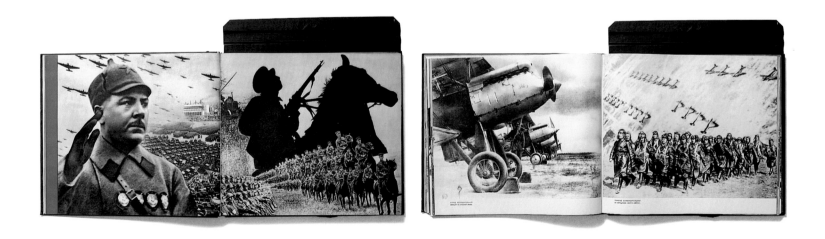

Various photographers
The Land without Unemployment

'We believe this book will serve its purpose. It will, we are sure, make more widespread and general a knowledge of the facts and tendencies of the planned socialist construction now being accomplished in the USSR.' These optimistic words introduce a remarkable propaganda photobook published in the United States at a time when it was believed that the socialist experiment had much to offer, when the American Communist Party and other socialist organizations had plenty of supporters and were able to exercise their rights to free speech under the US constitution.

Margaret Bourke-White, whose leftist views were no secret, made several highly publicized trips to the Soviet Union beginning in 1930, and brought out her favourable view of the Soviet experiment *Eyes on Russia* a year later. *Land without Unemployment*, by contrast, is an unashamedly propagandist book, originally published in Germany and featuring texts by well-known leftist German writers such as Ernst Glaeser and Alfred Kurella. The photographs emanate from Soviet sources, and were edited in Germany; thus they are part of the international socialist propaganda machine. The book delineates the usual iconography of such enterprises – a happy working population and soaring production – and many of the pictures indicate the influence of Rodchenko and the New Vision on Soviet photojournalism. The captions are frequently embarrassing – for example, an image of a girl swimmer is captioned, 'Communism is not a menace to beauty.' However, in his text, Alfred Kurella makes a more considered case for the socialist way of life and the collectivization of society. This is an extremely interesting book, reminding us that during the Great Depression of the 1930s the American left had a voice, and was not afraid to use it.

Various photographers **The Land without Unemployment**
International Publishers, New York, 1931
268 × 180 mm (10½ × 7 in), 240 pp
Hardback with full black cloth and jacket
230 b&w photographs
Edited by Ernst Glaeser and F G Weiskopf; postscript by Alfred Kurella

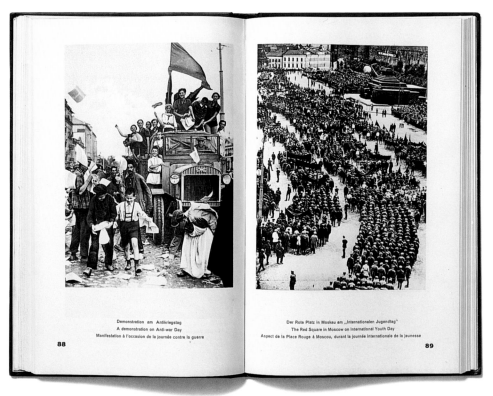

Demonstration am Antikriegstag
A demonstration on Anti-war Day
Manifestation à l'occasion de la journée contre la guerre

88

Der Rote Platz in Moskau am „Internationalen Jugendtag"
The Red Square in Moscow on International Youth Day
Aspect de la Place Rouge à Moscou, durant la journée internationale de la jeunesse

89

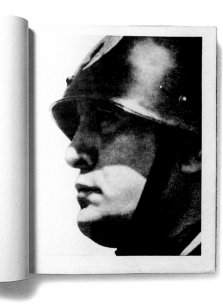

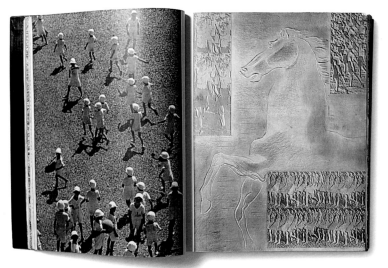

Manilo Morgagni, ed. **Italia imperiale (La Rivista illustrata del 'popolo d'italia')**
(Imperial Italy (Italian People's Illustrated Magazine))
La Rivista Illustrata del 'Popolo d'Italia', Milan, 1937
446 × 375 mm (17½ × 15 in), 624 pp
Hardback with cardboard slipcase (not shown)
Numerous paintings, illustrations and b&w photographs
Various authors; photographs by Stefano Bricarelli, Frederico Patellani, Lucio Ridenti and Bruno Stefani; illustrations by Bramante Buffoni,
Erberto Carboni, Paolo Garretto, Ruggero Micaelles, Marcello Nizzoli and Mario Sironi

Manilo Morgagni
Italia imperiale (Imperial Italy)

The best Italian propaganda photobook from the fascist era has to be *Italia imperiale*. A 'special issue' of the magazine *La Rivista illustrata del 'popolo d'italia'* (Italian People's Illustrated Magazine), this enormous volume is the ultimate guide to the Italy of Benito Mussolini, the Italian equivalent of the great Russian propaganda photographic books.

The book combines some excellent modernist photography with painted illustrations and photocollages, but its immediate impact derives from its size – a full-page photograph or montage on this scale has enormous power, especially the many splendid industrial and architectural photographs in the New Vision style. Particularly notable is a close-up portrait of Il Duce, which is almost life-size, overbearing and impressive.

Italia imperiale runs through the more-or-less standard iconography of propaganda books, beginning with history – close-ups of Roman ruins, an account of the Venetian and Genoese maritime republics – before introducing Il Capo and accounts of Italy's ill-fated colonialist military adventures of the 1930s in such places as Ethiopia and Somalia, before we are given extensive and interesting views of Italy under construction. There are many fine examples of architectural and industrial photography. The architectural imagery primarily features buildings in the 'fascist modern' style, that rigidly classical mode that seemed to be adopted by all the fascist countries, but nowhere more successfully than in Italy, its natural home.

Pay Christian Cartensen, Hans Hitzer and
Friedrich Richter
Deutschland (Germany)

Anonymous
Deutschland Ausstellung (German Exhibition)

It is not simply a result of the Nazis' innate distrust of
the avant garde that German propaganda photobooks
tend to be more straightforward and less obviously
vital than their Soviet counterparts. It is also due to the
fact that many of Germany's best photographers and
artists had left the country. However, both *Deutsch-land* (Germany) and *Deutschland Ausstellung* (German
Exhibition), the small book published to mark the
occasion of the German cultural exhibition at the 1936
Berlin Olympic games, incorporate Soviet-style mon-
tage techniques with a degree of flair.

 Deutschland, as its title would suggest, runs through
the cultural and economic achievements of Hitler's
Germany, beginning with a survey of the country itself,
the land, the people and the cities, and progressing to
the development of industry and the autobahns, before
ending on a more militaristic note with the armed
forces and the National Socialist party. The book culmi-
nates with a *coup de théâtre* worthy of Rodchenko or
Lissitsky. A double-page spread of Hitler Youth adoring
the Führer has a fold-down flap that, when opened up,
reveals a huge blood-red swastika flag.

 The Berlin Olympic Games in 1936 was the occasion
for the publication of perhaps the most successful
example from the Nazi era of the propaganda pho-
tomontage in the full-blown Soviet style. A trade fair and
a cultural exhibition were held alongside the games, and
the catalogue was designed by the noted Bauhaus
teacher, Herbert Bayer. An architect, typographer and
photographer, Bayer worked for the Berlin office of the
international advertising agency, Dorland, and was not
a Nazi – indeed he emigrated to America in 1938 and
became a respected American citizen. For this striking
book he created a series of elaborate and colourful pho-
tomontages spread across two pages, the New Vision
meeting Constructivist collage. The most renowned is
one that depicts the dynamism of the electricity indus-
try, as well as a montage showing a 'Triumph of the
Will' type gathering, without unduly emphasizing the
Nazi element. As this was a cultural event, and the
publication was intended for an overseas as well as a
domestic market, it was only circumspect to underplay
the more belligerent face of National Socialism.

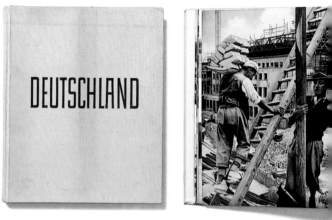

Pay Christian Cartensen, Hans Hitzer and Friedrich Richter **Deutschland** (Germany)
Volk und Reich Verlag, Berlin, 1936
(Also published in English and Spanish editions)
340 × 260 mm (13¼ × 10½ in), 260 pp
Hardback with full white linen
Numerous b&w, colour photographs and photomontages, and 1 fold-out
Various anonymous photographers and illustrators

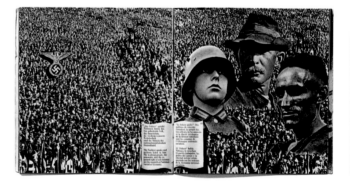

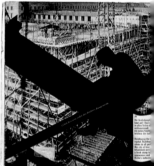

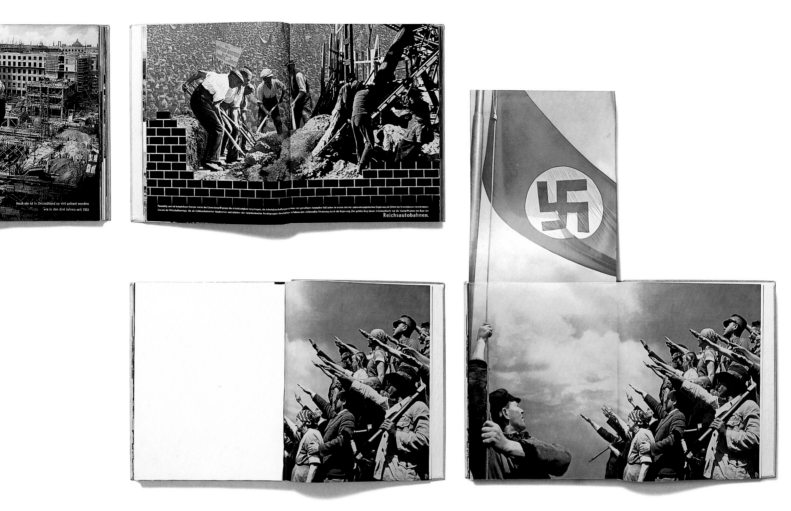

Anonymous **Deutschland Ausstellung** (German Exhibition)
Deutschland Ausstellung, Berlin and Frankfurt, 1936
211 × 211 mm (8¼ × 8¼ in), 28 pp
Paperback
14 colour photomontages
Text by anonymous author; design by Herbert Bayer

Various photographers **Nippon** (Japan)
Kokusai Bunka Shinkokai, Tokyo, 1937
275 × 305 mm (10³⁄₄ × 12 in), 64 pp
Hardback
Edited by Goro Kumada; various photographers,
including Yonosuke Natori, Ihei Kimura, Masao
Horino, Yoshio Watanabe, Ken Domon;
photomontages by Goro Kumada

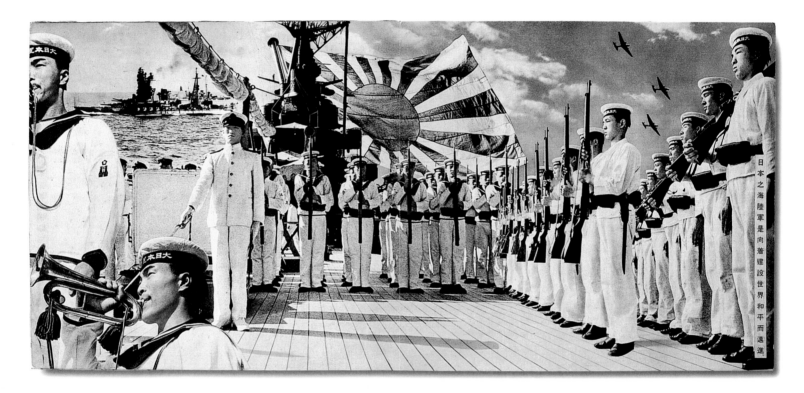

Various photographers
Nippon (Japan)

The rise of Japan during the 1930s as a nationalistic, militaristic nation created widespread international tensions, particularly after the country fought a brutal war in Manchuria in 1931. In 1934, as part of the Japanese efforts to mollify the West, the journal *Nippon* (Japan) was launched. This was a quarterly photographic magazine, printed in English, French, German and Spanish. The model was clearly *USSR in Construction*, and as with that magazine, and other propaganda journals from totalitarian states, money was no object. The best Japanese designers and photographers were employed to ensure that Japan presented its best face to the world.

And just as *USSR in Construction* generated books, so did *Nippon*. In 1937 the book *Nippon* was published. It contained a number of photomontages on the subject of Japanese culture and achievements, fabricated from the work of *Nippon* magazine staff photographers. These included two young men who would figure prominently in postwar Japanese photography – Ken Domon and Ihei Kimura.

These montages are both complex and exuberant, inspired by European models, but adapted to local cultural traditions. The flattened, non-hierarchical pictorial space, for example, is derived from the *ukiyo-e* (floating world) woodblock prints of the eighteenth and nineteenth centuries. Since these prints had also influenced the spatial concepts of modernism in the West, an interesting cyclical influence is at work in this book. A

further link with Japanese traditions is seen in the actual form of the book. The montages are strung together in a single accordion, or fan fold-out, like the cheap Japanese 'pillow books' that were printed in their thousands from woodblock engravings. In all, *Nippon* demonstrates a fascinating blend of innovation and tradition, and is arguably the highpoint of both the Japanese propaganda and the modernist photobook.

Heinrich Hoffmann
Das Antlitz des Führers (The Face of Hitler)

It is doubtful whether the title of Heinrich Hoffmann's book, *Das Antlitz des Führers* (The Face of Hitler) constitutes a deliberately ironic reference to August Sander, whose own famous *Antlitz der Zeit* (Face of Our Time, 1929) (see page 124) was banned by the National Socialists. The Nazis were not, it seems, strong on irony. But like Sander's great book, Hoffmann's is a series of portraits. While Sander concentrated on the cataloguing of types, however, Hoffmann focused on only one: Adolf Hitler. As his personal photographer, it was his task to cultivate the 'face' of the Führer, carefully portraying the roles that the leader was required to adopt when guiding Germany to its bright new future – everything from 'father of the people' to military strategist, to friend of little children.

Das Antlitz des Führers collects one portrait of Hitler per year, accompanied by excerpts from his writings and speeches. It starts in 1919, the year Hoffmann became Hitler's 'official' photographer, and culminates in 1939. However, there are slight anomalies – for example, the 1929 and 1934 portraits seem to have derived from the same studio session.

Although the portraits tend to show Hitler in military uniform, there is little to indicate that the Führer was actively engaged in exterminating a whole section of his own German citizenry or about to plunge the nation into a disastrous war. Victorian phrenologists would be disappointed, because if evil has a face, it is not seen in Hoffmann's generally formal portraits, which show the thoughtful side of Hitler, a man taking his responsibilities calmly and soberly. The face of evil has been masked by the cloak of public office.

Hitler was highly aware of his image, and the impression he most wanted to project was one of statesmanship. In 1933, after he came to power, he banned any photographs that showed him as the caricature German in lederhosen. He was contemptuous of the fact that Mussolini would allow himself to be photographed in a bathing costume. The face of Hitler shown in this book is thus a sober one, perhaps epitomized by the book's most outstanding image, where he stands alone in a field, leaning against a fence, head bowed, looking careworn. Here the message is of the leader as an isolated being, no demigod but a man who will sacrifice all for the well-being of his people. We know, of course, that the message and the reality were two very different things. Hitler was prepared to sacrifice all his people for the sake of a mad dream.

Heinrich Hoffmann **Das Antlitz des Führers** (The Face of Hitler)
Zeitgeschichte Verlag Wilhelm Andermann, Berlin, 1939
265 × 190 mm (10¹₂ × 7¹₂ in), 40 pp
Hardback with decorated paper
16 b&w photographs
Preface by Baldur von Schirach; introduction by Heinrich Hoffmann

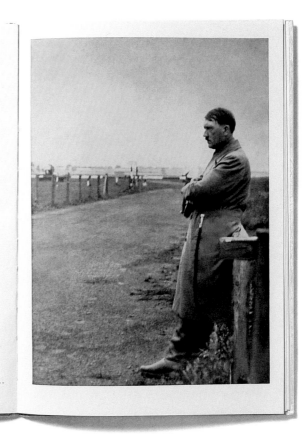

Auf dem Wege zum Großdeutschen Reich: Einsame Stunden der einsamen Entscheidungen . . .

Archibald MacLeish
Land of the Free

Land of the Free, compiled by the poet and some-time Librarian of Congress, Archibald MacLeish, can be regarded as basically an American propaganda photobook. However, as we have seen, the line between documentary, propaganda and report is a thin one, and often in the eye of the beholder. Described by MacLeish on the jacket as 'a book of photographs illustrated by a poem', it has been seen by some commentators as liberal agitprop, tending towards the subversive and the unpatriotic. William Stott, for example, talks of its 'militant tone', though he admits that it was perhaps

appropriate at the time. Others, however, see the book less in political terms, and more as a fusion of art with documentary to make a heartfelt but measured declaration about the condition of the United States during the Great Depression.

To a non-American the interesting thing about the book's tone would seem to be its fusion of political breast-beating and anger with optimism – an individual expression of the ideas behind Roosevelt's New Deal programme. So the book's title is both ironic and yet an article of faith. The next line of 'The Star-Spangled Banner' – 'the Home of the Brave' – is never far away, in spite of the pictures of breadlines, barbed wire, strikes and union men being beaten up by the police.

The book was unusual for its time in that its simultaneously published British and American editions had different covers (shown here with the British version on the left). It is illustrated with carefully chosen photographs, primarily from the files of the FSA and the Allied News Photo-Agency. The latter supplied the more 'newsy' and downbeat pictures of strikes and so on. Many FSA 'classics' are there, such as the inevitable *Migrant Mother*, along with other fine images by Dorothea Lange, Walker Evans, Russell Lee and the usual suspects. Despite its propensity for sentimentality and tendentiousness, *Land of the Free* is a curiously inspiring book, a remarkable document of the general sentiment of the era.

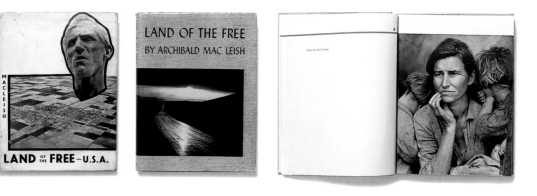

Archibald MacLeish, ed. **Land of the Free**
Boriswood Ltd, London, and Harcourt, Brace and Company, New York, 1938
238 × 184 mm (9¼ × 7¼ in), 188 pp
Hardback with full linen and jacket
88 b&w photographs
Poem by Archibald MacLeish; photographs from government archives, mainly FSA;
design by Robert Josephy

Erwin Berghaus
USA – nackt!: Bilddokumente aus Gottes eigenem Land
(USA – Naked!: Photographs from God's Own Country)

USA – nackt! (USA – Naked!) sounds like the title of a Weegee book. Coincidentally, his *Naked City* was published within two years of this volume, and both sought to strip American society bare. However, the author of *USA – nackt!* would hardly have approved of Weegee, who was not only Jewish but represented the American decadence that this Nazi book aimed to expose. The United States had entered World War II, and one of the book's principal targets, the steadfastly antifascist Franklin D Roosevelt, is pictured with a caption quoting him as saying: 'Now I have my War.'

It is fascinating to compare *USA – nackt!* with Archibald MacLeish's *Land of the Free*. Both are extended picture stories with captions, but while MacLeish exudes that eternal (infernal) American optimism, despite the country's rough passage through the 1930s, Berghaus has a very different take. The pictures that he chooses are almost identical, drawn from newspaper imagery and FSA material (a variant of Dorothea Lange's *Migrant Mother* is included), but both captions and image twist the meaning around and paint as damning a picture as possible. There are references to President Roosevelt's 'friends' – Jews and Freemasons – and the caption under an image of him affectionately greeting his secretary does not fail to mention that she is the 'Jewess Ruth Goldberg'; Hollywood is referred to as 'America's Jerusalem'.

Decadence and class/race relations are further targets. One of the images reproduced is the well-known Margaret Bourke-White picture of a Negro breadline queue in front of a poster featuring a smiling white family in a car, with the slogan 'America, the World's highest Standard of Living'. This kind of ironic juxtaposition is repeated endlessly, the Nazis laying on the sarcasm not with a trowel but with a shovel. A page of photographs of lynchings is captioned 'The Land of the Four Freedoms'. It is a hypocritical, poisonous little book in the mode of the *Illustrierte Beobachter* (Pictorial Observer) and other Nazi literature, but it is also an important and fascinating demonstration of the thin line between document and propaganda, and how the meanings of photographs are constructed and defined by their context.

Anonymous
La Colonizzazione del latifondo siciliano, primo anno
(The Colonization of Rural Sicily, First Year)

Since this photobook documents the achievement of a totalitarian government, it can rightly be classified as propaganda. Yet the tone of the book is dry, factual and downbeat. Its anonymous makers should perhaps have been sent to Russia to learn how to make more powerful propaganda books – were fascist Italy not at war with communist Russia. *La Colonizzazione del Latifondo Siciliano* (The Colonization of Rural Sicily) documents improvements to especially poor areas of Sicily, brought about by the Mussolini government. As such, it is both propaganda and factual document, and again raises the question of where propaganda begins and documentary ends. Indeed, it is so objective and unspectacular in its presentation that it could easily be compared by postmodern bibliophiles to the kind of Conceptual photobooks produced in the 1970s by artists such as Ed Ruscha or Bernd and Hilla Becher, especially in its use of a grid layout to reproduce the repetitive grey images.

And yet the book tells a compelling story. Beyond the photographs, which are absolutely fascinating in their scrupulous objectivity, the book presents the actual legislation framing these improvements – decrees that brought roads, water, power supplies and model housing to underprivileged parts of Sicily. They are not the flashy, monumental projects that one associates with fascist regimes, and this hugely interesting historical document reminds us that no matter how repulsive the ideological bent of a government, the everyday business of running a country still continues. It also reminds us that, free from the messy compromises of democracy, totalitarian governments tend to be better at making the trains run on time.

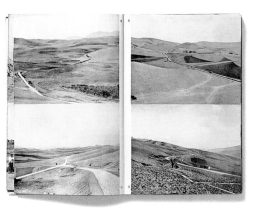

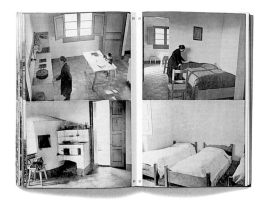

Anonymous **La Colonizzazione del latifondo siciliano, primo anno**
(The Colonization of Rural Sicily, First Year)
Ministero dell'Agricoltura e della Foreste, 1940
262 × 180 mm (10½ × 7 in), 412 pp, plus 1 loose page of sheet music
Paperback
378 b&w photographs
Various anonymous documents

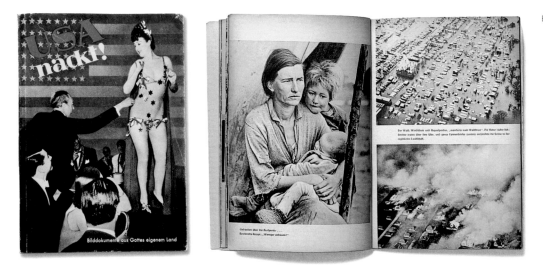

Erwin Berghaus, ed. **USA – nackt!: Bilddokumente aus Gottes eigenem Land**
(USA – Naked!: Photographs from God's Own Country)
Brunnen Verlag/Willi Bischof, Berlin, 1943
249 × 179 mm (9¾ × 7 in), 130 pp
Paperback with jacket
146 b&w photographs
Text by Erwin Berghaus; various anonymous photographers

Gerhard Puhlmann
Die Stalinallee (Stalinallee)

Propaganda photobooks come in all shapes, sizes and ideologies. Sometimes they tell half-truths; sometimes they lie outright; sometimes they are as factual as company reports. Gerhard Puhlmann's photographic record of East Germany's most trumpeted reconstruction initiative, whilst clearly extolling the virtues of the enterprise, is in the latter category, the most benign of propaganda books.

The Stalinallee, which was renamed the Frankfurter Allee and the Karl-Marx Allee in 1961 (when Stalin's name fell from grace), was the most important town-planning project to be carried out in East Berlin. This vast east-west boulevard, 75 to 80 metres wide, ended at the Alexanderplatz, the centre of Soviet-occupied Berlin. Designed by a team under the East German architect Heinrich Henselmann, it was an enormously ambitious scheme, the first phase of which was lovingly documented in Puhlmann's book. Not only was it regarded as a vast social housing project, but it was also an aesthetic expression of the new socialist society. It was built between 1952 and 1957 in a monumental Neo-classical style that became a model for town planning throughout East Germany, chosen in opposition to the preferred modernist public architecture of Western capitalism.

If the Stalinallee was somewhat severe, the flats were well designed – though built a little too quickly – and provided decent housing for the East Berlin population at a time when a large proportion of the city – 25 per cent, rising to 80 per cent in the city centre – had been destroyed or badly damaged. The associations with Stalin have not prevented them from fetching healthy prices in the current Berlin housing market, nor, following reunification, have such bulwarks of capitalism like Citibank or McDonalds been too proud to take space in this fascinating street, beautifully and exhaustively documented by Puhlmann in this book.

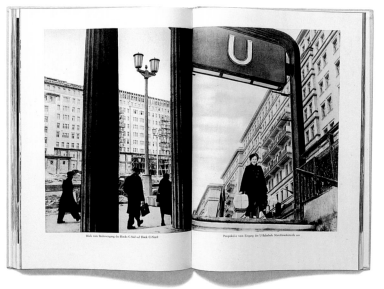

Gerhard Puhlmann **Die Stalinallee: Nationales Aufbauprogramm**
(Stalinallee: The National Reconstruction Programme)
Verlag der Nation, Berlin, 1952
339 × 240 mm (13½ × 9¾ in), 204 pp
Hardback with full buff linen and jacket
286 b&w photographs, 3 photomontages and illustrations
Various anonymous photographers

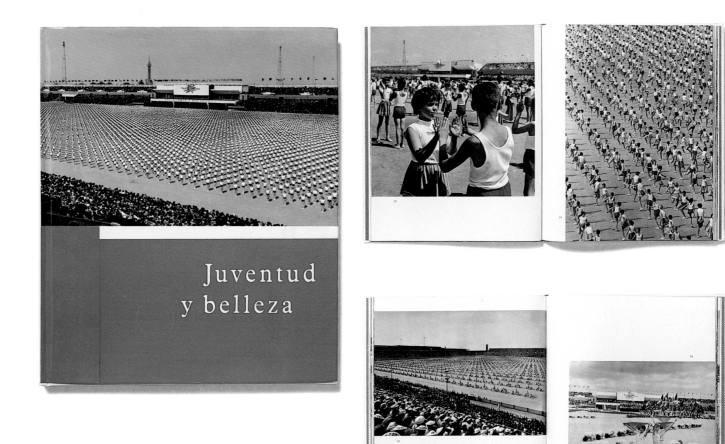

František Kožík **Juventud y belleza** (Youth and Beauty)
Artia, Prague, 1961
275 × 240 mm (11 × 9½ in), 82 pp including 1 gatefold
Hardback with jacket
81 colour photographs
Text by František Kožík; photographs by Karel Neubert; design by Jaroslav Sváb

František Kožík
Juventud y belleza (Youth and Beauty)

A feature of totalitarian governments, whether of the left or the right, is to organize the masses, partly to keep them happy, partly to keep them in line. A way of doing this is through the cult of the body beautiful and the sporting achievements of the nation. *Juventud y belleza* (Youth and Beauty), made by František Kožík for the Czech communist regime, looks at that country's sports festivals. The book's title is in Spanish, indicating that this is a propaganda publication aimed at the export market, as many of these books were.

In totalitarian societies where the individual is seen as one cog in a vast collective enterprise, the mass rally is a vital part of state ritual, and a potent image. One immediately thinks of the Nuremberg rallies in Nazi Germany, photographed by Leni Riefenstahl, Heinrich Hoffmann and others, or of Alexander Rodchenko's angular New Vision photographs of massed ranks of Russian athletes. Kožík takes Rodchenko's rational approach, photographing from far away and from above to capture the overall pattern of stadia filled with serried ranks of athletes. This kind of shot emphasizes the subsuming of the individual into the mass of uniformed, identical humanity. He also photographs from low down and close up, concentrating on sturdy-thighed girls and broad-shouldered youths, the standard iconography of 'strength through joy' sports propaganda. This is a relatively benign aspect of the propaganda genre, although the trope transfers seamlessly to a view of the massed ranks of the military. The point of the book is that it is about national pride and national health, printed in vibrant colour, and demonstrates Kožík's excellent eye for pattern, texture and hue.

Various photographers
Shqiperia Socialiste Marshon
(Socialist Albania on the March)

As the twentieth century drew to a close, and the communist system was under increasing pressure from the sheer success of Western capitalism, the stylistic convergences between the propaganda book in the socialist countries and the company report in the capitalist countries became more and more apparent. Whereas the propaganda book in the 1930s and 40s loudly proclaimed itself as such, postwar books sought to distance themselves from the rhetoric of overt propaganda and to masquerade as the purely documentary.

The enormous growth of television would seem partly responsible for this. While television took over as the main disseminator of visual messages, the indiscriminate ubiquity of photographic imagery on the box made consumers – even in countries where free thinking was frowned upon – suspicious of photography's claims to veracity. Both makers and consumers of photographic images became increasingly aware of the kinds of rhetoric and strategies involved. Thus those seeking to persuade by means of photography tried to make photographs that appeared to be without rhetoric, as close to the appearance of an unmannered, transparent report as possible.

Shqiperia Socialiste Marshon (Socialist Albania on the March) is a good example of this more subdued kind of propaganda book. A survey of socialist progress in Albania, it touches the usual bases – the land, the people, the culture, the economy, military and sport – but is largely free of the bombastic tone of prewar propaganda photobooks. The graphic design is functional rather than flamboyant, and the photographs are closer in appearance to their Western counterparts in photojournalistic books or volumes of travel, industrial or sports photographs.

Various photographers **Shqiperia Socialiste Marshon**
(Socialist Albania on the March)
Shtëpia Botonjëse, Niam Frashëri, Tirana, 1969
300 × 335 mm (12 × 13 in), 242 pp
Hardback with full red cloth
158 colour and 51 b&w photographs
Text by anonymous author

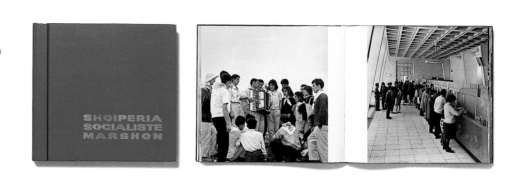

Anonymous
Long Live the Bright Instruction

1966 was a momentous year in Chinese politics, for it marked the beginning of Mao Zedong's Cultural Revolution and the forming of the notorious Red Guards. *Long Live the Bright Instruction* celebrates five years of the Cultural Revolution, which Mao and his intimates initiated in an attempt to regain power after he had been demoted following the failure of his main policy initiative in the previous decade – the 'Great Leap Forward'.

This is a true propaganda book in the sense that the bright colour photographs – most of them as carefully staged as an advertising shoot – totally mask the reality of the Cultural Revolution while extolling its virtues, exactly at the point when it was becoming discredited. The photographs show groups of workers, peasants and Red Guards, happily smiling, getting on with the 'revolution', or sitting around studying their copies of *Quotations from Chairman Mao Zedong* (1964) – better known as the notorious *Little Red Book* – the publication that became the ideological basis for the Cultural Revolution.

The reality was somewhat different. During the Cultural Revolution violent purges were carried out on a scale to match Stalin's iniquities during the 1930s. The Red Guards, mostly disaffected youths, ruthlessly attacked 'bourgeois' professors, and 'non-revolutionary' bureaucrats and workers, until in 1969 the army had to be brought in to quell a growing crisis. By 1971 the Cultural Revolution was not over but – especially following the mysterious death of Mao's main supporter, Lin Piao – it was tottering to an end. Images of Lin Piao at the front of the book have been defaced or, more frequently, torn out in most extant copies.

Anonymous **Long Live the Bright Instruction**
People's Liberation Army Picture Publishing, Beijing, 1971
292 × 260 mm (11½ × 10¼ in), 232 pp
Hardback with full red cloth, plastic cover and cardboard slipcase (not shown)
67 colour and 79 b&w photographs

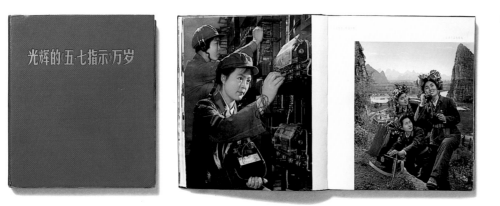

Anonymous
Mao Tsetung

While Hitler had his own personal photographer in Heinrich Hoffmann, Mao Zedong had Xu Xiaobing and his wife, Hou Bo, who took the photographs in this book. She was Mao's official portrait photographer from 1950 until 1962, when she aroused the ire of the Chairman's fearsome wife, Jiang Jing, and was sent to a labour camp on the orders of this future member of the Gang of Four.

Hou Bo was never credited as the author of these official portraits, nor received copyright. Thus, unlike Hoffmann, she did not become rich as a result of the fact that her photographs were published in their hundreds of millions, distributed and shown everywhere – especially during the Cultural Revolution – carried around by the Red Guards and prominently displayed in every Chinese home.

Like Hitler, and political leaders everywhere, Mao insisted on acting out his favourite roles for the camera – among them Mao the Prophet, Mao the Educator and Mao the Strategist. This was symptomatic of the almost unprecedented personality cult that surrounded the Chinese leader, who seemed to have a creepy resistance to the normal signs of ageing. Although overlaid with the inevitable heavy retouching and tailored to the demands of propaganda, Hou Bo's portraits cannot hide his tremendous force of character and vitality. However, even in the more tender, private moments, there is little sign of the mask slipping; no affection or humanity creeps out.

Looking at some of the superb, iconic images in this fascinating book, which was published in six languages – English, Mandarin, Japanese, French, German and Spanish – it seems incredible that the official reason for Bo's fall from grace was the allegation that she had never taken a good photograph of the Chairman. The real reason, it appears, was quite the opposite. Madame Jing wanted to monopolize Hou Bo's photographic talents for her own aggrandizement, and when the photographer refused, she spent three hard years in a labour camp, emerging almost blind, and then spent a further seven years before her rehabilitation working as a cleaner for the New China Press Agency.

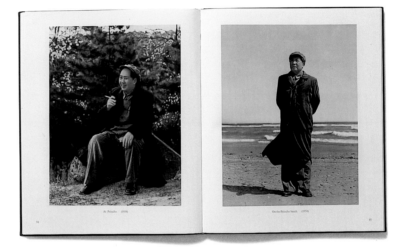

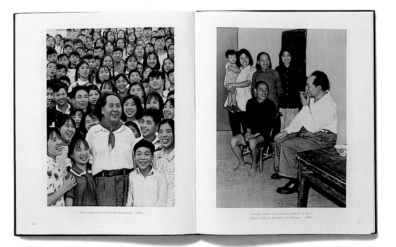

Anonymous **Mao Tsetung: A Selection of Photographs**
The People's Fine Arts Publishing House Foreign Languages Press, 1978
370 × 310 mm (14¹⁄₂ × 12¹⁄₄ in), 216 pp
Hardback with full red cloth, acetate cover and cardboard slipcase (not shown)
200 colour photographs
Edited by the Editorial Department of Chinese Photography; foreword by anonymous author

Memory and Reconstruction
The Postwar European Photobook

There now remains only one weekly magazine in Europe of high photographic quality – Paris Match, *founded in March 1949. With few exceptions, the others endeavour to excite the public with sensational pictures rather than satisfy them with creative ones. People of discernment with a taste for good photography may find certain monthly magazines like* Du *(Zurich),* Réalités *(Paris), and* Magnum *(Cologne) more appealing. But the best of European photography is now to be found in books rather than magazines, and a library of photobooks, despised by philistines, is as vital to visually sensitive people as good stereophonic records are to serious music lovers.* Helmut Gernsheim (1965)[1]

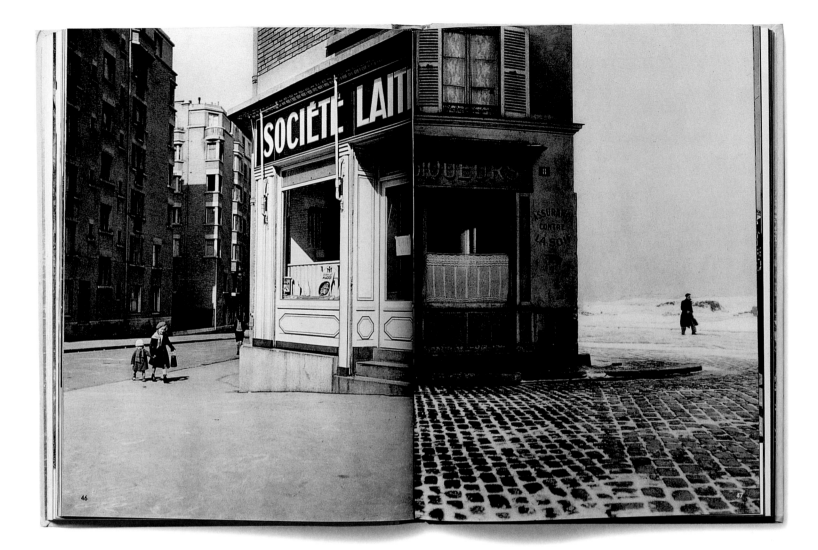

Blaise Cendrars and Robert Doisneau
La Banlieue de paris (The Suburbs of Paris)
Pierre Seghers, Paris, 1949

Doisneau's best book, characteristically
humane, captured the postwar suburbs
of Paris just before they changed beyond
recognition from spirited working-class
neighbourhoods to the urban wasteland
that architects and planners created from
the 1960s onwards.

During the years immediately following the war the primary tasks facing Western Europe and the United States (the situation was a little different in Soviet-dominated Eastern Europe) could be defined as reconstruction and reconciliation. And even in retrospect it is difficult to appreciate how successful Western Europe was in achieving these aims, due mainly to the carrot supplied by the Marshall Plan (a programme of loans provided by the United States for the purposes of rebuilding) and the stick waved by the Soviets. The collective effort of the democracies was remarkable, even if one could say that the imminent threat from the communist bloc concentrated minds to a large degree. In only four years West Germany, occupied by the United States, Great Britain and France, achieved a significant measure of self-government, and an equitable place in the community of Western democracies.

In the arts, reconstruction and reconciliation were also the watchwords, but the best art holds up a critical mirror to life, and reconstruction and reconciliation were accompanied by memory and reflection. The European avant garde, as it did following World War I, reacted with a nihilistic art movement that expressed the built-up residue of rage, grief, bitterness, anxiety and guilt following the conflict. After the Great War it was Dada. Following World War II it was the literary movement Existentialism, which focused on the individual following the failure of the collective represented by the war.

Many photographers who had been involved in the war had issues to resolve – either to publish work that they had made before the war or to look back on their involvement in the conflict. Clearly,

the group that had suffered most was the Jews of Europe, the object of ruthless and systematic extermination. The first task of photography was therefore to provide visual evidence of the Holocaust. One of the most poignant photobooks ever published – *KZ: Bildbericht aus fünf Konzentrationslagern* (Photo Report from Five Concentration Camps, 1945) – was a flimsy paperback that contained a graphic catalogue of the horrors of the death camps and other atrocities. This was dropped by parachute and otherwise distributed to the German people to tell (or remind) them of the crimes that had been committed by their late government. As we shall see in Volume II, Jewish organizations, too, put together books of photographs of Nazi atrocities, using snapshots found in the camps, or taken from captured guards, sometimes copying the pictures by re-photographing them when they had no ready access to a printing press. In this way photography and the photobook bore powerful and irrefutable witness to what had happened in Nazi-occupied countries, informing a shocked, almost disbelieving, world.

Holland, for example, had suffered greatly during its occupation, and Dutch photographers were determined that their deprivations should not be forgotten. During the war, as happened in several other countries, Dutch photographers had formed a clandestine group to document what was happening. De Ondergedoken Camera (The Underground Camera) group – so-called because it was forced to photograph surreptitiously – contained many of those photographers, such as Cas Oorthuys and Emmy Andriesse, who would be at the forefront of a remarkable era in Dutch photography and photographic publishing during the 1950s and 1960s.

After the war The Underground Camera became the GKf group, and in a manifesto published to mark its exhibition 'Foto '48' at the Stedelijk Museum in Amsterdam, the group rejected the formalism of the prewar New Vision (it was German-inspired after all), and proposed a return to politically committed social documentary photography. Although the political commitment would become somewhat diluted over time, these photographers developed a strong documentary style, which would be utilized not only in their personal photobooks, but also in imaginative and radically graphic photographic reports for Dutch companies. The publishing highpoint of the Underground Camera/GKf photographers (at least in group form) was *Amsterdam tijdens den hongerwinter* (Amsterdam during the 'Hungerwinter'), published in 1947, a collective survey of their work during the last year of the war. This served not only as a testament to a time of extreme deprivation in Holland, but demonstrated the future strength of Dutch photography. The informal, raw quality seen in much of the work derived from the fact that it was often done secretly and 'on the run'; this influenced the aesthetic of the peacetime documentary approach in the form of a new spontaneity and informality.

The clandestine imperative of much wartime photography also figures in late-1940s Czech photography. *Na jehlách těchto dní* (On the Needles of These Days, 1945), by Jindřich Štyrský and Jindřich Heisler, had first been published in a minuscule underground edition in 1941. Whilst not a book dealing directly with the Nazi occupation of Czechoslovakia – the pictures were in fact Štyrský's surreal street images from the mid-1930s – Heisler's impassioned text, especially his call to kill all oppressors, made its meaning clear enough, so that the secret nature of its publication was a necessity. The first 'trade' edition in 1945 was both a memorial to Štyrský (who had died in 1942) and an expiatory document following the conflict.

Several other Czech books dealing with the war were published in the years immediately following, including Zdenek Tmej's *ABECEDA: Duševního prázdna* (Alphabet of Spiritual Emptiness, 1946). This remarkable book, a triumph of art over adversity, was a record of Tmej's experiences when taken away by the Nazis to work in Breslau and, like Štyrský's little masterpiece, gave notice that Czech photography was set to continue in the rude health it had enjoyed before the war. However, the communist takeover in 1948, and the allying of Czechoslovakia with the Soviet bloc, drastically reduced the horizons of all the arts in the country. Experimentation and individualism were discouraged, and Czech photography became so retrenched for a number of years that it seemed to consist only of Socialist Realist photography and – mercifully allowed to continue with his unashamedly romantic vision – the work of Josef Sudek.

The centre of European photographic publishing, however – despite vestiges in Czechoslovakia and Western Germany and serious competition from Holland – remained Paris, simply because the prewar culture of humanistic, or 'concerned' photojournalism quickly re-established itself there. An important factor was the foundation in 1947 of the international photo-agency, Magnum, by Robert Capa, Henri Cartier-Bresson, David 'Chim' Seymour and George Rodger. The founding in 1949 of the weekly journal, *Paris Match* – which quickly became a market leader – and the existence of monthly journals like *Réalités*, proved that the Parisian market for photojournalism remained strong, helped undoubtedly by the city's position as hub of the fashion industry and also by a strong nostalgia for prewar glories. And this, it might be said, was in spite of the fact that postwar Paris was much less important as an international art market.

Crucially, many of the great French humanist documentary photographers of the 1930s were still around, and would be joined by a new postwar generation. The undisputed leader of the pack was Henri Cartier-Bresson. A much lauded retrospective exhibition held at the Museum of Modern Art, New York, in 1947 had established him as one of the world's most important photographers. And his already unassailable stock was raised even further in 1952 with the publication of one of the most renowned photobooks of the century, his *Images à la sauvette*, which was published in the English-speaking world as *The Decisive Moment*. It is unquestionably one of the great books, but the happy decision to call it *The Decisive Moment* rather than *Images on the Run*, or *Stolen Images*, which would have been more literal translations of *Images à la sauvette*, contributed greatly to its success, for it gave the world not just a photographer but a photographic concept that could be easily grasped and demonstrated to perfection in the pages of the book. *The Decisive Moment* was followed by *Les Européens* (The Europeans, 1955), an equally eloquent testimony to Cartier-Bresson's total command of his idiom.

In the period between the end of the war and the beginning of the 1960s all the major French photographers working in the humanistic documentary mode produced photobooks. Notable works appeared by Robert Doisneau, Izis, Brassaï, Jean-Philippe Charbonnier and André Kertész – now an émigré languishing in the United States. His *Day of Paris* (1945) made perhaps the definitive statement on his Parisian heyday in the 1920s and 30s.

Paris was the birthplace of Existentialism, the philosophy of Jean-Paul Sartre and Albert Camus. Its bleak and nihilistic elements, and its concentration on the individual, had an obvious attraction to a generation that had just been dragged through the negative and wholly collective experience of the war. Existentialist ideas found their expression in various art forms, which in broad terms meant a focus on raw process, on the spontaneous and the unconscious, and indubitably on the self. While these approaches inevitably filtered through to photography, strangely, they did not overtly touch French photography, which remained generally faithful to the humanist idiom of the 1930s. Existential ideas in photography were adopted more by photographers outside France, and will be examined in the next chapter.

Paris, nevertheless, was an important centre for innovation in several ways. Cartier-Bresson's first two books had been issued by Tériades, the renowned publisher of the magazines *Minotaure* and *Verve*, and of books by Matisse and other major artists of the School of Paris. But it was a pair of newer publishers who produced two highly significant photobooks from the United States that exemplified the new Existential photography and had been turned down by American publishers. Firstly, Editions du Seuil, which had been founded in 1939 but had only begun its rapid rise through the ranks of French publishing when Jean Bardet and Paul Flamand took over in 1945, published William Klein's *New York* in 1956. Two years later, Robert Delpire, a former medical student who founded a publishing house in 1951 with Pierre Faucheux, published Robert Frank's *Les Américains* (The Americans). Thus Paris was still an influential arena in which publishers were willing to take a chance on new and somewhat risky material.

However, Delpire's basic agenda was to publish work that was broadly in the documentary vein – as exemplified by his close friend, Cartier-Bresson. Delpire had a keen interest in anthropology, and

many of his books displayed this kind of pedagogical imperative. In the early 1950s, for example, he published the likes of Brassaï's *Séville en fête* (Seville Festival, 1954), Henri Cartier-Bresson's *Les Danses à bali* (Dances at Bali, 1954), Robert Doisneau's *Les Parisiens tels qu'ils sont* (Parisians As They Are, 1954), George Rodger's *Le Village des noubas* (The Village of the Nubas, 1955), and Werner Bischof's *Indiens pas mort* (From Incas to Indians, 1956), which also included work by Pierre Verger and Robert Frank.

That list was typical of Delpire, and French publishers generally. Even *Les Américains* was published, not as the Existential road trip it would become when reincarnated as *The Americans*, but as the first in a series that Delpire planned called *Encyclopédie essentielle*. Thus, for its French (and Italian) publication Frank's intensely personal, highly emotive imagery was given a degree of intellectual respectability with supporting texts by such literary luminaries as Simone de Beauvoir, Erskine Caldwell, William Faulkner and John Steinbeck. A few years later Delpire brought out a companion volume to Frank's, René Burri's *Les Allemands* (The Germans, 1963), a much underrated book, but one nevertheless firmly back in the more classic genre of European photojournalism.

The example of Robert Delpire indicates that, as in any kind of publishing, initiatives are taken and innovations made by individuals, often one enthusiastic individual within a publishing organization. The majority of the photobooks discussed in this book have many disadvantages for publishers. Well-produced photobooks are expensive to make, and the market, whilst being an established 'niche', is nevertheless small. This has been a recipe for publishing disaster in the past, and thus many photographers owe their photobooks to the singular patronage of an enthusiast like Delpire.

This would hardly seem to substantiate the claim made in the Introduction that the photobook is the link between photography the art medium and photography the mass medium. However, such books, while generally having print runs in the low thousands (and seldom more than ten thousand), can nevertheless, like poetry from small literary presses, become enormously influential, even if talked about more often than seen. And like some poetry books, the photobook can suddenly strike a chord with the public and sell much more than the average, like Delpire's *Américains*. He did not benefit from it, but since it was published in the United States and the word got out, Frank's masterpiece has been kept more or less in print by various publishers.

Delpire, indeed, has a long track record, having produced many photobooks, but often in postwar Europe publishers would engage with photography for a regrettably brief period. An individual or publishing house would become enthusiastic about photobooks, raise the money to publish a few, then quietly disappear from photobook history as the economic realities became apparent, even though they might have published other types of book for decades afterwards. Sometimes it was a group of outstanding photographers in a particular time or place who would stimulate a publisher to enter the photobook field for a time.

Such was the case in Spain, where another enlightened publisher in the Delpire mould, Editorial Lumen, owned by Oscar and Esther Tusquets, produced a series of notable photobooks in the 1960s, thanks to the presence in Barcelona of a number of outstanding photographers centred around the Agrupación Fotográfica de Catalunya (The Catalan Photographic Group). The Tusquets had acquired the Barcelona publishing house in 1960, and almost immediately began a series *Palabra e imagen* (Words and Pictures), utilizing the talents of such brilliant photographers as Joan Colom, Ramón Massats, Oriol Maspons and Julio Ubiña. Their two best-known titles were Colom's *Izas, rabizas y colipoterras* (1964), and *Toreo de salón* (Playing at Bullfighting, 1963) by Maspons and Ubiña, both with texts by the leading Spanish novelist, Camilo José Cela. With its high standard of words and pictures, the *Palabra e imagen* series deserves to be much better known amongst aficionados of photobooks, as do the best books of other publishers at this time, who nurtured the talents of their leading photographers in Italy, Portugal, Austria, Denmark and Sweden.

As previously mentioned, one of the most active photobook cultures in the postwar years was Holland, rivalling and perhaps exceeding even France. Dutch publishers were active in issuing photographically illustrated books of all kinds, ranging from nostalgic views of the Dutch countryside and towns before the war damaged them, to books documenting the postwar reconstruction, and even

works by the Dutch avant garde. Frequently, pragmatic Dutch photographers would work on their own off-beat projects while undertaking more conventional commissions at the same time. But this was not seen as a contradiction, and Dutch publishers allowed photographers a freer rein than most countries, even in projects of a more commercial nature. While many publishers in the 1950s had both conservative and radical photobooks on their lists, leading Dutch publishers such as Contact and De Bezige Bij were not only willing to countenance the more personal book projects of photographers like Ed van der Elsken, Joan van der Keuken and Sanne Sannes, but also to incorporate the most advanced ideas in typography, graphic design and layout into their more apparently conventional illustrated books. As the photo-historian Rik Suermondt has written:

> *The photobook experienced an enormous growth in the Netherlands in the second half of the 1950s. New combinations of image and text were ferociously experimented with. The hot item of discussion was whether the image as a means of communication in the society of today was capable of replacing the word. Television, after all, was finding its way into Dutch living rooms on a large scale and more ... people were going to the cinema.*[2]

Suermondt's remarks might be applied (to a lesser extent) to several other European countries. But what of Germany? At the beginning of the 1930s German photographers had stood at the vanguard of modernism. The 'Film und Foto' (FiFo) exhibition of 1929, plus a number of groundbreaking books published around that time by August Sander, Karl Blossfeldt, Albert Renger-Patzsch and others, and also Franz Roh's modernist manifesto *Foto-Auge* (Photo-Eye), had placed German photographers at the forefront, not only of European, but also of world photography. During the Nazi period, however, many of the country's best photographers – who were Jewish – had emigrated or been engulfed by the Holocaust. Thus after the war German photography, not unnaturally, was in a rudderless state. Perhaps more slowly than in other European countries, the magazines and publishing houses were re-established, and the German talent for photojournalism began to produce figures of note like Stefan Moses, Robert Lebeck and Chargesheimer (Carl Hargesheimer).

But the most notable development in postwar German photography prior to the 1960s was the Fotoform movement, instigated by Dr Otto Steinert and others. This was a valiant attempt to turn the clock back to the defining moment of 'Film und Foto', as if the Nazi hiatus had never existed. The impetus for formalist modernism had been taken up by the United States, largely because so many figures from the Bauhaus and New Vision schools had emigrated there. László Moholy-Nagy and other Bauhaus/New Vision veterans carried on the old tradition at the New Bauhaus in Chicago and at other American universities. There were, however, many photographers in Europe who rejected the documentary approach and, like their counterparts in the United States, favoured a more formal kind of photography.

Such photographers found their champion in Europe in Steinert and the Fotoform group. A teacher of photography at the Saarbrücken School of Arts and Crafts, Steinert organized three major exhibitions, beginning in 1951 and featuring such leading lights of the 'subjective interpretation of reality' as Peter Keatman, Heinz Hajek-Halke, Toni Schneiders and Hans Hammarskjöld. He also edited two books and a small catalogue entitled *Subjektive Fotografie* (Subjective Photography), the initial book published in 1952, the second in 1955. The first, subtitled *Ein Bildband moderner europäischer Fotografie* (A Collection of Modern European Photography), opened with vintage work by the likes of Man Ray and Moholy-Nagy, and included a text by Franz Roh, as if to prove that National Socialism was just a bad dream. But although Fotoform was significant in suggesting a pan-European movement in creative photography (albeit German-led) and therefore a reconciliation following the war, the group's formalist abstract approach eventually petered out down a cul-de-sac of its own making. Documentary, especially photojournalism, remained the predominant tradition in Europe.

In the 1960s another European country became a centre of photographic excellence, after having spent an even longer period than Germany in the doldrums. The photographic culture of Great Britain, one of the inventors of the medium, had, as John Szarkowski pithily put it, lost its way: 'For purposes of approximate truth, it might be said that photographic tradition died in England sometime around 1905 ... England had forgotten its rich photographic past, and showed no signs of seeking a photographic present.'[3]

Two factors sparked British photography back into life – one a specific photographic event, the other a profound cultural shift. Firstly, thanks to Szarkowski, Bill Brandt was given the distinction of a retrospective exhibition at the Museum of Modern Art in New York, following a warm reception – on both sides of the Atlantic – for his startling photobook, *Perspective of Nudes*, in 1961. As it had done for Henri Cartier-Bresson some 14 years previously, the accolade of a major MoMA show both stimulated Brandt's own career and gave young British photographers a role model of genuine international reputation

Brandt's success was a boost for British photography at a time when the country's art as a whole was being turned on its head by a socio-cultural cataclysm – the so-called 'Swinging 6os'. As with many cultural upheavals in the 1950s and 1960s, its roots could be traced to World War II. In Britain's case the legacy of the war was the dismantling of the British Empire – beginning with the crucial loss of India in 1947 – and an erosion of entrenched class barriers. The 'Swinging 6os' phenomenon was Britain's version of the youth revolution that was happening generally in Europe, the United States and Japan, but in Britain it took a particularly potent and positive form, and was singularly successful in rejuvenating British art.

Much of this success, it must be said, was in the area of the popular arts – in music, with the Beatles and the dozens of rock groups that followed them; in fashion, with Carnaby Street, Mary Quant, and the first supermodel, Twiggy; and in the British contribution to that largely Anglo-American art movement, Pop art. If most of this activity was outside the so-called 'high' arts, there was a concurrent upsurge in activity in all the arts, high or low. The example set by the many working-class kids made good in the popular arts and media – native wit and talent triumphing over snobbery and privilege – not only shook the class system, but also challenged Britain's endemic conservatism regarding all forms of art.

One area in which working-class kids made especially good was photography, particularly in the fields of fashion and advertising, although a figure such as Don McCullin also represented a new wave in British photojournalism. Fashion photographers like David Bailey and Sam Haskins followed Britain's fashion designers into international recognition, and they published lavishly produced and innovatively designed photobooks to cater for a new, visually literate and fashion-conscious audience. In Michelangelo Antonioni's seminal film about the 'Swinging 6os', *Blow Up* (1966), the David Bailey-like protagonist is a young, successful fashion photographer, who is seen to be working on a photobook – not a photobook of fashion or celebrity portraits, but a gritty, photojournalistic book on down-and-outs.[4] Fashion photographers, it seems, beginning with Richard Avedon and his book *Nothing Personal* in 1964, had an innate urge to be upwardly mobile in an artistic sense, and to create documentary photobooks that made little money but proved their altruism. And yet it was the more typical commercial books by European and American fashion photographers that – like *Blow Up* – represented an important part of the whole 1960s zeitgeist, an antidote to the world's problems. For despite events like the Cuban missile crisis, the assassination of John F Kennedy, the Vietnam War and worldwide student unrest, the decade of the 1960s was a generally optimistic era, when the first postwar generation began to play its part in life's affairs (if only to take part in a student sit-in), and the combatant nations finally put World War II behind them.

The 1960s was the decade of youth and free love – of sex 'n' drugs 'n' rock 'n' roll – and the many commercial photobooks of the decade reflected this. In London the South African photographer Sam Haskins made several books featuring naked women, presented in an alluring, though not entirely innovative, combination of grain, graphics and gravure, the most important of which was *Cowboy Kate and Other Stories* (1965). Many softcore sex photobooks were published in the 1960s, the heyday, after all, of *Playboy*, *Penthouse* and Tom Wesselmann. Sanne Sannes, a Dutch photographer, became briefly notorious for his posthumously published erotic photonovels *Sex a Gogo* (1969) and *The Face of Love* (1972). France, of course, could hardly be left behind in the matter of the erotic photobook. The Arles photographer, Lucien Clergue, had virtually invented the genre (at least for the mainstream market) with his 1957 book *Corps mémorables* (Memorable Bodies). This book, with its distinctive cover by

Picasso, was the first mainstream publication to show female pubic hair, allowable only because Clergue did not show the faces of his models, which gave rise to considerable controversy. *Les Erotiques du regard* (The Erotics of the Gaze, 1968) by Marc Attali and Jacques Delfau, was both more erotic and more intelligent than most other examples of the genre. The artist Henri Maccheroni's *Cent photographies du sexe d'une femme* (One Hundred Photographs of a Woman's Sex) (see Volume II), published in 1978 from pictures made earlier, tried to do for the female genitalia what Ed Ruscha had done for gas stations. Maccheroni's rigorously conceptual project, however, was not published as an artist's bookwork, but by one of those small, typically Parisian presses that specialize in intellectual pornography. The renowned German graphic designer Gunter Rambow also concentrated on female pudenda in his book *Doris* (1970), but whereas Maccheroni's formality can be seen as an example of a serial approach that would become highly significant in the 1990s, Rambow's full-on 'Pop art' 1960s graphics now seem a little heavy and dated.

This study has concentrated on what might be termed the 'froth' of 1960s photobooks, because that, in a real sense, was what was important about the decade, at least in Western European photographic publishing. There were, of course, deeply serious photobooks being made by European photographers, and different forces at work in the United States and Japan. However, the comparative frivolity of much European photobook publishing of the period – the 'Swinging 60s' might also be termed the 'Commercial 60s' – represented one crucial psychological step forward for the continent: it indicated that World War II was truly over.

During the 1970s the focus of attention in photography shifted somewhat from Europe to the United States. The primary reason for this was the fact that since the early 1960s the formidable weight of American art institutions – museums, universities, the New York art market – had begun to support photography in the same kind of way that they had supported Abstract Expressionism. It took Europe a decade or so before its own institutions began to follow suit. Comparatively speaking, photobook production in Europe in the 1970s was lacklustre compared to the enormous upsurge of activity in the United States, but sometimes it is necessary to experience a fallow period before the next bumper crop can be harvested.

It might be said that the seeds of European photography's future were being sown in an altogether different field. In 1970 a book called *Anonyme Skulpturen* (Anonymous Sculptures) (see Volume II) was published to some acclaim in the avant-garde art world, though to rather less in the photographic world. The authors were the German husband-and-wife team of Bernd and Hilla Becher, and the work – flat, undemonstrative, elevational photographs of industrial architecture and machinery – looked both backwards and forwards. Unlike Otto Steinert's Fotoform group, the Bechers looked backwards to the 'objective' rather than the 'subjective' German photography of the 1920s and early 30s, and also to an era in European industrialization that had largely ended with World War II. But the Bechers also represented the future. They looked forward to a new integration between the traditional arts and photography, and to a new period of vigour and excitement in European photography, when there was a cross current of mutual development and interaction between photographic cultures, the like of which has rarely been seen before in the medium's history.

Anonymous
KZ

This small but important book, consisting of a mere 32 pages and 44 shocking photographs, was distributed in Germany by the American War Information Unit at the end of the World War II in order to convey to the civilian population the enormity of the crimes committed by the Nazis in the name of the German people. Thus this book, which is not much more than a pamphlet, may represent the single most significant use of photography as a witness in the medium's history. The book shows, with a terse accompanying commentary, images from five of the concentration camps liberated by the Allies in 1945 – Buchenwald, Belsen, Gardelegen, Nordhausen and Ohrdruf.

The names of the individual camps – although now infamous – do not matter in a sense, for the pictures from each show a similar litany of horror – piles of naked corpses, shocked, starved survivors and stunned German civilians brought in to witness what had been happening close to their homes, without their knowledge, or with a knowledge suspended by psychological denial.

Any further commentary on this book is superfluous. It might be crass to mention design in such a context, but the layout was certainly given consideration by the book's makers so that maximum impact was achieved, even with photographs as devastating as these.

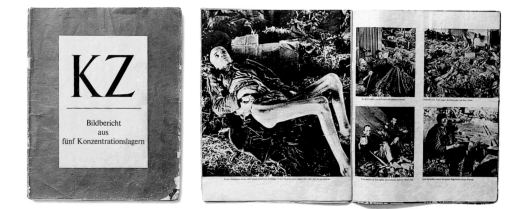

Anonymous **KZ: Bildbericht aus fünf Konzentrationslagern** (Photo Report from Five Concentration Camps)
American War Information Unit, 1945
270 × 220 mm (10^1⁄$_2$ × 8^1⁄$_2$ in), 32 pp
Paperback
44 b&w photographs
Various anonymous photographers

Jean Cocteau and Pierre Jahan
La Mort et les statues (Death and the Statues)

'The job of the poet (a job which can't be learned) consists of placing those objects of the world which have become invisible due to the glue of habit, in an unusual position which strikes the soul and gives them a tragic force.' This statement in the introduction to *La Mort et les statues* (Death and the Statues) by Jean Cocteau not only describes the essence of the poet's art, and the photographs of Pierre Jahan, to which he was referring, but also elucidates the art of photography in general, which is supremely about the visual poetry of things. And it is probable that Pierre Jahan, who enjoyed a long career photographing the city of Paris, never came closer to capturing the poetry of things than in this collaboration with Cocteau. A roll or two of images photographed in a breaker's yard formed the basis of arguably the best French photobook to look back on the war in its immediate aftermath.

The statues photographed by Jahan had been ripped from their plinths or torn from buildings by the occupying Nazis and taken to this Parisian warehouse to be broken up and then melted down for their metal – a Saragossa Sea of disembodied heads, disarticulated limbs and limbless torsos. Jahan was photographing this statue graveyard at a time when other photographers were photographing human graveyards – at Belsen, Dachau, Buchenwald and Treblinka. And yet his evocative, poignant photographs – without negating the value of witnessing and documenting human suffering – articulate something particularly apt about the recent events they symbolize. These simple pictures of junked statues speak strongly about loss, about barbarism, about the trashing of culture, and other issues of great importance, proving that poetry is sometimes as necessary to understanding as factual documentation.

Martien Coppens
Impressies 1945 (Impressions 1945)

Martien Coppens was responsible for a number of topographical photobooks during the 1930s and 1940s, documenting the architecture, landscape and art of his native Brabant. These were in a similar vein to the publishing house Contact's *De Schoonheid von ons Land* (Our Beautiful Country), showing a comparable focus on the cultural heritage of Holland. As the title of Contact's series implies, the kind of photography employed was traditional, large-format, topographically precise, with an emphasis on the picturesque, on heritage and continuity rather than change.

It was this kind of rhetoric that was employed by Coppens for his 1947 book *Impressies 1945* (Impressions 1945), but his subject was radically different. He still concentrated on the Dutch landscape and architectural heritage, and photographed it in his usual romantic style, but now his theme was the Dutch heritage interrupted by the discontinuities and disruption of war. He chose the lighting carefully, often a combination of sun and cloud that would allow him to set a ruin picked out by sunlight against a glowering, cloudy sky. Add luscious gravure printing, and Coppens's ruins look less like real buildings than stage sets. In all of his work, and in this book in particular, Coppens opposed the prevailing trend in Dutch photography of the time, which was

progressing towards a gritty, Existential realism, and he was criticized for it by other photographers.

Coppens, who habitually dealt in nostalgia, photographed this devastated landscape in the only way he knew, even exaggerating the romantic rhetoric of the ruin. But like Jean Cocteau and Pierre Jahan in *La Mort et les statues*, Coppens demonstrated that there were many different ways in which artists and photographers could come to terms with what had happened to Europe.

Martien Coppens **Impressies 1945: Geteisterd Nederland**
(Impressions 1945: Stricken Holland)
NV Uitgevermaatschappij, Eindhoven, 1947
341 × 242 mm (13½ × 9½ in), 130 pp
Hardback with buff paper, green cloth spine, and jacket
66 b&w photographs
Foreword by Martien Coppens

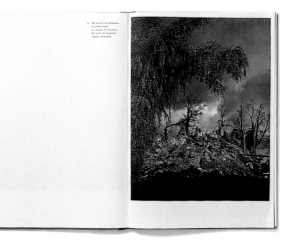

Jean Cocteau and Pierre Jahan **La Mort et les statues** (Death and the Statues)
Editions du Compas, Paris, 1946
337 × 258 mm (13¼ × 10¼ in), 42 pp
Paperback with cardboard slipcase (not shown)
20 b&w photographs
Text by Jean Cocteau; photographs by Pierre Jahan

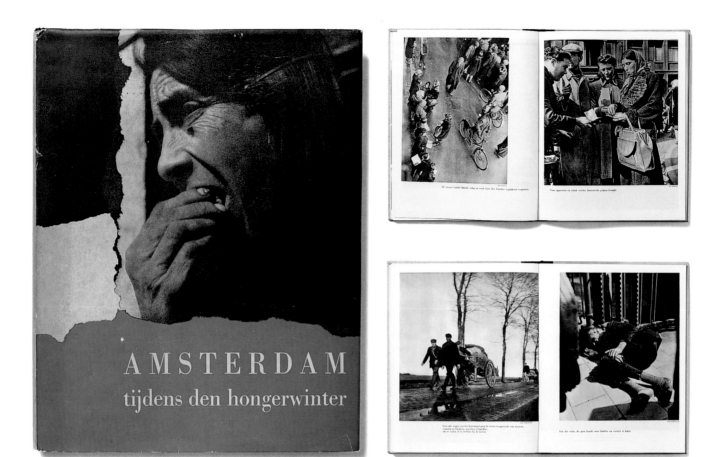

De Ondergedoken Camera (The Underground Camera) **Amsterdam tijdens den hongerwinter** (Amsterdam during the 'Hungerwinter')
Contact/De Bezige Bij, Amsterdam, 1947
278 × 222 mm (11 × 8¾ in), 128 pp
Hardback with grey paper, black cloth spine, and jacket
100 b&w photographs
Introduction by Max Nord; photographs by Cas Oorthuys, Emmy Andriesse, Charles Breyer, C Holtzappel,
Ad Windig, Kryn Taconis, Hans Sibbelee, Marius Meyboom, F Lemaire and others

De Ondergedoken Camera
(The Underground Camera)
Amsterdam tijdens den hongerwinter
(Amsterdam during the 'Hungerwinter')

This book was published two years after the liberation of Holland from the Nazis. It marks both an end and a beginning. When it was published, the leading members of the Underground Camera group, like the country, were about to move on. As members of a new group, GKf, most of them took part in the exhibition 'Foto '48'. *Amsterdam tijdens den hongerwinter* (Amsterdam during the 'Hungerwinter') looked back, while 'Foto '48' looked forward, but both shared a manifesto that made a passionate plea for an anti-formalist documentary photography that would help forge a more just and free Holland, following the occupation.

Thus this is not simply a book remembering and commemorating Amsterdam's dreadful winter of 1944–5, but also a political rallying cry for the future. As the journalist Max Nord wrote in the book's introduction: 'Was it not in those times that we dreamed our most beautiful dreams? ... While uniformed Germans marched along Amsterdam's canals, their clipped songs resounding past the overcrowded prisons, we had a clear vision of the most perfect freedom.'

Nevertheless, the publication's first task was to bear witness, as photographers like Cas Oorthuys and Emmy Andriesse knew when they made these pictures, often at some risk. The story told is of extreme hardship – hunger, poverty and cold. People stand in food queues or search desperately for firewood, while others lie dead or dying on the streets. But it also showed resilience and resistance: the forging of identity cards, the

printing of underground magazines. Much of the book is shot in a style that could be regarded as the opposite of formalist – not exactly anti-formalist, but a mode where the primary consideration was getting the picture, no matter how out-of-focus or blurred it might have been. This snatched, off-kilter approach generated an immediate, spontaneous aesthetic of its own, which fed directly into postwar Dutch photography in an extremely positive way. So this was an important book in that sense also. It was a landmark publication by a group of photographers with both an ethical and an aesthetic attitude, a group who would exert a great influence on Dutch photography and the Dutch photobook in the late 1940s and 50s.

Jindřich Heisler and Jindřich Štyrský
Na jehlách těchto dní
(On the Needles of These Days)

In the mid-1930s Jindřich Štyrský made several photographic series that showed the clear influence of Eugène Atget, not so much in terms of subject matter, but of mood. Atget had made a major impact on Czech photography, especially the Surrealists, his underlying melancholy apparently appealing strongly to the Czech temperament.

In 1941 Štyrský incorporated work from two series made from images taken in Prague and Paris between 1934 and 1935, *Muž s Klapkami na očich* (*The Man with Blinkers on his Eyes*) and *Zabí Muž* (*Frog Man*), together with a text by fellow Surrealist Jindřich Heisler, into a work entitled *Na jehlách těchto dní* (On

the Needles of These Days). The original, with Heisler's direct and repeated call to rise up against the occupying Nazis – 'Regret each blow that fails to find its mark' – was published clandestinely in a minuscule edition with tipped-in silver gelatin prints and, as a consequence, is extremely rare. Hardly less rare is the first 'true' publisher's edition, brought out after the war in 1945, with a spare, elegant design by another distinguished Czech Surrealist, Karel Teige. The book, economically yet beautifully produced, functioned both as a memorial to Štyrský (who died in 1942), and in the larger context as an oblique, poetic meditation on war and the Nazi occupation.

Štyrský's pictures are of peeling facades, mannequins in shop windows, a mask, fairground signs, street objects – the familiar iconography of 1930s Surrealist photography – but his square yet subtly off-kilter

vision invests them with a brooding, almost manic disquiet. Unlike Atget's photographs of similar subject matter, which are calmly meditative, Štyrský's images exhibit an enervating neurosis that signifies death and decay in a clearly melodramatic manner. But the melodrama, and even the rather too obvious final sequence of children's coffins, a cemetery and a shattered, upside-down cross, which accompanies Heisler's repeated exhortation to rebellion, fails to dent either Štyrský's authority or his pictures' power. The same observation might be made of Heisler's rambling hallucinatory text, which has little to do with the pictures – but that is frequently the nature of Surrealist image/text collaborations. This remains a haunting photobook, 50 years after the war. It is a prime example of one of the photobook's great truths – it's not necessarily the individual pictures that count, but what you do with them.

Jindřich Heisler and Jindřich Štyrský **Na jehlách těchto dní** (On the Needles of These Days)
FR Borový, Prague, 1945
213 × 152 mm (8¾ × 6 in), 68 pp
Paperback with glassine jacket
28 b&w photographs
Text by Jindřich Heisler; photographs by Jindřich
Štyrský; design by Karel Teige

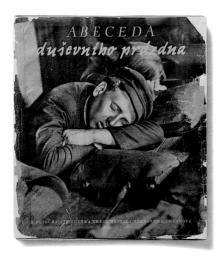

Zdenek Tmej **ABECEDA: Duševniho prázdna** (Alphabet of Spiritual Emptiness)
Zádruha Nakladatelství AS, Prague, 1946
239 × 221 mm (9½ × 8¾ in), 120 pp
Paperback with jacket
45 b&w photographs
Text by Alexandra Urbanová

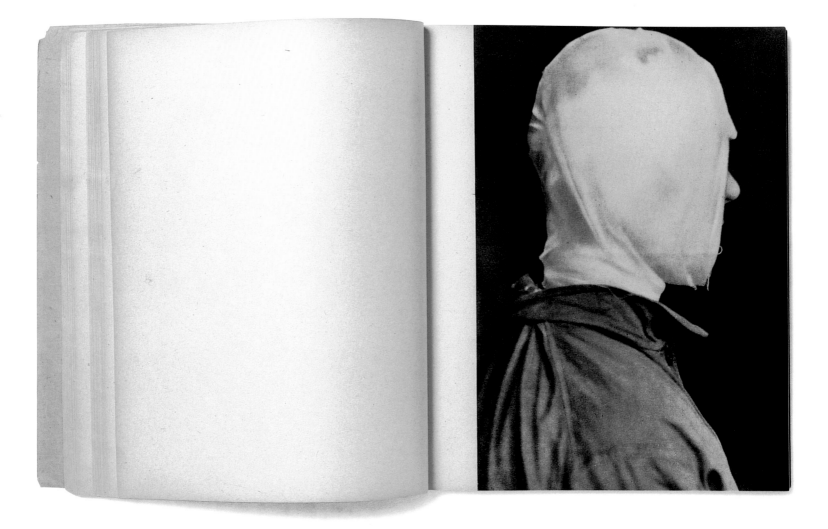

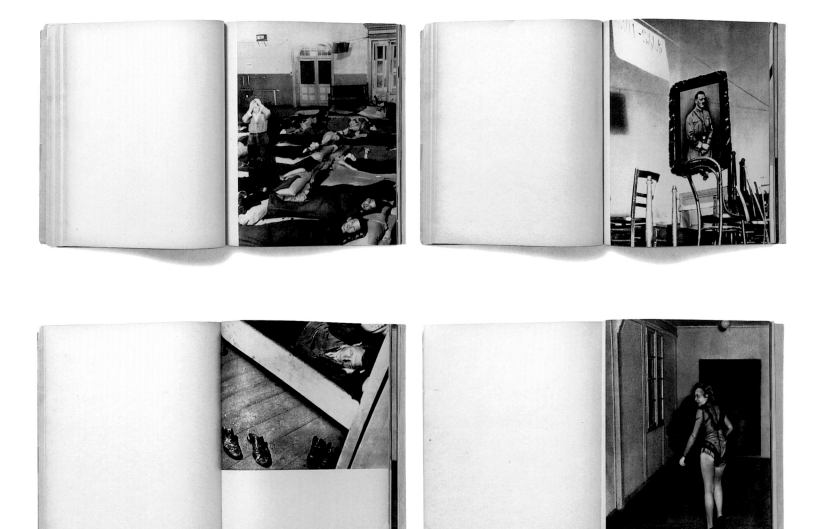

Zdenek Tmej
ABECEDA: Duševniho prázdna
(Alphabet of Spiritual Emptiness)

Apart from Jindřich Štyrský's *Na jehlách těchto dní* (On the Needles of These Days), the war inspired a number of fine Czech photobooks, including another with a memorable title, Zdenek Tmej's *ABECEDA* (Alphabet). Whereas the former is an elliptical look at the psychological state induced by war, Tmej's book is a remarkable document of his war experiences (psychological and otherwise). It is also a beautifully produced, if fragile, book, a strange combination of luxury and cheapness: lusciously inked gravure printing on rough paper that is little better than newsprint.

When Tmej was forced, like many young Czechs, to work for the Nazi war effort in Breslau, he had the foresight to carry two cameras in his backpack on his way to a doubtful future in Germany, and the courage and perspicacity to use them. Apparently the Gestapo found the images, but (clearly misunderstanding their potency as pictures) allowed him to keep them as 'souvenirs'. The resulting book, distilled from around 200 negatives, is notable not simply for its historical value, but also for Tmej's ability to make formally elegant images that are invested with a poetic weight that is quite remarkable given the circumstances of their making.

Tmej contrasts the bleak interiors of the empty workmen's quarters – a ballroom with rows of bunks and mattresses on the floor – with their cramped condition when full to overflowing with depressed, demoralized humanity. Anonymity is his watchword as he charts the dehumanizing effect of men being forced unwillingly from their homes to live in overcrowded accommodation, fed only gruel on enamel plates. Perhaps the most telling sequence in the book is at the end, in a series taken in the 'foreigners-only' brothels arranged by the Nazis for the workers' leisure time. In these haunting, sad images, the desperation and loneliness of both the women and their clients is made manifest in the forced gaiety and bleak anonymity of their exchanges; a world of spiritual emptiness made eloquently clear.

André Kertész
Day of Paris

Following the success (despite its limited print run and release) of Alexey Brodovitch's *Ballet* in 1945, the New York publisher J J Augustin brought out a book of photographs by André Kertész, *Day of Paris*, almost certainly on Brodovitch's recommendation. At the time Kertész was working for Condé Nast, photographing interiors and making other pictures of a workaday commercial nature. Thus he must have welcomed this opportunity to publish the best of his humanist documentary imagery, made between 1925 and 1935 when he lived in Paris.

Day of Paris is not the first book to feature his Parisian photographs, but thanks to its elegant design – credited jointly to Brodovitch and Peter Pollack – it is the most fully realized. It loosely follows a familiar scenario, a 'day in the life' of Paris, beginning with the gargoyles of Notre Dame and giving us a photographic modernist's tour of the city, nodding appreciatively at Henri Cartier-Bresson along the way, and ending up with Brassaï in a series of nocturnal views.

The keynote of the book is elegance. The Brodovitch/ Pollack design, a long way away from Brodovitch's *Ballet*, exemplifies this, its restraint matching the innate conservatism of Kertész's approach. Although he is frequently hailed as a founder of the humanist documentary approach, this book would seem to indicate that Kertész was more interested in patterns than people. His eye seems to sharpen up when faced with a still life, and his street portraits tend to be of stock street characters straight out of central casting. But *Day of Paris* is a good natured, if somewhat emotionally distanced, view of Paris, singularly devoid of any real social comment. Presumably, this was meant to be supplied by George Davis's captions, which, in attempting to convey an authentic whiff of the streets by apparently eavesdropping on everyday conversations, merely add an arch note. In the end, *Day of Paris*, despite the presence of the radical Brodovitch, is deeply nostalgic in tone. In the uncertain days following the war, however, nostalgia for prewar Paris was both inevitable, and probably an important part of the healing process.

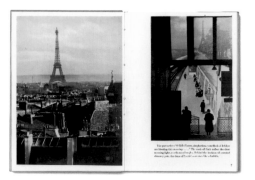

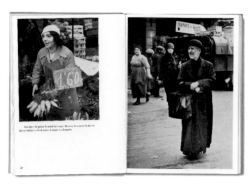

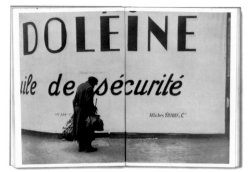

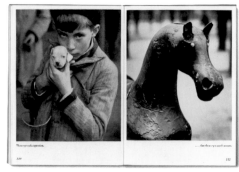

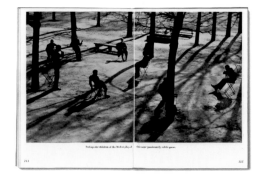

André Kertész **Day of Paris**
 J J Augustin, New York, 1945
 242 × 110 mm (9½ × 7 in), 148 pp
 Hardback with full buff cloth and jacket
 103 b&w photographs
 Edited by George Davis; jacket design by
 Alexey Brodovitch; book design by Peter Pollack

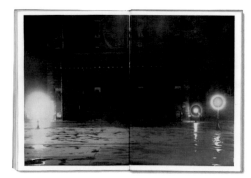

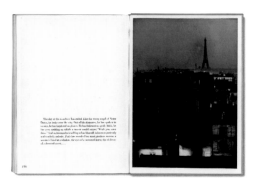

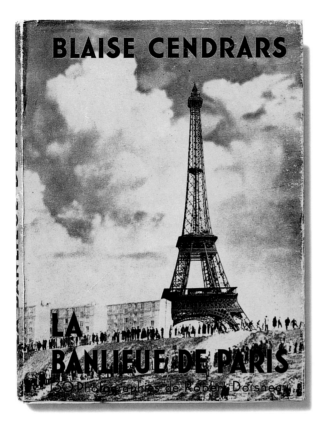

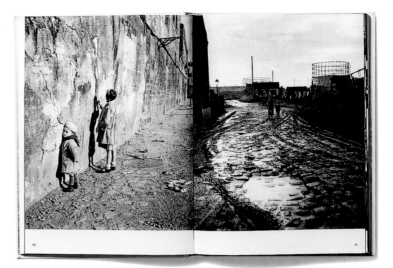

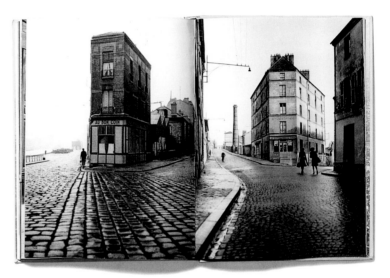

Blaise Cendrars and Robert Doisneau **La Banlieue de paris** (The Suburbs of Paris)
Pierre Seghers, Paris, 1949
233 × 172 mm (9¼ × 7 in), 196 pp
Hardback with yellow paper cover and jacket
130 b&w photographs
Text by Blaise Cendrars

Blaise Cendrars and Robert Doisneau
La Banlieue de paris (The Suburbs of Paris)

Like Brassaï's *Paris de nuit* (see page 134), whose cover credited the writer of the introduction Paul Morand rather than the photographer, *La Banlieue de paris* (The Suburbs of Paris) presents writer Blaise Cendrars, not Robert Doisneau, as the book's primary author. Doisneau, however, at least makes the cover, and this time the discrepancy is not so inequitable. The Swiss-born poet and novelist had been photographed by the up-and-coming Doisneau, and they had become friends. Cendrars encouraged Doisneau to pursue and broaden the scope of a self-assigned project on the Paris suburbs. He found Doisneau a publisher, Pierre Seghers, then lent the cachet of his name and talents in writing the text.

Doisneau took full advantage, repaying Cendrar's patronage with what is his best book. It displays all his characteristic warmth and humanity, yet it is a serious work that is generally free from the cuteness and the annoyingly obvious visual jokes that can sometimes push him into the dubious category of 'humorous' photographer, detracting from his real achievements.

When Doisneau began to photograph the suburbs of Gentilly and Montrouge, they were still the tough but spirited working-class communities celebrated in the poetic-realist films of Julien Duvivier and Marcel Carné. But Doisneau caught them just as they were about to change and expand beyond recognition, making this book a valuable document that looks unsentimentally yet affectionately at a popular idea of the French working class. There are hints of the changes to come, most notably on the book's cover, which is a montage of the

Eiffel Tower combined with one of the barrack-like apartment blocks that were to spring up all round Paris. Socially too, the suburbs were about to change, with new cultures and new communities being absorbed (or not) into the urban wasteland that architects, planners and politicians created from the 1960s onwards.

K (Keld) Helmer-Petersen
122 Colour Photographs

In the history of photography, that is to say the history of photography according to the art museum, colour photography became an artistically viable medium around the early 1970s, with the emergence of such photographers as Stephen Shore and William Eggleston. However, in 1948 the Danish photographer Keld Helmer-Petersen published a book of colour photographs that prefigured their work by two decades or so. He had begun to photograph in colour during World War II, and clearly had ambitions for this still tricky medium. As he writes in his self-published book: 'The following reproductions have been selected from my attempts … to create pictures of a somewhat greater aesthetic value than that usually aimed at by colour photographs.'

His aim was to make the kinds of pictures that could only work in colour, and not in black and white. This is not as easy as it sounds, since it requires both paying attention to the issue of colour and preventing it from becoming the dominant concern. He achieved his ends in a similar way to Shore or Eggleston, by concentrating on the mundane and the everyday. The book is full of deceptively simple pictures, urban still lifes, bold close-ups, images that verge on the abstract but stress the materiality of objects, which, amongst other things, means emphasizing their colour.

Following the publication of *122 Colour Photographs*, Helmer-Petersen carried out some assignments for *Life* magazine, and then in 1950 went to the United States on a scholarship. Here, he taught evening classes at the Chicago Institute of Design, where his colleagues included such luminaries as Aaron Siskind, Harry Callahan and Yasuhiro Ishimoto. His book did not achieve the recognition that it might have received had its publication been less local and limited and it is almost unknown today. However, it deserves credit as a singular, remarkably early and largely successful attempt to make colour photography work.

K (Keld) Helmer-Petersen **122 Colour Photographs**
Schoenberg, Copenhagen, 1948
340 × 242 mm (13¼ × 9½ in), 132 pp
Hardback with grey-blue paper, buff paper spine, jacket and brown card
slipcase (not shown)
122 colour photographs
Observations by K Helmer-Petersen; essay by Svend Kragh-Jacobsen;
cover design and typography by Høy Petersen

René Groebli
Magie der Schiene (The Magic of the Tracks)

One effect of World War II was to bring most formal experiments in photography to a temporary halt. It was difficult to be concerned with pure aesthetics while such momentous historical events were taking place. But in the aftermath of the conflict, photographers, both individually and collectively, turned their attention once more to making purely formalist pictures, exploring not only the aesthetic and non-documentary qualities of the medium, but also looking at new ways of making photobooks, and integrating photographs more closely with text and graphics.

Magie der Schiene (The Magic of the Tracks), self-published by the Swiss photographer René Groebli, demonstrates both aspects of this tendency. It takes a set of personal photographs investigating certain formal issues and turns them into an elegant photobook by carefully setting them into a framework of text, graphic design, typography and production. The result is a wholly integrated piece of work, with each element given equal importance. It is a superb example of the spare, clean, international style of graphic design developed after the war, and centred around the Swiss magazine *Graphis*.

The 14 photographs, reproduced in fine gravure, are about the experience of train travel, particularly speed and movement. Groebli captures this by making simple, graphic pictures, and constructing a series of formal variations that investigate blurring and freezing movement, sharp and soft focus. The result is an extremely elegant mood piece, a self-assigned project turned into an immaculate showcase for the talents of all concerned.

René Groebli **Magie der Schiene** (The Magic of the Tracks)
Kubus-Verlag, Zurich, 1949
240 × 182 mm (9½ × 7¼ in), 24 pp
Card wrappers with loose pages and bellyband (not shown)
14 b&w photographs
Poem by Albert Ehrismann; text by Hans Ulrich Gasser

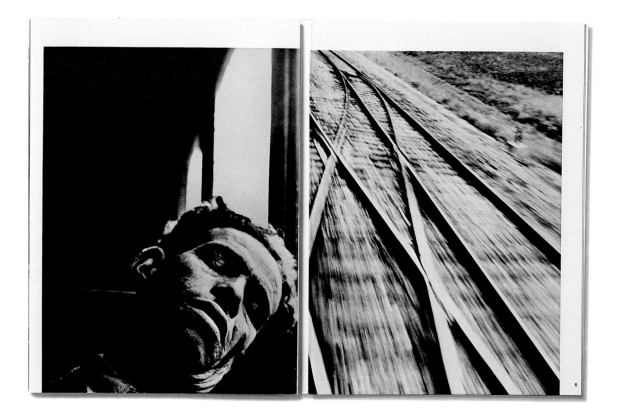

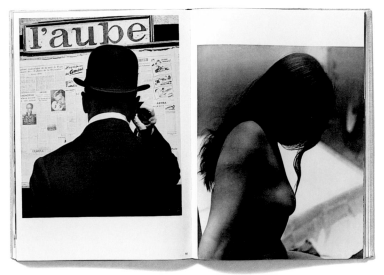

Dr Otto Steinert, ed. **Subjektive Fotografie: Ein Bildband moderner europäischer Fotografie**
(Subjective Photography: A Collection of Modern European Photography)
Brüder Auer, Bonn, 1952
296 × 220 mm (11$\frac{1}{2}$ × 8$\frac{1}{2}$ in), 154 pp
Hardback with full grey cloth and jacket
111 b&w photographs
Texts by Dr Otto Steinert, Professor Dr J A Schnoll, Gen. Eisenwerth and
Dr Franz Roh; various anonymous photographers

Dr Otto Steinert
Subjektive Fotografie (Subjective Photography)

If photographers like René Groebli and K Helmer-Petersen represented the formal wing of European photography in an individual sense, Fotoform represented it collectively. The group included Dr Otto Steinert and the photographers Peter Keatman, Heinz Hajek-Halke, Toni Schneiders, Hans Hammarskjöld and Christer Strömholm. Its exhibitions, as well as the two *Subjektive Fotografie* (Subjective Photography) books published by Steinert, were highly influential, and its approach to photography might be compared to the kind of formalist work being made around the same time at the Chicago Institute of Design and other teaching centres in the United States. The comparison is entirely apt, for both European and American tendencies shared a common heritage – the Bauhaus. The Chicago brand of new formalism, however, was overlaid with home-grown aesthetic ideas derived from Alfred Stieglitz and American modernism that gave it a richness and a complexity lacking in the Fotoform group.

Part of the problem with the Fotoform philosophy was that, even in its own terms, it was a retro rather than a progressive movement. The first volume of *Subjektive Fotografie* began with works by photographers such as Moholy-Nagy and Man Ray, looking backwards at the New Vision era and its defining moment, the 'Film und Foto' exhibition.

But the work produced by Fotoform members differed from that of its predecessors in two vital respects. Firstly, it was intensely purist, where New Vision modernism was decidedly not. Fotoform photographers valued fine technique and impeccable finish, and favoured the abstract over the realistic. Secondly, photography during modernism's first phase tended to be accompanied by a utopian sentiment, no matter how experimental the work or how vague the sentiment. Fotoform photographers swung increasingly towards a subjectivity and personal expression that when added to their interest in abstraction, resulted in a tendency to produce a sterile formalism, devoid of any meaning outside aesthetics. This alienated some of the members, such as the Swedish photographer Christer Strömholm, who left the group to pursue a personal photography in the documentary mode. Indeed, the rise of this kind of photography in the 1950s cut away Fotoform's ideological base. Thus although *Subjektive Fotografie* was a widely influential book for a while, its significance waned fairly quickly and the movement withered away through the 1960s.

Stefan Kruckenhauser
Ein Dorf Wird (A Village is Born)

Like Gerhard Puhlmann's *Die Stalinallee* (Stalinallee) (see page 182), Stefan Kruckenhauser's *Ein Dorf Wird* (A Village is Born) follows the progress of a reconstruction project following World War II. This is more modest than the Berlin project, and is a product of private rather than state enterprise, the construction of a 'model village' at Kennelbach in Austria, south-east of Lake Constance.

Population growth in the 1950s led to a housing shortage all over Europe, and Austria was no exception. *Ein Dorf Wird* documents the building of 22 houses in Kennelbach to accommodate workers in the nearby Schindler textile factory. The book, like the houses, was sponsored by the Schindler company, and is therefore as much a propaganda book as the *Stalinallee* report – although it could equally be categorized as a company book, or perhaps a public-relations exercise.

Whatever the vested interests behind it, *Ein Dorf Wird* is also a document of a tangible achievement, a small victory for civilization. The village, or workers' settlement, was built in just over a year, from May 1950 to June 1951, on land donated by the Schindler company – some 28,500 square metres, the book proudly informs us. The workers were able to buy the houses on company mortgages. Kruckenhauser documents the whole process in a straightforward, elegant style, bringing a unified vision to the whole, reminding us that while photography is especially good at dealing with human misery, it can also lend itself well to the more positive aspects of life.

Stefan Kruckenhauser **Ein Dorf Wird** (A Village is Born)
Otto Müller Verlag, Salzburg, 1952
261 × 236 mm (10¼ × 9½ in), 136 pp
Hardback with full grey cloth and jacket
112 b&w photographs
Foreword and introduction by Dr Fritz Schindler

Paul Strand and Claude Roy
La France de profil (A Profile of France)

In the early 1950s Paul Strand moved from the United States to Europe, largely to escape the spectre of McCarthyism. Following the success of his book, *Time in New England* (1950), he published a succession of volumes along similar lines – documentary studies of people and places, linked with accompanying texts by writers sympathetic to his socialist, anti-colonialist politics. These were printed in East Germany, not just for the excellent gravure but to demonstrate a degree of political solidarity. He published work made in France, Italy, Egypt and Ghana, but this volume – the French book – is different from the others and occupies a singular place in his bibliography. His intention had been to find the perfect French village or small town and to photograph it in depth. But the ideal community was not forthcoming, so instead he utilized images that he had gathered from all over France to make this book with the left-wing writer, Claude Roy.

Of all Strand's books, *La France de profil* (A Profile of France) is the truest collaboration with a writer. It is Roy's book as much as Strand's. Not content only to write a text explaining the imagery, or describing France, Roy allowed the physical form of his writing to be guided by the form of the pictures. Pages were conceived as image-text pieces, with the writer's handwritten texts wittily echoing the photograph's compositional lines across the pages, or combined with photographs placed amongst paragraphs collaged from newspapers. All this was couched in the most illustrious gravure from the DDR.

Strand's photographs follow his consistent themes, which were thoroughly set by that time. Despite his search for the ideal community in which to work, he was never especially culturally specific, but used individual people and places to talk about universal issues – the dignity of the ordinary man, the relationship between man and nature, the necessity to work, and human mortality. Frequently, the gorgeousness of his photographs distracts from these themes, but they are there, and if one sometimes finds it hard to tease them out, one is more than adequately compensated by the sheer beauty of his images.

In contrast to his work in films, it seems that Strand never quite reconciled politics and art in his still photography. He was a photographer to his fingertips, the kind that seeks and finds poetry everywhere. *La France de profil* exemplifies this to perfection, including more weathered walls even than Atget, as well as equally weathered faces, lustrous clouds over fecund fields, and a fine picture of a lazy reed-lined stream.

Paul Strand and Claude Roy **La France de profil** (A Profile of France)
La Guilde du Livre, Lausanne, 1952
280 × 220 mm (11 × 9¾ in), 128 pp
Paperback with glassine jacket
71 b&w photographs
Text by Claude Roy

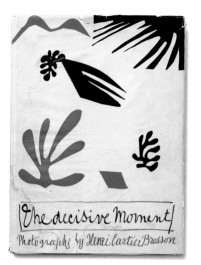

Henri Cartier-Bresson **The Decisive Moment**
Simon and Schuster, New York, in collaboration with Editions Verve, Paris, 1952
370 × 274 mm (14¹⁄₂ × 10³⁄₄ in), 158 pp
Hardback with decorated paper, jacket and laid-in 12-pp caption booklet
126 b&w photographs
Introduction by Henri Cartier-Bresson; afterword by Richard Simon; cover/jacket illustration by Henri Matisse

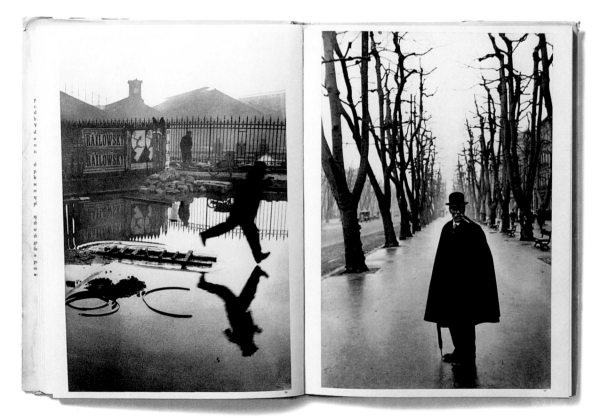

Henri Cartier-Bresson
The Decisive Moment

Henri Cartier-Bresson
The Europeans

The Paris-based Greek publisher, Tériades (Stratis Eleftheriadis) – renowned for making deluxe books with such artists as Matisse, Miró and Léger, and for his magazines *Minotaure* and *Verve* – had planned a book

with Henri Cartier-Bresson in the late 1930s. The war intervened, and following the photographer's successful retrospective show at MoMA in 1947, Tériades eventually published *Images à la sauvette* in 1952 – or as it was happily retitled for its American co-edition (published the same year), *The Decisive Moment*. This version is featured here, as well as the American co-edition of *Les Européens* (The Europeans), because their publication in the United States made Cartier-Bresson an international superstar. Strictly speaking,

The Decisive Moment is a monograph of Cartier-Bresson's best work, but it has overriding unifying factors that elevate it into a great photobook. The first is the concept of the 'decisive moment' itself, which defines the elegance of Cartier-Bresson's imagery: the instant when all the elements in the picture-frame come together to make the perfect image – not the peak of action necessarily, but the formal peak, exemplified by the wonderful puddle leap behind the Gare St Lazare shown here. No one achieved it more often or better,

Henri Cartier-Bresson **The Europeans**
Simon and Schuster, New York, in collaboration with Editions Verve, Paris, 1955
370 × 274 mm (14¹⁄₂ × 10³⁄₄ in), 134 pp
Hardback with decorated paper, jacket and laid-in 8-pp caption booklet
114 b&w photographs
Introduction by Henri Cartier-Bresson; cover/jacket illustration by Joan Miró

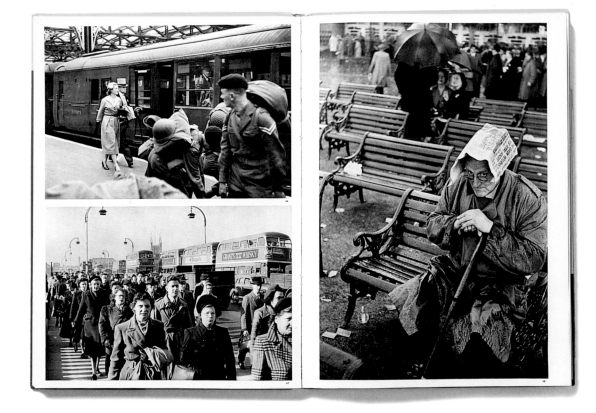

but allied with it was Cartier-Bresson's thoroughly clear-eyed view of the world – astute, non-sentimental, beautiful, profound. Crucially, for all their formal grace, his pictures are distinguished by his humanist view of life.

The Decisive Moment is one of the greatest of all photobooks, and Cartier-Bresson repeated its artistic success three years later with *The Europeans*. The format of the book is the same, this time with a cover designed by Joan Miró. What gives *The Decisive Moment* a slight edge is the fact that it contains images chosen from the whole of his career prior to the 1950s, while those in *The Europeans* were made from 1950–55. As its title suggests, *The Europeans* has a more specific theme – postwar life in Europe – and although for most photographers this would tend to be a strengthening factor, in this case it might be felt to be a marginal weakness; Cartier-Bresson is at his best when at his most universal.

Jean-Philippe Charbonnier
Chemins de la vie (The Roads of Life)

Jean-Philippe Charbonnier was one of France's leading photojournalists for many years, especially during the 1950s and 60s. He worked broadly in the humanist mode, and this book might be regarded almost as a manifesto for that genre. Published only two years after Edward Steichen's great exposition of humanist photography, 'The Family of Man', it follows a broadly similar structure: a journey through the seven ages of man, from birth to death, compiled from pictures taken all round the world.

Also like 'The Family of Man', it tends to depoliticize the human condition by emphasizing universals rather than specifics. Charbonnier shows that activities such as eating, dancing and making out on the street take place in similar circumstances throughout the world. He demonstrates less of a sentimental streak than the American Steichen, and this fine book ends in a welter of ambiguity, a mixed message to say the least.

As in life, the going gets tough as we approach the finale. Firstly, two images – of a man ill in bed, and of an operation – are followed by a picture from one of Charbonnier's most renowned series. At the end of World War II he photographed the execution of a French collaborator and he reproduces an image from that sequence here: the man walking to the place of his death, accompanied by a priest. This grim photograph is followed by slaughter in an abattoir, before the final image turns things around once more. Two children walk down a country road, and the painful journey through life begins again.

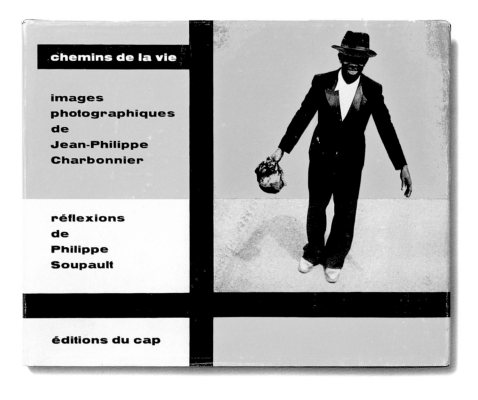

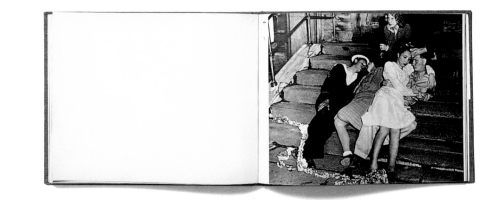

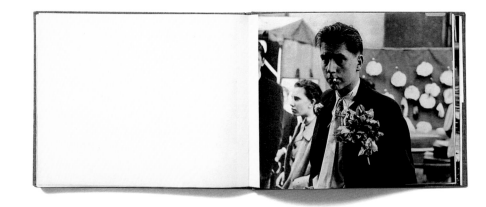

Jean-Philippe Charbonnier **Chemins de la vie** (The Roads of Life)
Editions du Cap, Monte Carlo, 1957
210 × 270 mm (8½ × 10½ in), 164 pp
Hardback with full green cloth and jacket
70 b&w photographs
Reflections by Philippe Soupault

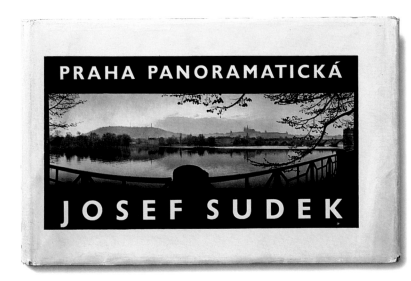

Josef Sudek **Praha panoramatická** (Prague Panorama)
Státní Nakladatelství Krásné Literatury, Hudby a Umení, Prague, 1959
225 × 353 mm (9 × 14 in), 296 pp
Hardback with full white decorated cloth and jacket
284 b&w panoramic photographs
Poem by Jaroslav Seifert; design by Otto Rothmayer

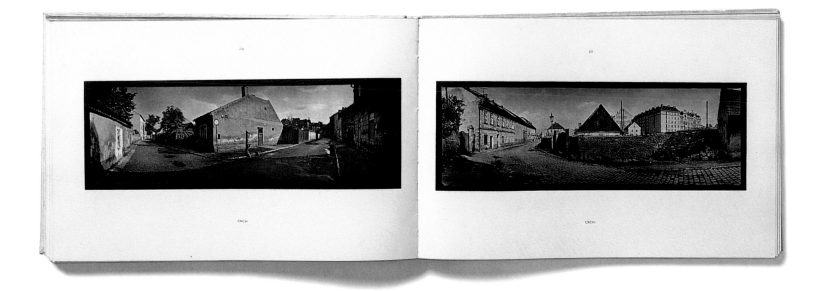

Josef Sudek
Praha panoramatická (Prague Panorama)

In a career spanning from the end of World War I to the 1970s Josef Sudek made many stunning photographs of Prague, ranging from grand vistas to raindrops on a window. The sheer abundance of his work would suggest that photography was as necessary to him as breathing. He claimed the city of Prague and its surroundings as comprehensively as Eugène Atget claimed Paris and its environs. Unlike Atget, however, Sudek published books, many of them anthologies of work, others on specific themes. His masterpiece is one of the most singular photobooks ever made, his *Praha panoramatická* (Prague Panorama) of 1959.

Sudek had always been intrigued by the photographic panorama, but it was the discovery of an old Kodak panoramic camera in a friend's house in the 1950s that inspired him to make the work by which he is now immediately recognized. Of all his books, this one sums up his love of Prague, in all weathers, in all seasons, and not just the historic, public centre, but the most slovenly industrial suburbs, and the scrofulous fringes where the city meets the country. The panoramic camera is a strong unifying element in the imagery, but so is Sudek's democratic eye, which disregards nothing. He treats cathedral and castle in exactly the same way as he treats a factory or a garage. The great public spaces of Prague, which, like the public spaces in any capital, could easily look boring or bombastic in the wrong photographer's hands, are here rendered intimate, while the humblest house or industrial building in a far-flung suburb is monumentalized, graced with Sudek's poetry. His prints are usually dark and a little gloomy, tending towards the romantic, but his feeling for light, weather and space in combination has never been surpassed. Who else could make such a ravishing picture of overhead tramlines and cobblestones in the rain?

The panoramic camera is a fickle instrument. It is not as easy to make good photographs with it as it looks, and it can often be the first refuge of the untalented. *Praha panoramatická*, however, is a veritable encyclopaedia of how to plot, construct and unify a panoramic photograph. And if this were not enough, Sudek even pulls off a near impossible trick at the end of the book: good vertical panoramas.

Victor Palla and Costa Martins
Lisboa: cidade triste e alegre
(Lisbon: Sad and Happy City)

Of the many postwar photobooks on European cities, this is one of the best, and its neglect at the time it was published is regrettable. Made by Victor Palla and Costa Martins, both architects, *Lisboa* (Lisbon) is amongst the most complex of modern photobooks in form and content. It took three years to prepare, the authors taking over 6,000 photographs. Uniquely for this period, it was initially issued as a partwork, in seven monthly fascicles.

Lisboa is particularly notable for using many of the book-making ideas developed by William Klein and Dutch photographers like Ed van der Elsken and Joan van der Keuken, and has a vibrant, cinematic feel, although it also employs text and poetry to great effect. Pictures are printed as large as they can be, followed by spreads of small images. There are half-sized pages, full double-page bleeds, fold-outs, pictures printed on coloured backgrounds. In short, this is an all-singing, all-dancing Euro photobook, a compendium of every design idea rolled into one volume. One might think that such a cornucopia of design strategies would be less effective, but here it works.

The book is clearly a visual paean to Lisbon, beginning with the children of the city, followed by random street portraits, progressing through a series of 'chapters' to such topics as the harbour, and then – as an excuse to introduce a little sex – the city's night life. Catalogued in this way, it sounds conventional and predictable, but the photographs of Palla and Martins are graphic and exuberant, and the book is superbly printed. Both as a photographic bookwork, and as a document of city life, it is considerably more than the sum of its parts.

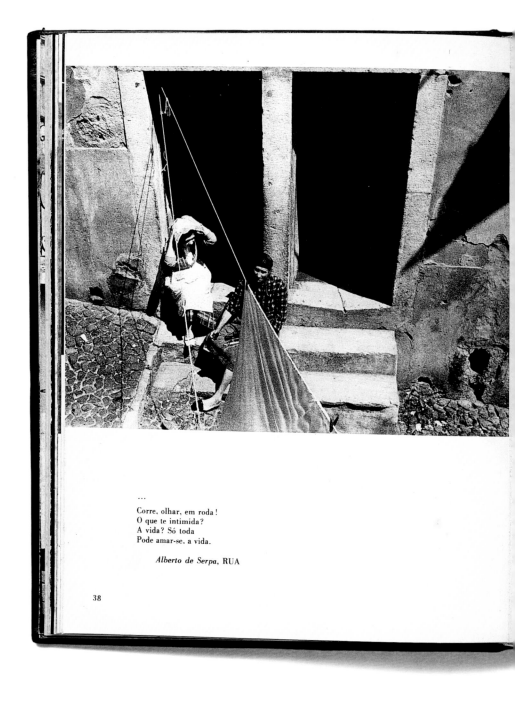

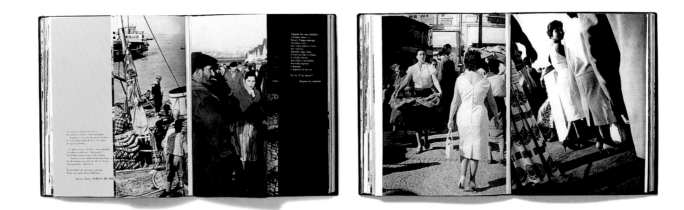

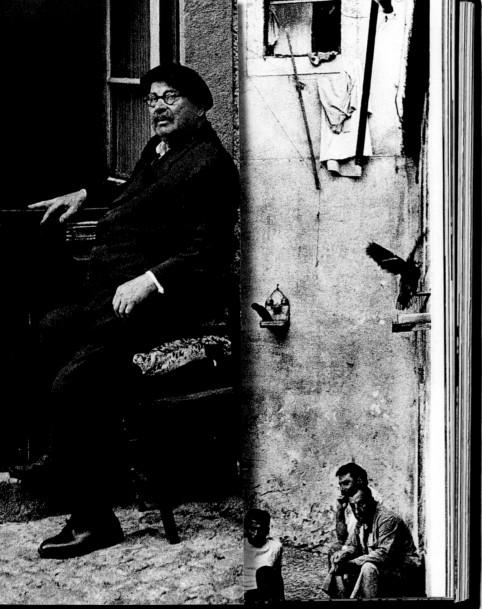

Victor Palla and Costa Martins **Lisboa: cidade triste e alegre**
(Lisbon: Sad and Happy City)
Circulo do Livro, Lisbon, 1959
(Also published in a deluxe signed and numbered
edition of 60, with slipcase)
279 × 225 mm (11 × 9 in), 174 pp
Hardback with full black paper-covered cloth and jacket
152 b&w photographs
Text by Rodrigues Miguéris; poems by Alexandre
O'Neill, Armindo Rodriques, David Mourão-Fèrriera,
Eugénio de Andrade, Jorge de Sena and José Gomes
Ferriera; photographs by Victor Palla and Costa Martins

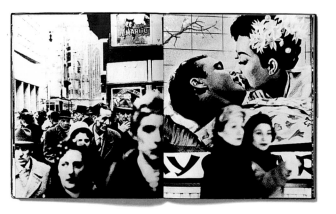

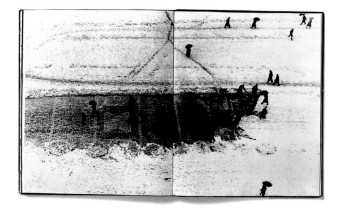

Mario Carrieri **Milano, italia** (Milan, Italy)
C M Lerici Editore, Milan, 1959
290 × 250 mm (11½ × 9¾ in), 166 pp
Hardback with decorated paper and jacket
135 b&w photographs

Mario Carrieri
Milano, italia (Milan, Italy)

Mario Carrieri was a leading Italian photojournalist and cinematographer who, as the endpaper of *Milano, italia* informs us, abandoned all other projects and commissions for two years between 1957 and 59 to photograph Italy's largest city in a raw, cinematic style. This was clearly derived from *New York*, by the American photographer William Klein (see page 243), which was an enormous influence on both the style and design of the photobook, especially in the countries in which it was published, including Italy.

Here, however, there is little of the wisecracking, cynical, *buffo* style – Klein's word for his comic mode of photography.[5] Milan is the hardest city in Italy, the most dynamic and least sentimental, and Carrieri does not spare us the more unattractive aspects of a thrusting metropolis in which commercial values hold sway over everything else. He generally confines himself to the city's grittier aspects, being drawn to the desolate outer suburbs, and even when photographing the city's glamorous centre, he manages to make it look dark and dangerous. The weather, too, is co-opted into his argument: his Milan seems a city of incessant drizzle and snow.

At the time he made *Milano* Carrieri was associated with the Italian neo-realist photographers, such as Cesare Columbo and Mario di Biasi, before he went on to become a distinguished photographer of sculpture. He made books on other cities, but none this extreme. Its concentration on the seamier side of life makes *Milano* one of the most important works of the neo-realist tendency of the 1950s.

Sune Jonsson
Byn med det blå huset
(The Village with the Blue House)

Like Walker Evans's *Let us now Praise Famous Men* (see page 144), Sune Jonsson's book is a documentary study of a rural community, with words and pictures in symbiotic relationship. Indeed, in *Byn med det blå huset* (The Village with the Blue House), the relationship is more symbiotic than most, for writer and photographer are one and the same. This is often a recipe for failure, but here it is a complete success; Jonsson proves himself to be highly accomplished in both fields.

A prolific and renowned figure in Sweden, he has made a study of his home town, which is in the far north of the country, in the district of Västerbotten. This was a village of 304 souls when he began to photograph, but only 299 when he finished. As might be expected from an insider's view, his vision is warm and sympathetic, full of sentiment yet without sentimentality. His photographs are like his text, simple, elegant, but profound, printed in a beautiful soft grey gravure. His eye for composition and tonalities may be compared to that of W Eugene Smith, but without Smith's unfortunate tendency to lay on the schmaltz with a trowel.

The book's 'story', too, is outwardly simple, yet deals with a vital issue: the daily lives of ordinary people. It is divided into sections – consisting of text and related pictures – each dealing with an aspect of village life, a particular character perhaps, or a significant event – a dance, a wedding, a funeral, a prayer meeting. Jonsson brings off a difficult feat, getting close to the ideal documentary book. He has made a report in words and pictures that deals with commonplace yet universally important issues, that is empathetic yet objective, that lacks hyperbole yet is richly expressive, and above all, that clearly displays a sense of its own integrity.

Bernhard Wicki and Georg Ramseger
Zwei Gramm Licht (Two Grams of Light)

In his afterword to this book, Georg Ramseger asks what constitutes a photographic document. It is a good question, since *Zwei Gramm Licht* (Two Grams of Light) seems to have little to do with documentary. This is an expressive, personal meditation on life, and the pictures, by the Swiss film-maker Bernhard Wicki, are moody, dark and grainy. Yet they also display a studied, graphic quality, a self-consciousness that keeps them in the documentary vein.

However we might choose to pigeonhole its style, *Zwei Gramm Licht* is a fine photobook, an urban mood piece that chronicles the photographer's wanderings across the postwar European landscape. Opening with three shots of caravan shanty towns, the journey is a gloomily romantic one. This mood is emphasized by the ravishingly dark gravure printing, craggy urban portraits, a wrecked car, grizzled tramps. Wicki's view of the human condition might be exemplified by a photograph he makes of a pretty, pensive young girl, caught – or trapped – behind the bars of a fence. Generally, this dark mood is sustained throughout. It is, indeed, fairly relentless, but Wicki allows us a glimmer of hope: the book ends, like Jean-Philippe Charbonnier's *Chemins de la vie* (The Roads of Life) (see page 210), with two people walking down a country road – perhaps towards freedom.

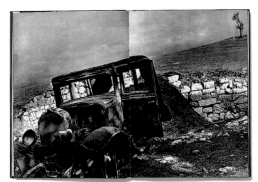

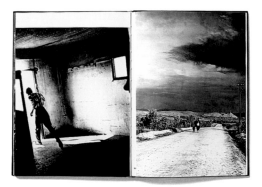

Bernhard Wicki and Georg Ramseger **Zwei Gramm Licht** (Two Grams of Light)
Interbooks, Zurich, 1960
275 × 200 mm (10¾ × 8 in), 104 pp
Hardback with full black cloth and jacket
71 b&w photographs
Foreword by Friedrich Dürrenmatt; afterword by Georg Ramseger;
photographs by Bernhard Wicki

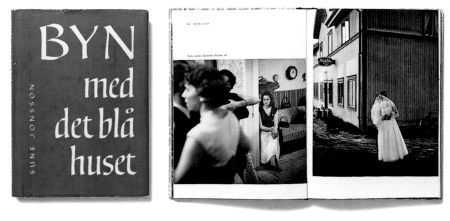

Sune Jonsson **Byn med det blå huset** (The Village with the Blue House)
Nordisk Rotogravure, Stockholm, 1959
211 × 152 mm (8¼ × 6 in), 138 pp
Hardback with decorated paper, black cloth spine and jacket
108 b&w photographs
Text and photographs by Sune Jonsson

BILL BRANDT **PERSPECTIVE OF NUDES**

Preface by Lawrence Durrell Introduction by Chapman Mortimer

Bill Brandt **Perspective of Nudes**
The Bodley Head, London, 1961
275 × 235 mm (9¼ × 8¾ in), 90 pp
Hardback with jacket
90 b&w photographs
Preface by Lawrence Durrell; introduction
by Chapman Mortimer

Bill Brandt
Perspective of Nudes

The series of nudes that Bill Brandt made between 1947 and 1960 – brought to triumphant fruition after he acquired an old wide-angle camera – is justly renowned. These startling images rewrote the language of nude photography in not one, but several quarters. Brandt's approach was primarily formal, but his own sensibilities, combined with photography's tendency to overwhelm form's purity with life's impurities, ensured that his nudes are as interesting for their psychological undertones as for the wealth of unexpected forms he conjured. He did so with a camera that was devoid of a practicable viewing mechanism and thus reduced him, in effect, to working by blind instinct.

The idea of 'woman as nature' had already amassed an extensive iconography, and Brandt contributed to it in a series of abstract, sculptural pictures made on the Sussex and Normandy coasts. Here the nude was transmuted from flesh to rock, as the photographer became ever more abstract in approach and increasingly formally adroit.

They are striking, popular and influential images, but are perhaps not as challenging as those he made in the interiors of Kensington and Hampstead mansion flats. In these Brandt pictured a world of faded grandeur, of Edwardian bourgeois homes metamorphosing into 1940s bedsit land – cavernous refuges for European émigrés or bohemian nonconformists. Drawing on a variety of visual sources – children's books, Surrealist dream imagery, film noir – Brandt fashioned a shadowy vision of sombre, enigmatic figures in hyper-spatial rooms, dreamy nocturnal protagonists in situations and *mise en scènes* that might have been devised by Alfred Hitchcock.

In the nude pictures Brandt is generally chaste – except for a regrettable late excursion into bondage. He is a disinterested, though not uninterested voyeur, his gaze more that of the artist than the man. However, there are certain nervy, transgressive undertones that throw a faint and intriguing psychosexual shadow over the proceedings. As David Mellor has described it, these works are 'soft vignettes of prohibition, trespass and anxiety-laden territory'.[6] The anxiety, it must be said, seems as prevalent in the models as in the photographer. Brandt's women, Mellor notes astutely, are both 'petrifying and petrified'.[7]

Brandt wrote that the photographer must teach himself to see with a child's curiosity, and this would seem to be the key. At close range, his ancient camera yields a Venusian giantism, where sometimes sharply defined, sometimes blurred mountains of flesh loom over the artist/observer. The effect is of those half-forgotten childhood memories of the mother's warm, soft, comforting flesh. It seems fitting that Brandt, the most cosmopolitan of English photographers – Hampstead intellectual, avowed aficionado of Secessionist Vienna, and psychoanalytical subject – should make nudes that are so classically Freudian in character.

Paul Strand and Basil Davidson
Tir A Mhurain: Outer Hebrides

Of Paul Strand's series of studies of people and places, the Hebridean book (also published in the United States) contains the highest ratio of truly memorable images The format of his books consisted of landscapes, still lifes and portraits. The main thrust of his imagery, marked by its textural interplay, was to render people an integral part of the natural world, emphasizing how they are shaped, nurtured, buffeted by nature, and indeed, in thrall to it. This may seem an odd message for a socialist artist to promulgate, but Strand came from a generation concerned with feeding the masses off the land, which created a kind of pastoral nostalgia.

'I like to photograph people who have strength and dignity in their faces: whatever life has done to them, it hasn't destroyed them', he wrote.[8] And yet the Scottish book in particular evinces a troubled tenor. The tones manipulated so carefully by Strand in order to balance his pictures bring his sitters into harmony, not just with nature, or society, but with the picture frame. It locks everything into a harmonious whole, but is an isolating act, the opposite of the socializing one to which he aspires in his work. The studied, frozen monumentality, the sense of 'timelessness', seems so far removed from our notion of what a politicized photographer should be doing that Alan Trachtenberg has even wondered whether we can really go to Strand for pictures of 'what's going on in the world'.[9]

Strand's subjects are removed from society, from the world, into a space that is 'other'. In his portraits there is, as Reynolds Price notes, 'no common physical feature, no common psychic moulding in their solemnity'.[10] This profound feeling of separateness generates an underlying despair in Strand's work. It does not necessarily negate his aim of lauding the rural proletariat, nor detract from his sitters' dignity, but, aided by the heavy gravure printing, couches everything in terms of a rich, voluptuous despondency.

Paul Strand and Basil Davidson **Tir A Mhurain: Outer Hebrides**
MacGibbon & Kee, London, 1962
280 × 225 mm (11 × 9 in), 152 pp
Hardback with full grey cloth and jacket
106 b&w photographs
Text by Basil Davidson

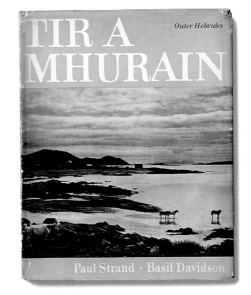

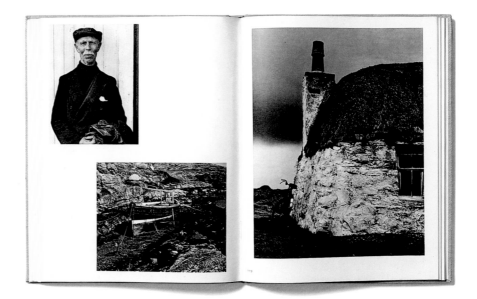

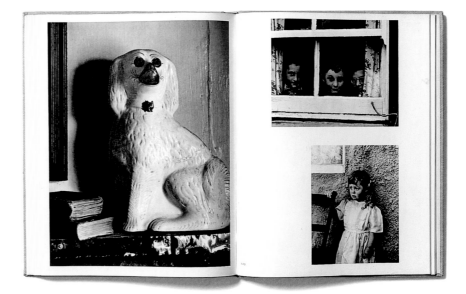

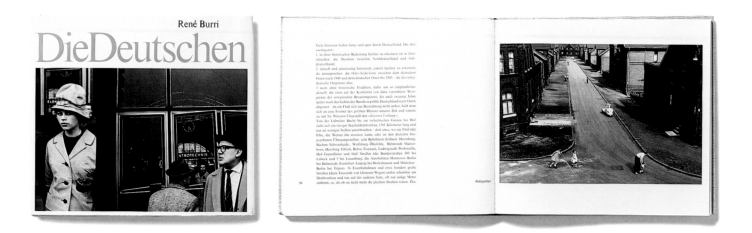

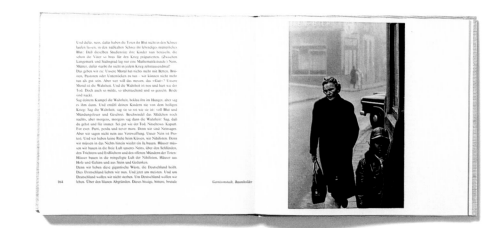

René Burri **Die Deutschen** (The Germans)
Fretz & Wasmuth Verlag, Zurich, 1962
185 × 210 mm (7¼ × 8¼ in), 170 pp
Hardback with full linen and jacket
88 b&w photographs
Texts edited by Hans Bender; text extracts by Heinrich Böll, Bertolt Brecht, Max Frisch,
Wolfgang Koeppen, Friedrich Sieburg, Diether Stolze and others

René Burri
Die Deutschen (The Germans)

Robert Frank's *Les Américains* (The Americans, 1958) (see page 247) was published by Robert Delpire as part of his *Encyclopédie essentielle* series. By the time Delpire published René Burri's *Les Allemands* (The Germans) in 1963, Frank's book had become, if not yet a classic, at least a *cause célèbre*, and the fine volume of his fellow Swiss perhaps did not receive the attention it deserved. Of course, most books would suffer in comparison to Frank's work of great, if occasionally wayward, brilliance. If Frank had not raised the bar to impossible heights, Burri's book would be more widely regarded as one of the best photobooks of the 1960s. Seen here in its German edition, *Die Deutschen*,

which was published the year before *Les Allemands*, exactly mirrors *Les Américains* in conception – an extended photo-essay of the same size and similar design, with excerpted text from writers commenting on the country's national characteristics.

Burri's pictures are sharp and incisive, occupying an interesting middle ground between the controlled framing of the classic photojournalistic mode and the casual looseness of Frank. But what he lacks, or perhaps chooses to downplay in his desire to be a fair-minded chronicler, is Frank's intensely personal vision. We might say that *Die Deutschen* is about what it purports to be about – Germany – while *Les Américains* is as much about Frank as it is the United States. This is not to say that Burri is lacking his own opinion, but that he allows for other opinions in the work. He is a documentary

photographer, a photojournalist, in a way that Frank is not. The story, too, that Burri was telling was a much more positive one. Despite the war and the division of Germany, at the time the photographs were taken West Germany represented a remarkable success story. Burri could have looked more at the darker side of the country's economic and social recovery from the Nazi period, but that would not have been entirely objective journalistically, and he is both a responsible journalist and an extremely talented photographer. *Die Deutschen* exemplifies these characteristics perfectly, leading one to suspect that this book is a truer representative of Robert Delpire's aims for the *Encyclopédie essentielle* series than Frank's idiosyncratic masterpiece.

Lucien Clergue
Toros muertos (Death of the Bull)

Unlike *Toreo de salón* (Playing at Bullfighting) (see page 220), Lucien Clergue's *Toros muertos* (Death of the Bull) takes us to the professional bullfight. Indeed, Clergue transports us right into the ring, almost rubbing our faces in the unpalatable facts surrounding the death of a bull. He focuses on the moment of truth – when the matador plunges his sword into the animal. The book begins with the sword thrust by a sober black-clad matador, looking remarkably like a priest, and from then on concentrates almost entirely on the bull and its noble or (depending on how you look at it) ignoble demise. In what are arguably the best photographs ever taken

of the bullfight, Clergue makes every effort to get close to his subject, usually using a low angle for maximum dramatic effect, and he spares us nothing of the spectacle's gory climactic moment.

The book's design, bold and cinematic, is also extremely effective in both heightening the drama and maintaining a dynamic flow to the action. By repeating a series of close-ups, and showing us very little of the stadium, the crowd, or other players in the drama, Clergue keeps our attention focused on the bull's plight, imparting a strong psychological sense to the drama. He emphasizes how primitive and elemental the whole business is – it is entirely about death, nothing less than ritual sacrifice, and by concentrating on the abattoir elements, he does not let us forget that. We are made

not only to feel a part of it, literally down there with the bull, but compelled to experience strong empathy with the creature.

And yet, despite this, it is difficult to tell from the images whether Clergue is pro or anti bullfighting. That is the book's great strength. By applying immediacy and spontaneity to a specific event, he puts us in the position of a participant rather than a spectator, giving us all the evidence we need to make up our own minds.

Lucien Clergue **Toros muertos** (Death of the Bull)
Ernst Battenberg Verlag, Stuttgart, and Editec, Paris, 1962
263 × 263 mm (10¼ × 10¼ in), 52 pp
Hardback with white cloth spine and card slipcase
(not shown)
30 b&w photographs
Poem and text by Jean Cocteau; text by
Jean-Marie Magnan

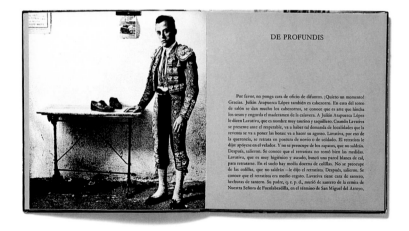

Camilo José Cela, Oriol Maspons and Julio Ubiña **Toreo de salón** (Playing at Bullfighting)
Editorial Lumen, Barcelona, 1963
225 × 215 mm (9 × 8¹₂ in), 84 pp
Hardback
30 b&w photographs
Text by Camilo José Cela; photographs by Oriol Maspons and Julio Ubiña

Camilo José Cela, Oriol Maspons and Julio Ubiña
Toreo de salón
(Playing at Bullfighting)

Camilo José Cela and Juan (Joan) Colom
Izas, rabizas y colipoterras

As the title indicates, the books published by Editorial Lumen under the imprint *Palabra e imagen* (Words and Pictures) in the early 1960s looked to integrate text and photograph without one necessarily holding sway over the other. The texts for two of these books were written by Camilo José Cela, then regarded as Spain's leading, and most controversial writer, a former soldier on the Nationalist side in the Civil War who became an outspoken anti-fascist, and was to win the Nobel Prize for Literature in 1989.

The first of these books contained photographs by Oriol Maspons and Julio Ubiña taken at a Barcelona bar, where young boys would go to learn bullfighting. Many who trained like this knew they would never fight a real bull; it was play – *toreo de salón* – rather than serious, and the photographers approached it in this way. The boys rented an old bullfighter's costume, and the 'bull' was a skull and horns mounted on to a pair of wheels and pushed by the teacher in order to show them the complicated moves required by a real toreador. Cela was a dark, eminently serious writer, but he found some of the joyous and amusing tone that Maspons and Ubiña had caught in their nevertheless gritty images of these Barcelona kids fighting fictional bulls in the middle of the street.

The second book that Cela made for Editorial Lumen was a good deal more controversial. *Izas, rabizas y colipoterras*[11] is perhaps the best known of his non-fiction books, noted both for its scalding text and the fine photographs of Joan Colom. Like Maspons and Ubiña, Colom was a leading photographer in the Catalan Photographic Group. *Izas* was one of Editorial Lumen's most controversial books, due entirely to its erotic content, which brought it much condemnation. Characteristically, Cela's text is brutal and frankly ribald. Colom's pictures are of prostitutes in the Raval, the Chinese quarter of Barcelona.

Colom was making an extensive documentation of this old, raffish Barcelona district at the time, and was reportedly annoyed that Lumen only used his images of the area's prostitutes, but they are wonderfully evocative, memorable and unified as a group. He photographs his subjects without prurient leering, or passing judgement; they are ruthlessly observed and wholly devoid of cheap sentimentality, yet entirely sympathetic. By combining body shape with gesture, he manages to evoke character and individuality, almost like a master draughtsman making a character sketch.

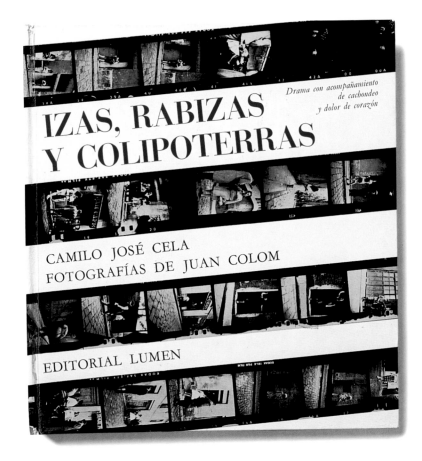

Camilo José Cela and Juan (Joan) Colom **Izas, rabizas y colipoterras**
Editorial Lumen, Barcelona, 1964
227 × 210 mm (9 × 8¼ in), 92 pp
Hardback
34 b&w photographs, including 1 gatefold
Text by Camilo José Cela; photographs by Juan (Joan)
Colom; design by Christián Civici and Oscar Tusquets

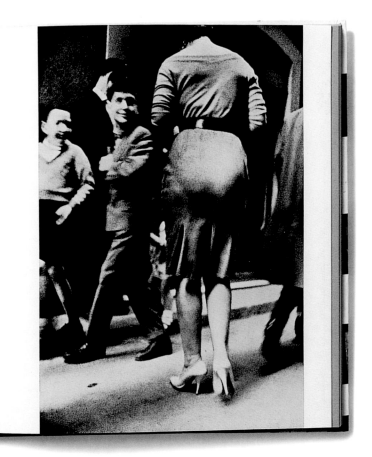

CISNE PARA ILUSIONES NIÑAS

¡Qué sonrisa de ángel en la cara del niño que mira putas! En el colegio le metieron miedo —¡vivan las putas!— pero nadie jamás le dijo que una puta, sobre serlo, era también una mujer (redondeemos el tópico: como su madre, como su hermana, etc.). El niño ignora que la puta todavía existe porque las crueles costumbres prohiben el amor. La puta es puta porque la sociedad ni sabe evitarla ni lo intenta siquiera. Prohibir las putas es tan ingenuo como lo sería prohibir el virus del cáncer (suponiendo que el cáncer sea producido por virus). Al niño le metieron miedo en el colegio —miedo al amor y a la mujer, que de la prostitución ni se habla—, y el niño nivela, por arriba o por abajo, a la hembra: todas son buenas y deseables, incluso las putas, o todas son nefandas y contaminadoras, hasta las que mejores pudieran parecer. A los frailes del colegio les convendría leer a Lope: *No hay mujer que sea buena / si ve que dicen que es mala.* Abandonemos este sermoneador tonillo, que allá cada cual. Veamos de poder hacerlo.

Hay cisnes callejeros para ilusiones niñas y hay también niños que van por la calle henchidos de ilusión. El niño suele tardar más tiempo en prostituirse que la niña; depende un poco de las criadas que tenga en su casa —si es niño rico— o de los arrestos y los apetitos de las vecinas —si es niño pobre. En todo caso es doloroso que el niño no vaya a su ser natural y por sus pasos, como el cachorro.

Los cisnes para ilusiones niñas llevan faja y no suelen vestir provocativamente. Si los niños no sonriesen como ángeles a punto de la caída, el cisne callejero, el cisne para ilusiones niñas, pudiera parecer su madre.

42

Izis (Izis Bidermanas) and Jacques Prévert
Le Cirque d'izis (The Circus of Izis)

The Lithuanian photographer Izis (Izis Bidermanas) was another of those remarkable émigrés from Eastern Europe who moved to Paris in the 1930s and thus graced French photojournalism. His book on the French circus, published in 1965, but bearing the stamp of an earlier era, is the best of his extensive bibliography – partly because of his ability to make so much of a clichéd subject, and partly because it is such a splendid book object. It is a large volume in *The Decisive Moment* mould, printed in the same kind of luscious soft grey gravure, and like Henri Cartier-Bresson's masterpiece, featuring a cover by a major School of Paris painter – Chagall this time rather than Matisse.

Le Cirque d'izis (The Circus of Izis) is very much a photo-text work, with montaged writings by Jacques Prévert, a collage of texts, newspaper cuttings, engravings and so on that detail the history of the various acts in a traditional circus. Izis's pictures, shot mainly in Parisian circuses but also in cities like Toulon, Marseilles and Lyons, are – as one might expect – affectionate and nostalgic, but also deeply melancholic.

A bitter-sweet, nostalgic view of circus life is to be expected, but Izis cuts much deeper than that. The difficulty of such a peripatetic mode of living is shown, but more than that, there is a desolate undercurrent, a feeling that the circus is a refuge for freaks – not the physical freaks who entertain unfeeling spectators, but psychological freaks, profoundly cut off from conventional society. A family of sorts, the protagonists seem to find solace in the company of other outsiders. This sense of Existential isolation is handled with sensitivity and empathy by Izis, who makes what might be just another hackneyed view of a popularly exotic subject into something profound, moving and extraordinary.

Izis (Izis Bidermanas) and Jacques Prévert **Le Cirque d'izis** (The Circus of Izis)
André Sauret, Monte Carlo, 1965
325 × 243 mm (12³⁄₄ × 9¹⁄₂ in), 172 pp
Hardback with full red cloth, jacket and clear acetate outer jacket
76 b&w photographs
Introduction by Jacques Prévert; 4 original compositions and jacket design by Marc Chagall

Bohumil Hrabal and Miroslav Peterka
Toto město je vespolečné péči obyvatel
(This Town is Under the Control of its Citizens)

Czech photography, it seems, is marked by a natural sense of irony and an innate surrealism. This book, by the photographer Miroslav Peterka and the distinguished writer Bohumil Hrabal is no exception, being firmly in the pessimistic tradition of immediate postwar works like Jindřich Štyrský's *Na jehlách těchto dní* (On the Needles of These Days). Like that book, this is an urban meditation that uses photographic fragments, glimpses of the urban streetscape, to make a wider point about our political situation in the late twentieth century.

The book's title may or may not be intentionally ironic. The dark, fragmented nature of the pictures indicate that it is, suggesting an anti-communist critique made just prior to the 'Prague Spring' of Alexander Dubček. If Prague is under its citizens' control, they are not maintaining it too well, and the book's mood is bleak and melancholic. Peterka details a familiar iconography of photographic melancholia – abstracted signs, mysterious doorways, peeling and crumbling walls, miserable-looking people on the streets, a broken mask lying by a lamp-post. With these apparent clichés, he creates an atmosphere of gloom and uncertainty, mirroring the alienated lives of modern man. He does, however, lighten the moods at the end with images of a wedding and then a baby, at least suggesting a ray of hope and possible redemption – though that might be just another irony.

Generally, Peterka's subtle, poetic cry of despair confirms the prevailing mood in a number of books in postwar Europe, where the blighted psychological mood remained long after the conflict had ended.

Chargesheimer (Carl Hargesheimer)
Köln 5 Uhr 30 (Cologne 5.30)

Chargesheimer was one of the most prolific German photographers of the 1950s and 60s, a portraitist and member of the Fotoform group, who also worked for the resurgent German illustrated press before the rise of television changed magazine photography irrevocably. *Köln 5 Uhr 30* (Cologne 5.30), however, is not so much a journalistic document as a photographer's personal project, probably generated by Chargesheimer's fascination with the deserted early morning city, possibly also as a try-out for one of the wide-angle lenses – 21 mm or 24 mm – that had been newly introduced and were popular with photographers of the day.

The project is executed with commendable German rigour, reminding us that Cologne is a stone's throw from Düsseldorf, where Bernd and Hilla Becher were reintroducing seriality into German photography at the time. Chargesheimer created a rigorous formal framework for this book, determined by the steep perspective generated by the wide-angle lens and the fact that every image is vertical. The vertiginous perspective focuses particularly on the ground in front of Chargesheimer, on directional arrows and other painted markings in the roadway – rather like Atget's concentration on cobblestones. The preponderance of street signs, and Chargesheimer's tendency to photograph the reconstructed Cologne rather than what was left of the old city, give the pictures a distinctly American feel.

Devoid of people, waiting for the first cars to arrive, the city has a vaguely sinister atmosphere, lifeless and inhuman. The new Cologne might have been a symbol of the postwar German economic miracle, but it represented a homogenized, dehumanized technological society, a product of global corporate capitalism.

Chargesheimer (Carl Hargesheimer) **Köln 5 Uhr 30** (Cologne 5.30)
Verlag DuMont Schauberg, Cologne, 1970
280 × 380 mm (11 × 15 in), 64 pp
Paperback with white card slipcase (not shown)
64 b&w photographs
Foreword and introduction by Dr Fritz Schindler

Bohumil Hrabal and Miroslav Peterka **Toto město je vespolečné péči obyvatel**
(This Town is Under the Control of its Citizens)
Ceskoslovensky Spisovatel, Prague, 1967
238 × 165 mm (9¹⁄₂ × 6¹⁄₂ in), 100 pp
Hardback with full black cloth and jacket
50 b&w photographs
Text by Bohumil Hrabal

Giulia Pirelli and Carlo Orsi
Milano (Milan)

Only a mere half-a-dozen years on from Mario Carrieri's *Milano* (Milan), the treatment of the same subject matter made by Giulia Pirelli and Carlo Orsi decisively reveals the influence of the 'Swinging 60s'. In a decade when optimism was suddenly around like spring in the air, Carrieri's pessimism has been transformed into exuberance, and the book looks and feels more like a company report on the city than a photojournalistic essay. Although there are a few distressed walls, they are there for picturesque, graphic effect rather than to denote poverty. The book's whole emphasis has changed from that of the socialist-inspired neo-realism of Carrieri, concentrating not on grim industrial pollution and grime, but on the dynamic, go-ahead character of Italy's economic hub and most cosmopolitan city.

The graphic design of this book, too, is different. It is bigger and bolder, the gravure has changed from grey halftones to a stark, 'soot and whitewash' black and white. Everything is harder-edged, more superficially attractive, with a distinctly commercial feel, the graphic effects being used more for their own sake than to underpin the meaning of the narrative. This makes *Milano* a typical 1960s photobook, just as Carrieri's was a perfect representative of the 1950s. In only a few years the angst of the 1950s had been replaced by the buoyancy of the 60s, though some might say that art suffered as a result. Nevertheless, this is a vibrant, energetic, sharp and covetable book, and if style tends to win out over substance, that was the 60s, that was.

Giulia Pirelli and Carlo Orsi **Milano** (Milan)
Bruno Alfieri, Milan, 1965
390 × 294 mm (15¼ × 11½ in), 106 pp
Hardback
54 b&w photographs
Introduction by Dino Buzzati; photographs by Giulia Pirelli and Carlo Orsi; design by Giancarlo Iliprandi

Marc Attali and Jacques Delfau
Les Erotiques du regard (The Erotics of the Gaze)

More film has probably been exposed on naked and semi-naked women than on any other subject in photography's history. Add all the naked men, and erotic photography is probably the genre with the largest body of work to its name. The only other serious candidate is the family snapshot. While such speculation is impossible to prove, it is clear that there is a good deal of photography devoted to the subject of sex.

And yet this publication features relatively few erotic books. Surely such a popular genre might have thrown up many more interesting volumes on a subject that fascinates most of us? The problem would seem to lie in the fact that erotic photography is not required to venture beyond the trite and obvious. The subject matter is enough, so why do more? It is, of course, a tricky subject, but is nevertheless a potentially fascinating one. As well as revealing gender and social mores, it overlaps with important issues of life and death, yet most of the photographers who have attempted it have dealt with it only superficially. Furthermore, many of those who do try to take it seriously become so serious that they generally fail to maintain the lightness of touch and the sure-footed step necessary to carry it off.

Les Erotiques du regard (The Erotics of the Gaze) by Marc Attali and Jacques Delfau largely succeeds in this delicate balancing act. It is a frank meditation on the male gaze, an essay in pictures and a kind of concrete poetry where the typography has equal status with the imagery. Unlike many of the so-called erotic books from the 1960s – the 'Free Love' era – *Les Erotiques* manages to examine the phenomenon of the male gaze, whilst at the same time doing the classically male thing of gazing.

The book is full of snatched images of women in public – on the streets and in cafés – voyeuristically focusing on their bodies – primarily legs. Yet in the context of the book the pictures declare themselves for what they are, so that the whole volume is as much self-regarding as regarding. It is a thoughtful book that concentrates on looking, yet is light-hearted and serious at one and the same time, which means that it both engages and disengages with the erotic in an interesting, thoroughly ambiguous, complex and tantalizing way.

Marc Attali and Jacques Delfau **Les Erotiques du regard** (The Erotics of the Gaze)
André Balland, Paris, 1968
345 × 255 mm (13¹⁄₂ × 10 in), 114 pp
Hardback with jacket
64 b&w photographs

Sanne Sannes
Sex a Gogo

Rambow (Gunter Rambow)
Doris

The 1960s, that decade of sexual liberation, was a period when censorship laws regarding the depiction of sexual acts became a little more relaxed in Western Europe and the United States, gradually paving the way for the laissez-faire situation that largely pertains today. Some countries relaxed these laws more than others – Northern Europe was notoriously more liberal – and both these books emanate from that quarter, from Holland and West Germany respectively.

When *Sex a Gogo* was published in 1969, Sanne Sannes had recently been killed in a car accident, at the age of 30. He had been responsible for a notable work in the Dutch *beeldroman* (photonovel) tradition, *Oog om Oog* (Eye for Eye). *Sex a Gogo* was much more light-hearted, a Pop art sexual manual, complete with psychedelic collaging and cartoon speech balloons, much influenced by the many 'underground' magazines that were such a feature of 1960s culture. The book's montages were devised by its designer, Walter Steevensz, who took over the project when Sannes died, and it is his vision as much as the photographer's that is evidenced in this typically 1960s comedy of sexual mores. Yet however comical, *Sex a Gogo* never allows us to forget about its erotic intentions.

Gunter Rambow's *Doris* is much more serious in every way. Rambow has been one of Germany's leading graphic designers for more than three decades. Despite its bright, bold cover, however, this book is more about the sex than the design. It contains two photo-series, each taking up about half the volume. The first consists of photographs of prone naked women with their legs spread – softcore pornography for West Germany at that time, hardcore pornography for most other countries. The second series consists of extreme close-ups of female genitalia, so close that they are semi-abstract – almost, but not quite making the cross-over into full abstraction.

Doris appeared at the time when the Women's Movement of the 1960s had begun to gather irresistible momentum, and one of the primary questions that women were asking was about their representation in images and the media. Paradoxically – or quite deliberately – at the same time the barriers of sexual censorship were tested, and in many cases pushed over. Rambow's book was preceded by a few others of this nature, and was greeted with outrage, but it was followed by many more. It may be seen as either a misogynist reaction against the Women's Movement or a blow against sexual repression, a critique of pornographic conventions or an astute piece of commercial pornography masquerading as art – or even as a work of groundbreaking photographic art.

Sanne Sannes **Sex a Gogo**
De Bezige Bij, Amsterdam, 1969
159 × 280 mm (6¼ × 11 in), 190 pp
Hardback
190 photocollages
Design by Walter Steevensz

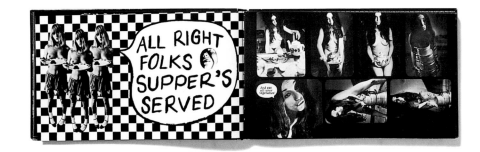

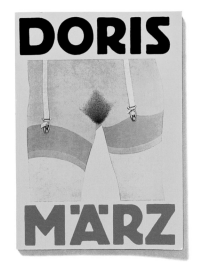

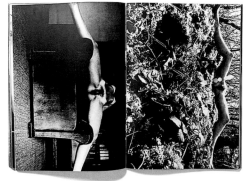

Rambow (Gunter Rambow) **Doris**
März Verlag, Frankfurt, 1970
324 × 237 mm (12¾ × 9¼ in), 140 pp
Paperback
142 b&w photographs
Jacket text by Berndt Höppner

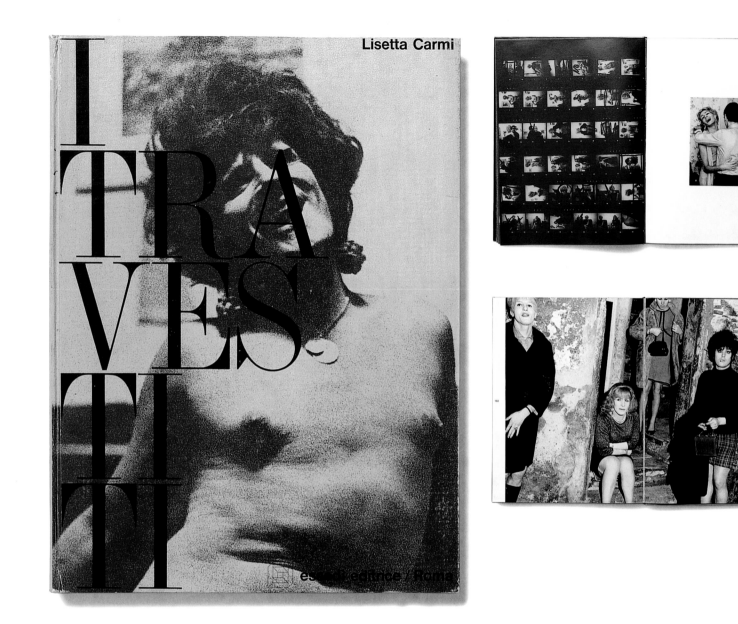

Lisetta Carmi **I Travestiti** (The Transvestites)
Essedi Editrici, Rome, 1972
320 × 240 mm (12¹₂ × 9¹₂ in), 164 pp
Hardback
146 b&w photographs
Texts by Elvio Fachinelli and Lisetta Carmi; photographs by Lisetta Carmi

Lisetta Carmi
I Travestiti (The Transvestites)

Like the circus, a popular and suitably exotic subject for the photojournalist, the world of the transvestite has often been visited by the photographer. In the wrong hands it merely yields a trashy haul of voyeuristic and prurient imagery. It is thus to the credit of the Genoese photographer Lisetta Carmi that she never goes for the cheap shot, yet is open and unblinking in her view of Genoa's transvestite quarter. Unlike other books on the same subject, this is a serious study, an attempt to understand and empathize with the social and sexual phenomenon of the transvestite, and Carmi's pictures are objective yet intimate. They are explicit enough for some critics to think them voyeuristic, but she spent a long time getting to know her sitters, and was clearly trusted by them.

Carmi made these pictures between 1965 and 1971, utilizing the spontaneous photographic aesthetic of the day. They were taken in the old Jewish quarter of Genoa, which had become a ghetto for both transvestites and transsexuals. The book's only false note is some sociological theorizing, based perhaps on an Italian sense of machismo, that makes the dubious claim that neither the many 'women' who worked as prostitutes, nor their male clients were gay. However, the book is both sociologically and photographically interesting, an eloquent plea, made by a real woman, for society to understand these 'other' women, trapped in the wrong bodies.

Koen Wessing
Chili, September 1973 (Chile, September 1973)

The book begins with a double-page spread of a pile of burning papers. On the top a face can be glimpsed: President Salvador Allende of Chile, overthrown by a military revolt. Allende had been democratically elected, but the United States, in one of the most disreputable episodes in its recent history, deemed his socialist government a Marxist threat to American interests in South America. The CIA actively worked to destabilize the country and supported the military *junta* of General Augusto Pinochet, who seized power in September

1973. The far-from-bloodless coup leaves today's Chile still trying to come to terms with the damage done to its democratic institutions over three decades ago.

The Dutch photographer Koen Wessing was on the streets of Santiago immediately after the coup happened. His gritty documentary pictures were quickly published in this no-frills, extremely elegant photobook by De Bezige Bij, publisher of so many of the best Dutch photographic books.

There are not many images in the book, but each is carefully considered, modest and succinct, spread across a double page in graphic gravure. Despite the difficulties of taking photographs in such a tense and

difficult situation, Wessing never forgets the value of composition and lighting control. The main thrust of the book is the coup's immediate aftermath, the shock and grief of the people, the rounding up of Allende's supporters (or suspected supporters) by the army, and their herding into the now notorious National Stadium in Santiago, where many would be tortured and killed. Wessing vividly captures one of these executions, in a two-page sequence that forms the book's climax.

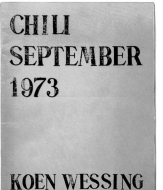

Koen Wessing **Chili, September 1973** (Chile, September 1973)
De Bezige Bij, Amsterdam, 1973
274 × 199 mm (10¾ × 7¾ in), 48 pp
Paperback
24 b&w photographs

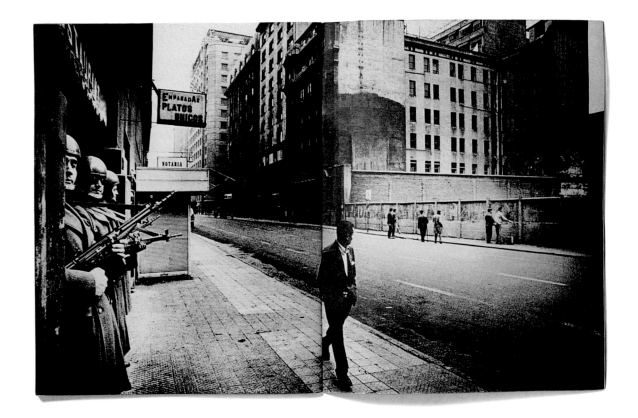

Josef Koudelka
Gypsies

Josef Koudelka's first claim to fame came when his dramatic photographs of Alexander Dubček's aborted 1968 Czech liberalization were widely published in the West. This gained him membership to Magnum in 1971, but it was the publication of *Gypsies* in 1975 that sealed his reputation as one of the finest photographers still utilizing the humanist documentary mode in the last quarter of the twentieth century.

On the face of it, Koudelka's gritty black-and-white photography in the classic photojournalistic style could be considered anachronistic. Like many photographers working in this manner, he is a thoroughgoing romantic. His choice of subject for this book – a people marginalized and discriminated against in most of Europe – would seem to call for a clear-headed approach if our sympathies are to be elicited, but Koudelka did exactly the opposite, opting for the full-blooded mythologizing rhetoric. He took the pictures mainly in Slovakia, the eastern part of Czechoslovakia, between 1962 and 1968, and the story he tells is one of a people set apart, in some sense out of choice, but primarily because no one wants them in their back yard. Successive Czech government initiatives had tried to put a stop to the Romanies' traditional nomadic ways by confining them to what were in effect ghettos, but they were ghettos without adequate housing or utilities.

Looking beyond the romantic accretions in the work, such as a tendency to heavy chiaroscuro and charcoal grain, one sees that the lives Koudelka is documenting are grim, lived out in squalid shanty towns, devoid of many basic necessities, poorly educated. But while showing this, Koudelka does not fetishize it, and nor does he patronize his subjects. His concern, albeit described in fairly broad strokes, is with these people as individuals – approximately half the book is taken up with formal, dignified portraits – and with their communal rituals. The obvious theoretical criticisms could be levelled at this project – formalist, photographic 'slumming', and so on – but the work totally disarms them.

Koudelka's approach has often been described as theatrical – and it is – but this word usually implies a whiff of the pejorative when applied to photographs, suggesting grandstanding and superficiality. The theatre of Koudelka is an eminently serious one, melodramatic and tragic, serious in the best sense of the word.

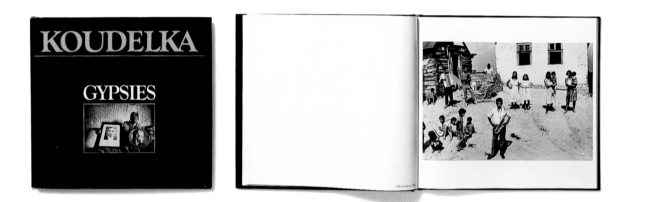

Josef Koudelka **Gypsies**
Aperture Inc., Millerton, New York, 1975
270 × 295 mm (10½ × 11½ in), 136 pp
Hardback with full brown cloth
60 b&w photographs
Prefaces by John Szarkowski and Anna Fárová;
essay by Willy Guy

Anders Petersen **Café Lehmitz**
Schirmer/Mosel, Munich, 1978
240 × 210 mm (9½ × 8¼ in), 116 pp
Paperback with jacket
88 b&w photographs
Text by Roger Anderson

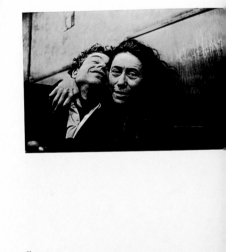

Luigi Ghirri
Kodachrome

Luigi Ghirri was one of the pioneers of creative colour in postwar European photography, and *Kodachrome* is as important in that context as *William Eggleston's Guide* was in American photography (see page 265). The pervasive influence of Eggleston is evident, but Ghirri seems less of a realist than the American, and more interested in exploiting the artificiality of colour and exploring its paradox – that it is both real and artificial at the same time.

The book would seem to be about the thin line between reality and artificiality. Ghirri is drawn to objects that make spatially and materially ambiguous pictures. He frequently photographs posters which, being composed of photographic images, depict a world of half-reality. He piles one representation on another, artifice upon artifice, exemplified by a picture taken in Modena where he photographs a path through bright green grass against the blue sky depicted in a poster.

Although probably not consciously, Ghirri's theme in *Kodachrome* relates distantly to that of Walker Evans's *American Photographs* (see pages 114–5): it declares itself to be as much about the act of photography as documenting the world – the way our view of the world is shaped by photographs. He continually reminds us that he is not recording but constructing a landscape. And he often includes signs of that construction, shooting objects through framed shapes, or using window reflections to make mirrored, or multiple images.

A modest paperback containing modest photographs that are more complicated than they seem at first glance, *Kodachrome* constitutes an important step for colour photography.

Luigi Ghirri **Kodachrome**
Contrejour, Paris and Punto & Virgola,
Rome, 1978
270 × 210 mm (10¹⁄₂ × 8¹⁄₄ in), 104 pp
Paperback
92 colour photographs
Preface by Piero Berengo Gardin; foreword
and photographs by Luigi Ghirri

Anders Petersen
Café Lehmitz

Café Lehmitz was at the end of the Reeperbahn in Hamburg, by the harbour. It was, as the Swedish photographer Anders Petersen muses, the end of the road for many who congregated there. The clientele comprised mainly older prostitutes, pimps, drug dealers, transvestites, homosexuals and assorted hustlers. In the 1920s this cast list would have inspired a Georg Grosz or Otto Dix painting. In the 1970s it graced one of the finest photobooks of the decade.

When Petersen discovered the Lehmitz and began to photograph it at the end of the 1960s, the café exuded a similar kind of world-weary decadence to that found in the Weimar Republic – it had probably been exuding it *since* the Weimar Republic. And Petersen documented it, candidly, warmly and non-judgementally, wholly avoiding the sentimental but exploitative gaze of conventional social reportage.

But he did not make these remarkable images as a piece of social reportage. A pupil of the renowned Swedish photographer and teacher, Christer Strömholm,

Petersen cultivated a similar diaristic approach, frequently directed at the fringes of society, frequently with a sexual edge. Such proclivities spring from his own leanings. He was a regular at the Lehmitz for two years or more while gathering these images. Although this does not make him a total 'insider' – the photographer always keeps some distance – it ensured that he was accepted as one of the crowd. He showed his sitters the work, even exhibiting it in the café, and regulars sometimes borrowed his camera and took pictures of each other. Under such circumstances, his photos become a diary of the riotous, drunken nights on which it was made. It is therefore more of a collaborative effort.

Clearly, all was not sweetness and light when making these hard-hitting pictures. How could it be otherwise in a sleazy joint at the wrong end of the Reeperbahn? But what Petersen depicts should not be regarded as a freak show, even if many of his subjects were lonely, desperate, nasty, sad people, down on their luck. Petersen captured what more distinguished names have failed to convey – the authentic whiff of downbeat urban life.

The Indecisive Moment
The 'Stream-of-Consciousness' Photobook

Frank … and Klein brought to the decade a feeling for its woes which, in retrospect, synthesizes it for us. There hovers in their work an oppressive sense of the odds against which people struggled, the dismal mood and chance of defeat that lowered the emotional horizon. This was all the more striking because of the general affluence of the period, underway shortly before the start of Frank's and Klein's major effort, in the great boom of 1955. These transplanted photographers found live and visual metaphors for the bleakness of this Cold War moment, and the deadness of the things in it. For those who remember the era, these photographic evocations of it have the keenest resonance; for those who came later, The Americans *and* New York *offer a wondrous guide.* Max Kozloff [1]

47

György Lőrinczy
New York, New York
Magyar Helikon, Budapest, 1972

Lőrinczy's style is rough, raw and uninhibited,
in the best stream-of-consciousness manner,
utilizing extreme blur, grain and solarization.

In the United States during the mid-1950s, two photographers were each making the works that would eventually form two of the most renowned photobooks of the twentieth century – William Klein's *New York* (1956) and Robert Frank's *Les Américains* (1958, published as *The Americans* in 1959). Both were foreigners of a kind, the former returning for a brief period to his homeland after living in Europe, the latter an immigrant to the United States from Switzerland. Though very different from each other, these books introduced a new kind of attitude into photography. The work was rough, raw and gestural. It was spontaneous and immediate, highly personal, echoing both the uncertain mood of the era and the characteristics that marked much of the art – especially the American art – of the 1950s.

Half the time the photographers seemed not to have even looked through the camera. Far from seeking the perfect composition, the 'decisive moment', their work appeared curiously unfinished. It captured 'indecisive' rather than decisive moments. It was exciting, expressive, flying in the face of accepted photographic good taste. Importantly, this was a style whose informality was far better suited to the book form than to a display of individual prints on a wall. Such was the spontaneity and intuitive quality of this kind of work that we might term it 'stream-of-consciousness' photography, the visual equivalent of the stream-of-consciousness writing of the 1950s American 'Beat' writers such as Jack Kerouac, William Burroughs and Allen Ginsberg. It is a quality that runs through much 1950s American art – bebop jazz, the 'action painting' of Jackson Pollock and his Abstract Expressionist

colleagues, method acting, hand-held-camera movie-making, improvised performance art. And just as documentary photography and the realist spirit in art was a direct response to the Depression and the 1930s, stream-of-consciousness art, in whatever medium, was a direct response to the Cold War and the 1950s.

The United States, like Japan and Europe, was recovering from the war, but the 'hot' war had been replaced by the Cold War and the threat of nuclear annihilation. The late 1940s and 50s, therefore, were years of angst for many Americans. The Cold War began at home, with a return of the 'Red Scares' of the 1920s. McCarthyism and the notorious House Un-American Activities Committee (HUAC), established in 1937 to root out subversive and 'Un-American' activities, created a climate of distrust, anxiety and paranoia that particularly hit the arts.

Paradoxically, during this age of anxiety, the United States entered an era of almost unprecedented prosperity. High employment levels led to an orgy of consumer spending. The arts, too, despite – or perhaps because of – the strictures of McCarthyism, enjoyed a period of unmatched vigour. Abstract Expressionism, a gestural painting style developed in the lofts of New York, not only replaced the Social Realism of the 1930s, but outmatched anything being done in Europe. Whereas before the war the United States had usually looked to Europe in order to see what was happening, now Europe looked to the United States. New York replaced Paris as the epicentre of the international art market, and at the beginning of the 1950s Jackson Pollock supplanted Pablo Picasso as the world's most renowned painter.

Early Abstract Expressionism owed a sizeable debt to Dada and Surrealism, derived partly from the émigré refugees from Hitler who had migrated to New York, and partly in response to the war and the political climate of the Cold War. There was a turning inward, away from the social and psychological expansiveness of Social Realism to the hermetic individualism of the subconscious and the intuitive. This is not to say that New York artists in the 1940s and 50s were any less concerned with the state of the world, but they expressed it differently – filtering it first through their own direct experiences. The filter was a safety valve against the nuclear threat and the social and political strictures of the time. Most serious artists feel that they are 'outside' bourgeois society to one degree or another, but 1950s New York art – frantic, raw, aggressively individualistic, alienated, incomprehensible compared to what had immediately preceded it – was particularly defensive, taking great pains to obscure its political and social concerns through the use of shock tactics. As Norman Mailer put it in 'The White Negro', his famous essay on the 'hipster':

> On this bleak scene a phenomenon appeared: the American existentialist – the hipster, the man who knows that if our collective condition is to live with instant death by the atomic bomb … why then the only life giving answer is to accept the terms of death as immediate danger, to divorce oneself from society, to exist without roots, to set out on that uncharted journey into the rebellious imperatives of the self.[2]

In order to tap into the self and this great well of personal experience, art became about process. The Surrealist concept of automatic drawing or writing was revived, though in a particularly American way. The intuitive act of making it, working fast and letting it spill out from the subconscious, became almost more important than the work itself. The archetypal image of 1950s American art is Hans Namuth's film of Jackson Pollock making a 'drip painting' – dancing round the canvas like a jazz dancer, flicking paint on to it with all the casual, concentrated panache of Joe Di Maggio hitting a home run.

The literary equivalent of Abstract Expressionism was the Beat Generation, and Pollock's alter ego in the world of American letters was Jack Kerouac. With the publication of his second novel, *On the Road* in 1957, Kerouac became an instant celebrity. Written on a single roll of unbroken paper during a frenetic three-week period in 1951, the book became one of American art's talismans, not only the most important and durable monument of stream-of-consciousness writing, but the most infallible guide to the social mores of the young rebels without a cause.

And as William B Scott and Peter M Rutkof have observed, Kerouac and his fellow Beat writers not only prized the experimental and the spontaneous, but had actually experienced the lifestyle described in *On the Road*. They:

exemplified the postwar avant garde's sense of profound alienation from the society they sought to understand. Identifying with the outcast and the outlandish, with black jazz music and consciousness expanding drugs, they crisscrossed America in the late 1940s and early 1950s in search of themselves and a truth they believed hidden by the stifling conventions of middle-class culture.[3]

The first photobook to prefigure or set out a photographic approach to this artistic and cultural upheaval was Alexey Brodovitch's *Ballet* in 1945. This book, which was not so much a part of the movement as a forerunner, is important because it demonstrates a significant aspect of the best stream-of-consciousness photography: that its essence did not just lie in the raw intuition of the work itself, but in its publication – in books and in the magazines of the time. Brodovitch's photographs of ballet companies visiting New York between 1935 and 1937 transgressed every notion of what a good photograph should be. He used a 35 mm camera in available light, and the resulting images are blurred, grainy, out of focus, harsh in contrast. These effects were exaggerated in the book, where they were laid out in an almost continuous strip like a movie. *Ballet* was raw yet sophisticated, its vivacity capturing the energies of the dance.

Brodovitch was a pivotal figure in the world of New York photography, magazines and fashion during the 1950s. As art director of *Harper's Bazaar* and editor of the short-lived but influential magazine, *Portfolio*, he guided the careers of such diverse photographers as Richard Avedon and Lisette Model. He also ran the legendary Design Laboratory, giving short workshop courses in photography and graphic design that most of the up-and-coming New York photographers attended at one time or another, including Richard Avedon, Garry Winogrand, Ted Cromer, Art Kane and Eve Arnold.

The approach of Brodovitch to teaching was simple: forget about fussy technique and polish, the tried or the tested; work with passion, trust your own experience, and always experiment; be yourself and dare to be different by breaking the rules. It was a similar message to that being taught by other prominent photo-teachers in New York – Sid Grossman of the Photo League before it became defunct, and Lisette Model, whose most renowned pupil was a young fashion photographer called Diane Arbus. It was a time of great energy in New York photography, and its exponents gathered together in Greenwich Village coffee houses, such as Helen Gee's Limelight café and photo-gallery, to argue passionately about the medium, forming cliques and warring factions just like the Abstract Expressionists and the Beats.

If Alexey Brodovitch was able to offer the gift of patronage by *Harper's Bazaar* to photographers, his equally powerful equivalent (and somewhat envious competitor) was Alexander Liberman at *Vogue*. It was Liberman who helped considerably with the gestation of one of the most influential photobooks of the 1950s – William Klein's *New York* – or to give it its full, hip, Beat title, *Life is Good and Good For You in New York: Trance Witness Revels* (1956).

Klein had worked in Paris for eight years and had moved from abstract painting to abstract photography. He returned to New York in 1954 and carried out *Vogue* assignments for Liberman. As so often happens in the case of returning expatriate artists, he saw his home town with fresh eyes. Struck by the city's brash energy and by the raw photographs in tabloid newspapers like the *New York Daily News*, he began to photograph on the streets. Thanks to Liberman, he was able to use liberal amounts of film, and had full access to the *Vogue* darkroom. On the surface, the results were akin to the confrontational, 'in-your-face' street photographs that others, such as Louis Faurer and Leon Levinstein were making at the time, yet they were invested with Klein's own brand of high-octane energy.

Unlike others who were out photographing on the streets, Klein was shooting specifically with a book in mind, mentally collating and sequencing even as he made the images, over a period of about three months.[4] Ironically, this greatest of 1950s photobooks by a native American was never published in the United States. Due in part to the efforts of Chris Marker, who would later become an important film-maker, the book was published in 1956 by Editions du Seuil in Paris, with editions in England and Italy.

The tenor of Klein's book is uncertain, aggressive, bleak, but it is also fashionably manic in its romantic Beat energies. It is patently less of a socio-political statement than Robert Frank's *The Americans*, which would follow Klein's lead. However, *New York* had enough bite, both as a document of an anxious era and as a book statement, to ensure that it was enormously influential, especially in Europe and Japan. Its impact was more occluded in the United States, but if it had been published there, it possibly would have eclipsed *The Americans*, if only for the fact that Klein was a more accessible role model than Frank.

The two great 1950s surveys of America in photobooks were both, so to speak, views from the 'outside'. While the expatriate Klein was photographing New York, the immigrant Frank was making a series of road trips across the country in classic Beat style, photographing under the auspices of a Guggenheim Fellowship. The result was *Les Américains*. Frank's book, like Klein's, was first published in Europe, by Robert Delpire in Paris, but – retitled *The Americans* – it also appeared in New York in 1959. There, it was profoundly influential on those young photographers sympathetic to its iconoclasm, and its reverberations spread out steadily throughout the 1960s. The hostile response from the old guard to Frank's shabby shocker of a book was almost guaranteed to endear him to a younger generation already at odds with the saccharine diet of *Look* or *Life*. It was also in complete contrast to the easy platitudes of the most popularly lauded photographic enterprise of the day, Edward Steichen's 'The Family of Man' (1955), which featured feel-good photojournalism at its most sententious. Frank's casual, offhand approach, his 'bracing, almost stinging manner'[5] and, above all, the other-side-of-the-tracks iconography drawn almost directly from *On The Road*, struck an immediate chord.

The Beat Existentialism of the Klein/Frank persuasion was also at work in European photography, particularly in Holland and Scandinavia. Still an underrated figure both in photography and photo-book-making, the Dutchman Ed van der Elsken was a freewheeling traveller like Klein or Frank, except that his territory was the world, especially the Far East. He was also a prolific maker of books. Along with his compatriot Joan van der Keuken he redirected the more socially inclined outlook of humanist documentary photography inward, making a photography that was as much about the process of its making as it was about the wider world. They began to develop a book form termed the *beeldroman* (the photonovel), an essentially self-reflexive genre. Van der Elsken's *Een Liefdesgeschiedenis in Saint Germain des Prés* (Love on the Left Bank, 1956) is perhaps the epitome of the genre, a diaristic but fictionalized look at the photographer's friends and lovers during his stay in the Left Bank area, the very home of Existentialism. He also made what is arguably the best photographic book on jazz, simply entitled *Jazz* (1959), but his masterpiece is *Sweet Life* (1966), a sprawling odyssey of a book, as exuberant as Klein's *New York*.

Van der Elsken was not the only European producer of stream-of-consciousness photobooks. Christer Strömholm's *Poste Restante* (1967) is another unjustly disregarded book, while perhaps the least known of all is by Van der Keuken. In its visual energies and cinematic style, *Paris mortel* (Mortal Paris, 1963) recalls another photobook classic from that city, the 1930s masterpiece *Paris* by Moï Ver (see Chapter 5).

Shortly after *The Americans* appeared, Frank abruptly announced his dissatisfaction with the still photograph, and went off to make experimental films. The post-Frank generation of American photographers, who had eagerly adopted his take on the American scene, found an extremely aware, enthusiastic, and above all articulate champion in Edward Steichen's successor as Curator of Photography at the Museum of Modern Art, New York – John Szarkowski. He had a keen appreciation of the American photographic avant garde and, along with the curator Nathan Lyons at George Eastman House in Rochester, he supported their work in a series of exhibitions. Because the titles of two of these shows made reference to the American social landscape, they became known as the Social Landscape school, or sometimes the Snapshot school.[6] In a wall text for a landmark show at MoMA in 1967 entitled 'New Documents', featuring three of the best of them – Diane Arbus, Garry Winogrand and Lee Friedlander – John Szarkowski explained their approach:

Most of those who were called documentary photographers a generation ago, when the label was new, made their pictures in the service of a social cause. It was their aim to show what was wrong with the world, and to persuade their fellows to take action and make it right.

In the past decade a new generation of documentary photographers has directed the documentary approach towards more personal ends. Their aim has been not to reform life, but to know it. Their work betrays a sympathy – almost an affection – for the imperfections and frailties of society. They like the real world, in spite of its terrors, as a source of all wonder and fascination and value – no less precious for being irrational. […]

What they hold in common is the belief that the commonplace is really worth looking at, and the courage to look at it with the minimum of theorizing.[1]

The American art museum's adoption of photography's avant garde during the 1960s was one of the most important features of that decade, and had a profound effect on the way in which photographers operated, and on the kinds of photographs they made. The Winogrand/Arbus/Friedlander generation not only turned from public towards more private concerns, but also started to look to the museum or gallery and to teaching for their income rather than to commercial assignments or the mass-circulation publication. This does not mean, however, that they neglected the book. Far from it, but they tended to make and publish their own books, or to rely on museum rather than publisher sponsorship. Winogrand's first publication, *The Animals* (1969), was brought out by the Museum of Modern Art, while Friedlander's *Self Portrait* (1970) was self-published by his own Haywire Press. Winogrand has never had a mainstream publisher, and Friedlander only in the 1990s, when Jonathan Cape, a London-based subsidiary of Random House, published several of his books.

During the 1970s and 80s the nearest thing to a mainstream publisher for non-commercial American photographers was Aperture Books, an offshoot of the quarterly magazine co-founded by Minor White in 1952. Managed by Michael Hoffman, who became editor-in-chief in 1965, Aperture was a non-profit, charitable organization, and frequently asked for a financial contribution from photographers. For serious photographers making decidedly non-commercial books, this was a price they were prepared to pay – whether willingly or reluctantly. Aperture books were well produced, if conservatively designed, and (for photobooks) distributed widely. Thus an Aperture book was a desirable calling card for any photographer, as may be attested by the fact that Aperture published a fair number of the best American photobooks of the 1970s and 80s.

Aperture's biggest coup by far came in 1972, when it published a posthumous book of the work of Diane Arbus. Arbus had died in 1971 at the height of her career. The Museum of Modern Art arranged a retrospective exhibition of her work that travelled widely, to great acclaim, controversy and disapprobation, and the Aperture monograph was effectively the catalogue to that show. To publish such chancy material (albeit with the imprimatur of MoMA) did an organization like Aperture much credit, but the risk was rewarded commercially. *Diane Arbus: An Aperture Monograph* has been in print ever since, and has sold over 300,000 copies, an unprecedented (and surely unforeseen) number since most 'independent' photography books are published in editions of less than 5,000.

The trend in American photography of the 1970s was to get one's work published either through a university press, as a catalogue, or by one of the little specialist presses that came and went. One small American publisher of the decade that lasted longer than most was Lustrum Press, founded by the photographer Ralph Gibson. Much of Lustrum's list, thanks to Gibson's own proclivities, was firmly in the personal documentary, stream-of-consciousness mode, such as Gibson's own 'trilogy', *The Somnambulist* (1971), *Déjà vu* (1973) and *Days at Sea* (1975); Michael Martone's *Dark Light* (1973) and Daniel Seymour's *A Loud Song* (1971). Gibson's trilogy and Martone's books could be described as personal documentary that segues into transcendental abstraction, but Lustrum's two most important books strongly upheld the stream-of-consciousness tradition.

Firstly, Larry Clark's *Tulsa* (1971) followed Danny Lyon's seminal *The Bikeriders* (1968) in providing an intimate, 'inside' portrait of an 'outsider' community – in Lyon's case, outlaw biker clubs; in Clark's case, young petty criminals and drug addicts in Tulsa. Secondly, Lustrum published an American edition of Frank's 'autobiography', *The Lines of My Hand* (1972), originally brought out in

Japan in a deluxe, boxed edition. If Lustrum had done nothing except make this cheap edition of the Japanese book available, it would have been contribution enough to the history of the photobook.

The publication of *The Lines of My Hand* in Japan was confirmation of the fact that the stream-of-consciousness style was the prevailing mode in Japanese photography in the late 1960s and early 70s. This was due mainly to the freewheeling Existential approach of a coterie of photographers centred around the magazine *Provoke*, which will be examined in the next chapter. Leading foreign photographers such as Klein and Van der Elsken had visited Japan and been extremely influential, and the interest in the gestural style led the publisher Yugensha to give Frank the full deluxe Japanese photobook treatment in *The Lines of My Hand*, thanks to generous sponsorship from Kazuhiko Motomura, a notable Frank aficionado. Frank hadn't made much new work since the beginning of the 1960s, but as he showed here, and in another Yugensha/Motomura collaboration in 1987, *Flower Is*, he was a highly imaginative repackager of his old material.

In many ways *The Lines of My Hand* can be regarded as the apotheosis of stream-of-consciousness photography. Along with two Japanese masterpieces, Takuma Nakahira's *For a Language to Come*, published in 1970, and Daido Moriyama's *Sashin yo Sayonora* (Bye Bye Photography), published in 1972, Frank's great confessional both sums up and marks the end not only of a photographic era, but a final coming to terms with the effects of World War II and the Bomb.

When Frank opined that 'Black and white are the colours of photography', he summed up both a photographic genre and an era. The visions of Frank, Klein, Van der Elsken and the Provoke group had been the photographic equivalent of film noir. And if classic stream-of-consciousness photography could only be done in black and white, the 1970s would inevitably bring that era to a close. By the end of the 1960s the world's political choice, which had in the 1950s been couched in black or white – communism or democracy – began to seem much more complex. There was at least a modicum of hope in the air, and the world itself seemed to have become more colourful.

In 1972 Stephen Shore's series *American Surfaces*, a suite of 320 prints, was shown at Light Gallery in New York. The whole show was purchased by Weston Naef for the Metropolitan Museum of Art,[8] demonstrating that the medium had become a good deal more respectable. Four years later a book was published to accompany an exhibition at the Museum of Modern Art by a little-known photographer called William Eggleston. The work of both Shore and Eggleston was diaristic, spontaneous, in the best stream-of-consciousness manner – apparently about little except the photographers' private sense impressions. It nevertheless differed from anything done by the Beat photographers, the social landscapists, or the European and Japanese Existentialists in one essential respect – the photographs were in colour. They therefore represented a giant step for the medium. Photographers had been using colour for at least a decade and a half before the more avant-garde practitioners began tentatively to explore its potentiality, but it took the imprimatur of the Metropolitan and the Museum of Modern Art rather than *Life* magazine to make it seriously accepted by the more artistically ambitious photographers, and even then only after a lengthy struggle.

The stream-of-consciousness style was related to an era and, as we have seen, gradually transformed itself at the end of the 1960s into the personal documentary or snapshot mode. Its influence, however, remains, for it is related to a fundamental impulse in photography – to make a visual diary of one's life. As stated before, Walker Evans wrote that at the heart of Eugène Atget's photography was 'the projection of Atget's person'.[9] Atget's formal style may have disguised this to an extent, but the diaristic impulse became more marked with the advent of small cameras, and a clear line of diaristic photographers can be traced through Henri Cartier-Bresson and André Kertész to Frank and Klein, and then to Van der Elsken, Provoke, Lee Friedlander, Garry Winogrand, Danny Lyon and many others in the late twentieth century.

At its best, stream-of-consciousness photography represented a political as much as a formal gesture. The politics were perhaps turned inwards, but were nevertheless very much a part of the rhetoric. The gestural spontaneity of the mode, its energy and irony, tended to mask the anxiety and dismay beneath. This potent combination of exuberance and despair is of course highly romantic,

and this has made the stream-of-consciousness photobooks amongst the most popular in photographic literature. But at the core of many of them is a truly dark heart, an elemental dismay, perhaps voiced most clearly by Garry Winogrand in 1963:

> *I look at the pictures I have done up to now, and they make me feel that who we are and what is to become of us just doesn't matter. Our aspirations and successes have been cheap and petty. I read the newspapers, the columnists, some books. I look at the magazines (our press). They all deal in illusions and fantasies. I can only conclude that we have lost ourselves, and that the Bomb may finish the job permanently, and it just doesn't matter, we have not loved life.*[10]

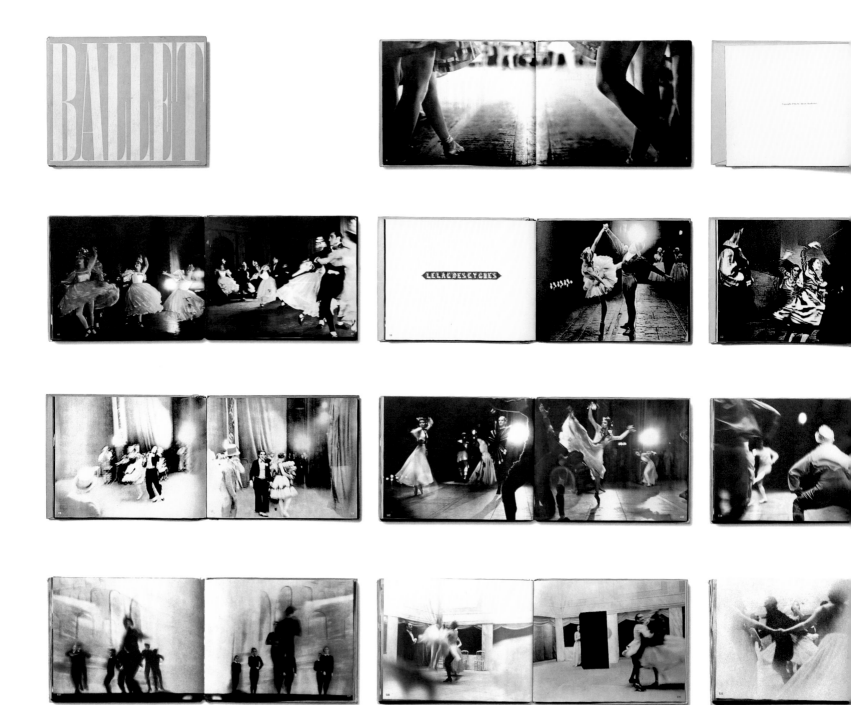

Alexey Brodovitch
Ballet

Although known primarily as a mentor and patron of photographers, due in large part to his position as art director and graphic designer at *Harper's Bazaar*, Alexey Brodovitch also made a legendary photobook of his own. *Ballet*, published in 1945 by J J Augustin in New York, has become a photobook legend for two reasons. Firstly, only a few hundred copies were printed,

so the book is more talked about than actually seen. Secondly, the volume was extremely radical, both in terms of the images themselves and their incorporation into the design and layout. As Kerry William Purcell has written in his seminal monograph on Brodovitch, his photographs both 'spat in the face of technique and pointed out a new way in which photographers could work'.[11]

The 104 pictures in *Ballet* had been taken by Brodovitch between 1935 and 1937. He photographed bal-

let companies visiting New York, including the Ballets Russes de Monte Carlo, with whom he worked in Paris during the 1920s. Brodovitch shot the photographs with a 35 mm Contax camera, during both rehearsals and performances, by available light, hand-held, and using shutter speeds as slow as a fifth of a second or more. This resulted in blurred images of the moving dancers and in high-contrast, grainy negatives exhibiting burnt-out areas of flare from the stage lighting. These pictures totally violated the accepted conventions

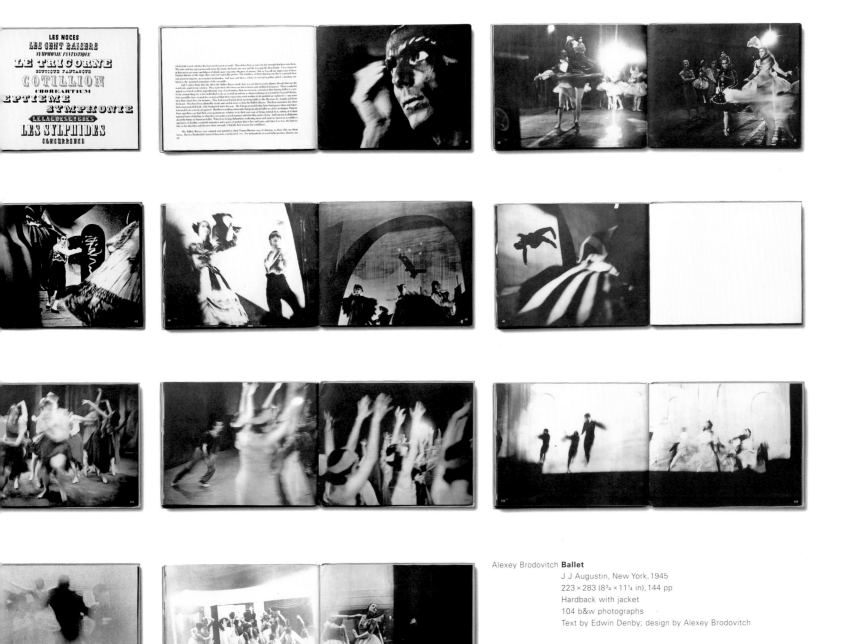

Alexey Brodovitch **Ballet**
J J Augustin, New York, 1945
223 × 283 (8¾ × 11¼ in), 144 pp
Hardback with jacket
104 b&w photographs
Text by Edwin Denby; design by Alexey Brodovitch

of good photographic technique, which demanded a sharp rendition of the subject and a wide, smooth tonal scale. Far from trying to mitigate these shortcomings, Brodovitch deliberately exaggerated them. He printed on high-contrast paper, bleached areas with the chemical ferricyanide to create more contrast, and enlarged tiny portions of the negative to increase grain – familiar strategies in the 1950s and 60s, but not in the 1940s.

Brodovitch's layout was as radical as his pictures. He divided the book into eleven segments, each cor-responding to a ballet. Every section was laid out in a continuous strip, each image bled across its own page, so that a double-page spread can often be read as a single panorama, and the whole section like a strip of movie film. This gives the book a vibrancy and a fluidity that perfectly captures the motion of the dance. In his book on the life and work of Brodovitch, Kerry William Purcell suggests that during his early years in Paris, the young designer may have seen Anton Giulio Bragaglia's *Fotodinamismo futurista* (Futurist Photodynamics)

(see page 90) and been influenced by that modernist pioneering work on photographic movement. Whether he did or not, *Ballet* is one of the most successful attempts at suggesting motion in photography, and certainly one of the most cinematic and dynamic photobooks ever published.

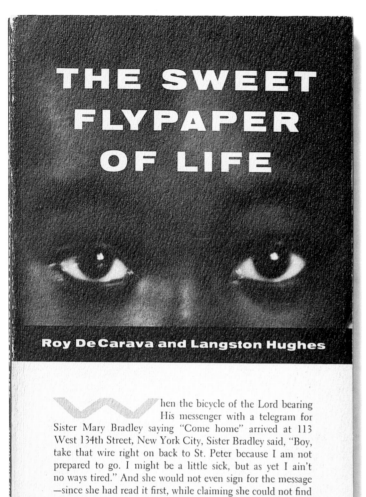

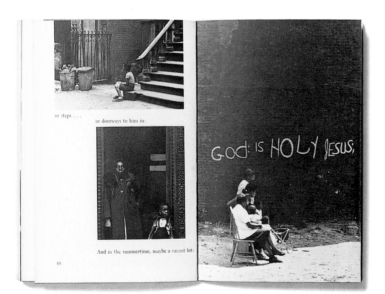

Roy DeCarava and Langston Hughes
The Sweet Flypaper of Life

As the documentary moved from a reformist and public to a more personal kind of expression, many photobooks of the 1950s rejected the close marriage of image and text that characterized the 1930s documentary photobook. Photography became more overtly elliptical, playing deliberately on the medium's ambiguities, and thus it was not considered necessary to utilize text in order to guide the reading of photographs in a book. Besides, certain documentary books had been criticized for 'putting words' into their subjects' mouths.

In Holland the *beeldroman* (photonovel) offered a possible solution to this perennial problem, combining fact (photographs) with fiction (an imagined text). A similar approach was taken in the United States by the photographer Roy DeCarava in *The Sweet Flypaper of Life*. DeCarava had received a Guggenheim Fellowship to photograph life in Harlem in 1953. After being turned down by several publishers, he embarked on a collaboration with the writer Langston Hughes, the leading black writer and a prime mover in the 'Second Harlem Renaissance'. *Sweet Flypaper* was published not as an out-and-out social documentary book, but with DeCarava's 'real life' images illustrating a fictional text by Hughes about life in Harlem.

The most significant feature of *The Sweet Flypaper of Life* (apart from its great title) is not its indeterminate status as fact, fiction, or even 'faction', but that a leading mainstream publisher took the chance of publishing a view of a minority community from the 'inside'. The fictional format enables DeCarava and Hughes to be positive, without the necessity to make claims for the all-inclusiveness of their view. In what seems an implicit criticism of so much social documentary – especially that dealing with minorities – Hughes makes their aims clear on the jacket of the original hardback edition (also published in 1955): 'We've had so many books about how bad life is. Maybe it's time to have one about how good it is.'

Certainly, *Sweet Flypaper* is a feel-good book. Roy DeCarava's pictures are lively, as is the book's design, featuring a pacy cinematic style. It is also a book that had more impact in its cheaper paperback edition (shown here), since, radically, Hughes's text begins on the cover. An earnest homily about the commonplace facts of day-to-day living as told by Sister Mary Bradley of 113 West 134th Street, it is undeniably sentimental, but *The Sweet Flypaper of Life* was both a publishing success and a vital corrective to a book like *Roll, Jordan, Roll* (see page 135) and thus represents an important step forward.

Roy DeCarava and Langston Hughes **The Sweet Flypaper of Life**
Simon and Schuster, New York, 1955
180 × 125 mm (7 × 4¼ in), 98 pp
Paperback
141 b&w photographs
Text by Langston Hughes

William Klein
Life is Good and Good For You in New York:
Trance Witness Revels

By virtue of its preface, written by Jack Kerouac, Robert Frank's *The Americans* is usually regarded as the epitome of the Beat photobook. But William Klein's magnum opus, *Life is Good and Good For You in New York: Trance Witness Revels*, a book with a Beat mantra for a title, surely has the edge in this regard. This is partly because it was the earlier model, partly because it is less political and more exuberant, and, importantly, because its conception is so complete – photographs, layout, design, topography, 'found' ephemera coalescing into what is in effect one of the first great 'Pop' books.

One could argue that not all of the pictures live up to these great images of exuberant kids and suspicious adults, but it is the design and editing that is paramount, and the great model for what was to follow. Its only real predecessor was Brodovitch's *Ballet*, but Klein was apparently unaware of the book when he laid out his volume in *Vogue*'s New York offices, using their state-of-the-art Photostat machine.

This relatively new technology enabled Klein to cut and paste, enlarge and reduce the images with ease, and surely contributed to the form of the design and layout. Pictures pile up one after the other, double-page bleeds following two pages of multiple imagery. The book's internal rhythm contains as many cadences, breaks and unexpected flights of fancy as a Sonny Rollins sax solo. *New York* (also published in the UK and Italy) is a quintessential monument to the American cultural scene of the 1950s in that, like the other art forms of that era, it is supremely about *process*. It is about the process of making photographs, and about the further process of editing and sequencing them, playing with them and making a coherent statement. *New York* is the upside to Frank's downside, much slicker, but none the worse for that. Klein's masterpiece reminds us that much great, serious art is often about play, achieved simply by experimenting with the possibilities of the material. Forget trance and witness – the revels are the thing.

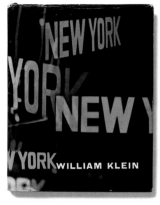

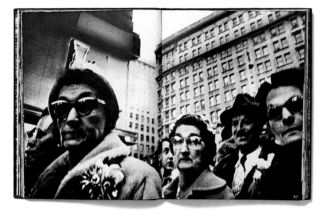

William Klein **Life is Good and Good For You in New York:**
Trance Witness Revels
Editions du Seuil, Album Petite Planète, Paris, 1956
275 × 215 mm (10 × 8½ in), 194 pp with
16-pp caption booklet
Hardback with full black cloth and jacket
188 b&w photographs
Design by William Klein

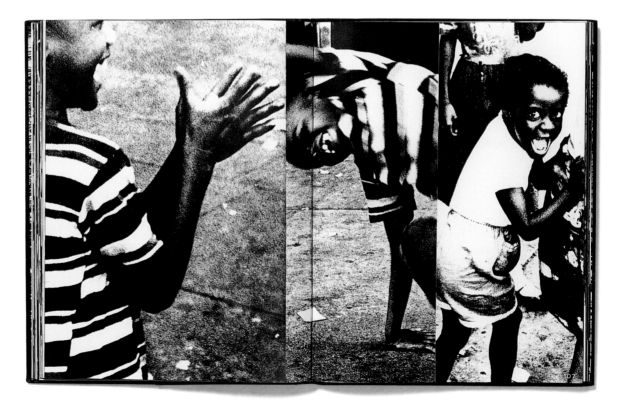

Joan van der Keuken **Wij zijn 17** (We Are 17)
CAJ van Dishoeck, Bussum, 1955
240 × 158 mm (9¹⁄₂ × 6¹⁄₄ in), 64 pp
Paperback
30 b&w photographs
Introduction by Simon Carmiggelt;
design by Joan van der Keuken

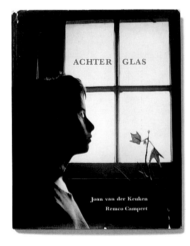

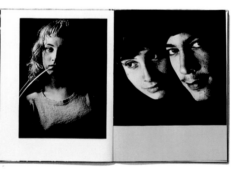

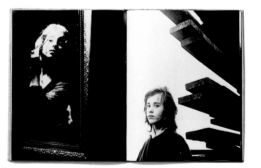

Joan van der Keuken and Remco Campert **Achter Glas** (Behind Glass)
C de Boer Jr, Amsterdam, 1957
298 × 242 mm (11³⁄₄ × 9¹⁄₂ in), 96 pp
Hardback with full off-white linen and jacket
100 b&w photographs
Text by Remco Campert

Joan van der Keuken
Wij zijn 17 (We Are 17)

Joan van der Keuken and Remco Campert
Achter Glas (Behind Glass)

In 1955, the 17-year-old Joan van der Keuken caused a stir in Dutch publishing with his book *Wij zijn 17* (We Are 17), prefiguring the even greater furore that would greet the publication of Ed van der Elsken's *Een Liefdesgeschiedenis in Saint Germain des Prés* (Love on the Left Bank) a year later. Van der Keuken's book was as innovative as Van der Elsken's in its treatment of a section of society – not a class exactly, but a societal group – that was beginning to be regarded as a class apart.

It is sometimes forgotten in these days of 'youth culture' that it was only from around the 1950s onwards that the young were first talked about in this way. Previously they had been regarded – given a modicum of wild oats sowing and youthful high spirits – largely as replicas of their parents. In the 1950s, however, with its anxious air of repressed rebellion, such attitudes were overturned. The Beat Generation, the Beatnik movement, James Dean – the original rebel without a cause – and a pouting, gyrating phenomenon called Elvis Presley, drew the world's attention to the fact that, since the war, a new alien species seemed to have been dropped on to the planet – the teenager.

Van der Keuken's two books, *Wij zijn 17* and his follow up, *Achter Glas* (Behind Glass, 1957), caught this mood perfectly. Whilst perhaps not stream-of-consciousness in style, they certainly are in terms of attitude, capturing a moment's experience in which nothing much happens except for the moment itself. The 30 pictures in *Wij zijn 17* are tellingly simple. Students lounge around in their rooms, doing nothing very much, as if waiting for their adult lives to begin. The mood is uncertain, capturing that moment when childhood ends and youth must take a deep breath and step out into the world.

This was also the theme of *Achter Glas*, Van der Keuken's second foray into the new form of the 'photonovel'. Two sisters, Georgette and Yvonne, do little more than sit by a window, day-dreaming. And it was this youthful lassitude, this apparent aimlessness, perfectly expressed by Van der Keuken, that caused a degree of controversy. But his view of teenage rebellion at the sulky rather than more active stage rings painfully true. It became a model for other books examining the same phenomenon, not the least of which is the recent work of Van der Keuken's compatriot, Helen van Meene, whose similar view of Dutch adolescents – now in colour – has also proved controversial.

Ed van der Elsken
Een Liefdesgeschiedenis in Saint Germain des Prés
(Love on the Left Bank)

Ed van der Elsken was the best known internationally of the Dutch photographers of the 1950s and 60s, due in no small measure to this book, which took the genre of the Dutch photonovel to a new level, and announced the presence in Europe of a stream-of-consciousness photographer on a par with William Klein. *Een Liefdesgeschiedenis in Saint Germain des Prés* (Love on the Left Bank) derives from the years when Van der Elsken lived in Paris – between 1950 and 1954 – focusing on an especially personal body of work that he made at that time: diaristic snapshots of girlfriends and acquaintances living on the Left Bank.

When *Een Liefdesgeschiedenis in Saint Germain des Prés* was serialized in *Picture Post* two years before its publication as a book, the magazine's readers were warned, 'this is not a film. This is a real-life story about people who do EXIST.'[12] The reference to film, however, was apposite, since the story is in fact fictional, and borrows a number of elements from cinema. Using the many existing photographs he had taken of his girlfriend, a striking Australian called Vali Meyers, and her friends, he wove a story of unrequited love between a hapless Mexican student, Manuel, and the charismatic Vali (renamed Ann for the book). This basic plotline gave Van der Elsken the chance to use his gloomily romantic snapshots of student hedonism, set in the bars, cafés, nightclubs and student pads of St Germain, at that time the home of Existentialism.

The story is not exactly sophisticated, and Van der Elsken's pictures are not such pure examples of stream-of-consciousness as some of his other work, but the book remains an important and influential early example of a genre that has become increasingly popular in the late twentieth century – the diaristic mode. The inheritors of Van der Elsken's approach range from Larry Clark to Nan Goldin, the 'I novels' of Nobuyoshi Araki, and any number of young contemporaries.

Furthermore, the level of the book is raised by the contribution of its designer, Jurriaan Schrofer, an important figure in Dutch photobook design of the 1950s. *Een Liefdesgeschiedenis in Saint Germain des Prés* was his first photobook, but he had distinctive ideas about the genre, particularly its relationship to film. Contrasting pages of small pictures with full-page bleeds was a common enough way to create a cinematic pace and feel, but more innovatively, Schrofer also used the idea of the flashback to great effect. The climax of Van der Elsken's narrative comes first, but we only realize this when we reach the last image, which is a reiteration of the book's opening. Cleverly, this symmetry also means that the volume makes some kind of sense when the pages are flicked from back to front, which is the way that many people naturally 'read' photobooks.

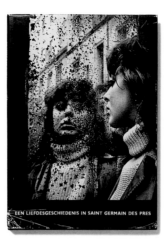

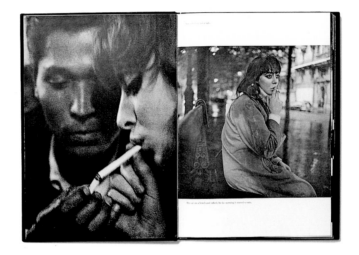

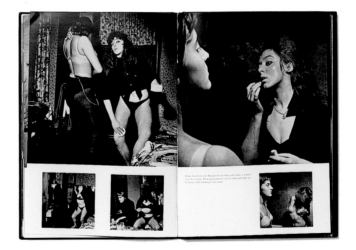

Ed van der Elsken **Een Liefdesgeschiedenis in Saint Germain des Prés**
(Love on the Left Bank)
De Bezige Bij, Amsterdam, 1956
270 × 200 (10³⁄₄ × 7³⁄₄ in), 112 pp
Hardback with full black cloth and jacket
216 b&w photographs
Text by Ed van der Elsken; design by Jurriaan Schrofer

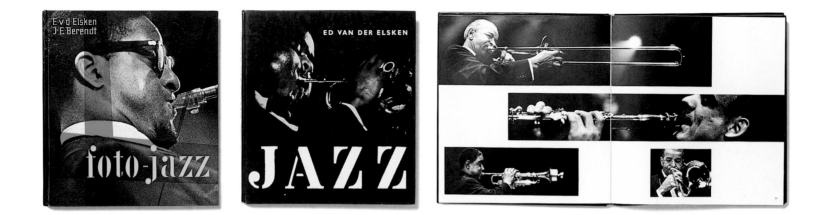

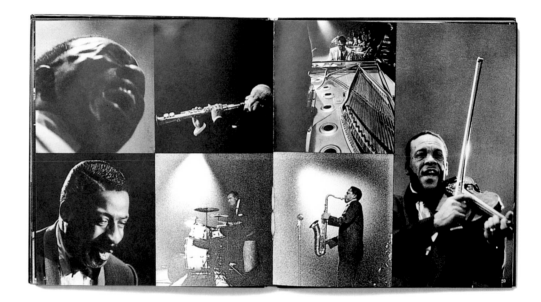

Ed van der Elsken **Jazz**
De Bezige Bij, Amsterdam, 1959
(Also published in German as *Foto-Jazz*, Nymphenburger Verlagshandlung, Munich, 1959)
178 × 172 mm (7¼ × 6¾ in), 116 pp
Hardback
109 b&w photographs
Texts by Jan Vrijman, Hugo Claus, Simon Carmiggelt, Friso Endt and Michiel de Ruyter

Ed van der Elsken
Jazz

The 1950s constituted a golden age for jazz music. The decade was also renowned for classic small-camera photography, much of it as rough and ready as the best experimental jazz. The two art forms combine to perfection in Ed van der Elsken's gem of a book, *Jazz*.

Jazz is an elusive art form, and there would seem to be two aspects to pinning it down in a photobook: the form of the photographs and the form of the book. Van der Elsken's assiduous attention to both makes this modest volume probably the most successful of the numerous attempts to do so. Jazz is a spontaneous, fluid, improvisatory art, best caught on the wing, and this generally means photographing in a variety of ill-lit places. Formal, carefully lit studio portraits may be perfect for album covers, but they hardly catch the essence of a performance. Small cameras and available light, using a slow shutter speed, are much more effective ways of ambushing the practitioners of what Whitney Balliett called the 'sound of surprise'.[13]

The form of the book itself owes much, one suspects, to Klein's *New York*, and possibly to Brodovitch's *Ballet*. As with *Sweet Life* (see pages 254–5), the covers varied according to the country of publication. Inside, the book begins with an image of a crowd 'digging' a concert, then builds into a series of variations on the relationship between performers and audience, constructed in much the same way as a jazz musician constructs an improvised solo. Pages are split into two-, three-, four- and six-part image combinations, resembling the clusters of notes in a saxophone or trumpet run. Graphically, vertical clusters of images suggest piano keys, while horizontal, stretched images recall held notes. The result is not just a succession of musicians' portraits, or even a documentary record of performance, but a book that visually echoes the music itself. Other photographers, perhaps closer to the jazz community, have made books on the subject, but Van der Elsken's is the work of an authentic jazz fan and a maker of authentic photobooks.

Robert Frank
The Americans

Robert Frank's masterpiece has become so much the photobook of legend in its first American edition that it is often forgotten that Delpire's original Paris edition was a different book. Its accompanying texts, gathered by Alain Bosquet, placed it more in a socio-documentary context – with a politically antagonistic, even anti-American point of view. Only with the Grove Press edition, denuded of text except for Kerouac's famous introduction – 'Anybody dont like these pitchers dont like potry, see?' – did it become (also in Kerouac's words) a 'sad poem sucked right out of America' – or out of Frank's despair.

What has made this arguably the most renowned photobook of all? Firstly, and perhaps most importantly, the majority of the pictures are instantly memorable, 'dry, lean, and transparent,'[14] as John Szarkowski has said of them, yet also weighty and profound, even

heartstopping. The sad-eyed lady of the lift, the lean sidewalk cowboy, the shrouded Miami car, the cynical Hoboken city fathers – images like these, and many others, could almost carry the book's heartfelt message individually, even if not part of such an adroitly sequenced totality. *The Americans* is a great book made in the main with great pictures, and that surely explains its eternal resonance.

Secondly, there is the sequencing. Four 'chapters', introduced in each case by the Stars-and-Stripes, have an internal logic, complexity and irresistible flow that moves from the relatively upbeat pictures at the beginning to a final image of tenderness and exhaustion on a road that has only one end. Ideas ebb and flow, are introduced, discarded, recapitulated, transfigured, transposed, played off and piled up against each other with the exuberant energy and precise articulation of a Charlie Parker saxophone solo. There are numerous themes, many moods – sad, happy, bitter, defiant, angry, sorrowful – but only one finale. As Tod Papageorge

has written, 'a continent is spanned, but its life compressed in a single grief'.[15] Jukeboxes like altars, cars like coffins, funerals, road accidents, crosses, flags like shrouds – there is much determined life in this book, but it has death at its heart.

In *The Americans* Frank has given us a vision of the United States that is as true or untrue as we care to make it. What is certain is that it changed the face of photography in the documentary mode. It struck a chord with a whole generation of American photographers who were not fooled by the sanctimony of 'The Family of Man', and it paved the way for three decades of photographs exploring the personal poetics of lived experience. Many memorable photobooks have been derived from this mass of material. None has been more memorable, more influential, nor more fully realized than Frank's masterpiece.

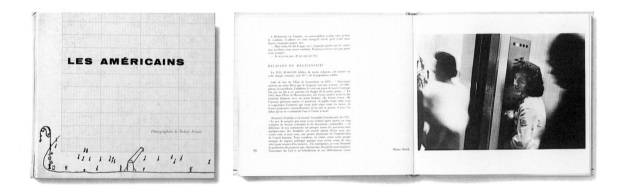

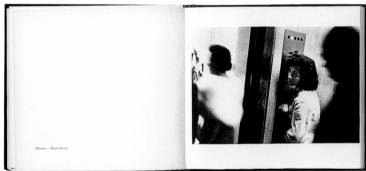

Robert Frank **The Americans**
Grove Press Inc., New York, 1959 (First published in 1958 as *Les Américains*
by Robert Delpire, Paris)
185 × 210 mm (7¼ × 8¼ in), 180 pp
Hardback with full black cloth and jacket
83 b&w photographs
Introduction by Jack Kerouac

Joan van der Keuken
Paris mortel (Mortal Paris)

From 1956 to 1958 Joan van der Keuken studied film-making in Paris, but also took thousands of photographs on the streets, very much under the influence of William Klein, whose book *New York* had appeared in 1956. At that time Paris was, if not exactly in turmoil, at least an uneasy city. Events of the day were dominated by the Algerian uprising, regular changes of government and Charles de Gaulle's rapid rise to power. Van der Keuken combines the American energy of Klein with an undertone of loneliness and desolation

that was typically European, seen in the work of his compatriot Ed van der Elsken, and such figures as Christer Strömholm and Robert Frank.

Van der Keuken worked hard to shape the mass of material that he had acquired into a cohesive book, making no fewer than three maquettes before he and his publisher were satisfied. The first and second versions are probably stronger, and certainly more radical than the final one, because Van der Keuken was experimenting with Klein's 'random' way of sequencing pictures, throwing them down and letting relationships form spontaneously. The earlier versions, however, were considered too radical in design by the publishers, the

Hilversum company of C de Boer Jr, who finally brought out the work in 1963 as a promotional vehicle, and therefore not in any great numbers.

Nevertheless, *Paris mortel* (Mortal Paris) can be added to the long list of classic photobooks made about the French capital. Like Klein's *New York*, the book is divided into six 'chapters', or segments, including the metro, street portraits, military parades and Père-Lachaise cemetery. The dark mood of each individual sequence rapidly piles up and feeds into the main theme of the city's 'mortality'. Although in the 1950s stream-of-consciousness tradition, *Paris mortel* would seem to have certain coincidental affinities with Moï

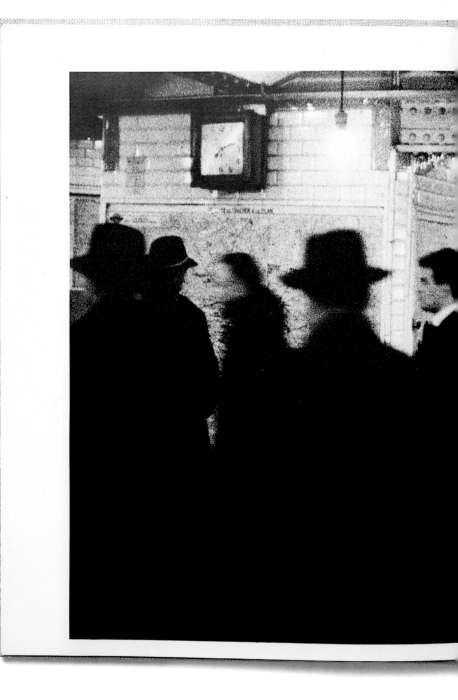

Joan van der Keuken **Paris mortel** (Mortal Paris)
C de Boer Jr, Hilversum, 1963
285 × 220 mm (11 × 8½ in), 68 pp
Hardback with full off-white linen and cloth-effect jacket
65 b&w photographs

Ver's *Paris* of 1931 (see pages 128–9). Van der Keuken, too, was concerned with burying the myth of romantic, timeless, immortal Paris. Both photographers were also film students, but Van der Keuken's book is not simply cinematic in pace and layout – most stream-of-consciousness books were – it also concentrates on Paris as a complex web of socio-political relationships. Like Ver's masterpiece, *Paris mortel* sees Paris not as a monument or artificial film-set, but as a working, and working-class, city. By also depicting Paris as a place where class issues are deeply entrenched, however, Van der Keuken's work largely lacks the optimistic energies of Moï Ver.

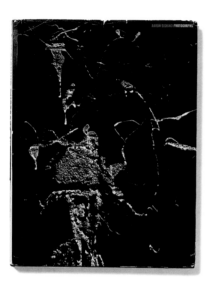

Aaron Siskind
Aaron Siskind Photographs

The tenor of Aaron Siskind's work might seem very different from stream-of-consciousness photography, and aesthetically it is, but he has more in common with the 1950s New York photographic school than might be supposed. Firstly, Siskind exemplifies the move at the end of the 1940s from social documentary to the more personally inflected photograph – albeit in an extreme way. He was a member of the Photo League during the late 1930s and 40s, and was a prime mover behind the League Feature Group's most ambitious project, *The Harlem Document* of 1938–40. However, his documentary practice always tended towards a formalist rather than analytical approach, and he fell out ideologically with some of the League's more politically motivated members as he developed the abstract style of work for which he is best known, and which is featured in this, his first book. Siskind made the move from realism to abstraction, whereas someone like William Klein, who began by photographing his own abstract paintings, travelled in the opposite direction.

If Siskind's elegant, static images of natural details, or of crumbling walls and peeling posters, are at odds with the sense of movement that characterizes stream-of-consciousness photography, what both have in common is the 1950s artistic concern with gesture. In Siskind's case, his subject was the gestures of others, both man and nature. This is not a sociological theme, but a socio-psychological one, and thus perfectly in keeping with the mood of the era, where documentary photographers were turning from objectivity to subjectivity, the socio-political to highly personal expression.

Conceived by its designer Ivan Chermayeff in an austere, classical style, and containing an introductory essay by the art critic Harold Rosenberg that shows him groping wildly for an understanding of photography as an art form, Siskind's first photobook remains his best. His rarefied aesthetic world might seem the antithesis of Klein's *New York*, but it is the obverse of the same coin, with shared antecedents, both in painting and photography. In a nutshell, Siskind could be said to represent the abstract strain of 1950s American art and photography, while Klein exemplifies the expressionist.

Aaron Siskind **Aaron Siskind Photographs**
Horizon Press, New York, 1959
360 × 240 mm (14 × 9½ in), 110 pp
Hardback with full black cloth and jacket
50 b&w photographs
Introduction by Harold Rosenberg; design by Ivan Chermayeff

Christer Strömholm **Poste Restante**
P A Norstedt & Söners Förlag, Stockholm, 1967
250 × 205 mm (10 × 8 in), 120 pp
Hardback with full black cloth and jacket
96 b&w photographs
Text by Tor-Ivan Odulf

Christer Strömholm
Poste Restante

Christer Strömholm was another talented European stream-of-consciousness photographer of the 1950s and 60s. He began as a follower of Otto Steinert's Subjective Photography movement in the early 1950s, but left when the group became too formalist in its aspirations. He was developing an interest in Existentialism, and as a result, his work became both spontaneous and diaristic in true stream-of-consciousness mode. However, he has always tended to focus on photographic metaphor as well.

Poste Restante might be considered Strömholm's *The Lines of My Hand*, his photographic autobiography or manifesto. In this book he shows himself to be as romantic as either Robert Frank or Ed van der Elsken. While he is perhaps less self-centred than Frank, and less melodramatic than Van der Elsken, there is an element of Scandinavian gloom in his vision. Sex and death and rock and roll is an apposite description of the book's tenor, as indeed it is for much stream-of-consciousness photography, and for the increasingly self-focused diaristic modes that have followed.

Like Van der Elsken's *Sweet Life* (1966), *Poste Restante* (as its title implies) derives from Strömholm's extensive travels – in Europe, Asia, Africa. Unlike Van der Elsken, the Swedish photographer is less overtly formalist, giving more significance to his subject matter. The roll call is not unfamiliar for photographers of an Existential bent – still lifes, funerals, posters, distressed walls, strip clubs, cemeteries, and naked women whom the photographer has apparently bedded.

The book's design is also formalist, relying on metaphorical and aesthetic comparisons between images rather than imposing a cinematic flow on the narrative. At times, given the subject list above, the metaphor and symbolism are a little heavy-handed. Nevertheless, *Poste Restante* remains one of the most significant European photobooks of the 1960s.

Richard Avedon and James Baldwin
Nothing Personal

It often seems that inside the celebrity portraitist and fêted fashion photographer Richard Avedon, there are two other photographers struggling to get out – the 'artist' and the political nonconformist. Some critics have dismissed this latter personality as just another commercial stance, totally at odds with the self-indulgent industry that feeds him. But it has surfaced from time to time, and never more so than in his 1964 book, *Nothing Personal*, which he made with his high-school friend, James Baldwin. It was, predictably, panned as opportunism masquerading as concern,[16] but it remains a surprisingly bitter, existential work, as jaundiced in its view of the 1950s United States as Robert Frank's ever was.

At the book's core is a portrait gallery of celebrities, including Dwight D Eisenhower, Allen Ginsberg, Arthur Miller, Marilyn Monroe, George Wallace, Malcolm X, Billy Graham, Bertrand Russell and Major Claude Eatherly (Hiroshima pilot). Such names confirm the book's historical themes, Civil Rights and the Bomb, locating it firmly in the 1950s. Though published in 1964, there is not a sign of JFK or the New Camelot.

The beginning of Baldwin's essay sets the tone: 'the country was settled by a desperate, divided, and rapacious horde of people who were determined to forget their past and determined to make money'. From that relatively mild start, his text develops into a withering tirade, although being American, he tries to end on a positive note. Similarly, Avedon follows his harrowing end sequence – of inmates in a Georgia insane asylum – with a brief coda comprising gentle family images shot on Santa Monica beach at twilight.

But elsewhere all is bitterness. Marilyn is transformed into a world-weary, glassy eyed waif; there's a reptilian Eisenhower, a sneering Wallace, a phantasmogoric Malcolm X, a naked, hirsute Ginsberg, and fearsome Daughters of the American Revolution. Avedon begins the book with an image of a woman building castles in the sand, followed by a series of wedding gatherings. He ends in the mental institution. In between is his celebrity rogues' gallery, in which it is difficult to separate heroes from villains. Is he trying to tell us something? Perhaps Avedon sees them all as victims, in this, his best book, his demonic version of *The Americans*.

Richard Avedon and James Baldwin **Nothing Personal**
Atheneum Publishers, New York, and Penguin Books, Harmondsworth, 1964
365 × 275 mm (14¹₂ × 11 in), 92 pp
Hardback with white paper and slipcase (not shown)
54 b&w photographs, including 2 gatefolds
Text by James Baldwin; design by Marvin Israel

Helen Levitt
A Way of Seeing

Some 20 years elapsed between the publication of Helen Levitt's *A Way of Seeing* and the taking of the pictures. But as with Walker Evans's *Many are Called*, the delay did not diminish the pictures. Indeed, they fitted perfectly into the post-*Americans* photographic world: Levitt's street pictures of New York children in underprivileged areas (like Evans's subway portraits) exemplify the shift from New Deal social documentation to a more personal and elliptical way of looking at life.

Levitt, a close friend of Evans, worked, just as he did, with the writer James Agee. She made her vibrant street pictures in the late 1930s and 40s, while Agee wrote his essay in 1946, when the book was due to be published by Reynolds and Hitchcock. However, the project was shelved when one of the firm's partners died, and it was only revived by Viking in 1964, by which time Agee had died. Apparently, someone at Viking edited Agee's original text, since the essay is not as infuriatingly convoluted as usual.

Levitt's photographs are beautiful – major, underrated works. Like Henri Cartier-Bresson, she achieves a rare balancing act: her pictures have sentiment without being sentimental, always maintaining an objective distance. Formally, she is looser than Cartier-Bresson, pointing towards a more casual style of 1950s New York photography eminently suited to the ebullient life in that city. Although these are warm photographs, her sympathy is tempered by an underlying clear-sightedness. But in the changing political climate of the 1940s, she cleverly sublimated this; the casual observer of these pictures, dazzled by their poetry, could easily miss the harsher realities masked by the surface warmth and *joie de vivre*.

Walker Evans
Many are Called

Although Walker Evans tends to be associated primarily with large-format view camera photographs, which utilize the medium's descriptive faculty, throughout his career he was also passionately interested in the small camera and the rather more spontaneous side of photography. Indeed, he rarely used a view camera after about 1940. Another interest was vernacular photography, anonymous imagery that not only displayed spontaneity, but seemed to have been made by the unaided camera alone. Several times in his career, he combined these interests to investigate the process of photographing, by making spontaneous, improvised images for which he relinquished as much control as he could to the camera itself.

In his subway series (shot from around 1938 and into the 1940s, but only published in 1966), Evans concealed a Contax camera beneath his coat, so that he could snap subway passengers without their knowledge. Framing and focusing were left somewhat to chance, the only conscious decision being when to release the shutter. This, of course, is usually the most important decision that any photographer makes.

The results are remarkably vibrant and sympathetic. The book builds like a series of film stills, each anonymous life segueing into the next. These travellers are largely devoid of overt signs of class (though one assumes that the rich avoid the subway), united by the wearying business of burrowing underground like moles. And yet, on closer inspection, the book's tone seems more positive. It speaks less of a population wearied by the vicissitudes of urban life, than of the way in which people simply withdraw into themselves during the interlude of travel between work and home. Evans's subway passengers may be lost souls, but they are also souls lost in thought.

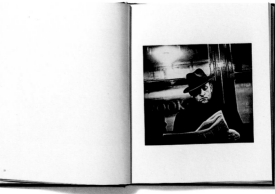

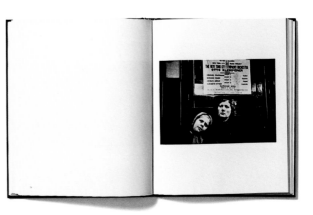

Walker Evans **Many are Called**
Houghton Mifflin, Boston, and the Riverside Press, Cambridge, Massachusetts, 1966
214 × 178 mm (8½ × 7 in), 192 pp
Hardback with full black cloth and jacket
89 b&w photographs
Introduction by James Agee

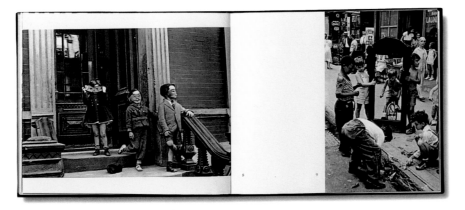

Helen Levitt **A Way of Seeing**
The Viking Press, New York, 1965
197 × 235 mm (7¾ × 9¼ in), 78 pp
Hardback with full black cloth and jacket
51 b&w photographs
Essay by James Agee

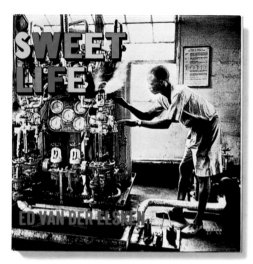

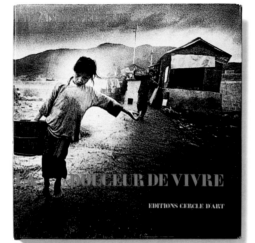

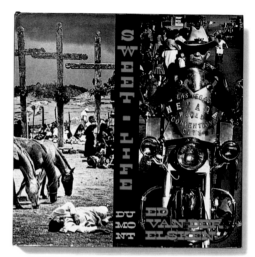

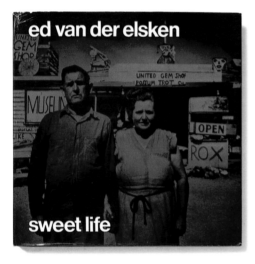

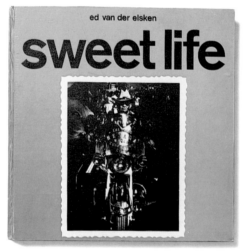

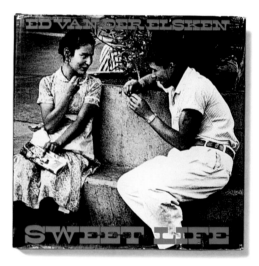

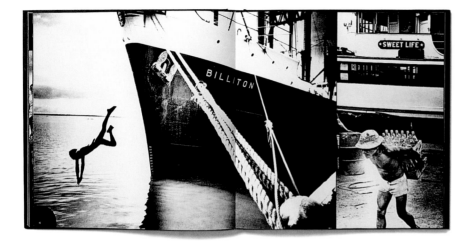

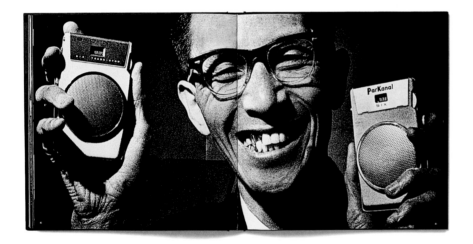

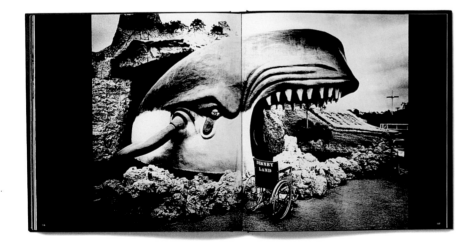

Ed van der Elsken
Sweet Life

Out of stream-of-consciousness photography emerged several distinct genres – the 'personal' documentary, the diaristic photobook, the photonovel and so on. Another was the photographic odyssey, the photographer's quest to find himself (it's generally a boy thing), the photographic version of *On the Road*. The epitome of this genre is, of course, Robert Frank's *The Americans*, but not far behind is Ed van der Elsken's epic photojourney – *Sweet Life*. Whereas Frank criss-crossed the United States, Van der Elsken was even more wide-ranging. *Sweet Life* is the result of a 14-month world trip that he made in 1960–1, covering West Africa, the Malay Peninsula, the Philippines, Hong Kong, Japan, the United States and Mexico. *Sweet Life* was the name of a little tramp steamer in the Philippines, which makes its appearance in the book. Not surprisingly, modes of transport form one of the volume's major leitmotifs.

Van der Elsken's rationale for this freewheeling odyssey is typically Existential: 'I didn't understand one damn thing about it, except that it's enough to keep me in a delirium of delight, surprise, enthusiasm, despair, enough to keep me roaming, stumbling, faltering, cursing, adoring, hating the destruction, the violence in myself and others.'

Although *Sweet Life* chronicles a journey, Van der Elsken's magnum opus has more in common with William Klein's *New York* than with *The Americans*. Like Klein, Van der Elsken designed the whole package himself, in an equally cinematic, improvisational, free-association way – there is no linear determinism in the narrative, though it does progress more-or-less logically from country to country. Like Klein, Van der Elsken brings into play a whole panoply of layout effects – double-page bleeds, crops, running pictures together and so on – and it is an unprecedented book in that it had a different cover for each of the six countries in which it was published. Also like Klein's book, Van der Elsken's was a big hit in Japan. His work constituted a significant influence on the young Japanese photographers of the 1960s, about to be hit by the iconoclasm of the Provoke era.

Van der Elsken's words quoted above describe the tenor of the book as much as his journey. *Sweet Life* is a sprawling, exuberant cornucopia, a preview of the pure stream-of-consciousness, machine-gun approach that would soon come with the Japanese Provoke photographers (see Chapter 9). And like the Provoke aesthetic, Van der Elsken's work has its dark and pessimistic undertones, although in *Sweet Life* bold, frantic energies predominate.

Ed van der Elsken **Sweet Life**
Harry N Abrams Inc., New York, 1966; published simultaneously in Germany (trade and book-club editions), Spain and Holland, and in 1968 in France and Japan (editions shown from top, left to right: American, French, German trade, Dutch, Spanish, German book club and Japanese with and without slipcase)
290 × 290 mm (11½ × 11½ in), 208 pp
Hardback
153 b&w photographs
Text and design by Ed van der Elsken

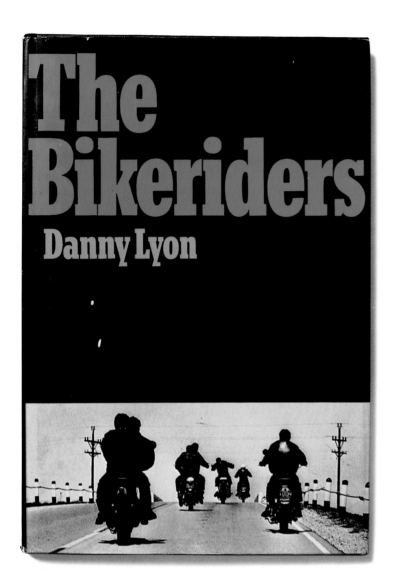

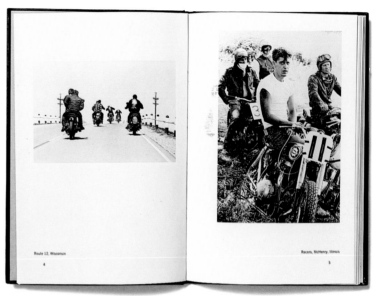

Danny Lyon **The Bikeriders**
The Macmillan Company, New York, 1968
238 × 166 mm (9¼ × 6½ in), 94 pp
Hardback with full black cloth and jacket
48 b&w photographs
Introduction by Danny Lyon; interviews with bikeriders from taped interviews

Danny Lyon
The Bikeriders

Danny Lyon was part of that loose grouping of American photographers in the 1960s known as the Social Landscape school, and who included Garry Winogrand and Lee Friedlander. However, he has had a more erratic career than others tagged with the label, and the term was in any case primarily a curatorial convenience. The 'group' was actually a bunch of individuals, with Lyon more individual than most. Indeed, Lyon may be described as one of photography's great loners, which largely explains his somewhat wayward career path, and a perception of him as something of an outsider, a maverick.

The Bikeriders, an important and influential work, was one of the first books to bring a new genre to late twentieth-century photography, a genre that became more central as the century progressed. Contrary to most of the other social-landscape photographers, who snatched life on the streets as they found it, Lyon photographed communities from the inside, making them an integral part of his life for the duration of the project, and even afterwards. In the case of *The Bikeriders* the community was the Chicago Outlaws biking club of Cicero, Illinois.

Despite their boasts about fights and gang-bangs in Lyon's interviews, which are reproduced in the book, they were not Hell's Angels, and the degree of transgression from everyday society shown by these 'outlaws' was not particularly acute. It hardly matches up to the gun-toting, amphetamine freaks whom Larry Clark would introduce in his book *Tulsa* only a few years later (see page 260). The mildly rebellious activities of Lyon's bikers, their youthful high spirits, were certainly not enough to frighten off a mainstream publisher like Macmillan.

Nevertheless, *The Bikeriders* represented a significant step in 1960s American photography, not only launching an important photographic career, but also giving a younger generation of photographers a spokesman of their own age. Like Joan van der Keuken in Holland, Lyon was part of the generation he was photographing, so was able to talk with an authentic voice about his subjects, understanding instinctively not only their hopes and aspirations, but also why they were rebelling against all kinds of adult authority.

Garry Winogrand
The Animals

As a garrulous, prolific photographer of American mores, Garry Winogrand was perhaps his own worst enemy, for the very profligacy of his photographic output seemed to defeat its gathering together into considered, coherent statements. He made a number of photobooks that may be accounted near misses rather than direct hits, since none quite reflected his importance as an image-maker, nor his position in American photography as a central figure of his generation. 'I photograph to find out what the world looks like in a photograph',[17] he said, a brilliantly succinct summing up of the photographic act, but one that left him open to accusations of formalism.

Though it is true that he was a formalist, this can be said of most artists, and beneath the formal games, the visual jokes and the outward ebullience lay a deeply troubled and troubling vision. Winogrand's modest first book, *The Animals*, is a case in point. The visual relationship between people watching animals in a zoo, and animals watching people, is a photographic cliché, used by many to raise an easy laugh. Winogrand follows suit, as in the rightly famous cover picture of an elephant's trunk meeting a human arm, with titbit in hand. But even in this gentle image, the poignancy is almost overwhelming, and as one turns the book's pages, one begins to sense that Winogrand was seething with anger – possibly at the plight of these caged creatures, possibly at the stupid humans who gawk at them.

Certainly, if not directly social, Winogrand's images would seem to talk of social things. The overriding tenor of his imagery was an elemental angst at the human condition, making him – for all his outward ebullience – one of the most pessimistic of photographers.

Garry Winogrand **The Animals**
 The Museum of Modern Art, New York, 1969
 190 × 215 mm (7¹⁄₂ × 8¹⁄₂ in), 54 pp
 Paperback
 45 b&w photographs
 Afterword by John Szarkowski

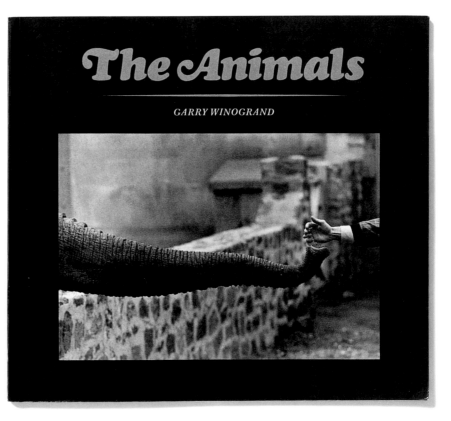

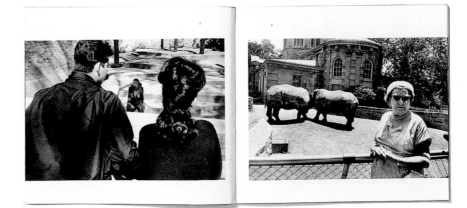

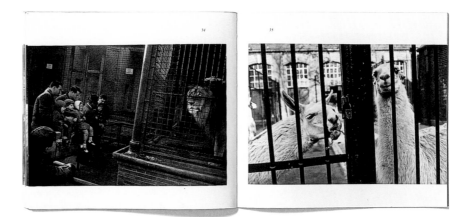

Lee Friedlander **Self Portrait**
Haywire Press, New City, New York, 1970
216 × 230 mm (8½ × 9 in), 88 pp
Paperback
42 b&w photographs
Introduction by Lee Friedlander

Lee Friedlander
Self Portrait

Together with Garry Winogrand, Lee Friedlander is the acknowledged leader of the so-called Social Landscape school, given the name after it was used in the titles of two influential exhibitions in which they featured during the early 1960s.[18] The soubriquet was partly ironic. As Nathan Lyons explained,[19] the 'landscape' explored by the post-Frank generation of American photographers was not simply the American scene – the actual landscape – but the landscape of photography. Its approach was not so much sociological as formal. Its vision was detached, laconic, witty and intensely personal. Thus the typically fractured urban landscapes for which Friedlander is famous are more formal collages made in the camera than documents of the urban scene or psychological examinations of contemporary experience. As Martha Rosler has written, he never forgets 'the meaning of a photograph'.[20]

Friedlander makes this clear in his first solo book in what has been a distinguished book-making career. Despite its title, *Self Portrait* (also published in a special hardback edition with a print) is essentially a landscape work, full of those slightly menacing urban and suburban photographs by which he changed the vocabulary of late twentieth-century photography. But he reminds us that these are photographic landscapes by including himself in each image, sometimes frontally, more often as a shadow or a reflection. In this sense, he pre-empts postmodernism in this hugely influential book. A key image shows him stalking a woman, a spiky-headed shadow on her fur coat. Thus he critiques the act of photographing, laying bare the process, and emphasizing that it is about personal point of view. *Self Portrait* is a complex, subtle work that functions as an oblique document of contemporary experience.

Diane Arbus
Diane Arbus

Published just after her untimely death in 1971, this book – whether or not aided by the artist's notoriety – has achieved massive sales for a volume of such uncompromising photographs. Edited by Doon Arbus and Marvin Israel, its title implies a mere trawl through her best-known images. It is that, but it is also a brilliant exposé of American life. Indeed, if it had been titled *American Photographs* or *The Americans*, it might have attracted very different readings from critics, for its dissection of American society is as cogent and penetrating as that of either Walker Evans or Robert Frank.

Arbus is regarded by many as little more than a voyeuristic photographer of 'freaks', however striking her imagery's formal qualities. But if one looks beyond the superficial controversies one finds not only a complex, but a subtle artist, and one working fully in the documentary mode. While it is true that she often photographed those outside society's norms, a more pertinent observation is that if she made 'normals' look like 'freaks', she also made 'freaks' look like 'normals'. Furthermore, her exploration of normalcy was complicated by gender issues. In her aggressive, full-frontal 'exploitation' of her subjects, Arbus appropriated an essentially male convention: that of *staring*. Indeed, it may well be her assumption of this prerogative of masculine domination that has attracted much of the negative comment, compounded by her undercutting of gender stereotypes. She was a great feminist photographer. Her women and girls are invariably strong – like the confident twins shown here – and her men are frequently damaged or uncomfortable in their surroundings.

Arbus may have exploited her subjects to a degree by utilizing them as sounding boards through which she could plumb the depths of her own psyche, but that is true of many photographers. The psychological is seldom divorced from the social. She tended to rail against cruel nature or uncaring society rather than the individual, and was thus emphatically *with* her sitters, not against them, telling their stories as well as her own. The psychological tenor in Arbus's oeuvre is not the monotonous, aggressive nihilism ascribed to it by some commentators. It varies from outright irony to gentle empathy, unequivocal delight to sheer desperation, Existential angst to righteous anger. Her vision was much more complex than many have acknowledged, perhaps perverse but never perverted – a beautiful, sad, moving testament to the human condition, brilliantly edited and sequenced.

Ralph Gibson
The Somnambulist

Ralph Gibson's Lustrum Press trilogy of the mid-1970s was immensely popular and influential. From the first book, *The Somnambulist*, Gibson took the stream-of-consciousness mode into new and potentially exciting territory – the unconscious. 'Gentle Reader', the brief introduction reads: 'A Dream Sequence in which all things are real. Perhaps even more so.'

The Somnambulist certainly delivers on that promise – taking us through moody landscapes and enigmatic interiors, frequently populated by naked women. The style could not be more representative of its era – Robert Frank meets Bill Brandt – and that potent combination, filtered through Gibson's personal sensibility, was an obvious reason for the book's success. Many of the pictures are amongst the most recognizable from the time – the hand and shadow on the door knob, the floating nude, and above all, the cover image – two hands grasping the prow of a boat. It is a surreal dreamscape, gently erotic, with a frisson of danger.

However, Gibson's dreams emanate from near the surface rather than from the darkest depths of the well of desire, and seem imposed from the outside rather than dredged up from within. In effect, *The Somnambulist* is retro-modernist formalism in a Surrealist disguise – Surrealism domesticated – a kind of hip pictorialism. But the problem with this kind of formalism, as opposed to the sort that purports to be documentary, is that it is timeless, and it is one of the medium's great paradoxes that 'timeless' photography will eventually seem dated, while photography that honestly deals with its time will resonate long afterwards. Despite this, Gibson's triology, much imitated but never equalled, demonstrated a fruitful area of enquiry for photography.

Ralph Gibson **The Somnambulist**
Lustrum Press Inc., New York, 1971
302 × 224 mm (12 × 8¾ in), 52 pp
Paperback
48 b&w photographs

Diane Arbus **Diane Arbus**
Aperture Inc., Millerton, New York, 1972
282 × 242 mm (11 × 9½ in), 184 pp
Hardback with white paper and jacket
80 b&w photographs
Text by Diane Arbus from taped interviews; edited by Doon Arbus and Marvin Israel; design by
Doon Arbus

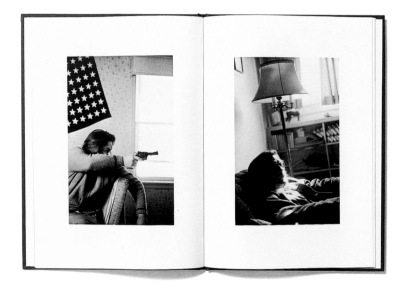

Larry Clark
Tulsa

If Danny Lyon pushed the door ajar on the renegade social document with *The Bikeriders*, Larry Clark opened it wide with his book *Tulsa* which first appeared in 1971. Lyon had shown youthful rebellion on an acceptable level, represented by the kind of kids who whooped it up on the weekends, but usually turned up for work (albeit wrecked) on a Monday morning. Clark, on the other hand, showed youthful alienation as a full-time way of life, with little or no way back into society. His documentation of communes in Tulsa, where serious drug-taking rated higher than casual sex on the activities list, extended the boundaries of acceptable subject matter for photographers, and made *Tulsa* one of the most talked about and important books of the decade.

Unlike *The Bikeriders*, which found a mainstream publisher, *Tulsa* was brought out by arguably the best of the small American photobook publishers of the 1970s, Ralph Gibson's Lustrum Press. Clark's photo-diary, containing gritty, graphic depictions of local teenagers shooting up, playing with guns and having sex, was an instant *succès de scandale*.

Its success amongst the photographic community was due largely to its perceived authenticity. Clark lived with these kids, did drugs with them, slept with them and included himself in the photographs. It was a true photo-diary, turning the documentary mode around. Instead of it being a view from the outside – from above – here was the authentic view from the inside. Following the publication of *Tulsa*, Clark even went to jail for a time, which served to enhance the book's street cred.

Of course, in reality, Clark's view was no more nor less authentic than anyone else's, but it was a view clearly informed by his intimacy with this community. Clark has continued to explore the theme of teenage sex and other transgressions in photobooks and movies, in an apparently admirable non-judgemental and disinterested manner. But unlike Nan Goldin, with whom he may be compared, there is an emotional coldness about his work that is somewhat disturbing. *Tulsa*, and his later book, *Teenage Lust* (1983), broke barriers, but their incessant focus on the sleazy aspect of the lives portrayed, to the exclusion of almost anything else – whether photographed from the 'inside' or not – raises concerns about exploitation and drawing the viewer into a prurient, voyeuristic relationship with the work. There is a fine line between honesty and exploitation; in Clark's case it seems finer than in others.

Larry Clark **Tulsa**
Lustrum Press Inc., New York, 1979, 2nd edition
303 × 220 mm (12 × 8¾ in), 66 pp
Hardback (originally published in paperback
in 1971)
59 b&w photographs

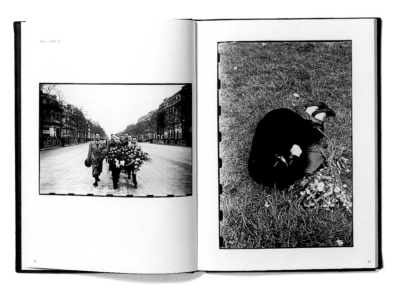

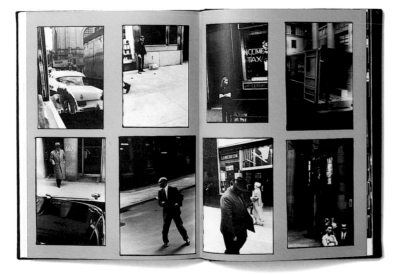

Robert Frank
The Lines of My Hand

This coveted photobook has been published in three completely different versions. The most renowned edition was brought out in 1972 in Japan by Yugensha, Tokyo, the first of a trio of notable books in deluxe format designed by Kohei Sugiura and sponsored by Motomura.[21] A revised and reduced version of *The Lines of My Hand* was published later that year in the United States by photographer Ralph Gibson's Lustrum Press, a paperback edition distinguished by its foul-smelling but evocative binding glue. Yet another, completely revised, version was published by Parkett/Der Alltag of Zurich in 1989.

The Lines of My Hand might be said to be Robert Frank's first retrospective monograph, but he doesn't make conventional monographs. Everything he does is a diary, a confession. Nevertheless, the book follows a broadly chronological path through his photographic career, including early work in Europe, South America and Great Britain, through to the United States and *The Americans* and the *Bus Project*, his last 'documentary' undertaking, which he abandoned to make a number of spellbindingly experimental films – before his retreat to Nova Scotia, where he now lives.

As a retrospective, however, *The Lines of My Hand* is as good as it gets. It might be argued that the problem with any project of this nature is that it takes bodies of work out of their original context and fails to give them much of a new one, except that of an artistic persona, which is usually less interesting than the work itself. Since Frank has had less of a 'career' in any conventional sense and more of a succession of reworkings of the legend, this objection is removed. And since he is its primary subject, the diaristic, confessional mode of the book is the ideal showcase. Given the bonus of Sugiura's design talents and the sheer appropriateness of Frank's vision to the Japanese treatment, he might have been the first foreign photographer to gain membership to Provoke had he not retired. The Motomura edition of *Lines* is certainly one of the photobooks most sought by collectors. Indeed, it approaches the level of *The Americans*, both as a book and as a fitting memorial for a great photographic figure.

Robert Frank **The Lines of My Hand**
Yugensha/Kazuhiko Motomura, Tokyo, 1972
359 × 326 mm (14 × 12³⁄₄ in), 125 pp, with 30-pp booklet insert and double gatefold
Hardback with full black cloth, and black cloth slipcase with photograph mounted on (two variants)
Numerous b&w photographs, contact sheets and montages
Design by Kohei Sugiura

György Lőrinczy
New York, New York

In 1968 the photographer György Lőrinczy took advantage of the Hungarian government's decision to relax its rigorous laws on citizens travelling abroad. The result was his book *New York, New York*, which projected a rather less jaundiced view of the Big Apple than that of many home-grown photographers. As a foreigner's vision, and in terms of photographic outlook, Lőrinczy's perspective clearly has affinities with that of William Klein, but his manic exuberance seems to run on pure energy, without the psychological tensions that underpin Klein's more realistic and informed vision of the city.

It seems unlikely that Lőrinczy saw the work of any of the Japanese photographers of the day, but his book has a similar 'anything goes' feeling, akin to the totally spontaneous style of someone like Daido Moriyama, who coincidentally, was photographing in New York around the same time (see page 301). Lőrinczy's style is rough, raw and uninhibited, in the best stream-of-consciousness manner. But he has nevertheless thought about *New York, New York* as a book, not only laying it out in a dynamic cinematic style, but employing such devices as printing one or two pages on tracing paper, or utilizing extreme grain, blur and even solarization. The latter, surprisingly, renders his depiction of the city's energies more rather than less real, and heightens the kaleidoscopic, rather hallucinatory feeling that Lőrinczy seems to have experienced on encountering this most vibrant of cities.

Lőrinczy clearly had a whale of a time in the headquarters of consumer capitalism, catching up on the 1960s and tasting some of its forbidden fruits, such as rock bands and experimental theatre groups. This excited, carefree, though not naive view of New York makes a refreshing change from the inbred cynicism of the streetwise native.

45

György Lőrinczy **New York, New York**
Magyar Helikon, Budapest, 1972
250 × 205 mm (10 × 8 in), 108 pp
Hardback with jacket
96 b&w photographs, 2 with blue printed tissue guard
Introduction by György Lőrinczy

Robert Frank
Flower Is

This is the second of two books that Robert Frank made with his Japanese patron Kazuhiko Motomura. Like the first – *The Lines of My Hand* – it was designed by Kohei Sugiura and is an equally ravishing production, elegantly slipcased and bound in light grey silk. Unlike *The Lines of My Hand*, *Flower Is* was never published abroad. Consequently – and also because only 500 copies were printed – it is one of the least known of Frank's books. This is unfortunate, because it is ravishing to the mind as well as the eye.

It is primarily a memorial volume to his daughter, Andrea, who was killed in an aeroplane crash in Guatemala in 1974, and begins with a multiple image entitled *To Remember Andrea, 1954–1974*. Made after his 'retirement' from photography and his move to Nova

Scotia, the book does not feature entirely new work; it consists of three suites from different periods in Frank's life. However, it does constitute a major new statement in still photography. The first suite concentrates on pictures of flowers taken in Paris between 1949 and 1951 – flower sellers, markets, flowers in the street and so on. The second was taken in Detroit car factories and on the streets in the South during 1955, a kind of coda after he made the work for *The Americans*. The third sequence unveils work made in Nova Scotia between 1976 and 1984, Polaroid images combined with terse, often despairing texts.

The whole tenor of the book is forlorn, which may be the adjective that best describes Frank's work as a whole. But this is particularly true of the work made after his daughter's death, an event to which he has alluded constantly since. Never have flowers – that most uplifting of photographic subjects – appeared so

woebegone. Seldom has the manic activity of industrial manufacture seemed so pointless. And the Nova Scotia landscapes and still lifes – beautiful, bleak, elegiac – reveal an artist at the height of his powers but hardly at peace with the world or himself.

Frank can sometimes be self-indulgent as an artist, but he can also portray real pain, and capture profound depths of human emotion better than almost any other photographer – indeed, better than almost any other artist in any medium. *Flower Is* can serve as an eminently fitting apotheosis for stream-of-consciousness photography. It is one of Frank's great books (which means it is one of the greatest of photobooks), demonstrating magisterially, as he himself says in the book's introduction, 'my hopes and my sadness with photography'.

Robert Frank **Flower Is**
Yugensha/Kazuhiko Motomura, Tokyo, 1987
340 × 250 mm (13½ × 9¾ in), 112 pp
Hardback with full grey silk and slipcase with photograph mounted on (two variants)
81 b&w photographs
Introduction by Robert Frank; design by Kohei Sugiura with Atsushi Sato

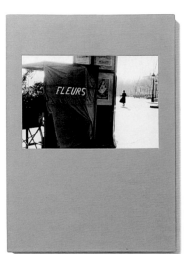

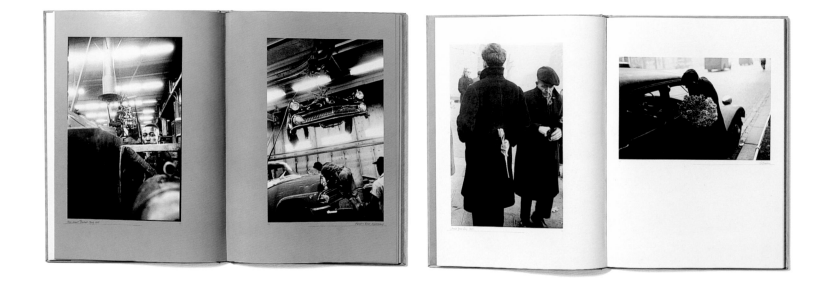

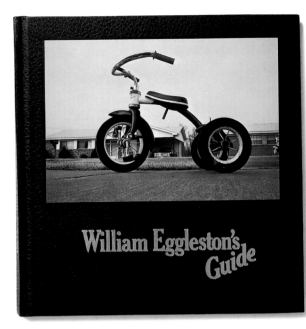

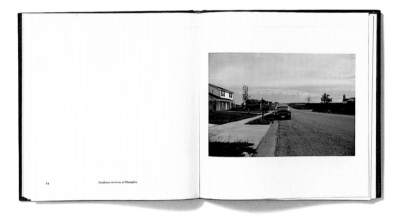

William Eggleston **William Eggleston's Guide**
The Museum of Modern Art, New York, 1976
235 × 235 mm (9¼ × 9¼ in), 112 pp
Hardback with full black leatherette and photograph
mounted on
48 colour photographs and 1 b&w photograph
Essay by John Szarkowski

William Eggleston

William Eggleston's Guide

William Eggleston's Guide, published to accompany an exhibition at the Museum of Modern Art in New York blandly entitled *Colour Photographs* in 1976, is one of the seminal photobooks. Like *The Americans*, it announced the arrival of a major photographic artist, and marks the end of the Frank/Klein era and the beginning of another type of stream-of-consciousness photography. For the *Guide* heralded the birth of colour photography, or more accurately, it marked the moment when it was perceived as artistically respectable.

Previously, colour had been regarded as irredeemably 'vulgar', according to Walker Evans and others. As John Szarkowski writes in one of his most adroit essays, included in the *Guide*, until this defining moment most colour photography had been 'either formless or pretty' – either an inchoate mass of uncontrolled iridescence, or simple chocolate-box kitsch. One might debate how Eggleston avoided these pitfalls, whether he tackled them head-on, or merely ignored them. Certainly, as Szarkowski wrote, Eggleston approached colour 'in a more confident, more natural, yet ambitious spirit', working not as though colour were 'a separate issue' – a problem – but a 'given', a natural part of the photographic process. Eggleston's pictures, no matter how colourful, were not *about colour*, but about the world.

However, the world that Eggleston depicted in the *Guide* has been the subject of much argument. Though many photographers of the day employed a snapshot aesthetic, their use of black and white necessitated fairly obvious artistic mediation. Eggleston's colour images seemed simply to replicate the banality of vernacular snapshots without any redeeming artistry. And in replicating the form, subject matter and intention of the drugstore snapshot so effectively – documenting a commonplace world of everyday suburbia so precisely – their meaning appeared to be both banal and arcane.

And yet the *Guide* constantly confounds such expectations. Eggleston's pictures are at once modest and monumental, vulgar and refined, ordinary and strange, prosaic and poetic, commonplace and unforgettable. As Walter Hopps has written, he has 'the ability to imbue seemingly modest subjects with extraordinary moral weight and dignity'.[22] Exactly what his 'subject' was has been another key aspect of the debate on Eggleston. Despite the fact that much of his work emanates from Tennessee – where he lives – he has denied being a 'Southern' photographer; the work was not a document of the South. Szarkowski contends that it is about experience, and this seems closer to the mark – experience allied with observation. Eggleston's world would seem to be a largely private one, and yet it clearly touches us all, and has irrevocably changed the way in which we look at the world in photographs.

Provocative Materials for Thought
The Postwar Japanese Photobook

The act of expression is the ceaseless process of rendering the invisible visible.
That which is visible, that which structures the everyday, passes for reality.
The act of expression requires a transition from a world of apparent certainties
to a world in which we cannot even locate ourselves. Koji Taki[1]

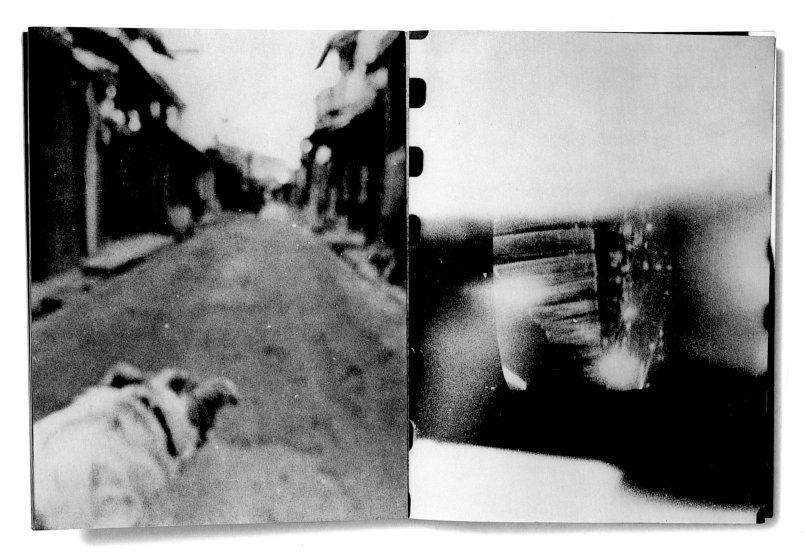

Daido Moriyama
Sashin yo Sayonara (Bye Bye Photography)
Shashin Hyoron-sha, Tokyo, 1972

One of the most extreme monuments of the Provoke period, and one of the most extreme photobooks ever published, *Sashin yo Sayonara* employs a radical language of blur, motion, scratches, light leaks, dust, graininess and stains.

Japan in the 1960s and early 70s marks a highpoint in the history of the photobook, another of those brief periods, like Russia in the 1930s, when photographic book publishing was at the forefront of a cultural renaissance that touched all the arts. The iconoclastic photo-magazine *Provoke* had a vital influence on Japanese photography and the Japanese photobook. It was an influence, one might contend, that was out of all proportion to the mere three issues published during its short, hectic existence at the end of the 1960s. But the Provoke group was only part of a wider tendency within the Japanese cultural avant garde in general and Japanese photography in particular.

The radical Provoke aesthetic was determined, like much late twentieth-century Japanese art and photography, by two causal factors of profound significance. One was a specific, cataclysmic event, the other a global phenomenon, with a particular effect on Japan. The specific event was Hiroshima; the long-term phenomenon, American imperialism. Since the nineteenth century the cultural relationship between Japan and the United States had been somewhat schizophrenic. Prior to World War II, Japanese photography, for all its inevitable local inflections, had largely aped the modernist-pictorialist modes of the West, while those who opposed Western values espoused a Marxist social documentary model. After Hiroshima the country was forced both to examine its past and question its future. To photograph doe-eyed nudes and dewy landscapes seemed not just inappropriate but positively obscene. Collective anguish – a nation's post-apocalyptic stress syndrome – lent a hard edge to the new Japanese photography, literature, film and art. While provoking a period of unprecedented

economic growth, the American occupation – both military and cultural – only exacerbated a festering residue of guilt, shame and anger. The country covered its wound with a band-aid of prosperity, but the schizophrenia remained.

Out of the madness, however, emerged a burst of creative expression. Japanese artists had found a subject, a cause. As Alexandra Munroe has written: 'At the centre of their thinking was ... the terrible knowledge they alone possessed of nuclear annihilation: Japan as ruins, as gaping emptiness was their ultimate subject.'[2] And they discovered the ideal means of expressing it by merging their own cultural roots with ideas emanating from another continent that was slowly coming to terms with the aftermath of war – Europe. French Existentialism, shrugging a nihilistic shoulder at the war just ended and the Cold War just beginning, struck a chord with Japan's disaffected intelligentsia, although the Japanese situation gave it a particular spin. As Munroe points out, the Japanese experience harboured a bleak philosophy, too bleak even to engender rage.

At first the only possible response to the atomic holocaust was to document its aftermath in a calm, objective fashion. Ken Domon's book *Hiroshima* (1958) brought the horror to an international audience, with gruesomely frank pictures of the survivors' scars, wounds, skin grafts and reconstructive surgery. Along with Ihei Kimura, Domon was Japan's leading photographer of the immediate postwar period, and represented the dominant photographic aesthetic of that era: social documentary based on a broadly humanistic approach. Both Kimura and Domon were influenced by classic photojournalism in the Cartier-Bresson mode, and were keen to set Japanese photography on a much more professional basis. Domon founded Shashinka Shudan (The Photographers' Group), in 1948, a photographic co-operative based on the Magnum Agency in Paris, which became absorbed into the Japan Professional Photographers' Society in 1950, of which Kimura was the founding chairman.

Hiroshima-Nagasaki Document 1961 (1961) repackaged Domon's earlier Hiroshima pictures for the Japan Council Against the A and H Bombs, and combined them with a number of new pictures by Shomei Tomatsu. This ground would be revisited constantly by Japanese photographers and artists for at least another decade, but in the three years between the two books attitudes were changing rapidly, as younger photographers were reconsidering how best to express the Japanese predicament. In *Hiroshima-Nagasaki Document 1961* Tomatsu was already beginning to push against the veristic limitations of the social documentary form with his expressive images of Nagasaki. In common with his younger colleagues, Tomatsu deemed the literal documentary approach an inadequate vehicle for a complete photographic representation of the tensions and paradoxes in Japanese society. A more aesthetic style was also brought to Japan by Yasuhiro Ishimoto. Ishimoto had been born in the United States, studied photography there but eventually settled in Japan, and introduced the cool, formal modernism of his teacher, Harry Callahan. In contrast, a rawer, more widespread Western influence resulted from the visits of William Klein and Ed van der Elsken in the early 1960s.

The 1960s constituted a crucial decade. It was the era when the world began to move on from the war, when the first postwar generation made its initial impact, in the arts and in the political arena. The 1960s generation of Japanese artists began to reconcile some of the contradictions in Japanese art by focusing on those same contradictions in Japanese society. Imitation of foreign modes gave way to genuine reinterpretation, and in diverse fields – in cinema, theatre, drama, graphic art and photography – a new Japanese style asserted itself, intensely true to its roots yet cosmopolitan in outlook. The period was one of widespread protest against Americanization but, ironically, it took an American to give Japanese photography the more radical form to best render the fragmented realities of Japan's ambivalent attitude towards the United States. In 1957, a year after its initial Parisian publication, Klein's *New York* was distributed in Japan. His raw, visceral style struck an instant chord, not just with social documentary photographers, but with graphic designers and more theatrically minded photographers like Eikoh Hosoe. By the time Van der Elsken's *Sweet Life* appeared in a Japanese edition in 1968, the gritty, intuitive style of photography's Existentialists had not only been absorbed, but taken to an extreme by such Japanese photographers as Daido Moriyama and Takuma Nakahira.

The design of *New York* was as much an inspiration as the photography itself. Graphic design and the printed page – in the form of the fine yet cheaply produced book – was a Japanese art that went back to the woodcut block and *ukiyo-e* (eighteenth- and nineteenth-century prints of the 'floating world'). Since Japan is an especially visually literate culture, the book was a natural outlet for photographers. The camera and electronic industries founded before the war grew rapidly afterwards, and Japan became a leading electronic media-based culture. But rather than destroying Japanese publishing, these industries gave it a new lease of life, especially photographic publishing. Major companies sponsored photographic publications, and leading journals such as *Asahi Camera*, *Nippon Camera* and *Camera Mainichi* became important outlets not simply for photography, but for the most progressive photography. The influential editor of *Camera Mainichi* during the 1960s and 70s, Shoji Yamagishi, was responsible for nurturing the careers of many of Japan's best photographers.

Rather than the making and selling of fine photographic prints, the main focus of Japanese photography was, and still is, on publication. Japanese photobooks are generally populist in outlook and relatively inexpensive. Not all are cheap, however. There is also a strong tradition for exquisite books made with the finest materials and the best printing. Cheap or expensive, attention to detail is paramount. A Japanese photobook is expected to have a 'rightness' about it, an appropriate balance of design and production values for the concept, even if that concept is a 'throwaway' one that calls for printing on newsprint or toilet paper. Consequently, the designer is an important part of the process, and figures like Kohei Sugiura and Tadanori Yokoo have been as significant in the development of the postwar Japanese photobook as the photographers themselves.

Prior to *Provoke*, the two most important bookworks of the 1960s were designed by Sugiura – finely crafted objects in the best Japanese tradition, combined with hard-hitting, radical photography. Firstly, *Barakei* (Killed by Roses), published in 1963, dramatically extended the pictorialist/surrealist strain in Japanese photography. A series of theatrical, erotic, collaborative portraits of the writer Yukio Mishima, it established Eikoh Hosoe's international reputation. Kikuji Kawada's *Chizu* (The Map, 1965) elevated the nominally literal photojournalistic mode to an astonishing level of allusion and symbol, and might be considered the first Provoke book. In its fastidious roughness and its despairing exploration of A-Bomb/Americanization themes, it set a model that was later equalled but never bettered.

In the early 1960s Kawada and Hosoe were both members of Vivo, a Tokyo-based agency to which most ambitious photographers – including Tomatsu, Ikko Narahara and the young Daido Moriyama – either belonged or maintained close contacts. Vivo was one of those groups that form, briefly flourish, then disband with regularity in Japanese photographic circles.

Out of Vivo emerged Provoke, founded by two writers with a keen interest in photography, Koji Taki and Takuma Nakahira, as well as Takahiko Okada and Yutaka Takanashi. Its influences included Japanese avant-garde literature and student protest politics, which gave the publication its wider relevance with the cultural avant garde. Both Taki and Nakahira had worked with Shomei Tomatsu on the landmark exhibition, 'The One Hundred Year History of Japanese Photography', organized under the auspices of the Japan Professional Photographers' Society in 1968 – the 'Year of Protest'. Taki was a critic and writer on aesthetics, while Nakahira was the editor of the magazine *Gendai no Me* (Modern Eye). Under Tomatsu's influence Nakahira abandoned this editorial job to become a photographer. He told Moriyama, 'I have become a photographer. These are dreadful times.'[3]

Though the group's members were encouraged by Tomatsu, Provoke was a reaction against his notion of the subjective documentary photograph in the broadly humanist tradition. Fired by the spirit of postwar Existentialism that informed much Japanese art, Taki and Nakahira pored over thousands of anonymous photographs while researching 'The One Hundred Year' exhibition. In this vibrant anonymity they could perceive a photography free from the sentimentality of Tomatsu, a photography that was as unconscious as the Surrealists' automatic writing, and seemed to capture raw, unmediated experience itself. With like-minded colleagues such as Okada and Takanashi, they debated how this primal photographic language was the antithesis of written language, and was wholly appropriate to their times. And they planned a new publication to explore these ideas.

The pivotal year was 1968. The country was enjoying unprecedented prosperity, yet there was dissension and protest, both over the Vietnam War and over the country's relationship with the United States. Trade unions and student marches, strikes and rallies culminated in '10.21 Antiwar Day' – the riots of 21 October. The battles between protesting students and police in the Shinjuku district of Tokyo were the worst that Japan had seen, and 734 students and activists were arrested. In November 1968 *Provoke No 1* was published. The issue began with the group's manifesto, written by Taki and Nakahira, and signed by Okada and Takanashi:

Visual images are not ideological themselves. They cannot represent the totality of an idea, nor are they interchangeable like words. However, their irreversible materiality – fragments of reality snapped by the camera – belongs to the obverse side of the world of language. Photographic images, therefore, often unexpectedly provoke language and ideas. Thus the photographic language can transcend itself and become an idea, resulting in a new language and in new meanings.

Today, when words are torn from their material base – in other words, their reality – and seem suspended in space, a photographer's eye can capture fragments of reality that cannot be expressed in language as it is. He can submit those images as documents to supplement language and ideology. This is why, brash as it may seem, Provoke *has the subtitle 'provocative materials for thought'.*[4]

The basic aim was to free photography from subservience to the language of words, a perhaps contradictory goal for a group who emanated primarily from a literary background. But in photography they saw a link between free writing, theatre and underground cinema, an art that was almost as much a performance art as the Butoh dance of Tatsumi Hijikata, the experimental theatre of Shuji Terayama, or the 'New Wave' films of Nagisa Oshima. In photography they saw a singularly appropriate means of expression for the turmoil of 1968. And, although nominally 'free' from ideology, Taki and Nakahira were both aware of and totally committed to the political dimensions of their magazine. *Provoke* represented youth, rebellion, despair, rage and hedonism. It was a perfect reflection of the Shinjuku entertainment area, whose transgressive values it shared. Indeed, *Provoke*'s transgressive nature did not escape Shomei Tomatsu, who declared that it was less of a photography magazine and more of a philosophical and political journal.[5] •

Provoke No 2 appeared in March 1969 with one important addition to the roster of photographers. In the issue, subtitled *Eros*, blurred nudes by Moriyama appear alongside a magnificent portfolio by Nakahira. Moriyama's nudes made a particular impression on a young employee of the Dentsu-a advertising agency named Nobuyoshi Araki, which might cause some to remark that Moriyama has a lot to answer for, but the issue progressed the ideas formulated in *Provoke No 1*.

Provoke No 3 (August 1969), arguably the best of three, carried things to an even greater extreme. The paper was rougher, the printing was rougher; above all, the photography was rougher, especially in the superb contributions of Moriyama and Nakahira. But then, almost as quickly as it appeared, the magazine ceased publication, through a combination of financial troubles and ideological differences. The book, *Mazu Tashikarashisha no Sekai o Sutero* (First Abandon the World of Certainty), however, which appeared in 1970, is regarded as the *Provoke No 4* that is announced in *No 3*. Despite its wonderful title and its ideological texts, the visual intensity of the three issues proper of the magazine seems diluted here, and it was in the group members' individual books that the *Provoke* spirit was carried forward.

Given the legendary status it has achieved in the 30 or so years since it first appeared, it is easy to overestimate *Provoke*'s influence at the time. Like most small magazines, its impact was felt only amongst the limited circle of cognoscenti – photographers and others interested in the Japanese avant garde – who actually bought or saw the magazine. 'I was inspired by *Provoke*', Araki has said. 'Most people paid no attention to it, but really it was like a bomb in Japanese photography.'[6] If so, it was more like a time bomb than a high-impact shell. A more apt metaphor, perhaps, is that it was a stone thrown into a pool, whose ripples continued to spread outwards over the years. Even the startlingly raw style of photography that it espoused was hardly unknown. It was featured regularly in the more progressive mainstream photography magazines like *Camera Mainichi*, and in 1969 Tomatsu

published his Provoke-style book *OO! Shinjuku*. There were also other magazines and radical groups. Araki was the guiding light behind the Geribara 5 (The Diarrhoea-Shit Reproductive Collective of 5), another short-lived group of the early 1970s, similar to Provoke, which published three books that are almost as eagerly sought-after by collectors as the three *Provoke* magazines. Individual photographers also brought out their own magazines – Moriyama's *Document* and Tomatsu's *Ken*, for example. Several magazine/book series were devoted to Japanese photographers, such as the influential *Workshop* series of 1974–6, published by the photography school Workshop, founded and supported by Hosoe, Araki, Nakahira, Kawada and Tomatsu.

Japanese photography of the late 1960s and 70s was characterized by major photographers coming together for some venture or other and then going their separate ways. But Provoke remains the most important of these ventures. It gave Japanese photography of the 1960s a philosophical focus, placing it within the framework not only of the avant garde of the time but also within Japanese politics and international photography. *Provoke* was Japanese photography's primal scream. That scream reverberated for some time, due largely to the photobooks that emanated from the magazine, and it still echoes in the later work of Tomatsu, Moriyama, Araki et al.

The story of the Japanese photobook following the Provoke period could be summed up in two words – Nobuyoshi Araki. There has hardly been a dearth of either photobook publishing or fine photography in Japan since the 1970s, but this compulsively prolific figure has produced more than 300 photobooks, and many more have been published by would-be Arakis. Furthermore, Araki's work has encompassed enough styles single-handedly to reflect a diverse Japanese photographic culture – from a post-Provoke street documentary to Manga sado-eroticism to rigorous Conceptualism in the German mode. Araki has experimented with innumerable formats and ways of making books. Despite recent criticism about his passion for bondage, he has tried out more ideas in terms of narrative, sequencing and design than any other photographer, and he remains a crucially important maker of books, with an influence extending far beyond Japan.

No other Japanese photographer has come anywhere near Araki's dominance in the photobook field, but there have been individual highlights. Masahisa Fukase's *Karasu* (Ravens) in 1986, for example, is one of the greatest of photobooks, due to its metaphoric and rhythmic power. Toshio Shibata and Naoya Hatakeyama have updated the calmer, more contemplative style of Japanese landscape photography, while George Hashiguchi ploughs his own furrow of formal documentary portraiture. But the figure who has attained an international reputation to rival Araki's is Hiroshi Sugimoto, whose approach is the antithesis. With work as austere, precise and elegant as a Zen garden, Sugimoto has a natural propensity for deluxe, limited-edition books, as precisely engineered as a machine. Combining the Japanese tradition with Western conceptualism, Sugimoto has made a distinctive series of photobooks that are masterpieces of minimalist design and packaging.

An important recent development is the young school of 'photo-diarists', who were influenced by what Araki called the 'I Novel' – the mode that has informed his photography from first to last – and his collaboration with another influential American visitor, Nan Goldin. Of these, the most interesting are Hiromix and Masafumi Sanai. Hiromix (real name Toshikawa Hiromi) is a phenomenon, a young woman who has become successful in a photo-culture where traditionally women are on the other side of the camera, acquiescent subjects for aggressively male photographers like Araki. The fact that Hiromix makes nude self-portraits and nude snapshots of her friends has undoubtedly been at least partly responsible for her enormous success. Nevertheless, her rise has encouraged not only a plethora of young women, but also young male photographers to document lives that are almost totally Westernized, very different from those of the Provoke generation.

Provoke has recently been discovered, or rediscovered, by Europe and the United States and figures like Tomatsu and Moriyama are now fêted in the West. In 2002 alone Moriyama published two major books in the United States,[7] typically rough work housed in sumptuous, limited-edition *hommages* to the halcyon days of Provoke. The angry young men who sought to take photography to the absolute limits of coherence are now revered as old masters.

Yasuhiro Ishimoto
Aruhi Arutokoro (Someday, Somewhere)

Like William Klein, Yasuhiro Ishimoto represented an influential link between Japanese and American photography, although from a different photographic tradition. Ishimoto was born in San Francisco, then moved to Japan with his parents in 1924 before returning to the States in 1939. Following internment in the war, during which he learned photography, he studied under Harry Callahan and Aaron Siskind at the Chicago Institute of Design, graduating in 1952. He returned to Japan in 1953, but continued to travel between the two countries. Thus his work is an interesting and distinctive blend of cultural influences, neither wholly Japanese nor wholly American in style. The legacy of his wartime internment clearly left an indelible mark. As Tsutomu Watanabe writes in the book's introduction, Ishimoto's imagery 'is characterized by what might be described as psychological shadows'.

In 1958 he had the distinction of producing the first major postwar Japanese photobook, the elegant *Aruhi Arutokoro* (Someday, Somewhere). Shot in Chicago and Tokyo, the book is divided into three sections. The first concentrates on forms and textures on Japanese streets, and displays the tendency to abstraction and formalism that marked the Chicago School of the Callahan-Siskind era. Ishimoto adds a Japanese austerity to this familiar idiom, but sections two and three are more interesting. Here he turns to beach and street candids, reminiscent of the anonymous street portraits of Callahan or Walker Evans, but given his own quirky voice – a wistful, world-weary quality that applies even to his images of children playing. Like Callahan, his voice is measured and distanced. Unlike Callahan, the distance is respectful and warm rather than cool, while the dark tenor pervading his work gives his pictures a singular edginess, especially in his creepy portraits of children wearing Halloween masks.

Aruhi Arutokoro is a photobook of truly international stature, providing Japanese photographers with a model of expression that transcended both the parochial and the purely documentary tendency dominating Japanese photography of the time.

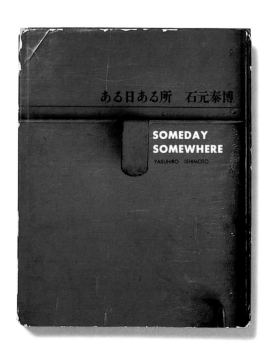

Yasuhiro Ishimoto **Aruhi Arutokoro** (Someday, Somewhere)
Geibi Shuppan, Tokyo, 1958
285 × 229 mm (11¼ × 9 in), 168 pp
Hardback with black cloth, yellow spine and jacket
7 colour and 178 b&w photographs including various gatefolds and fold-outs
Preface by Tsutomu Watanabe; design by Ryuuichi Yamashiro

Ken Domon
Hiroshima

Shomei Tomatsu and Ken Domon
Hiroshima-Nagasaki Document 1961

Shomei Tomatsu
11.02 Nagasaki

These three key books, along with Kikuji Kawada's 'symbolic reportage' in *Chizu* (The Map, 1965), constitute photography's most significant memorials to the defining event in twentieth-century Japanese history. They also illustrate a clear progression towards truly world-class Japanese photographic expression. That Japanese photographers should be reaching out towards the world is clearly important in this case, for the 'world' – in the shape of Japanese imperial expansion, and the inevitable reaction to it – was responsible for the terrible events graphically recorded in these three volumes.

The reaching out begins with *Hiroshima* by Ken Domon. Fine gravure printing and a cover by Joan Miró seem designed to provide an international focus and to lend a dignity to the horrors that are unflinchingly confronted within. The events are recorded in a careful and respectful way, as if the act of making the book could somehow begin the process of reconciliation and healing.

This sober, measured though didactic tone is continued in the *Hiroshima-Nagasaki Document 1961*. Shomei Tomatsu's images are more symbolic, more emotive, yet with its accompanying factual texts and the imprimatur of the Japan Council Against the A and H Bombs, the polemic is contained within the framework of reason and measured calm. The tone is that of the clinical and objective documentary witness.

Context is everything, and when Tomatsu's images were republished in his own *11.02 Nagasaki*, the effect was quite different. All the rhetorical stops were pulled out, and it is a tighter, more compact book than the other two. *Nagasaki* begins with Tomatsu's justly renowned close-ups of various artefacts damaged by the explosion – a watch stopped at precisely 11.02, a headless statue and, most powerful of all, a melted beer bottle. This is one of those rare images that is worth a thousand others, where the fused glass stands in for all the wrecked bodies. The horror that this simple image evokes – more than all Domon's well-meaning pictures of reconstructive operations – demonstrates conclusively that Tomatsu was right to abandon the literal in favour of the allusive and metaphorical as the most appropriate trope for describing the postwar Japanese dilemma.

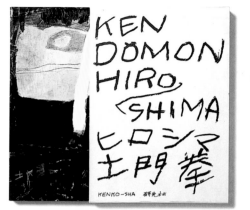
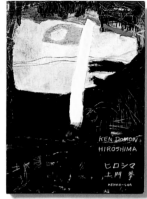

Ken Domon **Hiroshima**
Kenko-sha, Tokyo, 1958
355 × 262 mm (14 × 10¹₂ in), 176 pp
Hardback with full black cloth, jacket (with reproduction of painting by Joan Miró),
glassine, white card slipcase and cardboard box (not shown)
1 colour and 164 b&w photographs
Text by Ken Domon; design by Shigejiro Sano

Shomei Tomatsu and Ken Domon **Hiroshima-Nagasaki Document 1961**
The Japan Council Against the A and H Bombs, Tokyo, 1961
280 × 175 mm (11 × 10³₄ in), 138 pp, plus separate 54-pp paperback informational booklet (same dimensions)
Hardback with full white cloth, cardboard inner sleeve fitting into card outer sleeve (not shown)
92 b&w photographs (71 by Tomatsu, 21 by Domon)
Preface by Hideki Yukawa; explanatory notes by Kiyoshi Sakuma, Nobuo Kusano, Ryusei Hasegawa and Toshio Hata;
design by Kiyoshi Awazu, Kohei Sugiura and Kazunobu Shimura

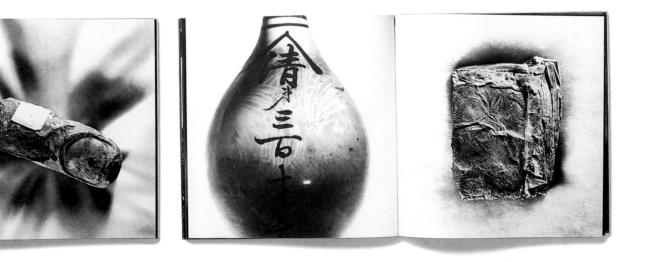

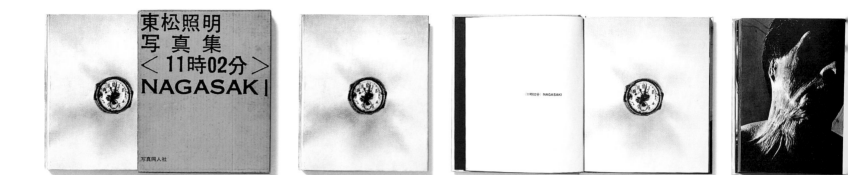

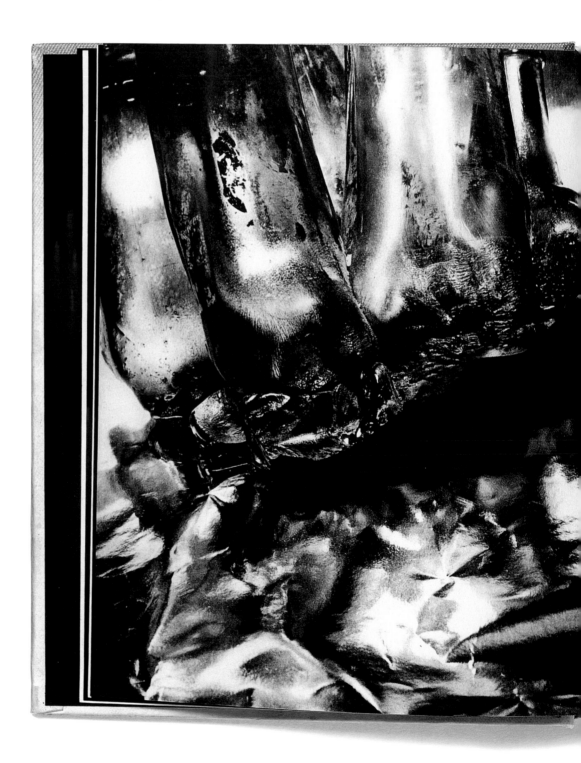

原爆の火災のため溶解したビールびん

Shomei Tomatsu **11.02 Nagasaki**
Shashindojin-sha, Tokyo, 1966
225 × 198 mm (9 × 8 in), 168 pp
Hardback with cardboard slipcase
119 b&w photographs
Text by Tamaki Motoi and interviews with survivors

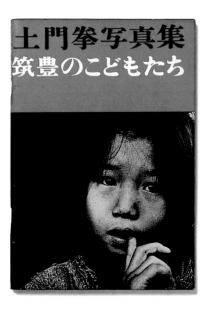

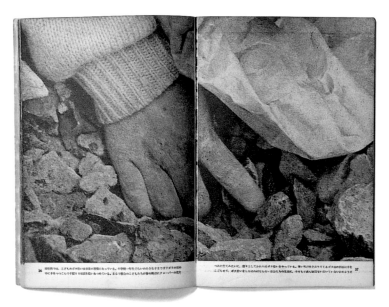

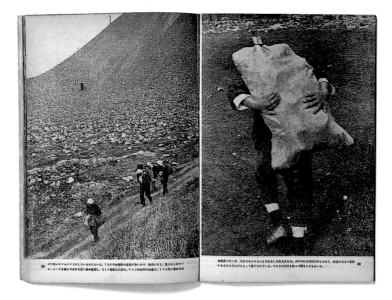

Ken Domon
Chikuho no Kodomotachi
(The Children of Chikuho)

Ken Domon, along with Ihei Kimura, is widely regarded as Japan's leading photographer of the immediate post-war years. His book documenting the aftermath of the Hiroshima attack, published in 1958, brought him to the attention of those beyond the photographic world. He worked in the classic photojournalistic mode, seeking to document Japanese life in the troubled aftermath of the war, and was the driving force behind such groups as Shashinka Shudan (The Photographers' Group) Agency, which replicated both the working practices and journalistic ethic of the Magnum photo agency in Paris. Domon's photographic philosophy was strictly humanistic; he was a 'concerned photographer' in the classic mould, believing that his duty was to record the world exactly as he saw it, and convey his message unambiguously to the widest audience possible.

During the late 1950s, at a time when the rest of the Japanese economy was beginning to recover to prewar levels, the coal-mining areas of Chikuho and Kitakyushu, in the far south of Japan, suffered both from a population exodus and pit closures, due to their distance from the Tokyo area and decreased demand as the focus of Japanese manufacturing shifted towards the electronic industries. Domon documented the effects of this drastic decline on the miners and their families in two books in 1960, *Chikuho no Kodomotachi* (The Children of Chikuho) and *Rumie chan wa Otosan ga Shinda* (Rumie's Father is Dead). Both books look at the plight of the district's children, who were doubly hit by the decline. Firstly, the economic situation led to their fathers' unemployment. Then, as the adults moved away to find work, there was a tendency for the remaining mines to employ more underage labour

Chikuho no Kodomotachi is both the better-known, and the better book. Domon works in a classic photojournalistic manner, using the small camera directly and without artistic pretensions. Domon aimed to reach out to the broadest possible readership, thus – in deliberate contrast to the luxurious production of *Hiroshima* – he had the book printed cheaply, on rough paper, in the manner of a bound newspaper. It was priced at only 100 yen, and sold over 100,000 copies.

Ken Domon **Chikuho no Kodomotachi** (The Children of Chikuho)
Patoria Shoten, Tokyo, 1960
257 × 180 mm (10¼ × 7 in), 96 pp
Paperback
83 b&w photographs
Foreword by Noma Hiroshi; postscript by Ken Domon

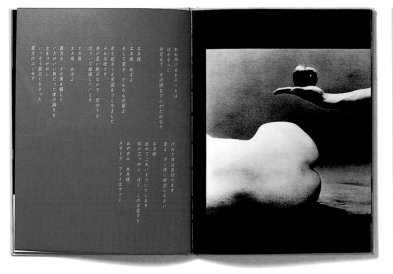
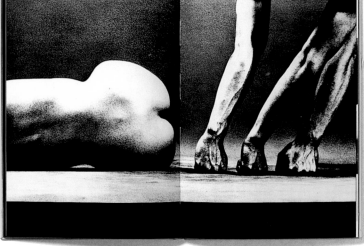

Eikoh Hosoe **Otoko to Onna** (Man and Woman)
CamerArt Inc., Tokyo, 1961
243 × 188 mm (9½ × 7¼ in), 64 pp
Hardback with full yellow cloth, jacket, bellyband and card slipcase with additional bellyband
34 b&w photographs, English translation booklet inserted into export copies (not shown)
Poems by Taro Yamamoto; texts by Ed van der Elsken and Tatsuo Fukushima; jacket and design by Minoru Araki

Eikoh Hosoe
Otoko to Onna (Man and Woman)

Otoko to Onna (Man and Woman) was the first of Eikoh Hosoe's book collaborations with the dancer Tatsumi Hijikata, a key figure in the 1960s Japanese avant garde. It is not as opulent as the luxurious volumes that would follow, but it is still printed in the heavy photogravure, with intense whites and rich blacks, that became his trademark. This was partly a result of a visit to Japan by the Dutch photographer Ed van der Elsken, who would influence Japanese photography in general, and Hosoe's work in particular.

Hosoe had attended Hijikata's adaptation of Yukio Mishima's homoerotic novel *Kinjiki* (Forbidden Colours), a premiere to rank in notoriety with Stravinksy's *The Rite of Spring*. The show was given a single performance, which involved simulated sex with a chicken and the animal's eventual death. This enormous *succès de scandale* is regarded as the birth of Butoh, a singular fusion of European folk and contemporary dance styles with native traditions. Despite its intensely Japanese qualities, the style, dramatic and rhetorical, focuses on the human body in a way alien to the Japanese, where there was no tradition of the nude in an abstract sense, only nakedness.

Hosoe's book is a series of photographs – characterized by Hosoe's elegant and precise sense of form – recording an evolving performance by Hijikata's ensemble, which gradually becomes more abstract as it progresses. The 'dance' itself is a series of musings on the subject of sexuality. It begins with the women, carrying such symbols of fecundity as a fish or a flower, but eventually Hijikata, with his finely-honed musculature, takes centre stage. As so often in Japanese art, the women are relegated to a supporting role – essential, but supporting nonetheless.

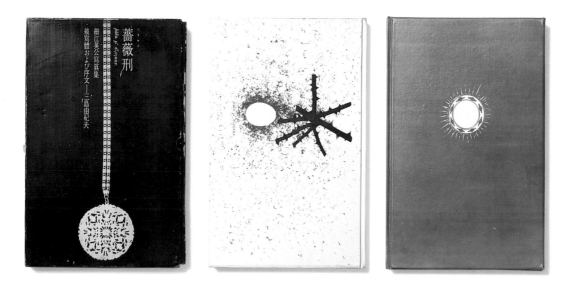

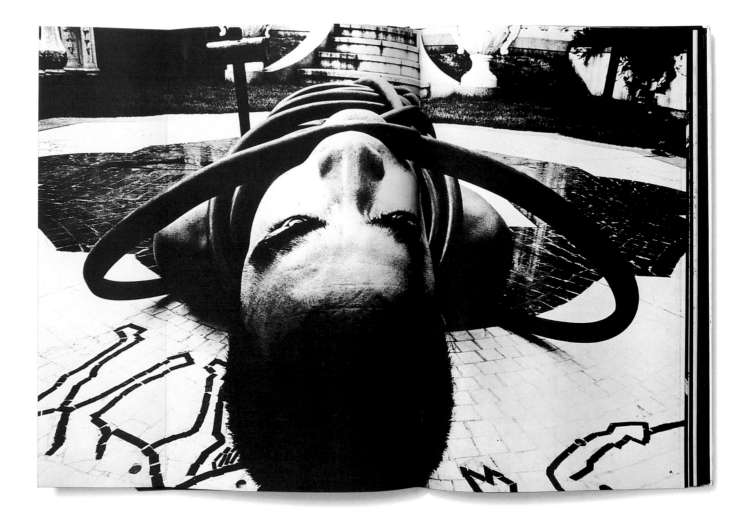

Eikoh Hosoe and Yukio Mishima
Barakei (Killed by Roses)

Both Japanese editions of *Barakei* (Killed by Roses) are significant, not only because of the remarkable collaboration between Eikoh Hosoe and Yukio Mishima, but also because they were designed by the two most influential Japanese graphic designers of the postwar years – the first edition by Kohei Sugiura and the second by Tadanori Yokoo. Each is an original working of the material in its own right, and the second, one of the most complex bookworks ever made, also memorializes a defining moment in Japanese culture.

Mishima had admired Hosoe's photographs of Tatsumi Hijikata, and invited him to his house to take a publicity portrait. Hosoe found the famous writer in his garden, dressed only in the traditional Japanese loincloth, and came up with the apparently serendipitous idea of photographing him lying on a marble mosaic zodiac, with little more than a garden hose coiled around his body. Thus began, as Hosoe put it in a note in the American third edition, the 'destruction of a myth'.

The photographer was being disingenuous. Rather than destroying the myth, he was creating it. In his preface to the first edition, Mishima was equally disingenuous: 'One day, without warning, Eikoh Hosoe appeared before me, and transported me bodily to a strange world.' That world, he continued, was 'abnormal, warped, sarcastic, grotesque, savage, and promiscuous'. Mishima allowed Hosoe unprecedented directorial freedom, but as in other such close collaborations between photographer and subject, just who had the ultimate control is open to question. What emerged was a series of extraordinary theatrical tableaux – Japanese surrealism meets Italian mannerism – that certainly contributed to the iconicity of Mishima, the samurai saviour of the country's soul. Hosoe's images were baroque, kitsch, frequently sadomasochistic, disturbingly narcissistic and clearly homoerotic, despite the presence of women in a number of the pictures.

Mishima worshipped the 'spurious and artificial', wrote the film director Nagisa Oshima, an avowed political opponent, in a scathing essay.[8] But, despite its hyperbole and kitsch, this is a truly disturbing book, the product of a powerful if warped mind at work. It has its imitators, but most of them are pale shadows of the original. Authenticity cannot be manufactured and, as subsequent events confirmed, Mishima was playing it for real.

Eikoh Hosoe and Yukio Mishima **Barakei** (Killed by Roses)
Shuei-sha, Tokyo, 1963
427 × 275 mm (16¾ × 11 in), 98 pp
Hardback with cloth, clear acetate jacket and black cardboard slipcase
43 b&w photographs, 4 colour illustrations on rice paper, 2 gatefolds
Photographs by Eikoh Hosoe; model and introduction by Yukio Mishima;
design by Kohei Sugiura

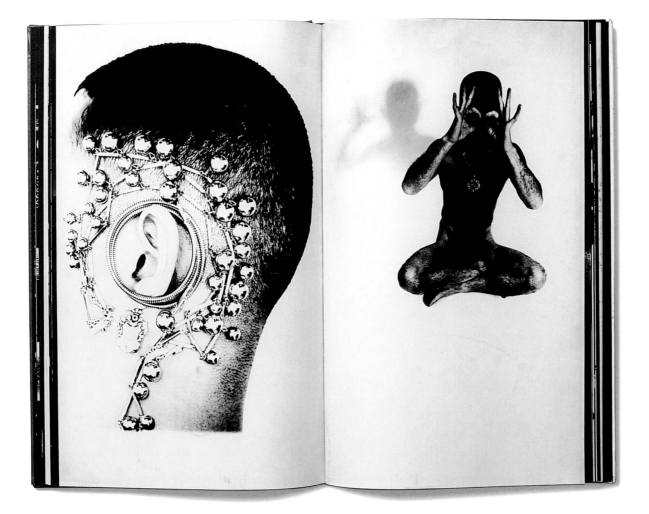

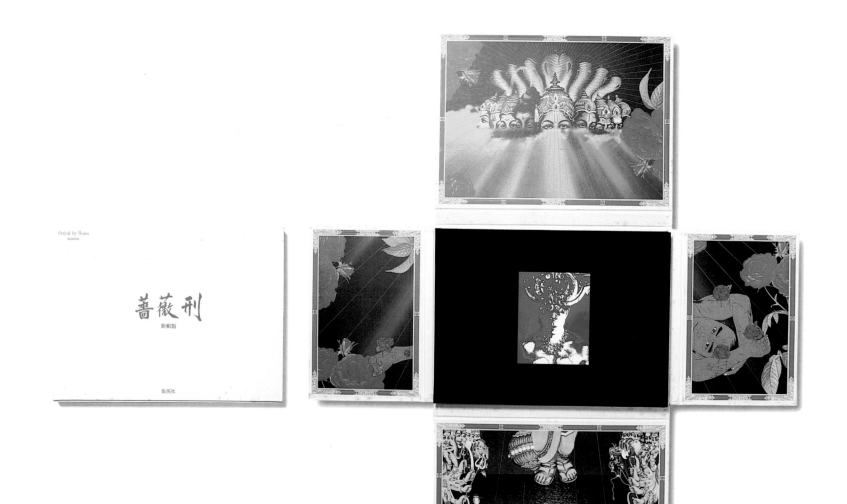

Eikoh Hosoe and Yukio Mishima
Barakei Shinshuban (Ordeal by Roses Re-edited)

Barakei Shinshuban (Ordeal by Roses Re-edited) reads the cover of this astonishing book – re-presented by Mishima himself. The first of the writer's many changes was to alter the English translation of the title from *Killed by Roses* to *Ordeal by Roses*, which Mishima felt reflected the original Japanese more accurately. In a new preface he outlines the rest of the changes: Some pictures from the original were dropped and the whole was substantially reordered in five sections entitled 'Sea and Eyes', 'Eyes and Sins', 'Sins and Dreams', 'Dreams and Death' and 'Death'. The first section consists of painted montages by Tadanori Yokoo, who had been brought in to design this memorial for Mishima – the controversial writer had planned to commit *seppuku* (ritual suicide) to coincide with the book's publication.

Yokoo created one of the most complex photographic books ever. Bound in black velvet, it nestles in a portfolio case, whose lining is covered with more of Yokoo's highly coloured illustrations, a blend of Pop art with *ukiyo-e*. Inside the book the content is even more startling. Hosoe's photographs are printed in the most luscious photogravure imaginable, with blacks as deep as the ocean. In the penultimate section, a sequence of multilayered combination imagery, where Mishima's body is merged into baroque paintings, a sepia ink is substituted, before returning to black for the final 'Death' sequence. This mainly consists of the writer's glistening, near-naked torso adorned with a rose, against the elaborate carved background of a French Empire-style chaise longue.

Mishima committed public suicide in December 1970, in protest at Japan surrendering once more to the United States by signing the extension of the US–Japan security treaty. Hosoe waited until the furore had died down before publishing *Barakei Shinshuban* the following year. Even without the bizarre circumstances of its genesis, it is by any standards an extraordinary book.

Eikoh Hosoe and Yukio Mishima **Barakei Shinshuban** (Ordeal by Roses Re-edited)
Shuei-sha, Tokyo, 1971
387 × 540 mm (15¼ × 21¼ in), 104 pp
Hardback with full black velvet, white cloth portfolio case with full-colour printed illustrations pasted
inside, and outer cardboard box (not shown)
39 b&w photographs, 6 colour illustrations
Model and preface by Yukio Mishima; photographs by Eikoh Hosoe; illustrations and design by
Tadanori Yokoo

Eikoh Hosoe
Kamaitachi

Many Japanese photobooks are designed around the ritual of removing them from their slipcases or covers and opening their pages. The second book collaboration between Hosoe and the dancer Tatsumi Hijikata makes a complex ceremony even of viewing each photograph. Every picture page is a blue gatefold that must be carefully unfolded before the image can be viewed. Looking at this book cannot be done in a hurry.

Kamaitachi derives from a journey that Hosoe made to the far north of Japan's main island after returning home from a European trip in 1964. He travelled with Hijikata to the Tohoku region. Both had been born there, but Hosoe's parents had left soon after his birth. He had, however, been evacuated there as an 11-year-old, to escape the firebombing of Tokyo, but had found the episode an unhappy one. As a young boy in the north, Hosoe had heard of the Kamaitachi, a weasel-like demon who purportedly haunted the area's rice fields and would slash any person he encountered. On their journey they came upon a great plain of rice fields that triggered Hosoe's memory, and he conceived the idea of shooting Hijikata in a series of tableaux that recreated the Kamaitachi legend. The result was a spontaneous and therefore intensely personal dance drama, a kind of exorcism using the local landscape and people.

The Kamaitachi functions as a wild free spirit in a land restricted by tradition. As such, the demon (Hijikata) is at once beguiling and dangerous, representing such impulses as earthiness and sexuality. He seduces women and carries off small children, like the Pied Piper. Such unruliness is seen throughout the series but most clearly in one of the signature images, of a tiny Hijikata leaping gleefully through a great landscape of paddy fields. That there might be a price to pay for such abandon is abundantly clear in the menacing sky, which hangs over the scene like a shroud.

Hosoe might not have been concerned, like many photographers in the 1960s, with contemporary urban life, but to choose tradition as a subject in Japan is an implicit comment on modernity. Even the urbanists would make work relating to country life. Hosoe's focus on rural tradition was thus perfectly in accord with the modernity of the Provoke crowd, and the dualities in *Kamaitachi* – or for that matter, *Barakei* (Killed by Roses) – made Hosoe's books as relevant to the situation in 1960s Japan as those of Shomei Tomatsu or Daido Moriyama.

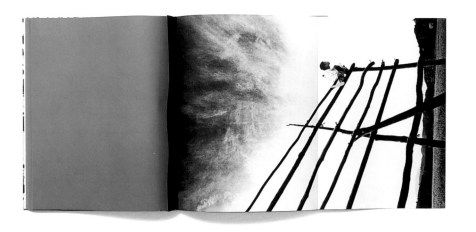

Eikoh Hosoe **Kamaitachi**
Gendaishicho-sha, Tokyo, 1969
375 × 310 mm (14¾ × 12¼ in), 82 pp
Hardback with full white cloth, clear acetate jacket, white card slipcase and outer card box (not shown)
33 b&w gatefold photographs, back of gatefold printed in blue
Preface by Shuzo Takiguchi; dance by Tatsumi Hijikata; poem by Toyoichiro Miyoshi; design by Ikko Tanaka

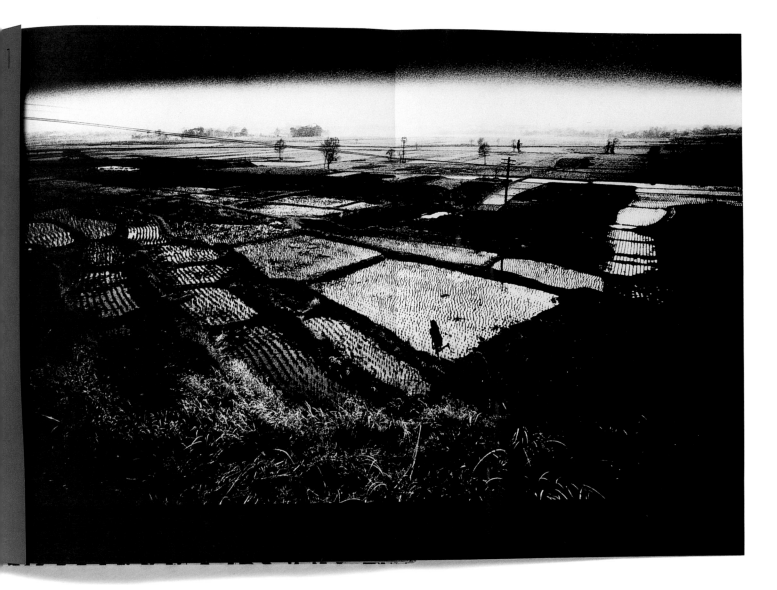

Kikuji Kawada
Chizu (The Map)

Chizu (The Map) is the ultimate photobook-as-object, combining a typical Japanese attention to the art of refined packaging with hard-hitting photography, text and typography – a true photo-text piece. No photobook has been more successful in combining graphic design with complex photographic narrative. As its cover is unfolded, and the various layers inside peeled away like archaeological strata, the whole process of viewing the book becomes one of uncovering and contemplating the ramifications of recent Japanese history – especially the country's tangled relationship with the United States.

The narrative begins to unfold with the delineation of the book's publication date – 6 August 1965, the twentieth anniversary of the bombing of Hiroshima. This, as with so many Japanese books of the period, is its central theme, though sub-themes proliferate.

Inside the slipcase, printed with a topographical chart, is another wrapping, a black paper chemise that unfolds like a map to reveal words and phrases in Japanese and English – 'keloid/rocket/sign/energy/machine/popcorn/you are my sunshine/7-up/secret/war department/gum gun/drink coca cola/manhattan/atom' – a cryptic, prose poem repeated on the jacket over a suggestive image of burning paper.

The next layer is the book's introduction, in which Kenzaburo Oe writes: 'I saw a map close to my wounded eyes. While it was nothing but a little piece of ground stained with heavy oil, it really appeared to me like a map of the world full of violence, in which I was to live henceforth.' The photographic imagery is consistent with this thought. It juxtaposes images of military memorabilia of the Special Attack Corps (Kamikaze) from the Museum at Etajima with abstract close-ups of blistered and radiated wall surfaces from Hiroshima, and other evidence of the bombing – melted glass, fused glass, a woman's hairpiece. The abstract images

are presented as the outer pages of gatefolds that open to reveal pictures of tattered uniforms, farewell letters, identity cards, military insignia, a crumpled rising-sun flag, contrasted with symbols of the culture that displaced Japan's imperial history – billboards, television sets, Coca-Cola bottles. As Mark Holborn has put it, these are 'signs of a new occupying state, the consumerist remnants of a different kind of invasion ... In the cracked concrete Kawada traced the lines of his national identity.'[9]

Kawada's photographs are a masterly amalgam of abstraction and realism, of the specific and the ineffable, woven into a tapestry that makes the act of reading them a process of re-creation in itself. In the central metaphor of the map, and specifically, in the idea of the map as a series of interlocking trace marks, Kawada has conjured a brilliant simile for the photograph itself – scientific record, memory trace, cultural repository, puzzle and guide.

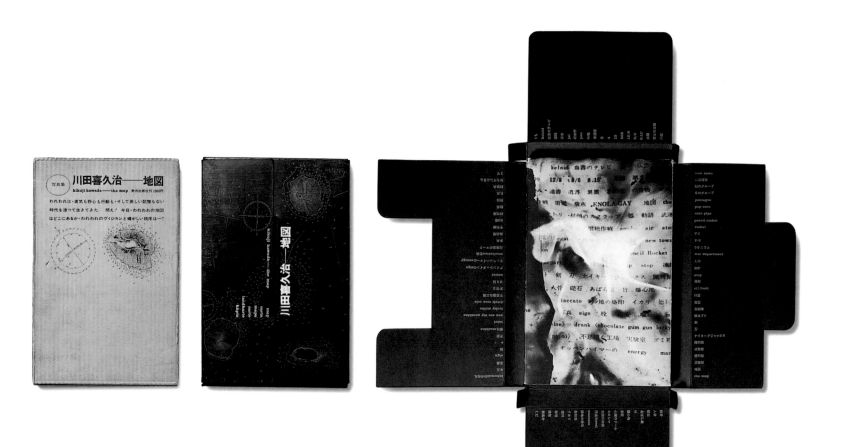

Kikuji Kawada **Chizu** (The Map)
 Bijutsu Shuppan-sha, Tokyo, 6 August 1965
 230 × 150 mm (9 × 5¾ in)
 Hardback with folded broadside insert, jacket, black paper
 die-cut chemise and cardboard slipcase
 49 b&w photographs, 23 4-panel b&w gatefolds
 Text by Kenzaburo Oe; design by Kohei Sugiura

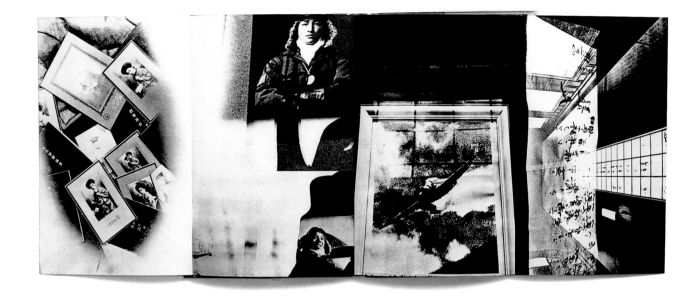

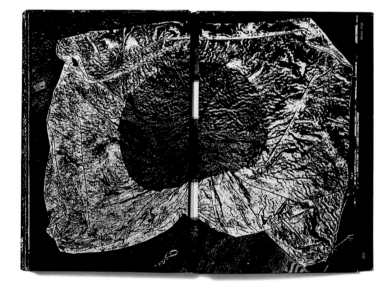

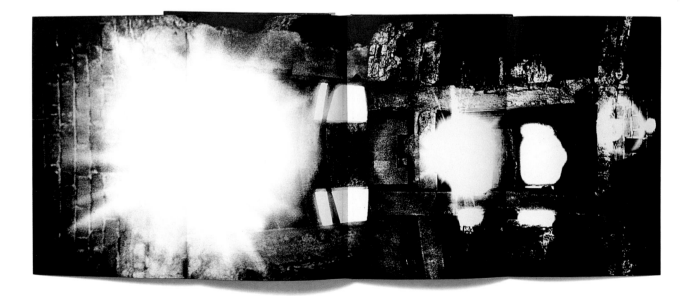

Daido Moriyama
Nippon Gekijo Shashincho
(Japan – A Photo Theatre)

A major subject of postwar Japanese art, especially in the 1960s, was the conflict between tradition and modernity. Just as Japanese industry appropriated Western technology, Japanese artists were equally voracious borrowers. Taking elements from both Western and traditional models, they sought to make new hybrids. But some of the most radical Japanese art of the 1960s was being forged out of traditional performing arts. Figures like Tatsumi Hijikata and his Butoh dance movement, and Shuji Terayama's Tenjo Sajiki Theatre Group galvanized the visual artists as well as audiences with their iconoclastic daring, mixing up neo-Dada, beat poetry, surreal eroticism, Noh and Kabuki with alacrity and invention. Photographers and film-makers fed off this vibrancy, and when Daido Moriyama published his first book in 1968 – *Nippon Gekijo Shashincho* (Japan

– A Photo Theatre) – it was a fusion of like-minded documentary, expressionism and theatricality.

The book's core was a series on theatre that Moriyama had made for the magazine *Camera Mainichi* called *Entertainers*. Moriyama, who had assisted Eikoh Hosoe on *Barakei* (Killed by Roses), took these theatrical images and combined them brilliantly with images of other types of urban outsiders to make a metaphor of theatre-as-life, and of life-as-theatre. He sought the world of the hipster, the freak, the 'other', from the avant-garde Terayama theatre group, which featured nude women, dwarfs and burlesque characters of all kinds, to the more vernacular nightlife of the city, the strip joints, gangster bars, and backstreet Kabuki theatres, a fusion of the old and new, high and low, insider and outsider, freak and non-freak. 'My underlying thought', Moriyama wrote, 'was to show how in the most common and everyday, in the world of the most normal people, in their most normal existence, there is something dramatic. This kind of everyday existence is remarkable,

fictional. This kind of chaotic everyday existence is what I think Japan is all about.'[10]

The kind of conjunction Moriyama makes between various outsider groups is remarkably similar to connections that Diane Arbus was making at the same time a continent away (see pages 258–9). But Moriyama went further. Whereas Arbus used a frontal, traditional photographic mode, Moriyama employed a gestural, disjunctive style, eschewing conventional technique, and he even ended the book with a series of photographs of aborted foetuses. Following Kikuji Kawada's *Chizu*, Moriyama's book shows all the elements of the Provoke style falling into place in a tour-de-force of Existential expressionism.

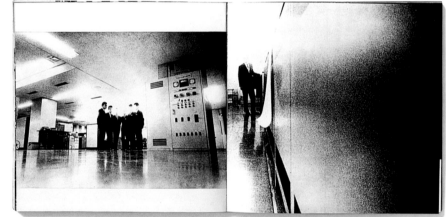
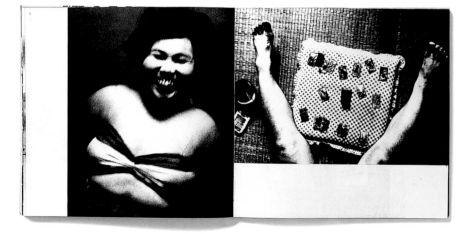

Daido Moriyama **Nippon Gekijo Shashincho** (Japan – A Photo Theatre)
Muromachi-Shobo, Tokyo, 1968
210 × 220 mm (8¼ × 8¾ in), 150 pp
Paperback with card slipcase (not shown)
145 b&w photographs
Text by Shuji Terayama

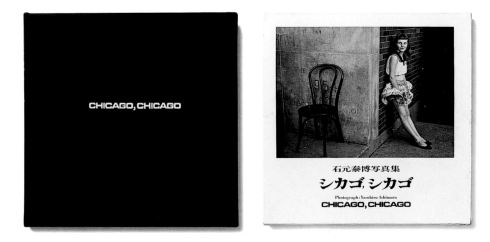

Yasuhiro Ishimoto **Chicago, Chicago**
Bijutsu Shuppan-sha, Tokyo, 1969
275 × 283 mm (10⁷⁸ × 11¼ in), 224 pp
Hardback with full black cloth and white card slipcase
208 b&w photographs
Foreword by Harry Callahan; text by Shuzo Takiguchi;
layout by Yusaku Kamekura

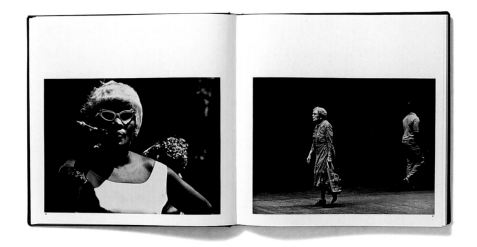

Yasuhiro Ishimoto
Chicago, Chicago

By his own admission Yasuhiro Ishimoto always considered himself something of an outsider in Japan. Although he took Japanese citizenship in 1969, the work he chose to publish in that momentous year for Japanese photography concentrated on pictures taken in the United States. At a time when most of the leading Japanese photographers were actively caught up in their country's volatile political situation, Ishimoto seems deliberately to have maintained his distance, declaring his independence with a body of work that was different in both style and approach from either the existential excesses of the Provoke school, or the baroque theatricality of Eikoh Hosoe.

Chicago, Chicago confirms this singularity and the promise shown in his earlier *Aruhi Arutokoro* (Someday, Somewhere). The later book demonstrates a photographer influenced by both Japanese and American

sources and adopting neither wholeheartedly – a position that is both his strength and his weakness. It is arguably more completely realized, thematically tighter, than *Aruhi Arutokoro*, and yet the earlier work was fresh and new, a surprise. Nevertheless, its old-fashioned, humanist virtues are considerable. Like the earlier work, the book is split into sections, seven of them this time, revealing various aspects of Chicago and the two major photographic preoccupations of Ishimoto at the time – the formal urban landscape and the street portrait.

If the portraits and street-life images win out, it is because people are more interesting than things, and the photographer himself is more challenged by people, less prone to exercising merely formal concerns, though no Ishimoto image is ever less than elegant. But given the momentous times in which he lived, his work seems to lack social focus compared to that of Shomei Tomatsu or the Provoke photographers. This is apparent even in his photographs of harassed anony-

mous faces on the city streets, or of black churchgoers, or his justly renowned images of children in disturbing Halloween masks.

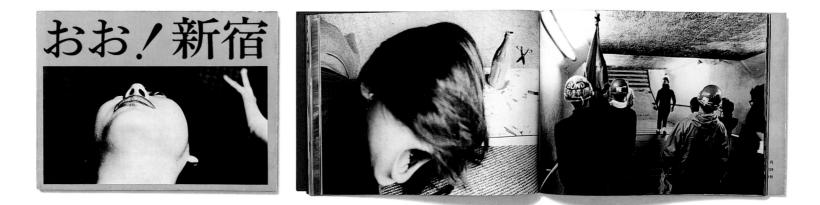

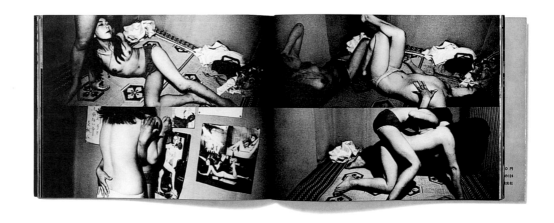

Shomei Tomatsu **OO! Shinjuku**
 Shaken, Tokyo, 1969
 186 × 260 mm (7¼ × 10¼ in), 96 pp
 Paperback
 120 b&w photographs
 Jacket text by Shomei Tomatsu

Shomei Tomatsu
OO! Shinjuku

'Shinjuku is youth Shinjuku is underground Shinjuku is happening Shinjuku is hip Shinjuku is sex Shinjuku is civilization's womb Shinjuku is crime Shinjuku is the now of the 60s and at the dawn of the 70s a violent gale is going to blow away your freedom ... OO! Shinjuku.' Shomei Tomatsu's rhetorical text on the back cover of what has been called his 'Provoke book' indicates the central position of the Shinjuku district in the mythology of postwar Japanese counter-culture, like Haight Ashbury in San Francisco or Kreuzberg in Berlin. If the archetypal Shinjuku photographers are Daido Moriyama and Nobuyoshi Araki, Tomatsu comes close to matching them. He adopts a much more freewheeling style than usual, in a radical book that explores three primary themes associated with the district: sex, drugs and student riots. Yet despite the apparent playfulness of

the beat poetry on the back cover, this is an eminently serious, even despairing book. While Tomatsu is mindful of Shinjuku's raffish reputation, he does not exult in it like some, and places political ferment firmly at the book's centre.

Tomatsu photographs the various aspects of Shinjuku – the crowds, the nightlife, the vibrancy, the dropout youths standing on the street, drinking or sniffing glue, a comatose drunk on the sidewalk. He photographs the area's main industry – sex – through strip clubs, prostitutes and girlie bars. With the cooperation of a Butoh dancer and his wife, he photographed the sweaty delirium of lovemaking, catching her cry of ecstasy at the moment of orgasm. But he largely avoids the prurient voyeurism of others. Shinjuku sex is a desperate business for Tomatsu.

It is the great student protests of 1968, which thread their way through the narrative, that makes this book a historical document as well as a photobook of invention

and heart. From an upstairs window, Tomatsu photographed the helmeted figures – rioters and police – preparing for the struggle, and then the great antiwar riots of 21 October 1968, when Shinjuku was turned into a battlefield. He photographed blurred, indistinct figures running down the street, like those storming the Winter Palace in the October Revolution, or those desperately trying to escape German bullets in Dam Square. But the revolution, as the gloomy coda to Tomatsu's text admits, was doomed to failure. Too many in Japan knew which side their bread was buttered on. In the 'Year of Revolution' Japan's GNP was second only to that of the United States. Tomatsu might have represented the conservative old guard to the Provoke crowd, but this book is undeniably radical.

Ken Ohara
One

Ken Ohara is a Japanese photographer who has en-
joyed a significant career in the United States. As a
young man he emigrated there to study photography
at the Art Students' League and was apprenticed to
Richard Avedon and Hiro in New York. During his New
York years he made the work seen in *One*, although
the book was published in Japan.

Its very title suggests that Ohara's obsessive record-
ing of tightly framed single faces snapped on the
streets of New York represents an attempt to bring
mankind together, much as cavemen represented ani-
mals on their rock walls to ensure good hunting. Like
the works of the artist Christian Boltanski, which under-
mine Walter Benjamin's notion of the portrait as the
last refuge for the cult art object, these photos deny
the individuality of their subjects to make a wider
social observation.

Ohara has compiled a glossary of 500 faces – black,
white, Asian – and printed them with the same tonal
characteristics, thus eliminating differences in skin col-
our. Through this, and through tight framing that lo-
cates the eyes, nose and mouth in the same position
on each full-page bleed, he dispenses with the main
racial differences. Other specific physiognomic charac-
teristics that we think of as defining racial groups,
such as slanting eyes, broad noses, or thin lips, turn
out in Ohara's compendium not to be nearly as impor-
tant as the colour of the skin. Thus Ohara has taken the
utopian step of using the camera to turn humankind
into one big melting pot, his serial photographs mak-
ing almost ritual atonement for the sin of racism.

Ken Ohara **One**
 Tsukiji Shokan Publishing Co. Ltd, Tokyo, 1970
 275 × 222 mm (10¹₂ × 8³₄ in), 500 pp
 Paperback with jacket
 500 b&w photographs
 Jacket text by Hiro

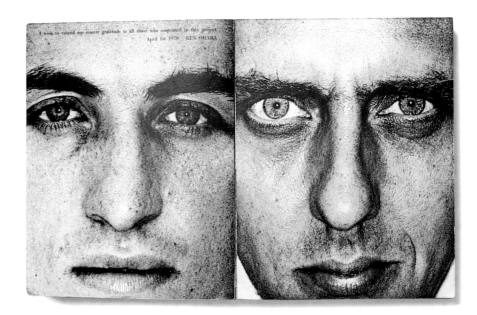

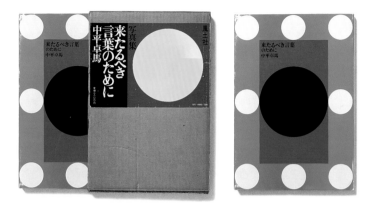

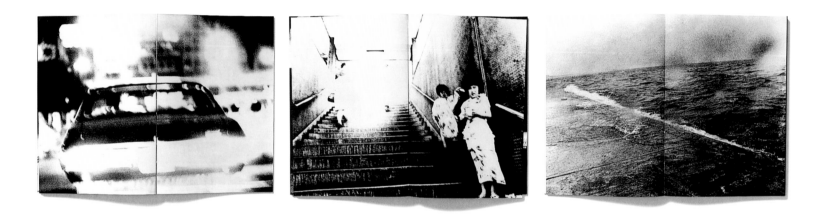

Takuma Nakahira
Kitarubeki Kotoba no Tameni
(For a Language to Come)

Through his photographs and writings Takuma Nakahira was both the chief polemicist for the Provoke group and its political conscience. Along with Moriyama's *Sashin yo Sayonara* (Bye Bye Photography), his book *Kitarubeki Kotoba no Tameni* (For a Language to Come) marks the apogee of the Provoke period. It exhibits all the characteristics of the Provoke style – an unabashed revelling in 'bad' photographic technique, the mannerisms of the New York School pushed to the edge of coherence. These qualities would tend to make the casual reader bracket it with Moriyama's masterpiece, yet a closer look at Nakahira's book – which appeared two years before *Sashin yo Sayonara* – reveals that Nakahira's sensibility is quite different.

Although the more political of the two, Nakahira did not photograph 'political' subjects directly, but utilized a troubled lyricism to express his disaffection with the colonization of Japan by American consumerism. Whereas Moriyama is jumpy and frenetic in tone, Nakahira displays a brooding calm. *Kitarubeki Kotoba no Tameni* closes (unlike some Provoke publications, it reads right to left, in traditional Japanese style) with several shots of the sea, and the book's narrative is punctured at intervals with marine images. Far from suggesting boundless space, this is a dark, bleak and menacing sea, with the consistency of soup, a metaphor for claustrophobia and a narrowing of horizons.

The other overwhelming metaphor in the book is fire, an apocalyptic, post-Hiroshima conflagration, often expressed indirectly in Nakahira's night pictures with swathes of burned-out lens flare. These 'natural' metaphors – water and fire – remind us that this is essentially a 'landscape' book, though a landscape of the mind. The two, however, are inextricably related, and Nakahira, who would himself 'burn out' as a result of alcohol addiction, depicts the burnt-out, shattered urban landscape with little hint of the exhilaration seen in Moriyama's work.

At the book's heart is a pair of almost identical images, stained and scratched by Nakahira, two-thirds of the way through the book. Tyre tracks in sand lead to what may be concrete bunkers on the horizon. In the sky, speckled marks of dark and light, along with scratched lines, suggest the conflagration. These are sad, beautiful pictures of half-light – and half-life. They are quintessential Provoke images, and stand for much postwar Japanese photography prior to the 1980s. Whether we look backwards at or forwards to the conflagration is unclear. The pessimism of Nakahira is not. The new language would seem one of despair rather than hope.

Takuma Nakahira **Kitarubeki Kotoba no Tameni** (For a Language to Come)
Fudo-sha, Tokyo, 1970
300 × 212 mm (11³⁄₄ × 8¹⁄₄ in), 192 pp
Paperback with jacket and card slipcase
103 b&w photographs
Text by Takuma Nakahira

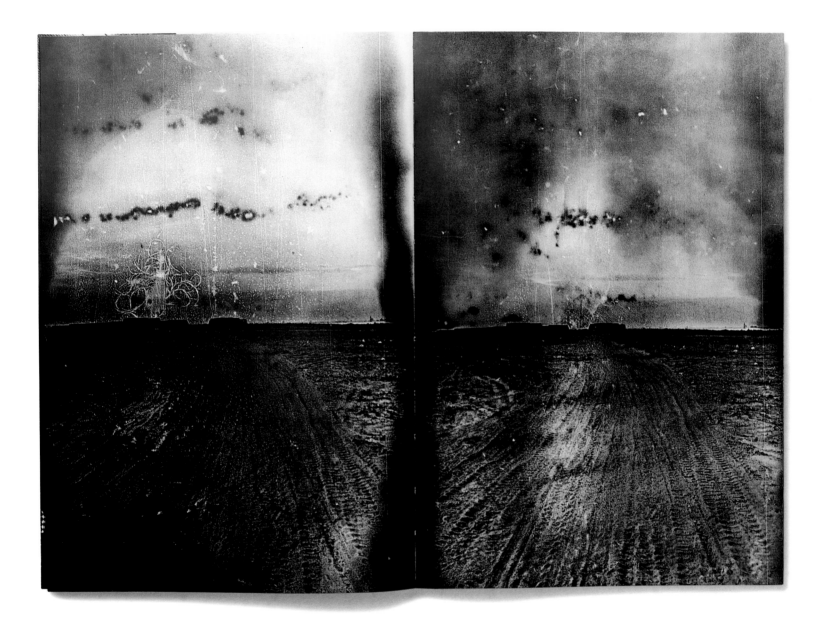

Nobuyoshi Araki
Zerokkusu Shashincho 24
(Xeroxed Photo Album 24)

While not a member of the Provoke group – he worked for the advertising agency Dentsu-a, and was technically therefore, the enemy – Nobuyoshi Araki was a great admirer of Provoke and was broadly in sympathy with its philosophies. Indeed, many of his aesthetic ideas were close to those of Takuma Nakahira. One of Nakahira's most quoted maxims was that photography is not an 'expression' but a 'record', an aphorism that was mirrored by Araki. 'Photography is copying', he said,[11] and to prove it, he made a series of books while still a salaryman, using the office photocopying machine. He produced 25 xeroxed photo albums, each published in an edition of 70, and distributed most of them to friends and colleagues. He also sent some, in a neo-Dadaist gesture, to individuals chosen at random from the telephone directory. As Akihito Yasumi has written, Araki 'decided to take advantage of being inside the establishment and to use guerrilla tactics'.[12] This inappropriate use of company equipment cost him his job (so the story goes), but the most prolific career in photobooks was born from these modest beginnings.

The photocopy books are anything but modest in terms of ambition, however. They number some 25 volumes in all. Repetitive, fragile, and now extremely valuable, the books focus largely on street scenes, portraits, nudes and images taken from television sets, the typical Provoke themes reworked in Araki's inimitable way. These handmade books, which Araki still produces – in colour now, and strictly for himself – at once look backwards to the origins of the photobook and forwards to the digital age, when every photographer with a personal computer has the capacity to produce photobooks at home.

Volume 24 is typical, consisting mainly of candid portraits of individuals taken on the streets – anonymous faces in the crowd. But the book's title explains their significance: these pictures of 70 anonymous Japanese were taken at the Osaka Expo on 15 August 1970, the 25th anniversary of the bombing of Nagasaki, the perennial theme in postwar Japanese photography and the theme for more than one of Araki's photocopy books.

Nobuyoshi Araki **Zerokkusu Shashincho 24 – Nihonjin Nanajyu 15/8/70**
(Xeroxed Photo Album 24 – Seventy Japanese 15/8/70)
Nobuyoshi Araki, Tokyo, 1970
258 × 180 mm (10¼ × 7 in), 140 pp
Paperback with sewn red silk binding
70 b&w photocopies

Nobuyoshi Araki
Senchimentaru na Tabi (A Sentimental Journey)

Nobuyoshi Araki's first published book (brought out privately) remains one of his best, despite the fact that he has now notched up well in excess of 300 publications. Following on from his somewhat ephemeral photocopy books, *Senchimentaru na Tabi* (A Sentimental Journey) states his aesthetic position perfectly, the first manifestation of what he calls the 'I Novel': 'I have begun with the "I Novel" – in my case it will most likely remain the "I Novel" – because I believe that nothing resembles the photograph as much as the "I Novel".'

In a single green page, printed in facsimile handwriting and pasted into the book after it was completed, Araki addresses the reader: 'Dear sir, I can't stand it anymore … I simply can't stand all those anonymous faces, all those naked bodies, all those private lives and scenes that are essentially fake. This book has nothing to do with the fake photographs you find everywhere.'

He makes no claims, he continues, for the veracity of the photographs to follow, for all he has tried to do is to follow the course of his honeymoon. Everything about the tone of this book, however, from its confessional mode to its production, is calculated to persuade the reader that the truth is being told. The book is downbeat, wistful, elegiac. The small pictures, printed one to a page – leading from the wedding portrait on the cover to the first, famous image of Araki's young bride Yoko, looking pensive on the train leading to the honeymoon destination, to the hotel interiors and tourist spots – are almost drained of expression. The tale, just an ordinary story about what ordinary people do on honeymoon, is told in modest grey snapshots, the kind of pictures anyone could make.

Only a sequence where Araki photographs Yoko's face as he makes love to her, and a sudden, prescient image of a single grave, lift the whole out of the ordinary. But that is enough – in the book's simplicity there is great depth of feeling. It functions both as a record of the honeymoon, and as a masterly demonstration of the many ways in which the photograph acts as an incredibly potent memory trace. Although this book derives from the Existential aesthetic of the Provoke group, stylistically it is the antithesis of the expressionistic Provoke style, and declares decisively that Araki has arrived.

Nobuyoshi Araki **Senchimentaru na Tabi** (A Sentimental Journey)
Nobuyoshi Araki, Tokyo, 1971
240 × 240 mm (9¹₂ × 9¹₂ in), 108 pp
Paperback with green printed sheet tipped in later to first page
108 b&w photographs

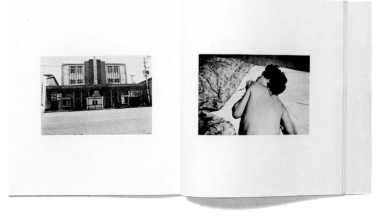

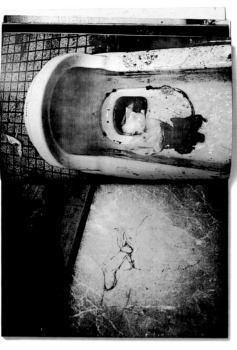

Yoshio Takase **Benjo** (Toilet)
Fukushu-Shudan, Geribara 5
(The Diarrhoea-Shit Reproductive
Collective of 5), Tokyo, 1971
258 × 185 mm (10 × 7¼ in), 104 pp
Paperback
104 b&w photographs

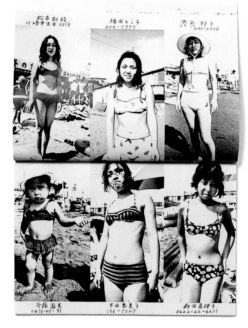

Nobuyoshi Araki, Yoshio Takase, Koji Yaehata, Naohosia **Mizugi no Yangu Redii-Tachi** (Young Ladies in Bathing Suits)
Tabogami, Fukuo Ikeda, Tomoko Kamiguchi ('Miss Geribara') Fukushu-Shudan, Geribara 5 (The Diarrhoea-Shit Reproductive
Collective of 5), Tokyo, 1971
258 × 185 mm (10 × 7¼ in), 102 pp
Paperback
300 b&w photographs

Yoshio Takase
Benjo (Toilet)

Nobuyoshi Araki, Yoshio Takase, Koji Yaehata,
Naohosia Tabogami, Fukuo Ikeda, Tomoko Kamiguchi
('Miss Geribara')
Mizugi no Yangu Redii-Tachi
(Young Ladies in Bathing Suits)

The tendency for photographers to form groups has been a feature of Japanese photography. Following the dissolution of Provoke, another small avant-garde group flourished briefly in the early 1970s. Geribara 5 (The Diarrhoea-Shit Reproductive Collective of 5) published three books that are almost as sought after by collectors as the three issues of *Provoke*, in some measure due to Nobuyoshi Araki's participation in the group. There is some debate over Araki's precise involvement in the three volumes produced – a neo-Dada tendency to dissemble accompanied all the group's activities – but his conceptual influence is clear to all who know his work. Indeed, the third Geribara volume, *Five Girls*, is a lesser version of the kind of book that Araki would make many times in his career.

Much more interesting are the first two books of the trio. The first, *Benjo* (Toilet), is one of those photobooks that startles simply by virtue of its subject-matter. It may be regarded as either a brilliant post-Duchampian exercise in neo-Dada camp, or a schoolboy scatological joke – or both. It might also be an incisive social document. The book is attributed to a single member of Geribara 5, Yoshio Takase, and is a compendium of public toilets in Tokyo. These are not, however, those estimable comfort stations visited every hour by a conscientious cleaning staff, but the filthiest, fly-blown, shit-stained, stinking cess pits containing the crudest, most misogynistic graffiti, and shot in extreme Provoke style.

The second Geribara book, *Mizugi no Yangu Redii-Tachi* (Young Ladies in Bathing Suits), is equally controversial. It is a strictly Conceptual book, each page containing a trio of three-quarter-length portraits of teenage girls on the beach, the majority posing somewhat self-consciously for the camera. The sheer repetitiveness of these bland images tells us much about the homogeneity of teenage culture, but that is not the controversial aspect. Beneath each photograph is the girl's address and telephone number, printed in facsimile handwriting. The inevitable invasion of privacy inherent in the process of taking and publishing pictures is one thing. If the personal details below the photographs were valid,[13] the book raises issues that go beyond imagistic representation into areas verging on abuse or sexual harassment.

Ihei Kimura
Pari (Paris)

Ihei Kimura's *Paris* was photographed during three visits to the city in 1954, 1955 and 1960, although the book was only published in 1974, the year of the photographer's death. A volume that would seem unremarkable in style for that year is not so when one considers that much of it was shot, in colour, in the 1950s. When photographed, it was well ahead of its time, and even its design and production are not quite as conventional as they might seem at first glance.

Paris is notable for two things. Firstly, it has a distinctive colour palette, composed of cool blues, greys, browns and purples. Secondly, there is Kimura's view of the city itself, which teeters between conventional travel photography and something much more original. Kimura did not slavishly follow the Japanese tourist's itinerary, but he was certainly aware of the 'creative' Paris, the Paris of painters, film-makers and photographers such as Brassaï and Doisneau – or Henri Cartier-Bresson, with whom he stayed when he visited the city. It seems that Kimura decided to revisit the clichés and see what he could make of them, having been given a supply of new colour film with which to experiment.

What he appears to have discovered is a residue of Atget's Paris (see page 127), at a time when the work of the French photographer was much less known to the photographic world than it is now. Kimura's Paris, like Atget's, is a nostalgic one, a city of crumbling textures and decaying structures, of courtyards and back alleys, of autumnal mists and winter gloom. Aided by his colour palette, it is a much more romantic vision than Atget's unsentimental view, but his book nevertheless has a distinctive voice that takes him beyond mere romanticism. Kimura's predilection for the patina of neglect is as heartfelt as the Frenchman's. It would seem to come from within rather than without, and his romantic strain is mitigated by a stream-of-consciousness grittiness that may derive from French Existentialism or from the psychological malaise felt by most Japanese so soon after Hiroshima. At times Kimura certainly photographs Paris as if the city were in terminal decay rather than, as so many see it, an open-air museum with some artfully distressed surfaces.

Ihei Kimura **Pari** (Paris)
 Nora-sha, Tokyo, 1974
 262 × 190 mm (10¹⁄₂ × 7¹⁄₄ in), 318 pp
 Hardback with full white linen, card slipcase and 20-pp separate
 booklet (212 × 137 mm; 8¹⁄₂ × 5³⁄₄ in) with texts
 153 colour photographs in double-page spreads, 1 single-page
 colour photograph
 Texts by Sasaki, Koji Taki and Shinji Obkuda

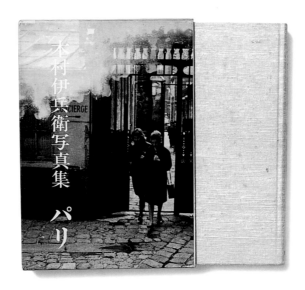

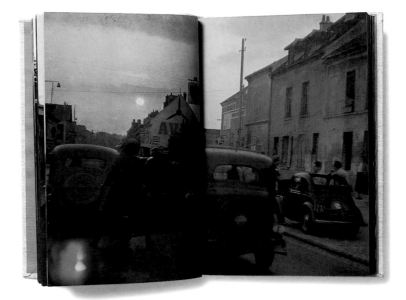

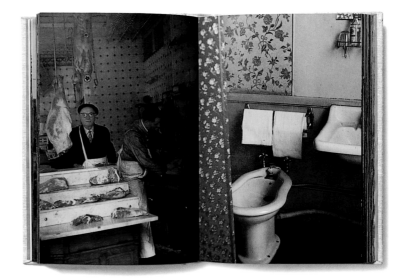

Daido Moriyama
Sashin yo Sayonara (Bye Bye Photography)

Sashin yo Sayonara (Bye Bye Photography) is the most extreme monument of the Provoke period, indeed one of the most extreme photobooks ever published. Daido Moriyama pushes both the form of the photographic sequence and the photograph itself to the limits of legibility, with a brilliant barrage of stream-of-consciousness imagery culled from his own pictures, found photographs – such as shots of car accidents – and images taken from the television set. Any notion of 'good' technique is thrown out of the window. The pictures exhibit all the qualities of reject negatives discarded in the darkroom then retrieved from the bin. The photographic language is one of blur, motion, scratches, light leaks, dust, graininess and stains, like Robert Frank or William Klein on speed.

Moriyama's vision is entirely consistent, and his willingness to be led to the edge of photography's coherence is the photographic equivalent of Surrealist automatic writing by a camera that almost has a mind of its own. 'I wanted to go to the end of photography', he declared,[14] and the book is a summation of the Provoke period. It reads like a jerky hand-held *cinéma vérité* film. The pace is frenetic, the image bombardment never lets up, and we reach the book's end in a state either of breathless exhaustion or on an image-fuelled high. The tone is so ambiguous that it is not clear whether we are experiencing a dream or a nightmare, exhilaration or despair – or both at the same time.

Sashin yo Sayonara is also a key Provoke document because of its text, a debate between Moriyama and

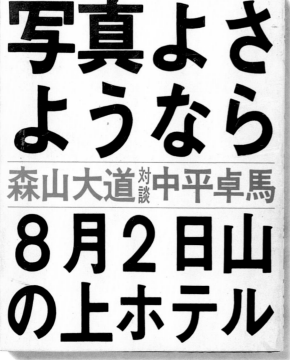

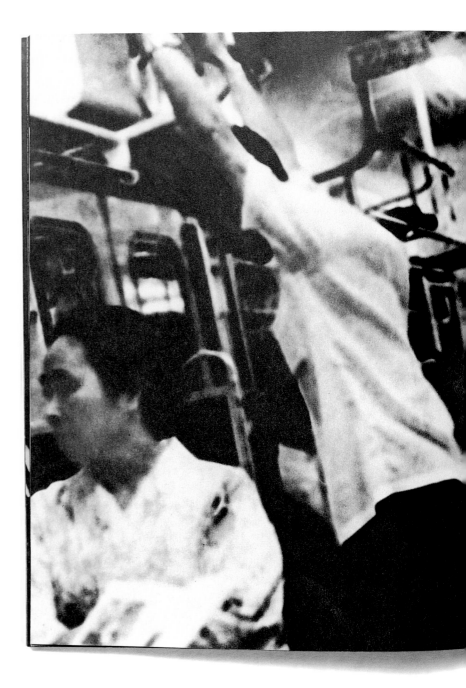

Daido Moriyama **Sashin yo Sayonara** (Bye Bye Photography)
Shashin Hyoron-sha, Tokyo, 1972
230 × 182 mm (9 × 7¼ in), 308 pp
Paperback with jacket
137 b&w double-page photographs
Text is conversation between Daido Moriyama and Takuma Nakahira
at the Yamanoue Hotel on 2 August 1972

Provoke co-founder, Takuma Nakahira. The conversation illustrates the ideological differences between the political and 'non-political' wings of the group. Moriyama, in contrast to the deeply political Nakahira, was interested primarily in distilling raw experience, indeed, in calling into question the meaning of all experience. These are images of nothingness, or rather of a vibrant nihilism – bleak urban vistas and anonymous crowds seen out of the corner of a jaundiced eye, women stalked as if by a voyeur, a blank, glowing television set or wall. But the vision of the 'apolitical' Moriyama, which attempts to go beyond subjectivity and establish a dialectic of anonymity, nevertheless reflects the alienation, the angst, and the love-hate relationship with American materialism felt by the student rebels of the 1960s. As Tadanori Yokoo has said of Moriyama, 'The more he tries to avoid political themes the more political his work seems to become.'[15]

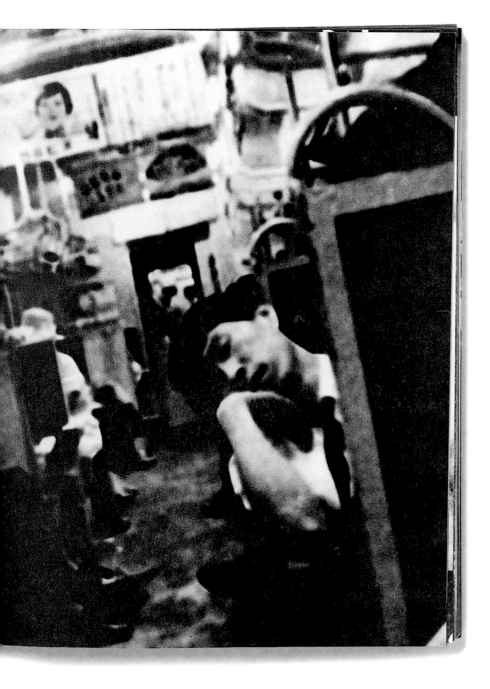

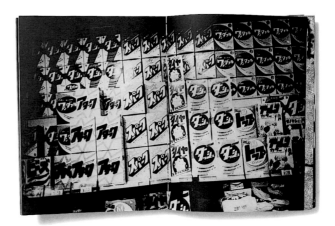

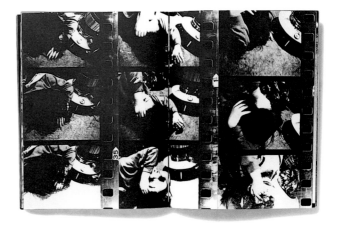

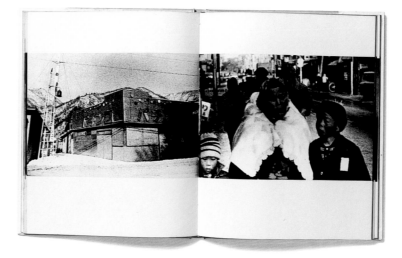

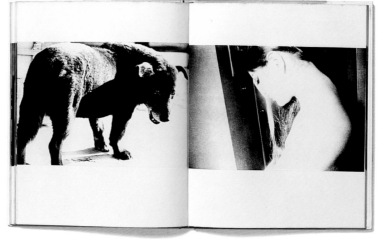

Daido Moriyama **Karyudo** (Hunter)
Chuo Koron-sha, Tokyo, 1972
265 × 220 mm (10¹⁄₂ × 8³⁄₄ in), 120 pp
Hardback with jacket and bellyband
104 b&w photographs
Introduction by Tadanori Yokoo (in English); text by Shoji Yamagishi

Daido Moriyama
Karyudo (Hunter)

The third of Moriyama's great photobooks of the Provoke era was published a few months after *Sashin yo Sayonara*. That book had taken him to the edge. He had become disillusioned with photography and had intended to quit, and although he would later take a long hiatus from the medium, *Karyudo* (Hunter), part of the series '10 Photographers' published by Chuo Koronsha (1972) temporarily pulled him back from the brink. It is not as extreme as *Sashin yo Sayonara*, but shares the same attitudes and indeed some of the same material; in particular, imagery from his *Accidents* series, a Warholian appropriation of found photographs from magazines and television relating to violence and car crashes.

Karyudo is Moriyama's 'road' book. He was a great admirer of Jack Kerouac's *On the Road*, and had been in the habit of travelling intermittently around Japan, shooting out of car windows with little idea of how the resulting images might be used. If his first book explored the notion of life-as-theatre and photography as a theatrical event, and *Sashin yo Sayonara* experimented with the medium's ability to reflect a psychedelic dream state, this book (as its title implies) is about the photographer as voyeur. As Tadanori Yokoo famously writes of Moriyama in one of the book's texts: 'He takes his pictures from the point of view of a Peeping Tom or a rapist. For me they are sex fantasies that arouse my dormant tendencies towards sex crimes. Eyes that see from the windows of a moving car or from the shadows are those of a criminal. His pictures are like

someone who talks without looking people in the eye.' Though Moriyama's *Hunter* pictures certainly have a predatory, detached air, Yokoo is deliberately sensationalist. There is also the existential angst that pervaded *Sashin yo Sayonara*, and which takes us beyond sex and violence, to primal fear, a dread of our eschatological existence. In *Nippon Gekijo Shashincho* (Japan – A Photo Theatre) Moriyama was part of an outsider world, an alternative community. In *Karyudo* he is alone, devoid of community – a perpetual, lonely outsider looking in.

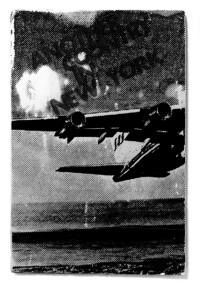

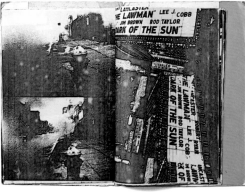

Daido Moriyama **Mo Kuni New York** (Another Country in New York)
Daido Moriyama, Tokyo, 1974
315 × 225 mm (12¹⁄₂ × 8¹⁄₂ in), 32 pp
Paperback with serigraphic wrappers (two variants), stapled
52 b&w photocopies

Daido Moriyama **'71-NY**
PPP Editions, in association with Roth Horowitz LLC,
New York, 2002
235 × 160 mm (9¹⁄₄ × 6¹⁄₄ in), 400 pp
Paperback with jacket and cardboard slipcase (not shown)
210 b&w photographs, plus 14 pp of contact sheets
Interview with Daido Moriyama; essay by Neville Wakefield

Daido Moriyama
Mo Kuni New York (Another Country in New York)

Daido Moriyama
'71-NY

When Daido Moriyama's friend the designer Tadanori Yokoo had a show at the Museum of Modern Art, New York, in 1971, Moriyama 'tagged along' for two months. It was his first trip out of Japan, and he produced a masterpiece of improvised book-making from the images he shot there with his half-frame camera. In 1974, he rented a Tokyo shop and a photocopy machine for 14 days, and produced the copies of the book *Mo Kuni New York* (Another Country in New York) while each customer waited.[16] Every day Moriyama would decide on a slightly different sequence for the images, so that as well as the two different silkscreen covers, there are many slightly varying copies amongst the unknown number he made.

Nearly 30 years later the pictures were published in an elegant, desirable package, printed in rich gravure under the title *'71-NY*. The edition is more formalized, the production more sumptuous, yet this is no nostalgic *hommage* to the halcyon days of Provoke. It is a superb bookwork in its own right, and one with obvious contemporary relevance. And yet there are inevitable differences in the way in which the two presentations use the work. The photocopy methodology inevitably pushed Moriyama's imagery to the limits of coherence, as was the intention. The newer book, while remaining sympathetic to Moriyama's raw tone, shows a mellower Moriyama.

In keeping with the darker edges of his vision, Moriyama's New York isn't exactly a comfortable, bourgeois city. Yet exuberance and vitality effectively counter angst and despair. Although Moriyama was on vacation when he made the pictures, exploring the city of his cultural heroes, Klein, Warhol and Weegee, Yokoo stated that he was edgy during his stay in New York.[17] The pictures certainly have the frenetic pace typical of his work at the time, demonstrating all his visual concerns.

Yutaka Takanashi
Toshi-e (Towards the City)

Toshi-e (Towards the City), by another of the original founders of Provoke, is the last and most luxurious of the group's books. It consists of a main volume containing 62 large photographs, with a gleaming metal disc pasted to the front cover, and a smaller, paper-bound booklet including 54 photographs, housed in a black portfolio box. This striking disc presumably represents the rising sun of Japan, or the rising sun of Japanese capitalism, but any symbolism is ironic, for the work is dark and troubled in tone.

Both aesthetically and spiritually, Yutaka Takanashi's photographs are close to those of Takuma Nakahira.

They share a similar brooding lyricism and, like Nakahira, Takanashi is a landscape photographer at heart, exploring a comparable post-apocalyptic scene. The book's images exhibit the familiar Provoke gestural aesthetic; many of them look as if they were shot out of car windows, either speeding away from or towards the eponymous city, which we may read as Tokyo, or the modern Japan. *Towards the City* is a book about economics, consumption and the inevitable price paid for the economic boom in polluted skies and a land strewn with waste and detritus.

If *Toshi-e* marked the close of the Provoke era, it is perhaps fitting that it did so with the thoughtful pessimism of Takanashi rather than the nihilistic rage of Daido Moriyama. For many Japanese the 1960s had

ended with an acquiescent whimper rather than a revolutionary bang, when Japan ratified the joint security treaty with the United States. The big issue in the 1970s was not so much Americanization as Japan's own economic miracle, and the cost the country paid for unbridled consumerism. Takanashi addresses this complex question with lyrical passion.

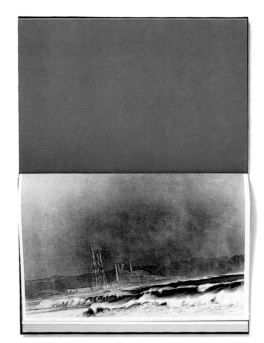

Yutaka Takanashi **Toshi-e** (Towards the City)
Yutaka Takanashi, Tokyo, 1974
426 × 286 mm (16¾ × 11¼ in), 130 pp
Hardback with full black cloth and metal disc, black cloth portfolio box and 126-pp paperback booklet titled 'Tokyo-Jin' (257 × 182 mm; 10 × 7 in)
62 b&w photographs in book, 54 b&w photographs in booklet

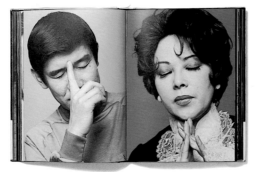
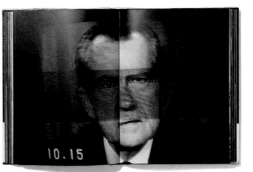

Kishin Shinoyama **Hareta Hi** (A Fine Day)
Heibon-sha, Tokyo, 1975
298 × 225 mm (11½ × 8¾ in), 348 pp
Hardback with full black leatherette, clear
acetate jacket, and slipcase (not shown)
230 colour photographs
Design by Masatsugu Kameumi

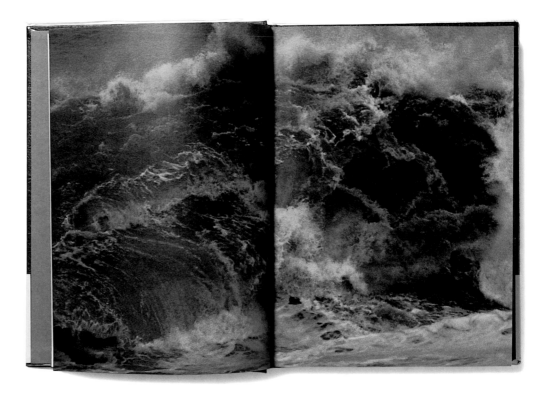

Kishin Shinoyama
Hareta Hi (A Fine Day)

Hareta Hi (A Fine Day) is a fascinating early book by
Kishin Shinoyama, who has become one of Japan's
best-known commercial photographers. It is not only
an early conceptual exercise by a Japanese photo-
grapher, but also one executed completely in colour.
Shinoyama's book consists of 23 photographic se-
quences of around 10 photographs each, which have
little in common with each other at first glance, either
stylistically or in terms of content. They range from stu-
dio portraits of Japanese women to landscapes in which
the weather features prominently, to images of such
figures as Richard Nixon.

The element linking the images turns out to be the
fact that each sequence comments on a different event
that took place in 1974. These events have apparently
been chosen at random, but are of evident significance
to the photographer. Some are relatively trivial, parochial
occurrences, others register much higher on the Richter
Scale of newsworthiness, such as the price of rice in
Japan, or Nixon's resignation as President of the United
States. Other clear linking factors are US–Japanese rela-
tions, and the weather. Reports of hurricanes, typhoons
and tidal waves feature prominently, and the book's
title clearly refers to the understandable Japanese con-
cern with the unpredictability of the natural elements.

Hareta Hi would seem to be about randomness –
the randomness of life itself, of natural disaster and hu-
man accomplishment, even the random nature of the
way in which our knowledge of things is transmitted.
There seems to be no real link between the events
depicted here except that they were chosen. The same
may be said of the photographs themselves. The pri-
mary link between them was not that Shinoyama took
them, but that he included them in this baffling, hyp-
notic book.

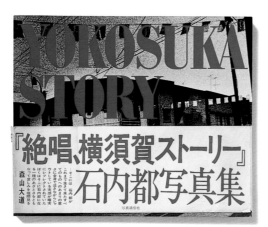

Miyako Ishiuchi **Yokosuka Story**
Sashin Tsushin Co., Tokyo, 1979
235 × 270 mm (9¼ × 10½ in), 106 pp
Paperback with bellyband
107 b&w photographs
Texts by Ken Bloom and Miyako Ishiuchi

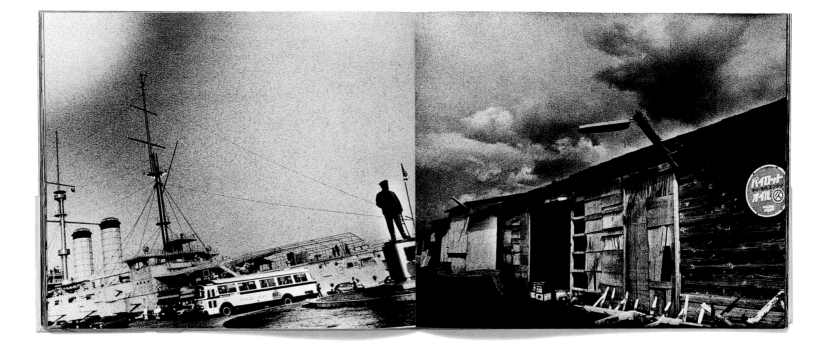

Miyako Ishiuchi
Yokosuka Story

Miyako Ishiuchi has been one of Japan's leading female photographers since the 1970s, known particularly for the trilogy of books she made at the end of that decade, of which *Yokosuka Story* (1979) is the middle one. The others are *Apartment* (1978) and *Endless Night* (1981). In broad terms, the trilogy might be said to be about the spirit of place, but in keeping with the tenor of Provoke, a clear influence here, it is most definitely a troubled spirit with which she deals.

Yokosuka Story documents Ishiuchi's return to the town in which she grew up, the port of Yokosuka on the Miura peninsula facing Tokyo Bay. The Americans built a large naval base in the area, second only in size to its base at Yokohama, an installation that generated a similar mythology of embitterment. Ishiuchi's book documents how, upon her return to the district, she found that the effect of the building of the base – which involved the flattening of mountains – and the stationing of military personnel, had drastically altered both the topography of the area and its social character.

It is a bitter book, clearly demonstrating that the 1960s resentment of American power still existed a decade later, although Ishiuchi also displays the ambivalence the Japanese felt towards the United States. As Ken Bloom writes in his essay for the book: 'On stepping into a room filled with these images wall-to-wall, you are drawn into conflicts between fear and love.' But there is little place for dreamy nostalgia in Ishiuchi's vision. The eloquently shot and presented imagery is harsh and bleak, photographed in the classic Provoke style – wide-angle, high-contrast, grainy, off-kilter. Ishiuchi recounts how she was prevented from shooting freely in the area by both the US military and the Japan Defence Force, and this seems to have fuelled her negative attitude. Her tale is one of insidious and alienating urban destruction.

Seiji Kurata
Flash Up: Street PhotoRandom Tokyo 1975–1979

The tattooed *yakuza* (gangster) pictured on the jacket, strutting his stuff in a loincloth on top of a Tokyo building, samurai sword in hand, indicates that we are in for another tour of the raffish nightspots of Shinjuku. But Seiji Kurata, a student of Daido Moriyama, has a unique photographic voice. *Flash Up*, his first photobook[18] is a notable addition to this iconography, one of the best debut publications since Nobuyoshi Araki's in the 1970s.

The cast is familiar – *yakuza*, strippers, transvestites, Hell's Angels, members of the ultra-nationalist Black Dragon Society, and ordinary punters living life on the edge for an hour or two. The plot, too, is well worn – sex, drinking, gambling and a dash of violence to spice the mix in the form of brawls, gang fights and traffic accidents. Kurata, however, makes telling photographs from this familiar mix. He has an unerring instinct for images that suggest stories. They are highly polished, detailed pictures, full of information, and his pioneering technique, using a medium-format camera, was much copied. His tone is distinct, cooler than Moriyama's similar to Araki's, but focused more on the sociological and less on the sexual, like his contemporary, Keizo Kitajima, who made a similar study of Okinawa nightlife.[19]

Kurata's full-on flash style and choice of subject-matter has evoked easy comparisons with Weegee, but he remains resolutely his own man and, despite that familiar walk down Shinjuku's mean streets, this remains one of Japan's best photobooks of the 1980s.

Seiji Kurata **Flash Up: Street PhotoRandom Tokyo 1975–1979**
Byakuyashobo, Tokyo, 1980
296 × 211 mm (11¾ × 8¼ in), 160 pp
Paperback with jacket, clear acetate outer jacket and bellyband
199 b&w photographs
Texts by Takashi Ueno, Kazuo Nishi and Akira Hasegawa (the last in English); design by Akira Suei

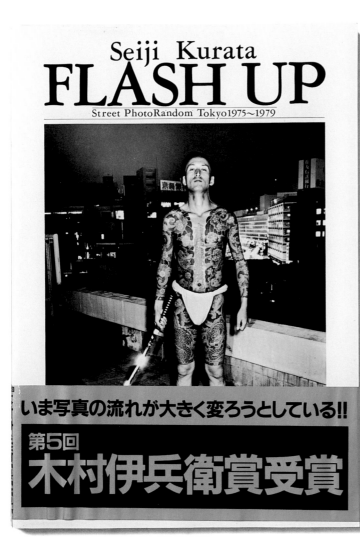

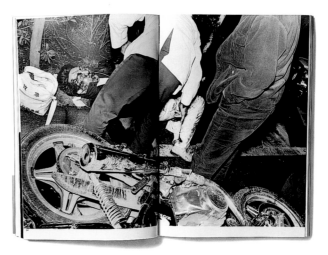

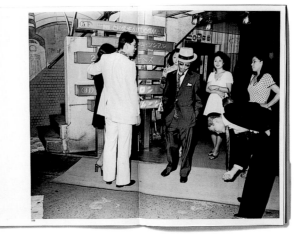

Masahisa Fukase
Karasu (Ravens)

Karasu (Ravens) is arguably the post-Provoke master-piece of Japanese photobooks. A link with Provoke is not wholly inappropriate, since Masahisa Fukase is of that generation, and the photography in *Karasu* is a similar combination of the intensely personal with the metaphorical, another allegory for the state of the country.

The book was generated, however, out of the purely personal: a trip that Fukase made in 1976 to his birth-place, the northern island of Hokkaido, following divorce from his wife of 12 years. Such painful rites of passage inevitably lead to reflection. In Fukase's case, this took the form of shooting pictures from the train window. In many of the photographs flocks of ravens were visible, and these became Fukase's obsessive subject. The

raven is a symbol of ill-omen in Japan as in the West, and its ominous presence became, as in Hitchcock's 1963 film, *The Birds*, a metaphor for unease.

Karasu is a technical as well as an aesthetic tour-de-force. Even though Fukase makes his pictures in bad light and bad weather, never bothering with technical niceties, the results are both luminous and beautiful. He enlarges tiny portions of his negatives, pushing for the limits of legibility. One climactic image of silhouetted birds in formation, wings outstretched against a grainy sky, metamorphoses into a wire news service image of overhead warplanes, a significant, and traumatic image for postwar Japan.

But if *Karasu* is a bitter indictment of the industrialized country, dehumanized and picked over by the natural scavengers of capitalism, the skies heavy with pollution, it is also a superb demonstration of how the

photobook can also deal with the private. This is as vivid a picture of personal depression as has been depicted in photography. In most of the pictures Fukase's contact with fellow human beings is only fleeting and conducted at a distance. But then he visits a masseuse. His image of this naked, ageing woman, her face screwed up in her own silent howl of anguish, pierces the narrative like a knife.

Fukase's cry of despair is perhaps one of the most romantic of photobooks; it stands out because it was made at a time when such romanticism was frowned upon. Its strength is that it works on so many levels – graphically, descriptively, technically, metaphorically. The imagery is beautiful, surprising, haunting, but ultimately it is Fukase's masterly handling of the narrative and rhythm that makes it so memorable.

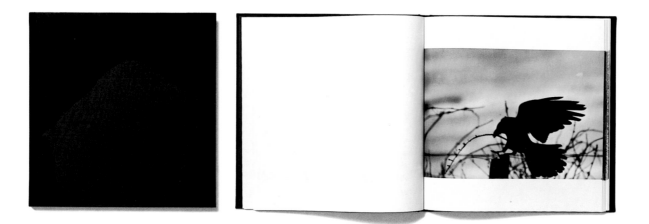

Masahisa Fukase **Karasu** (Ravens)
Sokyu-sha, Tokyo, 1986
264 × 264 mm (10¹⁄₂ × 10¹⁄₂ in), 131 pp
Hardback with full black cloth, glassine and card slipcase
62 b&w photographs
Text by and edited by Akira Hasegawa; design by Kazhyuki Goto

Nobuyoshi Araki
Tokyo Lucky Hole

The subject-matter with which Nobuyoshi Araki is immediately (and notoriously) associated is sex. The majority of his books, whether depicting cityscapes, landscapes, still lifes or cloudscapes frequently also contain nudes, usually women, often bound elaborately with ropes. To some this suggests that Araki is a misogynist, or cynically exploitative. To others it suggests that to him sex is as natural as breathing, eating, or photographing, and that he is simply being honest in featuring the subject that is on most men's minds for most of the time.

Tokyo Lucky Hole is one of Araki's best-known and most controversial books, primarily because a greatly expanded, hardcore version of the work was published by Benedikt Taschen, Cologne, in 1997. The original Japanese version, however, was less pornographic, though still not a book to give Auntie Mabel for Christmas. It documents sex clubs in the Kabuki-cho area of Shinjuku in the early 1980s, which enjoyed a particular era of laissez faire until a crackdown by the city authorities in 1985. Surprisingly, for all his interest in the sexual, Araki has done relatively few projects with sex workers, and this is an exhaustive documentation of the Japanese sex industry, featuring most kinds of staged sex act.

As usual, Araki's view is that of the voracious photographer who cannot stop clicking, even when participating in the 'action' himself. He is the inexhaustible voyeur, sticking his camera into every tawdry nook and cranny. Even more than in his other books, he is gleefully unrestrained, the perpetual tumescent adolescent, a kid in a candy store.

In the original Japanese edition the Japanese censor has had *his* way with Araki. Exposed genitalia are covered in black stickers, which tends to make the book even more prurient or, for those who value the book for its social documentary content, adds an piquant layer of postmodern irony.

Notes

Introduction

1 Beaumont Newhall, *The History of Photography: from 1839 to the Present Day*, Museum of Modern Art, New York, 1978 (4th edition); Helmut and Alison Gernsheim, *A Concise History of Photography*, Thames & Hudson, London, 1965.

2 See Robert Taft, *Photography and the American Scene*, Dover Publications, New York, 1964 (republication of 1938 edition, Macmillan Company, New York); Gisèle Freund, *La photographie en france aux dix-neuvième siècle: essai de sociologie et d'esthétique*, Monnier, Paris, 1936; Walter Benjamin, 'The Work of Art in the Age of Mechanical Reproduction' (1936), in an anthology of his writings, *Illuminations Parts I–VII*, Harcourt Brace Jovanovich, New York, 1968, pp 217–28. In this seminal essay, Benjamin defines photography as a mass medium that will radically change the function of art. He argues that photography subverts an art object's uniqueness, its 'aura', thus hastening politicization. He also notes and appreciates photography's potential to challenge accepted conventions of seeing.

3 In Andrew Roth, ed., *The Book of 101 Books: Seminal Photographic Books of the Twentieth Century*, PPP Editions and Roth Horowitz LLC, New York, 2001, p 3.

4 Ralph Prins, in conversation with Cas Oorthuys in 1969, quoted in Mattie Boom and Rik Suermondt, *Photography Between Covers: The Dutch Documentary Photobook After 1945*, Fragment Uitgeverij, Amsterdam, 1989, p 12.

5 John Gossage, email to authors, 6 August 2002.

6 Lincoln Kirstein, Afterword, in Walker Evans, *American Photographs*, Museum of Modern Art, New York, 1938, p 190.

7 Susan Sontag, *Susan Sontag On Photography*, Farrar, Strauss and Giroux Inc., New York, 1977, pp 134–5. Sontag asks, where is the authorial consistency in the work of the nineteenth-century photographer Eadweard Muybridge? He is known for his landscape photographs of Panama and Yosemite, his studies of clouds, and most notably, for his investigation into human and animal locomotion. While each body of work exhibits stylistic consistencies in itself, there would be nothing, she argues, to connect the Yosemite landscapes with the movement studies if we did not know that they were by the same author. Thus style in photography, she concludes, would seem to be more a by-product of subject matter than considered authorial treatment.

8 Lewis Baltz, quoted by Mark Haworth-Booth, afterword in Lewis Baltz, *San Quentin Point*, Aperture Inc., Millerton, New York, 1986, p 63.

9 Christoph Schifferli, ed., *The Japanese Box*, Edition 7L/Steidl, Paris, 2001. Box containing six Japanese publications, reprinted in facsimile: *Provoke No 1* (1968); *Provoke No 2* (1969); *Provoke No 3* (1969); Takuma Nakahira, *For a Language To Come* (1970); Nobuyoshi Araki, *A Sentimental Journey* (1971); Daido Moriyama, *Bye Bye Photography* (1972).

Chapter 1

1 Allan Porter, 'The Volumes From Lille', in *Camera*, Lucerne, December 1978, p 3.

2 See Larry J Schaaf, *Out of the Shadows: Herschel, Talbot, & the Invention of Photography*, Yale University Press, New Haven and London, 1992, p 66. Weston Naef cites another source for the notion of the photobook. He states that the idea of combining letterpress print with photographs was first mentioned in correspondence between Talbot and the Italian botanist Antonio Bertolini. Talbot sent him samples of calotypes, which the Italian pasted into a blank scrapbook, together with Talbot's letters, extracts from British periodicals relating to the subject, and one or two of his own articles relating to the calotypes. The collage principle central to so many important photobooks was established early, it seems. See Lucien Goldschmidt and Weston J Naef, 'From Illusion to Truth and Back Again', in *The Truthful Lens: A Survey of the Photographically Illustrated Book 1844–1914*, Gollier Club, New York, 1980, p 11.

3 Frederick Scott Archer's wet-plate process of 1851 was the final nail in the coffin for the daguerreotype. Using glass as the support for the light-sensitive coating produced a system that was more light sensitive – and therefore faster. The glass-plate negative eliminated the disadvantages of both daguerreotype and calotype, and in conjunction with the albumen print (see note 13) became the standard negative-print technique for much of the nineteenth century.

4 Beaumont Newhall, op cit, p 33.

5 Joel Snyder, 'Inventing Photography', in Sarah Greenough, Joel Snyder, David Travis and Colin Westerbeck, *On the Art of Fixing a Shadow*, National Gallery of Art, Washington DC and Art Institute of Chicago, 1989, p 14.

6 Unsigned review in *The Atheneum*, London, no 985, 12 September 1846, p 939.

7 *The Atheneum*, London, no 904, 22 February 1845, p 202.

8 *The Atheneum*, no 985, op cit, p 939.

9 Unsigned review in the *Literary Gazette*, London, no 1432, 29 June 1844, p 410.

10 The most notable publications by Hill and Adamson are *A Series of Calotype Views of St Andrews*, published by D O Hill and R Adamson, at their Calotype Studio, Calton Stairs, Edinburgh (1846), and a number of presentation albums entitled *100 Calotype Sketches*. The content of these varies slightly from example to example, but the aim was to present an overview of the duo's work selected by themselves. Thus they may be regarded as the first 'career monographs' by a photographer.

11 Louis-Désiré Blanquart-Evrard's announcement of the establishment of his printing works, quoted in Isabelle Jammes, 'Louis-Désiré Blanquart-Evrard 1802–1872', in *Camera*, Lucerne, December 1978, p 13. For a detailed survey of Blanquart-Evrard's technical innovations and his publishing business, see also Isabelle Jammes, *Blanquart-Evrard et les origines de l'édition photographique française, catalogue raisonné des albums photographiques*

édités, 1851–1855, Librairie Droz, Geneva and Paris, 1981.

12 A salt, or salted-paper print, was made on thin writing paper coated with silver-salt solutions, and printed in contact with a negative in sunlight. Salt prints were generally, though not always, made from paper negatives and are therefore usually characterized by a roughish texture, with some loss of detail, resulting from the fact that the paper fibres of the negative are also incorporated in the final image.

13 The glossy finish imparted by coating the paper with albumen gave an image that sat on the paper rather than in it, enabling photographers to maximize the long tonal scale and precise detail available with the glass-plate negative.

14 A detailed technical survey of the many early photomechanical processes is beyond the remit of this book, but for more information see such volumes as Gordon Baldwin, *Looking at Photographs: A Guide to Technical Terms*, J Paul Getty Museum, Malibu, and British Museum Press, London, 1991; William Crawford, *Keepers of Light*, Morgan & Morgan, New York, 1979.

15 The book was originally issued in parts for purchasers to bind according to their own individual preferences. Atkins intended the complete work to consist of three volumes containing 389 pages of captioned plates and 14 cyanotype title and text pages. The first volume was issued in 12 parts, volumes 2 and 3 complete. The British Library copy (shown here) is complete, with 22 additional plates. Each surviving copy of the book, or parts of the book – around twelve in all – is slightly different, bolstering the argument for the work to be considered as an album rather than as a book, though the same is true of many early published books.

16 Larry J Schaaf, *Sun Gardens: Victorian Photographs by Anna Atkins*, Aperture, New York, in association with Hans P Kraus Inc., New York, 1985, p 8. This is the standard publication of the work of Atkins, and we are indebted to Dr Schaaf's research.

17 See Francis Steegmuller, ed., *Flaubert in Egypt*, Penguin Books, London, 1996, for Flaubert's and, sometimes, Du Camp's account of their journey.

18 Maria Morris Hambourg, ed., 'Extending the Grand Tour', in Maria Morris Hambourg, Pierre Apraxine, Malcolm Daniel, Jeff L Rosenheim, Virginia Heckert, *The Waking Dream: Photography's First Century, Selections from the Gilman Paper Company Collection*, Metropolitan Museum of Art, New York, 1993, p 88.

19 John Murray's books (both published by J Hogarth, London) are *Photographic Views in Agra and Its Vicinity* (1858) and *Picturesque Views in the North Western Provinces of India* (1859).

20 Letter from Tripe, dated 22 July 1856, to F A Murray, Private Secretary to the Governor of Madras, quoted in John Falconer, 'A Passion for Documentation: Architecture and Ethnography', in Vidya Dehejia, *India Through the Lens: Photography 1841–1911*, Freer Gallery of Art/Arthur M Sackler Gallery of Art, Smithsonian Institution, Washington DC, 2000.

21 Tripe's five other books (all 1858) are *Photographic Views of Poodoocottah*; *Photographic Views of Ryakotta and other places in the Salem District*; *Photographic Views of Seringham*; *Photographic Views of Tanjore and Triwady*; *Photographic Views of Tricinopoly*.

22 Félix Teynard, quoted in Kathleen Stewart Howe, 'The Essence of Egypt: The Calotypes of Félix Teynard', in Kathleen Stewart Howe, *Félix Teynard: Calotypes of Egypt: a catalogue raisonné*, Hans P Kraus Jr Inc., 1992, p 133.

23 Charnay named a ruined city near the Guatemalan border Ville Lorillard in honour of his patron.

24 Another edition of Charnay's Mexican buildings, with a shortened text and fewer photographs, was published in 1864: *Le Mexique et ses monuments anciens*, Émil Bondonneau, Paris.

25 Richard Ovenden, *John Thomson (1837–1921) Photographer*, The National Library of Scotland/The Stationery Office Ltd, Edinburgh, 1997, p 77.

26 James Borcoman, *Charles Nègre 1820–1880*, National Gallery of Canada, Ottowa, 1976, p 46.

Chapter 2

1 Alan Fern, 'Documentation, Art, and the Nineteenth-Century Photograph', in Joel Snyder and Doug Munson, eds., *The Documentary Photograph as a Work of Art: American Photographs 1860–1876*, University of Chicago, Chicago, 1976, p 11.

2 Joel Snyder, 'Photographers and Photographs of the Civil War', in Joel Snyder et al, op cit, p 17.

3 Marta Braun, 'The Expanded Present: Photographing Movement', in Ann Thomas, ed., *Beauty of Another Order: Photography in Science*, Yale University Press, New Haven and London, in association with the National Gallery of Canada, Ottawa, 1997, pp 173–4.

4 Peter Hamilton and Roger Hargreaves, *The Beautiful and the Damned: The Creation of Identity in Nineteenth Century Photography*, Lund Humphries/National Portrait Gallery, London, 2001, p 114.

5 Lucien Goldschmidt, 'Tangible Facts, Poetic Interpretation', in Lucien Goldschmidt and Weston J Naef, op cit, p 3.

6 John Szarkowski, in John Szarkowski and Lee Friedlander, *E J Bellocq: Storyville Portraits – Photographs from the New Orleans Red-Light District, circa 1912*, Museum of Modern Art, New York, 1970, p 16.

7 Keith Davis, *George N Barnard; Photographer of Sherman's Campaign*, Hallmark Cards Inc., Kansas City, Missouri, 1990, p 170.

8 Ibid, p 172.

9 For excellent analyses of O'Sullivan's Western survey work and the background to the survey volumes, see Joel Snyder, *American Frontiers: The Photographs of Timothy H O'Sullivan*, Aperture Inc., Millerton, New York, 1981, and Rick Dingus, *The Photographic Artifacts of Timothy O'Sullivan, 1867–1874*, The University of New Mexico Press, Albuquerque, 1982.

10 Brigadier General A A Humphreys, in Lieutenant George M Wheeler, *Report Upon United States Geographical Surveys West of the One Hundredth Meridian* (7 Volumes), US Government Printing Office, Washington DC, 1875–89, *Volume 1 – Geographical Report*, pp 31–32.

11 Volumes of photographs were published to accompany the reports of King and Wheeler, in editions ranging from only one up to 300.

12 John Falconer, 'A Passion for Documentation: Architecture and Ethnography', in Vidya Dehejia, op cit, p 80.

13 In common with many nineteenth-century photobooks, Duchenne's publication could be bought in various editions, with different images pasted in. The specification given here refers to the volume in the British Library.

14 Muybridge was taken aback when, in 1882, Stanford published Muybridge's Palo Alto photographs to illustrate his book *The Horse in Motion*, without mentioning the photographer's name on the title page. He sued for breach of copyright, but lost on the grounds that he been Stanford's employee at the time.

15 The work was available as a bound book or in a portfolio. Individual plates could also be ordered from a catalogue – minimum order 100 plates.

16 *Animal Locomotion*, despite its cost, was moderately successful, but it was the publication of the much cheaper popular versions, with halftone reproductions – *Animals in Motion* and *The Human Figure in Motion* – that made Muybridge's work more widely available.

17 Josef Maria Eder, *History of Photography*, Columbia University Press, New York, 1945.

18 In platinotypes, or platinum prints, iron salts rather than silver-based light-sensitive salts are used. During development they cause a platinum precipitate to form the image. They are characterized by their extremely wide tonal scale, and are much more permanent than silver prints.

19 The Stone volumes could be bought separately but also bound together as a set. We have chosen to feature *Vol I – Festivals, Ceremonies, and Customs* as a separate book, since *Vol II – Parliamentary Scenes and Portraits*, is less interesting.

20 A further cache of royal mummies was found by Victor Loret in 1898, when he discovered the tomb of the XVIIIth Dynasty pharaoh, Amenhotep II, in the Valley of the Kings. Principal remains from both finds are listed in the catalogue.

21 Roland Barthes, *Camera Lucida: Reflections on Photography*, Jonathan Cape, London, 1982, pp 78–9.

Chapter 3

1 Julia Margaret Cameron, letter to Sir John Herschel, 31 December 1864, now in the National Museum of Photography, Film and Television, Bradford.

2 Charles Caffin, quoted in John Szarkowski and Susan Weiley, eds., *Photography Until Now*, Museum of Modern Art, New York, 1989, p 159.

3 In the Charter of Incorporation of the Royal Photographic Society, revised on 12 August 2003, photography is defined as follows – 'photography shall mean the Art or Science of the recording of light or other radiation on any medium on which an image is produced'. The Society still has special-interest members' groups such as Archaeology and Heritage, Imaging Science, Nature and Medical. Similarly, the SFP also continues with an 'art-science' mission

for photography.

4 R Child Bayley, quoted in Nancy Newhall, *P H Emerson: The Fight for Photography as a Fine Art*, Aperture Inc., Millerton, New York, 1975, p 62.

5 H P Robinson, quoted in ibid, p 63.

6 Peter Henry Emerson, *The Death of Naturalistic Photography*, self-published, 1890.

7 Photogravure is a photomechanical printing process evolved by Karl Klic in 1879, although in the 1850s a similar method, known as héliogravure, was developed in France. A copper plate was sandwiched between carbon tissues and then chemically etched to different depths in proportion to the light values in the original print. The etched plate was then printed on a copperplate press.

8 Letter from Emerson to Brassaï, dated September 1933, quoted in Nancy Newhall, op cit, p 133.

9 Letter from Walker Evans to Hans Skolle, 28 June 1929, quoted in John T Hill and Jerry Thompson, *Walker Evans at Work*, Harper and Row, London and New York, 1982, p 24.

10 Mark Haworth-Booth, 'The Dawning of an Age: Chauncey Hare Townshend: Eyewitness', in Mark Haworth-Booth, ed., *The Golden Age of British Photography 1839–1900*, Aperture Inc., Millerton, New York, in association with the Victoria and Albert Museum, London, 1984, p 17.

11 Roy Flukinger, *The Formative Decades: Photography in Great Britain, 1839–1920*, University of Texas Press, Austin, 1985, p 68.

12 Cameron published a second volume of different scenes from *Idylls of the King and Other Poems* in May 1875, then at about the same time, a 'miniature edition' with a slightly different title appeared: *Illustrations by Julia Margaret Cameron of Alfred Tennyson's 'Idylls of the King' and Other Poems*, with 20 reduced prints. See Helmut Gernsheim, *Julia Margaret Cameron: Her Life and Photographic Work*, Aperture Inc., Millerton, New York, 1975.

13 Helmut Gernsheim, op cit, p 83.

14 Ian Jeffrey, 'Peter Henry Emerson: Art and Solitude', in Mark Haworth-Booth, op cit, p 116.

15 The whole enterprise cost some $1.5 million. 500 sets of the pictures were made – 1,500 small gravures, 722 large gravures in each – of which 272 were bound, these being on sale by subscription for $500. For a comprehensive study of the project see Mick Gidley, *Edward S Curtis and the North American Indian, Incorporated*, Cambridge University Press, Cambridge, 1998. The word 'incorporated' in its title indicates its focus: the economic aspect of the venture and what that meant in socio-cultural terms.

16 Curtis, quoted in ibid, p 21.

17 The book was extremely popular, running into several printings and editions. In 1928, the 6th edition (shown here) was revised and enlarged, the number of illustrations being increased from 77 to 100.

18 A bromoil print relies on the hardening of bichromated gelatin upon exposure to light. After exposure, the print is washed in water, which penetrates the paper in proportion to the softness of the gelatin. An oily pigment is then brushed or rolled on, penetrating in inverse proportion to the amount of water

absorbed by the gelatin to produce the image. A gum, or gum bichromate print, is formed of pigment, such as watercolour dyes, suspended in gum Arabic sensitized with potassium bichromate. When exposed to light, this hardens according to the light intensity and is made permanent by washing away the unhardened areas.

19 A silver gelatin, or silver print, is the standard twentieth-century black and white photographic print, consisting of paper coated with silver halides suspended in gelatin. Introduced in 1882, silver prints had virtually replaced albumen prints by 1895.

Chapter 4

1 László Moholy-Nagy, *Malerei Fotographie Film*, Bauhaus Bücher 8, Albert Langen Verlag, Munich, 2nd edition, 1927, p 9.

2 Umberto Boccioni, quoted in Martin Gaylord, 'How the Futurists Got the Picture', *Daily Telegraph*, London, 24 January 2003.

3 Margit Rowell, 'Constructivist Book Design: Shaping the Proletarian Conscience', in *The Russian Avant-Garde Book 1910–1934*, Museum of Modern Art, New York, 2002, p 61.

4 The practice of combining photographs or cutting them up and pasting them together into new composite images can be called either photomontage or photocollage. The French modernists tended to call the technique 'collage' (from the French word for glue), the Germans and Soviets preferred the term 'montage', after the cinema technique and the German word *montieren* (to assemble), both of them clear references to Constructivism.

5 The Berlin Dadaists, such as Raoul Hausmann, claimed that Russians like Gustav Klutsis 'stole' the photomontage idea from them, but the recent dating of some of Klutsis's montages to 1919 or earlier suggest that, although there were close links between Russia and Germany at the time, the whole idea was 'in the wind', so to speak.

6 Quoted in John Willett, *The New Sobriety, 1917–1933: Art and Politics in the Weimar Republic*, Thames & Hudson, London, 1978, p 76.

7 Solarization is a partial reversal of tones caused by re-exposure to light during the development of film or paper.

8 Maria Morris Hambourg, 'From 291 to the Museum of Modern Art', in Maria Morris Hambourg and Christopher Phillips, *The New Vision: Photography Between the World Wars. Ford Motor Company Collection at the Metropolitan Museum of Art*, Metropolitan Museum of Art/Harry N Abrams Inc., New York, 1989, p 58.

9 Christopher Phillips, 'Resurrecting Vision: The New Photography in Europe Between the Wars', in *The New Vision*, op cit, p 67.

10 Walker Evans, *On Photographic Quality*, from Louis Kronenberger, ed., *Quality: Its Image in the Arts*, Atheneum, New York, 1969, p 165.

11 The differences between the first and second editions are mainly textual, but are also pictorial. Moholy-Nagy expanded his text, adding six pages to the book. The typographical design was altered slightly, and some illustrations changed. More visibly, the spelling of the title was changed, from *Malerei Photographie Film* to *Malerei*

Fotographie Film.

12 See Kim Sichel, *Germaine Krull: Photographer of Modernity*, MIT Press, Cambridge, Mass., 1999, for a discussion of the gestation and reception of *Métal*.

13 Alfred Döblin, Introduction to August Sander, *Antlitz der Zeit: Sechzig Aufnahmen deutscher Menschen des 20. Jahrhunderts*, Verlag Ernst Wasmuth AG, Berlin, 1928, p 18.

14 Walker Evans, 'The Reappearance of Photography', in *Hound and Horn*, Concord, New Haven, Connecticut, Vol 5, October–December 1931, p 126.

15 Štyrský made 12 collages in all, 10 of which (in the form of copy prints) were included in the standard edition, and 11 (but not the same extra image) in the slightly larger deluxe edition. Copies 1 to 10 are deluxe, and 11 to 69 are standard. Adam Boxer of the Ubu Gallery in New York, who owned most of the collages and is the leading expert on the book, points out that since they were handmade, there are variations, even between the standard copies. He estimates that, at most, there are around 20 surviving copies.

16 Jindřich Štyrský, quoted in Vladimír Birgus and Jan Mlčoch, *The Nude in Czech Photography*, KANT, Prague, 2001, p 31.

17 Translated by Margaret Walters.

18 Interview between Peter Webb and Hans Bellmer held in Paris on 15 January 1972, quoted in Peter Webb, *The Erotic Arts*, Secker and Warburg, London, 1975, p 370.

19 Robert Stuart Short, in *Eros and Surrealism*, in Peter Webb, op cit, p 256.

20 Le Comte de Lautréamont (Isidore Ducasse), *Les Chants de maldoror*, trans. Alexis Lykiard, Allison and Busby, London, 1970, p 177.

21 Herbert Molderings, 'Photography as Consolation', in Philippe Sers, ed., *Man Ray Photographs*, Thames & Hudson, London, 1982, p 15.

22 See Arturo Garmendia, *La Mancha de sangre: Un clásico recuperado*, in *Dicine*, no 63, Mexico City, July–August 1995, pp 13–16.

23 John Szarkowski, *Walker Evans*, Museum of Modern Art, New York, 1972, p 20.

24 Walker Evans, 'On Photographic Quality', in Louis Kronenberger, ed., *Quality: Its Image in the Arts*, Atheneum, New York, 1969, p 165.

Chapter 5

1 Anne Wilkes Tucker, 'Photographic Facts and Thirties America', in David Featherstone, ed., *Observations: Essays on Documentary Photography*, The Friends of Photography, Carmel, California, 1984, p 41.

2 John Grierson, quoted in Introduction to Forsyth Hardy, ed., *Grierson on Documentary*, Harcourt, Brace and Company, New York, 1947, p 4.

3 Richard Griffiths, 'The Film Faces Facts', in *Survey Graphics 27*, no 12, New York, December 1938, p 259.

4 Quoted in William Stott, *Documentary Expression and Thirties America*, Oxford University Press, Oxford and London, 1973, p 130.

5 Ibid.

6 Walker Evans, 'On Photographic Quality', op cit, p 170.

7 Lincoln Kirstein, Afterword to Walker Evans, *American Photographs*, op cit, p 189.

8 Maria Morris Hambourg, 'From 291 to the

Museum of Modern Art', in Maria Morris Hambourg and Christopher Phillips, *The New Vision: Photography Between the World Wars. Ford Motor Company Collection at the Metropolitan Museum of Art*, Metropolitan Museum of Art/Harry N Abrams Inc., New York, 1989, p 57.

9 Over 12 books using images drawn from the FSA files were published in the era. Herman C Nixon's *Forty Acres and Steel Mules* (1938), and Richard Wright's *Twelve Million Black Voices: A Folk History of the Negro in the United States* (1941), make significant use of government photographic archives.

10 Daile Kaplan, quoted in Alan Trachtenberg, *Reading American Photographs: Images as History, Mathew Brady to Walker Evans*, Hill & Wang, New York, 1989, p 198.

11 Robert Adams, 'Photographing Evil', in Robert Adams, *Beauty in Photography: Essays in Defense of Traditional Values*, Aperture Inc., Millerton, New York, 1981, p 74

12 See Alan Trachtenberg, 'Camera Work/Social Work', in Alan Trachtenberg, op cit, pp 164–230, for a detailed development of this argument regarding Hine's early pictures and his later *Men at Work* series

13 Bertolt Brecht, quoted in Susan Sontag, op cit, p 23

14 Paul Strand, 'An American Exodus by Dorothea Lange and Paul S Taylor: Reviewed by Paul Strand', in *Photo Notes*, New York, March–April 1940, p 2

15 Ibid.

16 Sander's great work has now been published much as he envisaged it, in a seven-volume set with 619 illustrations. See August Sander, *Menschen des 20. Jahrhunderts*, Schirmer Mosel, Munich, 2001.

17 Franz W Seivert, quoted in Klaus Honnef, Rolf Sachsee and Karin Thomas, eds., *German Photography 1870–1970: Power of a Medium*, DuMont Verlag, Cologne, 1997, p 17.

18 Max Kozloff, 'Abandoned and Seductive: Atget's Streets', in *Afterimage*, Rochester, New York, Vol 13, no 9, April 1986, p 17.

19 Berenice Abbott, *The World of Atget*, Horizon Press Inc., New York, 1964.

20 Walker Evans, 'The Reappearance of Photography', in *Hound and Horn*, Concord, New Haven, Connecticut, Vol 5, October–December 1931, p 126.

21 See Alain Sayag, 'The Expression of Authenticity', in Alain Sayag and Annick Lionel-Marie, eds., *Brassaï: No Ordinary Eyes*, Centre Georges Pompidou/Editions du Seuil, Paris and Thames & Hudson, London, 2000, p 24. Brassaï had contracted with an underwear manufacturer called Vidal to publish a book called *Intimate Paris*, with a text by Pierre MacOrlan, as a companion volume to *Paris by Night*. But Vidal apparently prevaricated, then brought out the 48-page *Voluptés de paris* in 1932, of which Brassaï never acknowledged authorship. Thus the 'secret' pictures published in 1976 were not as 'unknown' as that book claimed.

22 David Mellor, 'Brandt's Phantasms', in Mark Haworth-Booth and David Mellor, *Bill Brandt: Behind the Camera*, Phaidon Press, Oxford, 1985, p 71.

23 See, for example, William Stott in *Documentary Expression and Thirties America*, op cit, who is especially vituperative about Caldwell and Bourke-White, particularly in comparison with James Agee, lauded for his objective and sober approach (sic) to the problem of the documentary form.

Chapter 6

1 Stephen F Cohen, preface to David King, *The Commissar Vanishes: The Falsification of Photographs and Art in Stalin's Russia*, Canongate, Edinburgh, 1997, p 7.

2 Sidney I Landau, ed., *Cambridge Dictionary of American English*, Cambridge University Press, Cambridge, 1999.

3 Margarita Tupitsyn, 'Back to Moscow', in Margarita Tupitsyn, *El Lissitsky: Beyond the Abstract Cabinet, Photography, Design, Collaboration*, Yale University Press, New Haven, Connecticut and London, 1999, p 44.

4 El Lissitsky (1932), quoted in Margarita Tupitsyn, op cit, p 43.

5 Peter Reichel, *Images of the National Socialist State: Images of Power – Power of Images*, in Klaus Honnef, Rolf Sachsee and Karin Thomas, eds., *German Photography 1870–1970: Power of a Medium*, DuMont Verlag, Cologne, 1997, p 68.

6 Ibid, p 72.

7 In 1933 both *AIZ* and John Heartfield decamped to Prague, where the publication continued for a time.

8 See Margarita Tupitsyn, *The Soviet Photograph 1924–1937*, Yale University Press, New Haven, Connecticut and London, 1996, pp 58–60, for a discussion of the design of the Soviet Union Pavilion at PRESSA. See also her *El Lissitsky: Beyond the Abstract Cabinet*, op cit, for more on El Lissitsky and PRESSA.

9 Margarita Tupitsyn, *The Soviet Photograph*, ibid, p 130.

10 David King, *The Commissar Vanishes*, op cit, p 126.

11 For a detailed discussion of the genesis of this particular book, see Margarita Tupitsyn, *El Lissitsky: Beyond the Abstract Cabinet*, op cit, pp 46–50. She argues that through the 'Westernized' representations in this book, Sophie Küppers acted out feelings of longing for the life she had led in the West.

Chapter 7

1 Helmut and Alison Gernsheim, *A Concise History of Photography*, Thames & Hudson, London, 1965, p 289.

2 Rik Suermondt, 'From Documentary Picture-Book to Artist's Book', in Mattie Boom and Rik Suermondt, *Photography Between Covers: The Dutch Documentary Photobook After 1945*, Fragment Uitgeverij, Amsterdam, 1989, p 33.

3 John Szarkowski, *Looking at Photographs, 100 Pictures from the Collection of the Museum of Modern Art*, Museum of Modern Art, New York, 1973, p 120.

4 The pictures of down-and-outs, seen briefly when the hero shows his maquette to his agent, were actually by Don McCullin, who would go on to excel in another area in which British photographers became pre-eminent – war photography.

5 William Klein, in conversation with the authors, Paris, 14 November 2003.

6 David Mellor, in Mark Haworth-Booth and David Mellor, *Bill Brandt: Behind the Camera*, Phaidon Press, Oxford, 1985, p 84.

7 Ibid, p 85.

8 Paul Strand, quoted in Calvin Tomkins, 'Profile', in *Paul Strand: Sixty Years of Photographs*, Aperture Inc., Millerton, New York, 1976, p 32.

9 Alan Trachtenberg, introduction in Maren Stange, ed., *Paul Strand: Essays on his Life and Work*, Aperture Foundation Inc., New York, 1990, p 6.

10 Reynolds Price, 'The Family: Luzzara, Italy, 1953', in Strand, *Essays*, op cit, p 258.

11 There is no English equivalent for this title.

Chapter 8

1 Max Kozloff, 'William Klein and the Radioactive Fifties', in Max Kozloff, *The Privileged Eye: Essays on Photography*, University of New Mexico Press, Albuquerque, 1987, p 47.

2 Norman Mailer, 'The White Negro: Superficial Reflections on the Hipster', reprinted in *Advertisements for Myself*, André Deutsch, London, 1961, p 301.

3 William B Scott and Peter M Rutkoff, *New York Modern: The Arts and the City*, John Hopkins University Press, Baltimore and London, 1999, p 337.

4 William Klein, in conversation with Martin Parr, 28 July 2003.

5 Walker Evans, in *US Camera 1958*, New York, np.

6 'Toward a Social Landscape', organized by Nathan Lyons, and featuring work by Garry Winogrand, Lee Friedlander, Duane Michals, Danny Lyon and Bruce Davidson, opened at George Eastman House, Rochester, New York, in December 1966. This followed an exhibition earlier that year at the Rose Art Museum, Brandeis University, curated by Thomas Garver – the show that coined the term 'social landscapist' – 'Twelve Photographers of the Social Landscape'.

7 John Szarkowski, wall label for 'New Documents'. The exhibition ran at the Museum of Modern Art, New York, from 28 February until 7 May 1967.

8 Stephen Shore's 1972 work was eventually published in 1999 by Schirmer Mosel, Munich, as *American Surfaces 1972*, Schirmer/Mosel, Munich, and Die Photographische Sammlung, Cologne, 1999. See Volume II.

9 Walker Evans, *Hound and Horn*, op cit, p 126.

10 Garry Winogrand, quoted in John Szarkowski, *Winogrand: Figments from the Real World*, Museum of Modern Art, New York, 1988, p 34.

11 Kerry William Purcell, *Alexey Brodovitch*, Phaidon Press, London, 2002, p 132.

12 Van der Elsken's 'story' was run in serial form in *Picture Post*, London, over four issues during February 1954. *Why Did Roberto Leave Paris?* (Part One), 6 February 1954, pp 14–17; *Paris is the City of Jealousy* (Part Two), 13 February 1954, pp 32–357; *The Call of the Sea* (Part Three), 20 February 1954, pp 37–9; *Paris is No Mother* (Part Four), 27 February 1954, pp 38–40.

13 Whitney Balliett, *The Sound of Surprise*, E P Dutton Inc., New York, 1959.

14 John Szarkowski, *Looking at Photographs: 100 Pictures from the Collection of the Museum of Modern Art*, Museum of Modern Art, New York, 1973, p 176.

15 Tod Papageorge, *Walker Evans and Robert Frank: An Essay on Influence*, Yale University Art Gallery, New Haven, Connecticut, 1981, p 8.

16 See James Brustein, 'Everybody Knows My Name', in *The New York Review of Books*, New York, Vol 3, no 9, 17 December 1964; Truman Capote, 'Avedon's Reality', in *The New York Review of Books*, New York, Vol 3, no 12, 28 January 1965. Theatre critic Brustein's vituperative review of *Nothing Personal* was answered a month later by an equally vituperative letter in Avedon's defence by Truman Capote.

17 Garry Winogrand, quoted in Dennis Longwell, ed., 'Monkeys Make the Problem More Difficult: A Collective Interview with Garry Winogrand', in *Image*, Rochester, New York, Vol 15, no 2, July 1972, p 4.

18 The exhibitions were 'Twelve Photographers of the American Social Landscape', Rose Art Museum, Brandeis University, 1966, curated by Thomas Garver, and 'Toward a Social Landscape', George Eastman House, Rochester, New York, 1966, curated by Nathan Lyons.

19 Nathan Lyons, introduction to *Contemporary Photographers: Toward a Social Landscape*, Horizon Press Inc., New York, in collaboration with George Eastman House, Rochester, New York, 1966, np.

20 Martha Rosler, 'Lee Friedlander's Guarded Strategies', in *Artforum*, New York, Vol 13, no 8, April 1975, p 47.

21 The other two in Yugensha's trio are Jun Moringa's *River* (1980), and Frank's *Flower Is* (1987).

22 Walter Hopps, 'Eggleston's World', in Gunilla Knappe, ed., *William Eggleston*, Hasselblad Centre, Göteberg, 1999, np.

Chapter 9

1 Koji Taki, essay in Koji Taki and Takuma Nakahira, eds., *Mazu Tashikarashisa No Sekai O Sutero* (First Abandon the World of Certainty), Tabata Shoten, Tokyo, 1970, quoted, with translation by Linda Hoaglund, in Andrew Roth, *Provoke*, Roth Horowitz LLC, New York, 1999, catalogue of exhibition held at the Roth Horowitz Gallery, New York, 23 September – 23 October 1999.

2 Alexandra Munroe, 'Postwar Japanese Photography and the Pursuit of Consciousness', in Sandra S Phillips, Alexandra Munroe and Daido Moriyama, *Daido Moriyama: Stray Dog*, San Francisco Museum of Modern Art/Distributed Art Publishers, New York, 1999, p 33.

3 Takuma Nakahira, quoted in Akihito Yasumi, 'Journey to the Limits of Photography: The Heyday of Provoke 1964–1973', booklet in Christoph Schifferli, ed., *The Japanese Box*, Edition 7L/Steidl, Paris, 2001, p 12.

4 Koji Taki and Takuma Nakahira, 'The Provoke Manifesto', in Koji Taki, Takuma Nakahira, Yutaka Takanashi and Takahiko Okada, *Provoke No 1*, Provoke-sha, Tokyo, 1968, p 1 (translated by Nabuko Kobayashi).

5 Shomei Tomatsu, quoted in 'The Provoke Era: Turning Point in Japanese Photography', *Déjà-vu*, 931010, no 14, Tokyo, 1993, p 150.

6 Nobuyoshi Araki, quoted in ibid.

7 See Daido Moriyama, *Shinjuku*, Nazraeli Press, Tucson, in association with Getsuyoshi/Yutaka Kambayashi, Tokyo, 2002, and Daido Moriyama, *'71-NY*, PPP Editions, in association with Roth Horowitz LLC, New York, 2002.

8 Nagisa Oshima, 'Yukio Mishima, The Road

to Defeat of One Lacking in Political
Sense', reprinted in Nagisa Oshima,
*Cinema, Censorship and the State: The
Writings of Nagisa Oshima*, MIT Press,
Cambridge, Mass., 1992, ed., Annette
Michelson, trans. Dawn Lawson, p 225.

9 Mark Holborn, 'Junin-No-Me', in *Black Sun:
The Eyes of Four, Roots and Innovation in
Japanese Photography*, Aperture Inc.,
Millerton, New York, 1986, p 16.

10 Daido Moriyama, letter to Sandra S Phillips
(undated 1998), quoted in Alexandra
Munroe, 'Postwar Japanese Photography
and the Pursuit of Consciousness', in
Sandra S Phillips, Alexandra Munroe and
Daido Moriyama, op cit, p 32.

11 Nobuyoshi Araki, quoted in Akihito Yasumi,
'Journey to the Limits of Photography: The
Heyday of Provoke 1964–1973', booklet in
Christoph Schifferli, op cit, p 17.

12 Akihito Yasumi, ibid.

13 In a conversation with Martin Parr in Tokyo
in August 2003, Araki indicated that
approximately half of the telephone numbers
were real, whilst the rest were fictional.

14 Daido Moriyama, *Inu No Kioku* (A Dog's
Memory), Asahi Shimbunsha, Tokyo, 1984,
quoted in 'Journey to the Limits of
Photography: The Heyday of Provoke
1964–1973', booklet in Christoph Schifferli,
op cit, p 20.

15 Tadanori Yokoo, 'A Cowering Eye', in Daido
Moriyama, *Karyudo* (Hunter), Chuo Koron-
sha, Tokyo, 1972, np.

16 See Daido Moriyama, quoted in *'71-NY*, op
cit, np.

17 Tadanori Yokoo, 'A Cowering Eye', in Daido
Moriyama, *Karyudo* (Hunter), op cit.

18 Some of the work in *Flash Up* was
published as a 'prepublication', as no 8
in the WorkShop series of publications on
contemporary Japanese photography by the
PhotoWorkShop Photography School,
Tokyo, in 1976.

19 Keizo Kitajima, *Okinawa I – IV*, Keizo
Kitajima, Tokyo, 1980.

Select Bibliography

General Histories of Photography

Michel François Braive, *Era of the
Photograph: A Social History*, trans. David
Britt, Thames & Hudson, London, 1966

Josef Maria Eder, *History of Photography*,
Columbia University Press, New York, 1945

Michel Frizot, ed., *A New History of
Photography*, Könemann, Cologne, 1998

Helmut and Alison Gernsheim, *A Concise
History of Photography*, Thames &
Hudson, London, 1965

Helmut and Alison Gernsheim, *The History of
Photography from the Camera Obscura to
the Beginning of the Modern Era*, Thames
& Hudson, London, 1969

Sarah Greenough, Joel Snyder, David Travis and
Colin Westerbeck, *On the Art of Fixing a
Shadow*, National Gallery of Art, Washington
DC, and Art Institute of Chicago, 1989

Ian Jeffrey, *Photography: A Concise History*,
Thames & Hudson, London and New York,
1981

The Photography Book, Phaidon Press,
London, 1997

Naomi Rosenblum, *A World History of
Photography*, Abbeville Press, New York,
1987 (revised edition)

Naomi Rosenblum, *A History of Women
Photographers*, Abbeville Press, London
and Paris, 1994

Robert Sobieszak, *Color as Form: A History of
Color Photography*, International Museum
of Photography at George Eastman House,
Rochester, 1982

John Szarkowski, *Photography Until Now*,
Museum of Modern Art, New York, 1989

Books on Photobooks, Magazines and
Artists' Bookworks

Carol Armstrong, *Scenes in a Library: Reading
the Photograph in the Book, 1843–1875*,
MIT Press, Cambridge, Mass., 1998

Mattie Boom and Rik Suermondt,
*Photography Between Covers: The Dutch
Documentary Photobook After 1945*,
Fragment Uitgeverij, Amsterdam, 1989

Stephen Bury, *Artists' Books: The Book as a
Work of Art, 1963–1995*, Scolar Press,
Aldershot, 1995

Riva Castleman, *A Century of Artists' Books*,
Museum of Modern Art, New York, 1994

Harold Evans, *Pictures on a Page: Photo-
Journalism, Graphics and Picture Editing*,
Heinemann, London, 1978

Helmut Gernsheim, *Incunabula of British
Photographic Literature 1839–1875*, Scolar
Press, London and Berkeley, 1984

Lucien Goldschmidt and Weston J Naef, *The
Truthful Lens: A Survey of the
Photographically Illustrated Book
1844–1914*, Gollier Club, New York, 1980

Horacio Fernández, *Fotografía Pública:
Photography in Print 1919–1939*, Museo
Nacional Centro de Arte Reina Sofía,
Madrid, 1999

Steven Heller, *Merz to Emigré and Beyond:
Progressive Magazine Design of the
Twentieth Century*, Phaidon Press,
London, 2003

Kathleen S Howe and Catherine H Roehrig,
*Félix Teynard: Calotypes of Egypt: a
catalogue raisonné*, Hans P Kraus Inc.,
New York, Robert Hershkowitz Ltd, London
and the Weston Gallery Inc., Carmel, 1992

Isabelle Jammes, *Blanquart-Evrard et les
origines de l'édition photographique
française, catalogue raisonné des albums
photographiques édités, 1851–1855*,
Librairie Droz, Geneva and Paris, 1981

Cornelia Lauf and Clive Phillpot, *Artist/Author:
Contemporary Artists' Books*, DAP, New
York, 1998

Robert Lebeck and Bodo von Dewitz, *Kiosk:
A History of Photojournalism*, Steidl,
Göttingen, 2001

Sabine Röder, ed., *Sand in der Vaseline:
Kunstlerbuch II, 1980–2002*, Walter König,
Cologne, 2002

Andrew Roth, *Provoke*, Roth Horowitz LLC,
New York, 1999

Andrew Roth, ed., *The Book of 101 Books:
Seminal Photographic Books of the
Twentieth Century*, PPP Editions and Roth
Horowitz LLC, New York, 2001

Margit Rowell, *The Russian Avant-Garde Book
1910–1934*, Museum of Modern Art, New
York, 2002

Larry J Schaaf, *Sun Gardens: Victorian
Photographs by Anna Atkins*, Aperture,
New York, in association with Hans P
Kraus Inc., New York, 1985

Specialist Publications

Jaroslav Andel, Anne Wilkes Tucker, Alison
de Lima Greene, Ralph McKay and Willis
Harthorn, *Czech Modernism, 1900–1945*,
Museum of Fine Arts, Houston, 1989

Ken Baynes, ed., *Scoop, Scandal and Strife:
A Study of Photography in Newspapers*,
Lund Humphries, Bradford and London, 1971

David Campany, ed., *Art and Photography:
Themes and Movements*, Phaidon Press,
London, 2003

Keith F Davis, *An American Century of
Photography: From Dry-Plate to Digital*,
Hallmark Cards Inc., in association with
Harry N Abrams Inc., New York, 1999
(revised edition)

Vidya Dehejia, ed., *India Through the Lens:
Photography 1841–1911*, Freer Gallery of
Art and the Arthur M Sackler Gallery,
Washington DC, in association with Mapin
Publishing, Ahmedabad and Prestel,
Munich, 2000

Gisèle Freund, *La photographie en France aux
dix-neuvième siècle: Essai de sociologie et
d'esthétique*, Monnier, Paris, 1936

Helmut Gernsheim, *The Origins of Photography*,
Thames & Hudson, London, 1982

Helmut Gernsheim, *The Rise of Photography*,
Thames & Hudson, London, 1988

Jonathan Green, *American Photography:
A Critical History, 1945 to the Present*,
Harry N Abrams Inc., New York, 1984

Andy Grunberg and Kathleen McCarthy Gauss,
*Photography and Art: Interactions Since
1945*, Abbeville Press, New York, 1987

Maria Morris Hambourg and Christopher
Phillips, *The New Vision: Photography
Between the World Wars. Ford Motor
Company Collection at the Metropolitan
Museum of Art*, Metropolitan Museum of
Art/Harry N Abrams Inc., New York, 1989

Peter Hamilton and Roger Hargreaves, *The
Beautiful and the Damned: The Creation of
Identity in Nineteenth Century Photography*,
Lund Humphries/National Portrait Gallery,
London, 2001

Mark Haworth-Booth, ed., *The Golden Age of
British Photography 1839–1900*, Aperture
Inc., Millerton, New York, in association
with the Victoria and Albert Museum,
London, 1984

Mark Haworth-Booth, *Photography, An
Independent Art*, Victoria and Albert
Museum, London, 1997

Mark Holborn, *Black Sun: The Eyes of Four,
Roots and Innovation in Japanese
Photography*, Aperture Inc., Millerton, New
York, 1986

Klaus Honnef, Rolf Sachsee and Karin
Thomas, eds., *German Photography
1870–1970: Power of a Medium*, DuMont
Verlag, Cologne, 1997

Tom Hopkinson, ed., *Picture Post 1938–50*,
Allen Lane, London, 1970

André Jammes and Eugenia Parry Janis,
*The Art of French Calotype with a Critical
Dictionary of Photographers, 1845–1870*,
Princeton University Press, Princeton, NJ,
1983

Marie-Thérèse and André Jammes, *Niépce to
Atget: The First Century of Photography
from the Collection of André Jammes*, Art
Institute of Chicago, Chicago, 1977

David King, *The Commissar Vanishes: The
Falsification of Photographs and Art in
Stalin's Russia*, Canongate, Edinburgh, 1997

Larry J Schaaf, *Out of the Shadows:
Herschel, Talbot and the Invention of
Photography*, Yale University Press, New
Haven and London, 1992

William Stott, *Documentary Expression and
Thirties America*, Oxford University Press,
Oxford and London, 1973

John Szarkowski and Shogi Yamagishi, eds.,
New Japanese Photography, Museum of
Modern Art, New York, 1974

John Szarkowski, *Looking At Photographs:
100 Pictures from the Collection of the
Museum of Modern Art*, Museum of
Modern Art, New York, 1973

Ann Thomas, ed., *Beauty of Another Order:
Photography in Science*, Yale University
Press, New Haven and London, in
association with the National Gallery of
Canada, Ottawa, 1997

Anne Wilkes Tucker, ed., *The History of
Japanese Photography*, Yale University
Press, New Haven, Connecticut and
London, in association with the Houston
Museum of Fine Arts, Houston, 2003

Margarita Tupitsyn, *The Soviet Photograph
1924–1937*, Yale University Press, New
Haven, Connecticut and London, 1996

Margarita Tupitsyn, *El Lissitsky: Beyond the
Abstract Cabinet, Photography, Design,
Collaboration*, Yale University Press, New
Haven, Connecticut and London, 1999

Index

Picture credits

Bibliothèque Nationale de France, Paris: 24, 27m, 27b; Bodleian Library, University of Oxford (Ref: Arch. K b.18): 69; The British Library, London: 23, 25, 26, 27tl, 27tr, 28, 29, 33, 35, 42, 44, 50, 51, 52, 53tl, 53tr, 54–55, 61, 66, 68, 70–71, 72–73; Early and Fine Printing Collection, Birmingham Central Library/Photo Brian Colier: 43; The Egypt Exploration Society, London: 58; The Manfred Heiting Library/Reproduction Robert Wedemeyer:103; Ryuichi Kaneko: 113, 178; National Museum of Photography, Film & Television, Bradford/Science & Society Picture Library: 32tl, 32tr, 53bl, 53br; Photography Collection Miriam and Ira D Wallach, Division of Art, Prints and Photographs, The New York Public Library, Astor, Lenox and Tilden Foundations: 46; Rare Books Division, The New York Public Library, Astor, Lenox and Tilden Foundations: 13, 30; Royal Geographical Society, London: 32bl, 47t; Simon Finch Rare Books, London: 31, 48; Spencer Collection, The New York Public Library, Astor, Lenox and Tilden Foundations: 20–21; Stuart Collection, Rare Books Division, The New York Public Library, Astor, Lenox and Tilden Foundations: 45; V&A Images: 22, 32br, 47m, 47b; Wilson Centre for Photography: 67.

Additional photography by Ian Bavington Jones.

Authors' Note

Whilst every endeavour has been made to standardize and ensure the accuracy of the technical book descriptions, cataloguing a publication is not as simple as it seems; often the most basic aspects require interpretation. With foreign titles, for example, the decision regarding a book's name is sometimes more a matter of personal interpretation than of simple translation. Many books, especially nineteenth-century ones, have long titles, subtitles and even sub-subtitles, raising the question of what exactly to include. We have opted for brevity in most instances. Nineteenth-century photobooks were often sold without binding so that individual owners could have them bound to their own specification. Some of the examples shown here have been re-bound by libraries for conservation purposes. In these cases, a fascicle cover rather than a bound volume is illustrated. Similarly, some early books were not consistent in the number of pages included, and thus page extents have not always been provided until they become more relevant. Even the publisher's details are open to interpretation, especially with co-editions, or where the book gives insufficient information. Some books do not even indicate the date of publication; others, such as Germaine Krull's *Métal* (Metal), may actually have been released prior to the given date. In these cases, the date printed in the book itself is cited. Usually, authorship is attributed to the person whose name appears on the cover of the book, even though this is frequently not the photographer. However, there are some anomalies. *Atget, Photographe de Paris*, for example, contains Atget's photographs and his name is on the cover, but in keeping with common bibliographic practice, authorship has been ascribed to Berenice Abbott. This is because Atget was dead when Abbott conceived and edited the book, and it is primarily her 'view' of his work. In the interests of clarity for the general reader, standard units of measurement are used, indicating the approximate page size rather than the cover. Japanese books that read right to left are presented accordingly. All books are first editions unless otherwise stated.

Authors' Acknowledgements

Many people have helped with this book in terms of feedback, information and ideas. We thank you all, but in particular:

Paul Arnot
Dirk Bakker
Ian Bavington Jones
Antoine de Beaupre
Sven Becker
Chris Boot
Adam Boxer
Victoria Clarke
Robert Delpire
Hans Dieter Reichert
Joan Fontcuberta
Bruce Gilden
John Gossage
Ed Grazda
Paul Hammond
Mark Haworth-Booth
Shunichi Ito
Ryuichi Kaneko
Chris Killip
David King
William Klein
Eric Chaim Kline
Muboko Kobayashi
Melissa Larner
Michael Mauracher
Corinne Noordenbos
Serge Plantureux
Amanda Renshaw
Mario Saggese
Marcus Schaden
Christoph Schifferli
Richard Schlagman
Renate Sextro
Bart Sorgedrager
Margaret Walters
Mari West
Samantha Woods

DATE DUE